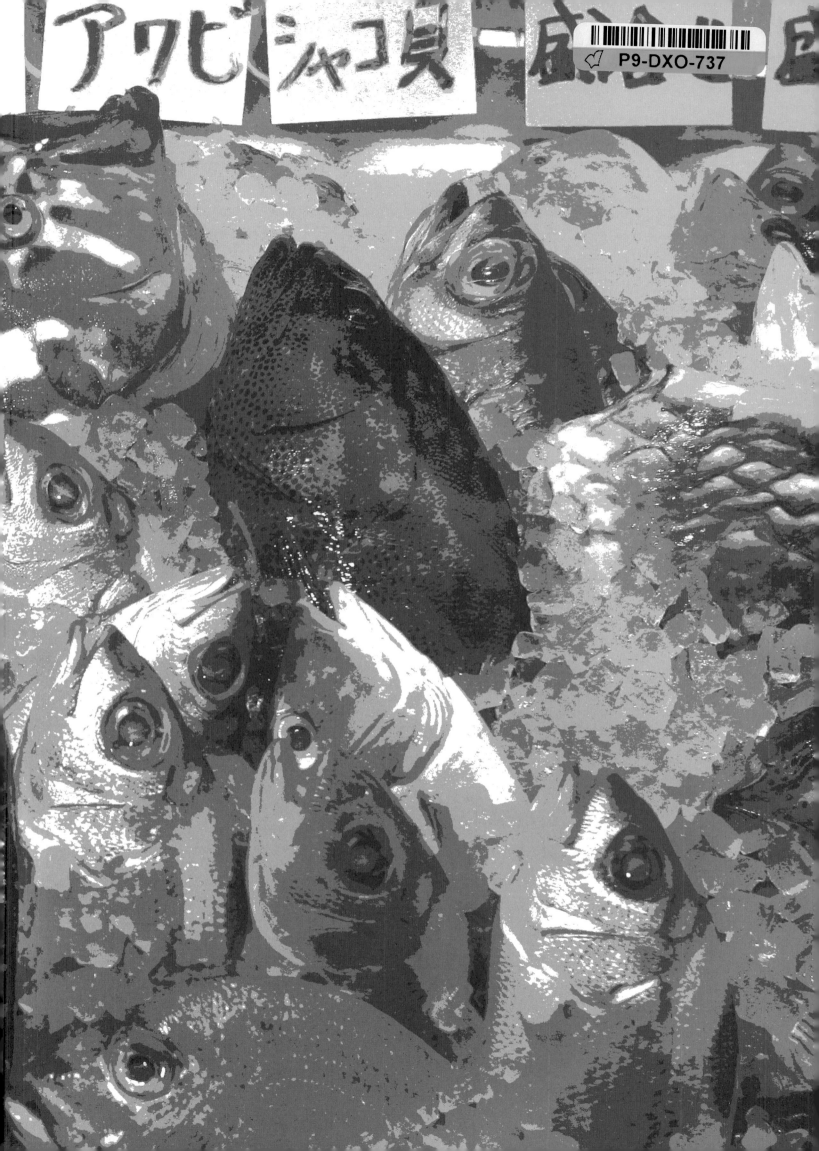

WHAT I EAT

AROUND THE WORLD IN 80 DIETS

Photographed by Peter Menzel

Written by Faith D'Aluisio

Foreword by Marion Nestle

This book presents 80 people around the world
and what they ate on one ordinary day. It is organized according to the
number of calories consumed, from least to most.

Material World Books
Napa, California

Ten Speed Press
Berkeley

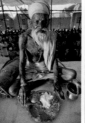
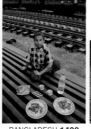
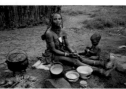

KENYA **800** KCALS PER DAY BOTSWANA **900** INDIA **1000** BANGLADESH **1400** NAMIBIA **1500** CHINA **1600** USA **1600**

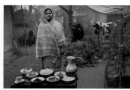
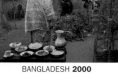

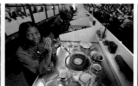
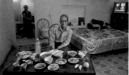
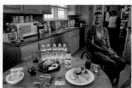
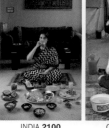

BANGLADESH **2000** USA **2000** NAMIBIA **2000** VIETNAM **2100** USA **2100** INDIA **2100** CHAD

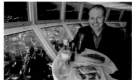
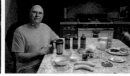
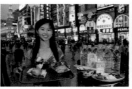
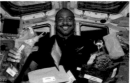
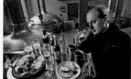

CANADA **2600** USA **2600** CHINA **2600** USA **2700** GERMANY **2700** TAIWAN **2700**

WHAT I EAT Around

LATVIA **3100** USA **3200** EGYPT **3200** USA **3200** YEMEN **3300** BRAZIL **3400**

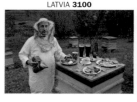
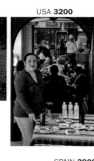
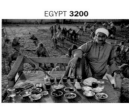
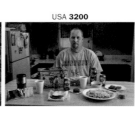
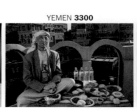
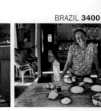

USA **3800** SPAIN **3900** LATVIA **3900** USA **3900** RUSSIA **3900** USA **4000**

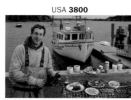
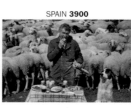
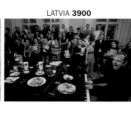
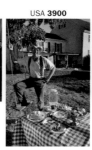
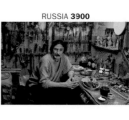

NAMIBIA **4300** GERMANY **4600** CANADA **4700** JAPAN **4800** TIBET **4900** IRAN **4900** BRAZIL **5200**

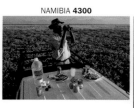
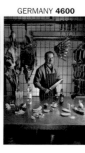
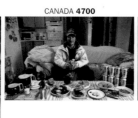
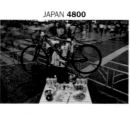
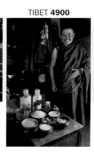
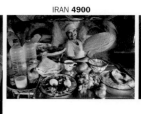
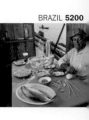

USA **1700** CHINA **1700** BANGLADESH **1800** CANADA **1900** USA **1900** USA **1900** CHINA **1900**

USA **2300** ICELAND **2300** IRAN **2400** USA **2400** INDIA **2400** KENYA **2400** VIETNAM **2500**

EN **2700** USA **2700** MEXICO **2900** INDIA **3000** **3000** ISRAEL **3100** KENYA **3100**

the World in **80** Diets

JAPAN **3500** USA **3500** USA **3600** GERMANY **3700** USA **3700** AUSTRALIA **3700** ECUADOR **3800**

Y **4000** VENEZUELA **4000** EGYPT **4000** USA **4100** SPAIN **4200** CHINA **4300**

USA **5400** TIBET **5600** VENEZUELA **6000** GREENLAND **6500** USA **6600** NAMIBIA **8400** GREAT BRITIAN **12300**

Contents

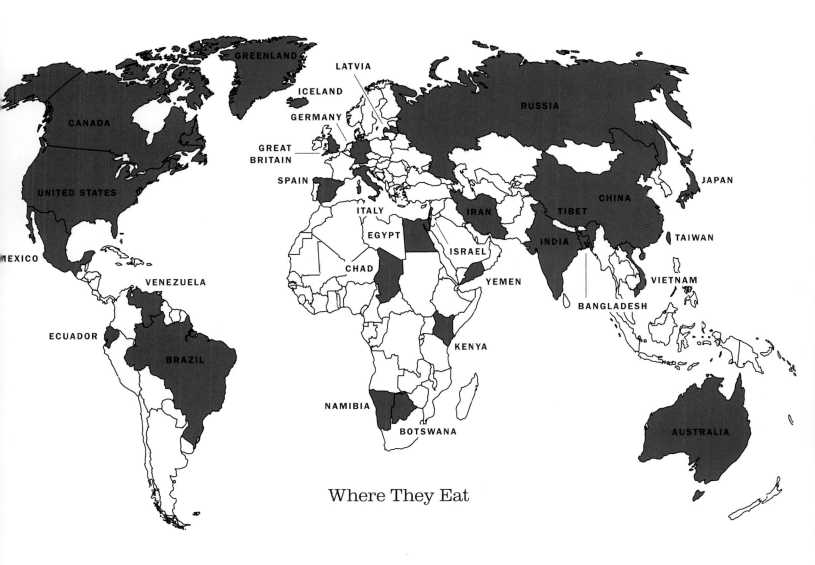

Where They Eat

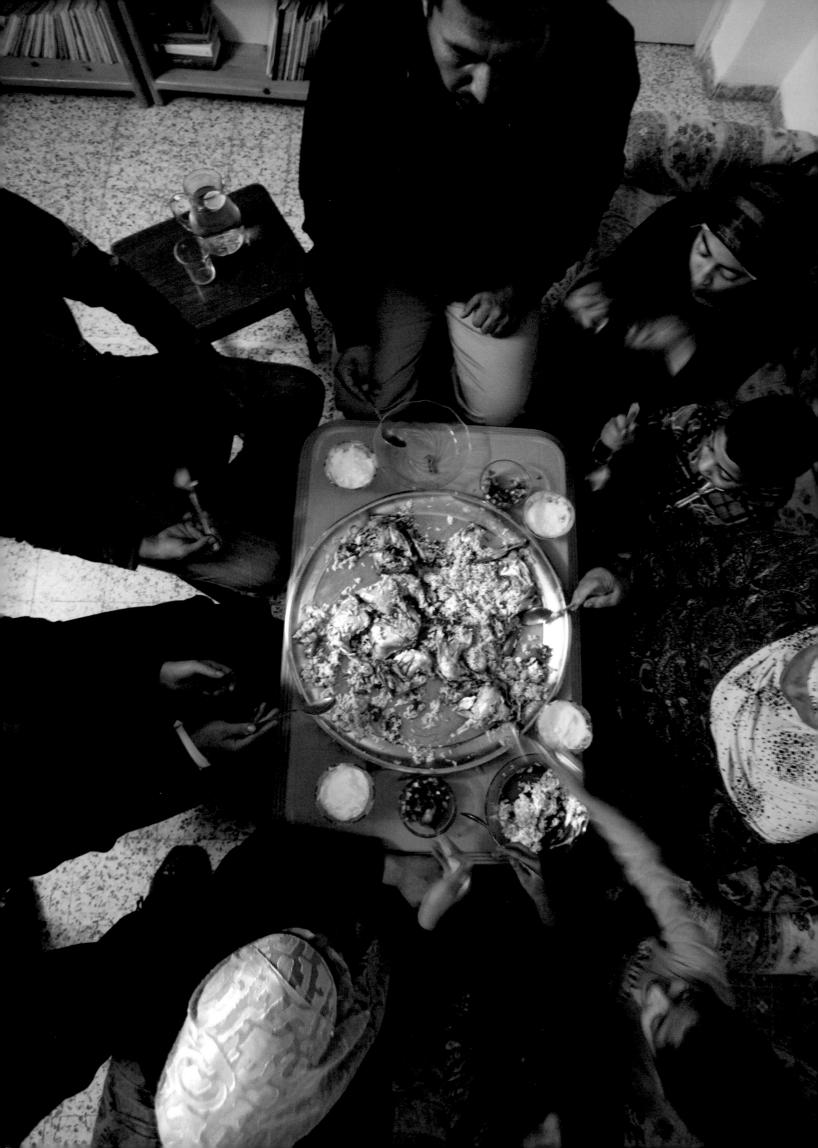

Everyone Eats

By Marion Nestle

In this astonishing and gorgeous book, writer Faith D'Aluisio and photographer Peter Menzel give entirely new meaning to the well-worn adage "You are what you eat." They searched the world to find 80 people who could hardly differ more in age, occupation, income, and nationality, but were willing to provide a list of everything they might eat in one day. In doing so, these people revealed volumes about their identity, culture, and daily life, and the world they inhabit.

What I Eat presents the stories people told of the foods they ate in one day, in sequence of the number of calories contained in those meals. Totaled up, the calories in their meals ranged from a starvation-level 800 to a seemingly impossible 12,300. Are such diets typical?

As Faith explains in her introduction, the calories listed here are not meant to be seen as precise representations of average daily intake. Instead, they are brief, impressionistic cross-sections that may well include under- or overestimations of usual daily food consumption. Even so, this book provides an incomparable documentary record of the stunning diversity of foods, diets, and occupations that sustain life in today's world.

Most of the people interviewed for this book say they have more than enough to eat, sometimes much more. Only a few do not, so the book begins, appropriately, with them. The Maasai herdswoman (800 calories) and the runaway Bangladeshi boy (1,400 calories) stand for the billion or so people in the world who go hungry every day, and the many more who barely get by.

For the rest of us, the variety of food choices is astounding. The stories in this book illustrate the unwelcome transition from traditional foods to processed junk foods as globalization expands. What people eat reflects the economic effects of globalization, as well as the effects of a globalized food supply on health and the environment. Together, these 80 diets have more to tell us about the human condition in this century than any textbook or statistical table ever could.

Let's thank Peter and Faith for giving us this magnificent document of the ways in which food affects our lives and actions, and gives us so much pleasure. They inspire those of us privileged to choose our diets according to our own desires—such as the luminaries who summarize their views below—to do so responsibly and ethically.

Abdul-Baset Razem and his family eat a midday meal of *makloubeh* (upside-down casserole of chicken, rice, and vegetables) in the Palestinian Territories.

I, for example, love food. The pleasure of food underlies my usual advice: Eat less, move more, eat plenty of fruits and vegetables, and don't eat too much junk food. I find this advice easy to follow, as it leaves plenty of room for choice while promoting a food system that is more just and sustainable and better able to provide enough delicious food for everyone on this planet, poor and rich alike.

Marion Nestle is the Paulette Goddard Professor of Nutrition, Food Studies, and Public Health at New York University and author of Food Politics *and* What to Eat.

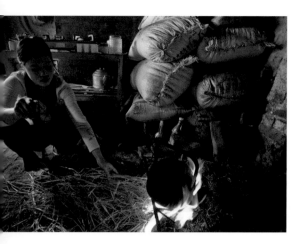

Nguyễn Thi Huong boils water for tea over a rice straw fire in the cooking house of her family compound outside Hanoi, Vietnam.

I rarely cook at home. I eat at work. **There is nothing in my refrigerator at home except fruit.**

> **Ferran Adrià** • *Head chef and owner of El Bulli, in Spain, regarded as one of the best restaurants in the world*

I've developed into a grazer at night. During the day I eat very little. When I sit down with the rest of the staff for our preservice meal, I like to have a green salad with white vinegar and olive oil, not much else. I want a clean mouth when service starts. I spend the evening tasting—sauce bases, grains, mountains of braised vegetables, and a steady diet of different meats and meat cuts. I taste to correct seasoning, adjust acidity, check doneness. I taste to learn how well we've trained the cooks. I taste to better understand the components of a dish. **I taste to stay in business. I don't taste for pleasure.**

> **Dan Barber** • *Winner of the 2009 James Beard Foundation Award for Outstanding Chef*

My diet was essentially Ameri-omnivorous with a heavy focus on meat (corned beef and hot dogs in early years, more international later) and animal products in general. At some point I saw the writing on the wall: This style of eating wasn't sustainable for me, or the land, air, or water, or, for that matter, the animals. **I devised a diet for myself that was called (by my friends) "vegan before 6 p.m."** For most of the day I eat nothing processed, no junk, no animal products. At night I do whatever the hell I want. I figure I've changed my calorie intake from 10 or 20 percent unprocessed plants to somewhere over 50 percent. I've done it over three years, and it's been easy and feels permanent.

> **Mark Bittman** • *Author of* Food Matters *and* How to Cook Everything

The only difference between "treat" and "threat" is the letter h. These harmful food habits include huge portion sizes and a high frequency of eating, especially high-fat and high-calorie foods. When we cut back on these habits, we can reclaim our health, and also dedicate the saved resources to those in obvious need. We call this "outdulgence"!

> **Graham and Treena Kerr** • *Chef and producer of* The Galloping Gourmet

The reason I took off more than 75 pounds in the last year was because nobody told me to. I realize taking off weight is a self-induced mental exercise. Although I glibly said I took off the weight by "shitting more than I was eating," my diet was even simpler. **I just ate less—a whole lot less. And my brain thought it was a good idea.**

> **Richard Saul Wurman** • *Creator of the TED and TEDMED conferences*

My food intake is tempestuous, a series of mad crushes that sometimes don't last long but can be very intense. I'm inconstant over time, and preternaturally ardent in the moment. For a week I'll fall into the grip of peanut butter, preferably crunchy, by the heaping spoonful, just before midnight, day after day. I had a torrid affair not so long ago with a lamb meatloaf with a salty feta heart. And of late I've fallen under the spell of chicken salad, so perfect with the right amount of mayonnaise, so receptive to my beloved dill. Add some slivered almonds and I'm a goner—at least for a short while.

> **Frank Bruni** • *Author of the best-selling memoir* Born Round *and former restaurant critic for the* New York Times

I travel for a living, mostly in remote areas. On assignment, I eat what is put in front of me. **Often you don't know if the chicken head floating in the soup is reserved for the honored guest or is a joke on you.** Best to assume the former. After 30-some years of this, I've developed a cast-iron stomach and catholic tastes. On the trail, I eat lightweight but filling oatmeal and couscous. At home, it's rib eye or elk steak, generally with my own perfectly made *chimichurri*, a salad in and of itself.

> **Tim Cahill** • *Founding editor of* Outside Magazine *and best-selling author*

You can learn to love or hate anything. Vegetables are a "free pass"—delicious and easy to love. Lemon juice is my preferred dressing, and steaming my preferred mode of cooking them. I try not to use oil dressing, even olive oil, which adds an amazing amount of calories. In general I avoid frying, or even sautéing in oil, and prefer grilling, steaming, and roasting. I try to teach myself not to like cheese (which

is hard), butter, milk, things that are "white" (flour, rice, etc.), desserts, sugar in coffee—sugar in anything except naturally in fruit, the second category I allow myself without hesitation. I try not to drink spirits but allow myself a few glasses of wine a few days a week (many calories). Also, I've learned that the portions we tend to eat are ridiculous. **I am better off with one-fifth of my original typical portion, so that old Italian tradition of serving food in family platters is gone.** (We used to eat our first plateful as fast as possible so we could take more from the family platter before it was all gone.) That's what I've learned so far in a life that is always changing. The key, of course, is to train myself to love the things that are good for me and eschew the things that are not.

Francis Coppola • *Filmmaker, wine producer, and hotelier*

Coming from a family farm where I milked cows, collected eggs, and butchered our animals, I gorged on the high-protein, high-fat diet, although we also had a big garden. Sometimes I ate the game that I'd hunted. Then I did a big research program on nutrition and cancer and had my head turned. The results favoring plant-based foods were dramatic, and also consistent with some remarkable work of others. Ever since, my wife, our five grown children, five grandchildren, and **I have been eating an entirely plant-based diet.** After our taste preferences changed, it's been no turning back, for over 20 years now.

T. Colin Campbell • *Jacob Gould Schurman Professor Emeritus of Nutritional Biochemistry at Cornell, and coauthor of* The China Study

Los Angeles is probably the most diverse food city in the world at the moment: the hub of a great agricultural area, the nation's largest port, the epicenter of twenty-first-century immigration, and the seat of the American imagination. As the belly tasked with making sense of it all, I couldn't imagine confronting a more varied diet, careening from pitch-perfect Modenese restaurant meals to live Korean seafood to armloads of perfect tangelos to the sensation that **I am assembling a cow's head in my stomach, one taco at a time.**

Jonathan Gold • *Pulitzer Prize–winning restaurant critic and author of* Counter Intelligence: Where to Eat in the Real Los Angeles

Everyone teases me about my diet. I don't eat much, and I don't think about the calories or nutritional value at all. In the early 1970s, when I first learned about intensive (factory) farming, I became a vegetarian. **Since I stopped eating meat, I have felt "light" and believe this is why I have so much energy.** If everyone thought about the food they eat—where it came from, how many "food miles" it traveled, and how it was produced—they would probably make changes in their eating habits, especially if they were to think of how the production of huge quantities of cheap meat affects the environment, the suffering of the animals, and human health.

Jane Goodall, PhD, DBE • *Founder of the Jane Goodall Institute and UN Messenger of Peace*

My favorite food, bar none, is brussels sprouts—roasted, sautéed, or (most often) steamed for just a few minutes, not too long, not so long that they lose their crunchiness or bright green color. Spaghetti with pesto sauce, or with olive oil and garlic and topped with a little chopped parsley or a sprinkling of peas, followed by a salad of romaine lettuce and arugula with vinaigrette, accompanied by a glass of red wine and a bottle of seltzer—that is my idea

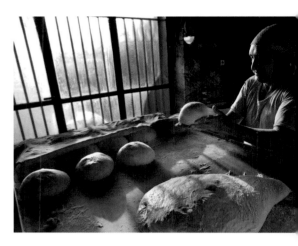

Baker Akbar Zareh, who works seven days a week, prepares rounds of dough that he'll bake in his gas-fired clay ovens to make flat cracker bread in Yazd, Iran.

of a perfect meal. While I'm cooking, a martini is nice, made with gin straight out of the freezer.

Hendrik Hertzberg • *Senior editor of the* New Yorker *and author of* ¡Obámanos!: The Birth of a New Political Era

I'm a thin restaurant critic, something people don't like. It's by design, not happy genetic accident. After losing weight on a sensible diet just as I was hitting teendom, **I eliminated temptation by giving in and deciding to eat what I want most.** That's sugar, bread, cream, and cheese—the perhaps not fantastically healthful staples of my diet, but amply supplemented with constant fresh vegetables and meat (artisan-raised of course!), and (sustainable) fish. And I eat pretty much all the time, always keeping a bit of appetite for the next taste.

Corby Kummer • *Restaurant critic, coauthor of* The Pleasures of Slow Food, *and a senior editor at the* Atlantic

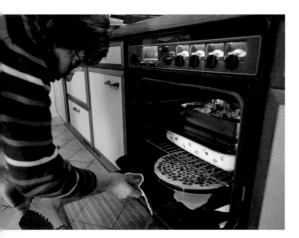

Marie Paule Kutten-Kass checks the cherry custard cake and the chicken that she's baking simultaneously for her family's lunch in Erpeldange in Bous, Luxembourg.

You are only as young as the last time you changed your mind, and **the easiest way to change your mind is to eat a food you've never eaten before**. The more improbable the food, the wider your horizon will be stretched.

> **Kevin Kelly** • *Senior maverick for* Wired *and author of* What Technology Wants

A few years **after high school, I read about the Maasai practice of drinking cattle blood for strength. I tried it for six weeks, drinking a quart a day** from a slaughterhouse in Oakland until I got a clot stuck in my throat. Now, 75 years later, I get all my protein from egg whites and fish. No cake, no pie, no candy, no ice cream, but I do have one glass of wine with my dinner. I work out every morning, seven days a week—even when I'm traveling. I hate it. But I love the results! That's the key, baby!

> **Jack LaLanne** • *The Godfather of Fitness and author of* Live Young Forever

One of the things I most love about food as a subject is its endless variety, and the bottom line on our understanding of food and health has seemed for some time to be that **the more biochemical diversity in our diet, the better**. For both of these reasons, I eat all kinds of things all the time and especially enjoy making and eating all-inclusive dishes: Asian curries and Mexican moles with a dozen or more ingredients melded together. The one thing I eat every day is yogurt from a culture I got from an Indian friend about 15 years ago and have kept going ever since.

> **Harold McGee** • *Author of* On Food and Cooking

For years Americans have lived under the pall of the food puritans, mostly feeling guilty because they can't adhere to the punishing dogma of skinless chicken breasts, bran cereal, skim milk, and raw broccoli. **The average eater can't stick to this soulless diet for long, so splurges on pornographic food: chicken nuggets, 32-ounce sodas, corn chips, and donuts.** The long-life alternative to these extremes is the diet of real, traditional, nutritious, delicious, satisfying food I've enjoyed my entire life: cheese omelets with bacon, rich homemade soups, pâté, caviar with sour cream, juicy sausage, aged cheese, beef stew, creamy raw milk, strawberries with whipped cream, and yellow grass-fed butter so thick on your bread that you make teeth marks in it. The best revenge is eating well.

> **Sally Fallon Morell** • *President of the Weston A. Price Foundation, founder of A Campaign for Real Milk and author of* Nourishing Traditions

I grew up in Texas on a diet consisting mainly of chili, cheeseburgers, and chalupas, washed down with Dr. Pepper. (Hey, if it's from a Dr., it has to be good for you, right?) When I was profoundly depressed and unhealthy at age 19, I began studying with an ecumenical spiritual teacher who patiently explained that if I began eating a predominantly whole food, plant-based diet, along with exercising and practicing meditation and yoga, I would feel better, not only physically, but emotionally. It was true. Now, three decades of clinical studies have proved that this approach can often stop or even reverse chronic diseases including coronary heart disease, prostate cancer, type 2 diabetes, elevated cholesterol, high blood pressure, and obesity. Our latest studies show that **when you change your lifestyle, you change your genes**—turning on genes that prevent disease and turning off genes that cause prostate cancer, breast cancer, heart disease, and other illnesses—over 500 genes in only three months.

> **Dean Ornish, MD** • *Founder of the Preventive Medicine Research Institute and author of* The Spectrum

"Why aren't you fat?" People always say it accusingly, as if someone who's spent her life writing about food and restaurants should be overweight. The answer is that I eat with all my senses and savor every bite. **The trick is to understand your own hungers—and follow no rules.** Your body knows what it needs; you just have to learn to listen.

> **Ruth Reichl** • *Author, editor, and restaurant critic*

The key to my diet is provenance. It is dictated by what is available that is locally produced, seasonal, and organic. **I'll deprive myself of tomatoes for the whole year until they are ready, but when they are, I truly enjoy them.**

> **Alice Waters** • *Chef, activist, author, and founder of Chez Panisse and the Edible Schoolyard*

At 31, I was a young academic physician and neuroscientist full of ambition and hubris. Then, one October evening, I replaced a missing subject in my own brain scanning experiment—and discovered I had brain cancer. For years after the initial treatment, I continued to eat lunch the way I had perfected it, standing up in the elevator between my lab and the clinic: chili con carne, a white bagel, and a can of Coke—every day. **After I relapsed and had to go through treatment again, I became curious about how I could strengthen my body against cancer.** It started with food. I've become a Mediterranean eater: many vegetables, much fish, splendid fruits, herbs and spices, and very little red meat, sugar, or white flour. I still can't get over the fact that I feel so much healthier now than I did before I had cancer!

David Servan-Schreiber, MD, PhD • *Adjunct professor of general oncology at the M. D. Anderson Cancer Center and author of* Anticancer: A New Way of Life

For the most part, we maintain a Chinese takeout and pescatarian household. I cook whatever veggies Farm Fresh to You delivers that week and compost the scraps. Beans, tofu, rice, potatoes, and pasta are staples. For fish, I consult two iPhone apps, one to find species with low mercury levels, the other to see if they are sustainable. We don't make it a habit to have junk food in the house, but in airports and at truck stops, I buy Cheetos. When traveling in other countries, I always eat the local cuisine, but just the vegetarian offerings. There are occasional slip-ups in translation: The sautéed "beans" turned out to be bees. The popular local snack that looked like Cheetos was actually deep-fried larvae.

Amy Tan • *Best-selling author*

I grew up eating a very mainstream mid-twentieth-century diet. Through college and medical school I ate anything and everything, often in great quantity. Then in 1970 I made a lot of changes in my lifestyle, including my food choices. I saw that at age 28 I was overweight, not in shape, and not prepared to undertake the kinds of travel and exploring I wanted to do. **I took up yoga, increased my physical activity, practiced meditation, and became a lacto-vegetarian.** My body responded dramatically, motivating me to continue on this path. I started eating fish in the mid-1980s and now mostly eat fish and vegetables. I grow a lot of my own food and love to cook. My nutritional philosophy is summed up in my anti-inflammatory diet, based on the Mediterranean diet. I avoid refined, processed, and manufactured food, and love olive oil, vegetables of all kinds, good Japanese food, green tea, and dark chocolate.

Andrew Weil, MD • *Founder of the Arizona Center for Integrative Medicine and best-selling author*

Growing up in a Midwestern agricultural family, my interest in food started early. I later studied food science, medicine, and public health, and my research has tracked the diets of several hundred thousand people for three decades. We have seen that **replacing refined starches, sugar, red meat, and dairy foods with whole grains and plant sources of proteins and fats is associated with far better long-term health and well-being**. Fortunately, this led me to the traditional Mediterranean diet, which is far more enjoyable than the beef, mashed potatoes, and gravy of my childhood.

Walter Willett, MD, PhD • *Professor of epidemiology and nutrition at the Harvard School of Public Health*

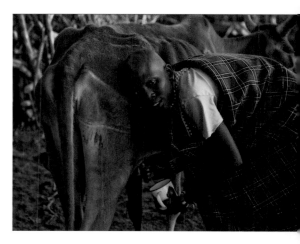

Noolkisaruni Tarakuai, the third of four wives of a Maasai chief, milks a drought-stricken cow at her home near Narok, Kenya, and is able to draw only a half cup of milk.

In my twenties I studied the diet of wild chimpanzees by staying with the same individual from dawn to dusk. Long walks were accompanied by crawling, climbing, and running through difficult brush. **Sometimes I spent the day without any human food.** Chimpanzee diets included about 10 to 20 different foods a day, but however hungry I was, the forest smorgasbord was a miserable experience. A find of a few wild raspberries brought rare joy, but mostly the fruits were as fibrous as sugarcane, and as strong in their flavor as crab apples or hot radishes. I could never come close to filling my stomach. Simple dishes of pasta or rice that awaited me in camp after dark became as rich a promise as any feast. We are a lucky species. Most other species would like to have their meals cooked. We alone get the privilege!

Richard Wrangham, PhD • *Ruth Moore Professor of Biological Anthropology at Harvard University and author of* Catching Fire

Around the World in 80 Diets

By Faith D'Aluisio

An Egyptian camel broker spends the day bargaining with butchers at a market an hour outside Cairo. During her rickshaw ride to work, a Bangladeshi seamstress uses the folds of her sari to shield her lunch from the rising dust on crowded Dhaka streets. In Kenya's Great Rift Valley, a Maasai mother draws a half cup of milk from a drought-stricken cow to mix with porridge for her herdsman. A U.S. long-haul trucker stops his 18-wheeler for a fast-food lunch in Illinois. They are among the 80 individuals from 30 countries who agreed to share what they eat and other details of their lives in this book.

What I Eat: Around the World in 80 Diets is a showcase of real people and what they eat, from the frigid North Atlantic waters off of Iceland to the steaming Amazon Basin and from Africa's Great Rift Valley to the Tibetan plateau. It invites you to explore the lives of people in the farthest reaches of the world, and maybe the people in the house next door, to see how your own diet compares.

Five years ago my husband, photojournalist Peter Menzel, and I ate our way around the globe and produced a book detailing what 30 families in 24 different countries consumed in one week's time. The book, *Hungry Planet: What the World Eats*, presented portraits of these families posed with one week's worth of food, along with stories about their daily life. Around the time that the book was published, nutrition had come to the fore as a topic of national and international conversation. Concern over rapidly rising rates of chronic diet-related diseases linked to overconsumption reinforced statistics that showed we'd entered a new world order: For the first time in the history of the planet, overfed people outnumbered the underfed.

Rising incomes around the world explain some of the overconsumption. As people have more disposable income, they tend to move away from a basic diet of whole grains, legumes, and vegetables and eat more meat and dairy products, more sweets, and more processed food. Labeled "nutrition transition," this shift to more fattening foods is universal. If there's money to be made, marketers and marketeers rush in.

The response to the book and subsequent exhibitions was overwhelming, fueled in part by readers' interest in comparing their own families to those in the book, for better or worse. But even before its publication, we had begun a new global trek taking our original concept—the food portrait—and applying it to individual people. We traveled around the world again, this time portraying scores of people from disparate backgrounds, each with one typical day's worth of food. The result: *What I Eat: Around the World in 80 Diets*.

A patron finishes his meal at a Shibuya-area fast-food restaurant in Tokyo, Japan. The Wendy's hamburger chain closed all of their 71 restaurants in Japan at the end of 2009.

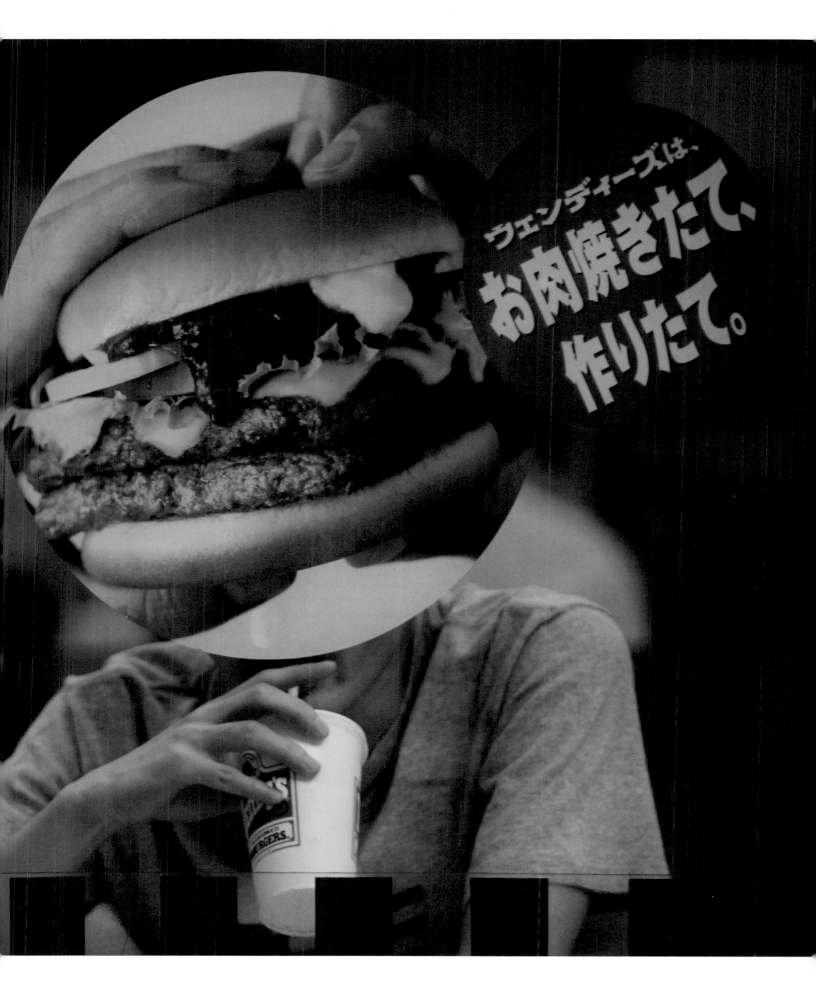

ウェンディーズは、お肉焼きたて、作りたて。

Introduction

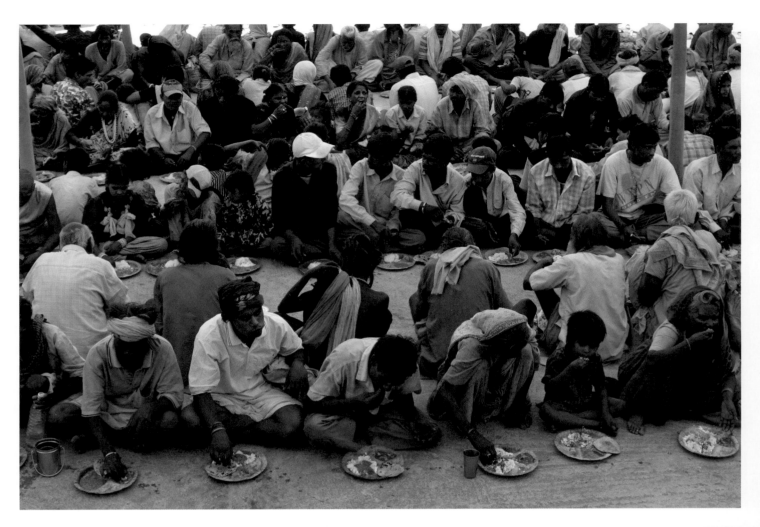

During the Hindu festival Kumbh Mela, thousands of pilgrims eat free meals of vegetarian curry and dal (above) served by volunteers at an ashram in Ujjain, India. At right: A saleswoman staffs a fish counter at the Central Market in Riga, Latvia—one of Europe's largest and most ancient markets.

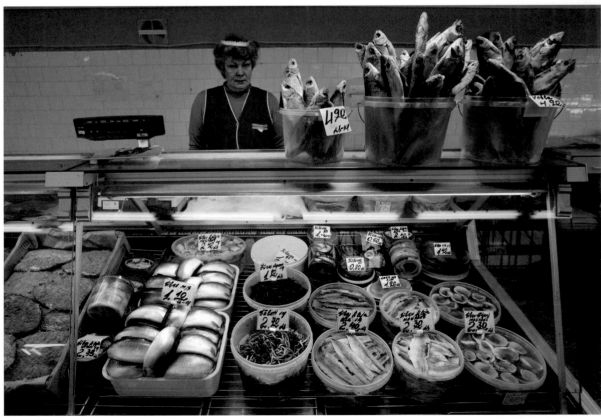

The Order of the Book • The idea of a day's worth of food as a snapshot in time is the construct for *What I Eat*—the conceit, if you will: a day's worth of food on one ordinary day for people from all walks of life, from all over the world. We've organized prior books around the geographic location of our subjects and arranged them in alphabetic order or by continent. In *What I Eat*, profiles are arranged by calories consumed, from least to most. Our five Chinese subjects (a high-rise welder, a farmer, an acrobat, a video gamer, and a college student) appear in the book where their calorie count drops them, as do the two Latvians (a beekeeper and a voice coach), the two Spaniards (a bullfighter and a shepherd), and scores of others from around the globe. All are presented in a food portrait with what they ate on a typical day, at a particular moment in time, along with a thoroughly documented food list detailing that day's worth of food. The accompanying essays help situate them in the global community.

I worried initially that organizing the book around a count of calories would cause readers to think that number represented the average caloric intake for that person over time, but it doesn't. The coverage in these photoessays is based on what a person ate on a recent typical weekday, plucked from memory of that day, eating habits, personal preferences, and larder. This is not a clinical study or ethnographic food census, nor is it meant to look like one. Whatever was eaten on that day became the basis of the coverage. Bangladeshi seamstress Ruma Akhter's 1,800 calories (page 62) dwindle at the end of the month as she and her family run out of cash before her payday at the factory. New York model Mariel Booth's 2,400 calories (page 110) could rise or fall depending on whether she's slimming down for a job or indulging in comfort food with her boyfriend. Conversely, calorie restrictor Michael Rae's calorie count (page 72) does only what he commands it to do, as he deftly crunches the numbers and bends the calories to his will.

We decided against evaluating people's level of physical activity, relying instead on the photographs, story, and life circumstances to help readers gauge for themselves how active or inactive each person is. There's no usable scale across cultures. Even seemingly simple labels like "strenuous," "active," "moderate," and "sedentary" were too ambiguous and arbitrary to employ.

The Middle • Perhaps unsurprisingly, many of the people in *What I Eat* bunch up in the middle of the book—in the 2,000 to 4,000 calorie range—but in isolation, the numbers have less meaning. They must be understood in the context of the person's life.

For example, the calorie count for sumo wrestler Miyabiyama (page 204) is 3,500. The mountain of a man spent years force-feeding himself many more calories than that to achieve his fighting weight. Now it takes fewer calories to maintain his 400-pound bulk. The week we interviewed him, he was in training for a tournament—one of six big yearly matches—so he wasn't drinking alcohol or eating at restaurants with sponsors of his club. His calorie count would have been higher at those times.

The calorie count of Tennessean Rick Bumgardener (page 50) is 1,600—a seeming impossibility in relation to his size and weight (468 pounds), but the day's worth of food pictured is his weight-loss diet as he struggles to qualify for obesity surgery, which he currently weighs too much to undergo. At the time of our visit, Rick's food options were a mere shadow of their former composition, and the retired school bus driver reported that he often missed his target. "I didn't get to this size eating rabbit food," he said, eyeing his unlimited supply of raw vegetables.

At 800 calories for a day's worth of food, Noolkisaruni Tarakuai of Kenya (page 22) has the fewest calories of our 80 individuals, so she appears first in the book. Jill McTighe of Great Britain (page 320), who struggles with binge eating, appears last with 12,300 calories. Neither woman's day's worth of food would be sustainable for very long, but including them is informative.

In the big picture of life, Jill's binge that day would be moderated by other days when she might eat only 5,000 calories, or fewer, but on still other days, she might have consumed more. Her diet wasn't sustainable in the long term and she knew it, even at the time of the photograph. We include a postscript in which Jill reports on how she's faring now.

At the other extreme is Noolkisaruni, whose diet of 800 calories on the day we covered her is also unsustainable in the longterm. But from time to time she eats part of a goat or receives food aid. If the rains start, her animals will give more milk. If you looked at her diet over, say, a month or more of daily calorie counts, her average daily caloric intake would be higher. But on that particular food-stressed day on the semiarid plain, Noolkisaruni ate porridge, a little milk, and a piece of fruit her husband brought her.

It is the same for all of the people covered in this book: Their calorie counts are a direct reflection of the circumstances and moment in time when we covered them. Carpenter's assistant and part-time tattooist Louie Soto (page 152) has days when he follows his weight-loss diet and days when he doesn't. He said that he toes the line most of the time in an effort to get to a healthier weight, but still doesn't eat many vegetables. "We tried to start buying them," he says, "but it's kind of more expensive so we switched back to 'regular' foods." Markus Dirr (page 272), whose business is meat, eats a lot of it. He's also a caterer and tastes whatever he makes. If we had covered him on a catering day when he was preparing meat in puff pastry, it would have been in his food portrait, and his calorie total would have been affected accordingly.

Because we focused our attention on regular workdays, there's no alcohol listed for people who imbibe only on weekends, unlike Slava Grankovskiy (page 238) in Russia and Ernie Johnson (page 208) in the United States, who both copped to two to six beers a night—or Peter and myself (pages 328 and 329), who both have wine or beer with dinner.

A common hazard in field work, especially where food (and drink) reporting is concerned, is that people sometimes tell you what they think you want to hear, or try to present themselves in the best light. Most people don't do so on purpose, but knowing this, we employed our years of journalistic experience to provide as accurate coverage as possible. That said, one extra tablespoon of vegetable oil adds around 120 calories to a bottom-line calorie count—every little bit, a slippery slope.

The Fieldwork • When we went to a country, we had usually already determined the occupation of the people we'd seek and the region in which they'd live, but not exactly whom we would cover. We chose subjects from all walks of life and then worked with them to figure out what would constitute a typical day's worth of food. As an example, in Kenya's tea-growing Kericho district, we found Kibet Serem (page 170), the son of a tea plantation owner. The personable 25-year-old agreed to participate despite being

busy and we followed him around his parents' farm as he milked his cows. Over the course of several meetings, we learned about his life, his plans, and his day-to-day diet. His mother, Nancy, gave us a cool, fermented grain drink to enjoy as we worked, and we shared their lunch of rice and beans.

In discussions with Kibet, we determined that the previous day was a typical food day for him and drew up a detailed list of what he ate to provide the basis for the food in the photo. Kibet's mother and sister-in-law helped ensure that the food on the list was correct, and we continued to make adjustments right up until the portrait was done. Sometimes we had to make adjustments afterward. If something showed up that was redundant or turned out to be incorrect, we noted that in the written food list and ensured that the calorie total was accurate.

Occasionally food disappeared before a photograph. This happened with the bird plums in Viahondjera Musutua's list (page 40). They were eaten before we could photograph her and therefore are listed but noted as not being in the picture. In Shanghai, when KFC neglected to put Chen Zhen's french fries in the bag with her typical order (page 132), we had to do her photo on Nanjing East Road without them, as we raced to stay a step ahead of the police. They were trying to shut us down because they thought we were shooting a KFC commercial.

Peter usually prefers to ask for forgiveness, rather than permission. We practiced for a quick setup and takedown of bike messenger Yajima Jun's day's worth of food (page 280) before we shot his portrait at a bustling Tokyo intersection at rush hour without a permit and within view of a police substation. We took the photo with no one the wiser—and then got to do it again the next day after the camera memory card containing the best shots failed.

At times we bridged a cultural divide. In deeply conservative and patriarchal Yemen, men and women who aren't related don't sit together in conversation, but Fadhil Haidar permitted us to interview his wife, Saada (page 146) for a food portrait. A female translator couldn't come to Saada's home, so our 26-year-old male translator, Sami al Saiyani, who translated Ahmed Ahmed Swaid (page 192), the qat merchant, stepped in. "I cannot talk directly to her," Sami told us, so we made do with a makeshift method of indirect communication that I've employed before: "It was the first time for me to sit with a girl not in my family," Sami says. "I worked with you and we sat together in their house, but even today I have never seen her face. Her face was uncovered but I looked at Fadhil. When she talked, I talked to Fadhil, and when I asked a question, I talked to Fadhil. I was too shy to look at her."

After shooting the food portraits, we weighed all of the food with a digital scale—a big hit in the developing world, especially in the yak herder's tent in Tibet (page 302). If people ate in restaurants, we got recipe information from the chef. Iraq war veteran Felipe Adam's favorite café, Petite Sara, deconstructed his chicken sandwich for us (page 94).

It's instructive that our seemingly simple method didn't always work as planned. Penetrating the layers of the government oil company bureaucracy in Venezuela to get permission to board a remote oil platform in the middle of Lake Maracaibo was only the first frustrating step in completing the portrait of Oswaldo Gutierrez (page 308) on the helipad of the rig at dusk. But who would have thought that determining a day's worth of food for two topflight chefs would be even more

fraught with peril? We wanted to include chef Dan Barber (page 17), of Blue Hill at Stone Barns in upstate New York (and Blue Hill NYC), and Ferran Adrià (also page 17), owner of El Bulli, the famed restaurant on Spain's Costa Brava, but they aren't among the 80 individuals covered with a food list in this book. It turns out that their diets consist of too many incalculable single tastes of too many different dishes in the course of a night's service.

Dan, who's a friend of ours, did in fact share his day's worth of food. It was a healthy work of art hailing from Stone Barns' sustainable kitchen: yogurt and seasonal fruit (blueberries that Dan raved about), and fresh tomatoes, corn, and peas from the gardens. And then there was the matter of that small table we set up in the rear of the photograph to document his guilty pleasures: chocolate chip cookie dough and brownie trimmings. Dan said that he no longer ate that stuff, but he had quit so recently that I insisted we include it. "This is all in the past," he asserted. But he also said, "I'm really learning what it is about that. Food is love. At the end of the night, I'm done; there's exhilaration. It's over. There's tension, then there isn't. You're alone now. At that time of night [1 or 2 a.m.] that's comfort food." We represented the tasting he does by fanning out spoons and taping them in place, and then the kitchen staff applied the food. Still, those tastings made it near impossible to pin down his actual calorie count, so we settled for simply including the photograph here.

Trying to pin down Ferran Adrià's day's worth of food was harder than getting a reservation at his restaurant. Every time we thought we had an answer, we found that we didn't. We spent two days in that kitchen and came away knowing only that the man does eat a preservice meal with his staff before the restaurant opens, and that much of what El Bulli serves is developed in Ferran's laboratory kitchen in Barcelona. He taste tests in both places. Ferran provided an engaging example of how people's diets change. When I interviewed him at El Bulli, he said the only item in his fridge at home was beer. When we asked him again recently, that sole item had turned into fruit (page 8).

Pulitzer-prize-winning Jonathan Gold was just as elusive. The hands-on, stay-at-home dad is also the food critic at *LA Weekly*, and his food list was as slippery as Ferran's. It felt a bit as if by nailing down his day's worth of food I would somehow be stealing his soul. We did his photograph with what he reluctantly approximated was his day's worth of food, but later decided to forgo the food list in the book and let him delight in food on his own terms, writing about it in ways that no one else does. We're quite fond of the photo, which appears on page 327, but in hindsight we wonder whether we should have obscured the food as we did his physical identity. We were far luckier with food professional Lourdes Alvarez (page 180), owner of a Mexican restaurant outside of Chicago, whom we followed around as she cooked for her own food portrait. We did the photo at her dad's restaurant, where she grew up cooking at his side.

After we returned home, the tedious part began. Along with transcribing countless hours of interviews, we parsed the ingredients of every food item in the photos so the calorie counts could be calculated. And long after the portraits were taken, we continued to correspond with the subjects and translators about recipes, quantities, and preparation.

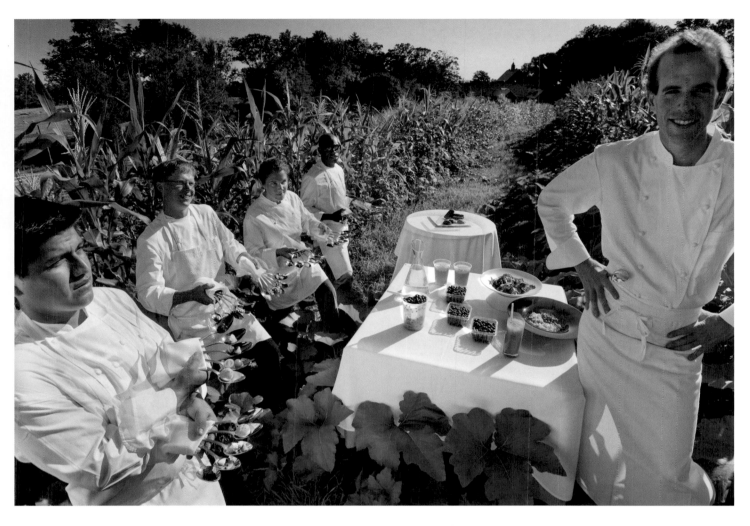

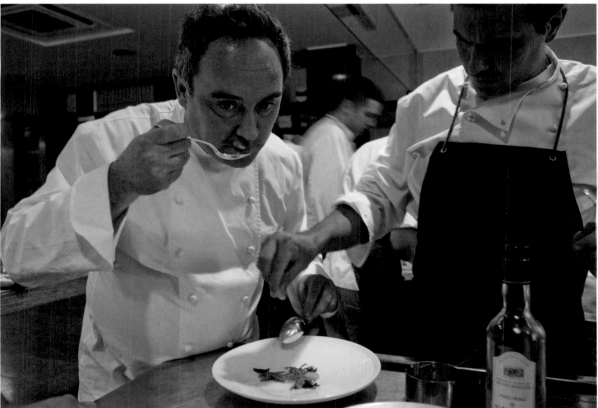

Chef Dan Barber (above) with his day's worth of food at his restaurant Blue Hill at Stone Barns, in Pocantico Hills, New York. Staff hold spoons representing the hundreds of tastes he takes during his cooking day. At left: Ferran Adrià, chef of El Bulli restaurant on the Costa Brava in northeastern Spain, tastes throughout the afternoon and evening as he oversees the chefs at his world-famous eatery.

Introduction

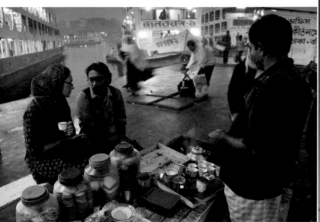
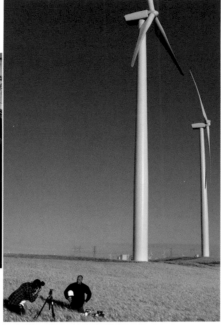
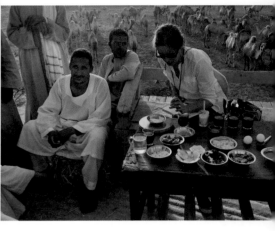

In the field, left to right: Buriganga River dock interview at dawn, Dhaka, Bangladesh. Photographing John Opris in California. Weighing Saleh the camel broker's food at Birqash Camel Market, outside Cairo, Egypt.

The Food List Methodology • We had hoped to find at least general calorie counts as a starting point for typical dishes (combination foods) in different countries but soon discovered that, while there was some research and nutrition data for specific food items, the overwhelming majority of combination foods were a caloric enigma not easily quantified. We did our own research.

As we calculated recipe breakdowns based on information from our subjects, our translators, and our agents, we were careful to gather information specific to the region we covered. India is a good example of this complexity. While the nation is largely vegetarian for religious, cultural, and economic reasons, commonality stops there. Recipes and dishes vary widely from north to south and east to west.

We covered Shashi Kanth (page 160) in the south, in Bangalore; his mother, Sumithra, who is from Mangalore on the southern coast, made a regional spicy *sambar* for us and cooks with a lot of coconut, which is widely used in dishes there. In central India, an ashram served Hindu ascetic Sitarani Tyaagi (page 30) and his fellows moderately spicy *toor dal* with white rice, potato curry, and *puri*. In northern India, Munna Kailash's wife, Meera (page 112), made spicier dal and curry on her hot plate in the small, cramped courtyard of their home while the bicycle rickshaw driver lounged in the midday heat and waited for lunch.

Our fieldwork was followed by months of work on the food lists. Staffer Kendyll Pappas finished the hard work of the lists with a final long-sought response from Katherine Navas (page 250) in Caracas, after months spent trying to reach her to verify facts. Kendyll and copy-editor-without-equal, Jasmine Star, worked hard at massaging the lists to be both correct and understandable to the reader. The underlying data is rigorous and sound—and still flying around in the ether on the Google Cloud (usable with variable degrees of success), where it was shared by nutritionists Colette LaSalle, RD, and Mary Nicole Regina Henderson, MS, RD, students at the University of California at Davis, as well as our agents and translators around the globe, all working together to research and hone the material.

Clarifications took up perhaps the largest part of our time in the completion of this book. Our translators and subjects suffered for months as we queried, requeried, and requested backup information.

After several requests for information regarding a Hanoi-style recipe for the Vietnamese noodle dish *pho*, our translator in Vietnam, Do Minh Thuy, kindly but firmly emailed this: "Don't worry if someone tells you to add white onions, bean sprouts, and sugar to the mixture. It's only because people in the south have different taste for *pho* than people in the north." Our longtime translator and intrepid travel companion in Taiwan and China remained tireless in pursuit of the truth. That's our son Josh, who plumbed the depths of the Taiwan Department of Health and obscure Chinese sources on our behalf to provide answers to thousands of questions.

We had long conversations with researchers at the U.S. Department of Agriculture (USDA) and with others about what we could and could not compare. After much research, we developed a strict set of guidelines that ruled which nutrition databases we would use to calculate calories. Some, like the database developed by McGill University's Centre for Indigenous Peoples' Nutrition and Environment, were used for quite specific purposes. Others were used more often and more generally, but before turning to them we first made sure we were comparing "apples to apples." This included knowing whether a database computed for an edible portion, or a portion including refuse. Additionally, some databases provided a confidence rating for different pieces of information, which was helpful.

The USDA nutrient database is the big kahuna of food composition databases. It's easy to use and up-to-date. We used that and several others, including Max Rubner-Institut's Bundeslebensmittelschlussel, a German nutrition database. A list of the databases we employed appears on page 332. Our nutritionists calculated calorie content in combination foods from ingredient lists and amounts that we supplied, using the software Food Processor SQL and INFOODS, the International Network of Food Data Systems, created by the Food and Agriculture Organization of the United Nations.

When in-country calorie data was available we used it, but in many cases, especially in the developing world, it wasn't, so we used the USDA database and other large databases. As long as we were only calculating calories and not delving into the complexities of other nutrients, this wasn't much of an issue. To provide more accurate

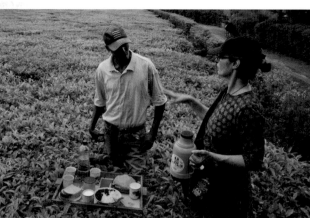

In the field, left to right: Photographing Ansis Sauka and the Kamer Latvian youth choir in Riga, Latvia. The authors at the Jameh Mosque in Yazd, Iran. Arranging Kibet Serem's food portrait in his tea field in Kenya.

information on unusual foods or practices, we consulted researchers who helped us answer specific questions. For example, when we needed to calculate the caloric value of butterfat consumed by the Himba, who were primarily milking beef cattle, we turned to Professor P. G. Bille at the University of Namibia. The Himba's traditional whole milk has less butterfat in the rainy season than commercial whole milk, and Professor Bille had the numbers for our rainy season coverage. We got values for fermented Tibetan milk from Professor Jyoti Prakash Tamang, who studies traditional foods at Sikkim Government College in India. Works we consulted on heritage grains and modernization of the food supply in Africa were invaluable.

So, given all this, who were the easiest people to calculate? Namibian Teri Bezuidenhout and American Jeff Devine, who both eat from the global marketplace. Teri (page 318), the Namibian long-haul trucker, bought all of his food for the road in easy-open packages imprinted with lists of ingredients and calorie totals. (At home he ate differently—typically cornmeal porridge and boiled beef—and his girlfriend was jealous that he got to eat processed foods on the road.) Most of Chicago ironworker Jeff Devine's food (page 316) was also packaged, including his numerous bodybuilding supplements.

Who was the hardest to calculate? Millie Mitra in the south of India (page 98), who employs a cook, has exacting tastes, and eats small portions of many dishes with many ingredients.

The Foreign Words • The food lists have undergone several metamorphoses to make them interesting, accessible, and accurate. One hurdle was the naming of foreign dishes. When the name of a single ingredient such as *sak* (green leafy vegetable) in microloan recipient Shahnaz Begum's food list (page 80) in Bangladesh is also used as the name of a dish with many ingredients, we generally dropped the foreign name if we were unable to make it clear without explanation.

Street vendor Lin Hui-wen's late-night snack, fried *cougan*, is dried tofu—but an entire dish made with *dougan* and other ingredients might be called *dougan* as well, so we separated the ingredients to make it clear (page 140). In some cases, we had to leave out minor ingredients because of space constraints; however, the main ingredients are always listed, and we tried to include specific spices and herbs as space allowed. In some cases, oil was included in the weighed portion of a food item. When extra oil was added, it generally appears as a separate item, but not always.

Words like *roti* (which means "bread" in a variety of languages) weren't always as descriptive as we needed them to be, so we used a description instead, for example, "whole wheat flat bread" rather than *roti*. Using the common name plus the description might have made it seem as though *roti* is always whole wheat flat bread. There are other similar cases where we opted not to include local names, for clarity.

The Diacritics • Because we cover so many different countries, many with their own set of accents, ensuring accuracy and consistency in regard to diacritics could have proven inordinately time-consuming. We opted to forgo diacritics altogether, except as a courtesy in personal names. We understand that this affects pronunciation and sometimes even meaning for native speakers. We regret any dissonance this may cause but do feel that the system we've implemented, for better and for worse, will work for most readers of this U.S. edition.

The Bottles and Boxes • Some beverage and package sizes may seem odd. This is typically because they were originally metric and then converted to U.S. units of measure, or vice versa. We included brand names when they existed; they appear in the food lists in italic.

Although water often appears in plastic bottles in order to hold it for the photo, if the individual didn't drink purchased bottled water, the labels were ripped off and no brand name appears in the food list. Coffee, tea, and creamers were problematic. Whether these appear with a combined volume or not, we computed calories for each ingredient, oftentimes using a recipe, such as in Bangladesh, where sweetened condensed milk, sugar, and tea are combined for one of the sweetest cups of hot tea on the planet. We compared the recipes of three different street vendors to determine values for a 7-liter (1.85-gallon) recipe and computed from there.

To learn more, visit us at www.aroundtheworldin80diets.com.

Introduction

The Foundation • It is only by virtue of the groundwork laid by others that we are able to view these 80 people around the planet through the lens of the seemingly simple premise of one day's worth of food.

In every country, the work we did was built on the work of others: food scientists and researchers, and cultural anthropologists who spend entire careers focused on specific peoples. Thanks to their scholarship, we could drop in on other cultures for days or a week and contextualize foreign ways of life based on their work, rather than starting at the beginning.

We also appreciate the insights of the seven essayists who contributed to this book, weighing in on different facets of the culture of eating. How and why did we leave our apelike ancestors behind in the forest and evolve into the dominant species on the planet? "Discovering cooking" is anthropologist Richard Wrangham's answer (page 78). What exactly is a calorie, and why is it important to understand the basics about this unit of food energy? Journalist Bijal P. Trivedi explains (page 120). Nutritionist Lisa R. Young of New York University discusses how portion sizes have gone terribly wrong (page 158), and veteran journalist and author Ellen Ruppel Shell makes sense of food taboos (page 242).

An adaptation of an essay by journalist and author Michael Pollan questions whether we are becoming less human as we relegate cooking, formerly a life-affirming daily activity, to a spectator sport (page 294). And we're honored to include an adaptation of Wendell Berry's essay "The Pleasures of Eating," written 20 years ago and perhaps even more relevant today (page 324).

A Bite of *What I Eat* • Despite the focus on individuals in this book, few like to eat alone. We had the pleasure of eating with many of our subjects as we worked our way around the world: beef and vegetable stew with Gordy and Denise Stine in Illinois; *uttapam* and *idli* with Millie Mitra in India; potluck Shabbat dinner with Ofer and Rachel Sabath Beit-Halachmi in Israel; fresh fish with Ernie and Andie Johnson in California; *tsampa* porridge with Karsal and Phurba on the Tibetan plateau; Crock-Pot beef stew with Louie and Jourene Soto in Arizona; shrimp and eggs with Sam Tucker in Maine; dark bread, honey, and cakes with Aivars and Ilona Radziņš in Latvia; honey-baked chicken with Joel and Teresa Salatin in Virginia; *chanko nabe* with the sumo wrestlers in Japan; *solyanka* and stuffed peppers with Slava and Larissa Grankovskiy in Russia; prosciutto and red wine with Markus Dirr in Germany; spicy chicken with Lan Guihua and pig knuckle soup with Chen Zhen and her family in China; fragrant *zereshk polow* with the Fotowat family in Iran; burgers with Kelvin and Deb Lester in Minnesota; pasta with Fr. Riccardo in Italy; and many others.

Our joys in life are to break bread with friends, reap harvest from the earth, know where our food comes from (and has been), and cook good food together. We humbly pursue these personal joys, which should be the right of every human being, and try to ignore the fact that the phrase "the joy of eating" has been trademarked by an American food and body care corporation.

Solange Da Silva Correia prepares her family's fish dinner by the light of an oil lamp at the kitchen window of their riverside farmhouse in Brazil's Amazon. With no indoor plumbing, she tackles anything messy on an overhanging counter, letting chickens and dogs clean up the scraps below.

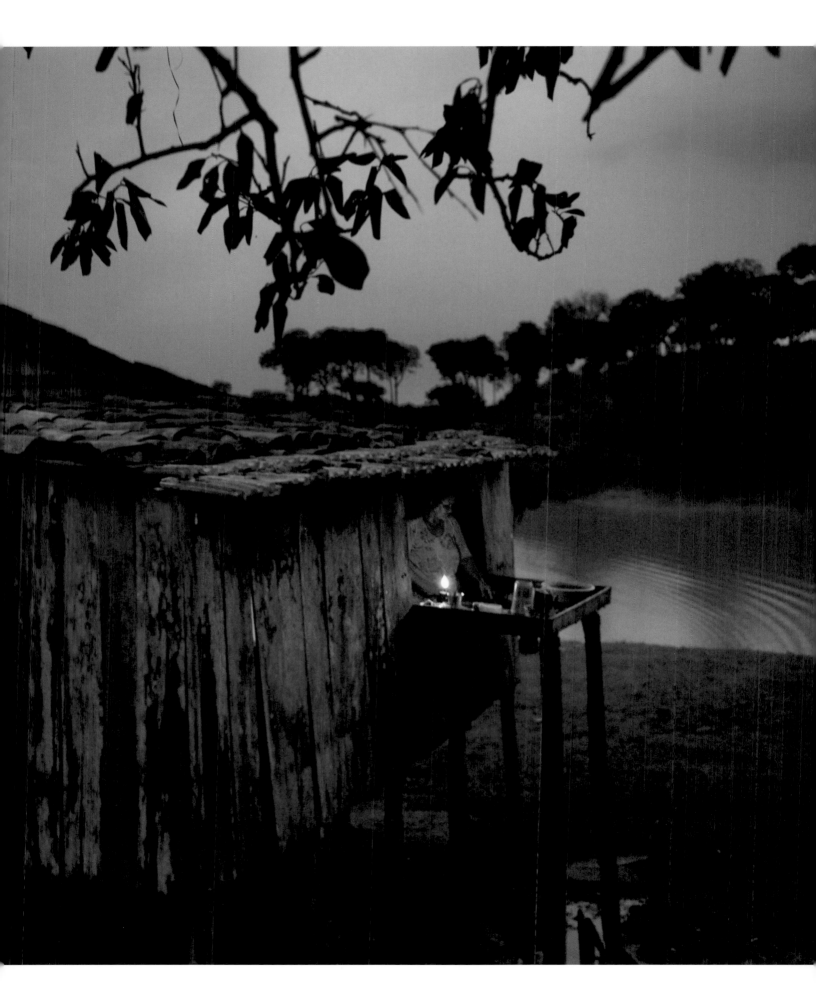

800

KENYA

Noolkisaruni Tarakuai
The Maasai Herder

ONE DAY'S FOOD

IN JANUARY

BREAKFAST AND DINNER Ugali (thick cornmeal porridge), 14.1 oz (only half is pictured) • Banana, 3.4 oz • Black tea (2), 12 fl oz; with whole milk, 2 fl oz; and sugar, 2 tbsp • Water, hauled from a reservoir and boiled, 2.1 qt

CALORIES 800

Age: 38 • Height: 5'5" • Weight: 103 pounds

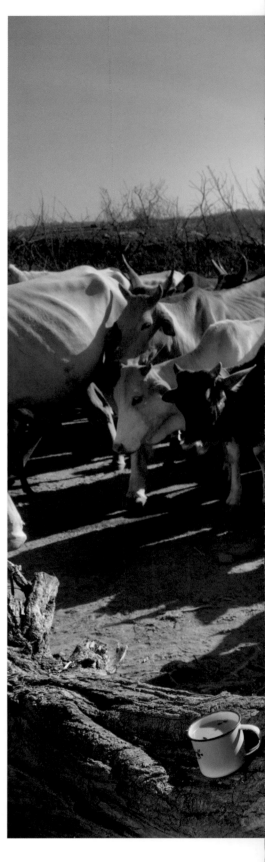

Historically, the diet of the semi-nomadic Maasai people consisted of meat, blood, and copious amounts of milk, but politics and encroaching development have taken a large bite out of communal land, making it difficult to successfully graze a large herd. Today, cornmeal and potatoes produced by others are more likely to be the centerpiece of the Maasai diet.

In times of drought, Maasai family fortunes are in jeopardy, and that's where most Maasai pastoralists in Kenya's semiarid Rift Valley find themselves these days: locked in a losing battle with Mother Nature.

SOUTHERN GREAT RIFT VALLEY • A typical Maasai man's conversation with a wife he hasn't seen for a while begins with "How are the cows?" The family herd is, in essence, the family bank account and, as such, is all-important. They keep their animals safe, count them often, sell them only when they have to, and, increasingly, rarely eat them.

When we meet Noolkisaruni Tarakuai in her village of Olgos, just outside the Masai Mara National Reserve, the 38-year-old mother of seven is organizing the butchering of a pregnant cow that has fallen and is dying. The reason for its distress isn't yet clear, but the cow is lying on the ground a 20-minute walk from her house, and she's going to have to kill it. Her husband, Kipanoi Ole "Sammy" Tarakuai, the local chief, is consulted, as the death of a cow is a serious matter, and he gives permission. Once the word goes out, every family in the area sends a representative or two to claim a bit of the meat. As a Maasai elder, Chief Sammy's role is to ensure the well-being of his clan, which generally means sharing everything he owns. Typically, all members of a Maasai clan have a responsibility to every other clansman, and sharing is common.

Three young men show up with matches and prepare to eat their instant meal on-site. They gather brush and sit down to wait for their piece of cow. A passing herdsman wanders by and waits for a piece as well.

Life on the dry, scrubby plain can be unforgiving, but there are both good and bad years. "In a good year," Noolkisaruni says, "I'll milk the cows until I have a calabash [gourd] full, then prepare milk tea and *ugali* [cornmeal porridge] for the children, and *ugali* and a cup of milk for the herdsman. The herdsman is the most important person here—without him, there's no milk. After he leaves with the herd, I eat *ugali* if there is some left and have a cup of milk myself." This is either fermented

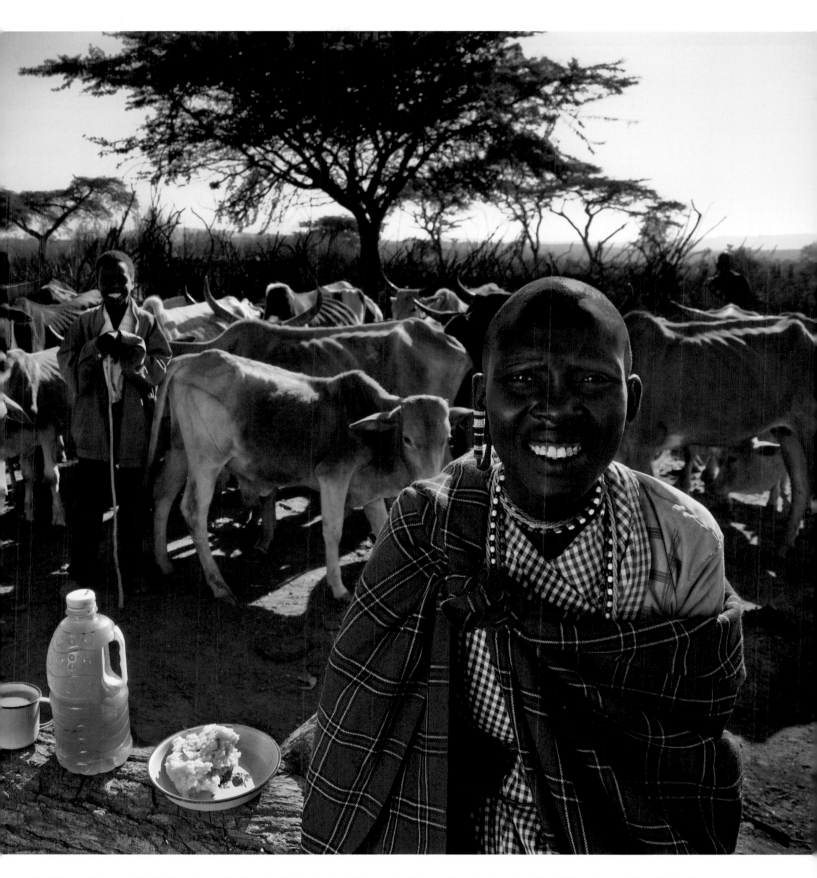

Noolkisaruni Tarakuai, third of four wives of a Maasai chief, at her family's corral with her typical day's worth of food. The prolonged drought that has taken a toll on livestock and wild animal populations alike throughout sub-Saharan Africa has also taken a toll on its people. There is little forage left for Noolkisaruni's cattle, and the gaunt cows produce barely enough milk for their calves, leaving only a pittance for Noolkisaruni's family and herdsmen. At left: Two months after we visited, the Tarakuai family sent a message saying, "The chief has fewer than 50 cows and calves left from his large herd of more than 400, and it is getting dire because the rains have not been adequate." The family was only able to salvage the hides, which they sold.

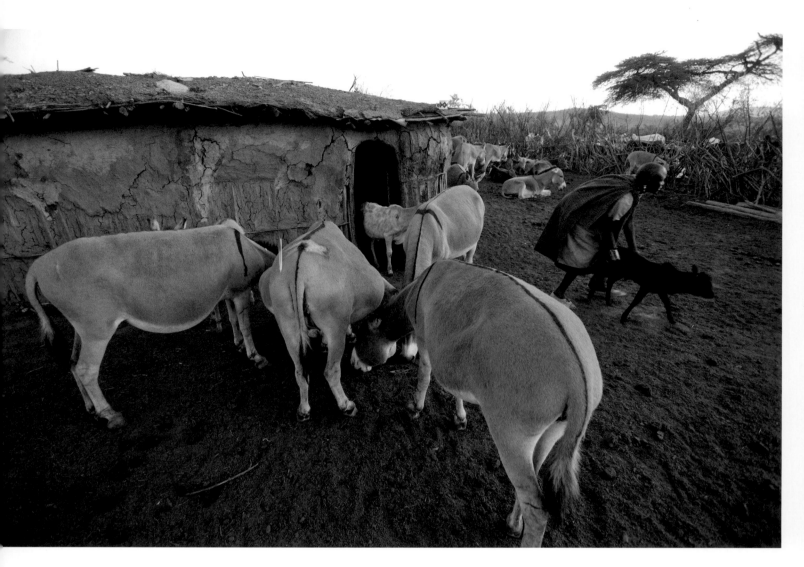

milk, which allows it to be kept without spoiling, or fresh milk. In drought years, she's lucky to get one cup of milk a day from her cows, which she splits between the children and the herdsman. Oftentimes, she herself doesn't eat until dinner.

"When I was growing up, meat was in plentiful supply," she says. "We had many livestock. The drought was less frequent. A goat was slaughtered every two days." Today they slaughter a goat only every week or so to cull the herd and provide protein to the children.

Three days ago they killed a goat. How many people did it feed? She gestures broadly at the distant houses dotting the countryside: "It's like a snack," she says, "a goat snack...like when you go and buy fried potatoes in a shop. There are many of us, so [one] goat is an instant meal." When the drought worsens, the animals are so skinny that they don't even kill them for the meat. "We sell the skins and feed the [carcasses] to the dogs," she says.

When times are good, she stocks up on cabbage, potatoes, onions, and tomatoes. In times of severe drought, she relies on food aid to feed her family—beans, rice, and wheat flour—which sometimes comes and sometimes doesn't. But even in drought, she says, if visitors show up at her door, as a Maasai wife she must give them refreshment. Just this morning two clansmen who were passing through stopped by. She gave them tea and all of the milk she had.

Noolkisaruni's greatest pleasure is her infrequent trips to the local market. (Usually the men in the family go.) While there, she enjoys a food that she herself did not grow up eating—*irio*. "It's a food of the Kikuyu," she says (Kenya's largest ethnic group). It's made of potatoes, corn, beans, and greens cooked together into a porridge. "I asked... how to make it," she says, "so I could make it for my children. It's really good with animal fat. Everybody loves it."

Today, here in the village, her neighbors arrive with sharp knives to help butcher the

downed, pregnant cow. One of the men slits its throat to kill it, then bleeds it out. A second man slices the belly, pulls out the dead calf, and sets it aside for the dogs. The butchering of the mother cow, by both men and women, is methodical and quick. The three men waiting with their impromptu barbecue lay their piece of meat across a few sticks and soon smoke wafts across the sandy wash where they work. The warm liver is given to several little boys; they run off and eat it raw.

As most of the villagers begin to carry their portions home across the flat, barren landscape, one of the men cuts into the stomach to unravel the cause of death. The autopsy reveals a long knotted chain of discarded plastic bags. Noolkisaruni says she isn't surprised: "The bags taste salty and the cows like salt." An earlier comment by Chief Sammy—that they will never buy livestock from big towns because there the animals feed on plastic bags—was strangely prophetic: The modern world's discards have become a threat to their way of life.

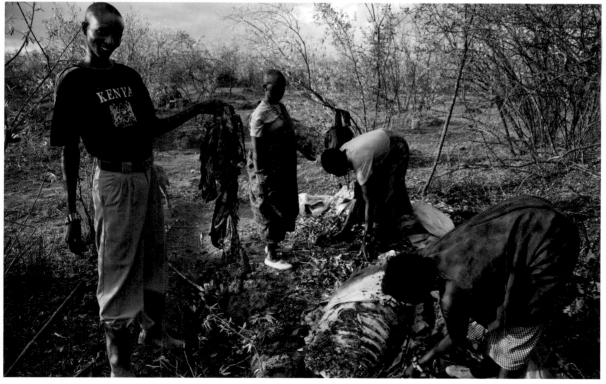

Before sunrise, Noolkisaruni (top left) helps a calf reunite with its mother before the morning milking. The cattle will spend the day on the arid plain searching for food. Later (top right), village women haul drinking water from the reservoir dug for them by an aid organization. In the afternoon, her family and neighbors butcher a pregnant cow (at left) that couldn't walk. A neighbor displays the cause: a tangle of indigestible plastic bags that was lodged in the cow's stomach.

In the early morning in her windowless, round, dung-and-mud house, Noolkisaruni Tarakuai rinses spoons in a cooking pot as her herder waits for his breakfast of cornmeal porridge—*ugali*—and sweet hot tea before setting off for the day to graze the family's cattle on the southern Kenyan plain. When the cows find enough to eat, there is also milk to drink—either fresh or soured for preservation. The amount of milk that Noolkisaruni can draw during drought is so minimal that there's no need to preserve it. It's barely enough to give just a taste to the herdsman, her husband, and her children; there's so little, she collects it in a tin cup rather than a gourd. The herdsmen, who can be paid in money or in goats, are people who have lost their herd to drought or predation by wild animals. They must work for someone else until they earn enough to rebuild their herd. The herdsmen live with the family full-time and only go home during school vacations, when the children can take care of the animals.

900

BOTSWANA
Marble Moahi
The Caretaker

ONE DAY'S FOOD

IN MARCH

BREAKFAST Motogo (thin grain porridge), made of sorghum, 11.3 oz; with sugar, 1 tbsp

LUNCH Madombi (boiled wheat flour dumplings), 6 oz • Beef, including marrow, 2.9 oz • *Knorrox* beef bouillon cubes, chili-pepper flavored, 0.2 oz • *Knorr* minestrone soup mix, 0.5 tsp

DINNER Motogo, made of sorghum, 10 oz; with sugar, 1 tbsp

OTHER HIV/AIDS antiretroviral medications • Water, hauled from a communal tap and boiled, 1.6 qt

CALORIES 900

Age: 32 • Height: 5'5" • Weight: 92 pounds

KABAKAI, NEAR GHANZI • Marble Moahi's hardscrabble life threatens to implode almost daily, but problems compound at the end of the month when her government food ration for AIDS orphans runs out. Only one person in her family of four qualifies for the food aid: her 14-year-old niece. That single ration of beans, grains, canned meat, vegetable oil, sugar, and apples has to be stretched to feed four because Marble has no other resources, and no income.

Her 21-year-old nephew, Kitso, is too old to receive the government food rations. Unemployment in their town is high, and Kitso says his friends have turned to theft. The only job he could find is herding his grandfather's cattle, 75 miles away, which he does for half the year.

Marble's 14-year-old son and her niece are

fed at school—until the school runs out of food. She asks family and friends for food to tide them over until it's time to pick up the next month's ration, then the cycle begins again.

Marble cooks a soft porridge called *motogo*, made from cornmeal or sorghum, for most meals. Her brother brings her a piece of meat once a month, which they eat with *madombi*, wheat flour dumplings, and she gets a small stipend from her father once a year when he sells a cow, but even all together, it isn't enough.

Marble's mother, a street vendor who made home-brewed beer, was the chief breadwinner of the family until she died in 2002. "She always took care of me," says Marble, who lived with her mother and has never married.

Marble nursed her sister, a school teacher who was diagnosed with HIV/AIDS, until her death in 2003. She isn't sure whether her niece and nephew know the cause of their mother's death.

The subject of HIV/AIDS remains largely taboo throughout Africa, even as it decimates the population and leaves millions of children orphaned. Botswana's rate of HIV infection is among Africa's highest: Roughly 24 percent of adults in Botswana are HIV positive, and an estimated 15,000 children are infected.

Marble herself was diagnosed as HIV positive in 2005. She gets her medication free of charge from a local clinic, along with education about proper nutrition that she can't afford to follow.

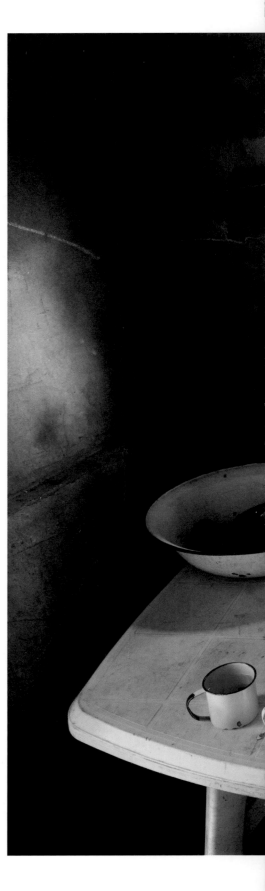

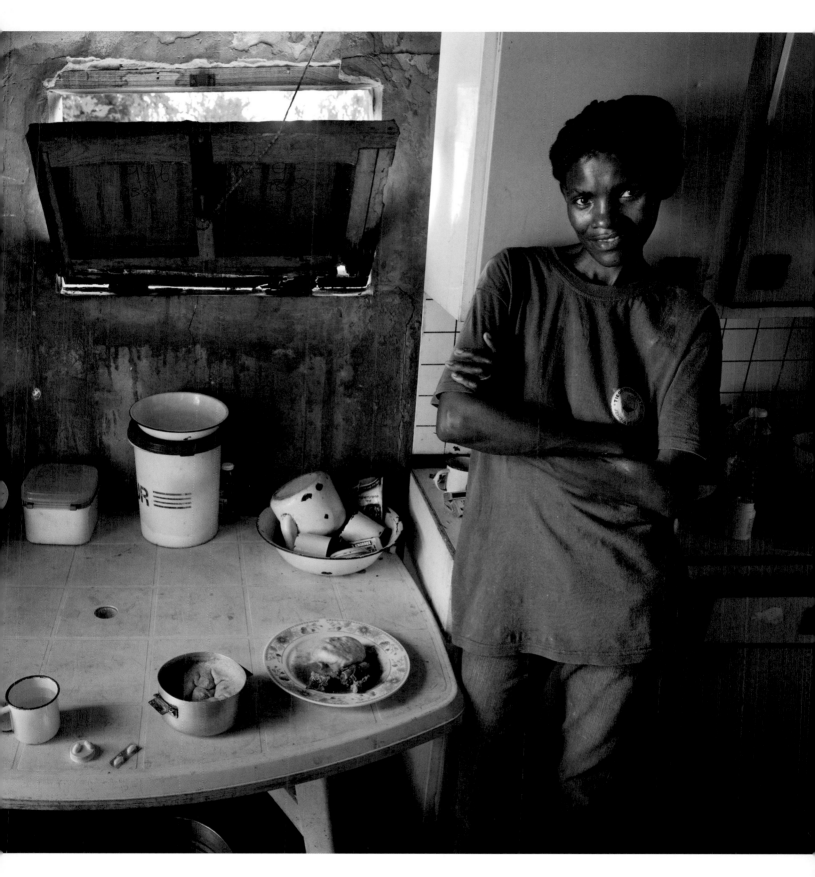

Marble Moahi, a mother living with HIV/AIDS, in the family kitchen house with her typical day's worth of food and her antiretroviral medications. Despite a decline in new HIV infections in sub-Saharan Africa, this region of the world remains the most heavily impacted by HIV/AIDS. According to 2008 estimates, over two-thirds of the 33.4 million people living with HIV/AIDS are African, and in sub-Saharan Africa women are disproportionately affected (60 percent). In Botswana in 2007, there were roughly 300,000 people living with HIV—one in four adults; due to AIDS, there were an estimated 95,000 orphans. At left: Children play just outside Marble Moahi's fence.

INDIA

Sitarani Tyaagi
The Sadhu Priest

ONE DAY'S FOOD

IN APRIL

BREAKFAST Boiled water, carried in his brass pot, 16.1 fl oz

LUNCH Potato curry, made with ghee, tomato, cilantro, coriander, cumin, turmeric, and ground chilies, 4.2 oz • Toor dal (yellow split pigeon peas), cooked with ghee, coriander, cumin, turmeric, ground chilies, and sugar, 5.3 oz • White rice, 8 oz • Puri (puffy, deep-fried bread), 3.5 oz

DINNER AND THROUGHOUT THE DAY Boiled water (not in picture), from communal taps and wells, 24.1 fl oz

CALORIES 1,000

Age: 70 • Height: 5'6" • Weight: 103 pounds

UJJAIN, MADHYA PRADESH • Twenty years ago, once-widowed, once-divorced farmer Sitarani Tyaagi gave his land, his tractor, his cows, and his house to his brother, renounced his material life, and became a sadhu priest.

Ascetic Hindus are a common sight in India, in groups or alone, living with no possessions beyond a bedroll and a vessel for water. "I saw the sadhus and the way they lived, and it looked like a good life," he says simply.

His three meals a day as a farmer were reduced to one when he became an ascetic. Like the millions of sadhus and other religious who wander the country while working toward spiritual enlightenment, Sitarani gets his daily meal from devout Hindu strangers or a local ashram (religious hermitage). In Hindu culture it's rare (in fact, bad karma) to turn a hungry priest away. "People are pretty good about sharing," he says.

His meal today is courtesy of an ashram in the city of Ujjain, Madhya Pradesh, at the religious and cultural festival Kumbh Mela—the Festival of the Pot. Hindus believe that long ago, during a battle between gods and demons, four droplets from a pot brimming with the nectar of immortality fell on the earth in four places—now the Indian cities Allahabad,

Haridwar, Nasik, and Ujjain. Every three years one of those cities holds a monthlong festival, and millions of pilgrims and Hindu religious come to purify themselves in the sacred river of that city.

Pilgrims have to eat, so ashrams in the host city set up temporary kitchens and covered dining areas where they serve free hot vegetarian fare to thousands of people each day: curries, rice, dal, and Indian flat bread—first come, first served.

A lifelong vegetarian, in accordance with both his family tradition and the Hindu tenet of nonviolence toward animals, Sitarani

doesn't miss eating three meals a day: "I eat what I need to eat," he says.

Sometimes when he's at his home ashram in the Guna district of north central Madhya Pradesh, 150 miles northwest of Ujjain, he'll have sweet *halva* with tea for breakfast, but he's only home for a month or two each year.

He doesn't chew *paan*—areca nut and betel leaf—but he does smoke marijuana, as do many of his religious brothers. Our interview concluded, the sadhu turns down a second plate of curry at the ashram and leaves to join a thousand of his fellows under a stand of trees near the Shipra River.

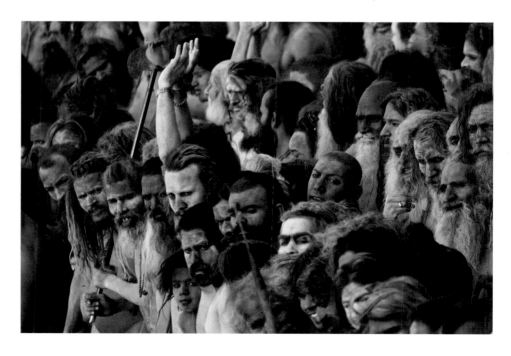

Sitarani Tyaagi, an ascetic Hindu priest, at an ashram in Ujjain with his typical day's worth of food. At right: Hundreds of Naga—naked ascetic holy men—on the Shipra riverbank before plunging in for a ritual bath during Kumbh Mela.

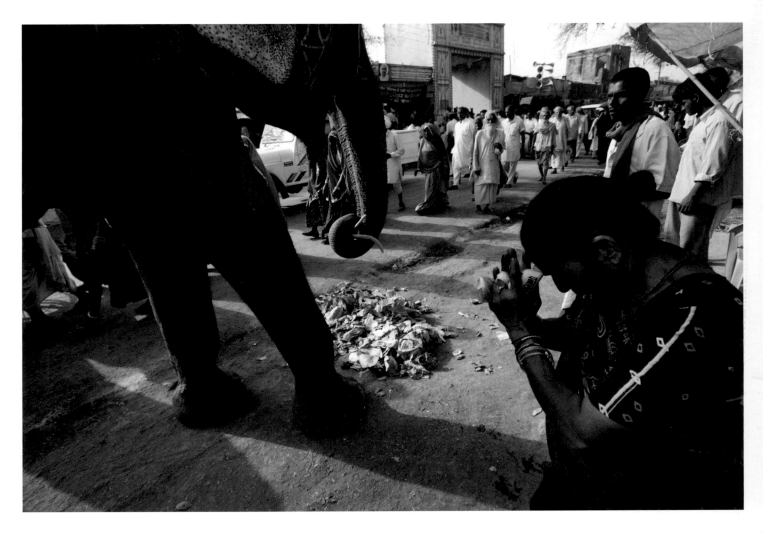

Holy men take a ritual dip in the Shipra River (at right) during Hinduism's great religious festival, Kumbh Mela, a monthlong festival that attracts millions. Top left: A painted pachyderm pauses for a snack of discarded cauliflower leaves and receives blessings from an admirer. Elephants, like cows and other animals, are shown respect throughout India, and Hindu deities are often represented in their form. At left: Sweet, fried *boondi*, a spiced chickpea flour confection, is prepared for pilgrims at an ashram.

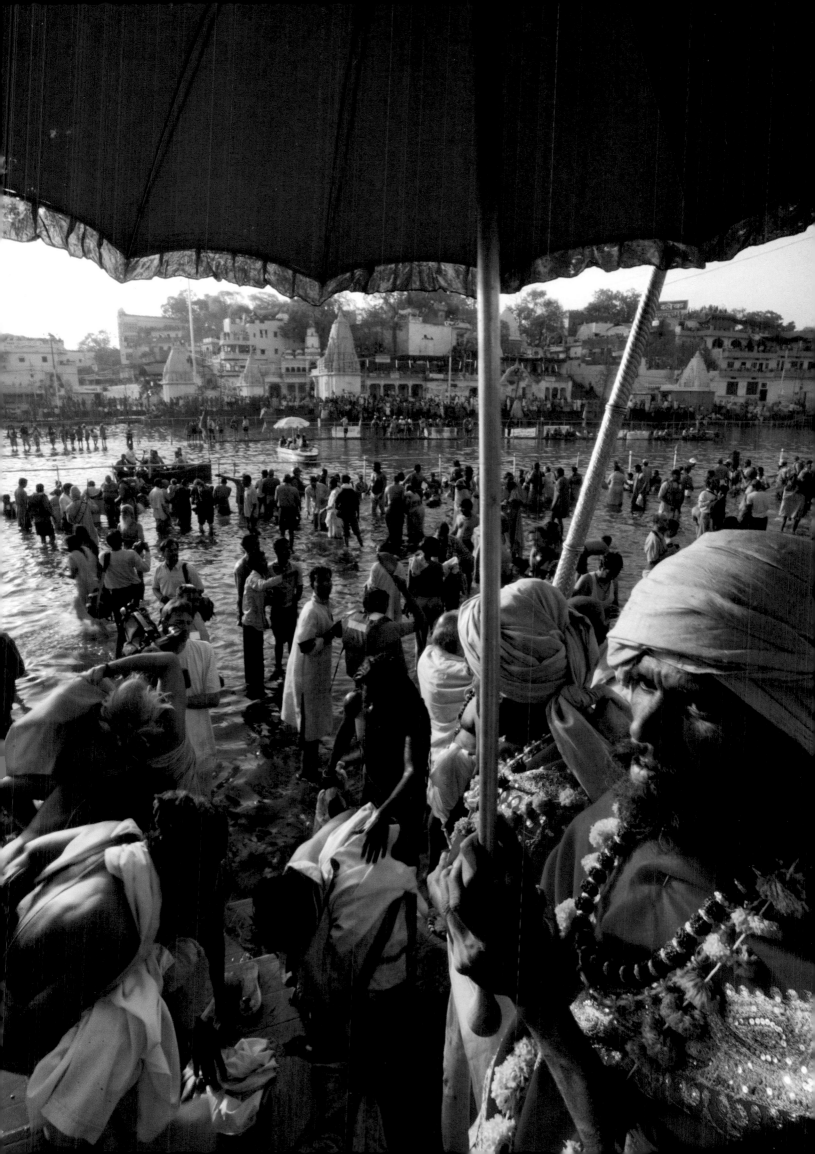

Hindus believe that the rivers in the Indian cities of Allahabad, Haridwar, Nasik, and Ujjain are sacred, and that bathing in those rivers during the religious festival Kumbh Mela will release them from past sins and mistakes and liberate them from the cycle of birth and death. Auspicious bathing days are determined by the position of the sun and the moon, and on these days more than a million pilgrims might descend for a dip. In Ujjain, thousands of police control the crowds at the Shipra River with whistles, poles, and batons to prevent stampedes and drownings, and bathing time is kept to 12 minutes per group. The festival attracts more pilgrims than any other religious gathering on the planet, including Islam's Hajj.

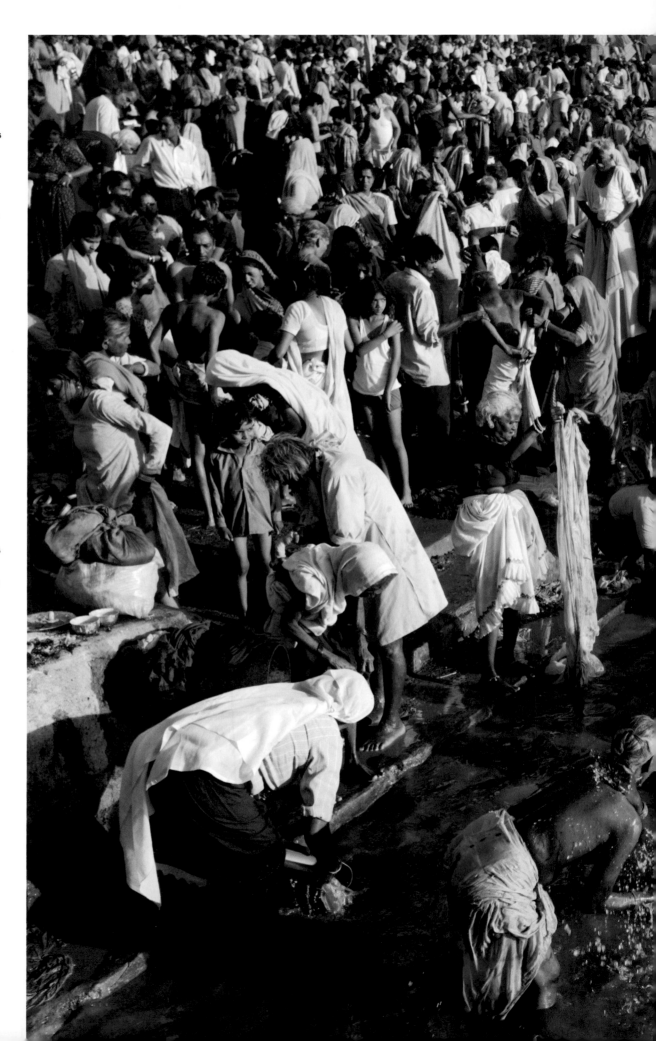

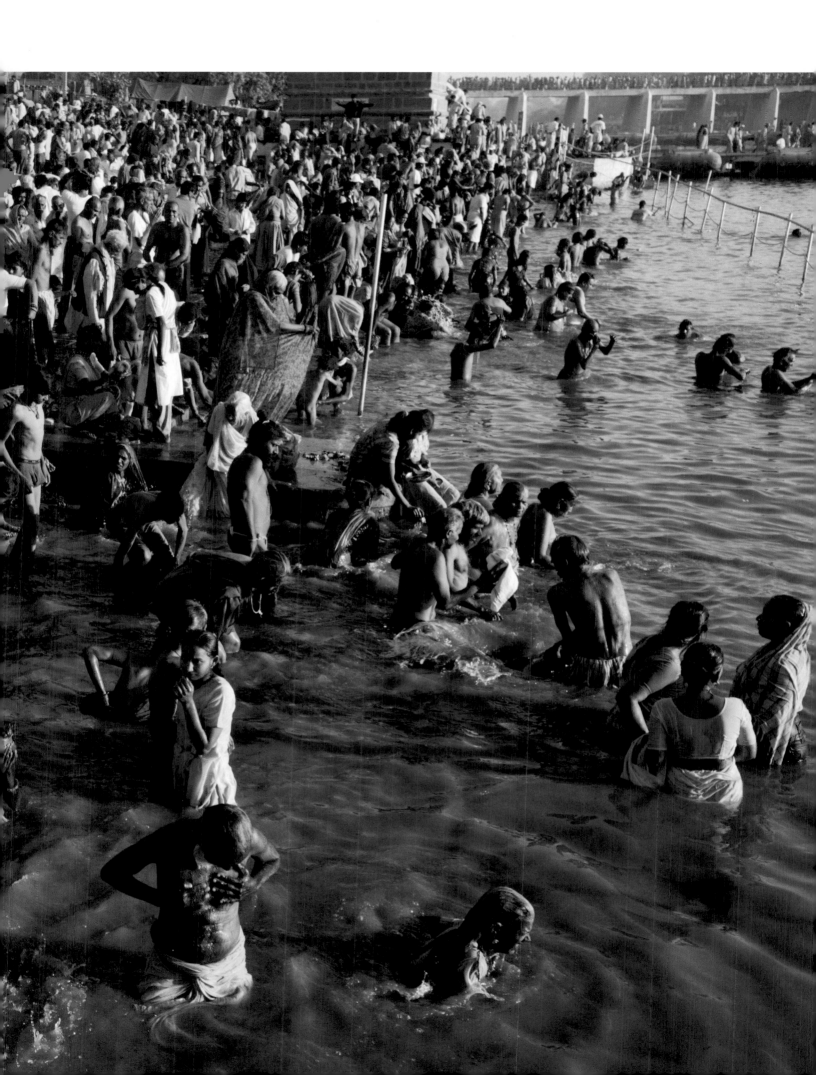

1400

Alamin Hasan
The Runaway Train Porter

ONE DAY'S FOOD

IN DECEMBER

BREAKFAST Sweet white bread roll, 2.8 oz • Black tea with sweetened condensed milk and sugar, 4 fl oz

LUNCH Vegetable curry of potato, green beans, onion, and garlic with turmeric, 3.2 oz • White rice, 13 oz

DINNER Vegetable curry of tomato, white radish, onion, and garlic with ground chilies and turmeric, 4.8 oz • White rice, 9.8 oz

THROUGHOUT THE DAY Black tea with sweetened condensed milk and sugar, 4 fl oz • Cigarettes (5) • Boiled water, 1.1 qt

CALORIES 1,400

Age: 12 • Height: 4'7" • Weight: 68 pounds

DHAKA • After a long ride on the roof of a train from his home in the north, 12-year-old Alamin Hasan arrived in Dhaka to look for work. Upon his arrival at the Kamalapur Railway Station, he saw boys carrying baggage for passengers and getting coins in return, and he never left the station. On that first day he had nothing to eat. He watched the boys and the official porters work, and the next day he competed for bags himself. On the job two weeks now, he's learned when to back off to avoid getting hurt. Confrontations and beatings among the handlers are common, and the meanest of them get the lion's share of the work.

At least 60 percent of Bangladeshis live on the margin, often in grinding poverty in one of the most densely populated countries on earth, and for many of Bangladesh's rural poor, Dhaka is a shining beacon of hope—until they arrive and find that there are too few jobs for too many.

On an average day Alamin earns about 60 to 70 taka ($0.89 to $1.04 USD), which he spends on food and cigarettes. If business is good, for lunch and dinner he buys rice and vegetable curry from one of the street vendors squatting on the pavement outside the station. On an especially good day, he'll have

enough money left over to buy tea and bread the next morning.

When we meet him, Alamin has a few coins in his pocket after hauling a man's suitcase from the first morning train to the taxi-rickshaw stand outside. No fights, arguments, shoves, or pushes necessary, as most of the other boys who vie for the jobs are still asleep on the platform, and the official porters haven't yet arrived to take their rightful spot (and tips).

Unfortunately, the previous night didn't end nearly as well. Like the other boys, Alamin sleeps on the covered platform between the tracks. When he awoke this morning, he found that his pockets had been turned out and the remainder of yesterday's earnings stolen.

Alamin was in school before he came to Dhaka, until his father left the family to start a new life with a new wife, taking both an emotional and a financial toll on the family. Alamin moved south after his mother said she couldn't feed him any more and kicked him out. When we call Alamin's mother to check his story, she says, "What mother sends her son away?" But she doesn't ask him to come back; she asks our translator if he can find Alamin a job that pays well so the boy can send some money home.

Alamin Hasan, a 12-year-old runaway, at the train station in Dhaka where he works and sleeps, with his typical day's worth of food. Working as a porter (at left), the boy earns enough in tips to eat more than he was getting at home.

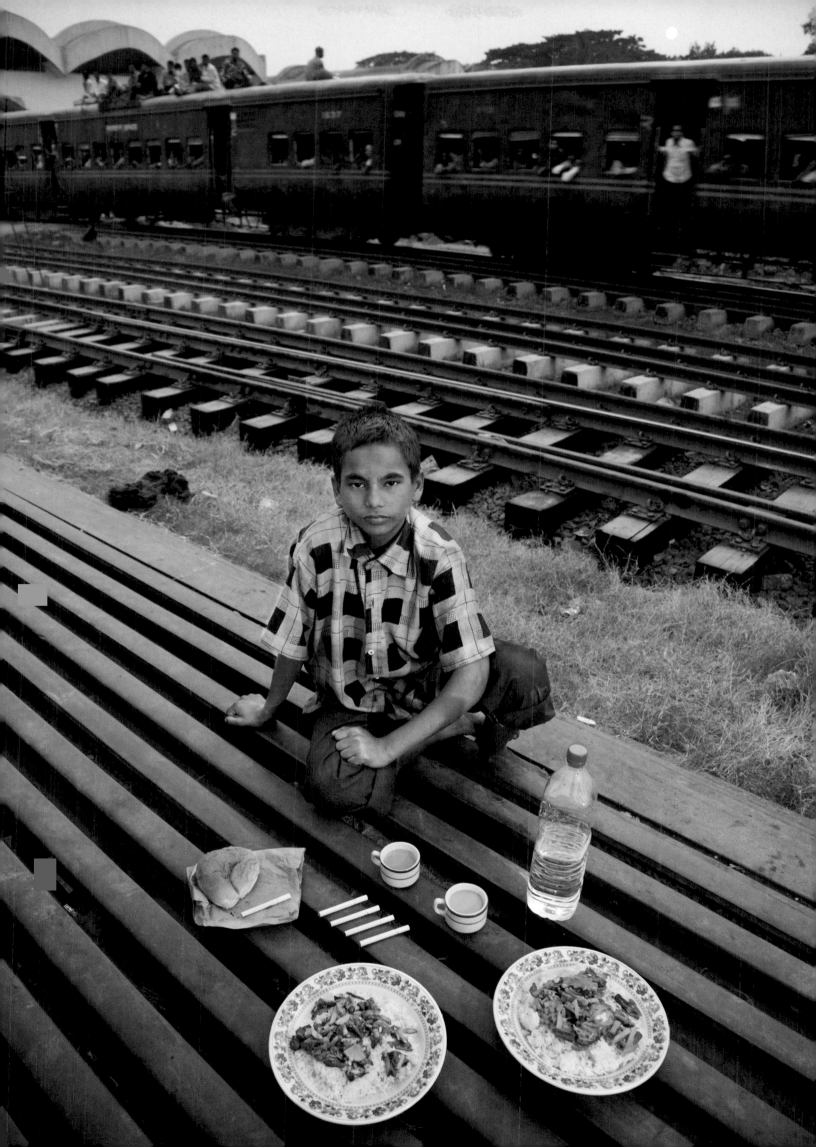

Bangladesh is among the world's most densely populated countries, with 7 million people living in the overcrowded capital city alone. Slum living in Dhaka is the norm, not the exception, and hardly the lowest of the city's economic rungs. Those who can't afford to pay rent squat, and the less fortunate sleep wherever they can find a spot. Entire families live in squatter's huts throughout the city, and even those that line the railroad tracks leading to the Kamalapur Railway Station (at right) afford more comfort and security than Alamin enjoys as he sleeps on the platform (bottom left), often falling prey to pickpockets during the night. Early morning finds him in a confrontation with an older porter among the rickshaws at the station entrance (top left), which ends with Alamin on the receiving end of a sharp slap to the head.

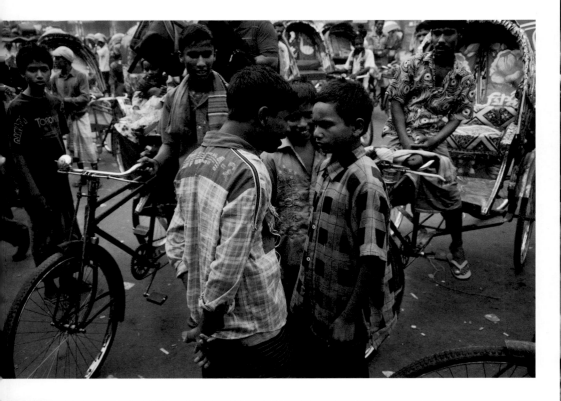

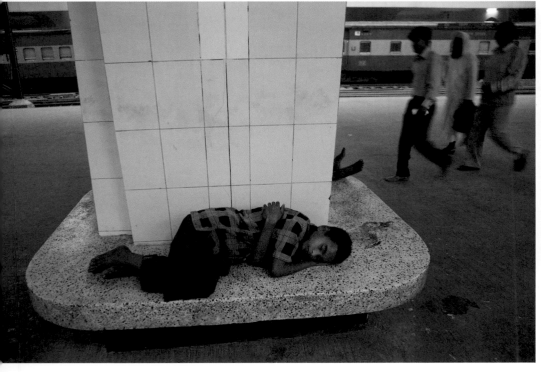

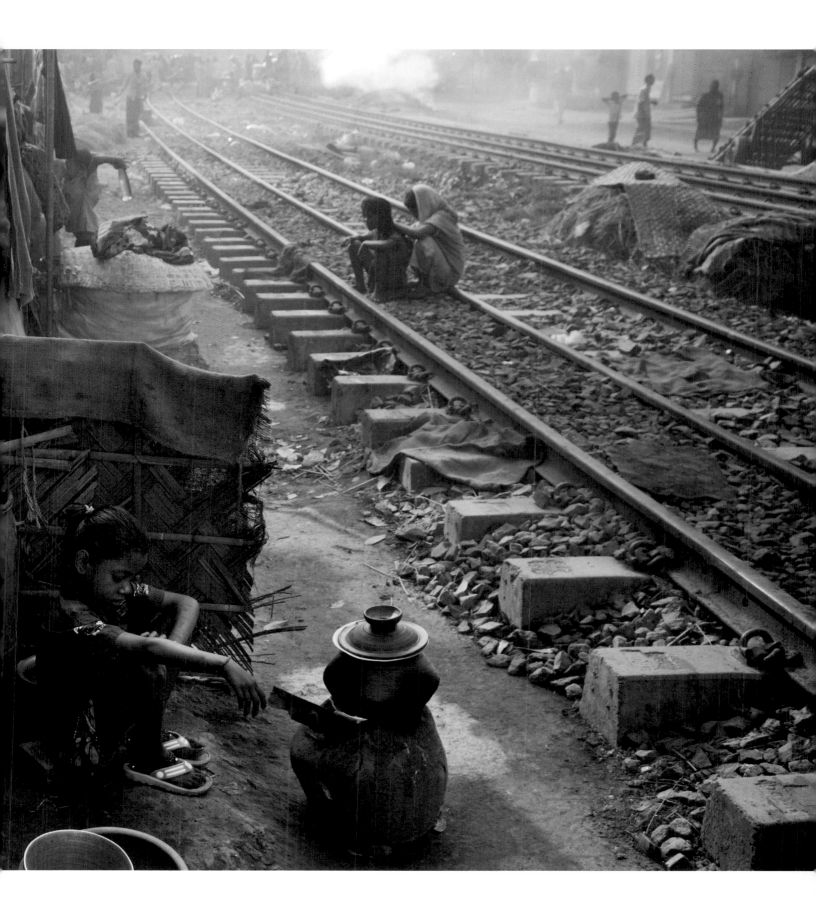

1500

NAMIBIA

Viahondjera Musutua
The Himba Pastoralist

ONE DAY'S FOOD

IN MARCH

FIRST MEAL OF THE DAY Cornmeal porridge, 1.7 lb; with sour whole milk, 11.3 fl oz

SECOND MEAL OF THE DAY Cornmeal porridge, 1.8 lb; with sour whole milk, 11.3 fl oz

THROUGHOUT THE DAY Sour whole milk, 26.3 fl oz • Bird plums (not pictured as she ate what she had picked before the photo was taken), 3.5 oz • Water from nearby river, 12 fl oz

CALORIES 1,500

Age: 23 • Height 5'8" • Weight: 160 pounds

The southern African nation of Namibia, born in 1990 after decades of often bloody geopolitical limbo, is home to a rich tapestry of ethnicities. One of its most intriguing is the Himba. Perhaps best known for the glaze of deep red ochre and butterfat that they wear over their hair and body both for beauty and as a sunscreen, these semi-nomadic pastoralists graze their substantial herds of cattle in the drought-prone, semiarid scrubland of northwest Namibia and neighboring Angola.

Cattle are the currency and treasure of the Himba, and milk the cornerstone of their diet, supplemented with cornmeal porridge, seasonal berries, and the occasional goat. Earlier generations were nomadic, hunting and gathering their food as they traveled with their herds, either a step ahead of drought or consumed by it. In the 1980s, 90 percent of their cattle died during a severe drought, and the Himba lived on food aid as they rebuilt their herds. These days they're no longer allowed to hunt wild game, and they're apt to grow corn and graze herds on land that's shrinking as conservation efforts and government constraints encroach. Although the Himba have proven themselves particularly adept at holding off unwanted development, some are leaving traditional villages for town life and wages. Still, many Himba live as their forebears did.

KUNENE REGION (KAOKOLAND) • There's milking to be done this chilly morning in March, but the women of Okapembambu village postpone the moment when they must finally rouse

themselves and leave their warm one-room mud-and-dung walled homes encircling the corral. They cuddle with their babies and children under thin blankets and softened leather, and sip *omaere*, a sour, fermented yogurtlike drink, from communal spoons carved out of gourds.

Twenty-three-year-old Viahondjera Musutua refreshes her body with *otjize*, the deep red ochre cream, where it rubbed off during the night and tends to her toddler. It isn't until her father, Muningandu, the headman and patriarch of this village of 30 extended family members, calls from outside that the women stir from their homes.

As a baby, Viahondjera was promised in marriage to her father's sister's son—a typical arrangement meant to reinforce clan ties—and she married at age 14. Now she lives a seven-hour walk south in her husband's village but returns every year for a couple of months to visit and claim her share of the family corn harvest. Her two older sons, age four and nine, are at home with their father and his first wife. She'll see them again when her husband comes with the donkey cart to pick up the corn.

Muningandu owns most of the village's cattle, inherited from his mother's clan. The Himba trace their lineage through both mother and father and belong to both clans—the patrilineal side for day-to-day living and ritual, and the matrilineal side for inheritance. The cows were passed down to Muningandu from his mother's brother and will be passed down to his sister's son—Viahondjera's husband.

This is the rainy season, and the women

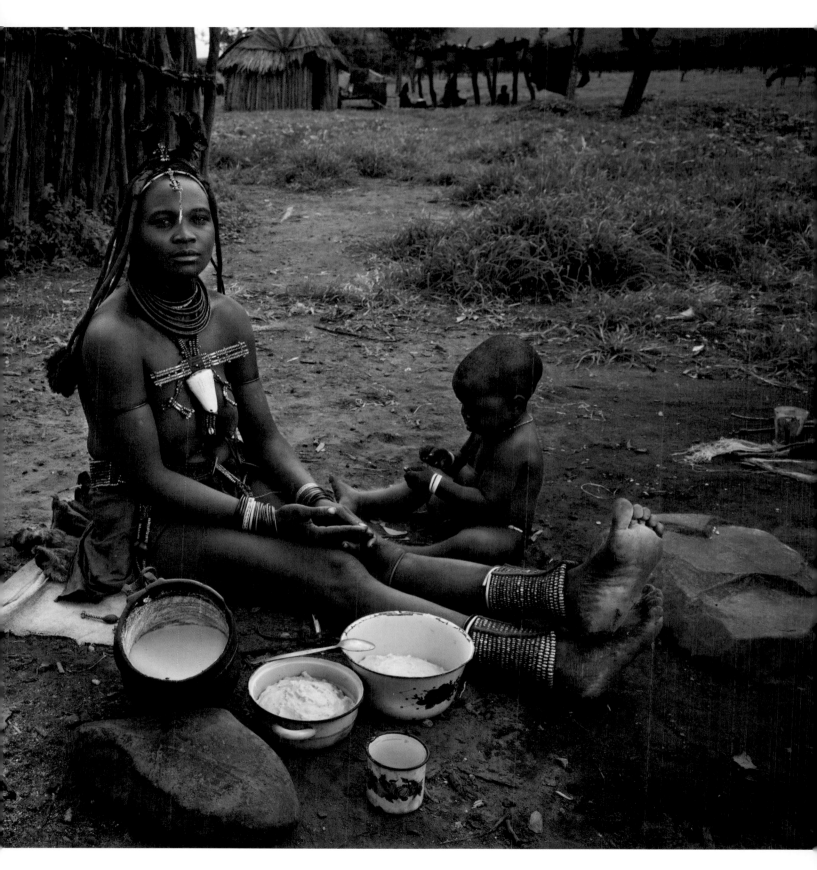

Viahondjera Musutua, a Himba tribeswoman, at her father's village with her youngest son and her typical day's worth of food. The 23-year-old mother of three lives in a small village a seven-hour walk south from her father's village but visits yearly to collect her share of the family corn. Her traditional dress includes a full body glaze of *otjize*, a cosmetic made of ground ochre, butterfat, and plant resin. She wears a fertility necklace and other jewelry made with leather and metal beads, a goatskin leather skirt she made herself, and an *erembe*, the traditional Himba headdress of married women. The hairstyles and adornments of both men and women change according to their stage of life.

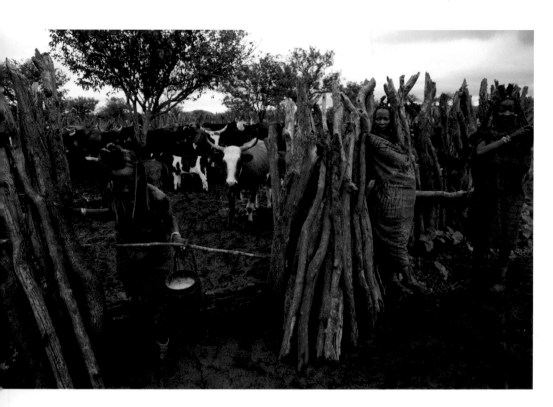

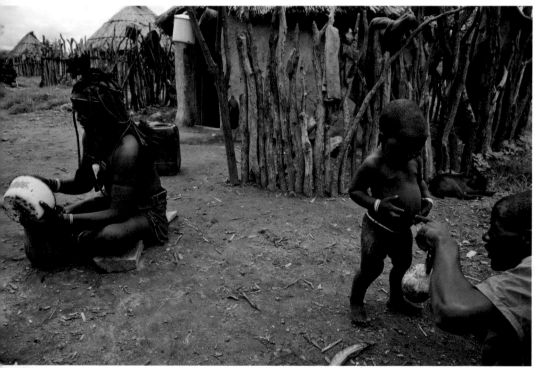

work in ankle-deep mud and manure to collect the day's milk, clutching blankets tinged with the ochre dust that colors everything they own. It's a delicate dance to milk, balance a baby, hold a cloak, and not fall into the mud as they work to separate calves from mothers and do the milking. Though it's much easier in the dry season, there's a trade-off: less milk, especially in drought years.

Muningandu milks a cow as well—one of his family's sacred cows, whose milk and meat is used for rituals and rites of passage. He's keeper of the sacred cattle, and also of the family's ancestral fire—the all-important connection between the living and the dead, used to commune with the ancestors.

The women set the fresh milk aside in pails with a bit of yesterday's milk to sour and preserve it, and then several cook cornmeal porridge in blackened three-legged pots—the same meal they'll cook later in the day. Sometimes there's corn to roast as a snack, but now they're out and won't have more until the harvest. When they run out of corn for porridge, Muningandu sells a cow to buy some. In the last year, he says, he's sold two cows and gifted or lent out a few others—a cultural practice that helps others start a herd, or at least subsist.

Viahondjera and her father's third wife, 20-year-old Mukoohirumbu, hang calabash gourds filled with milk from a tree and shake them to churn the milk into butter, for food and for the *otjize*. A lime green dime-store trinket swings saucily in front of Viahondjera's eyes as she works; a personal touch fastened to her *erembe*, an otherwise-traditional headdress worn only by married women. The *erembe* is shaped like animal ears and tied with a leather strap over her hair, which is caked with ochre and butter—a paste version of the same cream she applies to her skin, with ash added to help cut down on bugs. The women don't wash with water, and they rarely undo their plaits.

There are bird plums to harvest on the scrubby plain, but this year not many mopane worms, which they both sell and eat. They squeeze out the guts, cook the worms with salt, and dry them in the sun. When reconstituted, the worms cook like beef.

Although the villagers are surrounded by cattle and a herd of goats, there's rarely meat to eat except for celebrations. Meat is Viahondjera's favorite food, but she's not sure when she last ate it. Her father, resting in the aluminum lawn chair that he carts around to watch his cows, says of Viahondjera and her brother: "When we slaughter a goat, these two can finish it by themselves, body and bones."

During chilly mornings and evenings in northern Namibia's rainy season, the women of Okapembambu village draw steaming buckets of milk from their cows (top left), despite the distraction of ankle-deep mud and manure. Milk and its by-products are the Himba's most important source of nutrition. The women add a bit of soured milk to the fresh liquid to hasten the process of natural fermentation, and they shake calabash gourds for hours to make butter. They drink some of the soured milk, use some to make their cornmeal porridge, and mix butterfat with ochre to make their body cream. Bottom left: Viahondjera's older brother plays with her son as she eats porridge left over from breakfast.
At right: Viahondjera dips water from the shallow, muddy river near her father's village as her father's third wife, Mukoohirumbu, cleans her baby's face. They'll flip their headdresses back and carry the jugs of water home on their heads.

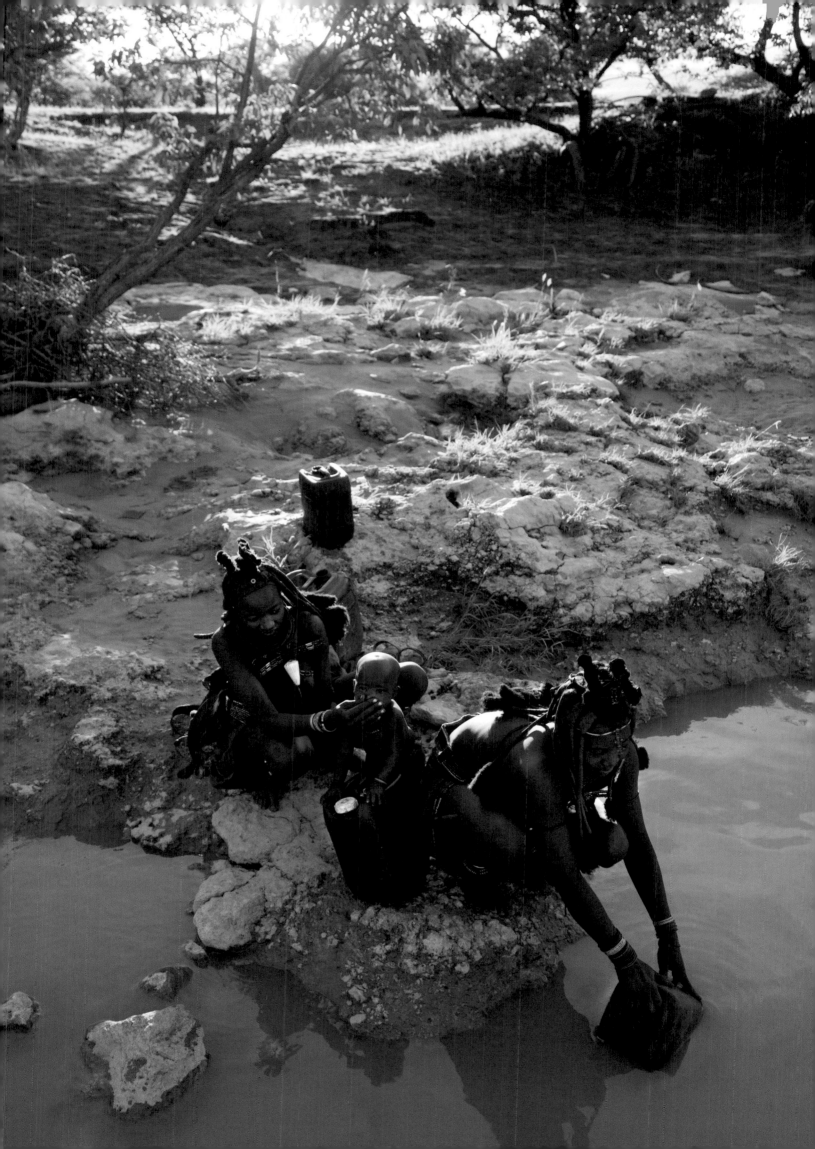

Namibians of all ethnicities converge on the Kunene region's district capital, Opuwo. While tourists might see a scruffy, trash-strewn shantytown filled with drifters, grifters, and bars, to many Himba, Opuwo is a foreign and exotic world that has virtually nothing in common with their quiet village life. Even on a weekday afternoon, Castle Bar #2 (at right) in the center of town is packed with people. Alcohol flows freely for those who can afford it, while those who can't try to solicit passersby for money, tobacco, and beer. Bottom left: At a local supermarket, a Himba woman and her son shop for staples and soda pop after receiving money from a tourist in exchange for a photograph. Some Himba are turning to tourism to kick-start their entry into the cash economy, setting up demonstration villages advertising "The Real Himba." Top left: Himba prepare a meal of cornmeal porridge in a vacant lot. They've come to Opuwo from Angola to get medical care for a family member who fell out of a tree and broke his arm.

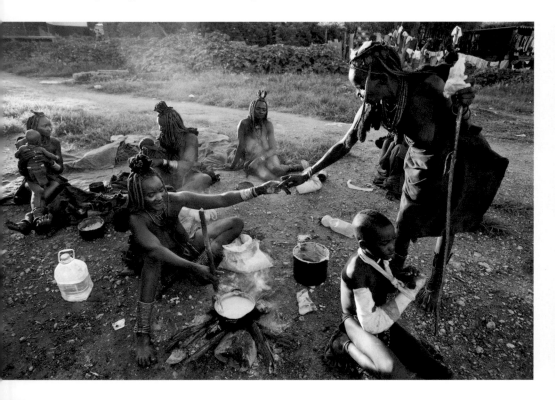

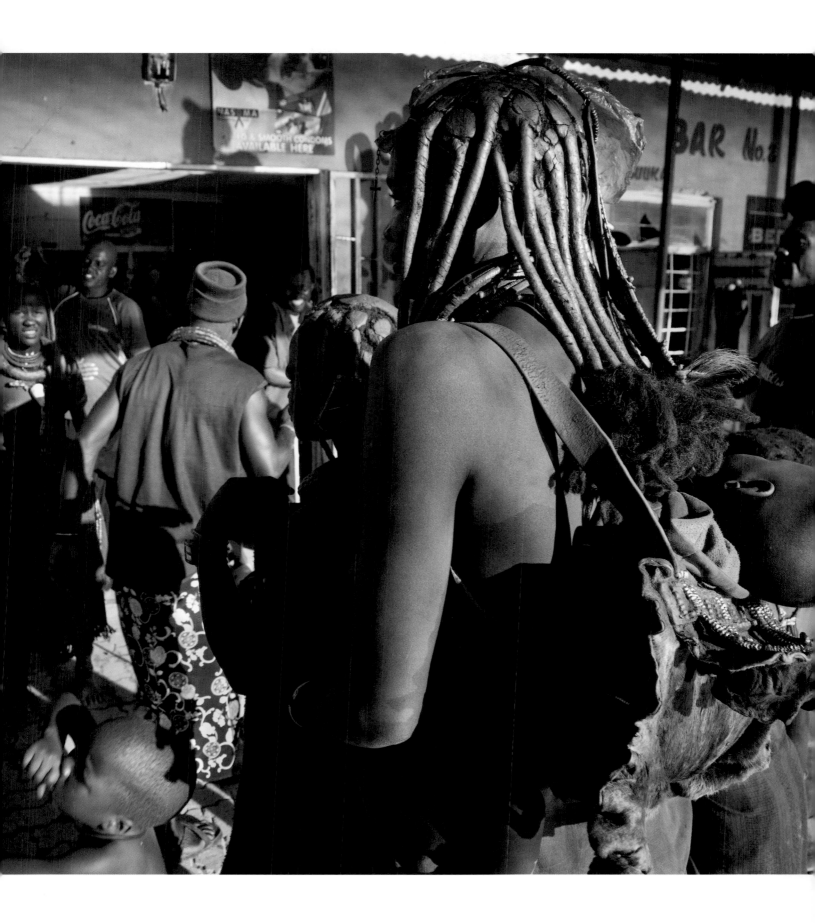

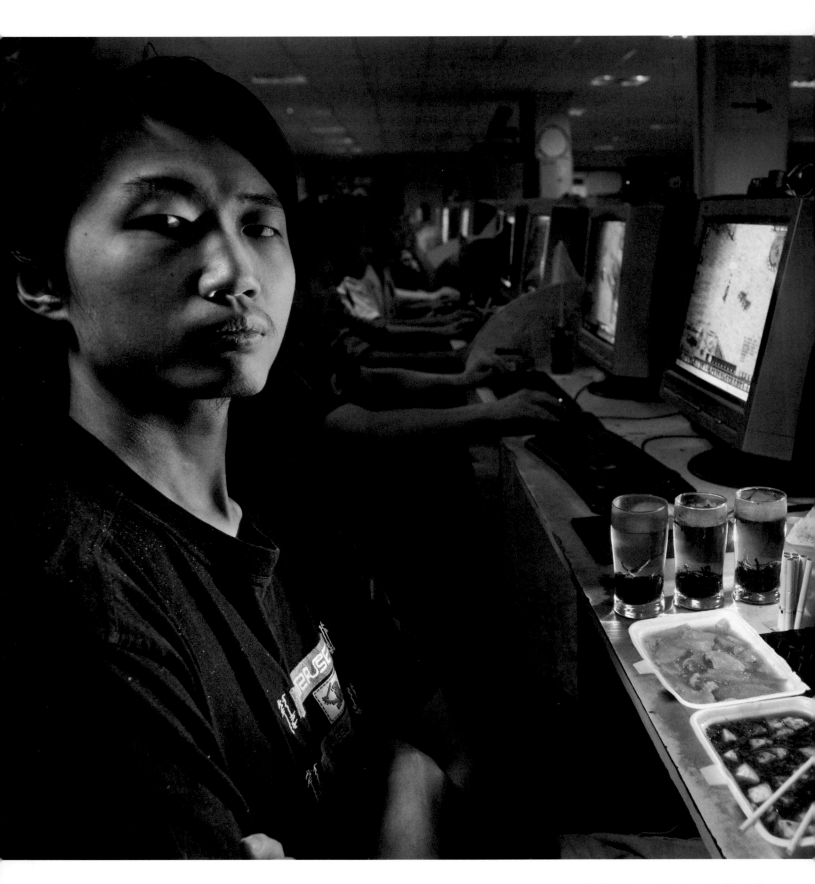

Xu Zhipeng, a freelance computer graphics artist and Internet gamer, in his rented chair at the Ming Wang Internet Café with his typical day's worth of food. He lives at his computer station, day and night, sleeping there when he's tired and showering once a week at a friend's apartment. His longest continuous game lasted three days and nights. When he tires of gaming at the café (at right), he reads fantasy books. "It's nice to rest your eyes on a book," he says, even though he's reading it online. China has more than 300 million Internet users—a number close to the entire population of the United States.

CHINA

Xu Zhipeng
The Extreme Gamer

ONE DAY'S FOOD

IN JUNE

LUNCH DELIVERY Mapo doufu (tofu and pork in a spicy red chili pepper sauce), 10 oz • White rice, 11.7 oz • Green tea (made with tea leaves brought from his home province of Hubei), 10.1 fl oz

DINNER DELIVERY Stewed chicken, 2.3 oz; with cooked winter melon, 7.9 oz • White rice, 13.3 oz • Green tea (Hubei Province tea leaves), 10.1 fl oz

THROUGHOUT THE DAY Green tea (Hubei Province tea leaves), 10.1 fl oz • Cigarettes (7)

CALORIES 1,600

Age: 23 • Height: 6'2" • Weight: 157 pounds

SHANGHAI • Computer graphic designer Xu Zhipeng, screen name "Mouse," is a full-time resident at the Ming Wang Internet Café in central Shanghai, playing web games for dozens of hours at a time and reading fantasy books online. "My friends think I'm super lazy," says the 23-year-old, who plans to live in the café for six months, after what he says was a particularly grueling year of work. "If you work an entire year," he says, "it's easy to get tired out."

He meets thousands of other gamers across the Internet to play MMORPGs, or Massively Multiplayer Online Role-Playing Games. Does he know anyone else as extreme as he is? "There's no one I know who's like me," he says. "Even my friends don't believe that I'm doing this—no one can play as long as I can." Ten hours straight inside an online role-playing game doesn't seem to wear him down at all. And his longest continuous game? Three days and three nights—straight. "Then I went comatose for a day," he says. When he gets tired he sleeps—in his chair.

The gamer attributes his desire for a half-year chairmanship to his youth. "I'm enjoying myself now," he says. "When I'm older, in

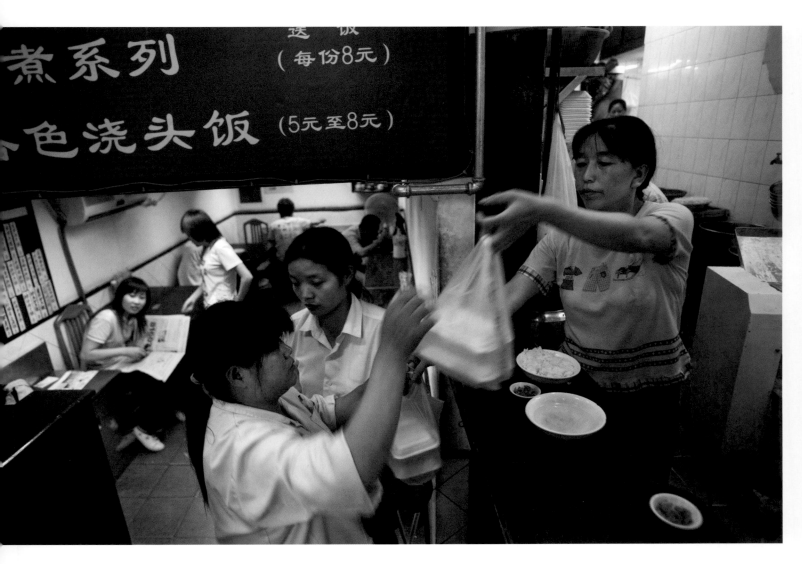

煮系列 送 饭
（每份8元）

色浇头饭 （5元至8元）

my thirties, my friends and I will start some kind of company." He has no doubt that he'll be successful.

Like most young, urban Chinese men of his generation, Zhipeng is an only child. His parents, both former professional volleyball players, put him through art school in Beijing, then paid a South Korean company to take him on as a computer graphics intern.

After graduating, he posted his resume online and began to pick up short-term freelance jobs in 3D animation and design, earning money to pay for his six-month Internet vacation. His parents gave him his grandparents' old government-issue apartment in the city of Wuhan, where he grew up. That's where he'll live when he

rejoins the freelance workforce. Does he play games when he's working? "Never," he says. But his current plan is to repeat the cycle, working only half a year and earning enough money to support another Internet vacation.

Zhipeng's favorite part of his current lifestyle is that he has no set schedule and no deadlines. When he's hungry, the tall, lanky gamer consults a short crumpled menu tacked on the wall around the corner from his computer, picks up the phone, and orders Chinese fast food or boxed lunches from a restaurant that delivers to his desk. He got rid of his mobile phone because people wouldn't stop calling. "I can use the phone here if I need to make a call,"

he says. Has he ever been to the place where the food he orders comes from? No. He doesn't even know their address; he just calls and it comes. Zhipeng eats only two times a day and drinks tea made from leaves his father gave him, from their home province of Hubei.

At home in Wuhan he cooks basic Chinese dishes for himself, and no meal is complete without rice. "I barely eat anything Western," he says. He doesn't like American fast food but his friends do, so occasionally he'll eat at McDonald's or KFC. He says he doesn't understand hamburgers. "There's no central taste. It's like eating cake," he says.

What about alcohol? "I drink it when I'm out with my friends." He doesn't drink soft drinks—the only one of his group who doesn't. "It doesn't quench my thirst," he says. "If I drink a soft drink or Coke, I still have to drink water, so why not just drink the water?" The food portrait complete, he turns his attention back to his screen—a medieval knight has just been stabbed.

"Even my friends don't believe that I'm doing this— no one can play as long as I can."

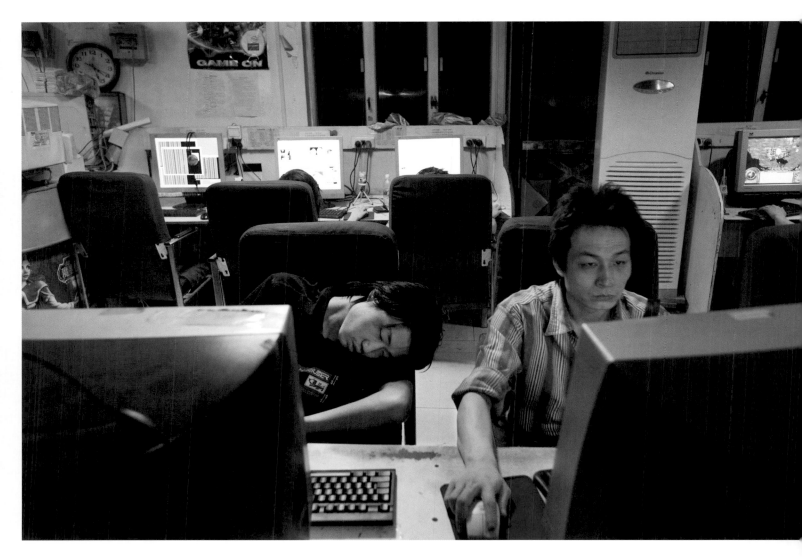

Twice a day Xu Zhipeng tears himself away from an online game for less than a minute to order a meal from the Wanglong Restaurant (top left). The food is delivered to his computer station 10 minutes later, where he eats it without interrupting his game. Sooner or later, he has to sleep, yet even at 4:27 a.m. (top right), most of the 300 seats are filled. At left: A view of Shanghai that Xu Zhipeng rarely sees: the Pudong skyline over the Huangpu River at night.

1600

USA

Rick Bumgardener
The Candidate for Obesity Surgery

ONE DAY'S FOOD

IN FEBRUARY

BREAKFAST 12-grain bagel, 1.5 oz; with *Jennie-O Breakfast Lover's* turkey sausage, 1.6 oz; and *Smart Beat* nondairy cheese substitute, American cheese flavored, 0.7 oz • *Quaker Simple Harvest* granola bar, chocolate chunk, 1.2 oz • Iced tea, 12 fl oz; with *Splenda* sweetener, 1 tsp

LUNCH *Lean Pockets* stuffed sandwich, Philly steak and cheese, 4.5 oz • *Green Giant* broccoli and carrots with Italian seasoning, 3.5 oz • Iced tea, 12 fl oz; with *Splenda* sweetener, 1 tsp

DINNER Chicken leg coated with light Italian dressing, baked, 4.7 oz • *Ronzoni Healthy Harvest* whole wheat blend, yolk-free pasta, with *Ragu Double Cheddar* cheese sauce and steamed broccoli, 8.6 oz • *Jello-O* sugar-free pudding snack, dulce de leche, 3.7 oz • Iced tea, 12 fl oz; with *Splenda* sweetener, 1 tsp

SNACKS AND OTHER *Quaker Simple Harvest* granola bar, roasted nut, 1.2 oz • *Nabisco 100 Calorie Packs, Planters Peanut Butter Cookie Crisps*, 0.8 oz • Baby carrots, 2.5 oz • Grape tomatoes, 2.4 oz • Cauliflower, 1.4 oz • Green onion, 0.4 oz • Radishes, 0.3 oz • *V8 100% Vegetable Juice*, low-sodium, 5.5 fl oz • *Crystal Clear* bottled water, 1.1 qt • Supplements: cranberry caplet; vitamin B_{12}; multivitamin • Medications: allopurinol, aspirin, calcitrlol, diltiazem, exenatide, glyburide, losartan • Other medications (not in picture, and only taken when needed): alprazolam, colchicine, fexofenadine, gabapentin, naproxen, simvastatin

CALORIES 1,600

Age: 54 • Height: 5'9" • Weight: 468 pounds

HALLS, TENNESSEE • Today, Rick Bumgardener's day's worth of food is a mere shadow of its former self as he struggles to lose enough weight to qualify for weight-loss surgery. How does it compare to his day's worth of food in the past, during a lifetime of overeating? He considers what his wife, Connie, has carefully portioned out for the photo and concludes, "I'd eat all that at one meal, plus another three whole chicken breasts and all the trimmings—potatoes, gravy, and biscuits."

"Country eating," the Tennessean calls it, and relentless snacking: "Get me a pack of saltine crackers, a long-handled spoon, and a jar of mayonnaise and I'll be happy," Rick says.

People with a BMI (body mass index) of over 40 are classified as morbidly obese. On Rick's first weigh-in at the University of Tennessee Medical Center in Knoxville, he weighed 499 and had a BMI of 73.7. The former school bus driver also suffers from crippling back pain, type 2 diabetes, and other chronic illnesses related to obesity. "Until I lose 100 pounds, they say it's just not safe to put me to sleep to do the surgery," he says.

There's counseling, nutrition guidance, and exercise therapy, but no decision yet about which surgery he'll receive. In gastric bypass, the surgeon creates a smaller stomach and reroutes the digestive system permanently; stunning weight loss is possible, but so are complications. In gastric banding surgery, an adjustable band constricts the usable portion of the stomach to the size of a golf ball. There are fewer risks, but the weight loss is generally slower. In either case, those who undergo these procedures need to adopt a healthier diet for life.

At the time of our interview, Rick was only down to 468 pounds, and losing the rest of the weight was proving to be an elusive goal. Connie is in charge of portion control, but she works full-time in a machine shop with their son, Greg, so Rick is on his honor to eat only what she parcels out.

There's no more mayonnaise in the Bumgardener kitchen, but Connie hasn't locked up the family larder. Does Rick cheat? "He does go in here and get stuff," she says, but she doesn't use the word "cheat." They've been married for over 30 years, and she knows

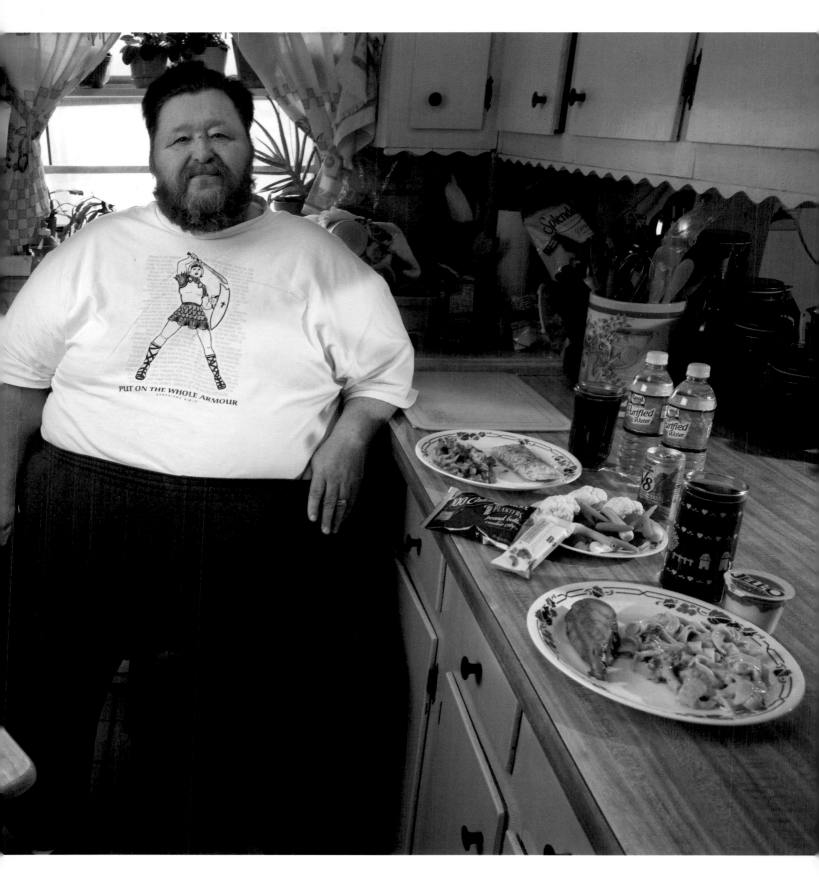

Rick Bumgardener, at home with his recommended daily weight-loss diet. Wheelchair-bound outside the house and suffering from a bad back and type 2 diabetes, he needs to lose 100 pounds to be eligible for weight-loss surgery. Rick tries to stick to the low-calorie diet pictured here but admits to lapses of willpower. Before an 18-year career driving a school bus, he delivered milk to stores and schools, and often traded with other delivery drivers for ice cream. School cafeteria staff would feed the charming Southerner at delivery stops, and he gained 100 pounds in one year. The prescription drug fen-phen helped him lose 100 pounds in seven months, but he gained it all back, plus more.

what he's capable of eating and how much less he's eating now. She leaves him a large bin of fresh vegetables, and he's allowed to eat as much of that as he wants. It used to be a tough sell: "Tomatoes I would eat," he says, "but cauliflower and carrots—you couldn't have paid me to eat them before."

Connie also leaves 100-calorie packages of what he'd rather eat—cookies and snack cakes. The packs are mental reminders of exactly how many extra calories he's eating. "You know, we all get hungry," she says.

Some snacks are harder to tally mentally. She reaches into the refrigerator. "This was a full pack of hot dogs when I left," she says, pulling out a partial pack. "He thinks I don't notice this stuff."

For breakfast and lunch, Connie relies heavily on microwavable foods like Lean Cuisine items and individual vegetable packets that Rick can heat and eat. She cooks a hot dinner, but Rick says, "She doesn't put it on the table where I can just dip it out of the dish like we used to do in years gone by. She fixes the plate and I eat it. If it's something pretty good, I'll say, 'Can I have more?' and she'll say no," he says, laughing. "But I just gotta ask!"

"I couldn't do it without her," Rick says a number of times during our visit, but he also says he knows that he is ultimately responsible: "Old habits die hard. My first thought whenever something's put in front of me is, 'Boy, that smells good.' But then I have to, you know, say to myself, 'Hold it, back up, slow down, you gotta watch yourself.'"

Over his lifetime, Rick has gained and lost hundreds of pounds, but he's motivated now by the success of a cousin's gastric bypass surgery and the realization that his quality of life is on a downward spiral. A longtime lay preacher who writes gospel songs and picks them out on his guitar, now he can't stand long enough to preach a service—or do much of anything without help. After 18 years as a school bus driver, he quit in 2001 because of both his weight and his increasingly bad back, despite surgery in 1998. "I just didn't feel safe driving with the steering wheel rubbing my belly," he says. "I'm not worried for myself. If something happens to me, I know where I'm going, but I just didn't want the responsibility of killing or injuring a child. Oh no, I couldn't handle that."

He looks forward to driving again, and to simple tasks that others take for granted: weed-eating, mowing the yard with his dog, Bear, at his side on the riding mower, and getting around under his own steam without a wheelchair.

Weighing in at 468 pounds for his first exercise class (at left) at Mercy Health and Fitness Center near his home, Rick learns a series of seated exercises. After the gym workout, he takes a water exercise class (bottom right), swimming for the first time since he was a teenager. Rick's new lifestyle rules out one of his favorite restaurant dinners with his wife, Connie, and son, Greg: three extra-large pizzas, crazy bread, and no vegetables. There would be leftovers, but not for long, Rick says, as he would eat all of them. A self-taught gospel singer, guitar player, and lay preacher, Rick used to enjoy preaching and playing on Wednesday evenings at Copper Ridge Independent Missionary Baptist Church before he became too heavy to stand for long periods. To relieve boredom, he wakes up late, plays video games, plays his guitar, and watches TV until the early hours of the morning. Singing an original song, "Give Us Barabbas," Rick sits in his reclining chair with his dog, Bear, at his feet (top right).

1700

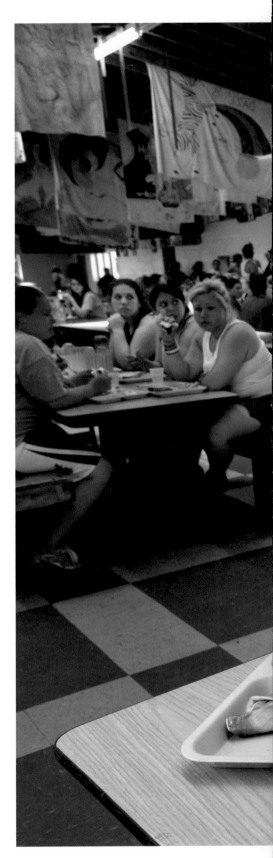

USA

Mackenzie Wolfson
The Weight-Loss Camper

ONE DAY'S FOOD

IN JULY

CAFETERIA BREAKFAST Apple pancakes (2), each with 2 tbsp of apple filling, 4 oz; with *Smucker's* sugar-free syrup, 1 tbsp • Turkey sausage, 1 oz • Skim milk, 4 fl oz • Orange juice from concentrate, 4.9 fl oz

CAFETERIA LUNCH Peanut butter and jelly sandwich: whole wheat bread, 4.6 oz; reduced-fat peanut butter, smooth, 1 tsp; *Smucker's* sugar-free jam, Concord grape, 1 tsp • Celery sticks, 0.8 oz • Baby carrots, 1.3 oz • Ambrosia (fruit salad): mandarin oranges, 0.9 oz; pineapple tidbits, 2 tbsp; shredded coconut, 1.5 tsp; mini marshmallows, 0.2 oz; plain yogurt, 1 tsp

CAFETERIA DINNER Chicken cacciatore: pulled chicken meat (without skin or fat), 2.5 oz; and vegetables, 3.6 oz; cooked with *Smart Balance* margarine, 1.5 tsp • Salad of lettuce, cabbage, and carrot, 1.1 oz; with fat-free Italian dressing, 0.5 tsp • Whole wheat pasta, 2 oz • Sugar-free fruit punch drink, 5.3 fl oz • Italian ice, 4 fl oz

CAMP SNACKS AND OTHER Apple (not in picture), 5 oz • Chocolate pudding (not in picture), 4 oz • Pretzel (not in picture), 1 oz • Tap water, 2.1 qt

CALORIES 1,700

Age: 15 • Height: 5'9" • Weight: 299 pounds

CATSKILL MOUNTAINS, NEW YORK • Low-calorie food choices, rigorous exercise, and nutrition counseling might not seem an attractive combination for a fun-loving teen's summer vacation, but Mackenzie Wolfson returns to weight-loss camp willingly each year, working on a problem she's faced since fourth grade. "We didn't get like this overnight," she says about being overweight, "and we can't fix it overnight." She says that school lunches, paid for in advance at her grammar school, were the beginning of her struggle with weight: "It was buffet-style, all you wanted."

At five foot nine, the athletic varsity softball player is taller than her friends and carries her 299 pounds more gracefully than many at the camp she's come to for the last four years. She doesn't expect, or even want, to ever be ultrathin. "I'd love to weigh 180," she says. "If I was [thinner than that], I think I'd look horrible. In 2004 I was 180, but I was shorter, and I looked great.

Some might say that weight-loss camp isn't working if you have to keep returning, but Mackenzie disavows that notion, saying there's comfort in knowing you're returning to a place where the kitchen is locked up tight. "There's no way I can just go grab some-

thing," she says. She's told her parents she wishes it were more like that at home. "We've emptied out the cabinets of everything that I shouldn't eat, no junk food—nothing worse than pretzels. But I have a very picky sister," she says. "They'd start bringing stuff back into the house. They kept a cabinet in the garage with a master lock on it. And one day I found the code."

Behavior modification is taught at the camp, but it's hard for a teenager to make health-conscious choices when her skinny friends are eating whatever they want. "After camp I would come home, and for the first couple of weeks I'd be really, really strict," she says. "I'd really try to focus on how I was eating at camp. But once I started going back to school and going out on weekend nights, and I had money in my pockets, whatever I would see, I just wanted it." What kind of foods? "Cakes, cupcakes, milkshakes."

How does she see herself? "When I look in the mirror, I'm not happy, but when I walk down the street and I look down at myself, I see legs and feet like anyone else. I feel normal when I'm walking, but when I see myself in the mirror, I know there's something wrong."

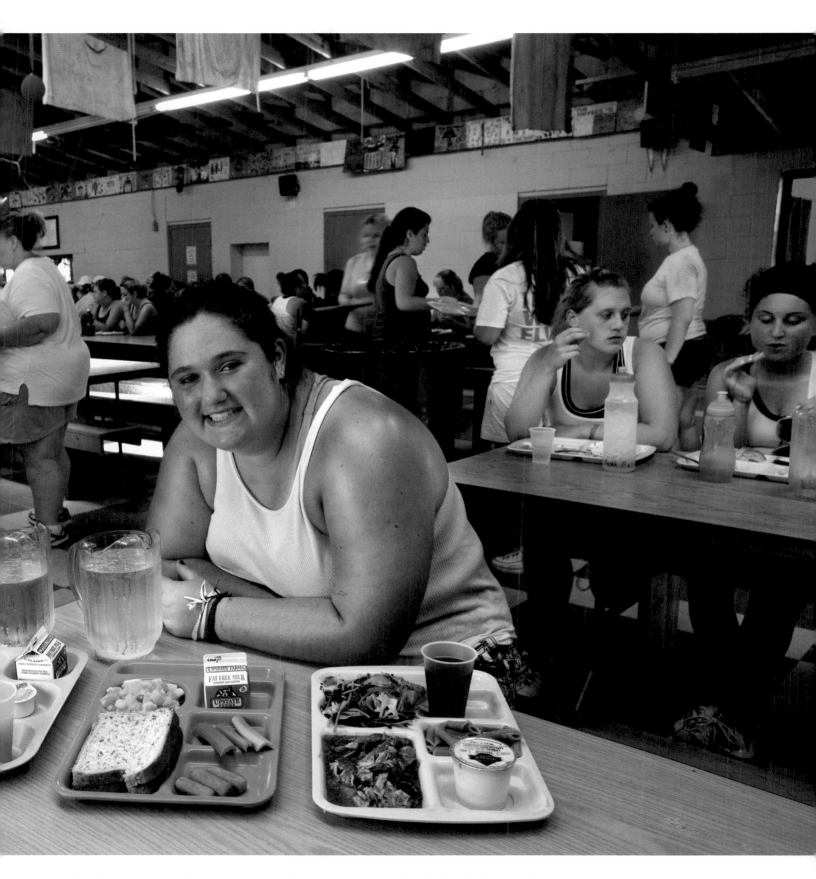

Mackenzie Wolfson in the cafeteria at Camp Shane with her prescribed day's worth of food. Dating back to 1968, Camp Shane is the oldest weight-loss camp in the country and is a heavy investment for parents. There are about 500 male and female campers housed in small cabins on shaded hillsides overlooking athletic fields, a small lake, and the camp's most important building, the cafeteria. "The food here is not bad. It's not what I would order in a restaurant," says 15-year-old Mackenzie. "You know, its been prepared low-fat, low-sodium, but when you eat it you're like, whoa, this isn't that bad. And it's really good for me... But before everyone goes, they pig out the week before. One summer I probably gained about five pounds the week before I went to camp."

1700 The Weight-Loss Camper • USA

Mackenzie, a natural athlete (top left), is an accomplished tennis player and a member of her school's varsity softball team. But in the heat of a hot summer afternoon (bottom left), there's no frenzy among the girls to join the fray in field hockey. "Off the fence, girls!" yells Coach Joey, but nobody moves unless it's time to sub out players. When the coach yells, "Subs!" relieved players run to the sidelines and try to give up their stick to a hapless substitute, with varying degrees of success. At right: After a no-second-helpings breakfast, the first activity of every day at Camp Shane is a stretching class for Mackenzie and 100 other girls.

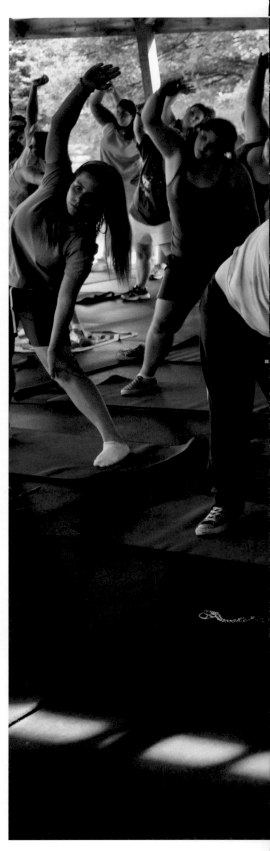

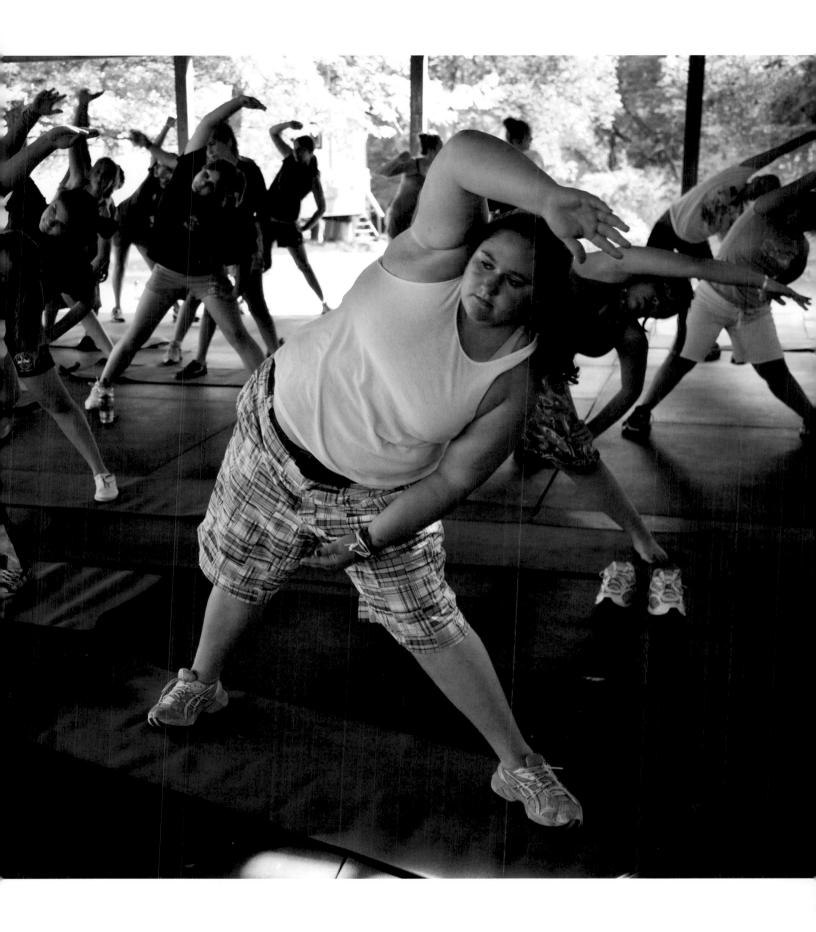

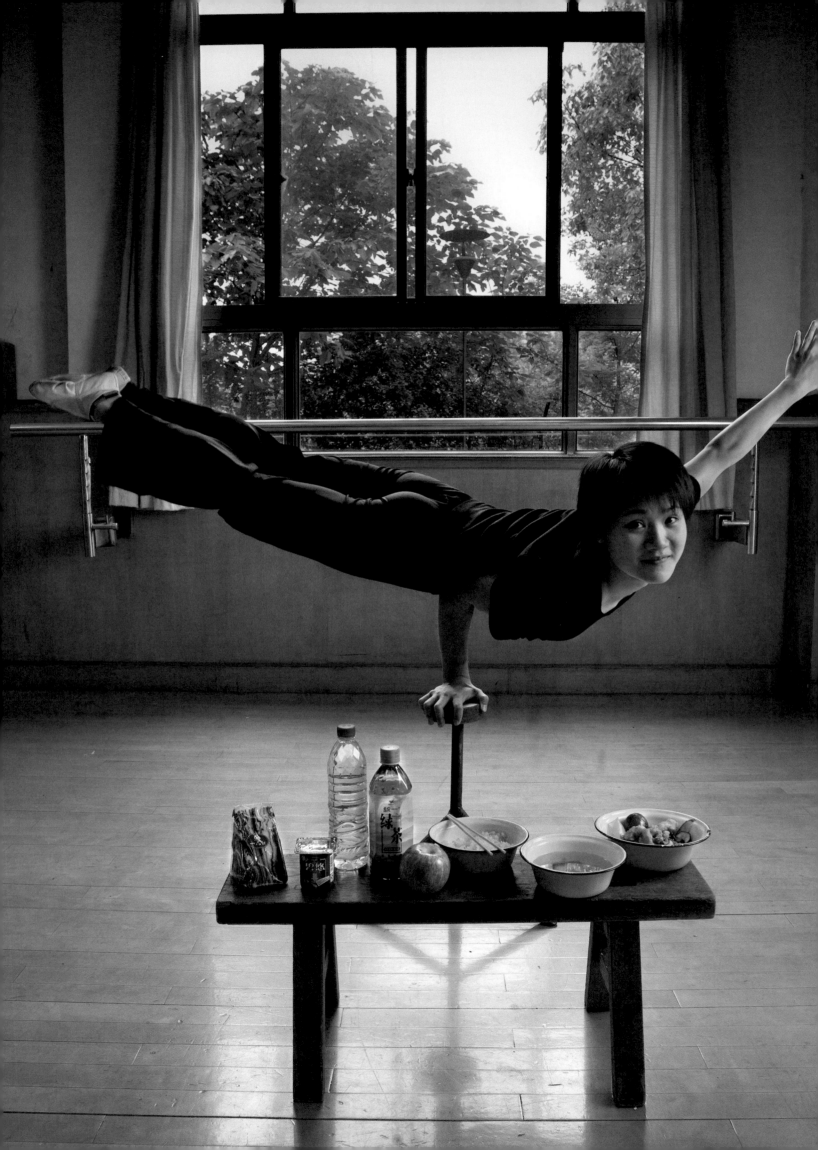

CHINA

Cao Xiaoli
The Acrobat

ONE DAY'S FOOD

IN JUNE

BREAKFAST *Yipin Xuan* cake, 5.5 oz • *Danone* yogurt, kiwi, 3.5 oz • Apple, 7.2 oz

LUNCH IN SHANGHAI CIRCUS WORLD EMPLOYEE CAFETERIA Zha paigu (pork ribs, breaded and deep-fried), 2.8 oz; with rice flour noodles, 3.5 oz; and stir-fried cucumber, 5.4 oz • Tea egg (hard-boiled egg stewed in salted tea), 1.7 oz • Salty vegetable broth with green onion, 9.8 oz • White rice, 5.9 oz

THROUGHOUT THE DAY *Uni-President* bottled green tea, unsweetened, 16.9 fl oz • Boiled water, 23.7 fl cz

CALORIES 1,700

Age: 16 • Height: 5'2" • Weight: 99 pounds

SHANGHAI • Timing, balance, and precision of movement guide acrobat Cao Xiaoli's day in her practice studio at Shanghai Circus World. The 16-year-old spends most of each day balanced on one arm, gripping the rotating head of a two-foot stand. She sets a stopwatch and balances on a single hand for a half hour, watching her form in the wall-sized mirrors.

Her teacher, Li Genlian, a retired acrobat, adjusts the angle of the teen's feet, twists her at the waist, and uses a fingertip to guide her free arm until it's perfectly extended. The young acrobat lowers herself to the floor and stretches for a bit before her next half hour of balance work.

Xiaoli is focused. This isn't playtime for the teen, and hasn't been since she arrived here at age seven. The young acrobats live 10 to a room in the Shanghai Circus World complex. They practice daily, perform seven nights a week, and are tutored in schoolwork every other day.

Professional acrobat intersects with teenager only when she meets a dorm-mate in the employee cafeteria and they giggle together briefly, amidst lion tamers, daredevil motorcyclists, and the clerical staff.

Lunch choices include fried pork ribs, duck basted in soy sauce, stir-fried cucumber, and tea eggs. Xiaoli will eat something, but she says nothing here inspires her to eat. She saves her appetite for when she's home with her parents. If she has a day off, sometimes her mother, a former acrobat, takes Xiaoli to Pizza Hut or a local Chinese restaurant, or makes her favorite dish, *tangyuan*—sticky glutinous rice balls with red bean paste in a sweet soup.

For breakfast Xiaoli and her friends buy yogurt, European-style cakes, and fruit. Xiaoli doesn't eat dinner, because most days there's a nightly show—her favorite part of the life of a professional acrobat.

She likes the crowd's reaction when she executes a particularly perilous feat, but not all of them come off as planned. At one time, Xiaoli was the acrobat who vaulted to the top of a pyramid of chair-balancing acrobats. But one night the pyramid collapsed and her safety harness broke. She crashed down on her head and spent months recuperating; Genlian says Xiaoli still deals with fear.

Now she works in a group of four girls who contort themselves inside an impossibly small porcelain barrel, then languidly roll themselves out to the amazement of the crowd. In her solo performance she sparkles—balanced on a pedestal that rises from the floor 20 feet into the air, in concert with music and light.

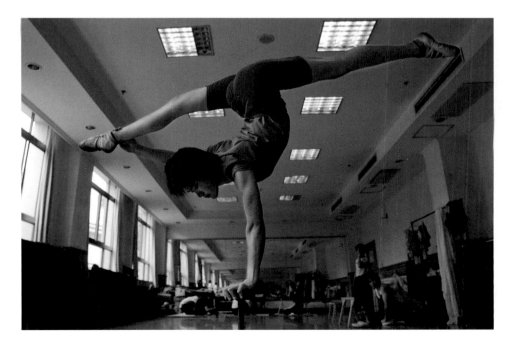

Cao Xiaoli, a professional acrobat, in the practice room at Shanghai Circus World with her typical day's worth of food. She started her career as a child, performing with a regional troupe in her home province of Anhui. At left: Xiaoli practices.

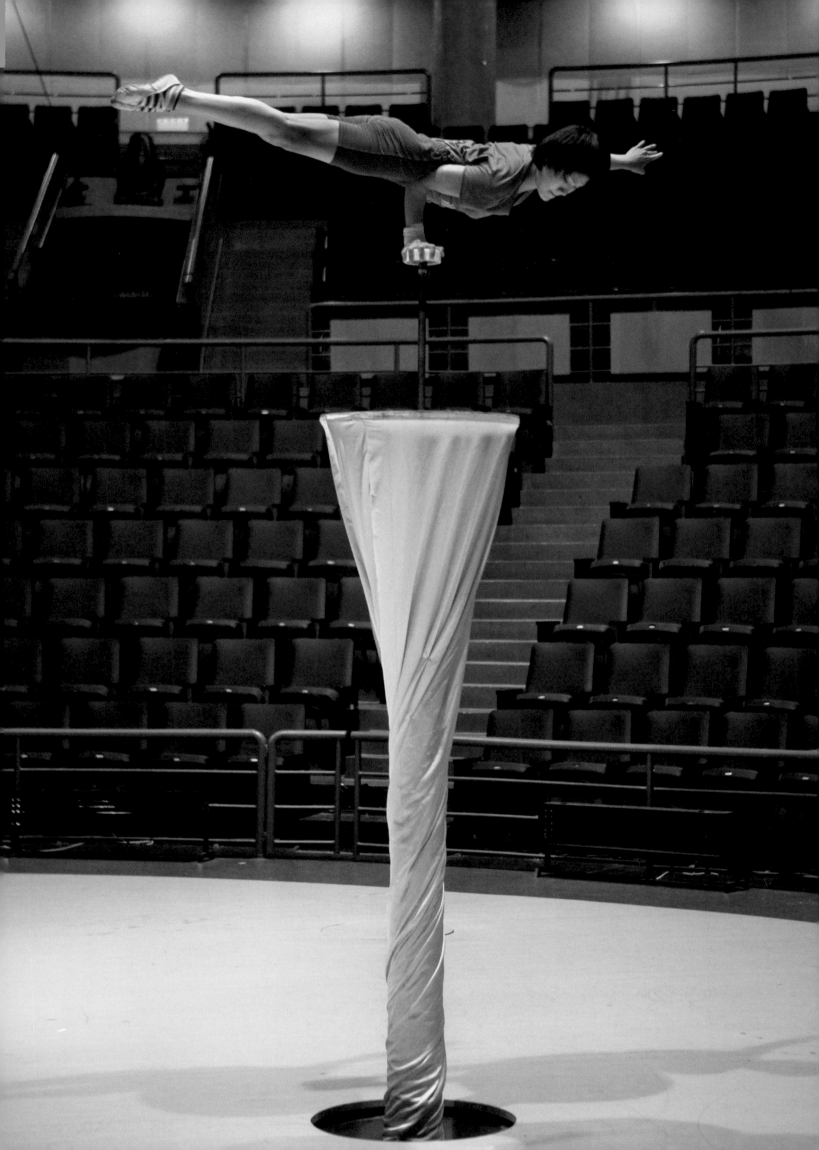

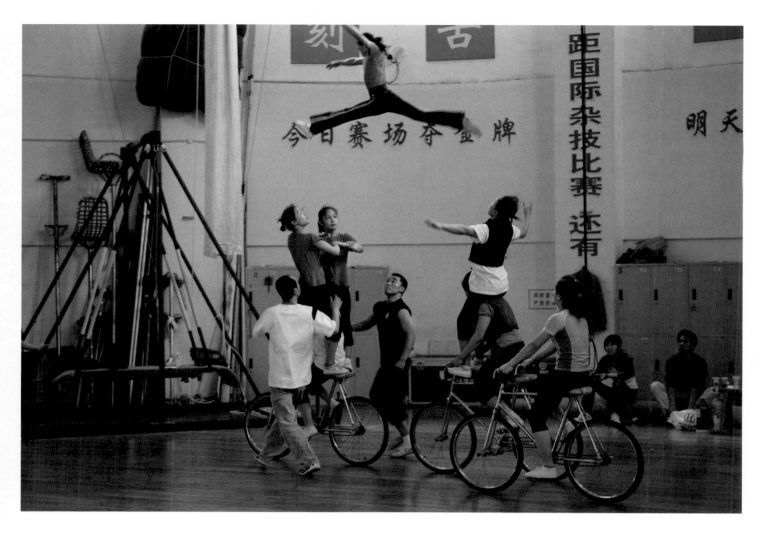

今日赛场夺金牌

距国际杂技比赛

明天

Cao Xiaoli practices five hours a day, lives in a room with nine other girls, and performs seven days a week. She says what she likes best is the crowd's reaction when she does something seemingly dangerous. At left: During the day's second practice at center stage, she concentrates on balancing on one hand. Top right: A troupe from Dalian tries out their cycling act. Bottom right: Shanghai Circus World's new domed building seats more than 1,600 people.

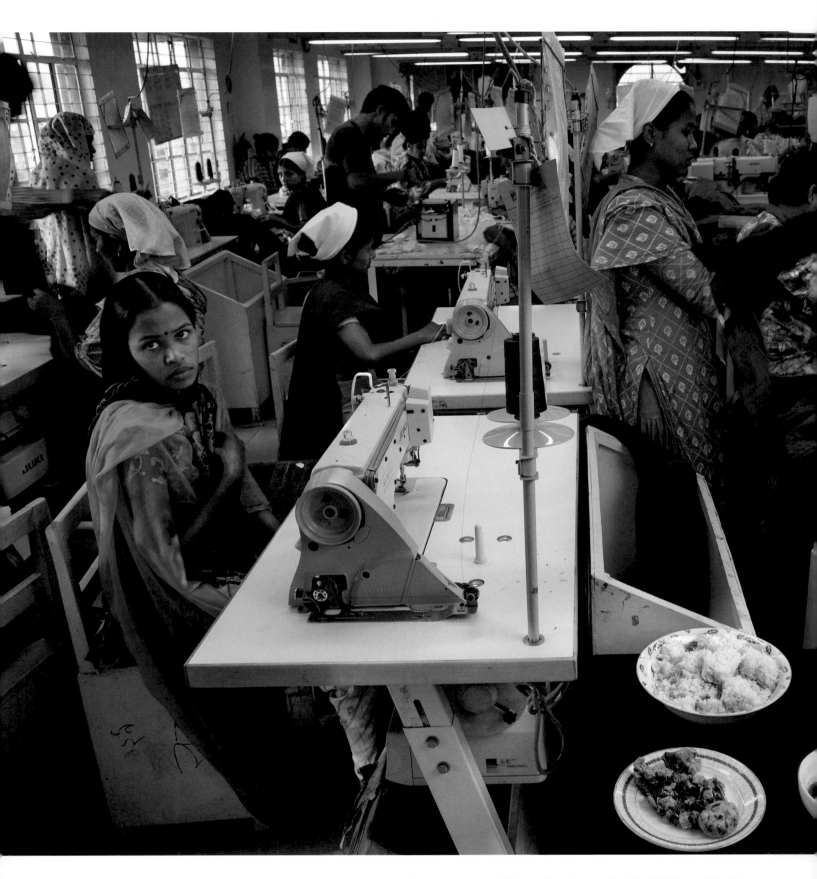

Ruma Akhter, a seamstress and one of over 6,000 employees at the Ananta Apparels company with her typical day's worth of food. While nearly half of Bangladesh's population is employed in agriculture, in recent years the economic engine of Bangladesh has been its garment industry, and the country is now the world's fourth largest clothing exporter, ahead of India and the United States. Dependent on exports and fearing international sanctions, Bangladesh's garment industry has implemented rules outlawing child labor and setting standards for humane working conditions.

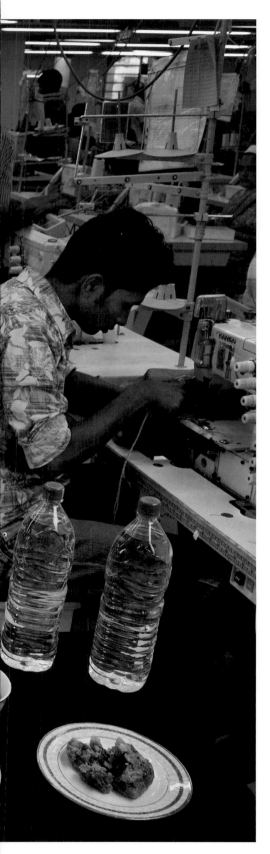

BANGLADESH

Ruma Akhter
The Factory Seamstress

ONE DAY'S FOOD

IN DECEMBER

BREAKFAST Potato, green beans, and carrot cooked with turmeric and oil, 5.9 oz • Alu bhorta (smashed potato mixed with onion and hot chilies), 1.8 oz • White rice, 9.2 oz

LUNCH Broth of onion, garlic, ginger, and ground chilies, 5.7 oz; with hard-boiled egg, 2 oz; and boiled potato, 4.4 oz • White rice, 9.2 oz

DINNER Potato, green beans, and carrot cooked with turmeric and oil, 5.6 oz • Masoor dal (pink lentils), cooked with onion, garlic, hot chilies, ginger, and turmeric, 5.6 oz • White rice, 9.2 oz

THROUGHOUT THE DAY Water hand pumped from community wells, 1.3 gal

CALORIES: 1,800

Age: 20 • Height: 5' • Weight: 86 pounds

Most of Bangladesh's citizens still work in agriculture, but the garment industry has helped transform the country's fortunes. Some say the companies are successful because they can pay low wages, which is true, but the industry has also helped create opportunity in a country where little existed before, especially for women—an economic boon for people with few other options.

DHAKA • Because conditions in some garment factories have grabbed the headlines for a number of years, it's perhaps understandable that the Dhaka-based Ananta Apparels is suspicious when we ask to cover one of their seamstresses for a book about food and culture. After we explain the project and they outline their adherence to international workplace standards and practices, we're allowed to choose a willing candidate in their downtown garment factory.

We work our way through several floors of industrious cutters, stitchers, washers, and designers until we spot 20-year-old Ruma Akhter on the sewing floor, stitching up a leg seam on what will become blue jeans—her small part of a large order for a famous U.S. clothing chain. She pores over the images of the people we've already taken for the project, chuckles at the photo of Miyabiyama, the sumo wrestler (page 204), and agrees to participate.

Thousands of rural Bengalis stream into Dhaka each year, spurred on by tales of friends—or friends of friends—with paychecks. Ruma's family made the move from their village farm, where they grew lentils, rice, and jute, to Bangladesh's capital city when Ruma, the oldest of four children, was 12. In fact, almost everyone in Ruma's village has moved to Dhaka. When we visit her neighborhood in Kamrangirchar, northwest of the city center, we're introduced to cousins, two aunts, a grandmother, and several longtime family friends, all of whom live in the area.

The Akhter family's home is a 10-foot square room constructed of corrugated metal. It's one of hundreds of identical single-story homes built in long continuous rows and rented by the month for 900 taka ($12.98 USD) per family. Narrow paths connect the rooms to communal kitchens, latrines, and the main street. The buildings are constructed on concrete slabs to keep them dry when the floods come—an inevitable fact of Bangladeshi life. Despite the crowded conditions, the tiny homes are tidy and well kept, inside and out. Even the packed earth alleyways are swept clean by the residents. The drawback to living here is that the surrounding area is piled high with mountains of trash, and when it rains litter flows freely through the walkways.

When we visit, shoes come off at the door, as is the custom throughout Asia, and

Young men play soccer at dusk on the roof of their seven-story apartment building (top left), across the alley from the apparel factory where Ruma Akhter and her colleagues work. At right: Ruma and fellow residents in their Dhaka neighborhood. Top right: Across town, travelers crowd onto ferries at the Sadarghat dock on the Buriganga River. The river acts as both a highway and a sewer, with 80 percent of the city's raw sewage draining into the river.

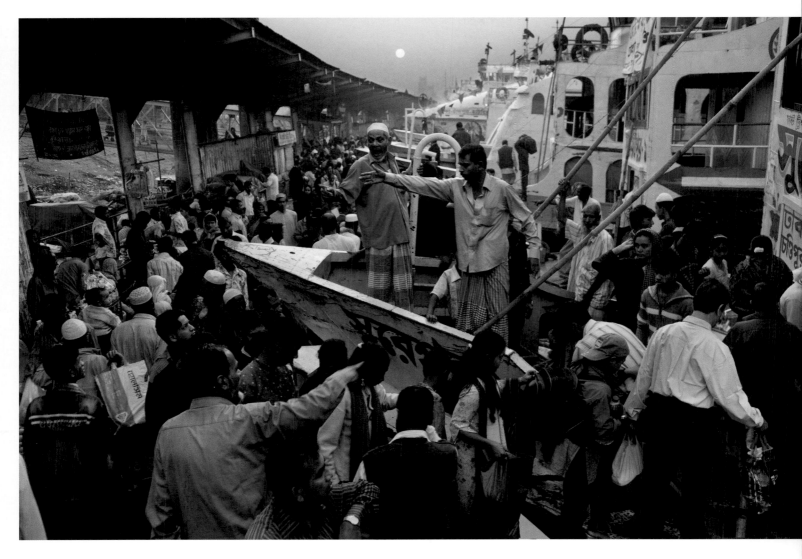

we sit on the floor of the living room, which is the bedroom at night and the dining room at mealtimes. Bedrolls are stacked in the corner, and a metal rack against one wall holds the family's clothing. A water bucket and cooking pots are nestled against another wall. The family has electricity but no refrigerator, so they shop for food every day. The brightest spots in the room are Ruma's threadbare light blue sari and a cloudy mirror with an orange frame tacked up on the wall by the door.

How does this house compare to their home in the countryside? "The size is about the same," Ruma says. Then she directs our attention gently to a different distinction, in essence telling us that the housing itself doesn't matter much to her: "It's better here [in Dhaka]," she says, "because the jobs are here."

Ruma takes us on a short walk, past the latrines and the community water pump, to the shared kitchen. It's an empty room with three floor-level gas burners and a window with bars on it. The women bring their utensils, cooking pots, and food to prepare curries, dals, and rice, then carry everything home again when they leave.

Ruma's mother usually cooks once a day and keeps the covered pots of food in their room, ready for mealtimes. The menu doesn't change much from day to day: potatoes smashed, mashed, and boiled—with chilies and without—usually with turmeric; dal cooked with onion, garlic, and ginger; and rice with every meal, scooped from a large pot. Everyone in the family likes meat, Ruma says, but they don't eat it very often because it's too expensive.

Ruma's father, Jalil, works seven days a week as a bicycle rickshaw driver, pedaling people and goods around the city. He rents the rickshaw he uses by the day, paying its owner almost half of what he earns, leaving him with about 3,500 taka ($50.48 USD) a month.

Ruma's monthly wage at Ananta is between 4,000 and 4,500 taka ($57.69 to $64.91 USD). Her only expense is her rickshaw ride to work and back, which costs 20 taka ($0.29 USD) each way. She rides with a friend from work and they split the fare. During rush hour the streets are jammed with thousands of rickshaws, taxis, minibuses, scooters, and pedestrians. Ruma's two-mile journey to work can take an hour, but it's virtually the only time she has to enjoy herself with a friend, so they ride and chat while the driver does the work. When we ask if her father ever takes her in his rickshaw, she laughs and says he doesn't. His route and schedule conflicts with hers. Apart from rent, most of their money is spent on food.

Where does she see herself in the future? Her father answers for her first and says that marriage is her future. She gives him a pat as she answers. "Women who earn their own money are respected," she says. "That's what matters to me. I have a good job. I'd like to move into a higher position at the company. I want to be a woman of substance who can pay her own way."

Bangladesh has the world's fourth largest Muslim population, and during the three days of Eid al-Adha, the Festival of Sacrifice, Dhaka's streets run red with the blood of thousands of butchered cattle. The feast comes at the conclusion of the Hajj, the annual Islamic pilgrimage to Mecca. In both the Koran and the Bible, God told the prophet Ibrahim (Abraham) to sacrifice his son to show supreme obedience to Allah (God). At the last moment, his son was spared and Ibrahim was allowed to sacrifice a ram instead. In Dhaka, as in the rest of the Muslim world, Eid al-Adha commemorates this tale, and the meat of the sacrificed animals is distributed to relatives, friends, and the poor. This is one of Ruma Akhter's favorite times of the year because it's one of the rare occasions when she gets to eat meat.

1900

Coco Simone Finken
The Green Teen

ONE DAY'S FOOD

IN OCTOBER

BREAKFAST French bread, 1.8 oz • Strawberries, 2.6 oz • *So Nice* soy milk, original, 7.5 fl oz

LUNCH Veggie Wrap: *Old El Paso* flour tortilla, salsa flavored, 2.5 oz; feta cheese, 1.8 oz; green bell pepper, 1.1 oz; lettuce, 0.4 oz; butter, 0.5 tsp • Apple, 5.6 oz • Carrots, 1.8 oz

DINNER *Jyoti* matar paneer (peas and Indian-style cheese), 6.1 oz • White rice, 6.6 oz

SNACKS AND OTHER Homemade zucchini bread with chocolate chips, 5.9 oz • Apple, 5.1 oz • 1% milk, 10 fl oz • *Super C* vegetable cocktail juice, 5.5 fl oz • *Yogi* chai tea, 8 fl oz • Tap water, 28.7 fl oz

CALORIES 1,900

Age: 16 • Height: 5'9½" • Weight: 130 pounds

GATINEAU, QUEBEC • French fries, gravy, grease, and cheese—*poutine*—is a beloved favorite across Canada that originated in Quebec in the early 1950s. The potatoes are fried in the grease, cheese curds are sprinkled on top, and the whole thing is smothered in thick, brown, meat-based gravy. Coco Simone Finken's father, Kirk, loves it, as does her French-Canadian mother, Danielle, and her sister, Anna, but it doesn't fit in with 16-year-old Coco's current diet regimen. She's a vegetarian these days.

It wasn't much of a stretch for the Finkens to support her dietary experiment; they've never eaten much meat, relying instead on the plant-based bounty of the land. The Finkens, who live a block and a half east of Lac Deschenes, a wide section of the Ottawa River near Ottawa, support local farmers and also grow some of their own vegetables in raised beds in their front yard, despite the short growing season and cold climate in their northern location.

Kirk and Danielle have worked to instill a green ethos in their daughters—and to leave a small ecological footprint on the earth. They live in a passive-solar, straw-bale house, and they buy organic foods to the extent that they can afford the higher cost. They purchase foods like vegetables, milk, and freshly ground peanut butter at the local natural foods store, but they try to economize on staple foods. Kirk does most of the family shopping, and buys staples at the no-frills supermarket chain Super C. "At the bigger markets," says Kirk, "everything is so seductive that you end up spending more money than you intended." He calls it consumer manipulation.

Coco's mornings generally start with a soy milk and fresh fruit smoothie, and then it's on the bicycle and off to school. The family doesn't own a car, so a bike is the best way to get around town.

While the rest of the Finkens might have a chicken dish and a fresh garden salad for dinner, they could just as easily eat a tofu dish, a simple homemade tomato soup, or Indian *matar paneer:* peas and Indian-style cheese in a spicy sauce. Other than Danielle, the family shares a universal dislike for only one food item: lumpy organic yogurt from the natural foods store.

Coco Simone Finken, a teenage vegetarian, at home with her typical day's worth of food. The family doesn't own a car, buys organic food if it's not too expensive, and grows some of their own vegetables in their front yard. At left: Coco blows out 16 birthday candles on a homemade carrot cake baked by her mother and sister.

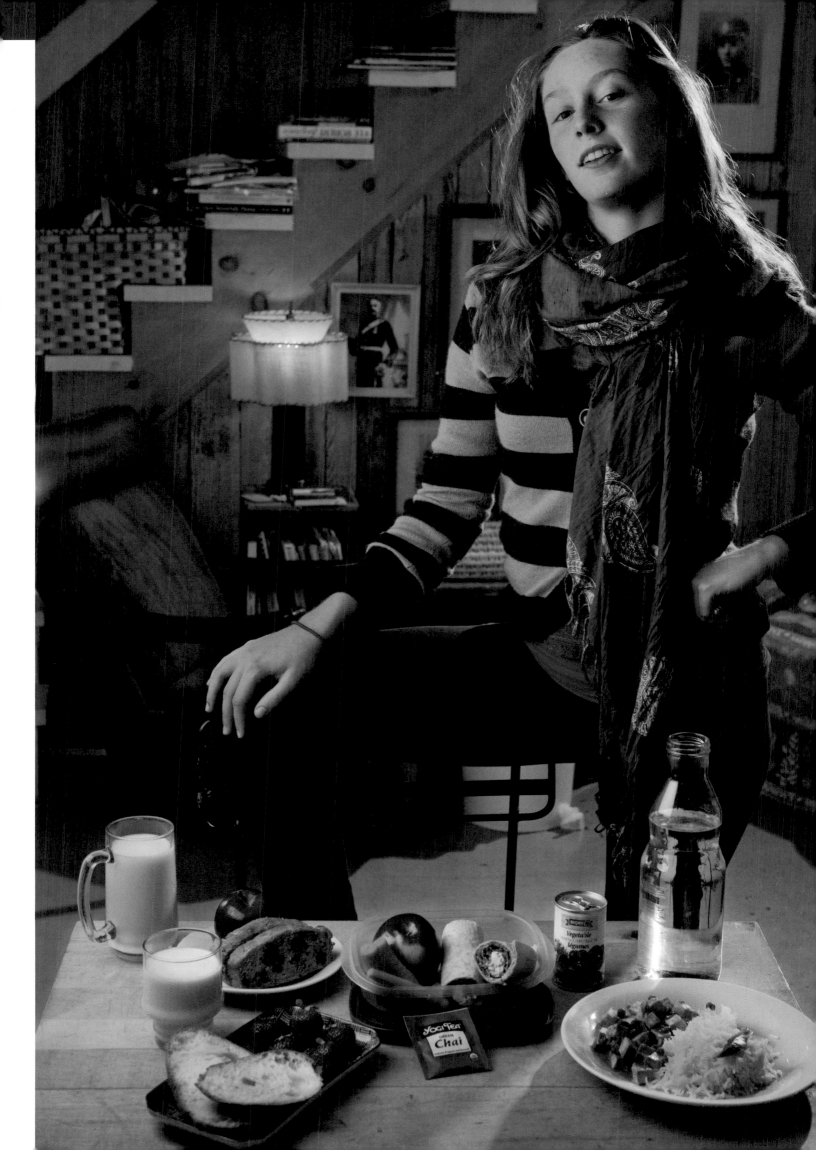

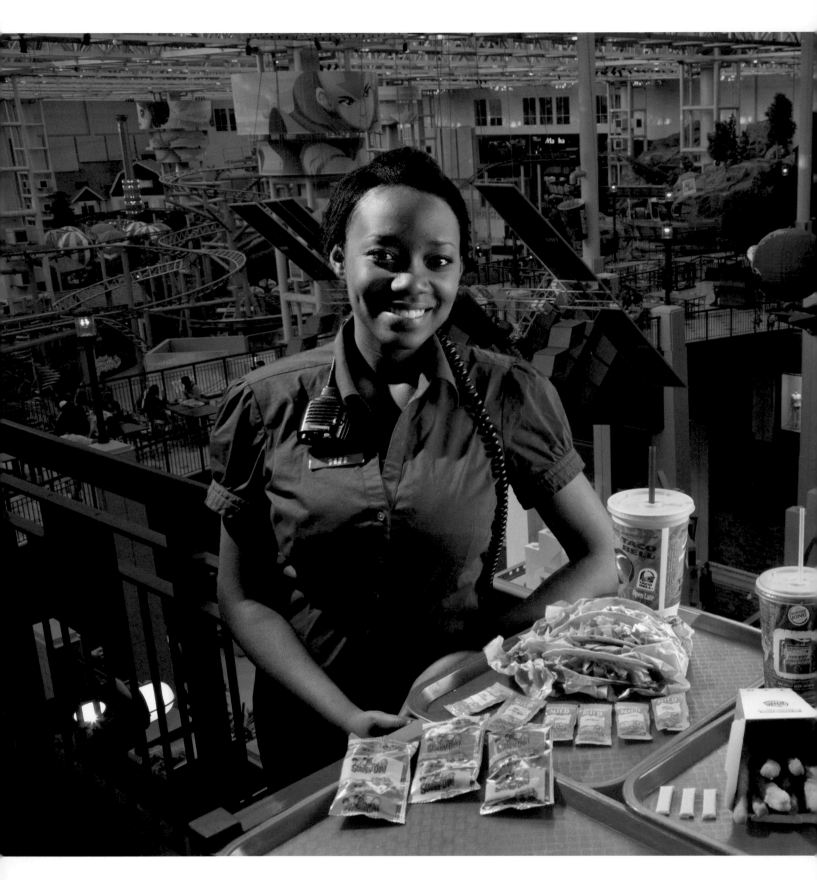

Tiffany Whitehead, a student and part-time ride supervisor at the Mall of America amusement park, with her typical day's worth of food. The Mall of America is the largest among some 50,000 shopping malls in the United States. In addition to a huge amusement park, it houses over 500 stores, 26 fast-food outlets, 37 specialty food stores, and 19 sit-down restaurants, and employs more than 11,000 year-round employees. In excess of 40 million people visit the mall annually, and more than half a billion have visited since it opened in 1992. At right: Tiffany's job involves a lot of walking. Her main beat is the amusement park area, where she responds to radio calls regarding stalled rides and lost children and answers visitors' questions.

USA

Tiffany Whitehead
The Mall of America Staffer

ONE DAY'S FOOD

IN JUNE

EARLY MEAL *Burger King Chicken Fries* (breaded, fried chicken strips), 3.7 oz • *Burger King* french fries, 4.5 oz • *Dr. Pepper*, 15.7 fl oz

LATER MEAL *Taco Bell* hard-shell tacos, ground beef (3), 10.3 oz; with *Taco Bell Border Sauce*, mild, 1.5 oz • *Mountain Dew Baja Blast*, 25.7 fl oz

SNACKS *Betty Crocker Scooby-Doo!* snacks, fruit flavored, 2.6 oz • *Stride Forever Fruit* gum, 3 pieces • Ice to chew, 1.3 lb

CALORIES 1,900

Age: 21 • Height: 5'7" • Weight: 130 pounds

BLOOMINGTON, MINNESOTA • Occasionally Tiffany Whitehead prepares a sandwich at home before racing off to school in downtown Minneapolis or to work at the Mall of America amusement park, but most days she dines with the Colonel or the King in the glow of the Golden Arches.

The 21-year-old beauty school student and amusement park ride supervisor still lives at home, but she rarely eats there. The amusement park is bookended by food courts, making it easy to grab a meal. She has her favorites, and price is a factor in her mealtime choices: "There's a Healthy Express," she says, "and I used to eat there, but they're really expensive. For the caesar wrap and the fruit smoothie, it was eight bucks every time!"

When she worked full-time, she sometimes brought frozen Lean Cuisine dinners to work because it was cheaper, and she still does on occasion: "I usually get the fettuccine Alfredo. I love Italian food."

She thinks the time saved by eating out trumps making food at home to carry to work and school; plus, none of her friends bring food from home, and they like to go out to eat together.

Although fast food is the glue that holds her diet together, she and her friends have other mealtime haunts as well. At Applebee's, "I get the half-price appetizers and a drink," she says. And there's a Chipotle near her school in downtown Minneapolis: "I get the burrito bowl...chicken, rice, sour cream, tomatoes, cheese, and lettuce." When she first started eating at Chipotle, she didn't know the chain was generally considered to be a healthier alternative to fast food. "I just like the taste," she says.

"I love any kind of vegetable," she says, but the only veggies she's eating these days are the shredded lettuce and tomato in her Taco Bell hard-shell tacos. Tiffany also loves fruit, and she laughs when she looks at her typical day's worth of food and discovers that her sole weekday serving of fruit comes in the form of fruit-flavored Scooby snacks. "I really love them," she says.

She expects she'll pay more attention to her diet as she gets older, but for now she works hard and spends her downtime eating out with friends at places they can afford.

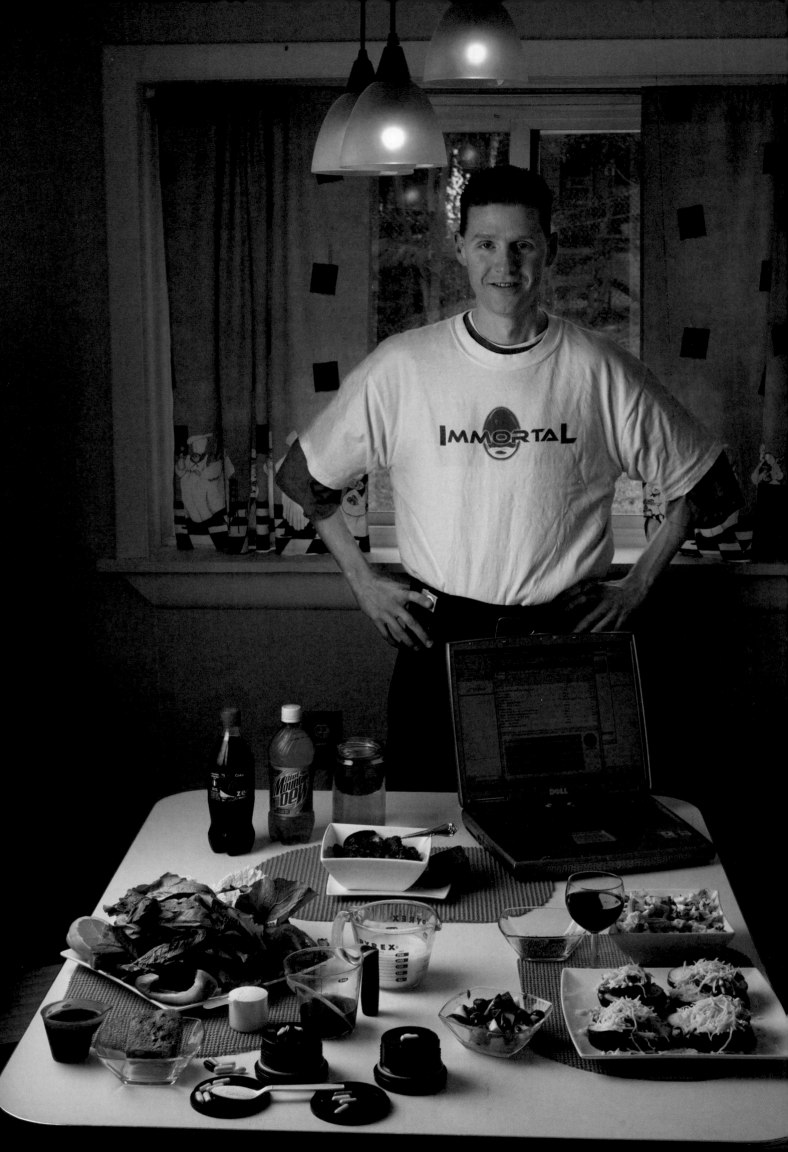

USA

Michael Rae
The Calorie Restrictor

ONE DAY'S FOOD

IN JULY

BREAKFAST Pomegranate juice (early morning), 2.7 fl oz • Salad of turnip greens, 3.7 oz; cabbage, 3.5 oz; tomato, 3 oz; and green bell pepper, 1.2 oz; with dressing (not in picture) of salsa, balsamic vinegar, flaxseed oil, and olive oil, 2.5 fl oz • Orange, 3.2 oz • Homemade rice bran muffin (with over 25 ingredients), 3.8 oz • Skim milk, 7.1 fl oz; mixed with instant coffee, decaf, 2.7 fl oz; and *Advanced Orthomolecular Research* whey protein powder, 1.5 tbsp

LUNCH Black bean soup, 9.2 oz • Homemade rice bran and chocolate brownie (with over 20 ingredients), 3.1 oz

DINNER "Chicken" salad: *Quorn Chik'n* meatless tenders, soy free, 3 oz; egg white, 2.7 oz; asparagus, 3.5 oz; and cauliflower, 3.5 oz; with flaxseed oil and olive oil dressing, 2 tsp • Eggplant "pizza": eggplant, 4 oz; zucchini, 4.5 oz; tomato, 4.1 oz; mushroom, 0.3 oz; mozzarella cheese, 2 oz • Apple, 2.5 oz; and hazelnuts, 0.5 oz; with fat-free ricotta cheese, 1 oz; and *Walden Farms* caramel dip, 1 tbsp • Pinot Noir, 3 fl oz

THROUGHOUT THE DAY Sencha green tea, 25.4 fl oz • Sencha green tea and chai tea blend (not in picture), sweetened with sucralose, 25.4 fl oz • *Coca-Cola Zero*, 20 fl oz • *Mountain Dew*, diet, 20 fl oz • Supplements (taken at specific times): vegetarian booster; inositol; pyridoxamine; benfotiamine; vitamin D; vitamin B_{12}; methylcobalamin; vitamin K_2; menatetrenone; *Advanced Orthomolecular Research Prostaphil-2* defined pollen extract; multimineral; strontium; zinc; carnosine; chlorophyll; lithium; arginine (amino acid); glycine (amino acid); lysine (amino acid); *Advanced Orthomolecular Research EGCG-MAX* green tea extract

CALORIES: 1,900

Age: 32 • Height: 5'11½" • Weight: 114

WHITEMARSH, PENNSYLVANIA • In the 1930s, Cornell University researchers discovered that rats fed a very low-calorie diet lived a lot longer than rats on a typical diet, and studies of other animals have yielded similar results. Formal studies on the effects of calorie restriction on human life span are relatively new, but Michael Rae is among a small, passionate group already practicing this diet—cutting daily calories by 25 to 30 percent. "I'm mortal," he says. "It's just reality. But I want to forestall death for as long as possible, and I sure as hell don't want to go through the aging process." Beyond the hopeful holy grail of a significantly longer, healthier life, proven benefits of calorie restriction (CR) include lowering of high blood pressure and a strengthened immune system.

CR can be practiced by meat eaters, vegetarians, and vegans alike. The only requirement is consuming fewer calories while still taking in adequate nutrition. CR is more life plan than diet plan, and for Michael it's all-consuming. "It's sort of a long-term experiment," he says. Since 1999, every morsel of food he eats has been weighed, and the resulting numbers have been crunched on a computer to tally calories and ensure optimum nutrition. The Canadian-born vegetarian is just under six feet tall and weighs from 114 to 118 pounds on average. He runs 15 minutes two to three times a week for bone strength and takes over 40 nutritional supplements daily—something he knows a lot about, having once been a supplement formulator. Michael hasn't eaten his favorite food, pizza, since he began CR. Does he miss it? "Of course," he says. "I really am unnecessarily fanatical about this. I recognize that." "Whoa," says his girlfriend, April Smith, laughing. "Can someone write that down?" "The reality is," says Michael, "I could eat more relatively empty calories than I do with no impairment to my calorie structure at all, but I don't."

Michael says his meals are tastier since April arrived on the scene. "She's a brilliant cook," he comments as she plates filamentous fungi—a meat alternative—sauced with sucralose-sweetened cranberry compote for Michael. "Baby, did you flax me?" she asks.

He does, adding a single teaspoon of flax oil to her dinner—a leafy green salad with yogurt. "We never eat the same thing for a meal because our nutritional and calorie needs are different," says April.

Michael is rigorous in his quest but acknowledges twin fantasies. "One is, I'm going to pick up the phone and just order a pizza and stuff the whole damn thing down my throat," he says. The other? "The day the immortality pill comes out, we're going to go down to KFC and gorge ourselves. And I don't even know if I'd still like KFC."

Michael Rae, at his suburban Philadelphia home with his typical day's worth of precisely weighed food. Michael is research assistant to the theoretician and biomedical gerontologist Aubrey de Grey, and they are the coauthors of the book *Ending Aging*. At right: Michael on a weekday run.

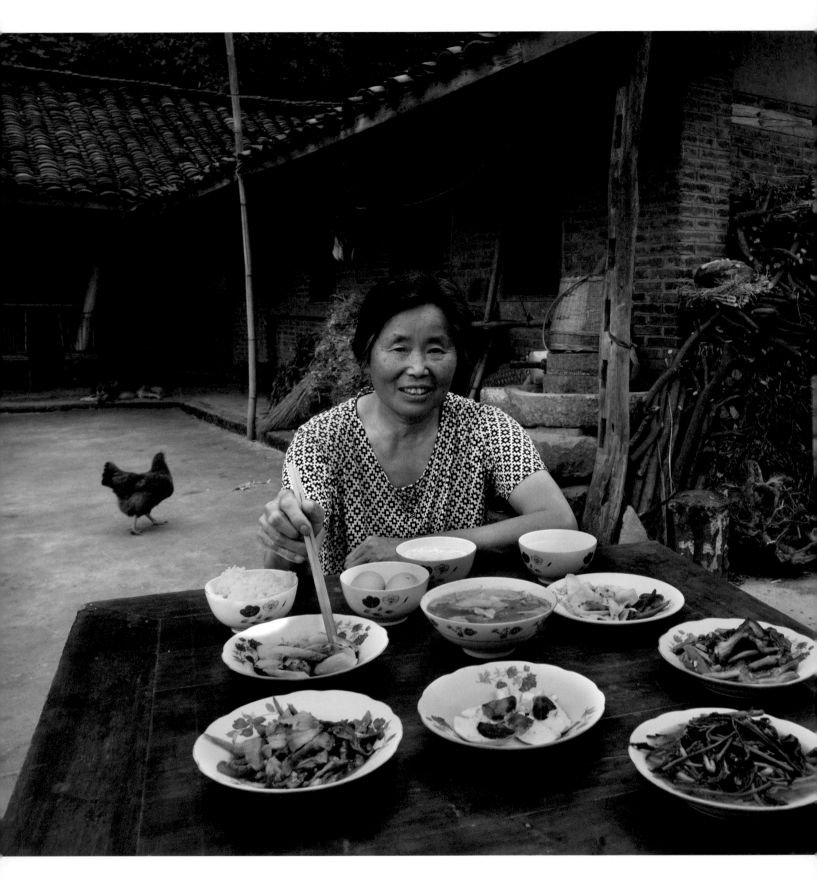

Lan Guihua, a widowed farmer, in front of her home with her typical day's worth of food. Her farmhouse is tucked into a bamboo-forested hillside beneath her husband's grave, and the courtyard opens onto a view of citrus groves and vegetable fields. Chickens and dogs roam freely in the packed-earth courtyard, and firewood and brush for her kitchen wok are stacked under the eaves. Although homegrown vegetables and rice are her staples, chicken feathers and a bowl that held scalding water for easier feather plucking are clues to the meat course of a special meal for visitors. In this region, each rural family is its own little food factory and benefits from thousands of years of agricultural knowledge passed down from generation to generation.

CHINA

Lan Guihua
The Citrus Grower

ONE DAY'S FOOD

IN JUNE

BREAKFAST Eggs, from her chickens, hard-boiled (2), 5.1 oz • Xifan (rice porridge), 6.7 oz

LUNCH AND DINNER Pickled Chinese cabbage and hot chili peppers with hot chili oil, 3.5 oz • Eggplant and green beans, boiled, 9.7 oz • Duck egg with salt, 3.2 oz • Stir-fried sweet potato eaves, 13.3 oz • Bottle gourd soup with ginger and hot chili oil, 14.3 oz • Cucumber, 4.2 oz; with hot chili oil, 1.5 tbsp • Hui guo rou (twice-cooked pork with green chilies in a red Sichuan pepper oil), 5.4 oz • White rice, 4.4 oz • Rice water soup (starchy water left over after cooking rice), 6.7 fl oz

THROUGHOUT THE DAY Well water, hot, 1.1 qt

CALORIES 1,900

Age: 68 • Height: 5'3" • Weight: 121 pounds

GANJIAGOU, SICHUAN PROVINCE • When we explain that we'd like to report on her typical day's worth of food, citrus grower Lan Guihua howls with laughter and suggests that we ask someone else. "My house is really run-down!" she says. The 68-year-old firebrand offers to introduce us to wealthier neighbors, but ultimately she agrees.

Guihua and her neighbors grow acres of mandarin oranges and a profusion of vegetables in this verdant temperate valley in China's south-central province of Sichuan. The 43 families of Ganjiagou village comprise Production Group 7—a title that's a throwback to the days of collectivization, which ended in the 1980s with the rise of privatization and the market economy. Guihua and the other villagers now grow their own vegetables, peanuts, and soybeans, and over a decade ago began to grow oranges as a cash crop.

We're lucky we caught Guihua at home. She says that when she's not planting, harvesting, chopping weeds, or grinding soybeans to make soy milk and *douhua*—a puddinglike tofu, she's playing cards with her friends in the nearby market town of Dongpo.

Guihua keeps ducks and chickens for the eggs and meat but stopped raising pigs 10 years ago, after her husband died. Now she buys pork or gets it from neighbors when they butcher. She doesn't eat it fresh—she cures it: "I cover the meat in salt, then I smoke it and hang it until I want to cook some."

Neighbors appear with fresh-picked sweet potato leaves, eggplant, squash, and other vegetables to help cook an impromptu feast. Despite our protest, Guihua kills a chicken for the lunch crowd, which grows larger by the minute as she invites every passerby at the top of her lungs.

The ill-fated chicken is chopped into pieces, salted, and steamed in one of two giant side-by-side wood-fired woks in Guihua's rustic kitchen. Her oldest friend, Hu Runzhi, sits on the dirt floor, all but hidden behind the wok stove, patiently feeding the fire with dried brush as the others cook.

They stir-fry the sweet potato leaves in homemade canola oil, make egg drop soup and a squash dish with ginger, and cook eggplant and green beans in pork fat, adding MSG with a liberal hand. There's *hui guo rou* (twice-cooked pork): thick pieces of fatty pork cooked with ginger and salt, then sliced thin and stir-fried again with soy sauce, chili paste, green onion, and spicy green chili peppers. The sumptuous village meal is served with white rice, slices of raw cucumber, and pickled cabbage—and an endless flow of homemade hot red chili oil.

After lunch, Guihua power walks up the steep hillside through bamboo thickets to show us her mandarin orange grove and visit her husband's grave, as she often does in the course of her day. "Hi, I'm here to see you again!" she says.

Lan Guihua visits with neighbors (top left) who are using their millstone to grind soy beans to make soy milk. After being soaked overnight, the beans are ladled into the hole at the top of the millstone and the juice from the crushed beans flows into the stone base and then into a bucket. Bottom left: With the help of a neighbor, and under the expectant gaze of Dudu the dog, Lan Guihua drains the blood of a freshly killed chicken into a bowl to use for spicy tofu soup. An hour later the chicken, along with hard-boiled duck eggs and half a dozen different kinds of fresh vegetables, will be served to visitors and neighbors in the large room off her kitchen. She lives next door to her son and daughter-in-law, but they aren't home to join the party. At right: The table is set with a first course of egg drop soup. Back in the kitchen, a neighbor fills the remaining bowls for last-minute arrivals invited to join the afternoon feast.

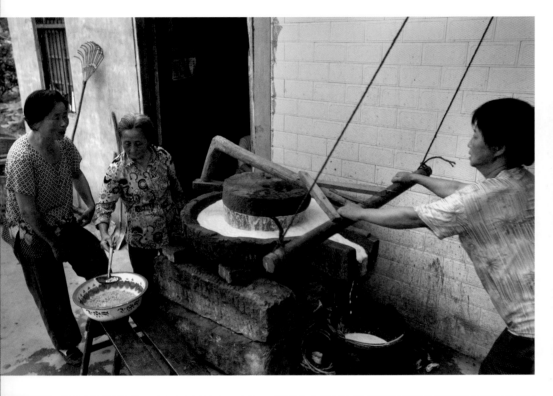

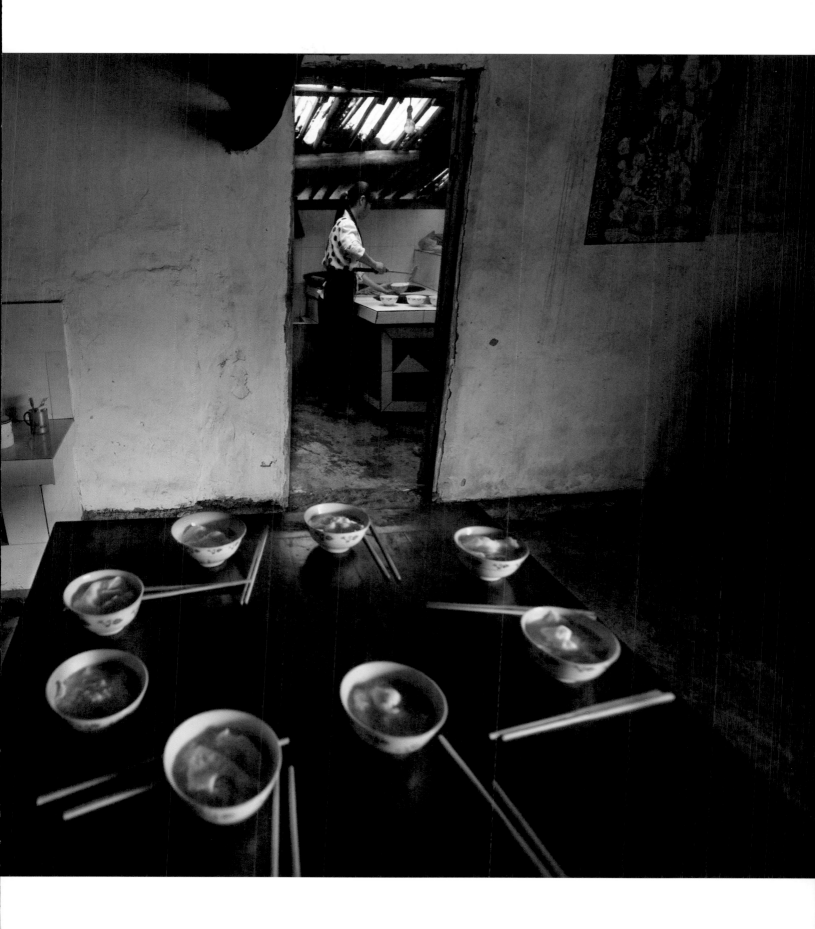

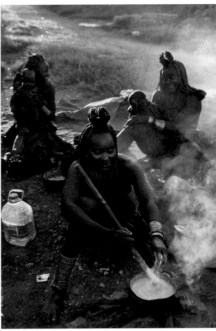

Why We Cook

By Richard Wrangham

One of the earliest cultural anthropologists, Sir Edward Burnett Tylor, was also one of the first scholars to ask if any cultures lived solely on raw food. His conclusion was clear. "The art of Cooking," he wrote in 1870, "is as universal as Fire itself among the human race." No culture lived without cooked food, not even the Inuit or Eskimos, who were often rumored to do so. Cooking was difficult for those inhabitants of the far north because plant fuel was scarce and the flame produced by burning animal fat was cool. Yet as early as 1605, British explorer James Hall found the natives of Greenland "boiling food over their lamps, in vessels with stone bottoms, and sides of whale's fins." The Inuit couldn't easily whip up a meal during

the day, so on the hunt they often ate fish or caribou parts cold and raw. However, at night a wife's clear duty was to produce a hot meal for her family. The practice in the arctic was the same as in the rest of the world. People everywhere did whatever was necessary to cook their evening meal.

Why we cook is a fascinating question. In the 1960s, anthropologist Claude Lévi-Strauss argued that cooking was all in the mind. He thought that cooked food holds no advantages over raw food except that it makes us feel human, because it allows us to eat in a distinctive way compared to all other species. Others have had more practical thoughts, noting that cooking kills harmful bacteria, destroys toxins, and promotes delicious flavors and textures. While all these effects are important, none is as influential as a simple fact that has been little appreciated until recently: Cooking gives us energy.

One way cooking increases the caloric value of food is by making energy-rich nutrients easier to digest. For example, starch is a vital carbohydrate that typically accounts for more than half of our calories,

Richard Wrangham is the Ruth Moore Professor of Biological Anthropology at Harvard University and author of Catching Fire: How Cooking Made Us Human. *He has been featured on NPR and in publications including* New Scientist *and* Scientific American.

but if we eat it raw, some of it may be so resistant to digestion that we derive little benefit from it. When we make a roux, we free long chains of glucose from the granules in which they have been imprisoned, and their liberation makes the sauce viscous, thick, rich, and more fully digestible. Heat similarly loosens the tight structure of proteins, exposing chains of amino acids to the action of digestive enzymes.

Cooking also reduces the work that our bodies must do to obtain nutrients. Cooked foods are easier to chew; for instance, heat converts the collagen in connective tissue in meat to gelatin. So cooked foods require less muscular action by the stomach and fewer secretions of the many molecules the gut produces to transform meals into nutrients the body can absorb. It is little wonder that the first of six reasons for cooking given by *Mrs Beeton's Book of Household Management*, published in 1861, was "to render mastication easy." The softer the food, the more calories we get from it.

Most animals appear to prefer cooked food if given the choice, with obvious effects on their weight. Pet cats and dogs share our risk of obesity because we feed them cooked, processed food. Farm animals are given cooked mash to improve yield. On the other hand, one of the best ways to lose weight is to eat all of your food raw. Most committed "raw foodists" are thin even though their diets are made up of

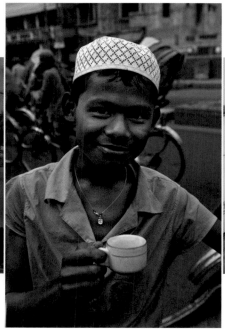

Left to right: Pilgrims pour boiling butter tea at a Buddhist monastery in Lhasa, Tibet. A Himba woman stirs cornmeal porridge in Opuwo, Namibia. Sumo wrestlers chop vegetables in Nagoya, Japan. Villagers prepare lunch in Sichuan Province, China. A rickshaw driver on his tea break in Dhaka, Bangladesh. A housewife cooks in the detached kitchen house of a suburban home in Dubai, United Arab Emirates.

domesticated fruits and other foods that have been bred by farmers to have nutritional quality far higher than those found in the wild.

In truth, our bodies aren't adapted to eating raw diets, which begs the question: Why are humans, alone among animals, biologically committed to including cooked foods in our diets? The immediate reason is clear. Compared to our cousins, the great apes, humans' intestines are small—too small to allow us to digest the tough, bulky, fibrous foods that chimpanzees and gorillas rely on.

Since experiments show that apes prefer cooked food, it seems likely that our ape ancestors would have taken advantage of cooked food soon after they learned how to maintain fire. But pinpointing that time is a challenge. Unfortunately, the archaeological record cannot help us, because it reveals no threshold point before which fires were absent and after which they were widespread. Instead, the number of locations where ancient campfires have been detected simply declines erratically as we look further back in time, so that before about half a million years ago there are few sites that can be identified as such with much confidence, though some locales suggestive of controlled fire have been found from more than 1 million years ago. The evidence from fossils is more helpful. Ancient human bones show that the diminution of our mouths, teeth, and guts, which now seems responsible for our inability to thrive on a solely raw foods diet, began almost 2 million years ago. That was when *Homo erectus* appeared, the first of our ancestors to share the size and shape of modern humans.

So our best guess is that almost 2 million years ago *Homo erectus* arose as the first species committed to cooking. The cuisine was undoubtedly simple. However, even mere roasting on coals would have dramatically transformed the fibrous roots, bitter seeds, and tough steaks of their diet into newly delicious meals. And because their food offered more nutrition and energy, these first cooks would have been evolutionary winners, able to forage and hunt farther and longer than before. Cooked food also strengthened their immune systems, enhanced the survival of youngsters, granted longer lives to adults, and, most importantly, bolstered fecundity and increased the birth rate. It also promoted growth of the brain.

Regardless of when our ancestors first cooked, the impacts were enormous and went far beyond our digestive apparatus. Eating cooked food reduced the time spent on chewing by several hours a day, making more time available for innumerable other activities. Among hunter-gatherers such as the Inuit, this led to an ironic development wherein the hours of chewing spared by the advent of cooked food were used by women mainly to prepare food for their families. It seems that men gained more. Because men could count on being fed, they could spend long hours in masculine activities such as hunting without having to bother with satisfying their own hunger until they returned to camp. There were other changes too. Because cooked food is so much softer than raw food, it allowed early weaning, creating a class of young children who needed others to prepare food for them—usually their mothers. Cooked food also created a focus around which family life became a new routine. Taking all of these effects into consideration, cooking might fairly be seen as the biggest increase in diet quality in the whole of our evolution, transforming us from prehumans to humans.

At the end of the nineteenth century, when debate raged about the number of human species, Sir Edward Tylor insisted that everyone alive today belongs to the same species. Had he appreciated the significance of his other observation, that everyone depends on cooked food, he might also have realized that this unity owes much to the ancient practice of cooking—a cultural trait so important that it has shaped our very biology and continues to influence our bodies and our societies to this day.

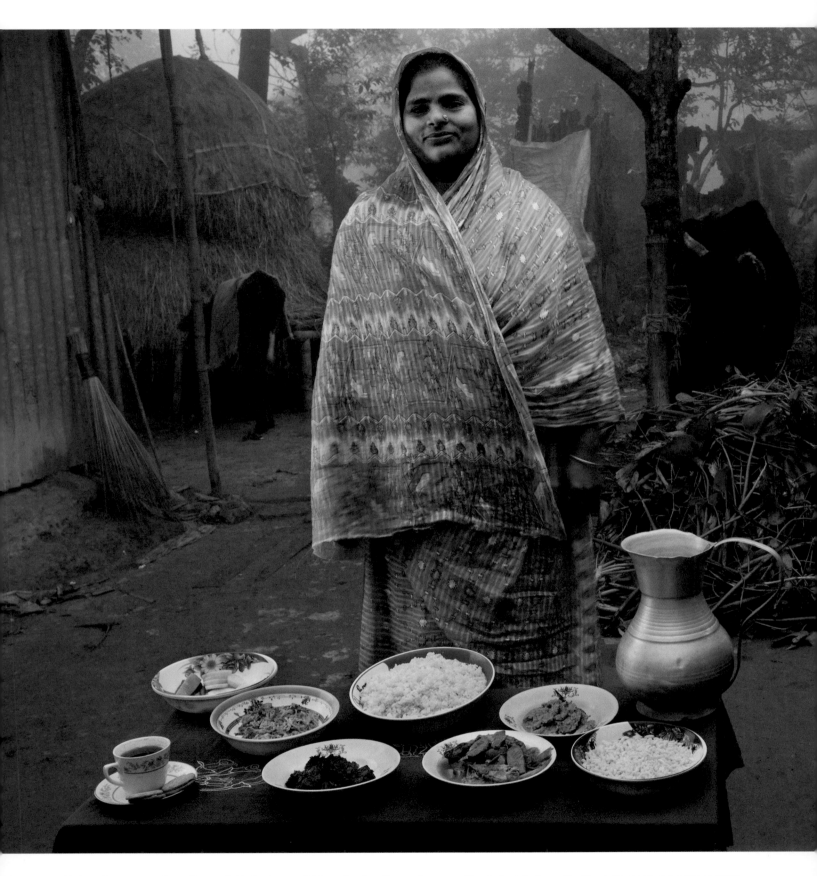

Shahnaz Begum, a mother of four, outside her home with her microloan-financed cows and her typical day's worth of food. Her cows eat a pile of water hyacinths gathered by her son from a pond beyond the haystack. At right: A microloan recipient stitches net bags destined for Dhaka; each bag sells for 1.2 taka ($0.02 USD). In order for a seamstress to make the equivalent of $1 (USD), she must sew 1,000 bags. Shahnaz's small business loan comes from the microlender BRAC, which loans money for business to tens of thousands of people, mainly women throughout Bangladesh and other countries. BRAC began as the Bangladesh Rural Advancement Committee but has since branched out into other developing countries and the acronym now serves as the microlender's name.

WHAT I EAT

BANGLADESH

Shahnaz Begum
The Microloan Milker

ONE DAY'S FOOD

IN DECEMBER

BREAKFAST Sweet biscuits (cookies), 0.6 oz • Black tea, 3.5 fl oz; with sugar, 2 tsp

LUNCH Amaranth leaves, stir-fried with small shrimp, onion, garlic, ginger, and hot chilies, 6 oz • Cauliflower, stir-fried with onion, green chilies, ground chilies, and a small amount of beef for flavoring, 6.3 oz • Fresh vegetable salad of tomato, cucumber, and chilies, 3.4 oz; with lemon juice, 1 tbsp • White rice, 12.8 oz

DINNER Khailsha (giant dwarf gourami, a freshwater fish) with snow peas, potato, and tomato, eaten with the fish broth, 13.8 oz • Dal bhorta (mashed lentils cooked with cilantro and oil), 5.9 oz • White rice, 12.8 oz

SNACKS AND OTHER Puffed rice, 1.3 oz • Well water, 28.7 fl oz

CALORIES 2,000

Age: 38 • Height: 5'2" • Weight: 130 pounds

Bangladesh is situated on the world's largest delta—the Ganges Delta—at the confluence of the Padma (lower Ganges), Jamuna (lower Brahmaputra), and Meghna Rivers. It is a magnet for natural disasters: flooding, earthquakes, droughts, and cyclones. Add civil strife and severe poverty to the mix, and the word "hopeless" might come to mind. But the programs of homegrown microlenders, like BRAC and the Grameen Bank, are a bright spot. They fund small projects that help impoverished people, especially women, own and run their own businesses and, hopefully, raise their families' standard of living.

BARI MAJLISH • The clatter of kitchen pots and the lowing of Shahnaz Begum's two dairy cows herald morning in the village of Bari Majlish, located in Bangladesh's low-lying rural countryside about 16 miles east of Dhaka. Women navigate narrow walkways between their corrugated metal houses to pump water from community wells; a calf tied up nearby, waiting impatiently for its mother's milk, head-butts anyone who walks close by.

There's companionable murmuring between open-air kitchens as wives, mothers, and daughters begin the day's cooking, heating sweetened condensed milk, still in the can, over low gas flames for sweet, hot tea—a national favorite. These same women will move into business mode after breakfast, to sewing machines, tiny home-based convenience stores, and other small income-generating projects, thanks in part to funds from the community-based microlender BRAC.

Shahnaz's own small business venture is calling—it's time for milking. She pulls the edge of her bright orange sari across her head and shoulders and grabs handfuls of water hyacinth, picked yesterday by her son,

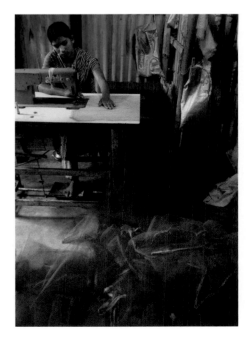

to feed to the cows while she milks. She and her family won't drink the milk; her husband, Amzad, will sell it in the Sonargaon market, where he works as a fruit vendor.

Under BRAC's microloan lending program, village women form clubs and together guarantee repayment of loans to individual members. Program agents make home visits and run workshops and education programs to help the women's business ventures succeed. The women receive 17,000 to 20,000 taka ($245.20 to $288.48 USD) per loan and have a year to pay it back.

The scent of sizzling hot chilies wafts through the village even at this early hour. Most women serve a breakfast of last night's leftover dinner: spicy vegetable curries, some with small freshwater fish or bits of beef. Shahnaz does as well, but for herself prefers a breakfast of store-bought cookies and tea with sugar.

Come midmorning, the whir of Bari Majlish's main cottage industry springs to life: manufacturing net shopping bags. Sew-

ing machines, center stage in just about every family's house, are surrounded by piles of brightly colored fishnet-style fabric used to make the bags. Shahnaz has her own shopping bag business, in addition to her cows, and pays three other women, who don't have loans of their own, to help. The net bags are shipped by the thousands to Dhaka—a booming business after the government outlawed storm-drain-clogging plastic shopping bags in the flood-prone capital city. Environmentalists say the net bags take longer to decompose and are a poor solution, but the switch to net bags in urban areas has created an economic boon for rural women.

As midday approaches, women begin the move from sewing machine to cookstove, and yet another facet of Shahnaz's entrepreneurship comes into view—there's a bit of a traffic jam in her kitchen. She and her husband built six rooms to rent, and the families who live there get kitchen privileges. Again, the sharp, pungent aroma of hot chili peppers, onions, ginger, and garlic fills the air as the women

cook in turns, squatting in front of Shahnaz's two-burner propane stove. Rice for the day was cooked earlier, and each woman's pot sits, covered, in her respective home. They chop vegetables on the blades of sharp upturned knives that have legs soldered on to hold them in place on the ground as the women work. One woman scales small fish with sand, then splits the fish on her upturned blade for fish curry.

Shahnaz's sister-in-law toasts thin pasta noodles, then cooks them quickly in a small amount of water. She also prepares mashed lentils and a beef and vegetable curry spiced with turmeric and ginger for her family. They save the water from cooking the pasta and rice in a large pot to give to the cows. Meanwhile, Shahnaz stir-fries *sak*—fresh leafy greens, in this case red amaranth leaves—with onion, ginger, and fresh green chilies. She and her family will eat the *sak* with rice and a curry of cauliflower and beef, and a fresh vegetable salad of tomato and cucumber. And then it's back to work for everyone.

Shahnaz rinses tiny fish for dinner at the village well (at left), then cooks with her renters and neighbors in a small lean-to (top left) next to her tin-clad house, which has a TV but no refrigerator. Her microloan-financed small businesses have enabled her to build six rooms that she rents out, each for $8.65 (USD) a month. In the nearby town of Sonargaon (top right), chickens and their sellers await buyers in the sprawling marketplace where Shahnaz's husband, Amzad, works.

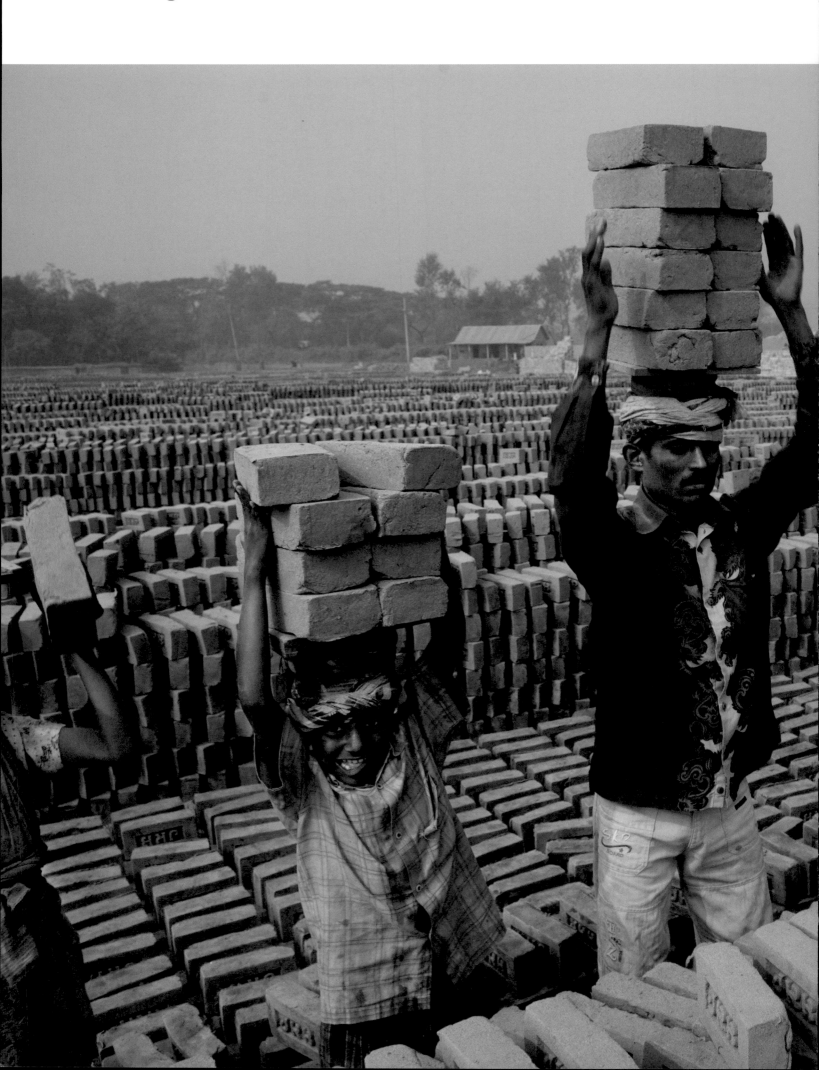

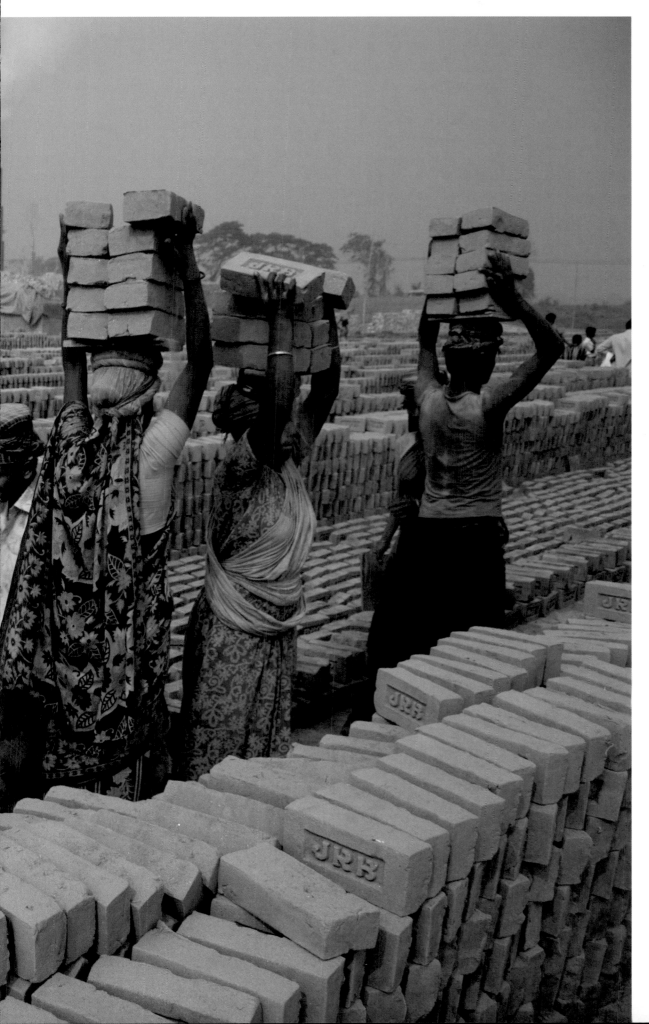

The heavy clay soils along the river near the market town of Sonargaon, outside of Dhaka, are well suited for making bricks. At the JRB brick factory, workers of all ages move raw bricks from long, stacked rows, where they first dry in the sun, to the smoky coal-fired kilns. After being fired, the bricks turn red. A foreman keeps tally, handing the workers colored plastic tokens corresponding to the number of bricks they carry past him. They cash in the chips at the end of each shift, taking home the equivalent of $2 to $4 (USD) a day. Unlike the garment industry, where child labor restrictions are more closely monitored, rural agriculture and industry are less regulated and there is little if any oversight or enforcement. Some laborers at a nearby site defend the use of child workers, saying poor families need their children to be breadwinners now if they are to have any kind of future.

2000

USA

Din Memon
The Taxi Driver

ONE DAY'S FOOD

IN SEPTEMBER

BREAKFAST Hard-boiled egg whites, 3.4 oz • *KCB Morning Tea Toast*, 1.3 oz • Coffee, 3.6 fl oz; with 2% milk, 3.2 fl oz; and *Equal* artificial sweetener, 1 packet

LUNCH Chicken curry, 7.1 oz • Chapati (wheat flour flat bread), 7.6 oz • Salad of lettuce, tomato, and cucumber, 4.2 oz; with *Marzetti* ranch dressing, 1.5 oz • Moong dal (split mung beans), cooked with onion, garlic, cilantro, turmeric, and crushed red chilies, 6.6 oz • *Coca-Cola*, diet, 12 fl oz

DINNER Vegetable curry of potato, green beans, onion, and hot chilies, 6.1 oz • Chicken kebab, 3.2 oz • White rice, 5.5 oz • Salad of lettuce, tomato, and cucumber, 4.2 oz; with *Marzetti* ranch dressing, 1.6 oz • Kheer (rice pudding), 4.9 oz; with *Equal* artificial sweetener, 1 packet • Tap water, 16 fl oz

OTHER *Coca-Cola*, diet, 12 fl oz • Tap water, 1.6 qt • Glipizide tablet

CALORIES 2,000

Age: 59 • Height: 5'7" • Weight: 240 pounds

CHICAGO, ILLINOIS • In 1985, Din Memon immigrated to the United States from Pakistan for the same reason that many people do. "Opportunity, freedom, and peace," he says, "that's what I expected, and that's what I got."

Din's slice of Chicago is the vibrant south Asian stretch of Devon Avenue that bisects the city's far North Side neighborhood of Rogers Park—a longtime settlement of immigrants of all stripes. Now it's home ground for Hindus, Pakistanis, and Bangladeshis—and Din, who has driven a taxicab in Chicago for the last 20 years and knows every inch of the area.

Here there are sari houses glowing with jewel-toned fabrics, shops with modest Muslim dress, hole-in-the-wall kebab and *biryani* shops, and restaurant palaces that host weddings and parties. "In downtown Chicago you can find some Indian and Pakistani restaurants," Din says, "but here you find them everywhere, and they're very good, very spicy." There are also hair salons, electronics shops, and groceries advertising *halal* meat (meat slaughtered according to Islamic standards), often against a backdrop of bhangra dance music and Indipop. "Everything is here," says Din, as he tours us around the neighborhood.

The former Pakistani immigration officer

arrived in the United States alone but acquired a family when he married Nazra Begum, a Pakistani woman already living in the United States with her brothers. "I didn't know her, she didn't know me," he says of their arranged marriage.

Despite his handy knowledge of restaurants in the area, the Memons eat most of their meals at home. Does Din cook? "No, no, I'm not a good cook," he says, laughing. "My wife, she does the cooking, and I do the driving." Nazra cooks only south Asian cuisine—she prepares *moong* dal every day, spiced with turmeric, crushed red chilies, and cilantro; cooks vegetable and chicken curries; and makes her own chapatis. If Din is close to home at lunchtime, he prefers to eat there. Does he eat American fast food? "Kentucky Fried or Popeyes or Subway," he says, "but mostly I like spicy food."

When Din was diagnosed with type 2 diabetes two years ago, doctors prescribed medication and recommended a weight-loss diet, which he follows, mostly. Nazra changed her traditional menus, too. Now she makes egg whites and dry toast for breakfast, serves smaller portions at all meals, and substitutes artificial sweetener for sugar in desserts, such as *kheer*, a sweet, cardamom-spiced milk and rice dish.

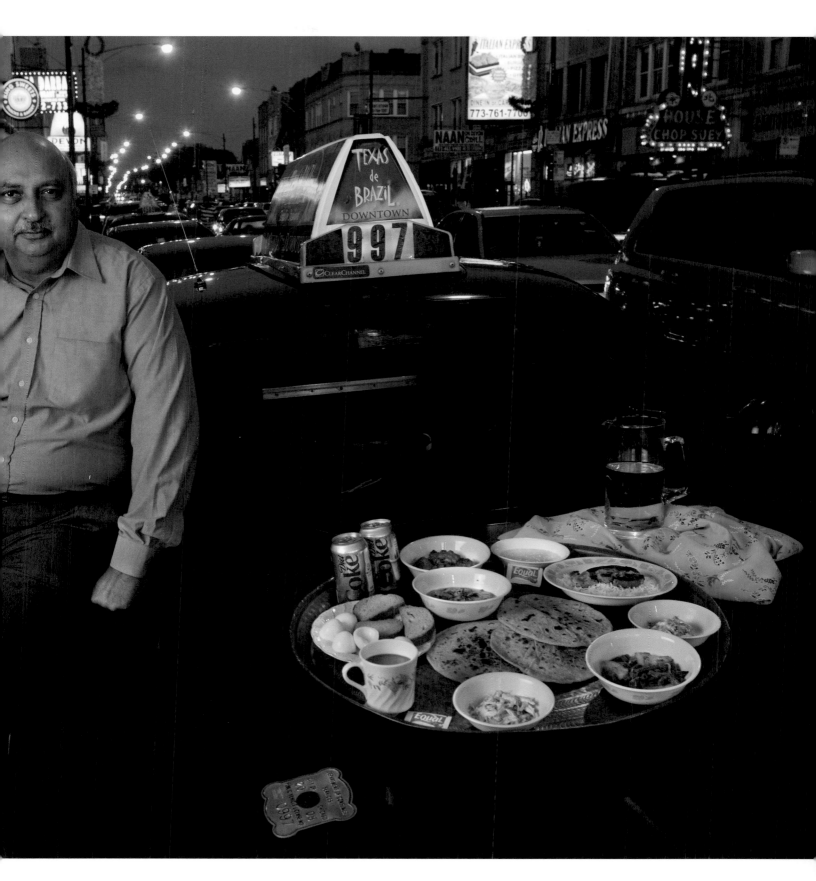

Din Memon, a Chicago taxi driver, on Devon Avenue with his typical day's worth of food arranged on the hood of his leased cab. Din came to the United States as a young man in search of freedom and opportunity and remains pleased with what he found. He has lived in Chicago for 25 years and has been driving a cab for the past two decades, five to six days a week, 10 hours a day. He knows where all of the best Indian and Pakistani restaurants are throughout Chicago, but prefers his wife's home cooking above all. His favorites? "Kebabs, chicken *tika*, or *biryani*—spicy food," he says. *Tika* is dry-roasted marinated meat, and *biryani* is a rice dish with meat, fish, or vegetables that is highly seasoned with saffron or turmeric.

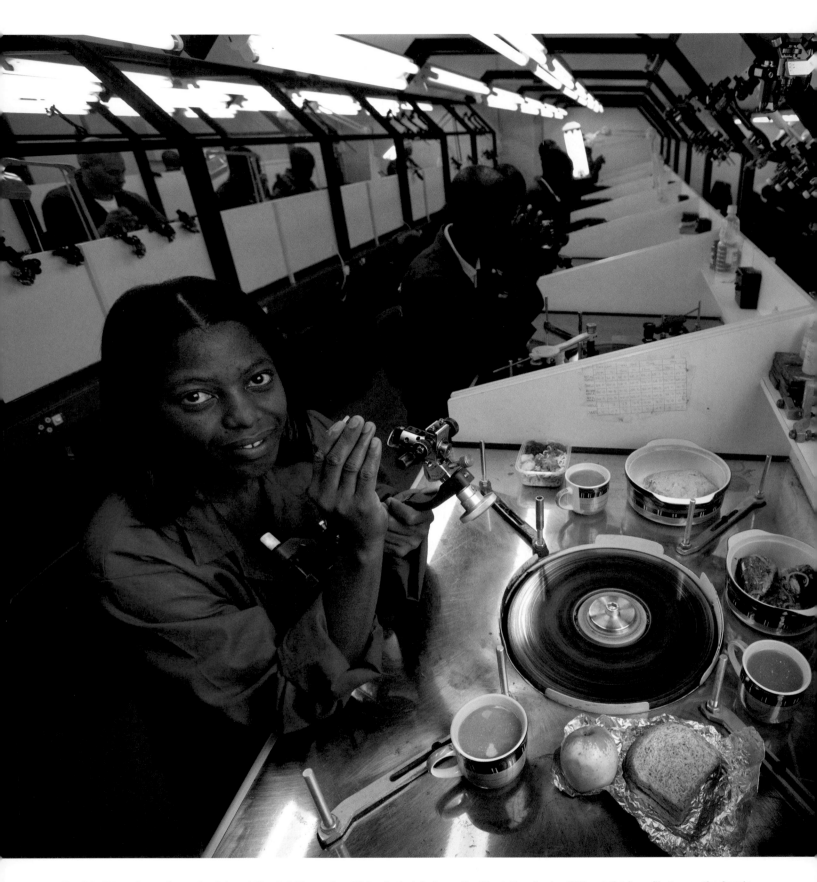

Mestilde Shigwedha, a diamond polisher at NamCot Diamonds, with her typical day's worth of food. Her simple childhood diet in a village near the Angola border evolved to include more global fare as her highly skilled work allows her to afford food (and housing) she didn't know existed before moving to Windhoek. World-renowned for its gem-quality stones, the country's diamond industry has raised the standard of living for thousands of Namibians. Because diamonds are the hardest natural material known, they can only be polished using other diamonds, in the form of diamond dust sprinkled on an oiled turntable. The diamond is clamped onto a tool that holds it at a precise angle to the turntable and carefully polished one facet at a time. At right: Mesti in her bedroom.

NAMIBIA

Mestilde Shigwedha
The Diamond Polisher

ONE DAY'S FOOD

IN MARCH

BREAKFAST DURING WORK BREAK Wheat bread, 3.8 oz • Apple, 5 oz • Black tea, 10 fl oz; with sugar, 1 tbsp; and nondairy powdered creamer, 0.5 tsp

LUNCH Spaghetti, 10.7 oz; with tripe (beef stomach), 2.5 oz; and potatoes, 0.8 oz; eaten in a sauce made from the beef broth flavored with onion, chili powder, and *Knorr* vegetable soup mix, powdered, 3.8 oz • Black tea, 10 fl oz; with sugar, 1 tbsp; and nondairy powdered creamer, 0.5 tsp

DINNER Millet and cornmeal porridge, 13.7 oz • Horse mackerel, 7.2 oz; with sauce of onion, tomato, and *Taste-Mate* curry powder, 6 oz • Black tea, 10 fl oz; with sugar, 1 tbsp; and nondairy powdered creamer, 0.5 tsp

CALORIES 2,000

Age: 28 • Height: 5'1" • Weight: 120 pounds

WINDHOEK • After a gem-quality rough diamond has been analyzed, planned, modeled, and shaped, Mestilde Shigwedha, a brillianteer at NamCot Diamonds in Namibia's capital city of Windhoek, works to unlock the diamond's inner beauty. The initial cuts are blocked in by cross workers, then brillianteers cut and polish a second set of facets to reveal the gem's inner fire. Even for highly experienced brillianteers, however, the task can be complicated, and the slightest mistake can cause a stone's value to drop significantly.

"Our manager is good," says Mesti, who has brilled stones for NamCot for seven years. "He tells us, 'If you feel like you don't know what to do, put the stone aside. Come back with a fresh mind—you'll get an idea.'" Diamonds are mined in Namibia, and the country is a signatory to the Kimberley Process, an international accord that attempts with varying degrees of success to keep conflict diamonds—traded by rebel movements to finance warfare—out of the legitimate diamond trade.

Mesti arrives at work at about 7:15 a.m., but she waits until the team's first break, at 10 a.m., to eat her breakfast. "I bring plain bread and a piece of fruit," she says. NamCot provides tea. There are dominoes and card games during meals and breaks in the cafeteria, but Mesti's tastes run more to outdoor sports. She plays netball on the company team, which she helped start. The sport is similar to basketball, except that teammates play in zones and can take only one step before passing the ball. "I love it," she says.

Most often, Mesti's lunch at work is last night's leftovers. Today it's spaghetti, and tripe spiced with chili powder and onion. When we ask if these foods were typical when she was growing up, she says, laughing loudly, "Nooo, of course not. Where would you find that?"

Mesti grew up in the north of Namibia near the Angola border. Her family lived in a mud-and-dung hut and farmed pearl millet (*mahangu*) and sorghum, grew watermelon, caught fish in seasonal streams, and gathered wild spinach. They didn't have onions,

seasoning packets, or pasta. She finds the idea of such foods in her village of Ombwana endlessly funny but has grown accustomed to their easy availability when she's back in the city: "The moment I come back to Windhoek, I say, 'Ahh, where are the onions? I need onions!' Because I know I can get them; the store is just down the street."

In her village, millet porridge is at the center of every meal. In Windhoek, Mesti prepares it only at night, with fish, chicken, or beef, but doesn't take it to work with other leftovers. "It's too heavy [to eat] during the day," she says. "But if I eat only macaroni or rice at night," she relates, "the next morning I ask myself, 'Did I eat last night? I can't remember.'"

Some Namibians eat porridge made of cornmeal, the way it's made in South Africa and Kenya. Mesti cuts her millet porridge with cornmeal to make it last longer, but growing up, she remembers, "we'd see the maize meal [cornmeal] and we'd say, 'Nooo! We want *mahangu*.' We believed that maize meal doesn't give you

energy. But others who have been eating that, they believe that theirs is the best."

Mesti's rented home in Windhoek is sparsely furnished, except for her bedroom, which is, in essence, a house within a house. She shares the kitchen and bath with two other renters who live the same way in the other bedroom. Her room is overstuffed with an upholstered queen-size bed, television, DVD player, stereo, microwave oven, refrigerator, photo galleries of Mesti and friends at company parties, and awards for work and sport.

When she opens the wall-size armoire, however, her heritage peeks out: millet and dried wild spinach from home. "This other side is for my clothes," she says.

She pounds the millet herself with a traditional mortar and pestle when she goes home to her village. "I brought the *mahangu* when I came back from holiday," she says. "I can take it to a machine in my village... but mostly we just pound it. It's good for your muscles," she says, flexing her toned, sinewy arms. "It's good for netball." So do people at

home generally still pound grain? "Yes," she says, "but nowadays the kids are very lazy: 'Mommy I'm tired,' they say. 'Take it to the machine.' We could never tell Momma we were tired. She'd say, 'What are you going to eat if you're tired?'"

She still eats other traditional foods from her village in the north, as well. One is a millet bread made by pounding the grain, and then, before it dries, mixing it with water, salt, and sugar: "A kind of pancake," she says. "If the house is full, then you can do three or four, so everyone can have a piece."

She doesn't really enjoy drinking water and doesn't drink soft drinks, but she loves *oshikundu*. This traditional beverage is made by pouring boiling water over millet with a little sorghum, and letting it stand. More water is then mixed in until it has a liquid consistency and it's set aside to ferment. How often does she make it? "It depends on whether I have the *mahangu*. The moment you bring it to work everyone is, 'Ooh, look what you have.'"

Flies feasting on *kapana*, strips of freshly butchered beef (top right), don't seem to bother customers at the Oshetu Market near the Katutura area of Windhoek. Vendors grill the popular snack over wood fires and serve it up by the handful in a piece of newspaper for about $0.50 (USD). At left: In downtown Windhoek, the Hungry Lion fast-food shop does a brisk business selling burgers, fries, and chicken. Top left: Mesti's netball team waits their turn to play in a city tournament. The team is sponsored by Mesti's employer, NamCot Diamonds, which is part of the Steinmetz Group.

Nguyễn Văn Thuan, a war veteran, with his wife in their studio apartment with his typical day's worth of food. Their small living space is located on the ground floor of the new and palatial four-story family home of his son-in-law, a successful machine repairman. Although he is completely healed, his war injuries strengthen his camaraderie with other wounded soldiers; Thuan's fellow delivery cart drivers are all wounded vets who have been given exclusive licenses by the government to operate in Hanoi traffic. While waiting for clients, they often rehash their war experiences. When asked about American soldiers, he says they didn't know the purpose of the war: "They didn't know why they were coming to this land. That's why they failed." At right: Thuan's war medals.

VIETNAM

Nguyễn Văn Thuan
The American War Veteran

ONE DAY'S FOOD

IN DECEMBER

BREAKFAST AT A QUAN PHO (noodle café) Pho (rice noodles, beef, onion, ginger, fish sauce, cilantro, lime juice, and chili pepper in beef stock), 1.5 lb • Rice wine, 1.2 fl oz

LUNCH Morning glory (garland chrysanthemum) soup with onion, tomato, and spices, 12.5 oz • Stewed pork, 0.9 oz • Boiled pork belly, 1.7 oz • Fried herring, 0.8 oz; with fish sauce, 2 tbsp • Pig's liver with carrot, broccoli, and cauliflower, 2.2 oz • Pickled mustard greens, 0.5 oz • Stir-fried bamboo shoots, 2 oz • White rice, 7.8 oz • Rice wine, 0.6 fl oz

DINNER Water celery and pork ribs with spices, in a water broth, 6.6 oz • White rice, 3.5 oz • Pickled cabbage, 3.5 oz • Rice wine, 1.2 fl oz

SNACKS AND OTHER Bananas (2), 3.6 oz • Orange, 5.9 oz • Green tea (4), 8.1 fl oz • Well water, 1 qt

CALORIES 2,100

Age: 60 • Height: 5'6" • Weight: 123 pounds

HANOI • Nguyễn Văn Thuan eats *pho*, a bowl of spicy rice-noodle soup, every morning at his favorite *pho* shop near Hanoi's Giap Bat train station. He drinks a tiny cup of rice wine, and then he's ready for work, hauling goods and people from one end of Vietnam's capital city to the other. He and other war veterans have a special license to drive small three-wheeled gas-powered carts—a club of sorts, as no one else is allowed to have them on the increasingly crowded streets of the city.

The veterans spot one another in the distance, wave as they work, and visit if there's no job, stopping for a cup of tea from a street vendor or lunch at a *com bui*—tiny restaurants occupying a few square yards of sidewalk throughout the city. *Com bui* means "dirty rice," a name that references their location, usually directly on the sidewalks of busy, dirty streets. They serve cheap, hot fare: barbecued and stewed pork, chicken, and duck, spicy skewers of beef, leafy greens in broth, vegetable stir-fries, dipping sauces, rice noodles, and rice.

At age 62 Thuan works nearly every day, preferring the camaraderie of his fellow veterans to sitting at home in Do Xa, formerly a rural village and now a southern suburb of Hanoi. When drafted into the Vietnam People's Army in 1969, he went willingly, he says, to fight in what his countrymen call "the Amer-

ican War," which Americans know as the Vietnam War. Hit by shrapnel in 1975, he suffered a head wound and a broken jaw, and was one of only 13 in his regiment of 130 to survive.

On their circuitous six-month march south, they each carried 3 kilos (6.6 lb) of rice and three biscuits as emergency ration. "We would eat whatever we could find," he says, "vegetables, bamboo root, crabs. If we went to a camp, we could ask for food. Local people would give us rice sometimes, or corn."

"Life was hard," he says, "even before the American War there wasn't enough food. We just had yellow potatoes and corn. We had rice only for the kids. Our life here now is like a dream compared to the past."

2100

USA

Felipe Adams
The Iraq War Veteran

ONE DAY'S FOOD

IN SEPTEMBER

BREAKFAST *Quaker* instant oatmeal, maple and brown sugar flavored, 1.5 oz (dry weight) • Apple, 7.7 oz • Coffee, 2 fl oz

LUNCH AT PETITE SARA CAFÉ Chicken sandwich: toasted wheat bread, 4 oz; grilled chicken breast, 6 oz; grilled onion, 2 oz; lettuce, 1.5 oz; mayonnaise, 2 tsp; mustard, 1 tsp; butter, 0.5 tsp • Fruit plate of cantaloupe, grapes, kiwi, orange, pineapple, plum, strawberries, and watermelon, 7.9 oz • *Honest Ade* drink, orange mango, 16.9 fl oz

DINNER Chicken breast, 4.5 oz; with *Tapatio* hot sauce, 0.5 tsp • White rice, 4.9 oz • Salad of lettuce and tomato (tomato not in picture), 1.4 oz • Salt, sprinkled over everything, 0.5 tsp

AT NIGHT BEFORE BED *Dannon Activa* yogurt, vanilla, 4 oz • Prune juice, 6 fl oz

SNACKS AND OTHER *Doritos* tortilla chips, nacho cheese flavored, 1 oz • *Trident Minty Sweet Twist* gum, 18 pieces • *Kirkland Signature* bottled water, 2.6 qt

CALORIES 2,100

Age: 30 • Height: 5'10" • Weight: 135 pounds

INGLEWOOD, CALIFORNIA • "I have a lot of flashbacks… If I could go back and just move two feet forward or back—" If he could have, Felipe Adams would have dodged the sniper's bullet that ripped through his chest in a Baghdad alley two months into his second tour of duty in Iraq.

After lifesaving operations, reconstructive surgeries, and years of therapy, daily life in the Los Angeles bungalow that his family retrofitted with Veterans Affairs assistance has become a rehab exercise for the entire family. Before the ambush, Felipe could run two miles in just over 11 minutes and was the most fit he'd ever been. Now he needs his father, Larry, or his brother Ben to help dress him after he spends an hour each morning giving himself an enema and catheterizing himself so he can pee. He has no sensation from the waist down, which means he doesn't know when he has to use the bathroom.

After the sniping, "he didn't eat for four weeks," says his mother, Maria. "He lost 35 pounds. He looked so small. He had bags hanging all around him—tubes everywhere." But after the first surgeries were completed, he could eat the foods he always had: "Whatever I ate went straight to the [colostomy] bag, so I wasn't really worried about what I was eating." Now that his plumbing has been surgically restored, he has to carefully monitor his diet. "I'm a big fan of steak," he says, "but it causes problems."

He's having to learn what he can and cannot eat. He eats chicken a lot and salad most days, and just about everything he consumes is geared toward determining how best to fuel his altered body. He weighs 30 pounds less than he did at the time he was shot. "I don't really feel hunger," he says. "I just know that at certain times of the day I've gotta eat." Can he feel when he's eaten too much? "The only way I notice is if my belly's bloated," he says.

Felipe Adams, a 30-year-old Iraq war veteran, at home with his parents and his typical day's worth of food after being paralyzed by a sniper's bullet in Baghdad. Damaged nerves that normally enervate a missing or paralyzed body part can trigger the body's most basic warning that something isn't right: pain. Felipe experiences these phantom pains, which feel like stabbing electric shocks, dozens of times a day; they cause him to grip his leg tightly for a moment or two until the sensation subsides (at left).

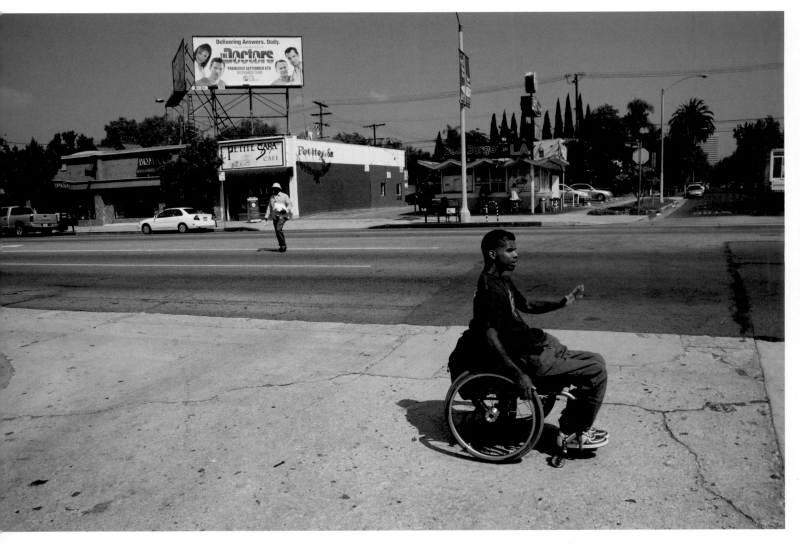

After helping Felipe get dressed, his father changes the sheets in his bedroom as Felipe shaves and gets ready for breakfast (top right). Felipe has already spent an hour in the bathroom going through his morning ritual. At noon he rolls out of the house for lunch at his favorite neighborhood café, Petite Sara, across busy West Pico Boulevard (top left). Later he spends part of an afternoon rehab session at the VA Long Beach Medical Center working on upper body strength (at right).

Black coffee and prune juice work as a laxative to help him deal with food not moving quickly enough through his system, and he eats yogurt with active cultures every day in an effort to use food rather than medication to aid his digestion.

Felipe's inquisitive nature serves him well as he exhaustively queries doctors to increase his understanding of the new rhythm of his body, which he has to control with information, rather than the muscles and brain signals most of us rely on.

One trick that his brain plays on him many times each day is phantom pain: a sensation of pain in limbs that he can otherwise no longer feel. "I take pain management courses, but since I don't have the same pain sensation every time, I have to use different methods for each individual pain. So when one hits, I have to register what pain it is to try to figure out what pain relief I want to conduct... It's a work in progress." He describes the pain as like an electrical shock. Maria jokingly offers to hit him when he's in the throes of an attack,

and despite the pain, he laughs. "That took my mind off it," he quips—when he can speak.

In fact, almost all of Felipe's new life is a work in progress, for him—and for his family. "It's starting to sink in now," says Maria, a social worker who continues to work so that she and her husband don't lose their health insurance. "We were always so busy when it first happened. Nonstop." Now comes maintaining their situation and making decisions about the future. Felipe had almost finished his degree in economics before he left college to join the army. He thinks he might return to school and study physics, and he'd like to travel to other countries again. One of the reasons he joined the military was to

quench a thirst for adventure. Since the accident he's been to Germany with his family to visit friends in the military, but he'd like to be able to travel alone.

More than three years after the shooting, he still has to travel to the VA Long Beach Medical Center three days a week and has more surgeries scheduled. Felipe says, "I'm still in the denial phase of the whole thing... Every morning I think I'm just going to jump up and my legs will be working again...but it hasn't happened yet. The first doctor said my spine was severely damaged and I'll probably never walk again, but other people say miracles happen, so I never give up hope."

"The first doctor said...I'll probably never walk again, but other people say miracles happen, so I never give up hope."

2100

INDIA

Millie Mitra
The Urine Drinker

ONE DAY'S FOOD

IN DECEMBER

FIRST THING IN THE MORNING Urine, 12 fl oz

MORNING Dragon fruit, 8.3 oz • Passion fruit, 3.9 oz • Coconut, 1.3 oz • Puffed lotus seeds, roasted with salt and oil, 0.4 oz • Revdi (sesame and jaggery candies), 0.4 oz • Sesame seeds, 0.3 oz • Amla (Indian gooseberries), sun-dried, 0.3 oz • Pine nuts, 0.2 oz • *Mili* tamarind candy, 0.1 oz

LUNCH Uttapam (flat bread made from black lentil and rice flours) baked with onion, tomato, green chilies, cilantro, and mustard oil on top, 4.8 oz • Idli (steamed, fermented bread made from rice and lentil flours), 3.6 oz • Tomato chutney, 2.9 oz • Coconut chutney, 0.9 oz • Blend of cilantro, mint, cumin, and lemon juice, 0.5 oz • Soy yogurt with water, cilantro, ginger, and green chilies, 12.3 oz • Bottled water, hot, 16 fl oz

AFTERNOON SNACK Puffed rice with onion, green chilies, and mustard oil, 1.5 oz • Hot water with honey and fresh lime juice, 8.7 fl oz

DINNER Pigeon peas and eggplant with onion, tomato, coriander, cumin, turmeric, and ground red chilies, 4 oz • Boiled potato with green chilies, curry leaves, cilantro, turmeric, ground red chilies, mustard seeds, and lime juice, 2.3 oz • Vagharelo bhaat (soft, sticky rice with onion, green chilies, curry leaves, cilantro, mustard seeds, and lime juice), 6.8 oz • Whole wheat flat bread, 2.9 oz • Soy yogurt with soft rice, green chilies, curry leaves, mustard seeds, and oil, 2.4 oz • Lime pickle, 0.4 oz • Cucumber, 5.6 oz • Turnip, 1.8 oz • Alu papad (thin, crispy bread made from potato starch, butter, and ground chilies), 0.4 oz • Bottled water, hot, 16 fl oz

CALORIES 2,100

Age: 45 • Height: 5'1½" • Weight: 123 pounds

BANGALORE • There's a battle raging in Millie Mitra's household about what to put on the dinner table. Through the years she has studied, mixed, and matched dietary ideals, "using foods to heal, and moving away from thinking of the body as an unintelligent machine that needs to be told what to do," she says. She is a grazer and says she eats foods that delight her senses as much as they nourish her body. She is particularly attracted to fruit: "I love the colors, the texture, the flavor, the scent, and most of all, they make me happy."

Her two daughters and husband, Abhik, will only follow her lead so far, and generally get sidetracked by a tub of ice cream. "Mom is a vegan," says her 12-year-old daughter, Tara, "and we're not. We like our milk products."

They also no longer drink their own urine, which Millie has done for most of the last 17 years. The practice, called *shivambu*, is described in ancient Indian texts, and ancient texts of other cultures as well. Practitioners variously believe that drinking urine is cleansing, has curative powers, and is spiritually beneficial. Urine is a by-product of blood filtration, not the body's general waste disposal system as most think, but that doesn't make it any more palatable for those who don't imbibe.

Millie's yoga instructor, who comes to her home for private lessons, is noticeably put off when confronted with a glass of Millie's urine, center stage in her day's worth of food. Millie tells him that she will be glad to discuss its value once he's educated himself.

Millie Mitra, an education consultant and homeopathy devotee, at home with her typical day's worth of food, including a glass of urine. Millie's quest for health includes yoga, a vegan diet, and topical applications of her own urine, as well as a daily glassful. At left: Pulin, her live-in cook, prepares *uttapam* as his daughter watches.

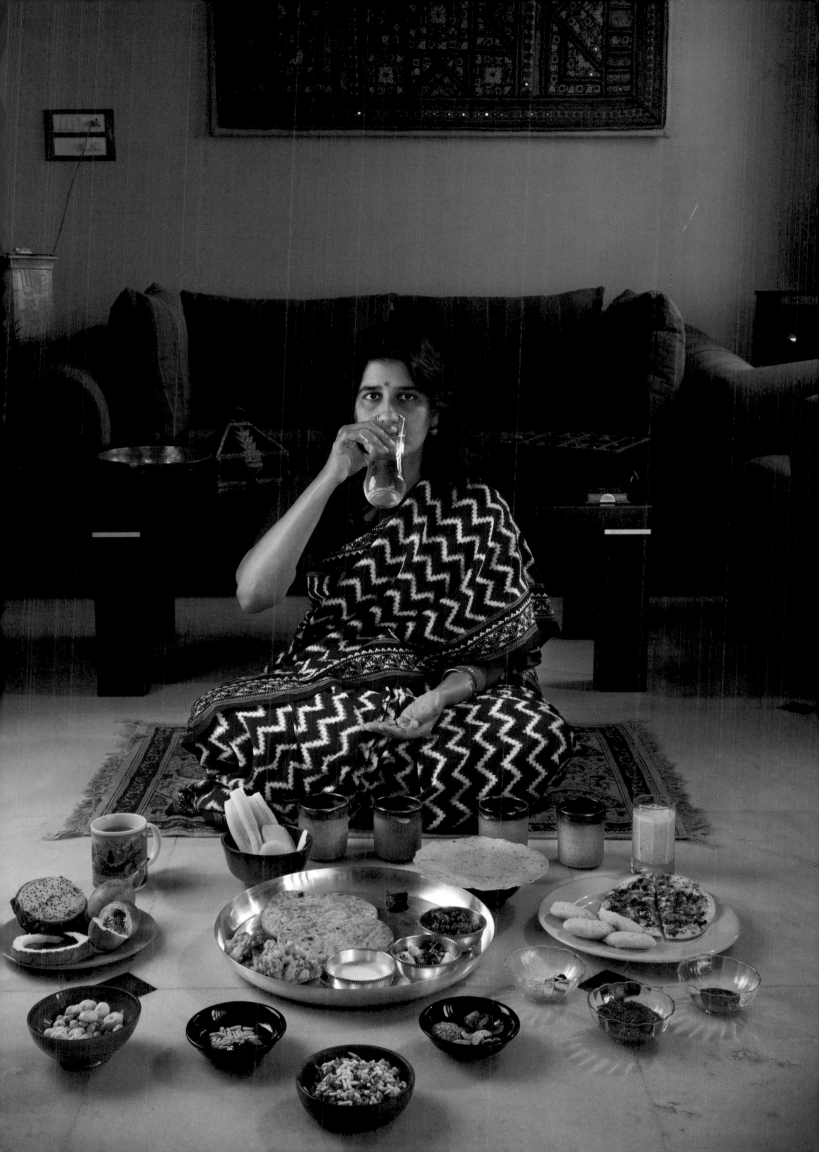

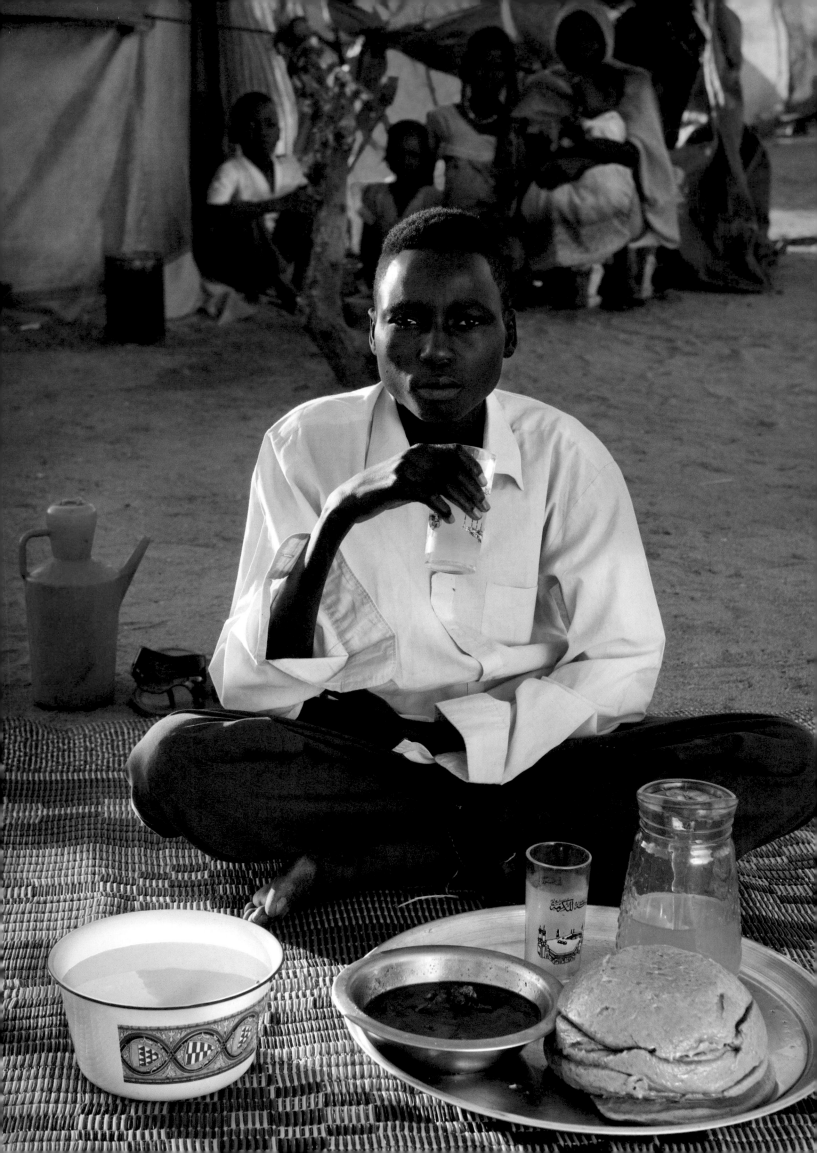

CHAD

Abdel Kerim Aboubakar
The Teenage Refugee

ONE DAY'S FOOD

IN NOVEMBER

BREAKFAST FROM FOOD AID Aiysh (thick, congealed grain porridge) of sorghum, with a coating of vegetable oil, 1.5 lb • Thin vegetable soup, 2.9 fl oz

LUNCH FROM FOOD AID Aiysh, 1.5 lb • Thin vegetable soup, 2.9 fl oz • Orange drink, powdered, mixed with water, 16 fl oz

DINNER FROM FOOD AID Aiysh, 1.5 lb • Thin vegetable soup, 2.9 fl oz

THROUGHOUT THE DAY Water trucked in from an Oxfam borehole, 16.1 fl oz

CALORIES 2,300

Age: 16 • Height: 5'9½" • Weight: 110 pounds

BREIDJING REFUGEE CAMP • Violent clashes and civil unrest have been a fact of life throughout much of Sudan's modern history, most recently between government-backed Arab Muslims and non-Arab black African Muslims in the Darfur region. When pro-government Janjaweed militia began burning villages and killing people near teenager Abdel Kerim Aboubakar's Masalit village in far west Darfur, he and his family were forced to flee.

They escaped over the border into Chad with thousands of other refugees, carrying little more than a cooking pot, a sack of grain, and a small bundle of clothes, to dwell in a hastily erected tent city.

Back home in Sudan, Abdel, the oldest of five children, had helped his widowed mother, D'jimia, manage their small farm and attended school when he wasn't needed at home. They owned a grove of mango trees, farmed a large vegetable garden, and kept a cow for milk. Their herd of sheep gave them income and a bit of fresh meat to eat.

In the camp D'jimia cooks the same staple grain porridge for breakfast, lunch, and dinner that she cooked at home, but instead of the bounty of her own land, she uses inter-

national food aid rations: sorghum or millet, sugar, salt, lentils, CSB (a corn-soy blend), and vegetable oil. The rations are doled out twice a month, and they get their grain ration milled by a local villager who takes part of it in exchange for the grinding. Water is trucked in by the relief agency Oxfam, and Abdel's mother and sisters haul it to the tent daily.

The amount of food each family is given is dictated by the number of people in the family. Since the smaller children in his family don't eat as much, Abdel gets a bigger share. Yet his mother worries that this still isn't enough to feed a growing boy. She hires herself and

Abdel out to local farmers for $1 USD a day so she can purchase dried meat and vegetables.

Mealtimes are different for Abdel than they were at home. According to Masalit custom, at age 16 he's a man and too old to eat with his mother and younger siblings. So he carries his aiysh and a bit of thin vegetable soup to a neighboring tent, where he eats with a man and his sons. Their meal looks exactly the same. All pick up handfuls of the hard, congealed porridge, dip it in their soup, and talk as they eat. Invitations to meals are always extended, but in a refugee camp, guests must arrive with their own food.

Abdel Kerim Aboubakar, a Darfur refugee, at the Breidjing Refugee Camp on the Chad-Sudan border, with his typical day's worth of international food aid, his family, and their tent. The camp (at right) houses 42,000 refugees—more than twice the number they planned for.

2300

USA

Ted Sikorski
The Man on the Street

ONE DAY'S FOOD

IN JULY

MORNING MEAL, IF HE HAS EXTRA CASH Bananas (4), 1.6 lb

HOT LUNCH PROVIDED BY HOLY APOSTLES SOUP KITCHEN Pasta, beans, and hot dogs in a flour and butter sauce, 10.7 oz • Collard greens, 1.5 oz • Salad of lettuce, tomato, onion, and carrot, 2.3 oz • Fruit salad, 3.1 oz • Bread with butter, 2.8 oz

SNACKS, IF HE HAS EXTRA CASH 2% milk, 1 qt • *Snickers* candy bars, fun size (3), 0.7 oz

THROUGHOUT THE DAY Tap water, 1.3 qt

CALORIES 2,300

Age: * • Height: 5'8" • Weight: about 168 pounds

*Ted declined to give his age

NEW YORK, NEW YORK • Every day is different for Manhattanite Ted Sikorski, but every day is also the same: a struggle to get himself fed, bathed, and sheltered. He dresses well, purposefully, but has been living on the street for over a decade. Why? "I got fired…and lived on my savings until they ran out," he says. He prefers not to say what he did for a living but says it was on Wall Street: "I'd rather not go into it." He also doesn't want to give his age because of the years he says he's lost.

He detests the word "homeless" to describe his situation, preferring instead the phrase "less fortunate."

He moves from place to place around the city, fitting in because his hair is trimmed and neat and his clothes are as spotless as those of any Wall Street professional on a day off. A casual observer wouldn't know that he's been walking for over an hour to get to a bathroom that he knows won't turn him away. He stows his belongings in various storage lockers. He doesn't want to say where he gets the money to pay for them, but he says he doesn't panhandle.

Where does he sleep? "I'm all over the place. During the summers I might be sleeping on the street, or in a bodega, or sometimes up near Central Park." Where did he sleep last night? "I'd rather not say." But he details at great length his struggle with the inevitable bureaucracy that attempts, with varying degrees of success, to provide services to the people of New York City who don't have a permanent roof over their head.

He knows most of the city's meal programs well, and volunteers his time at the one he thinks is the best: Holy Apostles Soup Kitchen in Chelsea, which has been serving thousands of weekday meals, without judging people's need, since 1982.

The food served up by chef Chris O'Neill and a staff of cooks and volunteers is well-balanced: pasta with meat, fresh vegetables, canned fruit, dessert, and bread with butter. "The food is very good," Ted says, but the nonjudgmental and caring atmosphere is what keeps him coming back.

"When I had some savings, before I fell into the street, I'd have one good meal a week, and twice a day I'd make a whole bunch of rice… I did this before I started going to soup kitchens. Before I went, I didn't even know if they'd allow me to go to a soup kitchen. The first time I came here was around the holidays one year. I still had an apartment. I started coming and no one said anything; they just fed me. If I had known that, I would have come a few years earlier," he says.

"My perspective is, this is a very big, unusual problem that I'm facing. And I think that everyone has to fight his own battle in life. I never thought that my life would turn out like this. It was very difficult in that first six-month period. I thought it was only going to be for a few months."

Ted Sikorski, an unemployed resident of the streets of Manhattan at Holy Apostles Soup Kitchen with his typical day's worth of food. Although Ted spends many hours a day walking, he admits to having to watch his weight, adding that many of his "residentially challenged" friends have the same problem. Over 1 million low-income residents use more than 1,200 nonprofit soup kitchens and food pantries in New York City. Some of the soup kitchens offer other benefits, such as showers, counseling, and entertainment. As in most big U.S. cities, it's easier to find a free meal in New York City than a place to sleep. Each night, more than 39,000 people sleep in the city's municipal shelter system, while thousands more sleep on the street.

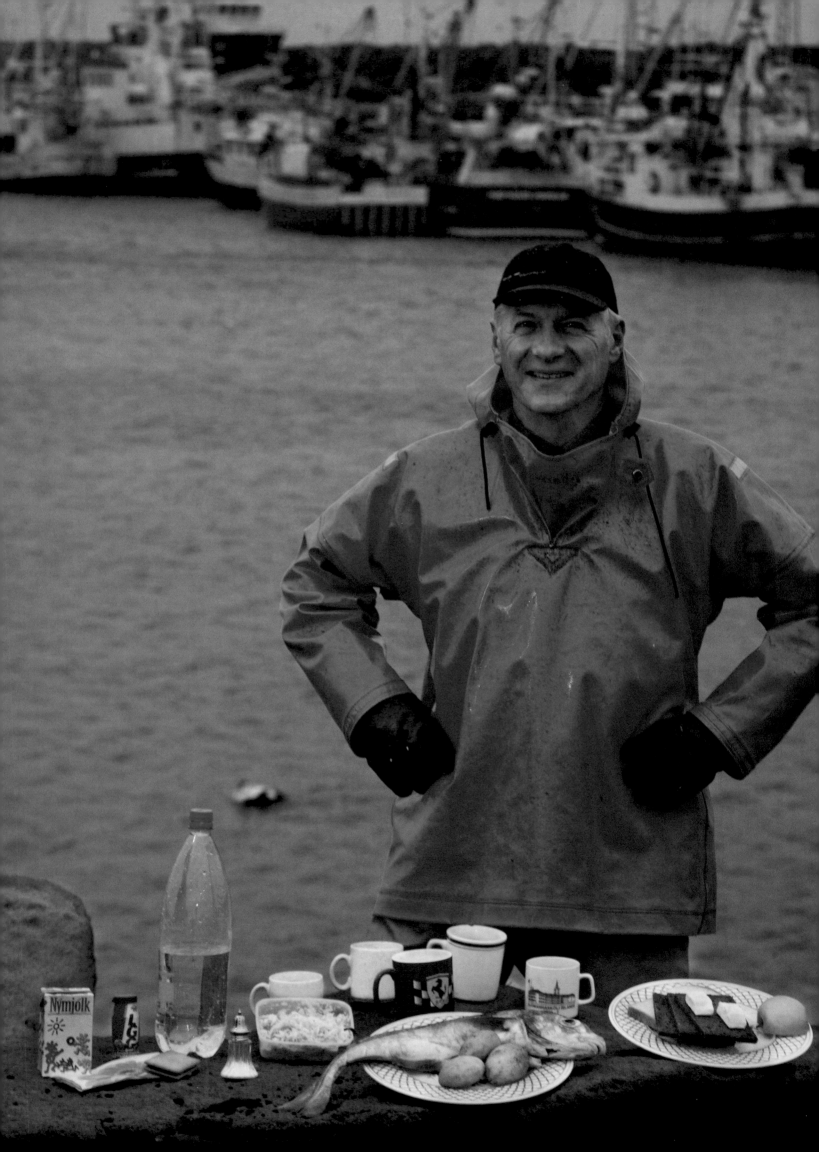

ICELAND

Karel Karelsson
The Cod Fisherman

ONE DAY'S FOOD

IN MAY

EARLY MORNING SNACK Sweet biscuit (cookie), 0.5 oz • *Nymjolk* whole milk, 8.5 fl oz

BREAKFAST AND LUNCH ON THE BOAT *St. Ellu* rye bread, 3.3 oz; and white bread, 1.1 oz; with butter, light, 2 oz • Apple, 5.3 oz • *LGG+* energy drink, strawberry, 3.1 fl oz • Coffee (5), 1.1 qt • Tap water, 12.7 fl oz

DINNER Cod, 4.4 lb (whole, raw weight); with salt, 1 tbsp • Homemade coleslaw, 6.3 oz • Potatoes, 1.1 lb • Tap water, 12.7 fl oz

CALORIES 2,300

Age: 61 • Height: 6'1" • Weight: 202 pounds

Formed by volcanoes erupting beneath the icy North Atlantic, Iceland has few natural resources except fish (principally cod), hydroelectric power, and geothermal heat, which is used to generate electric power. Iceland has little agriculture other than sheep raising, and fishing is essential to its economy.

SANDGERDI • Karel Karelsson eats a cookie with milk before dawn at his home outside Reykjavik, in Hafnarfjordur, then drives west, along the desolate lava-encrusted Icelandic coastline, to the Port of Sandgerdi.

The lifelong cod fisherman owned his own boat at one time, before selling it and hiring onto the *Thorkell Arnason*, a small, spry factory fishing boat owned by two brothers. Karel, four other younger fisherman, the engineer, and the captain head out to sea at daybreak to catch cod and process the fish in the belly of the boat. As the captain motors them 15 miles out, the others huddle over breakfast in the galley: hot black coffee, buttered rye bread, an apple, and an energy drink for Karel; and snack cakes, cucumber and tomato slices, Swiss cheese, and bread for the others.

The large trawling nets are mechanically cast into the sea, and the fishermen monitor

their progress. Hundreds of noisy gulls keep watch, squawking and swooping in the frigid air above the wake, waiting for their share of the catch. When the net returns, snaking in through an open port in the boat's hull and onto a conveyer belt, the men don bright red slickers and coveralls and work assembly-line-style, pulling silvery cod from the net and speaking sparingly over the mechanical groan of the machinery as they work. Fishing was nothing like this for small operations when Karel began fishing in 1958, but the rest of the crew is younger, and they have known nothing else.

The fish are slit open and gutted, sorted

into bins and crates by size, then iced. The guts drop into the sea through holes cut in the worktables, providing the gulls with their snack. Again and again the net is cast, until they catch their day's quota, set by the government each season to guard against depletion of stock. Then, after washing down their floating fish factory, they sit inside for coffee and breakfast leftovers or lunch. Karel's prize at the end of his workday, in the early afternoon, is fresh fish as part of his pay. The schedule suits him, he says, as there's plenty of time left to swim in the same bracing ocean he fishes, and there will be fresh boiled cod for dinner after his wife gets home from work.

Karel Karelsson, a commercial cod fisherman, at his home port with his typical day's worth of food. A few hours off the coast, the crew (at right) hauls in gill nets that have been set out and left overnight, untangle the cod, then sort, gut, and ice down the fish.

2400

IRAN

Atefeh Fotowat
The Miniaturist's Daughter

ONE DAY'S FOOD

IN DECEMBER

BREAKFAST Lavash (flat bread), 2.3 oz; with halva (sweet confection with pistachios and almonds), 2 tbsp; and butter, 1.5 tbsp • Walnuts, 0.6 oz • Feta cheese, 1.1 oz • Whole milk, 5.3 fl oz • Black tea, 3.7 fl oz; with a sugar disk, 0.1 oz

LUNCH Tah chin (chicken marinated in egg, yogurt, and saffron), 4.9 oz; with tah dig (crispy pot-bottom rice), 2.8 oz • Zereshk polow (rice with barberries), 8.8 oz • Homemade potato chips, 0.4 oz • Yogurt, 3.3 oz • Pickled vegetables, 2.3 oz • Green bell pepper, 0.6 oz • Lime juice, 1.5 tbsp • Doogh (salty yogurt drink) blended with mint, 6.6 fl oz

DINNER Lavash, 1.3 oz; with butter, 1.5 tbsp • Dates, 1.1 oz • Bottled water, 6.6 fl oz

SNACKS Pomegranate, 12 oz • Orange, 8.5 oz

CALORIES 2,400

Age: 17 • Height: 5'4½" • Weight: 121 pounds

ISFAHAN • In the household of Mostafa Fotowat, a Persian miniaturist painter, foreign guests have come to visit. Our presence dictates that his wife and daughter cloak themselves in accordance with Islamic custom—and government doctrine—covering their ears, neck, and hair in their home, as they do in public, when in the presence of men who aren't members of the immediate family.

It's not often that they have to prepare a meal in knee-length overcoats and scarves in their own home, but 18-year-old Atefeh and her mother, Mehri, persevere and turn out a sumptuous dish called *zereshk polow*, a rice dish flavored with barberries and saffron, served with saffron-and-onion-spiced chicken, fresh vegetables and greens from Mehri's garden, and a drinkable yogurt called *doogh*, flavored with mint. "It's the best *zereshk polow* you will ever eat!" says Atefeh's brother, Ali. All of the family meals are served on the floor, atop one of the precious silk carpets found in every room of the house.

Atefeh's mother is the guardian of her family's nutrition, and their eating habits are steeped in tradition. "Maybe I have a pizza when I eat with friends," says Atefeh, "but at home there is only Persian food." For another dish, *tah chin*, Mehri marinates chicken in a mixture of homemade yogurt, egg, saffron, and lemon juice, then flavors partially cooked basmati rice with the marinade mixed with beaten eggs, and layers both in a casserole to cook. The rice dish is turned over on a plate, revealing delightfully crusty "pot-bottom rice," called *tah dig*, and the tender chicken casserole—*tah chin*. The *tah dig* can be made alone as well. Atefeh's favorite meal is grilled trout seasoned with *haft advieh* (seven spices).

In light of her sartorial concealment, Atefeh's avocation is an interesting one: She studied painting and hopes to study in Paris and become a fashion designer. She spends hours on the Internet looking at the latest fashions. These days, however, there's little time for surfing the Web; university entrance exams are coming up in a few months.

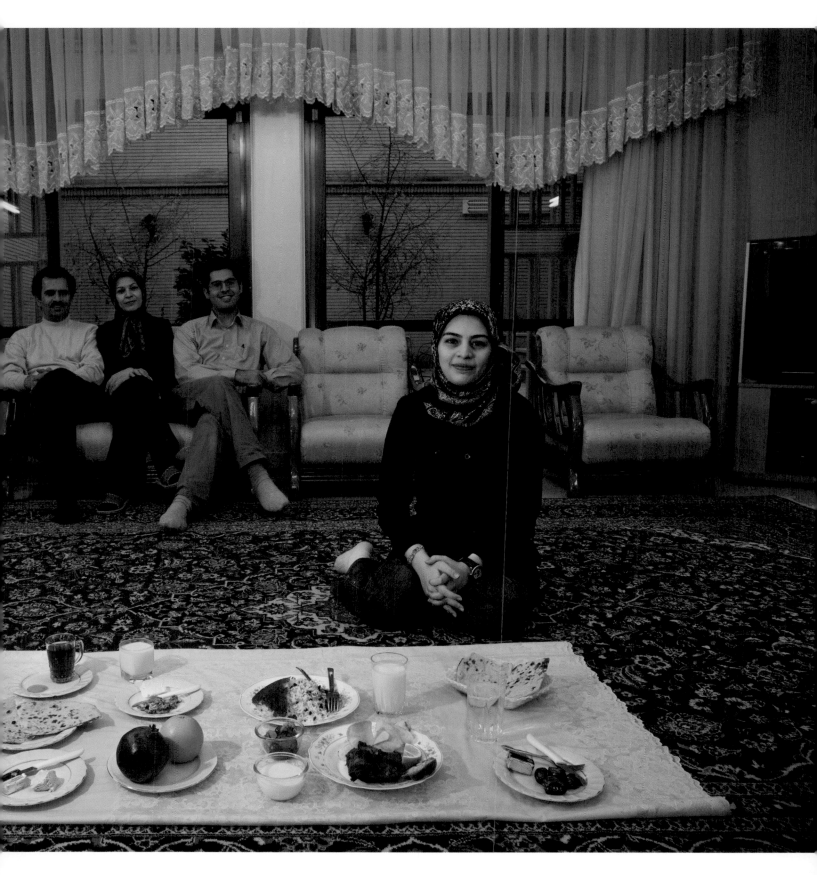

Atefeh Fotowat, a high school student and aspiring fashion designer, at home with her family in their elegant four-story home with her typical day's worth of food. Her father, a renowned miniaturist painter, is seated on the couch, along with her mother and her brother, a university student. Together, they exemplify the educated Iranian upper middle class in Isfahan, Iran's third largest city, famous for art and Islamic architecture. Atefeh's relaxed repose and her attire, combining jeans and headscarf, show her ease with foreigners yet respect for tradition. She aspires to turn her fashion designing avocation into a vocation by becoming a designer after college. At left: Atefeh looks at Paris fashions on the Internet in her bedroom.

Smoking tobacco in classic water pipes known as *ghelyans* (hookahs), three 15-year-old boys sip hot tea on a cold afternoon at a rooftop teahouse above the Grand Bazaar, overlooking Imam Square in Isfahan. Although the tobacco smoke is cooled and some of the harmful substances are filtered out as the smoke passes through a water-filled glass bowl before being inhaled, hookah smoking can be more harmful than cigarette smoking because typically a much greater volume of tobacco is consumed. Later that evening, a December snowstorm blanketed the city. Imam Square, one of the world's biggest city squares, has been designated as a World Heritage Site by UNESCO. At the far end of the square are a number of beautiful historic buildings: the Sheikh Lotf Allah Mosque, the Imam Mosque, and the Ali Qapu Palace.

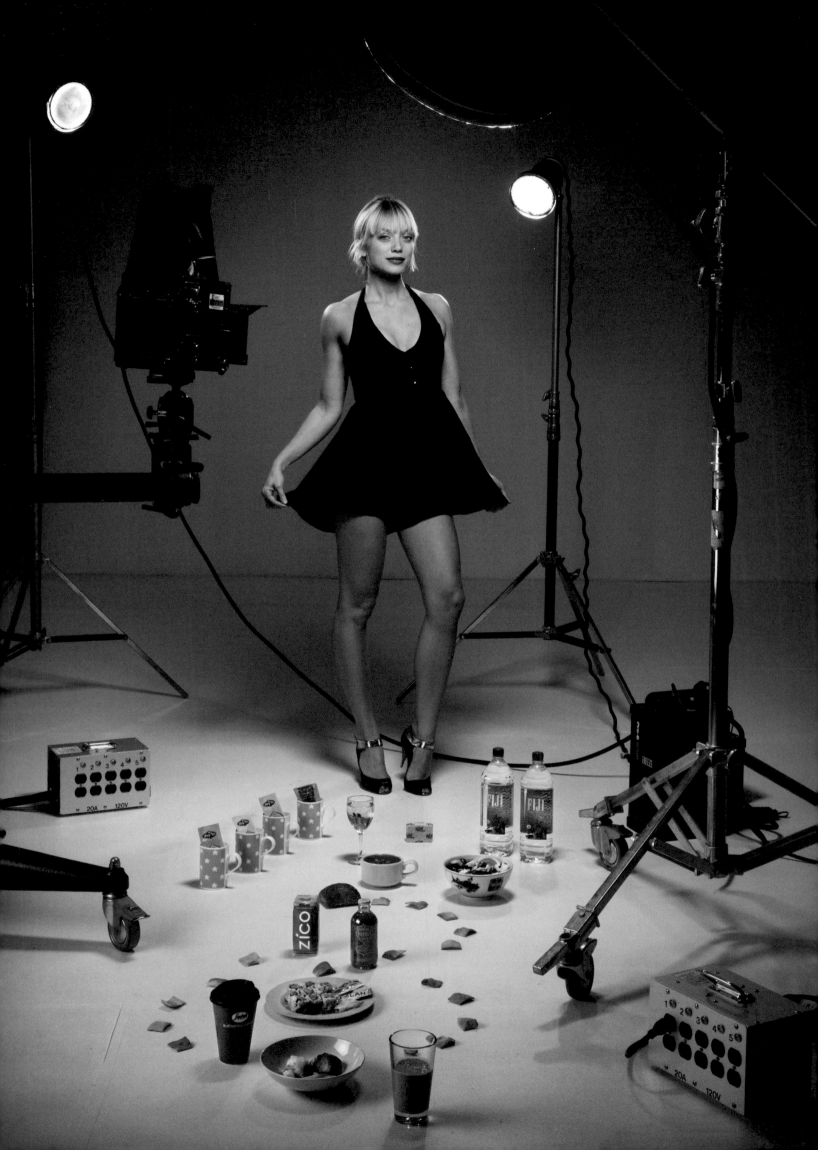

2400

USA

Mariel Booth
The Model Student

ONE DAY'S FOOD

IN OCTOBER

BREAKFAST Fruit salad of strawberries, blueberries, peach, and melon from Ruby's Diner, with low-fat yogurt, 9.3 oz • *Blue Diamond Almond Breeze* almond milk, 8.6 fl oz; mixed with *Whole Foods* soy protein powder, vanilla, 2 tbsp • Soy latte, 16 fl oz

LUNCH *Dean & Deluca* brown rice vegetarian sushi, 7 oz; with soy sauce, 1 tsp; and wasabi, 0.3 tsp • *Kombucha Wonder Drink* fermented tea, 8.5 fl oz • *Zico* coconut water, 11.2 fl oz

DINNER Tuna salad: *Bumble Bee* tuna, packed in water, 4.6 oz; corn, 4.4 oz; avocado, 3.3 oz; mixed greens, 2.2 oz; cucumber, 1.9 oz; kidney beans, 1.9 oz; tomato, 1.1 oz; with lemon juice and olive oil dressing, 1 tbsp • *Progresso Vegetable Classics* soup, minestrone, 13.1 oz • Multigrain roll, 2.7 oz • White wine, 6.2 fl oz

SNACKS AND OTHER *365 Everday Value* pita chips, 1.9 oz • *Tofutti Cuties* dairy-free ice cream sandwich, vanilla, 1.6 oz • *Yogi Tea* and *Numi* caffeine-free teas (4), 1.3 qt; with honey (not in picture), 2 oz • *Fiji* bottled water, 3.2 qt

CALORIES 2,400

Age: 23 • Height: 5'9½" • Weight: 135 pounds

NEW YORK, NEW YORK • She's tall, thin, blond, and beautiful, and she's been modeling since the age of 13. But at age 23, five feet, nine and a half inches tall, and 135 pounds, Mariel Booth is now too old and too fat to get the really good jobs.

This is Mariel's own blunt assessment, and one that is probably not shared by most passersby in New York City's East Village, where she lives in a fifth-floor walk-up with a boyfriend "who can eat anything he wants and stay skinny," she says.

She eats healthy food, but too much, she thinks. She struggles to reconcile the fact that she's at the perfect weight for her body type with her inability to fit into size 0 clothes: "That's what's so annoying. My weight is great. I'm a size 4½...which is a really bad size for modeling because I don't fit into the 4s and there's no market for size 6. It's irresponsible for me to be the weight I am. If I lost five pounds, I would probably make a lot more money."

Mariel Booth, a professional model and New York University student, at the Ten Ton Studio in Brooklyn with her typical day's worth of food. At a healthier weight than when modeling full-time, she feels good but laments that she's making much less money. At right: Reaching for Tofutti Cuties at a Whole Foods near her apartment.

A bout with bulimia in her teens gave Mariel early insight into the effect that the drive for thinness was having on her colleagues in the modeling industry, an industry rife with eating disorders. "Most of those really serious eating problems come with the girls who have to be size 0, [if] it's not natural," she says.

Her own desire for perfection is driving her nuts, but not so nuts that she starves herself: "I'm like your average working model—

midtwenties, catalog, not high fashion. Make enough money to support our lifestyle and maybe a little extra."

Her diet is in constant revision—largely vegetarian, but laced with a little meat at times and frequent forays into healthy eating fads. She loves salads and has since she was a little girl, but imagines that the ones she puts together at Whole Foods have a lot more calories than she'd like to think.

2400

INDIA

Munna Kailash
The Bicycle Rickshaw Driver

ONE DAY'S FOOD

IN APRIL

BREAKFAST Potato curry with tomato, onion, ginger, garlic, coriander, cumin, turmeric, crushed red chilies, and mustard oil, 5.3 oz • Parathas (wheat flour flat bread) (2), 3.5 oz • Black tea with whole milk, 10.1 fl oz; and sugar, 2 tbsp

LUNCH Potato and soy protein curry with onion, turmeric, garam masala (ginger, garlic, and ground red chilies), and mustard oil, 5.3 oz • Okra, stir-fried with onion, chilies, turmeric, and mustard oil, 3.5 oz • Dal (yellow lentils), cooked with chilies, coriander, cumin, turmeric, and mustard oil, 5.3 oz • Parathas (2), 3.5 oz • White rice, 5.3 oz • Cucumber, 3.8 oz; and onion, 4.9 oz

DINNER Homemade yogurt, 3.5 oz • Parathas (2), 3.5 oz

SNACKS AND OTHER Lavang lata (deep-fried pastry), 1.4 oz • Fresh lime juice, 2.3 fl oz • Black tea with whole milk (6), 9.1 fl oz; and sugar, 1.6 oz • Cigarettes (2) • Well water, 1.1 qt

CALORIES 2,400

Age: 45 • Height: 5'2" • Weight: 106 pounds

VARANASI • Most mornings, Munna Kailash wakes up at 6 a.m. and pedals his rickshaw to the Ganges River, looking for customers with deep pockets. "Tourists are up early to see the city," says the father of five, "and it's cooler."

Varanasi, a cultural and religious center in India's northern state of Uttar Pradesh, is steamy and hot in the summertime. Yet the impetus to get to work early is not solely his own. He is, self-admittedly, a man who likes to relax. He points at his wife, Meera, a small woman 10 years his junior. "She says to me, " 'Why are you here? Get out there! Go to work!'" He cackles in a high-pitched voice meant to sound like Meera's but sounds nothing like her. "No sleeping!" He acts this out with his hands, as if to lie on a pillow, grinning when she laughs.

Meera starts her day at the same time every day whether Munna goes to work or not. At 6:30 in the morning she's already cooking breakfast at the home of her employers, a pair of doctors. Then she returns home to prepare her own family's breakfast of sweet hot tea and homemade *chapatis*, a traditional flat bread. She works seven days a week for both the doctors and her own family. Her income and Munna's combined give them enough to cover daily meals, but little else.

She and their daughter Mamta, 21, who keeps house for another family, cook on a propane hot plate on the ground in the open-air courtyard of their modest home. Meera cooked with wood until they could afford a propane stove, and their oldest daughter, who lives in the countryside, still cooks with dried cow dung. "She is asking me for a stove," says Meera. "I told her I'd think about it when I have the money."

Munna comes home after a few hours of rickshaw work, sits companionably on a pile of dusty bricks, and watches his wife cook. "There's always dal," says Munna. "I'm not eating lunch without [it]." There is indeed dal for lunch, along with potato and soy protein curry, stir-fried okra, white rice, and fresh *paratha* (flat bread) used to pick it all up.

Meera juggles the cooking of the meal at a dizzying pace, all the while keeping her husband amused and her daughter a step ahead, mixing homemade garam masala for the curry and a heady combination of crushed cumin seeds and dried red chilies in a spoonful of hot mustard oil for the dal. "We prefer it to other oils, and we can buy it in smaller quantities," she says. After lunch and a nap, Munna will hit the street with his rickshaw for the afternoon rush. There will be yogurt and *parathas* for dinner, and he might bring Meera a sweet fried dough called *lavang lata* for dessert. "She loves it," he says.

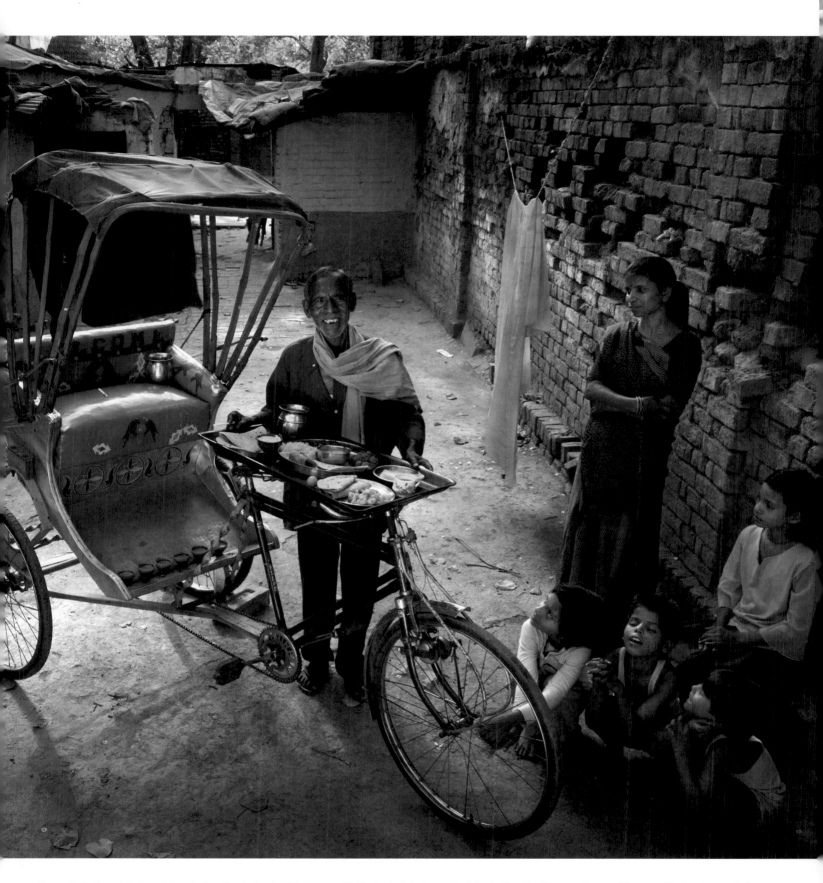

Munna Kailash, a rickshaw driver, in the alley in front of his house with his typical day's worth of food. His wife, Meera, who was 13 years old when he married her, watches with his nieces and nephews, as does his mother, who squats on the ground between two of his three sons. His neighbor, holding young goats, looks on. India has about 10 million cycle rickshaws, including passenger and cargo pedal carts. Although Munna owns his rickshaw, most rickshaw pullers rent from fleet owners for about $0.60 (USD) per day. A typical puller in a big city earns about $4 to $5 (USD) per day. Although slower than two-cycle smoke-spewing auto-rickshaws, bicycle rickshaws don't pollute the air, and the only heat they add to the atmosphere is from the bodies of their drivers.

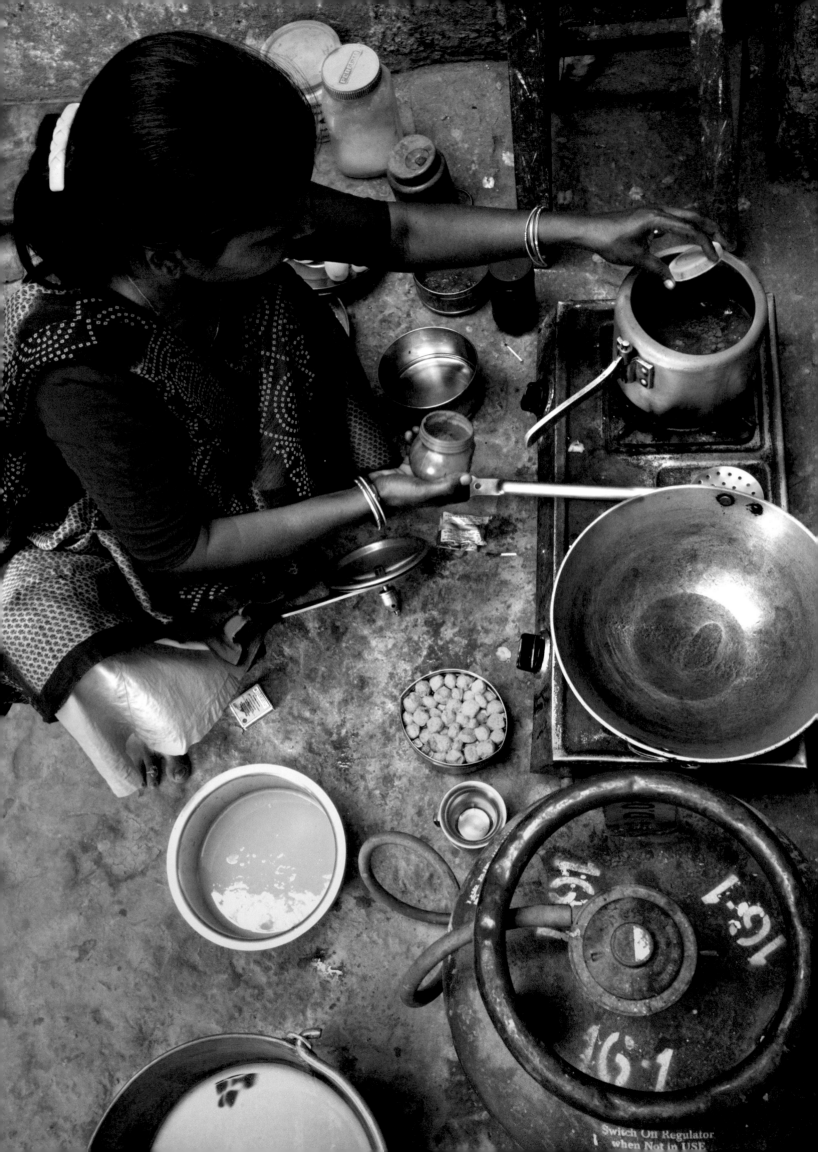

Squatting in their courtyard preparing lunch for Munna and the family (at left), Munna's wife, Meera, adds turmeric to dal that she cooked in a pressure cooker, while oil heats to cook potato and soy curry. Top right: Traffic swirls around a policeman in a roundabout in Varanasi's main shopping district as he keeps an eye on rickshaws, bicycles, pedestrians, a few cars, and two cows. At right: Munna ferries his wife, niece, and son on a shopping trip.

2400

KENYA
Roseline Amondi
The Microloan Fish Fryer

ONE DAY'S FOOD

IN MARCH

BREAKFAST Ndazi (fry bread), 2.8 oz • Black tea, 4.3 fl oz; with whole milk, 4.3 fl oz; and sugar, 1.2 oz

LUNCH Pinto beans cooked with onion, tomato, *Royco* spice mixture, and oil, 6.2 oz • White rice, 10 oz

DINNER Ugali (thick cornmeal porridge), 13.6 oz • Sukuma wiki (kale or collard greens, sautéed in oil with onion and tomato), 3.5 oz • *Coca-Cola*, 10.1 fl oz

SNACKS AND OTHER Deep-fried tilapia (not in picture), 2.8 oz • Black tea (3), 12.6 fl oz; with whole milk, 12.6 fl oz; and sugar, 3.5 oz • Tap water purchased on the street, 26.4 fl oz

CALORIES 2,400

Age: 43 • Height: 5'11" • Weight: 231 pounds

Steam and kitchen smoke intermingle with the haze of smoky burning trash to create an ever-present aroma in Kibera, the slum area that an estimated 1 million East Africans in Nairobi call home. Kibera inhabitants suffer extremely high rates of unemployment, high crime, ethnic unrest, and tumbledown housing. Without the support of nongovernmental organizations and philanthropic programs, conditions would be even worse.

KIBERA, NAIROBI • It isn't the money from her microloan that gives Roseline Amondi her greatest joy; it's the women's club that formed to get the loan. The group itself, which they call Nyota, meaning "star," guarantees the loans of the individual members, who run small businesses as fish fryers, convenience store operators, and fruit and vegetable vendors. The group is also a netball team, competing in community tournaments and leagues; Roseline is their manager.

Mama Sumaki (Mama Fish) is what Roseline's neighbors call her, and that's also the name of her restaurant, where she and her husband, George, have lived for 20 years and raised their four children. Her microlender, Umande Trust, a nongovernmental organization that built large community toilets and shower facilities in one part of Kibera, is one of many that operates in the slum. It's a place that gets few services from the government, because no one is supposed to live there.

Butchers ready their meat in small makeshift stalls, and vendors lay out fresh vegetables and fruit here and there throughout Kibera to sell by the piece for the day's cooking. Few can afford the luxury of stocking up on food and staples for future days, and hardly anyone has a refrigerator for long-term storage. Passersby stop to make purchases, or to visit on their treks to fill up water jugs at faraway taps.

Kibera residents trudge atop thoroughfares of mounded, compacted dirt and trash mucked up from open drainage ditches that run alongside the shacks and shops. Every year the mounded pathways get higher, and the jump from path to doorway over drainage ditch, longer and longer. School children in sparkling clean, albeit ill-fitting and threadbare, school uniforms hop over piles of rotting

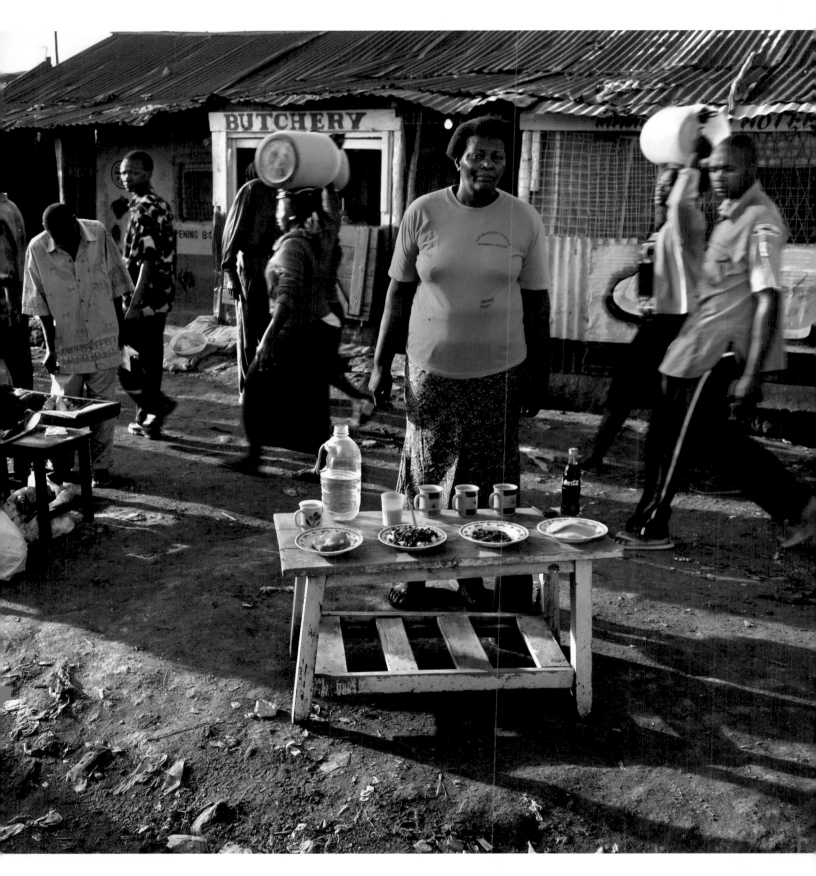

Roseline Amondi, a mother of four and microloan recipient, in front of her restaurant with her typical day's worth of food. A neighbor sells *mandazi* (the plural of *ndazi*, a sweet fried bread), as people hurry to work or school. Roseline and her husband, George, have lived in Kibera, Africa's biggest slum, for 20 years. A new community-built multistory toilet facility nearby charges residents a few cents per day, cutting down the number of "flying toilets"—human waste in plastic bags thrown onto roofs and into the open sewers lining the streets. At left: Roseline fries some tilapia to sell to people returning from work.

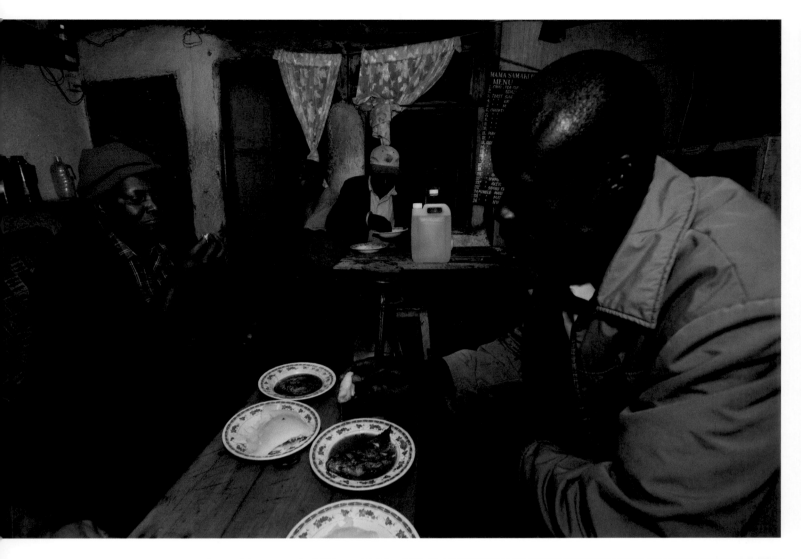

In an area the size of New York City's Central Park, nearly 1 million people live in tin houses (at right), with an average of five people in a typical nine-by-nine-foot room. Roseline and a neighbor, Kennedy Mbori (top left), eat in her restaurant, where her brother sleeps at night to guard against thieves. Top right: Shiny used shoes for sale along the railroad tracks that run near Kibera.

waste as they walk to school in groups of two and three, or hand-in-hand with their mothers.

In the morning there's a steady exodus of men and women trekking to workplaces throughout Nairobi. They return in droves in the late afternoon, and that's when Roseline sets up her fish-frying stand on the dirt path in front of her restaurant. She scores, salts, and then fries the fish and offers it for sale. She says this is a better business than her small restaurant, which sells traditional Kenyan fare but has a lot of competition from others in the area. "A lot of people like to buy fish when they're coming home," she says. "They don't have to prepare food."

Roseline's husband manages the restaurant cooking. When we visit, he's using a five-foot-long wooden paddle and both hands to stir a large vat of thick cornmeal porridge. A helper feeds the cooking fire in the alley behind their small, ramshackle building.

They serve cornmeal porridge, called *ugali,* and *sukuma wiki*—stir-fried leafy greens cooked with tomato and onion. *Ugali* and *sukuma wiki* (which means "push the week" in Swahili) are staple foods for Kenyans in homes throughout the country, offering basic affordable nutrition, in theory at least, in a country where 50 percent of the population lives in poverty.

Roseline finds herself pushing and pulling the week every day, stretching money and meals for both her family of six and at the restaurant. Sometimes meat is added to *sukuma wiki*, but only once a week at Roseline's home table. Her four children would eat meat every day if they could, she says, but cornmeal, greens, rice, and beans are cheaper.

One expense that they choose to take on, unlike most Kibera residents, is the cost of boarding school for their children. It would be far cheaper to send them to public school, but they hope that a better education will result in better-paying jobs. "Education is very important," says George. "If I'm educated, I can meet you anywhere and talk with you. Some here feel that way, but not many. The slum area isn't very good for children. It's not safe for them, so we decided to send them to boarding school."

Unfortunately, when tuition payments run behind, the school sends the children home until the parents can pay the fees. As soon as she can afford the payment, Roseline sends them back to school, usually with the money that was meant to buy fish for frying and food for the restaurant. A never-ending problem, and a vicious circle.

"The slum area isn't very good for children. It's not safe for them, so we decided to send them to boarding school."

The Agony and the Ecstasy of the Calorie

By Bijal P. Trivedi

Eleven baked potato chips: 120. Seven English walnuts: 185. One tablespoon of honey: 64. It's almost impossible to put a morsel into your mouth without thinking of the calories in it, all thanks to a man you've probably never heard of: Wilbur Olin Atwater. In the late 1800s, Atwater quantified the energy in a gram of carbohydrate, protein, and fat and used these values—basically the same ones we use today—to calculate the total calories in more than 1,000 different foods. The fruit of his labor—the calorie count—is now stamped on every packaged food item on the grocery shelf.

It also happens to be wrong.

Atwater had a simple goal: helping the poor get more nutritional bang for their buck. After analyzing the protein and total energy in various foods, Atwater found that, for example, 25 cents worth of cheese contained 240 grams of protein, three times as much as if the same money were spent on a sirloin of beef. Today, by contrast, the calorie count has become the foundation of the $40 billion weight-loss industry, as well as the concept that as long as you don't overstep a daily threshold of about 2,000 calories, you can eat whatever you like, be it a bowl of cereal, a steak, or a brownie. That would work fine if all calories were equal. But they're not.

Since Atwater first did his calculations, nutritional science has evolved. We know more about digestion, including how much energy it takes to break down different types of food and release their nutrients. We also know that food processing methods like grinding and cooking make it easier to unleash more of the calories locked up in food. The easier calories are for the body to harvest, the less work it does to get to them and the more likely they are to add to our waistlines. Nutrition labels don't take these factors into account, and, as a result, their calorie counts may be up to 25 percent off, either underestimating or overestimating the energy our bodies can extract from the food.

Atwater calculated the amount of energy contained in food by burning it and measuring the amount of energy released as heat, and then converting these heat measurements into units of energy called calories. But the body doesn't ignite food to unlock energy—it digests it. To estimate the proportion of this chemical energy actually available to the human body, Atwater analyzed human feces from research subjects on strict diets and discovered that approximately 10 percent of food passes through the body undigested. He also subtracted the energy lost via waste products in urine. After accounting for these losses, Atwater figured that each gram of protein or carbohydrate yields 4 calories, whereas each gram of fat packs a whopping 9 calories.

However, as it turns out, Atwater didn't subtract all of the energy spent on digesting food. Just like the old adage "It takes money to make money," it also takes energy to make energy. The process of digestion—chewing, swallowing, manufacturing enzymes, and moving the food through the stomach and gut, where it's broken down and

Bijal P. Trivedi is an award-winning freelance writer specializing in science, the environment, and medicine. Her work has appeared in publications including National Geographic, New Scientist, Wired, *and* The Economist. *She teaches in New York University's Science, Health, and Environmental Reporting Program.*

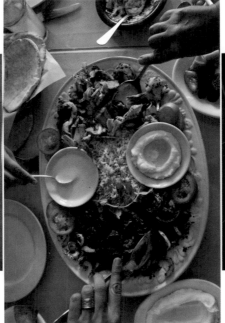

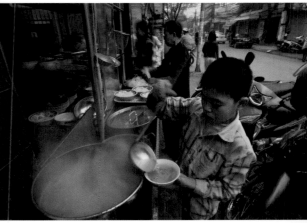

Left to right: Todd Kincer eats a plate of Hamburger Helper at home in Mayking, Kentucky. Lunch at a roadside restaurant near So village, Vietnam. A weekday meal at the home of a middle-class family in Luxembourg. Breakfast prepared for a houseguest in London. A platter of grilled meats and rice at a restaurant in Los Angeles. A young employee pours himself breakfast at a street pho noodle shop in Hanoi, Vietnam.

nutrients are extracted—takes energy. For example, it takes more energy to digest dietary fiber than it does to harvest calories from other carbohydrates. This fiber also nourishes the microbes that live in the gut, so they take a share of the calories too. Thus, the calories you get from dietary fiber are reduced by 25 percent (from 2.0 to 1.5 per gram). Similarly, 20 percent fewer calories should be attributed to protein (3.2 rather than 4.0 per gram) because as protein is broken down into its amino acids, toxic ammonia is released, which must be converted into urea for excretion. That too takes energy.

Beyond these considerations, today we manipulate our food in ways that dramatically impact how much energy we can get from them. Atwater didn't anticipate, for example, that at least 30 percent of coarsely ground whole wheat flour remains undigested, while today's refined white flour can be almost completely digested and therefore packs a higher caloric punch than indicated on the label. Grinding also makes the calories in meat more accessible. Experiments with Burmese pythons—popular for digestion studies because they remain motionless for up to 11 days after eating—revealed that grinding meat lowers the energy needed for digestion by about 12 percent.

Of all the things we do to our food, cooking is the most powerful way to release calories, since it helps break down proteins and starches. Like tightly folded origami, proteins hide much of their internal structure when raw. Add a little heat and they unfold, making the entire molecule more accessible to digestive enzymes. Simply cooking meat reduced the amount of energy pythons required for digestion by almost 13 percent, and when the meat was both cooked and ground, that number jumped to 23 percent.

The takeaway message? When food is scarce, cooking and grinding can help you squeeze extra calories out of each bite. If, on the other hand, you're looking to lose weight, ingredients that are less processed and food that isn't cooked at as high a heat contribute fewer calories to the body. Although these differences in calorie availability may appear minor, they add up, with far-reaching implications. As just one example, nutrition labels for foods rich in protein or dietary fiber overestimate the number of calories, making them appear less healthful and more calorie laden. In 2002, the Food and Agriculture Organization (FAO) of the United Nations assembled a panel of nutritionists to consider the topic; although they agreed that accounting for digestion would yield more accurate calorie counts, they decided that the system wasn't worth changing because recalculating tables and generating new calorie counts would be too burdensome.

Still, even if the calorie counts on nutrition labels aren't 100 percent accurate, they do provide a baseline estimate of available energy, which is valuable information for the more than 3 billion people on the planet who aren't getting an appropriate number of calories. According to the FAO, the number of undernourished individuals in the world was 1.02 billion in 2009. Conversely, the World Health Organization estimates that by 2015 about 2.3 billion adults will be overweight and 700 million more will be obese. The most basic cause of this "obesity epidemic" is the ubiquity of energy-dense food—high in sugar and fat and low in nutrients and fiber—and the simultaneous decline in physical activity.

For the undernourished, calorie counts, however flawed, are vital for helping doctors, nutritionists, and nongovernmental organizations channel sufficient food to each individual to provide the minimum number of calories required. For the overweight and obese, calorie counts provide an opportunity to know how much they're eating, and hopefully limit their consumption to more healthful levels. For all its shortfalls, Atwater's calorie count has transformed the way we eat, and for the time being, it remains an important tool for helping bring more balance to a world where some suffer from inadequate nutrition while others suffer from an excess.

2500

Nguyễn Văn Theo
The Rice Farmer

ONE DAY'S FOOD

IN DECEMBER

BREAKFAST Rice noodles, 2.7 oz (dry weight); boiled and eaten with fish sauce, 1.5 tbsp

LUNCH Pork loin cooked with bean sprouts and green onion, 3.6 oz • Pork back cooked with pickled mustard greens, 3 oz • White rice, 1.4 lb

DINNER Pork back seasoned with fish sauce and caramel sugar, 1.6 oz • Eggs, from his chickens, fried with green onion, 2.6 oz • Spinach and spinach water broth, 5.2 oz • White rice, 1.4 lb • Homemade ruou thuoc (strong rice wine with herbs), 1.9 fl oz

THROUGHOUT THE DAY Green tea, 7.8 fl oz • Tobacco, 0.5 oz • Boiled rainwater, 1.6 qt

CALORIES 2,500

Age: 51 • Height: 5'4" • Weight: 110 pounds

THO QUANG, OUTSIDE HANOI • Nguyễn Văn Theo puffs on a bamboo pipe full of tobacco and rocks his baby granddaughter on the landing outside his bedroom as his daughter-in-law, 21-year-old Nguyễn Thi Huong, prepares a midday meal in their small courtyard kitchen. All of the rooms open to the family courtyard, which has seen generations of Nguyễn babies dandled on the knees of countless grandparents.

Huong, who's married to Theo's oldest son, Doi, scoops rice from a bag of homegrown grain, dumps it into an electric cooker with rainwater, and sets the timer. She fries small pieces of pork loin in sizzling pork fat over a propane cookstove, then adds a giant handful of fresh bean sprouts and chopped green onion. She prepares a second small dish of pork back with pickled mustard greens. Rice is the centerpiece of the meal, and the other dishes serve as shared condiments, along with fish sauce and chrysanthemum greens in broth.

Doi, a mechanic in the village, will be home for lunch. These days it's just the four of them in the family compound, which in the past has always held many more.

In war and in peace, the Nguyễn family home has been in the village of Tho Quang, about an hour's drive south of Hanoi. But traditional life took a sudden turn seven years ago when Theo and his wife Vu Thi Phat decided she would move to Hanoi to live with her sisters and sell vegetables. It was a financial decision, made so they could, among other

things, afford to pay for a good future for their children: college for their daughter, and a large deposit to a Hanoi taxi company so their youngest son could drive a cab. Before the move, they had no income—they were subsistence farmers. Phat enjoys the bustle of the city; Theo prefers the quiet countryside.

Seven days a week Phat and her sisters awaken in their one-room Hanoi apartment at 3 a.m. to get an early start at the wholesale market so they can have their pick of the day's fresh produce. After that, the sisters are in competition with one another, each renting a few feet of sidewalk space, where they bargain and sell in rain or sunshine until 8 or 10 p.m. They are part of Hanoi's underground economy. Their sidewalk rental is illegal, and anywhere they set up, they're only steps ahead of the police, who sweep through occasionally and chase them off or take their vegetables.

Theo's life in the village moves at a different pace, more tuned to the seasons than the clock. He plants two crops of rice a year and one of corn, though sometimes flooding wipes them out. Some years he doesn't plant at all, instead renting his land to another farmer in exchange for a portion of the harvest.

Unlike farmers in villages closer to Hanoi, they haven't lost any of their rice fields to construction yet, but Hanoi's insatiable spread outward, and Vietnam's urbanization, looms on the horizon.

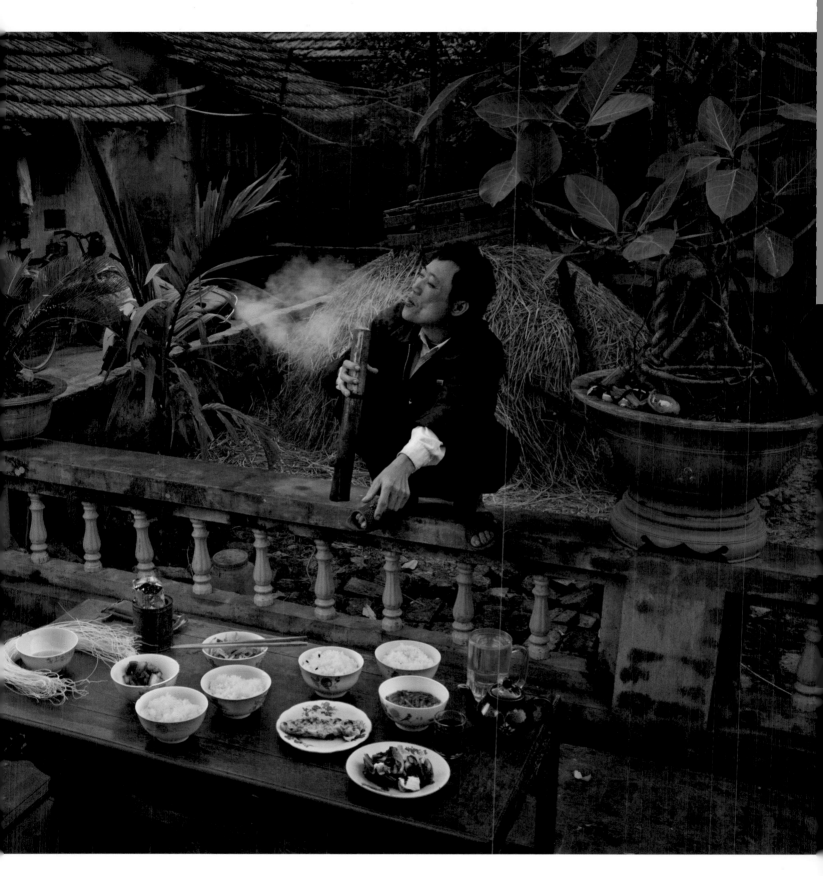

Nguyễn Văn Theo, a rice farmer, in his courtyard with his typical day's worth of food. Behind him is a pile of last year's rice straw, used for fuel to boil water in the family's small kitchen. Rainwater from the tile roof of the main house fills a cement cistern, providing water for drinking and cooking. Theo enjoys the relative tranquility of village life, compared to his wife's busy routine of selling fresh produce on the sidewalks of Hanoi. Floods ruined his rice crop a few months ago, so after last year's store of rice is eaten, the family will rely on his wife's income to buy this staple grain until he harvests the next crop.

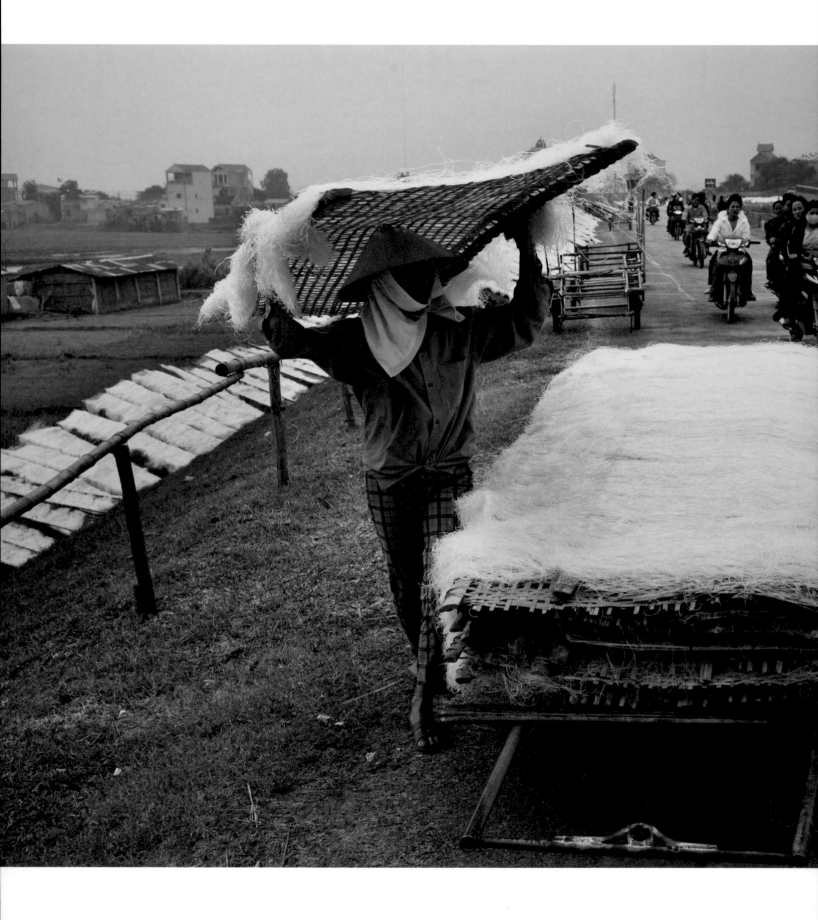

Racks of noodles are carted out to dry along the main road from the village of So (at left), 15 miles from Hanoi. The noodles are made from yam and rice starch. Top right: Eating her breakfast bowl of rice while tending her spot on the sidewalk of Doi Can Street, Theo's wife, Vu Thi Phat, visits with their son, Nguyễn Văn Doanh, a taxi driver in Hanoi. The fresh produce she has purchased at the wholesale market before dawn, displayed on the sidewalk, includes cabbage, root vegetables, green onions, long beans, cucumbers, ginger, lemongrass, garlic, a variety of greens, and tomatoes. Bottom right: The next day, Nguyễn Văn Doanh (top center, holding a bowl of rice), shares a meal with his father, brother, sister-in-law, and others in the rustic room that opens into the courtyard.

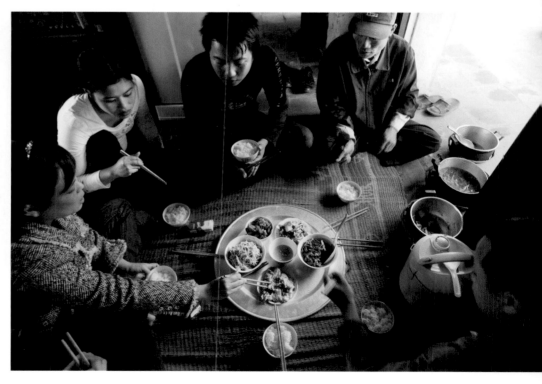

2600

Neil Jones
The Sky-High Manager

ONE DAY'S FOOD

IN JUNE

BREAKFAST Apple juice, 6.2 fl oz • *Starbucks* coffee with 2% milk, 16 fl oz; and raw sugar, 0.5 tsp

LUNCH IN CN TOWER KITCHEN Salmon, 5.7 oz; cooked with olive oil, 2 tsp • Nicoise salad: cherry tomatoes, 2.8 oz; potato, 2.3 oz; hard-boiled egg, 2 oz; haricots verts (French green beans), 1.8 oz; artichoke hearts, 1.6 oz; green olives, 1.1 oz; kalamata olives, 1.1 oz; and anchovies, 0.6 oz; with dressing of shallot, lemon juice, and olive oil, 1.2 fl oz • *Coca-Cola*, 8 fl oz • Tap water, 6.4 fl oz

DINNER Spaghetti, 10 oz; with homemade Bolognese sauce, 8 oz • Baguette, 1.9 oz • *McManis Family Vineyards* Cabernet Sauvignon, 14.8 fl oz • Tap water, 6.4 fl oz

OTHER *Voss* bottled water, sparkling, 12.7 fl oz • Vitamin C • Vitamin D

CALORIES 2,600

Age: 44 • Height: 6'2" • Weight: 220 pounds

TORONTO, ONTARIO • Neil Jones, born in England and raised in Canada, worked as a chef in London and Bermuda before returning to Canada. "I'd fill in for people in different restaurants," he says—spatula for hire.

Soon he was a freelance pastry chef and working his way up at the world's highest restaurant, in the CN Tower, which at one time was the world's tallest building. Today, as the tower's director of operations, he still keeps his hand on a pair of kitchen tongs; together with executive chef Peter George, he creates the menus and chooses the wines for the world's highest wine cellar.

At work he rides the elevator from his basement-level office up over 1,150 feet to order up a piece of fresh fish for lunch, whip up a salad himself, and eat at the gleaming stainless steel counter in the restaurant kitchen, his tie tucked into his shirt.

At home, he's the chief chef: "My wife didn't really know how to cook until she met me," he says. "I had never eaten a Kraft dinner until I met her. I didn't even know what it was. I said, 'Why would you do that?'" But when she explained, he still didn't understand. "It's been quite a learning experience for both sides."

Most nights it's a late pasta dinner or Indian food ordered in, with their schedule arranged around the needs of their new baby. "We decided to stay in the city instead of going to the suburbs," he says. They live in a Greek neighborhood with two grocery stores within walking distance. "There's all the fetas, there's all the lamb—you can get anything you want. So we don't shop like normal people; we don't go to the grocery store and buy a week's worth of groceries. We go…daily almost, because it's walking distance. Everyone says you spend too much money that way. I'd rather spend money on food…and on wine once in a while. That's what I enjoy."

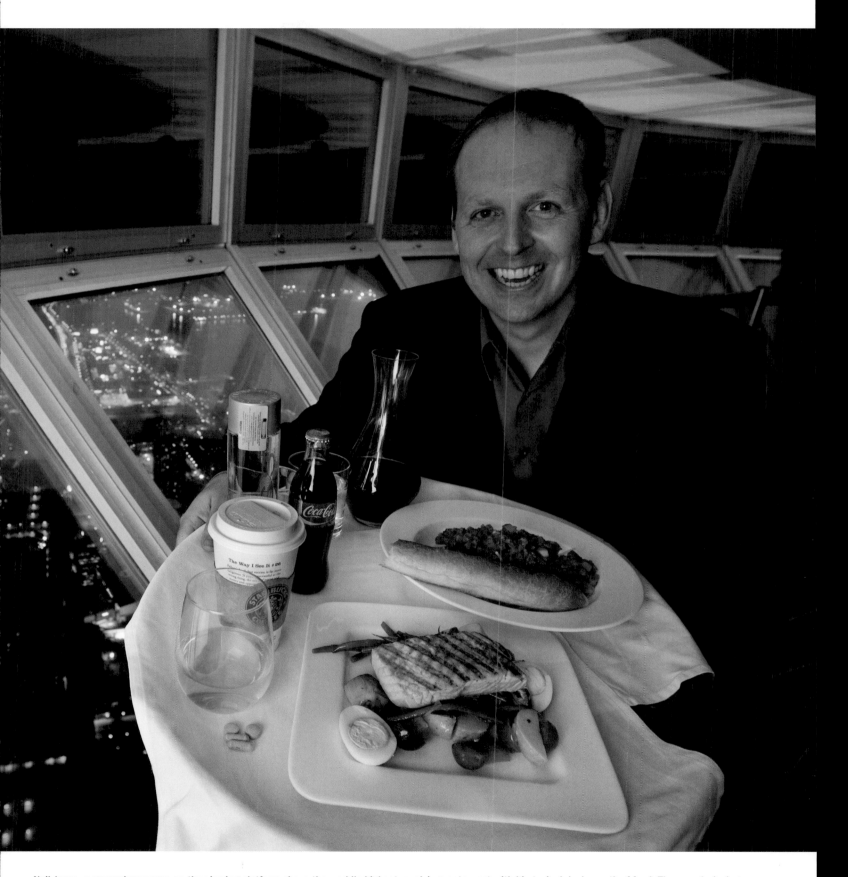

Neil Jones, a general manager, on the viewing platform above the world's highest revolving restaurant with his typical day's worth of food. The award-winning restaurant, which revolves 360 degrees, has awe-inspiring views and, for a tourist destination, surprisingly excellent food. At left: Illuminated at night by a recent multimillion-dollar lighting upgrade, the 1,815-foot tower's nightly hues mirror the Canadian flag's colors of red and white. Best-kept secret: The pricey entrance and elevator fee of about $25 per person is waived if you eat at the restaurant, making it cheaper to have lunch than to just see the sights.

Kelvin Lester, a floor supervisor at a meat processing company, at his kitchen table with his typical day's worth of food. The hands on the right belong to Kiara, his four-year-old adopted daughter. Several times a week, hamburger patties that he purchases at an employee discount wind up on his dinner table, and then go into his lunch box, along with his wife's homemade potato salad. With more than 20 years of experience grinding beef at the Rochester Meat Company, Kelvin says he always grills hamburgers—no matter who has ground them—until they are well-done, because any contamination is most easily rendered harmless by thorough cooking, meaning to an internal temperature of at least 160 degrees Fahrenheit.

WHAT I EAT

USA

Kelvin Lester
The Meat Grinder

ONE DAY'S FOOD

IN JUNE

BREAKFAST *Cheerios* cereal, 0.8 oz; with 2% milk, 3.3 fl oz • Bananas (2), 12.9 oz • *Great Value* raisins, 1.5 oz • *Tropicana* fruit punch, 6.7 fl oz • Coffee, 14.1 fl oz

PACKED LUNCH Hamburger: *Great Value* hamburger bun, 1.8 oz; *Rochester Meat Company* 100% ground beef hamburger patties (2), 6.6 oz; *Great Value* ketchup, 2 tsp; *Great Value* mustard, 1 tsp; *Frank's Red Hot* cayenne pepper hot sauce, 1 tsp • Homemade potato salad with egg, vinegar, paprika, tarragon, and onion powder, 9.3 oz

DINNER Cheeseburger: *Great Value* hamburger bun, 1.8 oz; *Rochester Meat Company* 100% ground beef hamburger patty, 3.3 oz; *Great Value* singles, American cheese. 0.8 oz; *Great Value* ketchup, 2 tsp; *Great Value* mustard, 1 tsp; *Frank's Red Hot* cayenne pepper hot sauce, 1 tsp • Homemade potato salad, 4.5 oz • 2% milk, 11.3 fl oz • *Michelob Golden Light Draft* beer, 12 fl oz

THROUGHOUT THE DAY Homebrewed *Lipton* iced tea, decaffeinated, 1.9 qt • Saint-John's-wort supplement • Coconut oil supplement

CALORIES 2,600

Age: 44 • Height: 5'11" • Weight: 195 pounds

GRAND MEADOW, MINNESOTA • Kelvin and Deb Lester count their pennies when they shop, use Internet coupons, and buy store brands rather than brand-name foods because they're cheaper. Basic common sense is how Kelvin sees it—getting the best value for his hard-earned dollars. The 20-year veteran grinder at the Rochester Meat Company in Rochester, Minnesota, also gets reduced rates on the hamburger patties and other meat products he produces, and he buys 200 ears of corn at a time in August, blanching and freezing them for long-term storage. "It's the best corn you can get," he says, "I don't like canned corn."

His tastes were honed on the family farm where he grew up, just above the Iowa border, near his current home in Grand Meadow, Minnesota. "All of our vegetables were fresh," he says. "We had cows, pigs, chickens, and rabbits; the rabbits and chickens we ate, and then we had the egg layers."

There were no store-bought snacks: "We didn't have pop or chips or Ho Hos," he says. "My mom cooked the pies and cookies and stuff." Now, 20 years later, his diet isn't all that different. "I'm not much of a chip eater," he says. Kelvin brews his own iced tea and drinks several bottles of it daily during his

7 a.m. to 3 p.m. shift, and he's one of the few at work who doesn't raid the vending machines for snacks and sandwiches, preferring to bring his own food from home. "Leftovers, usually," he says, "whatever Deb made last night, or what I grilled."

Two or three times a week, lunch includes meat samples cooked by the staff at the meat processing plant: frozen patties pulled off the conveyer to taste test, and to check seasonings and "grill performance."

At home after work, Kelvin is the grill master most nights, but only after Deb's houseful of day care charges leave at 5:30. Until then, he works outside or holes up in the garage at his workbench, building wooden toy trains, planes, trucks, and road graders, which he sells on eBay. His partner in the shop is his four-year-old daughter, Kiara, who has her own workbench and tools. "She's Daddy's girl," he says. "I come home, and she and I work in the garage or go play fetch with the dog. It gets her out of the house for a little bit and gives my wife a break."

The four-year-old's food preferences sometimes guide the family meal. "Sunday night is her night to choose, so last night we made chicken strips, from Walmart," he says, "and milk to drink, and shoestring french fries."

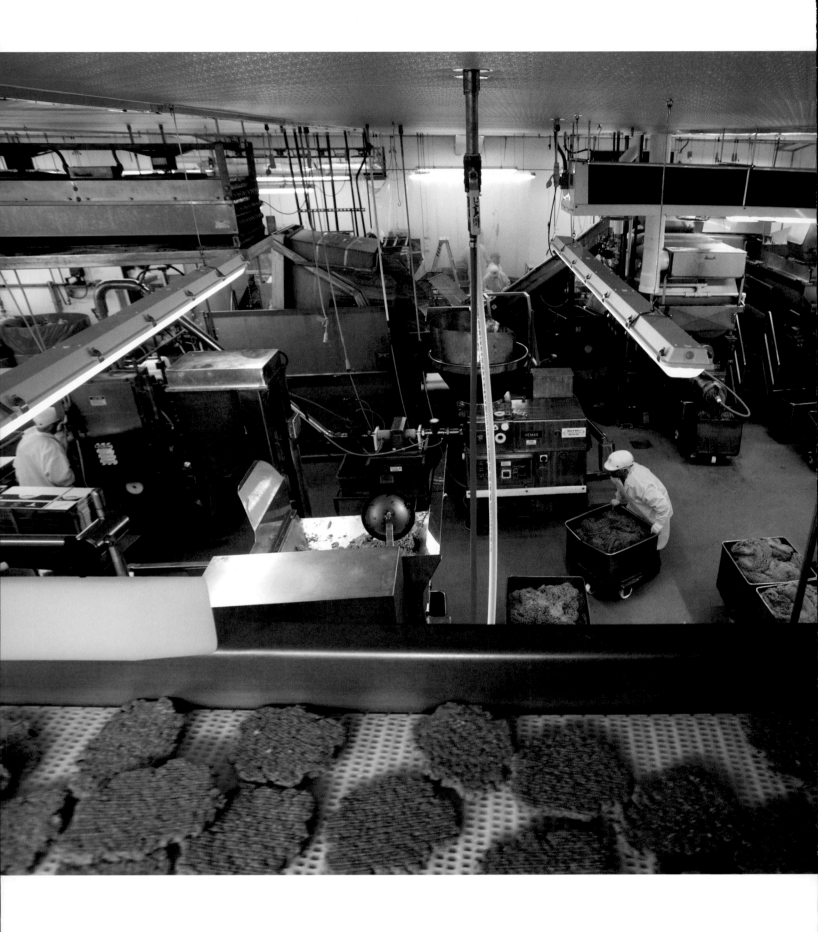

In the main grinding room of the Rochester Meat Company (at left), workers roll vats of freshly ground beef from the mixing and grinding machines to the machines that form the hamburger patties. The patties are spit out onto a conveyer belt that goes through spiral flash-freezing tunnels, and then the frozen pink pucks are packed into big boxes for restaurants. Top right: Kelvin maneuvers a 2,000-pound bin of "50s" (carcass trimmings that are half fat) toward the grinding and blending machines. Less desirable trimmings with a higher fat content are ground into blends with different percentages of lean meat. The ton of 50s is added to other leaner cuts, and sometimes reconstituted beef fat—which is even cheaper—is mixed in as well. Bottom right: At home after work, Kelvin grills hamburger patties, well-done, for the family's supper as his daughter Kiara looks on.

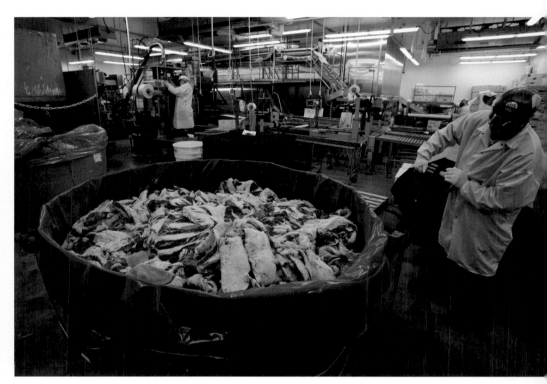

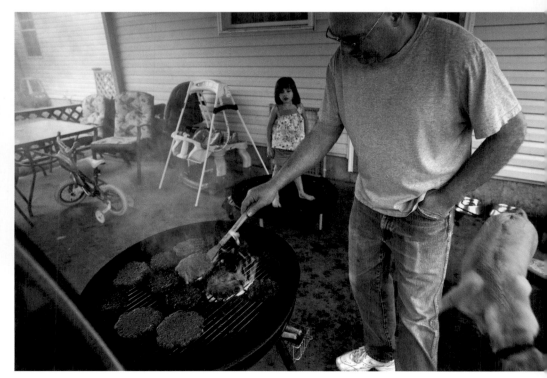

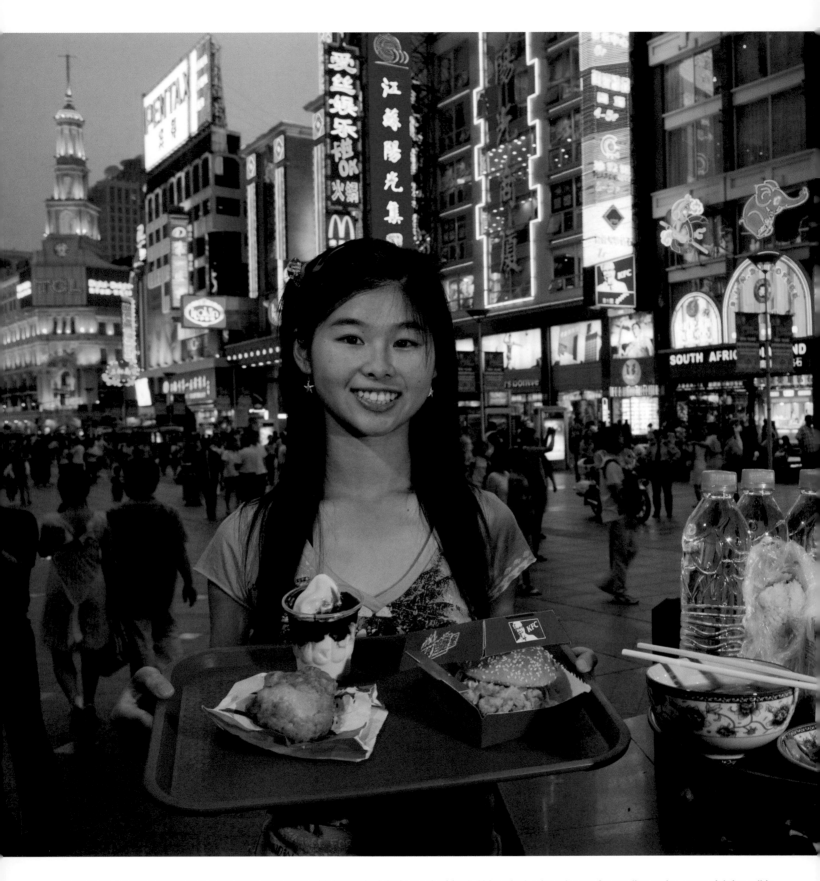

Chen Zhen, a university student, on Nanjing East Road with her typical day's worth of food. Although she doesn't care for noodles or rice, a special rice roll is her favorite snack: black glutinous rice wrapped around *youtiao* (fried bread), pickled vegetables, mustard greens, and flosslike threads of dried pork. Zhen and her friends eat at KFC about three times a week, something they couldn't afford without the company's coupons. Meanwhile, her father and grandparents, who live in a tiny apartment in northeast Shanghai, go without meat during the week so they can afford to share a special meal with Zhen on her weekend visits. At right: Chen Zhen and her family share a meal of greens with garlic, potatoes with green bell pepper, rice, and fava beans with pig's knuckles.

CHINA

Chen Zhen
The College Student

ONE DAY'S FOOD

IN JUNE

BREAKFAST Fantuan (rice roll) filled with youtiao (deep-fried bread), dried pork threads, pickled vegetables, and spicy, salted mustard greens, 7.3 oz • *Guangming* whole milk, 8.5 fl oz

LUNCH *KFC* breaded chicken thigh, regular, 3.7 oz • *KFC* crispy chicken sandwich, 4 oz • *KFC* french fries (not in picture), small, 2.3 oz • *KFC* hot fudge sundae, 5 oz

DINNER Suanchao youcai (a vegetable similar to bok choy, stir-fried with garlic), 2 oz • Hongshao qiezi (eggplant, stir-fried with garlic, soy sauce, and red chili pepper flakes), 2.9 oz • Soup of tomato and egg, 8 oz • White rice, 3.6 oz

THROUGHOUT THE DAY Bottled water, 1.1 gal

CALORIES 2,600

Age: 20 • Height: 5'5" • Weight: 106 pounds

SHANGHAI • Most days, Chen Zhen eats a Chinese breakfast, lunch, and dinner, whether in her college dormitory cafeteria at Shanghai Lixin University of Commerce or at home on the weekends with her family in northeast Shanghai. But a few times a week, she gets lunch at fast-food restaurant KFC: 'I like their chicken sandwiches and the french fries." And, she says, "They give out coupons."

The fast-food company KFC (its parent company began to shed the name Kentucky Fried Chicken in the early 1990s) was the first foreign fast-food entrant into the Chinese market, and was soon followed by most of the other big players in the American fast-food crowd. The company opens more than 300 new restaurants in China per year, and the coupons that KFC sprinkles liberally throughout the country are a big draw.

Zhen uses her part-time job in the Hello Kitty kiosk of a Shanghai department store to fund her restaurant visits with friends, but couldn't afford to do so without the pages of coupons they collect.

Zhen and her father have lived at her grandparent's government-issued flat since her parents divorced when she was six, and there's no money for restaurant visits. Her grandparents and her father, a state factory worker, eat vegetables and rice throughout the week so they can afford to buy meat to feed Zhen when she visits on weekends. Has her father ever

eaten at KFC? "Never," she says, giggling at the thought. "He only eats Chinese food."

Her favorite food at home is roasted duck, and she's a bit embarrassed to say how much of it she eats: almost the whole bird. At five foot five, she's a head taller than her grandmother and several inches taller than her father, probably due to better nutrition. She says that her family has sacrificed a lot to ensure that she has enough to eat, and a successful future: "It was very hard for my father to raise me," she says. "It was hard for him to earn money when I was little, and now he's paying a lot of money for me to go to school." Her hope is to do well in school, and then earn enough money to support her family. Is she a good student? "I think so," she says.

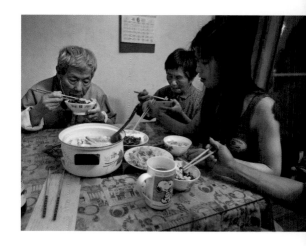

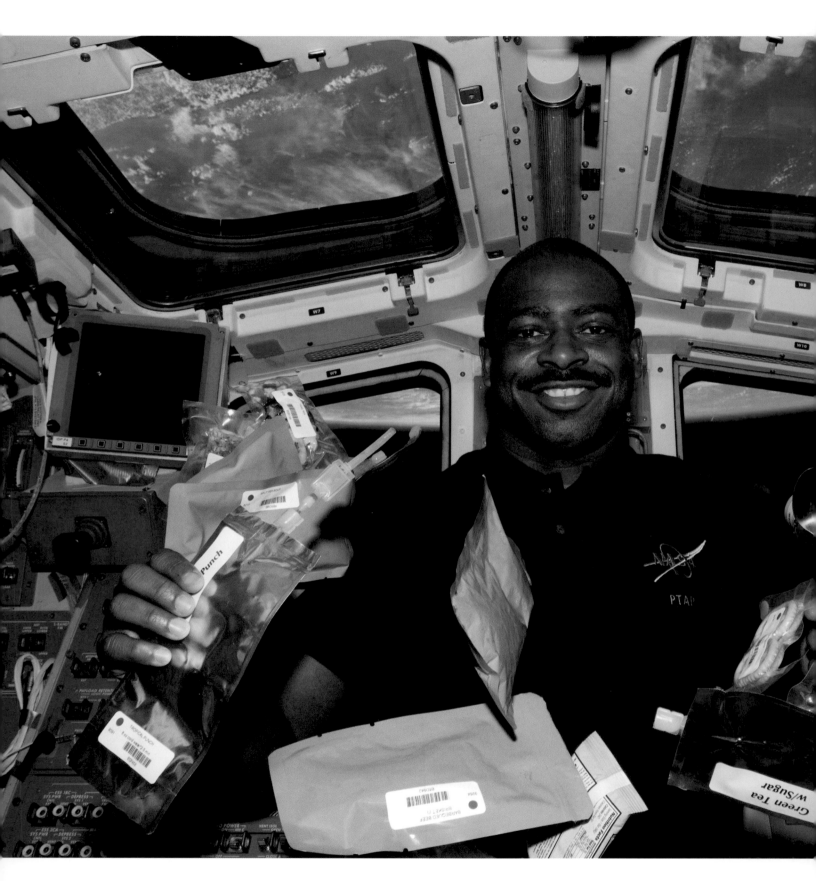

Leland Melvin, a NASA astronaut, on the flight deck of the Space Shuttle Atlantis with his typical day's worth of food. The early days of space travel were dominated by Tang, Space Food Sticks, and a variety of pastes squeezed from aluminum tubes—all designed to prevent the levitation of liquids and crumbs, which can be hazardous to the equipment. Over the years, space menus have become more palatable, and now astronauts can even enjoy fresh fruits for the first few days of a mission. The challenges of weightlessness extend to photography. Even with three fellow astronauts helping to wrangle Leland's floating food as shuttle commander Charles Hobaugh took the photo, all of the items in Leland's daily fare aren't clearly visible.

USA

Leland Melvin
The Astronaut

ONE DAY'S FOOD

IN FEBRUARY

NASA SPACE MEAL A Mexican scrambled eggs, 1.3 oz • Yogurt-covered granola bar, 1.2 oz • Vanilla breakfast drink, 1.4 oz • Orange juice, 1.2 oz

NASA SPACE MEAL B Split pea soup with ham bits, 7 oz • Chicken with peanut sauce, 7 oz; eaten in a flour tortilla, 1.1 oz • Mixed vegetables, 4 oz • Vanilla pudding 4 oz

NASA SPACE MEAL C Tuna salad spread, 2.9 oz; with crackers, 1.3 oz • Smoked turkey, 2 oz • Carrot coins with butter and parsley, 4.8 oz • Shortbread cookies, 0.5 oz • Green tea with sugar, 0.6 oz

SNACKS AND OTHER Citrus fruit salad, 5 oz • Trail mix with *Ocean Spray Craisins* (sweetened dried cranberries), 1.8 oz • *Clif Bar*, cranberry apple cherry, 2.4 oz • Tropical punch, 0.4 oz • Water, 3 qt

CALORIES 2,700

Age: 45 • Height: 6' • Weight: 205 pounds

Some items were dehydrated when weighed; calories and weights provided by NASA. Almonds and an extra *Clif Bar* floated into picture inadvertently.

The Detroit Lions picked up University of Richmond wide receiver—and chemistry major—Leland Melvin in the 1986 NFL college draft. He was on a fast track to a professional football career, but hamstring injuries soon ended that dream. His love of science proved to be the key to an even loftier future as a NASA astronaut. He didn't grow up dreaming of going into space, he says, but early mentors helped point the way, and today he does the same for others as he addresses children and educators around the country about the importance of science and mathematics. The 45-year-old has been a mission specialist on two shuttle missions to the International Space Station: STS-122 in 2008, and STS-129 in 2009.

LOW EARTH ORBIT • On the Space Shuttle, where six or more astronauts circle the earth for two weeks at a time at 17,000 miles per hour in confined quarters and weightless conditions, organizational systems are essential. The most basic is a color-coding system that personalizes every part of an astronaut's life in space: tools, instruction manuals, food packages, and even the urine receptacles in the toilet. That system, and Velcro, keep order in the house.

Each astronaut has a personal food locker stocked with his or her food, all in packets that are variously freeze-dried, thermostabilized (processed with heat to prevent spoilage), or what NASA calls "natural" foods because they need no extra treatment to send up, serve, and eat—items like candy, trail mix, granola bars, and jerky.

Certain foods become favorites quickly. "Tortillas are great because you can make a little sandwich from any meat," says Leland. "And peanut butter is great up there. It doesn't fly away from you. It doesn't crumble. It's easy to eat without having to use two hands."

Leland's color-coded spoon is the only eating utensil he needs for everything from scrambled eggs (which he douses with hot sauce) to buttered carrot coins to split pea soup. "If something gets away, you have to float up and catch it with your mouth," he says. "If I momentarily suspend my spoon in midair and someone bumps it, even if it's just a very slight acceleration, it will just meander off and then there's this frantic search for your spoon." Renegade spoons are to be avoided, but there is a backup spoon in his locker if he needs it.

There are other pitfalls, especially for the first-time flyer: "You pop some meat out of a can by accident, or you have corn kernels float away—there are guys that are kind and will bat it back," he says. "The guys that

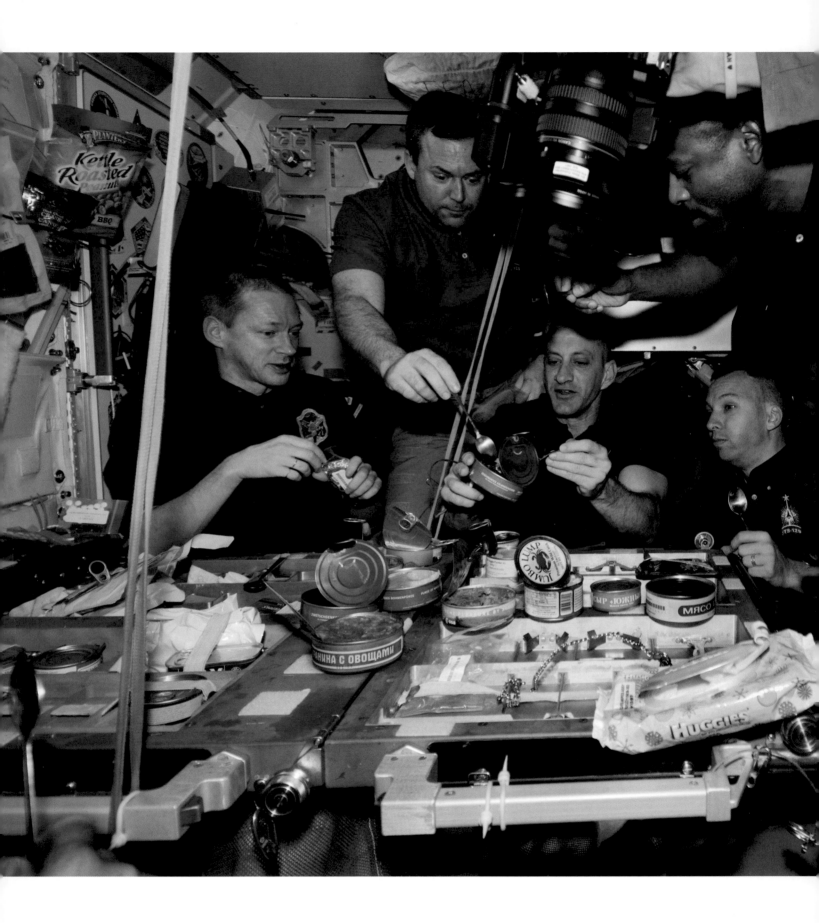

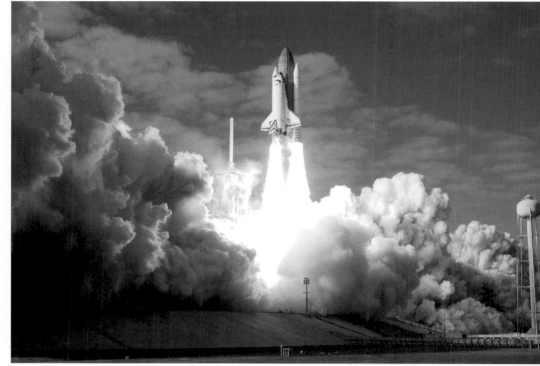

aren't will just open their mouths and eat your food"—mealtime humor for a very small club of high flyers. "You learn to be very efficient," he says. "That's rookie food."

Astronauts with downtime will prepare meals for others too busy to heat and eat their own. Do the astronauts eat meals together? "It depends on what you have in your schedule," he says. "If we're supporting a space walk over six hours, I'm pretty much camped out at the robotics work station... I'll bring over portable food and [attach] it to the top of the robotics work station. I can float up every so often and eat a Clif Bar, jerky, or anything that I don't need to use a spoon and two hands to eat."

On STS-129, the shuttle astronauts shared a potluck dinner with the crew on the International Space Station. Everyone brought a taste of home. "That was a glorious day for food," Leland says. "We had these potted calf cheeks—a Russian delicacy—and plum sauce, and we had some crab from the Europeans, and I think we had oysters too." The American astronauts brought meal packets of beef brisket and mashed potatoes with barbeque sauce. "It was a hit with the Russians," says Leland. "It's really tasty."

Not every food item is a rousing success— take beef jerky with peppers. Leland says, "The peppers would float off and you could not only get your eye put out with a pepper, but later when you go to the bathroom... We called it the 'ring of fire,'" he says. "We actually debriefed the food people on that one."

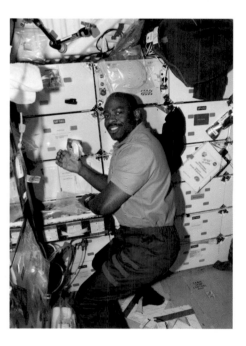

Atlantis **lifts off from the Kennedy Space Center (top right) on a mission to rendezvous with the International Space Station. The mission focused on delivering spare components that were staged outside the station during three spacewalks. Bottom right: Leland Melvin, with his feet anchored in loops for stability, retrieves food from his locker in** *Atlantis* **galley. At left: A potluck dinner in the galley of the Unity Node of the International Space Station. The crews share a meal of mostly canned treats saved for the occasion: crab, oysters, clams, tuna, mushrooms, and calf cheeks in plum sauce.**

2700

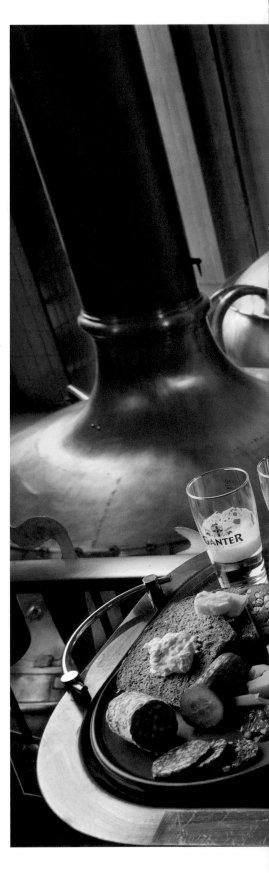

GERMANY

Joachim Rösch
The Brewer

IN MARCH

BREAKFAST Whole wheat bread, 1.6 oz; with *Bonne Maman* jam, strawberry, 1.2 oz; *Echter Deutscher* honey, 1.5 tbsp; and *Bodensee* butter, 2 tsp • Coffee (2), 16 fl oz

AT WORK *Haribo* gummy bears, 2.2 oz • *Ganter* beer (for taste testing), 25.4 fl oz

DINNER Homemade wheat and spelt carrot bread, 4.6 oz; with cream cheese, 1.5 tbsp; and *Bodensee* butter, 1 tbsp • *Casa Modena* hard salami, 3.2 oz • Emmenthal cheese, 3.2 oz • Cucumber, 2.6 oz • Yellow bell pepper, 1.6 oz • Homemade hot pepper relish with onion, squash, and tomato, 1 tbsp • *Ganter Spezial* beer, 16.9 fl oz

SNACKS AND OTHER *Ganter kep*star* cranberry drink (2), 22.4 fl oz • *Tafelwasser Oga* bottled water, 16.9 fl oz

CALORIES 2,700

Age: 44 • Height: 6'2" • Weight: 207 pounds

FREIBURG IM BREISGAU • On weekends, Joachim Rösch enjoys hot meals and barbecues with his wife, Silvia, and their two children, and long bike rides in this far southwestern corner of Germany's Black Forest countryside. But during the week he skips lunch, snacks on gummy bears, and eats cold fare at breakfast and dinner—and concentrates on beer, that most ancient of brews, and now the most widely consumed alcoholic beverage in the world.

The master brewer since 1997 for family-owned Ganter brewery, Joachim is also its technical director. He guides the crafting of its pilsners and lagers both by computer and with glass in hand to ensure quality. While modern-ization has streamlined the brewing process, Joachim still uses the look, aroma, and taste of a beer to judge whether it meets standards set over the company's 145-year history—which means a lot of taste testing. But there are other standards to be met as well. In order to call their product beer, German brewers have long had to follow a strict but simple formula called Reinheitsgebot (purity law), using only water, barley, hops, and yeast. Add anything else, even wheat, and it's not beer.

Bavarians first put such rules on the books centuries ago (sans yeast, as microorganisms were not yet known) to control prices and quality, and to conserve wheat and rye for bread baking. It's the oldest food-quality rule in history. When Bavaria joined the German Empire the Reinheitsgebot did as well, as a precondition for unification, effectively cutting off the naming as beer of all manner of other beerlike brews—spiced, herbed, fruited, and otherwise.

The purity law is important to many Germans and a great marketing tool for those who adhere, but a sore point for anyone trying to market beverages that don't fit the formula. The law was repealed by the EU Court of Justice in 1987 as restrictive to free trade. However, the label is still used, and in 1993 the formula was modified to include a few more ingredients. The concept remains a treasured ideal for many Germans.

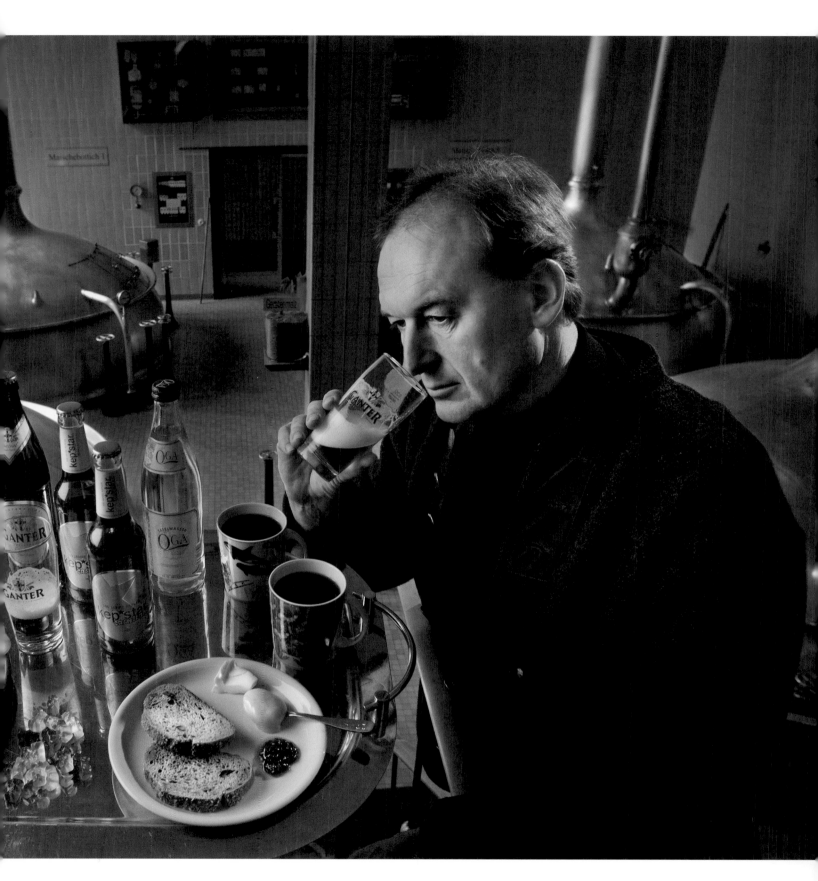

Joachim Rösch, a brewmaster at the Ganter Brewery, with his typical day's worth of food. The brewery's main hall showcases old polished copper vats, but Ganter now also uses stainless steel tanks with computerized controls in a blend of traditional and modern beer making. The brewery also installed new environmental infrastructure: rooftop solar panels and a wastewater treatment plant. Joachim's job requires him to taste beer a number of times during the week, and unlike in wine tasting, he can't just taste then spit it out: "Once you've got the bitter on the back of your tongue, you automatically get the swallow reflex, so down the chute you go," he says. At left: A Ganter beer sign marks the brewery's beer hall in the Muensterplatz, in the center of the old town.

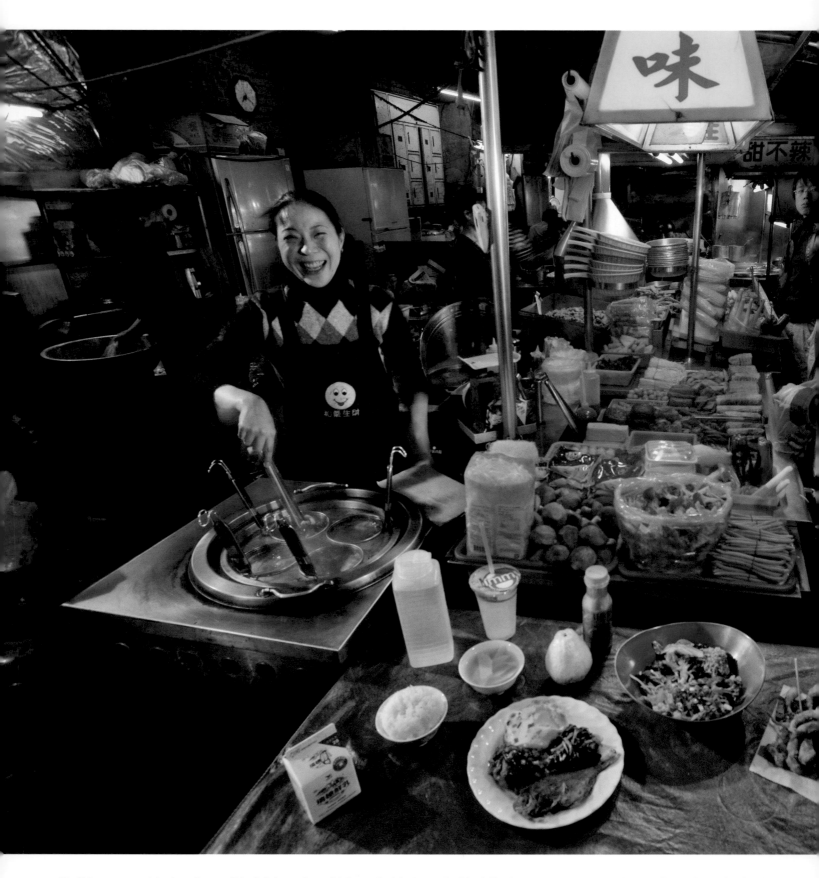

Lin Hui-wen, a street food vendor at a Taipei night market, with her typical day's worth of food. The busy street-corner-spot she occupies at the market is only one mile from Taipei 101, once the world's tallest building. Hui-wen cooks with her husband now, but before they married she cooked with her mother and her younger brother. "We steep the *luwei* broth slowly for three or four hours to blend the flavors," says Hui-wen, "then the food is cooked in the broth." She makes the broth in concentrated form and then brings it to the food stall, where they mix it with water and heat it. "I hire someone to cut up the vegetables," she says. Her kitchen helper is from Vietnam.

WHAT I EAT

Lin Hui-wen
The Street Food Vendor

ONE DAY'S FOOD

IN DECEMBER

LUNCH AT HOME Fried fish, 2.7 oz • Kung pao chicken (marinated chicken, stir-fried with peanuts, red chilies, garlic, and ginger), 3.2 oz • Steamed egg with chives, 3 oz • Boiled spinach, 2.3 oz • White rice, 8 oz • Bamboo shoots in a water broth, 6.7 oz • Guava, 11.7 oz

DINNER AT WORK Luwei (soy sauce broth with medicinal herbs; not in picture), into which the following are dipped to cook: pickled cabbage with green onion, 4.4 oz; *Uni-President Science Noodles* (instant ramen noodles), 3.1 oz; doupi (tofu skin), 2.7 oz; broccoli, 2.6 oz; cabbage, 2.5 oz; shuijing jiao (boiled rice flour dumplings with meat), 1.8 oz; mu'er (gelatinous tree fungus), 1.9 oz; bean sprouts with green onion, 1.4 oz

LATE NIGHT SNACK Fried dougan (dried tofu), 1.1 oz • Yansu ji (salty fried chicken), 1.1 oz • Fried Taiwanese tempura (fried fish paste), 1.1 oz • Fried squid tentacles, 1.1 oz • Fried chicken gizzards, 1.1 oz

THROUGHOUT THE DAY *Uni-President Rui-Sui* whole milk, 9.8 fl oz • Honey tea with lime, 15.2 fl oz • *Bernachon* coffee drink, 9.8 fl oz • Boiled tap water, 1.1 qt

CALORIES: 2,700

Age: 32 • Height: 5'2" • Weight: 121 pounds

TAIPEI CITY • As daylight fades in Taipei City, the big night markets, like Shilin in the north, open in carnival splendor. Part flea market, part food court, part tourist trap, these city-block-size neon markets offer trinkets, electronics, housewares, clothing, and mountains of food to vast crowds of Taiwanese who love to eat on the street. Stinky tofu, oyster omelets, and skewers of roasted intestines are popular snacks. Fatty pork on rice, pan-fried dumplings, and pig's blood soup never go out of style.

New stalls spring up to meet instant demand for trendy foods of the moment, usually foreign, like mini potato-cheese casseroles. Long lines snake through the market to these stalls. Everyone has to have it, until suddenly no one wants it, and then the next new snack appears.

With none of the fanfare or the crowds, street chef Lin Hui-wen and a small group of other vendors cook nightly for a strictly local clientele at the intersection of Xinyi and Da'an in downtown Taipei. Most of the vendors have been on the corner for years, and because permits are no longer issued by the government, those who have one treat it like gold. Each cook has his or her own specialty and a loyal customer base.

Hui-wen, a veteran of 10 years in this spot, cooks seven nights a week with her husband Wu Chang-en, plunging any of 40 different food items into a bubbling bath of Chinese medicinal herbs to boil quickly—a dish called *luwei*. Choices include mushrooms, tofu, peppers, pig's blood cakes, pig's ears, broccoli, green beans, chicken feet, chicken hearts, chicken wings, tree fungus, pheasant eggs, bologna, baby corn, and rice noodles. She boils the strong-tasting brew for hours to develop the flavors. "It's soy sauce, sugar, rice wine, and Chinese herbs," she says, but the herbs she uses, and the exact recipe, are a secret.

She's a new mother, but her daughter has already learned to keep her schedule. "She sleeps when I sleep," says Hui-wen. Neither is awake for breakfast; lunch, cooked by her mother-in-law, is the first and only meal of the day at home. Her mother cares for the baby while Hui-wen and her husband work.

Hui-wen eats her own *luwei* each night or buys a fried snack from one of the other vendors. She says that when she started working, her customers were primarily single office workers and students looking for a quick meal. Now they include mothers who buy her food and serve it at home, along with rice.

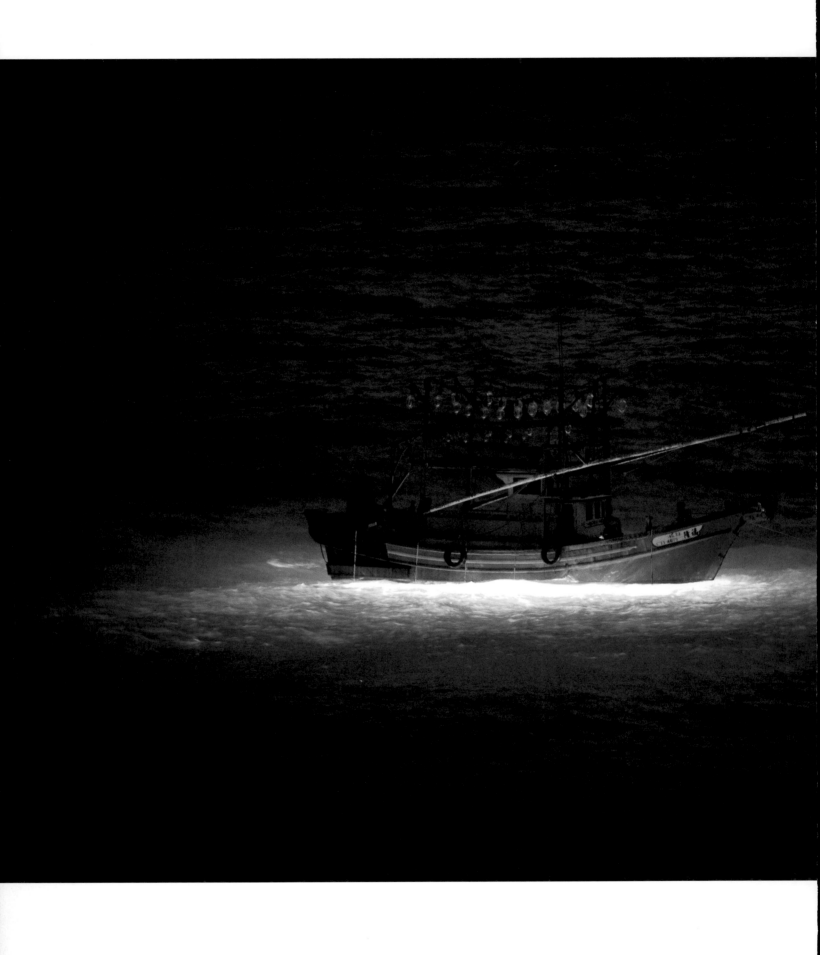

A fishing boat (at left) uses bright lights and nets to catch shrimp at night near the port of Longdong, on Taiwan's northeast coast. Just south of Longdong, the fish market at Daxi harbor has both a wholesale and a retail market. Top right: During an afternoon downpour, sellers help shoppers select crabs, shrimp, squid, and mackerel. Taiwan's 23 million people consume about 82 pounds of fish per person per year—less than the Japanese, but twice the consumption of mainland China. Bottom right: A basket of bigeye snapper on a bed of ice at the Daxi fish market.

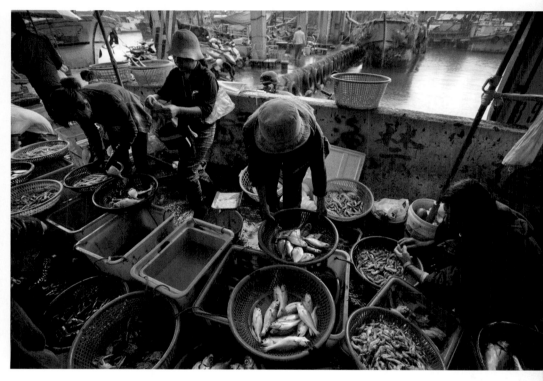

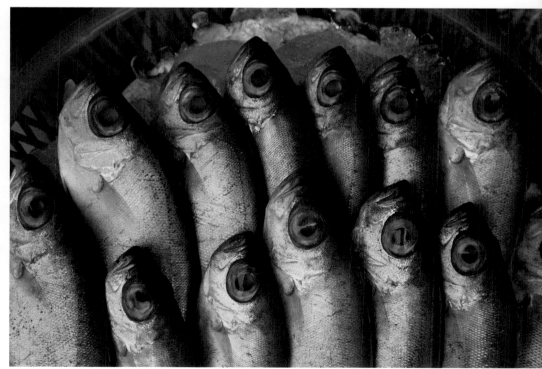

The Longshan Temple in downtown Taipei, although officially Buddhist and dedicated to the Goddess of Mercy, has traces of many other folk religions. The temple was rebuilt after it was damaged by an American air strike and resulting fire during World War II. In this living museum teeming with worshippers, people come to pray and make offerings, including orchids and seemingly any type of food, from fruit, cookies, and buns to boxed juice drinks and bags of sugar. The flowers and food items are left on the altar and surrounding tables, but before leaving, people collect the food they brought and take it home to eat, now imbued with the blessings of whatever gods they pray to. The temple is located in an old section of the city, and the area around the temple is host to a famous night market with fortune-tellers, blind masseurs, foot massage parlors, and hundreds of food stalls serving all manner of traditional Chinese fare, including chicken anuses, pig's feet, and fish bladders.

145

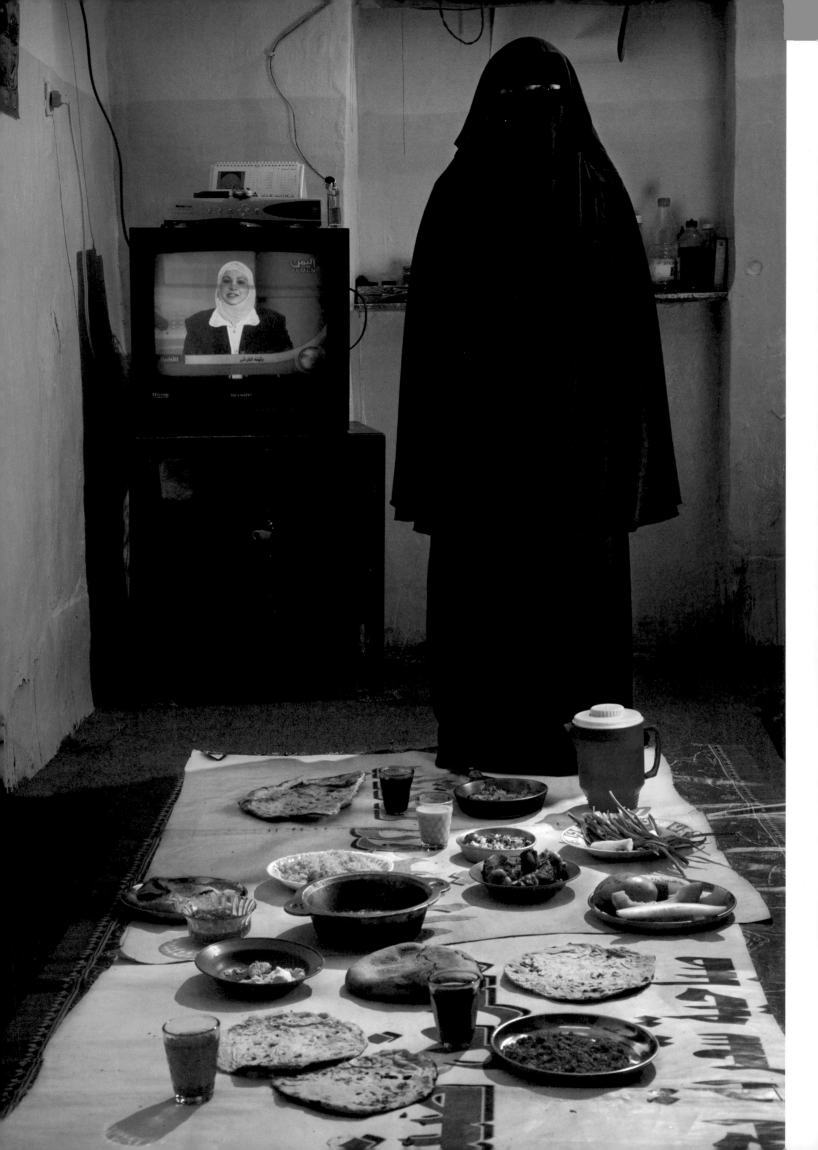

YEMEN

Saada Haidar
The Homemaker

ONE DAY'S FOOD

IN APRIL

EARLY MORNING Qishir (sweet, tealike coffee made from coffee bean husks), 4.1 fl oz

BREAKFAST Ful (fava beans), cooked with onion, tomato, and ground chilies, 5.6 oz • Khubz (wheat flour flat bread), 3.7 oz • Black tea, 3.4 fl oz; with sugar, 1 tsp

MIDMORNING SNACK Khubz, 1.8 oz; with tahini, 0.9 oz; and feta cheese, 0.9 oz

LUNCH Saltah (mutton, eggplant, tomato, and onion stew with hot chilies and hulbah, a foamy fenugreek topping), 8.7 oz • Rice, spiced with cumin and cardamom, 10.6 oz • Fresh tomato relish, 4.4 oz • Lahuuh (a fermented flat bread, similar to a pancake), 3.9 oz • Salad of cucumber, onion, carrot, tomato, cilantro, parsley, and lime juice, 5.8 oz • Green onion, 1.3 oz • White radish, 1.8 oz • Black tea with sweetened concensed milk, 3.2 fl oz

DINNER Scrambled eggs with tomato and onion, 3.8 oz • Maluuj (bread made from millet and wheat flours), 5 oz • Black tea, 3.4 fl oz; with sugar, 1 tsp

SNACKS AND OTHER Mango, 8.7 oz • Banana, 4.1 oz • Cantaloupe, 3 oz • Honeydew, 3.2 oz • Papaya, 4.1 oz • Qafuu'a (bread made from wheat and lentil flours; a full round is pictured, but only one-third is eaten), 4.1 oz • Calf meat on bone,* 9.2 oz • Bottled water, 1.6 qt

CALORIES: 2,700

Age: 27 • Height: 4'11" • Weight: 98 pounds

*Not incluced in calorie total, as she eats this only once a week.

Modern Yemen, born in 1990 with the unification of two colonially bred countries on the southern half of the Arabian peninsula, is the latest incarnation of this land of frankincense and myrrh, a center of civilization for over 3,000 years. The devoutly Islamic Arab population still maintains its tribal traditions, but the customs that have helped the Yemeni people survive throughout the centuries may be responsible, in part, for its rocky modern history. Today, this still largely agrarian country struggles with poverty, a poor record on women's rights, increasing water woes, shrinking oil revenues, secessionist movements, and few resources to fight jihadist members of al-Qaida entrenched there.

SANAA • After much searching and many dead ends in Yemen's capital city of Sanaa, we finally find a husband willing to allow his wife to be interviewed and photographed with her typical day's worth of food. Few women in this patriarchal, Islamic, and deeply traditional country interact with men outside their family. In accordance with tradition, in public they are covered from head to toe in black, for modesty. Even at weddings, the bride and groom are feted at segregated celebrations.

But Fadhil Haidar, 37, the driver for a bank executive and a transplant from a distant rural village where women are less cloistered, has agreed to let us interview his wife, Saada.

The Haidars married when Saada was 17, a marriage arranged by her parents in their rural mountain village, a nard 12-hour drive south of Sanaa. The two are cousins, and such marriages are a common practice in the Arab world, which places a premium on close kinship. In her home village, Saada and her family farmed terraced fields of grain and vegetables

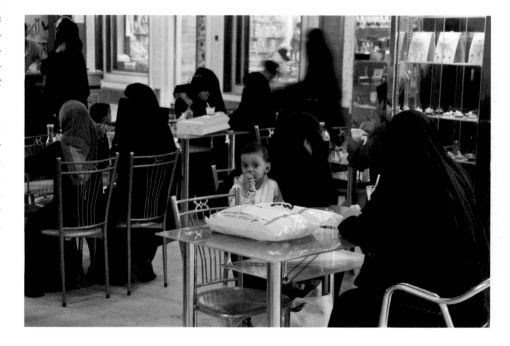

Saada Haidar, at home with her typical day's worth of food. In public she and most Yemeni women cover themselves for modesty, in accordance with tradition. At right: Women shoppers at a juice bar in Sanaa's "new town."

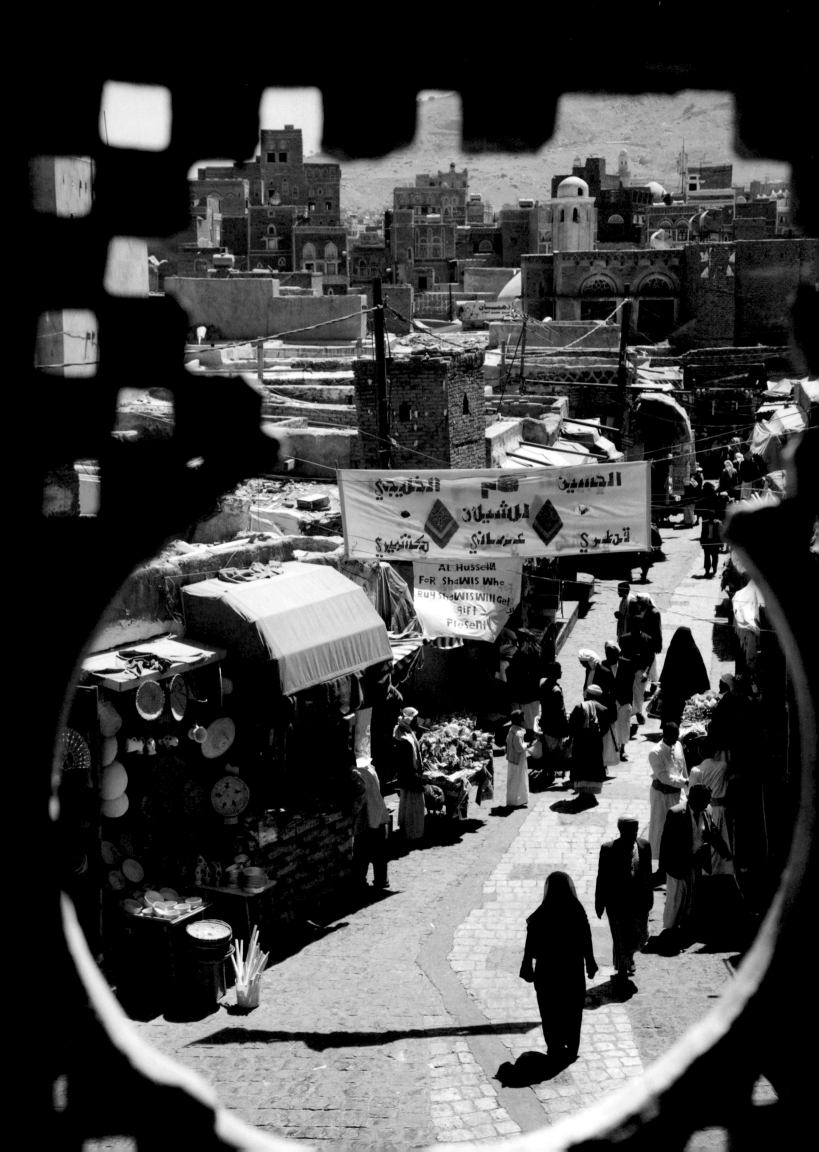

and kept sheep and cows. Like the other girls in her village, she never learned to read or write. Despite efforts to improve education, less than 30 percent of Yemeni women are literate.

The Haidars, who have three young sons, live in a rented flat in Sanaa's "new town," a sprawling suburb of 2 million surrounding the capital city's historic center. They moved to the apartment recently because it was cheaper. As is common in Yemen, 75 to 80 percent of Fadhil's income is spent on food, and a slight rent increase pushed them out of their home. But no matter how tight the food budget, Fadhil buys a bag of qat leaves each week to chew with his friends on the weekend. Women in Sanaa also chew, but Saada does not. When chewed, qat releases an amphetamine-like stimulant.

The Islamic call to prayer rings out across the city from its mosques, then the morning cup of *qishir* begins the day: husks of coffee beans steeped like tea in boiling water and served with sugar, plus cardamom, cinnamon, or ginger. For breakfast and other meals there is equally sweet black tea and *ful*—fava beans soaked overnight and stewed with tomato, onion, and chilies. They eat it with Saada's homemade flat bread. She calls it *khubz*—an Arabic word used for many types of bread. A wide variety of unleavened breads—flat or puffed, plain or seeded—are available throughout the country and a staple food, and she makes several different kinds.

There are snacks of fruits, feta, tahini, and bread, and most nights a light dinner of scrambled eggs and bread, but lunch is their main meal each day. Saada starts *lahuuh*—a fermented pancake-like bread, early. They'll eat it plain or covered in creamy yogurt and cilantro. She starts *saltah* early as well, so the flavor can deepen by the time Fadhil comes home for lunch, as he does every day. It's a thick, fiery vegetable and meat stew topped with a frothy fenugreek foam. Some days she makes it with chicken; today it's mutton. There is also rice spiced with cumin and cardamom, fresh tomato relish, and a chopped vegetable salad with lime juice. How does her day's worth of food differ from meals in her village? She says that grain porridge was the staple fare there, and fresh vegetables in season.

Saada, who has lived in Sanaa for a decade, was happy to move to the city for a better life. Her sister lives here as well, married to another cousin. But apart from their visits with each other, there are few invitations and little opportunity to socialize. In Yemen's traditional culture, those invitations come from family, and they left most of them behind.

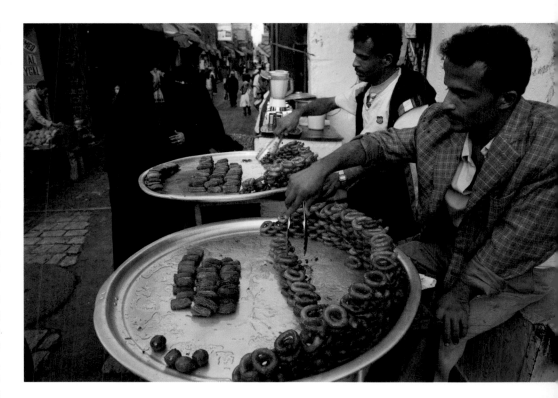

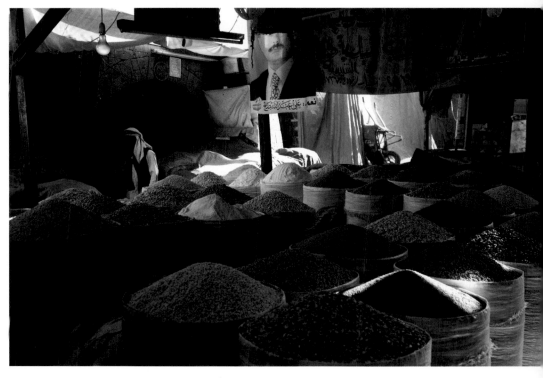

Except for the electric wires overhead and some Chinese goods, the souk in Sanaa's old city (at left) looks much as it has since the city emerged as a trade center in the first century BC. Ornate buildings crafted of stone and brick ring the warren of market shops and stalls that sell shoes, clothing, traditional *jambiyas* (daggers), gold, qat leaves for chewing, foodstuffs, and spices. Top right: Yemeni women tuck fried sweets into their handbags and a small boy buys sweet cactus fruit. Bottom right: A shopkeeper returns to his stall with a steaming glass of sweet tea, passing piles of beans, peas, peanuts, and flours. Although Yemen was once largely self-sufficient, in the past 50 years it has become dependent on foreign food imports, which now amount to 85 percent of the food supply.

Three women dressed in black *abayas* and shielded from the hot desert sun in wide-brimmed straw hats called *nakhls*, and even gloves, tend goats near Shibam, on the edge of the Arabian Peninsula's Rub al Khali, or Empty Quarter. This section of the Arabian Desert holds the world's largest stretch of sand. Further north into Saudi Arabia, this desert contains some of the world's richest oil and gas fields. Though modestly dressed, the women aren't adverse to throwing stones to keep their goats close by—or to keep strangers with cameras away.

USA

Louie Soto
The Carpenter's Assistant

ONE DAY'S FOOD

IN MAY

BREAKFAST Eggs (4), 7.6 oz; fried with butter, 1 tbsp • *Kraft* Cheddar cheese, 1.3 oz • *Corn King* bacon, 1.4 oz (raw weight) • Coffee with *International Delight* coffee creamer, French vanilla, 1.1 qt

LUNCH *Red Baron Singles* french bread pizza, three-meat, 5.5 oz

DINNER Steak, 1.3 lb (raw weight); cooked with vegetable oil, 1 tbsp • Wheat bread, 3.8 oz

THROUGHOUT THE DAY Salt, added to each meal, 1.5 tsp • Saladitos (dried, salted plums; not in picture), 1 oz • *Mountain Dew*, diet (4), 48 fl oz • *Sparkletts* and *Safeway Select* bottled water, 1.5 gal

CALORIES 2,700

Age: 30 • Height: 5'9" • Weight: 320 pounds

For centuries, Native American Pima Indians were a self-sufficient farming people with a talent for irrigation in a harsh desert environment. Louie Soto's Pima ancestors farmed in the Gila and Salt River region of what is now Arizona, but the river died with the diversion of water for non-Native development, and they could no longer grow their own food. There was famine, starvation, and, over time, loss of their cultural moorings. Now their traditional subsistence diet has been replaced by foods laden with processed flour, sugar, and lard.

Modern-day Pimas suffer from drastically high rates of obesity and diabetes compared with the larger U.S. population, and also struggle with alcoholism. However, the Gila River Indian Community is now turning to the tools of the modern world to repair the damage through social programs, using funds from the government, casinos, and resorts, along with a plan to regain some of their lost agricultural muscle after winning water rights.

SACATON, ARIZONA • Louie Soto's story reads like a case history for the problems that have plagued Native Americans since Europeans first arrived in the New World, but a closer look reveals a man resolved to change the course of his own personal history.

"I started drinking when I was 14," says 30-year-old Louie. "My parents were split up, and I would go to my dad's house and he would let me drink there. Back then we used to drink forties of King Cobra."

In his early twenties he graduated to a case of forties: twelve 40-ounce bottles of malt liquor over the course of daylong parties. He tapered off as he got older. "Every time I drank, I messed up my cars," he says. His diet was just as out of control as his drinking, and his weight ballooned to a high of 370 pounds.

One day, in 2007, "I just made up my mind to stop drinking," Louie says. It wasn't only for his two children and his wife, Jourene: "It was for me." He wanted to avoid the downward spiral of alcoholism he watched his father suffer —a long decline his father is still on today.

In one of those strange twists of circumstance, Louie was diagnosed with type 2 diabetes the week after he quit drinking. (Both sides of his family suffer from the disease.) He felt hopeless and started drinking again, but then fatherhood won out: "When I found out I was diabetic, it hit me kind of hard, but I wanted to see my kids grow up and be there for them— not be in the hospital dying or on dialysis."

Before the diagnosis, his normal breakfast was six fried egg sandwiches with sausage and cheese, and his other meals were just as extreme. He'd snack on three candy bars and two bags of chips throughout the day, drink Dr. Pepper, Gatorade, and AriZona tea, and then have more chips as an appetizer before dinner.

After his diagnosis, he learned that weight loss was important to help control his diabetes and took nutrition classes in portion control. He switched to diet soda and sugarless candy, and weight training and walking became a regular part of his day. After one year, he had lost 60 pounds. There are plenty of relapses, but he perseveres. Louie and his family didn't eat many vegetables before; do they now? "We tried to start buying them, but it's kind of more expensive so we switched back to 'regular' foods," says Louie. They still rely heavily on frozen pizzas and easy-to-cook items, but his portions are smaller.

Louie Soto, a carpenter's assistant and tattooist, of Pima, Tohono O'odham, Mohawk, Ottawa, and Mexican heritage, in his old home with his typical day's worth of food while dieting. At right: Louie's children and pitbull at their new home, financed by casino profits and built by the Gila River Indian Community.

2900

MEXICO

José Ángel Galaviz Carrillo
The Rancher

BREAKFAST Eggs, from his chickens (2), 3.5 oz; fried with vegetable shortening, 1 tsp • Homemade corn tortillas, 8.3 oz • Boiled and fried pinto beans, 5.1 oz • Whole milk, fresh from his cows, 9.7 fl oz • *Nescafe* instant coffee, 6.8 fl oz; with whole milk, 1 fl oz; and sugar, 1 tbsp

LUNCH Corn tortillas, 11.3 oz • Queso fresco (fresh white cheese), 4.2 oz • Boiled and fried pinto beans, 4.8 oz • Potatoes, 11.6 oz; cooked with vegetable shortening, 2 tsp • Fresh whole milk, 8.6 fl oz

DINNER Corn tortillas, 7.9 oz • Boiled and fried pinto beans, 4.9 oz • Fresh whole milk, 8.6 fl oz

THROUGHOUT THE DAY Well water, 1.3 qt

CALORIES 2,900

Age: 33 • Height: 5'8" • Weight: 167 pounds

LA DURA, SONORA STATE • José Ángel Galaviz Carrillo and his son Oswaldo are up at first light to milk the eight cows José owns with his brothers in their small village in northern Mexico's Sierra Madre mountains. Oswaldo catches the cows, and José ties their back legs together to keep them from running off as he milks. They don't eat their animals; they sell the calves in emergencies, and to buy what they can't grow—coffee, sugar, and oil.

The call of roosters echoes across the verdant valley, and the wind blows through the thick forests that encircle their farmland. A sister-in-law appears in the distance, winding her way along bucolic paths that pass each of the family's adobe houses, until she arrives with a bucket and takes some of the fresh milk to make white farmer's cheese.

It's an idyllic scene, but only the beginning of a physically demanding day. The family works largely as subsistence farmers, growing what they need to survive. Their houses are simple, with dirt floors and wood-burning kitchen stoves made from steel drums. When they're not farming, they travel by horseback into the forest for days to make charcoal, which they sell for $150 (USD) a ton; it's back-breaking work, and a conservation concern.

Today José will mend fences, weed his crop of corn and beans, and split wood for a cooking fire that burns most of the day. But first, there's breakfast cooked by his wife, Esthela: coffee, fried pinto beans, fresh corn tortillas, and eggs from their chickens.

José and his family are Pima—indigenous people who farmed in northern Mexico and the U.S. desert southwest long before Europeans arrived. While the diet of the Pima in the United States became filled with processed and refined foods as the country developed, the Pima in remote areas of northern Mexico continue to live traditionally, eating a diet high in carbohydrates and low in fat, while also remaining physically active. Studies show that their traditional diet and high level of physical activity have prevented them from succumbing to the chronic diseases that afflict the Pima in the United States.

Development has begun to affect Esthela and José's remote world in ways that they never anticipated when they were young: their village was electrified in December. They sold a calf and bought a refrigerator with the money, but they can't afford to plug it in.

José Ángel Galaviz Carrillo, a rancher, in his adobe brick house with his typical day's worth of food. At left: While José works on a fence with his nephew, José's recently widowed father, Manuel Peyez, 72, approaches to give advice.

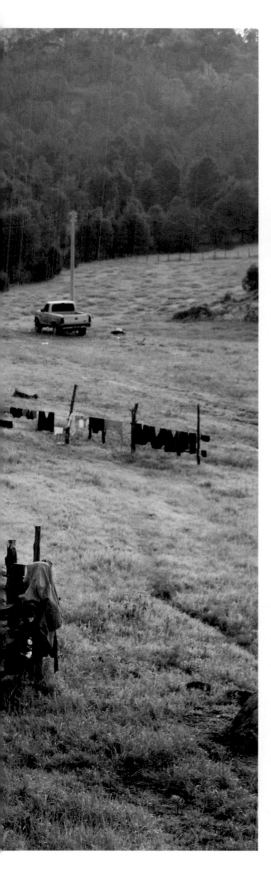

First thing in the morning, José heads out to the corral adjacent to his house to begin milking (at left), a chore that rotates among extended family members. Top right: Esthela makes tortillas by hand, cooking them on top of the wood stove, which also serves as a heat source during chilly Sierra Madre mountain winters. Her two youngest sons wait for breakfast, while her oldest son helps José with the milking. Practically self-sufficient, the family does buy some basic food and supplies, like powdered milk, at Disconsa, one of a network of government-subsidized stores catering to rural communities, in the town of Maycoba, six miles from their home. They grow their own corn and grind it, but Esthela keeps bags of masa flour on her pantry shelf for making tortillas. Bottom right: José and his youngest son, Favien, mop up their breakfast bowls of fried pinto beans with pieces of Esthela's tortillas.

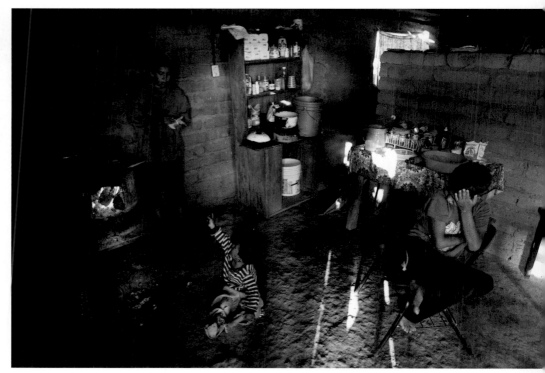

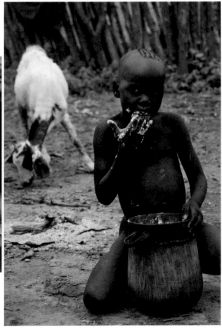
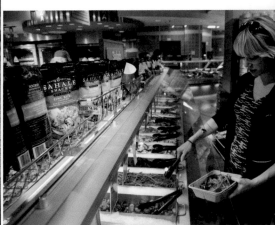

Portion Size Matters

By Lisa R. Young

When asked if I wanted my pizza cut into four or eight slices, I replied, "Four. I don't think I can eat eight."

—Yogi Berra

Fifty years ago food portions were smaller—and so were we. Americans are gaining weight. Lots of it. A key factor in the obesity epidemic in the United States boils down to the simple fact that we eat too much.

While the abundance we enjoy may seem like a good thing, it has its dark side. Thanks to creative marketing, food portions these days are two to five times larger than they were in the past. Bagels and muffins have more than doubled in size.

A bag of popcorn at the movies was once 5 cups; now a large bucket can contain 20 cups. And if you're one of the increasingly rare breed who eats meals at home, take a look around your kitchen. Unless your dishes are decades old, it's likely that your plates, bowls, and glasses are larger than those your parents and grandparents had. Even the tableware in our homes has gotten larger to accommodate the new colossal cuisine.

As consumers, we've grown accustomed to large portions and have come to expect them, a phenomenon known as portion distortion. The terms "small," "medium," and "large" aren't genuinely meaningful anymore, as manufacturers have increased the quantities associated with these sizes. When fast-food chains opened in the 1950s, a 16-ounce soda was deemed "large;" today that same amount is labeled "small." And we're encouraged to buy into this trend because the larger portion is usually a bargain, relatively speaking. For example, 7-Eleven's 20-ounce Gulp usually costs around 6 cents per ounce, while a 64-ounce Double Gulp is only 2.5 cents per ounce. This is beneficial to manufacturers if the food is cheap relative

Lisa R. Young, is the author of The Portion Teller Plan: The No-Diet Reality Guide to Eating, Cheating, and Losing Weight Permanently, *an adjunct professor of nutrition at New York University, and a nutritionist in private practice.*

to other expenses, such as packaging and marketing, which is often the case with poor-quality mass-produced foods. It doesn't cost the manufacturer much more to increase the portion size, and they benefit from an increased volume of sales.

Why are we enticed to buy more, rather than thinking about how much we really want or need? No one is making us buy bigger sizes, but many of us are so interested in "value" or getting a "good deal" that we often choose restaurants or products solely on that basis. In the popular Zagat restaurant guides, many of the entries focus on portion size and bargains instead of the taste of the food. We think bigger is better and want heaping platters and Godzilla-size burgers.

As portion sizes have gotten bigger, so have our waistlines. While a number of factors, including biological, genetic, and psychological, influence susceptibility to obesity, they don't fully account for our expanding girth. Our genes haven't changed much, and neither has our tendency to exercise (or not). What has changed is how much—and therefore how many calories—we eat.

The U.S. food supply currently produces about 4,000 calories per person per day—twice as many calories as most of us need. Although some of that food is wasted, it is clearly far too much food. But this doesn't stop the major food producers from their endless quest

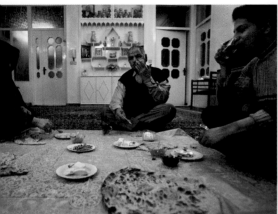
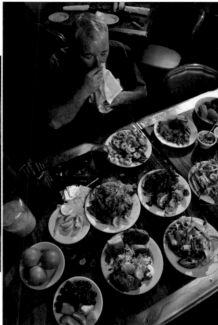
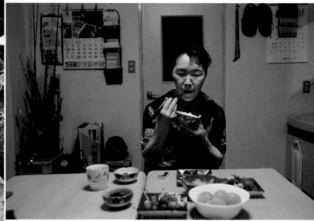

Left to right: Siblings devour monster-sized *pan dulces* in San Antonio, Texas. A Himba boy finishes cornmeal porridge in Okapembambu village, Namibia. Mariel Booth, an NYU student and model, gathers greens at a Whole Foods Market in New York City. A family eats breakfast at home in Yazd, Iran. Competitive eater "Collard Green" Hughes at an all-you-can-eat seafood buffet in Newport News, Virginia. A plastic food artist eats lunch at home during a work break in Tokyo, Japan.

to find seductive new ways to get us to eat more of their products. The Burger King signature hamburger sandwich, the Whopper, started out with only a single quarter-pound beef patty and contained 670 calories. Over the years, the Whopper has morphed into a variety of burgers, and today you can order a Triple Whopper with cheese, laden with 1,250 calories. How can something that accounts for over half of the average person's daily calorie needs possibly be marketed as a single portion? Unfortunately, most of us don't stop to consider that. We eat more when presented with more food, without giving much thought to portion size or how many calories we're consuming.

At some point in the vicious cycle of overeating and gaining weight, many of us turn to diets. As a nutritionist specializing in obesity, I feel like I've heard about nearly every diet out there—the Atkins diet, the Beverly Hills diet, the Zone diet, the South Beach diet, the cabbage soup diet, the grapefruit diet, the ice cream diet, Jenny Craig, Nutrisystem, and even the Subway diet. Despite the seemingly endless array of diets out there, the truth is, they generally don't work in the long term. My clients' diet sagas tend to echo with one recurring theme: losing weight just to gain it back again—and then some. Any diet that restricts calories can work in the short term, but if you don't learn how to eat healthfully, it's unlikely to work for the long haul.

Permanent weight loss can only be achieved through good eating habits that include an awareness of realistic, healthful portion sizes while also satisfying the appetite and the body's nutritional needs. Dietary guidelines and food labels can be good sources of information; however, typical portions greatly exceed standard serving sizes, often leading to consumer confusion. For example, a typical restaurant portion of pasta can equal or exceed the recommended intake of grains for an entire day. Even worse, one restaurant steak may contain several days worth of meat. Furthermore, many single-serving packages, marketed for one person to consume, actually

contain 2 to 3 servings. But if you buy a 20-ounce soda that contains 2.5 servings, it isn't likely that you'll share it with 1.5 other people.

Although awareness of how much you eat is the cornerstone of a successful weight-loss plan, we Americans simply aren't good at judging the number of calories in the foods we consume. Studies show that people tend to greatly underestimate their caloric intake. Keeping a food diary is the best way to be truly aware of what and how much you eat, and your eating style. A food diary will encourage you to eat mindfully and reinforce your commitment to eating more healthful foods, and to consuming less overall. For a food diary to be effective, you must be honest and accurate in recording what and how much you eat. As you gain insight into eating habits that aren't working for you, you can begin to work on making more informed choices and developing new, more healthful habits. This is the only true path to permanent weight loss.

In addition to keeping an honest and accurate food diary and developing a better awareness of realistic portion sizes, focus on eating fewer processed foods. By now, we all know that fruits, vegetables, and whole grains are more healthful choices. And because they are naturally packed with more nutrients and fiber, they're also more filling and satisfying. It's certainly a lot easier to guzzle down an 800-calorie Double Gulp soda than to eat 800 calories worth of fruits and vegetables. You might also take the time to slow down and enjoy your food more fully—eating more mindfully or sharing more meals with friends or loved ones.

Experiment and find which techniques work best for you. Whatever path you take to achieving a healthier weight, know that these steps also have a profound impact on your long-term health and well-being. Then multiply those benefits by a few million. The epidemic of obesity is alarming, and immensely costly. And it can only be turned around one person—indeed, one bite—at a time.

3000

INDIA

Shashi Chandra Kanth
The Call Center Operator

ONE DAY'S FOOD

IN DECEMBER

BREAKFAST Eggs (2), 3.5 oz; scrambled with onion, tomato, green chilies, and cilantro, 2.5 oz • Chapati (whole wheat flat bread), 3 oz • Whole milk, 5.5 fl oz • *British Biologicals Nutraceutical B-Protin* powder, 1.5 tbsp; mixed with whole milk, 5.5 fl oz

LUNCH Sambar (spicy curry of lentils cooked with carrot, onion, potato, and ground toasted spices including dried red chilies, coriander seeds, and black peppercorns), 5.8 oz • Chicken kebab, 3 oz • White rice, 5.9 oz

DINNER DURING WORK *Beijing Bites* chow mein combo meal, 7 oz

SNACKS AND BEVERAGES AT WORK *Five Star* chocolate bars (3), 3.4 oz • *Tropicana Twister Orange Thrill* fruit drink, 11.8 fl oz • *Tropicana Twister Apple Rush* fruit drink, 11.8 fl oz • *Kurkure* tomato chips, 1.8 oz • *Parle Melody* chocolate caramel pieces (3), 1.2 oz • Coffee (4), 12 fl oz; with nondairy powdered creamer, 1 tsp • *Orbit* sugar-free gum, peppermint, 6 pieces

SNACKS AND OTHER Orange, 5.8 oz • Cigarettes (6) • Filtered tap water, 1.6 qt

CALORIES 2,900

Age: 23 • Height: 5'7" • Weight: 123 pounds

BANGALORE, KARNATAKA • "There is no 'normal.' Every day is different—upside-down. Night is morning, morning is night," says Shashi Chandra Kanth. When America is awake, Shashi and his call center colleagues are as well, on the other side of the world in a high-tech office park in Bangalore, India, handling service calls from AOL customers. He dons a headset, queues up his first call, and becomes urbane and solicitous customer care consultant "Mark," helping AOL members with service issues and registration. "I can solve 99 percent of the problems that come to me," he says, "unless a member is really irate. Sometimes it takes a long time to reach a live person. I do understand that; time is very precious."

He works for Aegis, a large customer care company, and he likes talking to Americans. He's never been to the United States. "I don't know how people in the U.S. are, really," he says. "But some people who call are so touching. They keep on talking to you for one hour, two hours; they open their heart. They tell everything—about their kids, about what they're doing—everything! And the best thing is, they let you talk also."

Shashi clanks when he walks—the sound

of incentive pins and company spirit badges dangling from his belt. "Other people have these too," he says, laughing, "but they don't wear them like this—only me and my friend Kuldeep." Shashi is the cool kid in the room and, with over two years on the job, a senior consultant in an industry with high turnover. "This was only going to be for three months," he says of his tenure here, "for pocket money."

His life plans were upended when he was severely injured as a student in a mechanical engineering class in 2005—his shirttail caught in a machine and his face was mangled. "I cried when I looked in the mirror," he says. There were many reconstructive surgeries, and a job offer, but he didn't take it: "I was scared of machines."

Shashi works a nine-hour night shift at the call center and eats dinner with crowds of other young night workers at Beijing Bites or KFC on the ground floor of his office high-rise. "My mother wants me to bring a proper [Indian] lunch from home," he says, but he resists, preferring fast food with his friends. When he moved to Bangalore to go to school, his mother moved with him: "At home, it's a completely different lifestyle," says Shashi.

He eats chocolates to stay awake in the

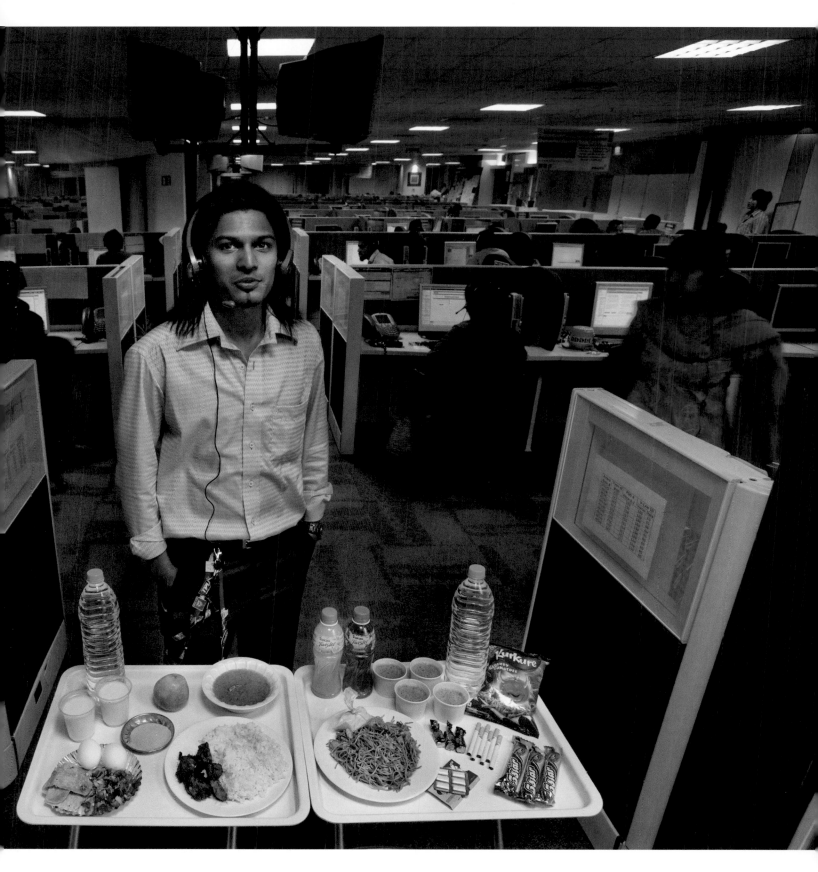

Shashi Chandra Kanth, a call center operator, in the AOL call center with his typical day's worth of food. Like many of the thousands of call center workers in India, he relies on fast-food meals, candy bars, and coffee to sustain him through the long nights spent talking to Westerners about various technical questions and billing problems. He took a temporary detour into the call center world to pay medical and school bills but finds himself still there after two years, not knowing when or if he will return to his professional studies.

Before he goes to his overnight job, Shashi parks his motor scooter (top left) on the sidewalk outside the apartment he shares with his mother. Bottom left: Before going to work, Shashi eats a late lunch while watching MTV. He loves his mother's traditional southern Indian food at home, but when he's at work his dinner options are KFC and Beijing Bites, the fast-food restaurants on the ground floor of the high-rise where he works, located on the edge of Bangalore. At right: A Hindu priest pours an offering of ghee onto a fire at the Shiva Temple on Old Airport Road. A 65-foot plaster statue of Lord Shiva in the lotus position sits before an amusement park-style Himalayan mountain-scape built of chicken wire and cement. This free popular attraction at the Kids Kemp shopping mall draws nearly 500,000 devotees on festival days.

waning hours of his shift, and after work faces a one-hour commute home, but a company-provided car service does the driving; the evening return trip takes two traffic-choked hours.

At home Shashi's mother, Sumithra Chandra, cooks the traditional fare of their south Indian hometown Mangalore, on India's western coast—spicy and sweet, and often coconut flavored. Most days there is a labor-intensive *sambar*—a fiery *toor dal* (yellow lentil) and vegetable stew, its flavor deepened with two rounds of hot chili peppers and spices sizzled in hot oil—which she serves with rice and chapatis. "I don't know exactly how she does it," says Shashi. "Seriously, I just eat it."

Mother and son are Hindu but not vegetarians, although his mother doesn't eat meat two days a week to honor Hindu deities. "On Monday it's for Shiva; on Fridays it's for Durga," he says. "But I eat meat every day."

When Shashi arrives home at 8 a.m., breakfast is waiting: *idli*—fermented dal cakes—with chutney and vegetable curry; or spicy eggs and chapatis. Then Shashi sleeps through the day. At 4 p.m. it's lunchtime, then, at 5:30, another long commute back to work. There's little time for anything but work and sleep, and a one- or two-day weekend. When does he see his friends? "I get U.S. holidays off," he says. "My mother doesn't know." On those days he stays with Kuldeep.

Lunch today is *sambar* with chicken kebabs and rice. Shashi flips through English-speaking channels and MTV as he eats. "He doesn't eat without the TV," Sumithra says. He laughs and responds, "She says that every day."

Some days his mother makes dessert, and she does today, because we're visiting. She makes halva, a confection found throughout the world in various forms. In India it's usually vegetable-based and very sweet. Today she makes it with carrot—grated, boiled, and caramelized—cooked with sugar and ghee. She heats ghee in a saucepan, adds the carrots, and cooks them into a paste, picking out bits with her fingers as it cooks to test doneness, but never tasting. She adds hot milk and coarse white sugar to the mixture, which bubbles and browns, then folds in ground cardamom, crushed cashews and pistachios, raisins, and cracked wheat. "I don't really know any of this," says Shashi. "I never go in the kitchen. If I go in there, it's going to be a big mess—big time. It's better to stay away." What's going to happen when his mother leaves for a month to visit his sister in Kuwait? "A lot of fast food and eating out," he says. "Don't tell my mother."

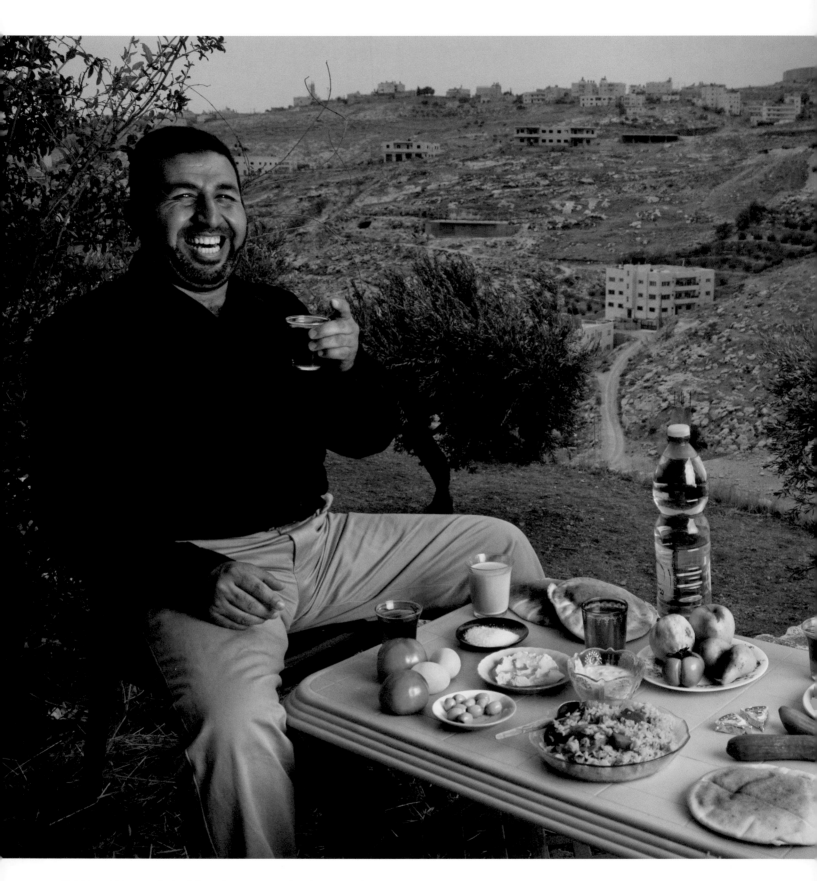

Abdul-Baset Razem, a Palestinian guide and driver, in a family member's backyard olive orchard with his typical day's worth of food. On the hilltop in the distance, Israel's 25-foot-high concrete security barrier cuts off this Abu Dis neighborhood from Jerusalem, turning a short trip into the city into an extremely long and circuitous journey requiring passage through an Israeli checkpoint on the highway. Constructed by the Israeli government to cut down on attacks and suicide bombings, the highly controversial 436-mile-long barrier was 60 percent complete at the time of this photo. For the majority of Palestinians, travel to and from East Jerusalem now requires special permits from the Israeli government—often difficult or impossible to obtain.

3000

Abdul-Baset Razem
The Palestinian Driver

ONE DAY'S FOOD

IN OCTOBER

BREAKFAST Eggs (2), 4.8 oz; scrambled with tomato, 4.6 oz • Pita bread, 8.5 oz • Labneh (soft cheese made from yogurt), 2.7 oz; with olive oil, 1 tsp • Tomato, 4.6 oz • Olives, 1 oz • Whole milk, 5.4 fl oz • Black tea, 3.5 fl oz; with sugar, 2 tsp

LUNCH Makloubeh (upside-down casserole), made with chicken, rice, and carrots, 14.6 oz; seasoned with cinnamon, black pepper, and allspice, 0.5 tsp; and cooked with olive oil, 2 tsp • Pita bread, 3.9 oz • Cauliflower (not in picture), 1.6 oz • Cucumber, 6.1 oz • Yogurt, 4.2 oz • Black tea, 3.5 fl oz; with sugar, 2 tsp

DINNER Savory beef pies (2), 4.1 oz • Black tea, 3.5 fl oz; with sugar, 2 tsp

SNACKS AND OTHER Apple, 5.4 oz • Pears (2), 5 oz • Guava, 6.6 oz • Persimmon, 3.6 oz • *Laughing Cow* cheese, 1.1 oz • Sous (juice drink made from licorice root; not in picture), 3.5 fl oz • Black tea, 3.5 fl oz; with sugar, 2 tsp • Bottled water, 1.6 qt

CALORIES 3,000

Age: 40 • Height: 5'6" • Weight: 204 pounds

WEST BANK AND EAST JERUSALEM • Abdul-Baset Razem, his wife, Munira, and their five children are visiting family in the West Bank city of Abu Dis, once a quick drive from their East Jerusalem home. Now, though, they face Israel's security wall and a checkpoint—one of many well known to the Palestinian, who ferries foreign news crews throughout the region.

This hillside family compound, where they picked and brined olives a week ago, faces the security wall, which they call "the snake." Politics comes up more than once during the time we spend together because it's truly inescapable, but today we move it to the back burner and concentrate on Abdul's day's worth of food.

As Muslims, Abdul and his family observe Islamic dietary law—animals that are *halal* (permitted) are slaughtered humanely. Pigs are *haram* (prohibited). Alcohol is also *haram*. Munira's *makloubeh*, a cinnamon-spiced rice and chicken dish cooked and then flipped over, is definitely not *haram*, and it's Abdul's favorite. "Ninety percent of the time there's rice for lunch," Abdul says. If he's working and doesn't come home for lunch, or if Munira is in a class at university, there are sandwiches or pizza out.

Abdul's niece and daughter carry in plates of guavas and persimmons and serve glasses of hot, sweet coffee as we discuss his list of food.

"Yesterday my brother and I put the chess board here," he says, pointing at a long, low table, "and they gave us a bowl full of fruits, and we sat and played and ate the fruit—maybe seven pieces, I ate!" he exclaims, thinking back. "Just eating it like that!"

"If you sit with me in my house for two or three hours and I give you sweet coffee, it means you are welcome," he says. "And before you leave you'll take another cup, and it means I'll see you again soon."

POSTSCRIPT • *While our food portraits are each a snapshot in time, we check facts throughout the editorial process. Abdul stopped answering us last summer, and it took months to learn that he was in Shata Prison in Israel. According to a court document read by a translator, Abdul was arrested because of membership in organizations judged to be illegal by Israeli authorities—receiving salaries and payments from them, and having a role in their activities. A colleague of Abdul's says, "A year ago, Abdul bought a camera and began documenting families in East Jerusalem whose homes had been destroyed by the Israeli government. Peaceful events, as far as I know.... He's been scheduled to appear in court, but his case keeps getting delayed."*

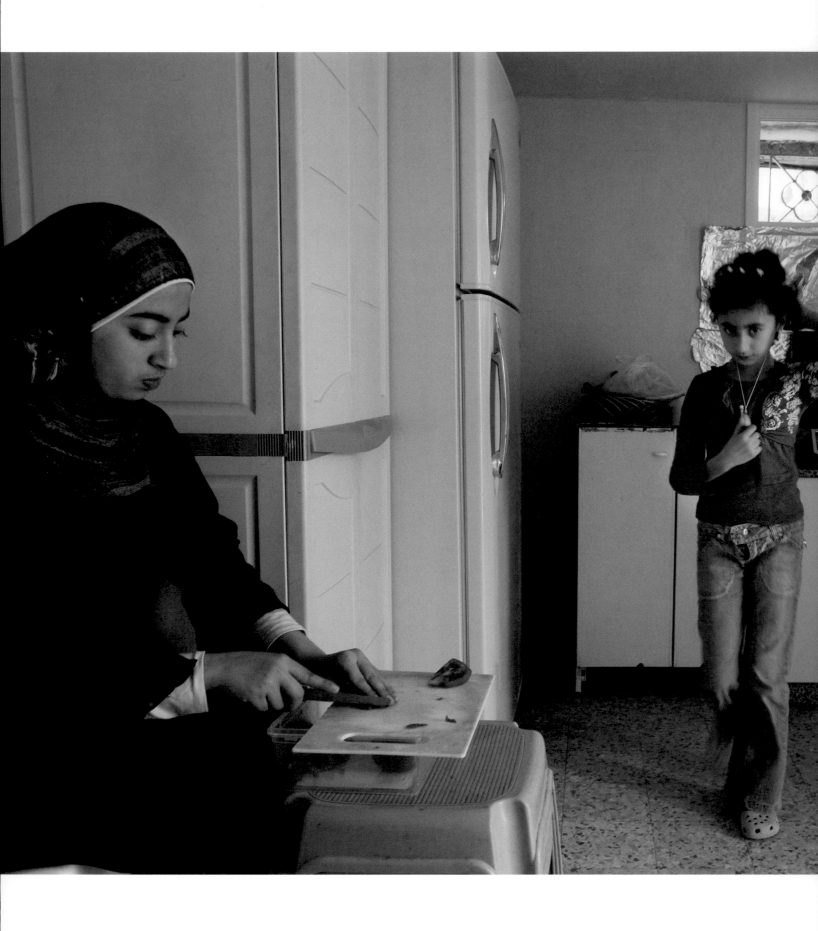

At dawn on a foggy morning, two visitors look out over the cemetery on the Mount of Olives (top right) toward the gold-leafed Dome of the Rock, the most famous Islamic monument in the Old City of Jerusalem. At left: Abdul-Baset Razem's wife, Munira, tends to the *makloubeh* at the stove, while his daughter Mariam, 14, chops tomatoes. His 8-year-old daughter, Maram, saunters through, escaping kitchen duties before the big weekend midday meal. Bottom right: A colorful selection of local dishes in a Palestinian restaurant in Abu Dis, just outside the barrier near East Jerusalem, includes hummus, olives, chiles, beets, cabbage slaw, and baba ganoush.

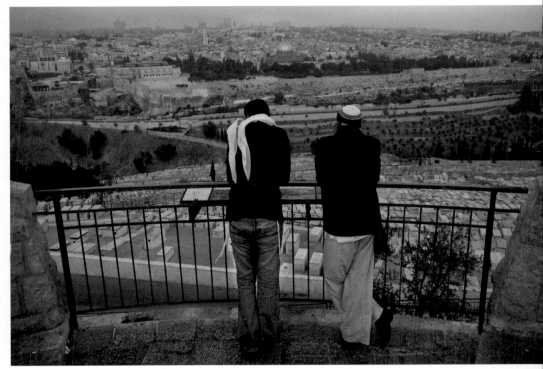

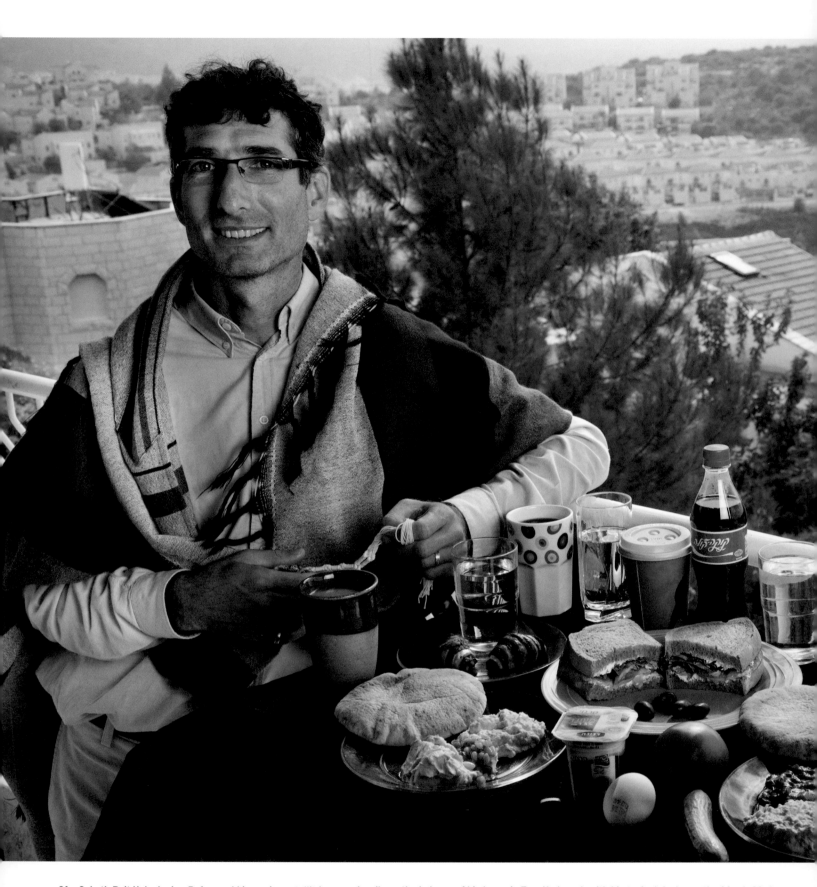

Ofer Sabath Beit-Halachmi, a Reform rabbi wearing a *tallit* (prayer shawl), on the balcony of his home in Tzur Hadassah with his typical day's worth of food. Ofer's town in the Judean Hills about 15 minutes southwest of Jerusalem is a communal settlement where residents lease land and houses from the state of Israel for a 99-year period. On Friday evenings Ofer leads the Shabbat service in a small portable building that is kindergarten by day and synagogue at night and on weekends. At right: Congregants gather in Ofer and Rachel's home for a meal that begins with the recitation of the *kiddush*, the prayer over wine. Challah, a bread with great religious and cultural significance and part of every Shabbat meal, is covered in the center of the table.

ISRAEL

Ofer Sabath Beit-Halachmi
The Rabbi

ONE DAY'S FOOD
IN OCTOBER

BREAKFAST Rugelach (pastry), chocolate (2), 3.3 oz • *Nescafe* instant coffee, 12 fl oz; with whole milk, 1 tbsp • Filtered water, 9.1 fl oz • Coffee (at work; not in picture), 8 fl oz

LUNCH Salmon sandwich: *Café Hillel* low-calorie bread, whole wheat, 5.4 oz; lox, 1.8 oz; tomato, 1.8 oz; lettuce, 0.2 oz; low-fat cream cheese, 1 tbsp • Kalamata olives, 0.7 oz • Coffee, 10.9 fl oz

MIDAFTERNOON SNACKS Pita bread, 2 oz • Hummus with pine nuts, 4.2 oz • Eggplant with mayonnaise, 3 oz • *Coca-Cola*, 16.9 fl oz • Coffee, 12 fl oz

DINNER Rigatoni pasta, 2.4 oz; with organic ketchup, 1.3 oz • Pita bread, 2 oz • Turkish tomato spread, 1.6 oz • *Dannon* yogurt, plain, 7.1 oz • Hard-boiled egg, 2.4 oz • Cottage cheese, 3.9 oz • Cucumber, 2.4 oz • Tomato, 6.9 oz • Filtered water 18 fl oz

SNACKS AND OTHER Ice cream, vanilla with caramel, 3.9 oz • Homemade cookies, 1.2 oz • Red wine, 7.2 fl oz • Multivitamin • Filtered water, 18 fl oz

CALORIES 3,100

Age: 43 • Height: 6'1" • Weight: 165 pounds

TZUR HADASSAH • "There are options," says Ofer Sabath Beit-Halachmi as we discuss the Jewish Reform rabbi's day's worth of food at his home outside Jerusalem. He means menu options, because what he eats depends upon whether he's working from home, has his daughter in tow, is out with his wife, Rachel, who is also a rabbi, or in Jerusalem for meetings. There are options, but there are also rules: *kashrut*—ancient Jewish dietary laws that detail which foods can and cannot be consumed, and how those foods must be prepared and eaten.

Among those allowed are animals with cloven hooves that chew their cud, certain poultry, and fish with fins and scales. All must be ritually slaughtered, and there can be no mixing of milk and meat in the same meal.

Rachel is a vegetarian, Ofer is not. Outside their home he eats fish and chicken, but they purposefully keep a vegetarian household to accommodate even the most observant Jew. "This makes it easier to host people from other denominations of Judaism," Ofer says. "An Orthodox person can eat at this table without any hesitation." Most Friday nights their home is filled with guests for Shabbat dinner.

The couple's lives and their scholarship are influenced by the concept of *eco-kashrut*, a term coined in the 1970s that draws more than the dietary laws into the equation. "I'm learning much of this from my wife," says Ofer. "She's very wise." *Eco-kashrut* is about ethical and sustainable agriculture and animal husbandry, but it also examines traditional dietary laws through the prism of humankind's heavy footprint on the earth, to lessen that impact both for the good of the earth and for spiritual well-being. Ofer is learning from his daughter, Tehillah, age 4, as well. These days the meal options he spoke of earlier are often defined by her tastes: much more pasta—one of her favorite foods—with organic ketchup.

3100

KENYA

Kibet Serem
The Tea Plantation Farmer

ONE DAY'S FOOD

IN FEBRUARY

BREAKFAST *United Millers Limited* white bread, 2.9 oz • *Ketepa* black tea with fresh whole milk from his cows, 8.8 fl oz; and sugar, 2 tsp

MIDMORNING SNACK Uji (thin fermented millet and cornmeal porridge drink) with sugar, 13.5 oz

LUNCH White rice, 8.4 oz • Pinto beans cooked with tomato, 9.5 oz • Yogurt, made at home by his mom from fresh whole milk, 10.6 oz

DINNER Ugali (thick cornmeal porridge) 2.5 lbs • Fresh whole milk, 9.3 fl oz • *Janis* candies (2), 0.3 oz

THROUGHOUT THE DAY *Ketepa* black tea with whole milk (2), 17.6 fl oz; and sugar, 1 tbsp • Tap water, 25 fl oz

CALORIES 3,100

Age: 25 • Height: 5'11" • Weight: 143 pounds

KIONGO, KERICHO • Lush green tea plants stretch like carpet over the Kenyan highlands west of Africa's Great Rift Valley. Workers with large sacks pick their way through this landscape plucking only the tenderest leaves at the tips for big tea companies like James Finlay and Unilever Tea Kenya. In a few weeks, the pickers will cover the same ground once again, plucking any new growth.

The country's smaller tea plantations, sometimes only an acre or two, account for 60 percent of the tea produced in Kenya. Farmers pick the tea leaves themselves or hire a worker or two to help finish the task before the young leaves mature past usefulness, and many sell through the quasigovernmental Kenya Tea Development Agency.

In the Kericho district, 25-year-old Kibet Serem manages a three-acre plot of tea on his parents' small farm, working alongside pickers he hires when the leaves are ready for harvest. They pick two or three times a month, harvesting 13,000 to 15,000 pounds of tea leaves annually, according to Kibet, who also cares for the family's cornfield and five cows. In drought-stricken Kenya, water has become a big issue in recent years, even in the highlands, a historically wet area. This affects the tea plants, the cows, the corn—and Kibet's bottom line.

Ethnically, Kibet's family is Kipsigis (Kalenjin) a traditionally pastoralist group that didn't farm much until being pushed off their grazing land by politics and development. His father, John, spent his youth tending cattle, but as an adult worked for a large tea company. He planted the family's tea when Kibet was young, and the boy grew up weeding and picking with his brothers and sisters. After high school he began to work full-time on the family farm. "I would have liked to go to university," he says, "but the funds weren't there."

The business-minded young man developed a plan with his father to buy neighbors' tea to sell in bulk. It worked well until the company he sold to canceled the contract, saying it wanted to deal directly with small holders. He's applied to Unilever Kenya for a similar contract but hasn't heard back.

We join Kibet and his father for a breakfast of sweet tea prepared with milk from the morning milking, sliced white supermarket bread, and a tangy, traditional sour milk beverage called *mursik*, made by his mother, Nancy, some days. She's still in the kitchen house, cooking milk over a fire to make yogurt.

Most days Kibet sells the family's milk to a nearby school. Other days he sells it to his mother for the yogurt, which she sells to their neighbors. "Do you have to buy it from her when you want some?" we ask cheekily. "No, she just gives me some," he says, laughing.

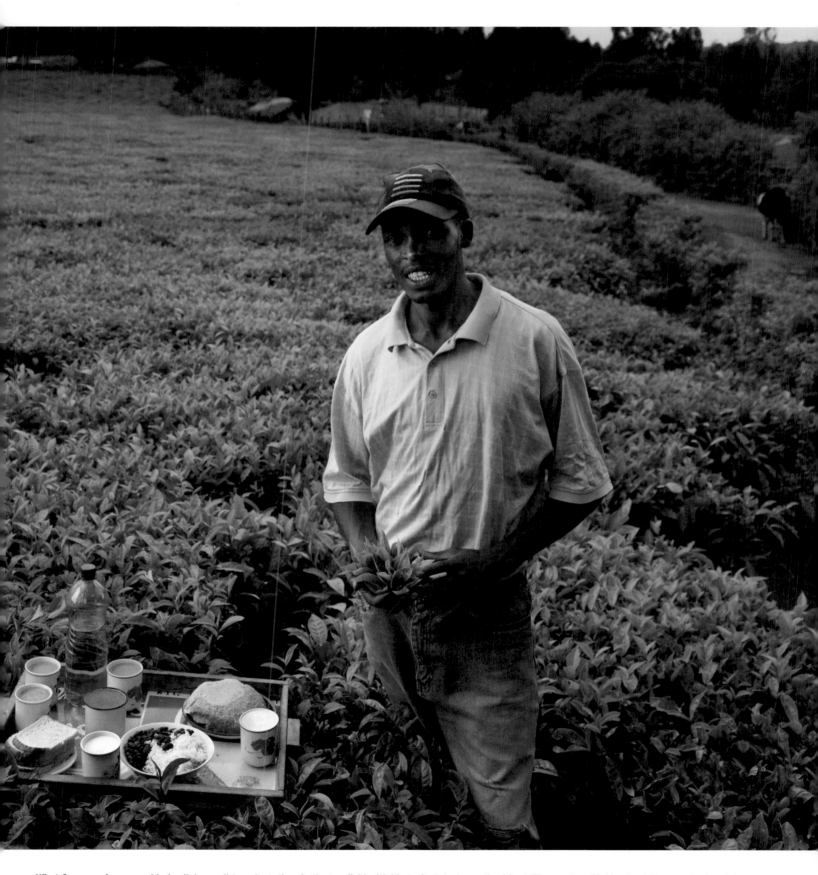

Kibet Serem, a farmer on his family's small tea plantation, in the tea field with his typical day's worth of food. The western highlands of Kenya collect moisture that evaporates from Lake Victoria, usually providing ample rain for the evergreen tea bushes that drive the local economy of the Kericho district and the country's exports. Kibet's family's three-acre plot produces between 13,000 and 15,000 pounds of tea a year, picked every two weeks or so throughout the year. The remainder of their farm is devoted to raising corn and five cows for milk.

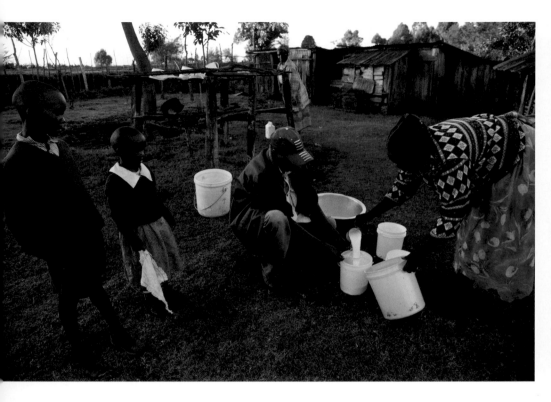

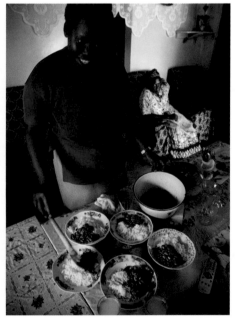

Kibet and his sister-in-law Emily strain the milk from the family's five cows (top left). An hour later, his mother, Nancy chats with Emily (at right) while the milk heats over a fire in their detached kitchen house. At lunch in the main house (bottom left), Emily dishes up pinto beans and rice as Nancy watches a Kipsigis music video. When Emily first moved to the village as Kibet's brother's wife, she had never cooked over an open fire. Nancy had to buy her a special pot so she wouldn't burn the *ugali* (cornmeal porridge).

Kibet lives with his parents, unmarried brother, and sister, as well as a ranch hand in the small house where he was born. He says that when he marries in a couple of years, he'll build a house next door.

While we work our way through Kibet's heavily grain-based diet to determine a day's worth of food for his photograph, his father, who's retired, spends most of the time staring up the hill at his other children's houses and grumbling that their lights are on during the daytime. "I should turn the lights out on them," he says. Kibet laughs.

Only the six who live in the main house live off the proceeds of the farm, although they share the milk with a sister-in-law, Emily, who helps with the milking. Kibet grows the corn, and the family has it ground into meal locally. It's used for *ugali*, the stiff, white porridge eaten by Kenyans throughout the country. When their own grain supply runs out, they buy dry corn. They also purchase rice and pinto beans to round out the family diet and typically eat meat only once or twice a week—goat or chicken, mixed with vegetables from the garden.

Kibet's midmorning snack is a mix of his Kipsigis culture and the modern world: He doses *uji*, a thin grain drink, with sugar—something his parents would never think of doing.

Do they drink any of their own tea? "The tea we pick is taken first to the factory and it's processed. Then we go to the shop and buy it," Kibet says, to general laughter.

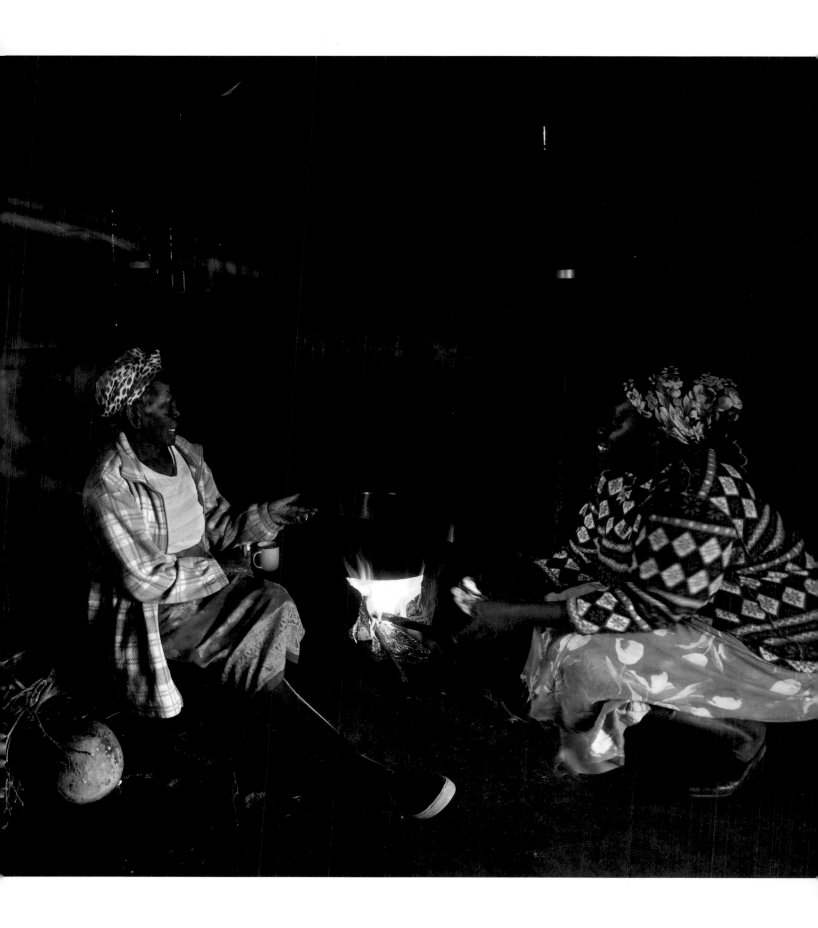

The Kericho district in the Great Rift Valley has rich volcanic soil, cool air, and a moist tropical climate that's perfect for growing tea. With its popular tea brand Lipton, Unilever has helped make Kenya the number one exporter of black tea in the world. On the company's vast holdings in the Kericho district, workers live in company housing amidst the lush, rolling tea fields. Since the evergreen tea bushes are picked every 14 to 17 days year-round, there is constant work for pickers. They're paid by the kilo of tea leaves and a field foreman reported that they can earn between $3 and $9 (USD) per day. To compete with Unilever and James Finlay, another huge corporate tea producer in Kenya, the Kenya Tea Development Agency represents half a million small-scale tea growers throughout Kenya.

3100

LATVIA

Aivars Radziņš
The Beekeeper

ONE DAY'S FOOD

IN OCTOBER

BREAKFAST Sour rye bread, 2.8 oz • Honey, 1 tbsp • Butter, 2 tsp • Hard-boiled egg, 2.3 oz • Homemade pork meatballs, 2.5 oz • Ham, 0.8 oz • *Lavazza* coffee, 11.2 fl oz

LUNCH Meatball and rice soup with sour cream and dill, 9 oz • Breaded pork cutlet, 6.9 oz • Boiled potato with sour cream sauce, 6.8 oz • Salad of lettuce, tomato, and onion with vinegar, 1.8 oz • Salad of carrots and cabbage with vinegar, 1.8 oz • *Lauku* kvass (fermented drink made from bread), 16.9 fl oz

TEA BREAK Cake with raisins and hazelnuts, 2 oz • Black tea, 9 fl oz; with honey, 1 tbsp

DINNER Fried homemade pork meatballs, 3.2 oz • Boiled potato with onion sauce, 7.7 oz • Cooked carrot with sour cream sauce, 2.8 oz • Salad of cucumber and tomato with sour cream sauce, 6.8 oz • Sour rye bread, 3.5 oz • *Lauku* kvass, 16.9 fl oz

CALORIES 3,100

Age: 45 • Height: 5'8½" • Weight: 165 pounds

VECPIEBALGA • Several years after Aivars Radziņš's estranged father died, his stepmother called to ask if he wanted some of his father's beehives. There were 10 of them, he recalls. "I didn't know anything about beehives and honey." He took a two-year beekeeping course in Latvia's capital, Riga ("everything is in Riga!") and turned it into a family project. Now they have 50 hives, sprinkled throughout the countryside and behind his house in the village of Vecpiebalga, in central Latvia.

In Latvia, honey is both a cottage industry and big business. "We could easily have 200 beehives and make it our full-time work," he says. "Right now it's a professional hobby."

Regarding the generic mass-produced honey on grocery store shelves, he admits that "some are good." But when it comes to the delicately flavored honeys that come from personal beekeeping husbandry and knowing where your bees have been buzzing around, "there is no comparison," he says.

Aivars, whose university degree is in mechanical engineering, is also a full-time forester and a part-time nurse and driver for his wife, Ilona, who's the sole doctor within a 15-mile radius of their house. So far, there haven't been any surgeries on the kitchen table, "but we have delivered babies," he says. "In the countryside, when we have an emergency it can take even an hour for help to arrive," says Ilona. And there are many small injuries. "One time a fisherman came with a big harpoon through his hand, and a fish on the end of it!" says Aivars.

While he speaks, the beekeeper attempts to slice a wholesome country rye, baked by a friend this morning and exchanged for honey. The dark, whole grain loaf was baked on a bed of maple leaves, both for beauty and to keep it moist in the wood-fired oven. "It should stand for a few days and mature," Aivars says, brandishing a knife, but he wants to cut it anyway, to share with us. As he saws

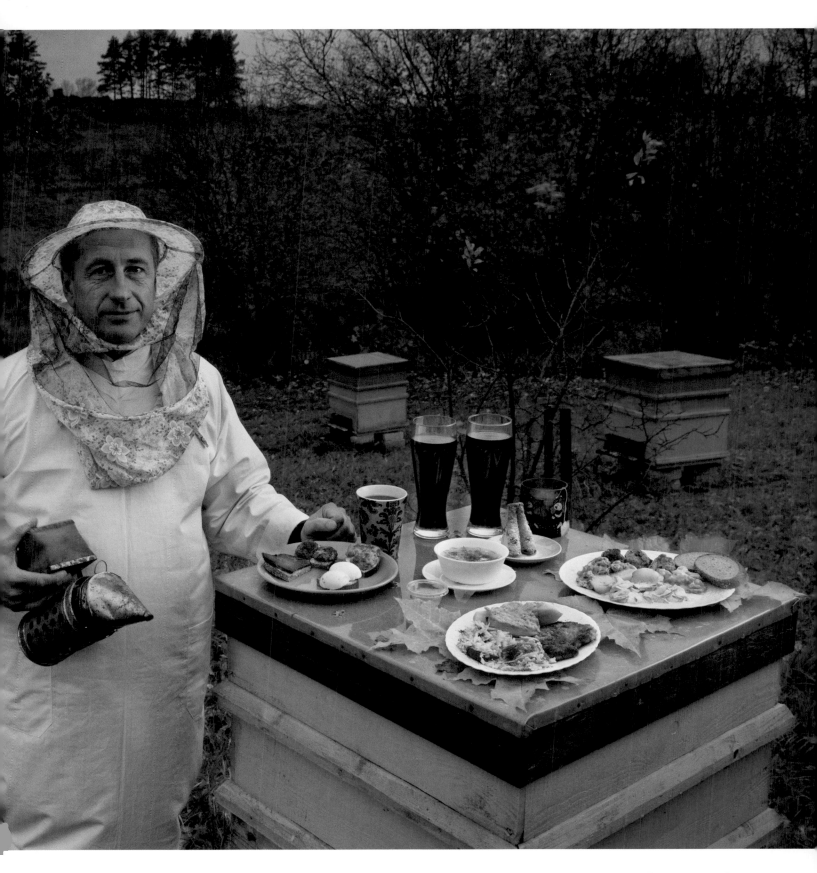

Aivars Radziņš, a forester and beekeeper, in his backyard with his typical day's worth of food. Since Aivars's government salary and his wife's pay as a rural doctor are both very low in this former Soviet republic, he used inherited beehives to create a home business producing honey to supplement their income. He holds a smoker and wears his beekeeping garb for the main portrait, and also models a nineteenth-century Latvian outfit (at left) that he wears when selling honey at local festivals and markets; last summer at the Latvian Song and Dance Festival his traditional dress took first prize. Although rich in culture and architecture, Latvia is among the poorest and least populated members of the European Union; its population has declined since gaining independence in 1991.

In their cozy kitchen (top left) overlooking the fruit trees and sauna house, Ilona makes tea for guests and shares her family's honey, drizzled on a dense slice of dark sour rye bread (bottom left). Received in exchange for honey, the loaf comes wrapped in maple leaves baked into the crust. Top right: The Radziņš family enjoys a traditional Sunday lunch at a neighborhood restaurant, complete with *kvass*, a fermented drink made from rye bread and sweetened with sugar or fruit.

at the bread, Ilona looks as though she'd like to take over the cutting, but she waits, watchfully. "I must change the knife maybe," he says. Finally, success. The maple leaves are crisp and dark, baked onto the bottom of the loaf, and cling to the slices as they're passed around. The bread has a woodsy aroma and a tangy bite, and the Radziņš's honey is a perfect accompaniment.

Aivars and Ilona have purposefully cobbled together a life that incorporates what they consider the best parts of country living: bartering for goods and services, gathering the fruits of the land with their three daughters, and living within modest means. A rural doctor in Latvia doesn't make much more than the country folk she treats. "We're here because we want to be here," says Ilona. "We understand that we can't get big salaries here in the country."

They build their honey business bit by bit and year by year, using their own labor and found materials to piece together what they need. "If we bought that sink [new]," says

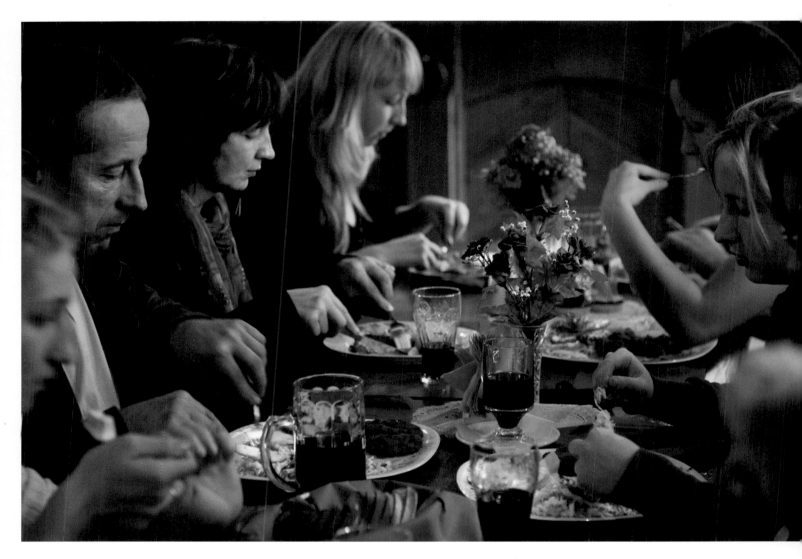

Aivars, pointing at a refurbishment project in the honey-processing building, "we would have to raise the price of the honey."

They get their potatoes and carrots from Aivars's mother and their milk from a local dairy. Crates of apples and cakes of creamy yellow beeswax are stacked in the entryway to their house. "Out here in the countryside, there's a lot of natural production," says Ilona. "Here [it's] bread and bees. In the neighboring district, people sell meat: raw and smoked meats, lamb and beef."

The family favors the flavors of the cold Baltic sea region: sour rye bread, sour cream sauces, pickled salads, preserved meats, cabbage, root vegetables, and dill weed. Aivars's favorite beverage is *kvass*, a drink made with fermented bread. Historically, these fermented, pickled, marinated, smoked, and dried foods were a necessity, due to the region's short growing season.

The climate also means long naps for the bees. Aivars says that although this results in lower production, the quality is higher, and his award-winning honey testifies to that. "In other countries, bees work a lot longer. They go around and keep making honey all year. Our bees work only four months a year. For the other eight months of the year they live in a very good house,' he says, laughing.

Does he blend the honey from his different hive locations? "We keep the honey in separate tanks," he says. "Then we can recall for the customers very funny stories about how their honey came to be made."

The couple experiments with herbal preparations made by infusing honey with herbs and root vegetables. A strong-tasting rutabaga honey they make is "more of a medication—for men's health," Ilona says euphemistically.

They also sell (and use) bee by-products as holistic remedies: bee pollen, propolis (the sap that bees use to plug holes in the hive), and royal jelly (the nutritious secretion fed to future queens and worker bees).

Aivars and Ilona also built their own sauna. As with beekeeping, Aivars studied the subject in depth before they built it. Now he sounds a bit like a sauna salesman as he sings its virtues, but it's an easy sell: The charming dacha-style house with wood-burning fireplace overlooks a natural plunge pool. "After we take a sauna, we swim in the pond, and then back to the sauna," he says. It's a nice way to end a bee-keeping day, or a day in the forest.

"Our bees work only four months a year. For the other eight months...they live in a very good house."

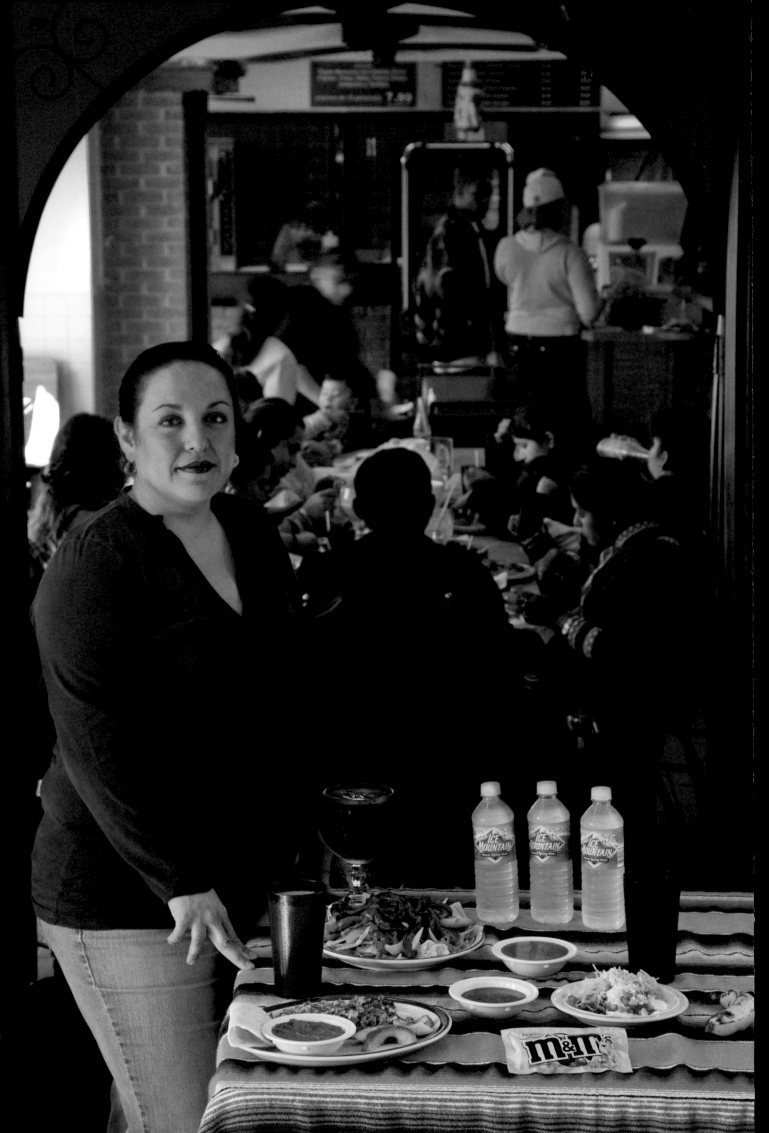

USA

Lourdes Alvarez
The Restaurant Owner

ONE DAY'S FOOD

IN SEPTEMBER

BREAKFAST Scrambled eggs with chorizo, tomato, and jalapeño, 8.2 oz • Flour tortilla, 1.2 oz • Homemade refried pinto beans, 4.9 oz • Avocado, 4.2 oz • Salsa, 2.6 oz • *Folgers* coffee with 2% milk, 15.8 fl oz; and sugar, 1 tbsp

LUNCH Steak salad: iceberg lettuce, 8.2 oz; skirt steak, 5.1 oz; avocado, 1.5 oz; tomato, 1.5 oz; carrot, 1.1 oz; green bell pepper, 0.9 oz; and onion, 0.4 oz; with *Bonne Chere Classic French* dressing, 4.8 oz • *Jamaica* hibiscus drink, made from a powdered mix, 16.8 fl oz

DINNER Vegetarian soft taco: flour tortilla, 1.5 oz; avocado, 4.2 oz; homemade refried pinto beans, 2 oz; Mexican rice, 1.6 oz; sour cream, 1.4 oz; iceberg lettuce, 1.1 oz; tomato, 0.6 oz; jack cheese, 0.5 oz

SNACKS AND OTHER *M&M's*, peanut, 1.7 oz • Banana, 4.6 oz • *Pepsi*, diet, 16 fl oz • *Ice Mountain* bottled water, 24 fl oz • Supplements and medications (not in picture): B_6, chromium, metformin

CALORIES 3,200

Age: 39 • Height: 5'2½" • Weight: 190 pounds

CHICAGO, ILLINOIS • "I make my *tres leches*, and *tres leches* chocolate, and flan," says Chicago native Lourdes Alvarez, referring to three-milk cakes and caramel custard. "I have customers who come just for that." Lourdes and her husband, Oscar, own El Coyote, a Mexican restaurant in the town of Alsip, south of Chicago. The booths in their converted Taco Bell fill up at lunchtime with both Latinos and other patrons from the neighborhood. They come for the sweets, but also for the fresh salsa bar, inexpensive tacos, and corn-on-a-stick coated with mayonnaise, lime, cheese, and chili powder. The chipotle chicken and chipotle chicken tacos are big sellers.

Desserts, though, are Lourdes's specialty. She took a cake-decorating class, and now the reverse side of her business card reads, "The Cake Lady." She turns out multitiered wedding cakes and confections for quinceaneras—coming-of-age celebrations for 15-year-old girls in Latin American cultures.

Lourdes, who was born into the restaurant business, splits her time between El Coyote and another restaurant 30 minutes away, Los Dos Laredos, owned by her father. Her father started the restaurant in 1966 in Chi-

cago's Little Village, southwest of downtown. It began as a small eatery, then expanded through the years along with the number of Mexican-Americans in the area. Lourdes grew up cooking and waiting on customers. "I'm there maybe two days a week," she says.

Lourdes eats most of her meals at work, wherever she is: "I just have emergency stuff at my house. Juices, a couple of eggs, some fruit for a milkshake in the morning." That's breakfast for her 10-year-old daughter, Alejandra, who hangs out at El Coyote after school. Oscar takes Alejandra to his mother's house for dinner most nights, as Lourdes rarely finishes her 10-hour day at El Coyote before 8 or 9 at night.

Lourdes has battled polycystic ovary syndrome since her daughter was born. Her doctor is treating this chronic condition with diabetes medication, as Lourdes is insulin resistant, though she isn't diabetic. One of the symptoms is weight gain. "Before I was diagnosed, doctors would say, 'You're just eating too much,' and I would eat less, go work out, and I didn't lose weight." After she began taking the medication she did begin to lose weight, but her doctor still presses her to lose more.

She says sweets are her dietary downfall: "Candy? Oh, yeah, I do like candy. Chocolate! That's my weak point. My husband will say, 'Why is there all this chocolate in here?' I keep it in the cupboard. I'll have three or four pieces, then three or four more. Just to feed that little urge." And then there are the donuts: "There's a Dunkin' Donuts behind us, and my daughter will say, 'Mom, we haven't had donuts for awhile,' And I'll say, 'Well, we can't, they go straight to our butts!' The bad thing is, we can't just eat one if we get them. Or my dad will say, '*Mija*, there's Mexican bread, have some.' Oh my god, they're huge! So I'll just have that little donut; in my brain I say it's littler, but I know the calories are probably the same!"

Lourdes Alvarez, restaurant owner and chef, in her family's Mexican restaurant, Los Dos Laredos, with her typical day's worth of food. She grew up in an apartment above Los Dos Laredos, where she still helps out two days a week. Other days she spends long hours at her own restaurant in Alsip, Illinois. At right: Lourdes takes a phone order, while her daughter, Alejandra, checks her mobile phone after school.

3200

Saleh Abdul Fadlallah
The Camel Broker

ONE DAY'S FOOD

IN APRIL

BREAKFAST Eggs (2), 3.8 oz; fried with butter, 1 tbsp; eaten with ful medames (fava beans cooked with garlic, lemon juice, cumin, and oil; not in picture*), 5.2 oz; and aish baladi (flat country bread), 8.6 oz • Fried potato chips, 1.3 oz • Tomatoes, 6.1 oz; with salt, 0.5 tsp • Feta cheese, 3.7 oz • Black tea, 3.8 fl oz; with sugar, 1 tbsp • Boiled water, 7 fl oz

LUNCH Goat meat broth with bone, 6.7 oz • Potato and tomato cooked with onion, garlic, cumin, Egyptian baharat (spice mixture), and oil, 6.7 oz • Soup of molokhiya (Jew's mallow), chicken stock, butter, garlic, and coriander, 4.5 oz • White rice, 7.5 oz • Black tea, 3.8 fl oz; with sugar, 1 tbsp

DINNER Aish baladi, 8.6 oz • Feta cheese, 2.3 oz • White rice, 6.3 oz • Fried potato chips, 1.5 oz • Black tea, 4 fl oz; with sugar, 1 tbsp • Boiled water, 7 fl oz

THROUGHOUT THE DAY Black tea (6), 20 fl oz; with sugar, 2.5 oz • *Cleopatra* king-size cigarettes, 1 pack

CALORIES 3,200

Age: 40 • Height: 5'8" • Weight: 165 pounds

*The dish at lower right (additional goat meat with broth) is a stand-in for the missing beans and isn't included in the calorie total.

BIRQASH, OUTSIDE CAIRO • Egypt's largest camel market was held on the outskirts of Cairo in Imbaba until 1995, when it was pushed into the far west suburbs to make way for land deals and developers. Now Saleh Abdul Fadlallah and the other camel brokers from Cairo and Giza jump on microbuses for the 22-mile commute to Birqash—a long, messy, cacophonous journey. Traffic lanes are merely a suggestion, microbuses stop to pick up and drop off with no warning, and staccato horns bleat unheeded, offering punctuation, if nothing else.

The camels coming to the market have it rougher, some traveling thousands of miles, over land and on ships, from Somalia, Sudan, Ethiopia, and throughout Egypt. Many have been offered at other camel markets along the way and were passed over. The camels arrive at the market in open trucks, packed in like sardines, to be sold for meat or as pack animals.

A herd of 10 untended camels, hobbled with ropes to keep them from running, kicks up sand and dust devils as they lurch around in the wide road that bisects the long, narrow market of Birqash. Their guard emerges from his sleeping berth, yelling, and beats them back into an open corral owned by his boss.

They bellow and spit as they stumble through the gate and join 50 other camels who have already run the gauntlet of beatings to get here.

Some of the men who work in the market live there, and some commute from home. Saleh usually commutes, but he eats many of his meals at work, which, most weeks, is every day. The top brokers rent office space and corral areas and hire other brokers to sell the thousands of camels that move through the market.

Even before first light, the market restaurant, which caters mostly to the brokers and guards, is serving breakfast: *ful medames* (garlicky mashed fava beans cooked in oil), eggs, fresh flat bread, and tea. A bright red sign overhead reads, "Drink Coca-Cola," and they do. The brokers often offer it to prospective buyers as they try to close a deal. The specialty of the house—meat of all kinds—will be served later by the butcher-turned-restaurateur who runs the place, but he's still cooking. He gets upset when the camels get too close and lick the tables.

Men in turbans and long, flowing robes scratch their beards and their bellies and cover their hot sweet tea to keep the sand out as they wait for the morning market to

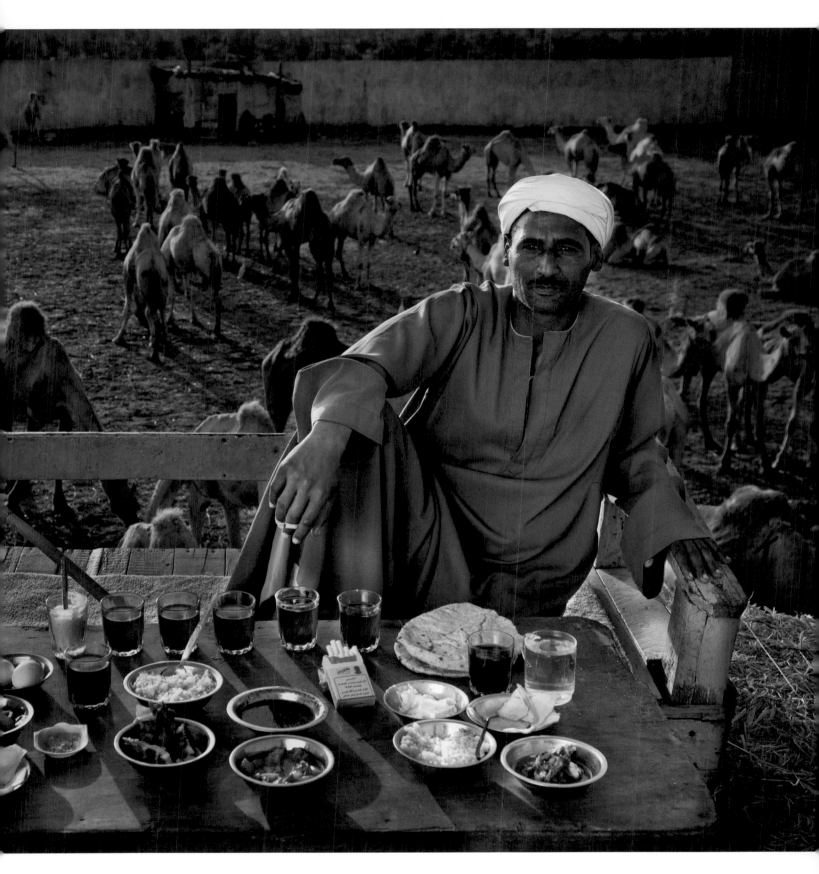

Saleh Abdul Fadlallah above a holding pen at the Birqash Camel Market with his typical day's worth of food. Contrary to popular belief, camels' humps don't store water; they are a reservoir of fatty tissue that minimizes heat-trapping insulation in the rest of their bodies; the dromedary, or Arabian camel, has a single hump, while Asian camels have two. Camels are well suited for desert climes: their long legs and huge, two-toed feet with leathery pads enable them to walk easily in sand, and their eyelids, nostrils, and thick coat protect them from heat and blowing sand. These characteristics, along with their ability to eat thorny vegetation and derive sufficient moisture from tough green herbage, allow camels to survive in very inhospitable terrain.

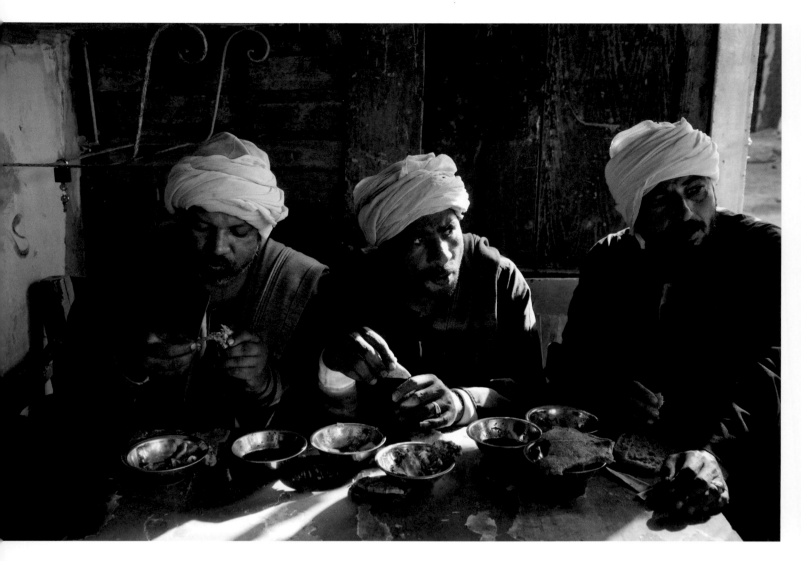

get underway. They're from as many different countries as the camels, and more; there are Jordanians and Saudis here, most of them middlemen.

A convoy of two blue trucks full of camels arrives from Somalia, all of the camels the worse for wear after their 10-day journey north on the Red Sea. Busloads of brokers and helpers arrive as well, and some head off for morning prayer in a mosque at the market.

Saleh, who learned the business of brokering from his father, says his father was much better at it. These are only the memories of a young boy though, as his father died at age 42, when Saleh was 12 years old. As the oldest son, Saleh became the family breadwinner and continued to work in the camel market, as a helper first, then as a butcher and a broker. He never attended school, but became a skilled negotiator in a pit of cunning negotiators. His son works with him, but he also attends school, "studying business," says Saleh, proudly.

Six men try to unload the Somali camels from their trucks but find that one of two camels blocking the exit is dead. Another is down and won't move despite repeated beatings. Finally, they pull his tail and he rises, unsteadily, and steps off the truck, followed by the others. The camels peer over the wall into the adjoining corral as they're led into their own.

Large herds of camels now fill the market road, the lead animals with bells to guide their hapless fellows as the market gets underway. Three Sudanese camels go for 12,000 Egyptian pounds ($2,182 USD). Another deal is made almost immediately: 9,000 ($1,636 USD) for two. A third transaction founders when the seller refuses 5,000 ($909 USD) for a single camel. A heavyset buyer in a long robe is served tea by a broker trying to make a sale.

Saleh carries an orange soda to a buyer who's purchasing camels for meat. A price is discussed, but the buyer says it's too expensive. The seller raises his voice. Saleh has one hand on each man's chest as he speaks in a low, constant pitch about the quality of the skinny animals.

Voices are raised, but that's how the game is played. Only once that morning does it get personal: "I'll make a deal with your son, but not with you!" shouts a buyer who has been pushed to his limit. The price the seller wants is too high. The deal falls through. "It's a kind of luck," says Saleh. "You might lose, or you might win. You don't know."

The prospective buyer complains, "Even if I sell it for 30 pounds for 1 kilo ($2.48 USD per pound), I can't make that money back!" "This is the best we have," says the seller's persistent son, trying again to close the deal, "15,000 for one."

The discussion gets heated at every point of sale, no matter whether buyer and seller are 50 pounds apart or 1,000. Ultimately, Saleh makes the deal—just one negotiation in a sea of negotiations happening simultaneously throughout the market.

A buyer throws his arms in the air: too expensive. A seller clutches the shoulder of the buyer, cajoling with a lower price. They grab each other's arms and the deal is made.

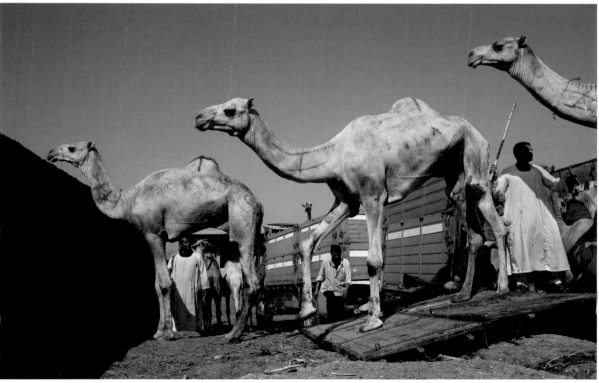

Truck drivers at the camel market (top left) have a midmorning meal of sheep meat, potato, onion, tomato, and flat bread in a rustic restaurant stall. Top right: Saleh grabs the wrist of a camel seller, using his brokering skills to end an argument and finalize the sale. At left: Camels from Somalia stiffly walk down the ramp from the truck that hauled them across the desert from a Red Sea port.

Domesticated since 2000 BC, camels are used less as beasts of burden now, and more for their meat. Because they can run up to 40 miles per hour for short bursts, dealers hobble one leg when they are unloaded at the Birqash market, forcing them to hop around on just three legs. They are marked with painted symbols to make them easier for buyers and sellers to identify. Both brokers and camels have a reputation for being surly, and the brokers don't hesitate to flail the camels with their long sticks to maintain their dominance.

187

3200

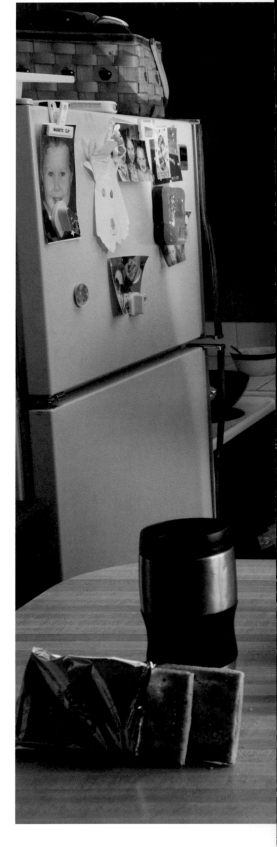

USA

Todd Kincer
The Coal Miner

ONE DAY'S FOOD

IN APRIL

BREAKFAST *Kellogg's Pop-Tarts*, cherry, frosted (2), 4.4 oz • Coffee (en route to work), 12 fl oz • Coffee (at work), 10.1 fl oz

LUNCH Bologna and cheese sandwich: *Heiner's Old Fashioned* white bread, 2.1 oz; *Fisher's* bologna, 3 oz; *Kraft* singles, American cheese product, 0.8 oz • *Pepsi*, wild cherry, diet, 12 fl oz • *Hostess Ding Dong* chocolate cake snack, 1.4 oz • *Dasani* bottled water, 12 fl oz

DINNER *Hamburger Helper Cheddar Cheese Melt* macaroni dish with hamburger, 1.6 lbs; with *Kraft Original* barbecue sauce, 1 tbsp • *Del Monte* canned peas, 3.1 oz • *Little Debbie* fudge brownies with walnuts (2), 4.3 oz

THROUGHOUT THE DAY Coffee (en route home), 10.1 fl oz • *Propel Invigorating Water*, berry flavored, 20 fl oz • *Pepsi*, wild cherry, diet, 12 fl oz • *Skoal* tobacco, wild berry flavored, 1.2 oz

CALORIES 3,200

Age: 34 • Height: 5'11" • Weight: 185 pounds

MAYKING, KENTUCKY • "I'm dipping Skoal while I work," says 34-year-old Todd Kincer, a car operator on a 10-man team extracting coal in an underground mine in eastern Kentucky. "It's a way to combat the dust—it keeps your mouth moist."

The company he works for, Sapphire Coal, does continuous mining using a machine with a large rotating head full of teeth that chews up coal deep underground. Operators in long, low-slung electric cars shuttle the coal to a conveyer belt that moves the coal outside.

The operation moves forward in a system known as room-and-pillar mining, in which support pillars of coal remain in place as the miners work, creating temporary work rooms stabilized by four- to six-foot-long roof bolts.

Todd's 10-hour work shift begins at 6 a.m. He eats breakfast on the way to work. "Black coffee and frosted Pop-Tarts—cherry, hopefully, or cinnamon sugar, or blueberry," says Todd, who shares his eating habits hesitantly. His wife, Christy, is more forthcoming: "I plan the menus for a week at a time," she says. Evidently, this is something that Todd has only just realized. "You do?" he says. "Oh, I guess you do."

After a quick cup of company coffee at the mine, everyone boards for the 15-minute ride to the face, deep inside the mountain at Advantage One Mine outside Whitesburg.

By necessity, Todd's workday meals are easy to eat. There's no stopping once the crews begin work, and they don't come out of the mine until their shift is over. "I'll take a sandwich from home," he says. "If they're cutting coal, you gotta keep moving; no way to eat with a fork and spoon. A sandwich, a diet pop—I'll have that and a Hostess Ding Dong cake."

Todd and Christy, who have three children, both work full-time. Christy cooks something easy most nights, like Hamburger Helper with double the noodles, she says, as that's the part the family likes best, paired with a can of vegetables. But sometimes she'll make something rib-sticking, like meatloaf with mashed potatoes and green beans.

They eat at family-style restaurants two times a week, and with fellow parishioners for lunch on Sundays after Todd's father, Harold, preaches at a Methodist church in nearby Seco.

What's Todd's favorite dinner? "Breakfast for supper," he says quickly, without having to think about it, "only every once in a while. We usually go to Dad's. If they're going to have breakfast for supper, they usually call and we'll go over there. And, I mean, it's a full-tilt country breakfast: fried eggs, sausage, ham, fried bologna, biscuits, gravy—everything."

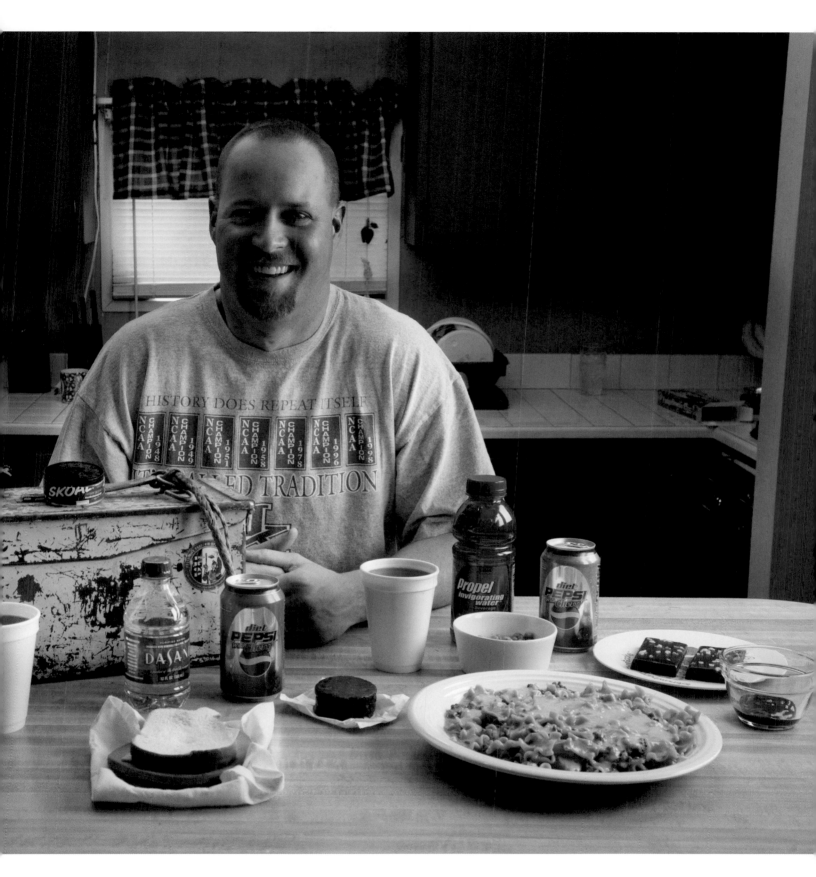

Todd Kincer, a coal miner, in his kitchen with his typical day's worth of food and his workday lunch box. After showering and scrubbing off the day's coal dust, Todd gets ready to dig in to one of his favorite meals: Hamburger Helper with double noodles. A college graduate drawn to the coal mine by the relatively high pay, Todd spends a 10-hour shift mining underground, driving a low-slung electric shuttle car that carries coal from the face of the coal seam, where it's being chewed up by a deafening, dusty mining machine, to a conveyer belt. The mine, located deep inside a mountain in the Appalachians near the town of Whitesburg, Kentucky, is pitch-black, except for headlights and headlamps. During winter months, Todd never sees daylight during the workweek.

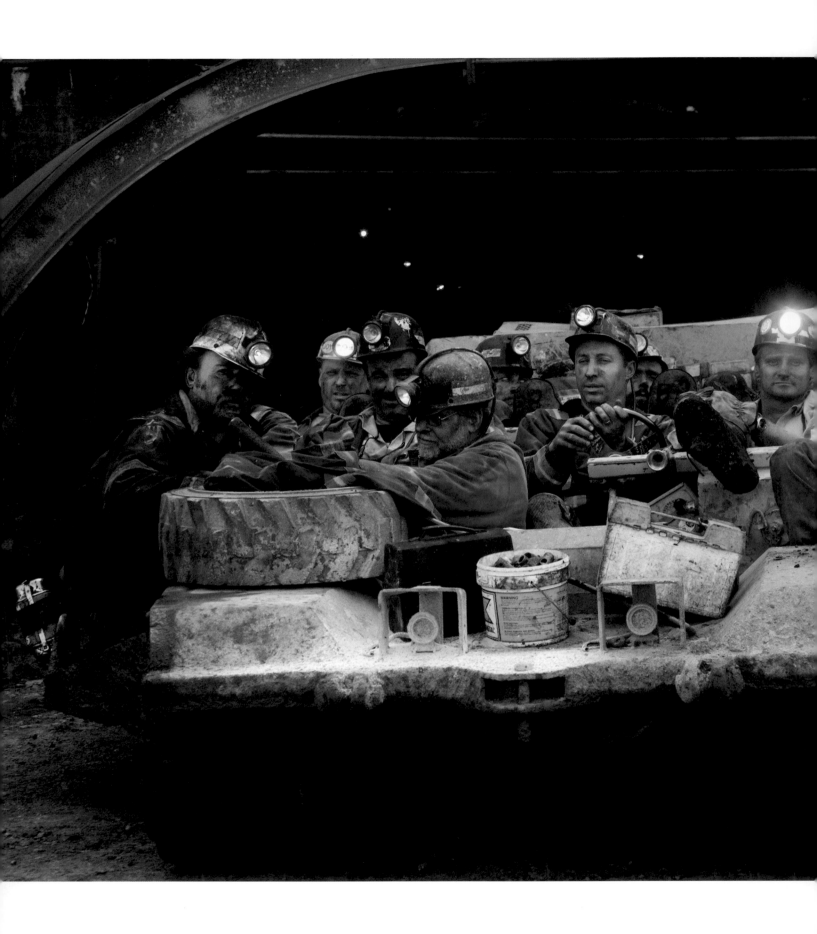

Emerging from the portal after a 10-hour shift, a dozen of Todd's coal-mining colleagues lounge on the "man car" (at left) that transports them to and from the coal face, several miles into the mountain, at the Advantage One Mine outside Whitesburg, Kentucky. On Sunday, Todd and his family attend Millstone Methodist United Church (top right), where the Reverend Harold Kincer, Todd's father and a retired coal miner, asks Jesus's blessings as he kneels and lays his hand on his wife, Judy, who plays music in the church. The service features fire and brimstone, interspersed with some fine singing by congregation members who take to the mic after handing over their CD of background music to the music director. After church, Todd and his wife, Christy, join extended family and friends at an all-you-can-eat restaurant buffet (bottom right) in Whitesburg.

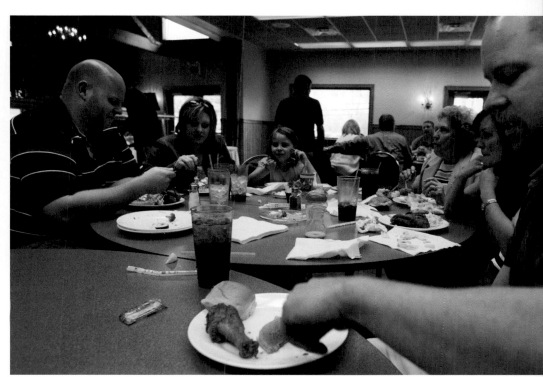

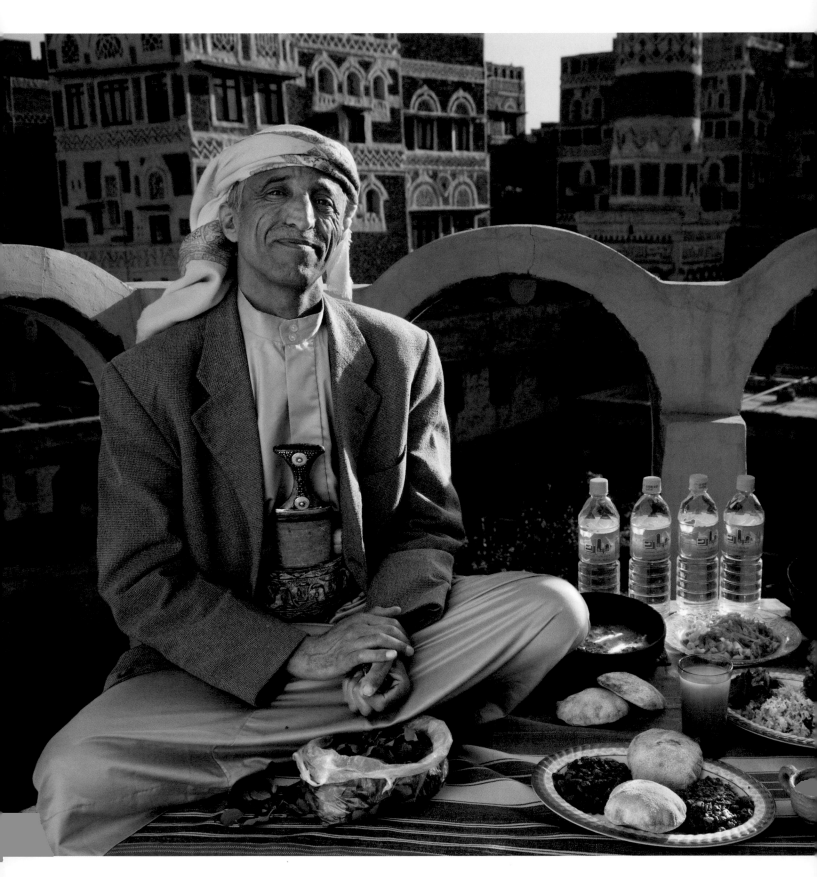

Ahmed Ahmed Swaid, a qat merchant, on a rooftop in the old city of Sanaa with his typical day's worth of food. Ahmed, who wears a *jambiya* dagger as many Yemeni men do, has been a qat dealer in the old city souk for eight years. Although qat chewing isn't as severe a health hazard as smoking tobacco, it has drastic social, economic, and environmental consequences. When chewed, the leaves (at right) release a mild stimulant related to amphetamines. Qat is chewed several times a week by a large percentage of the population: 90 percent of Yemen's men and 25 percent of its women. Because growing qat is 10 to 20 times more profitable than other crops, scarce groundwater is being depleted to irrigate it, to the detriment of other food crops and agricultural exports.

YEMEN

Ahmed Ahmed Swaid
The Qat Seller

ONE DAY'S FOOD

IN APRIL

BREAKFAST Ful (fava beans), cooked with onion, tomato, and ground chilies, 5.6 oz • Minced meat, 5.6 oz • Qudam (dense, yeasty pocket bread), 4 oz • Coffee, 1.5 fl oz; with sweetened condensed milk (not in picture), 2 tsp

LUNCH Lamb, 9 oz • Rice with carrot and onion, spiced with ginger, cinnamon, and cardamom, 9.1 oz • Saltah (beef, eggplant, tomato, and onion stew with hot chilies, coriander, and hulbah, a foamy fenugreek topping), 14.7 oz • Qudam, 3.8 oz • Salad of carrot, cucumber, green bell pepper, and onion, 7.2 oz; with vinegar and lime juice dressing, 1.5 tbsp • Mango, 12.2 oz • Cantaloupe, 12.1 oz • Mango juice, 8.3 fl oz • Qishir (sweet, tealike coffee made from coffee bean husks), 1.7 fl oz

DINNER Saltah, 8.7 oz • Qudam, 2 oz • White beans with onion and tomato, 9.8 oz

AFTER-DINNER SNACK Guava juice, 10.6 fl oz • Qat (herb chewed as a stimulant), 5.4 oz

THROUGHOUT THE DAY Bared bottled mineral water. 3.2 qt

CALORIES 3,300

Age: 50 • Height: 5'7" • Weight: 148 pounds

Yemen's capital city, Sanaa, is a sparkling showpiece of towering homes and mosques built of stone and brick and decorated with white gypsum and jewel-toned alabaster windows. Ancient and decaying at 2,500 years old, the small city was rescued and rebuilt by UNESCO and the government of Yemen in the 1980s. Sanaa leapt its high-walled border long ago and sprawled into the countryside, and the old town is now surrounded by a nondescript mash-up of business, government, and residential blocks. The population stands at 2 million and is expected to double in the next decade, despite a water crisis that could ultimately mean the death of the city and great woes for the country.

SANAA • A lifelong resident of Sanaa, Ahmed Ahmed Swaid still lives in the house where he was born, a five-minute walk to the warren of market shops and stalls of the city's old souk, where he plies his trade.

The meals his wife makes for their family of five are typically Yemeni: *ful* (mashed fava beans cooked with onion, tomato, and chilies), *saltah* (a thick meat and vegetable stew), unleavened flat bread, and fresh fruit in season. He drinks water and fresh juices throughout the day to counter the intense heat, but also drinks coffee and *qishir*, a sweet, hot bever-

age made from the husks of coffee beans, sometimes infused with spices. He doesn't care for tea, which sets him apart from many in the souk who drink it all day long.

The gregarious merchant lounges on a pillow in his cubbyhole stall each day and, like thousands of his countrymen, sells qat leaves to a Yemeni public that clamors for them.

The qat-chewing session is the great Yemeni social pastime for 90 percent of men and 25 percent of women. Chewing the leaves produces a euphoric, stimulant effect that lasts for hours. Ahmed chews qat himself—a bag a day with friends. His wife doesn't, he

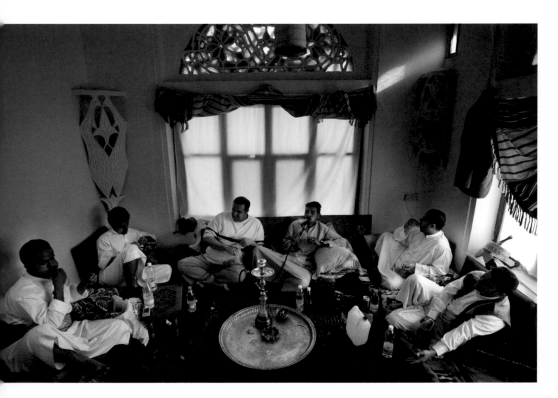

A traditional Thursday afternoon qat-chewing and tobacco-smoking session among friends in Sanaa can last five or six hours (top left). The men pick through the bag selecting leaves to chew until the masticated mass in their cheek is the size of a golf ball. Qat is harvested year-round (above). Its leaves lose their potency within a day, so they must be picked, sorted, washed, and rushed to market daily. At right: Ahmed sits and sells bags of qat at his stall in the old city's souk. A typical midquality bag of 6 to 8 ounces, chewed by one person in one session, costs about $8 USD.

says, because she doesn't like the taste.

A 15-minute drive northwest of the capital is Wadi Dhahr, site of Dar Al-Hajar, the famed Rock Palace. But the real attraction in the area is qat. Crowds of men in turbans and suit jackets sip hot, sweet tea and wheel and deal the green gold amidst a thick carpet of tattered plastic bags blown by the wind. Mango trees still dot the land, but most fruit orchards have given way to qat trees (*Catha edulis*), managed and harvested to feed the habit of the capital city and surrounds.

One grower, 80-year-old Ali, has built up a small fortune in qat just outside the town. Today he's overseeing his pickers, who work on ladders to harvest 125 pounds of qat that he's presold to a Sanaa wedding party. They've paid the equivalent of $2,000 USD in cash, enough for a wedding party of 250 men.

Some call chewing qat a social ill, others a necessary elixir, but in a country with 35 percent unemployment, it also means jobs. The qat industry is the second largest employer in the country, and qat is the country's single biggest cash crop, to the detriment of food crops.

But all of Yemen's crops are facing a crisis. One-third of all pumped groundwater is used to irrigate the qat orchards. Groundwater reserves are being rapidly depleted, forcing well drillers to dig to historic depths, tapping into prehistoric water deposits that are now disappearing too. The prediction is that Yemen will run out of water by the end of the decade, and Sanaa even earlier.

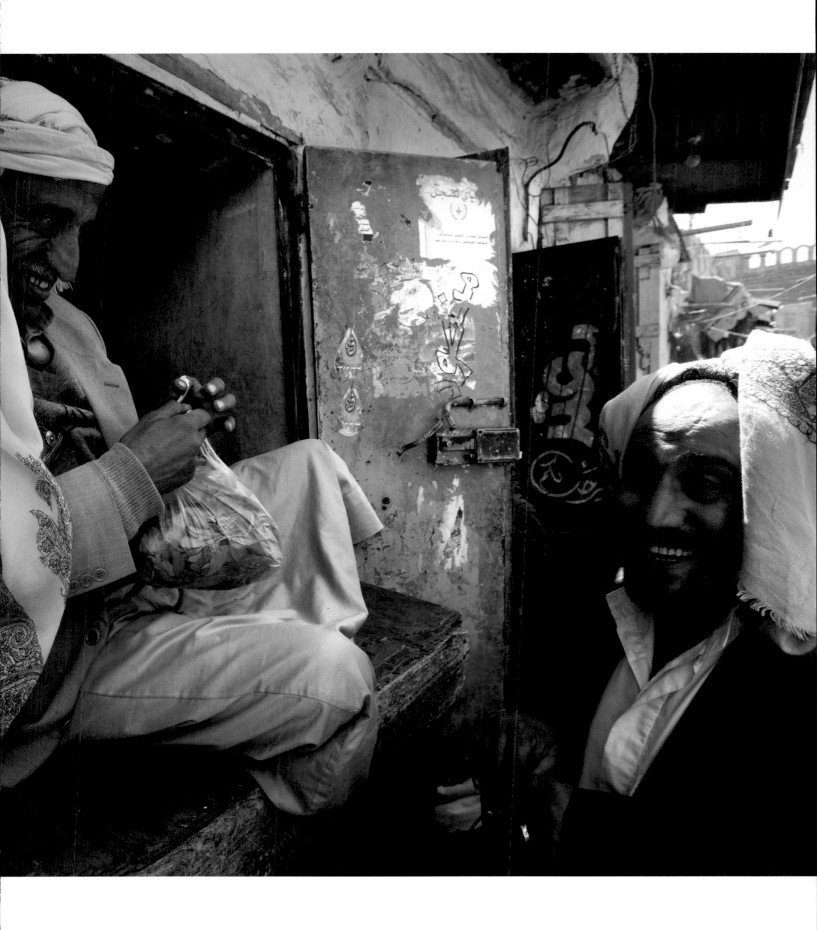

A dreamy vision of an ancient city, Sanaa's earth-toned multistory buildings are decorated with bands of white gypsum. The old town is the longest continually inhabited city in the world and a World Heritage Site, with more than a dozen *hammams* (traditional bathhouses), 100 mosques, and 6,000 houses that predate the eleventh century. Many of the houses, built from brick, have elaborate geometric friezes, colorful windows, and flat rooftop terraces, and some exceed seven stories. Closed to outsiders for two centuries until the end of the North Yemen Civil War in 1969, the old city was then threatened by modernization as wealthier residents increasingly abandoned the ancient crumbling center and moved to more modern and comfortable housing outside the city's core. In the past 100 years, Sanaa has become a sprawling metropolis, with the population increasing from 20,000 to 2 million. In the 1980s, the Yemeni government and UNESCO coordinated an international effort to preserve and restore the old city, resulting in a spectacular living monument of architectural and cultural beauty.

3400

BRAZIL

Solange Da Silva Correia
The Amazon Grandmother

ONE DAY'S FOOD

IN NOVEMBER

BREAKFAST Tucuma (star nut palm) fruit gathered near her house (5), 8.5 oz • Coffee (2), 8.5 fl oz; with nondairy powdered creamer (not in picture), 2 tsp; and sugar, 1.6 oz

LUNCH AND DINNER, PREPARED TOGETHER Peacock bass heads, stuffed with green mangoes and boiled with onion, garlic, and lemon juice, 1.1 lb (whole, raw weight, heads only) • Broth from cooking the fish (not in picture), 10 fl oz; with salt, 1 tbsp; with white rice, 9.3 oz; and pinto beans, 5.4 oz (dry weight), which are cooked with onion, 3.2 oz; garlic, 0.1 oz; and vegetable oil, 1 tbsp • Manioc flour, sprinkled on each dish, 9.8 oz

SNACKS AND OTHER Savory steamed cornmeal cake made from *Quaker* milharina (precooked cornmeal), 4.8 oz; with *Deline* margarine (not in picture), 1 tsp • Mangoes (6), 1.6 lb • Roscas (donut-shaped hard biscuits), 1.3 oz • *Richester* cream crackers, 0.8 oz • *Antarctica Bare* soft drink, made from the caffeinated fruit of the guarana plant, 1.1 qt • Well water, 2.1 qt

CALORIES 3,400

Age: 49 • Height: 5'2½" • Weight: 168 pounds

OUTSIDE CAVIANA, AMAZONAS • A flock of bright-colored parrots swoosh above the treetops by Solange Da Silva Correia's remote house deep in the Amazon rain forest. "They fly over every day," she says, as she peels and eats small yellow-green tucuma palm fruit in her kitchen, collected from under a nearby tree. Her husband, Francisco, watches the parrots from his canoe while setting his nets for fishing, and while tending to their herd of 28 cattle a half-hour boat ride away from their house. "They pass by in the morning and the afternoon," he says.

Solange and Francisco live a few miles outside the village of Caviana in a ramshackle farmhouse above a small artery of the Solimoes River—the upper Amazon in Brazil's Amazonas state. In any direction from their small outpost it's a six- to eight-hour journey by water, depending on the speed of the boat, to cities like Tefe, to the west, and the state capital Manaus, to the east. Throughout the Amazon River system, riverboats connect the sparse enclaves to one another.

The village of Caviana has well water, intermittent electricity, one phone, and one car and two trucks—though there's virtually nowhere to drive. At Solange's house, 20 minutes from Caviana by boat, there's neither electricity nor potable water. They haul water

from the village, keep it cool in clay jugs, and freeze it at their son's house, using the ice to keep perishables fresh in polystyrene coolers.

Solange says this isn't the life she expected to live when she was growing up in Tefe, a town with modern conveniences. "The life here is much more difficult," she says. Francisco was cultivating and processing jute near Tefe when the couple met and married; Solange was 16. They remained in Tefe for three years, until Francisco's father asked him to return to his family homestead near Caviana.

Their three children were born here, but their youngest, a daughter, died on a riverboat at the age of two as they rushed to get medical help after an accidental poisoning.

Cattle and fishing have supported the family. Like most fishermen in the Amazon's backwaters, Francisco fishes with long nets staked and hung curtain-style. Although it's cooler to fish at night, he doesn't do that anymore—he's had too many harrowing encounters with alligators.

His cattle are also vulnerable to jungle predators—especially jaguars—and he loses three or four cows a year. Two years ago, Francisco identified prints of the large cat near a carcass. He hung his hammock between two trees and waited several hours in the dark for the animal to appear, his 12-gauge shotgun

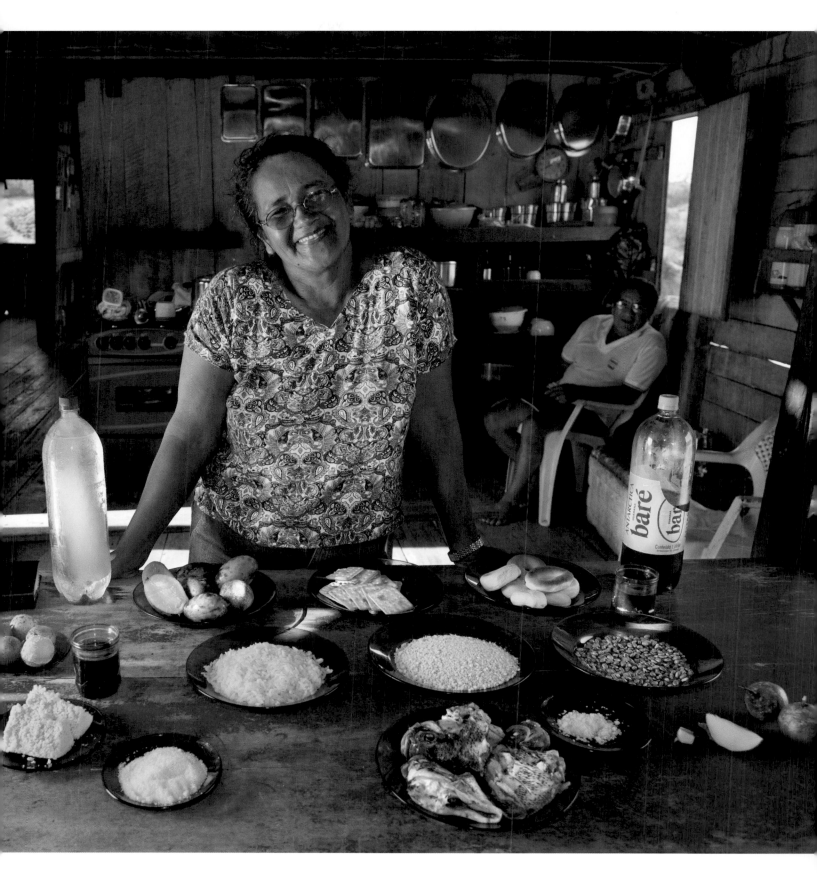

Solange Da Silva Correia, a rancher's wife, with family members in their house overlooking the Solimoes River, with her typical day's worth of food. She and her husband, Francisco (sitting behind her, at right), live outside the village of Caviana with three of their four grandchildren in a house built by his grandfather. They raise cattle to earn income—and sometimes a sheep or two to eat themselves—but generally they rely on their daily catch of fish, and eggs from their chickens, for animal protein. They harvest fruit and Brazil nuts on their property and buy rice, pasta, and cornmeal from a store in Caviana. They also purchase Solange's favorite soft drink made from *guarana*—a highly caffeinated berry indigenous to the country.

Solange helps her grandchildren get ready for school in the bedroom the children share (top left). After a breakfast that includes a savory cornmeal cake (bottom left), steamed in a tin-can contraption invented by Francisco, the children load up their backpacks and use one of the family's outboard canoes to get to school in nearby Caviana, 20 minutes downriver (top right).

in hand. Finally, at 10 o'clock at night, he decided it was time to give up and go home. He put down his gun to pack up the hammock. When he turned, there was the jaguar, silent and staring. Taking the one chance he had, he grabbed the gun and shot the shell in the chamber, killing the animal. "We ate it for five days," he says, adding that they shared a lot of the meat with friends and family. The hide stretches from floor to ceiling on the wall in their house, and the story ebbs and flows with time.

They never eat their cattle; they just sell 6 to 10 a year, depending upon the number lost to predators. They eat fish most often, and chicken occasionally. Solange's favorite part of her favorite fish—peacock bass—is the head. In the dry season she cooks outside over a wood fire, sometimes roasting the fish, but usually boiling it with onion and garlic and, if she has it, stuffing a green mango inside. She cooks beans every day, and alternates between rice and pasta. Coarsely ground manioc flour is sprinkled

liberally over all food, as is common throughout Brazil. During the rainy season, she cooks inside on a propane stove—the first inside stove she's ever owned, purchased five years ago.

On school days, the 49-year-old grandmother lights an oil lamp before dawn and presses clean clothes for the three grandchildren who live with her, using a heavy iron heated on the stove. She prepares a breakfast of buttered store-bought crackers and coffee with powdered milk for the sleepy-eyed trio, and reads Bible passages to them as they eat.

Some mornings she makes a cornmeal cake, steamed in a contraption invented by Francisco, and there are always seasonal treats gathered from their land: mangoes, oranges, guavas, mandarins, Brazil nuts, cashews, the palm fruits *tucuma* and *acai*, and *cupuacu*—a Brazilian rain forest fruit similar to cocoa beans.

Ten-year-old Iran Jr., eight-year-old Italoo, and Iris, seven, are the children of her son,

Iran, who lives in Caviana and works as an agent, negotiating prices in bigger towns for hardwoods cut from the family land and surrounding property. He also sells Brazil nuts collected by his father and his children. There is another, newer, member of the family as well: 17-year-old Irlene, who came to help care for the grandchildren. She's now pregnant with Iran's fourth child, a matter that Solange prefers not to discuss.

As Iris sips her milky coffee, she rests her feet on the shell of a river turtle leashed to the leg of the table. Solange plans to roast the animal next month: "That's birthday dinner for my grandson," she says, speaking about yet another grandchild—her daughter's three-year-old son. Empty turtle shells litter the kitchen, remnants of birthdays past.

Their breakfast finished and backpacks on, the children walk down the steep hillside from the house to the water's edge, past two different dogs with snakebite injuries, and motor to school in a small outboard canoe. Dried grass bleached by the sun lies

atop trees and brush, the mark of the river at its highest. This is the dry season in the Amazon. During the rainy season, generally January to May, the water will rise 40 to 50 feet and the boats will be moored just outside the door.

Solange and Francisco's sluggish bend in the river is called an *igarape*, which means "way of the canoe" in the language of the original inhabitants of the area—the Tupi. It's also a haven for mosquitoes, and everyone in the family has had malaria at least once.

After breakfast for the adults and another Bible passage, Francisco prepares to go fishing. What does Irlene plan to do today while her charges are at school? "Sleep," says Francisco, to general laughter, although Solange does not join in.

Solange has two great joys in life, she says: her grandchildren and the women's group at the First Assembly of God Church. She and the children motor over to Caviana on Saturdays for service and Bible study. This is also her weekly chance to visit with friends.

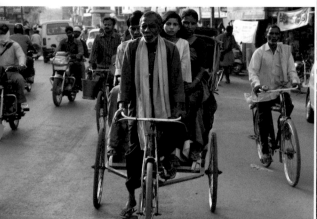

Moving the Idle Masses

By Mary Collins

I have no memory of the bicycle accident that occurred when I was in my early forties, robbing me of the fitness I'd developed as a competitive athlete. I cannot remember the faces of the Good Samaritans who found me on a trail by the banks of the Potomac River or the whoosh of the helicopter blades as I was airlifted to a trauma center. I only know that when I left the hospital days later, the shattered disks in my back forced me to join the ranks of the sedentary: the 3.4 billion people (about half the world's population) who live in metropolitan areas and seldom engage in even moderate exercise. This stands in stark contrast to the physical strength and fitness of the other half of humanity—the 3.4 billion people who live a more

fundamental existence and must still harvest, hunt, or gather to secure their daily calories.

What does it matter that so many people, especially in industrial nations, have removed physical activity from their dietary equation? Because my transition into the world of the idle masses was abrupt, I had a keen awareness of the far-reaching impacts on my own life. On a day-to-day basis, I struggled to sustain a healthy weight, battled depression, and couldn't focus well at work. And all around me I saw a culture equally immobilized, not under duress, but out of choice and because of all sorts of systemic obstacles. I saw a pattern of physical inactivity that evolved as entire communities started earning their daily bread not by a laborious and hands-on process of plowing, planting, harvesting, threshing, grinding, and kneading but at desk jobs and traveling almost exclusively by car, bus, train, plane, and other forms of transport.

This new way of life has many benefits. Nature struck a hard bargain with hunter-gatherers and early agrarian communities, who struggled

Mary Collins, a professor of creative writing at Central Connecticut State University, has worked as a freelance writer for the National Geographic Society and Smithsonian Magazine. Her most recent book, American Idle, *looks at the social, cultural, physical, and even moral consequences of a sedentary lifestyle.*

in an ongoing effort to obtain enough calories to continue that very effort. They lived much closer to the balance point, and being unsuccessful had dire consequences. For millennia, the average life expectancy was less than 50 years. Today's industrialized cultures are fortunate to be liberated from this harsh equation, and electricity, clean running water, and reliable access to decent food have conferred public health benefits that compensate for giving up a more rigorous way of life. But all humans have a physical legacy, and we ignore it at our peril. We can choose to turn our backs on the demands of a hunter-gatherer or agrarian lifestyle, but we cannot turn our backs on our need for some form of sustained physical movement.

Simply put, we are built to chase down a varied diet, and our bodies don't function well when we violate that legacy. The negative impacts are far-reaching and include increased levels of diabetes, heart attack, cancer, and even mental illness. Similar things happen to animals in zoos when their food is handed to them each day. They too suffer from obesity, diabetes, and cardiovascular diseases, ills that seldom occur in the wild, where they are free to run and roam, and challenged to hunt for their food—or to escape becoming a meal. Captive animals also experience mental distress: The wolf begins to tear at himself, and formerly docile creatures become aggressive. Some zoos now

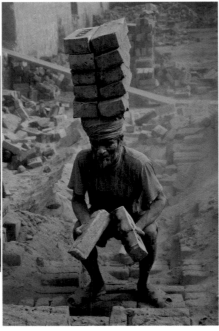
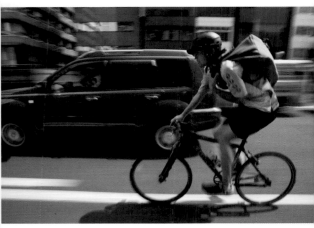

Left to right: Munna Kailash transports his family through traffic in Varanasi, India. Riverboat passengers relax in a web of hammocks on the Solimoes River, Brazil. Young women at a weight-loss camp stretch during a morning workout in the Catskill Mountains, New York. A 500-pound Gulf War veteran in Knoxville, Tennessee. A laborer at a brick factory near Sonargaon, Bangladesh. Yajima Jun delivers packages throughout Tokyo.

intentionally make animals search or work for their for food; for example, getting bears to search under rocks for grubs or having cheetahs chase down a piece of meat on a moving rope.

Unfortunately, most of the similarly contrived physical activities industrial countries encourage have proven poor substitutes for natural physical activity integrated into daily life. For example, in the United States the rise in organized sports in schools has, paradoxically, been mirrored by a rise in obesity. Although more kids on playing fields seems a laudable goal, somewhere this approach has taken a wrong turn. As Bill Sands, director of sports science at the United States Olympic Center in Colorado Springs, explains, children move far more during free play than they generally do in organized sports. In fact, he timed the activity in his daughter's one-hour volleyball practice and found that the kids were only getting about five minutes of vigorous activity. What seems like a good thing—kids playing a sport—fails to deliver the healthy boost it promises. And despite the fact that we spend billions of dollars on fitness programs, 65 percent of U.S. citizens don't get enough exercise, a figure that has remained basically unchanged since the 1950s.

In fact, with each new generation, industrial societies lower the bar for physical activity. For the first time, today's children may live shorter lives than their parents, entirely due to poor lifestyle habits. This is distressing on a personal level, and devastating on a broader level. In the United States, where the debate over health care rages across party lines and income groups, 80 percent of health care costs are lifestyle related. Getting people moving again is a cheap, simple, and highly cost-effective solution.

Why has it proven so difficult for most people in industrial societies to retain or reclaim a healthy level of physical activity? For a fortunate few, physical activity provides sufficient reward to inspire the effort, but for most, it doesn't. Most of us need to muster more personal discipline and willpower, but this can be difficult in the face of the many obstacles knitted into the fabric of our culture: poor city planning, unsafe public spaces, lack of time and money, and mental exhaustion from working and living in such a screen-centered society.

Despite this distressing state of affairs, small changes can bring about amazing results. Build a safe bicycle trail, and cycling increases by 25 percent. Add showers at places of employment, and employees increase their physical activity by more than one third. Embrace 15-minute paid movement breaks at work and increase productivity. Provide school students with 30 minutes of outdoor free play and improve test scores.

While we must each find a way of moving that works for us individually, an excellent place to begin is by renewing our connection to the land—and to our food. By reclaiming the bond between body, movement, land, and food so intimately interwoven into the lives of our ancestors, we can begin to rebuild our health at many levels. Working in the garden is good for the body and for the spirit. And no food that you purchase can be as healthful, fresh, seasonal, and local as what you harvest from your own garden or a community garden.

Admittedly, this solution isn't feasible for everyone, or in all seasons. But we can all examine our lives and find opportunities to increase our mobility. Even seemingly small changes can have a huge impact. As part of my recovery, I purchased a stand-up desk. It transformed my work space from a sitting nightmare, where I was lucky to put in four hours a day, to an oasis of movement and creativity where I can stand, sit (on a high stool), and pace at will for hours on end. From the first day I broke free of our modern chair culture, which sets off spasms in my back, I realized I could create new movement patterns with only subtle changes to my way of life. It was the most empowering moment of my rehabilitation.

3500

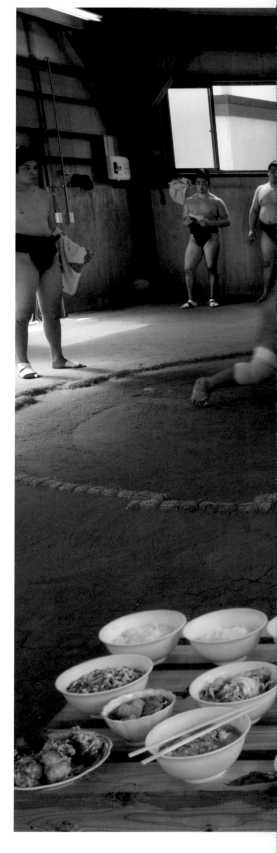

JAPAN

Miyabiyama
The Sumo Wrestler

ONE DAY'S FOOD

IN JUNE

EARLY WORKOUT Water (sipped ritually between bouts)

LUNCH AT THE SUMO STABLE Fried chicken, 6.2 oz • Chanko nabe (traditional sumo wrestlers' stew) with pork (2), 1.7 lb • Vegetable tempura, 2.7 oz • Cabbage, egg, and stewed chicken, 4.5 oz • White rice, 14.3 oz

DINNER AT THE SUMO STABLE Grilled hokke (atka mackerel, a saltwater fish), 3.5 oz • Scrambled egg with chives, 2.3 oz • Tuna, somen noodles, cucumber, and onion in a water broth, 1 lb • White radish and chicken in a water broth, 7.6 oz • Miso soup with chives, 10.9 oz • White rice, 15.1 oz • White radish, 1.8 oz • Pickled cucumber, 1.3 oz

THROUGHOUT THE DAY *Roots Aroma Black Original* bottled coffee (4), 1.3 qt • *So Ken Bi Cha* roasted barley tea, 2.1 qt • *Rokko No Oisii Mizu* bottled water, 1.6 gal

CALORIES 3,500

Age: 29 • Height: 6'2" • Weight: 400 pounds

NAGOYA • To the untrained eye, the sport of Sumo looks like a couple of fat guys duking it out in a fancy ring, but to sumo enthusiasts, it's a centuries-old fight for supremacy, steeped in ritual and Shintoism—"the way of the gods." Cleverness and experience count in the *dohyo*, or ring, but no one wins without sheer brute strength and a physical size of mammoth proportions. What does first contact feel like? "...Like hitting a wall," says Miyabiyama, of the Tokyo-based sumo club Musashigawa Beya.

Miyabiyama began his career as an amateur at age 15, packing on the pounds by force-feeding himself to achieve fighting weight as he moved up through the ranks to the top echelons of the sport. Now he eats to maintain his weight, which doesn't take much effort—or much food. Is he healthy? "My cholesterol is a bit high," he says, "but overall, I am." This doesn't extend to injuries, however, and his fortunes in the ring have ebbed and flowed because of them.

Miyabiyama has reached the level of *ozeki*—sumo's second highest—and has won several prizes, but this isn't a level that a sumo can hold on to. The wrestlers are promoted and demoted before each *basho* (grand sumo tournament) according to their previous performance. Only 42 wrestlers are allowed into the top division of professional sumo, and there are ranks within that division. The fact that there's no set criteria for achieving different levels in sumo makes it a bit of a moving target for the wrestlers, who are called *rikishi*.

Ritual guides all aspects of the life of the *rikishi*. Junior *rikishi* cook the food for the club, do the cleaning, and wait on their seniors, but Miyabiyama progressed quickly and did little of that: "I never really had the opportunity to cook much. I only reached chopping vegetables."

The junior *rikishi* sleep in one giant room that also serves as living and dining room.

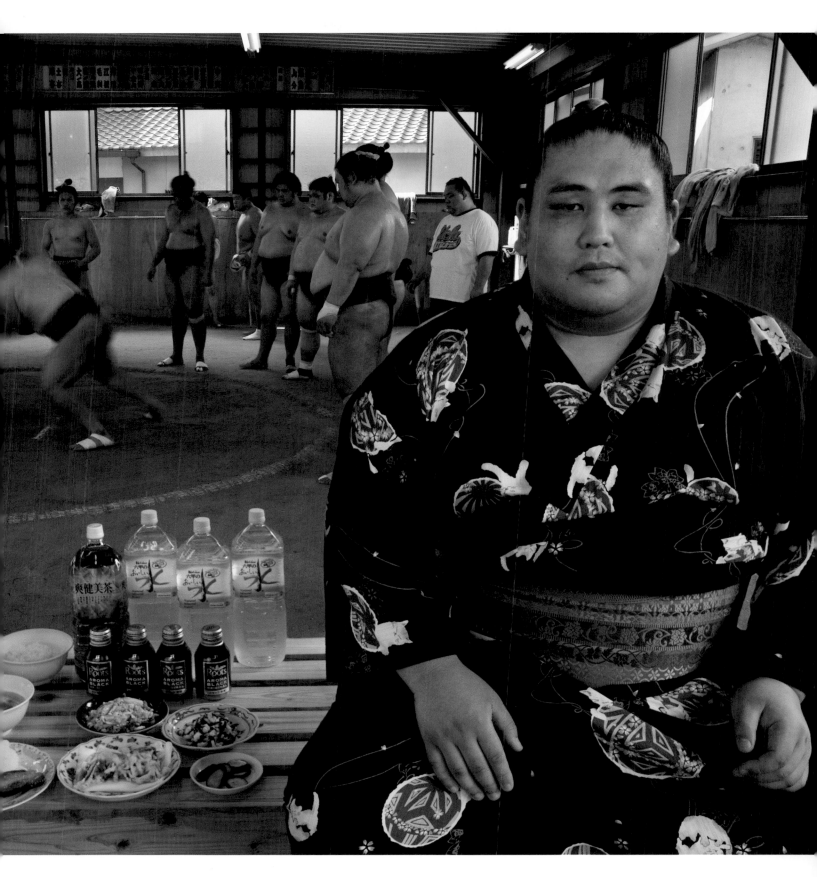

Takeuchi Masato, a professional sumo wrestler whose ring name is Miyabiyama (meaning "Graceful Mountain"), in the team's practice ring with his typical day's worth of food. In Nagoya, in preparation for a tournament, Miyabiyama's stable runs through a brutal three-hour practice—sweaty, combative, and silent. Miyabiyama wears the white *mawashi* (at left) denoting his *sekitori* status during practice. His food may not look like much for a 400-pound man, but it's enough to maintain his weight and give him energy for the ring. When he isn't in intensive training before a match, he is wined and dined nightly by sponsors. The portrait above is a composite, taken on two consecutive days: the sumo association wouldn't allow Miyabiyama to be photographed during practice.

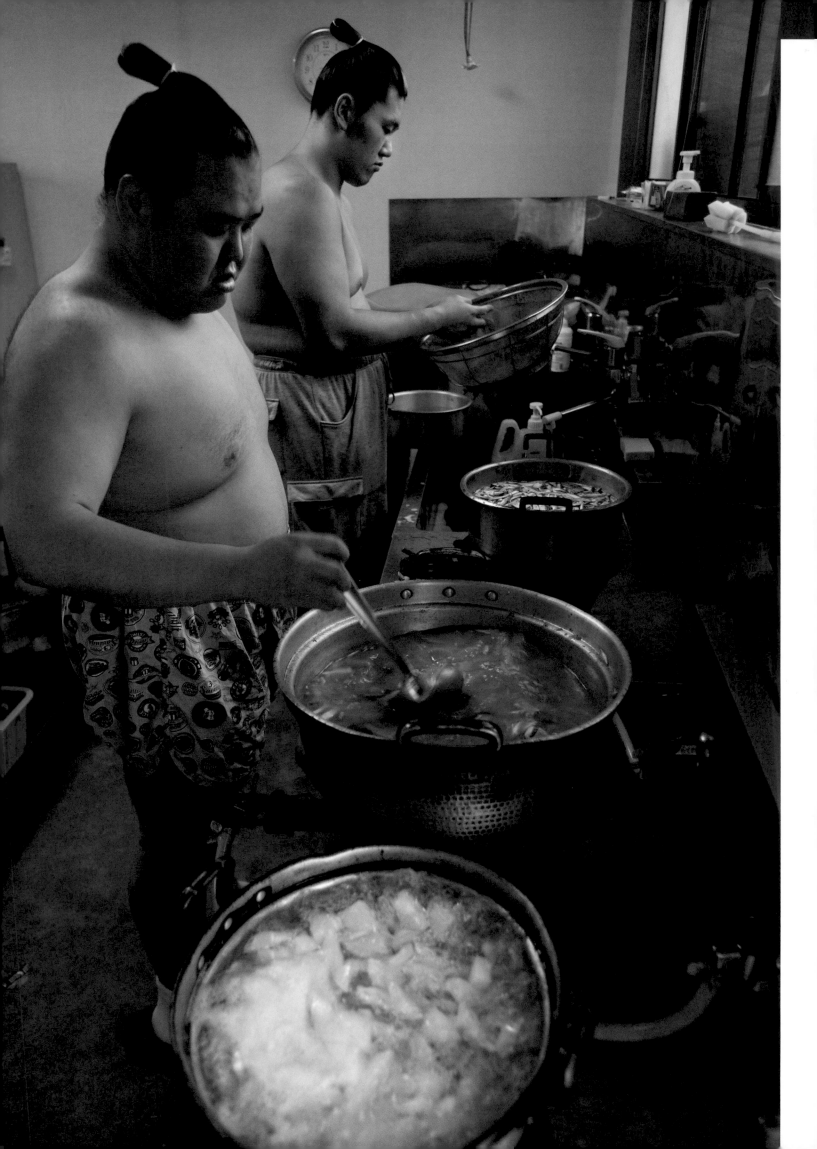

Upper-echelon fighters—called *sekitori*—have their own rooms and eat first, but no one eats in the morning. The junior fighters begin practice at 5 a.m. in black *mawashi* (loincloths) and are joined later by the *sekitori*, wearing white. All take only ritual sips of water during practice, which can last three or four hours. The first meal of the day is lunch.

Lunch and dinner consist of mountains of rice, pasta, and a high-protein vegetable stew with meat or fish, called *chanko nabe*, which, when cooked well, uses bone marrow and long cooking times to develop flavor. When cooked fast by busy wrestlers, the stew base often consists of packaged broth, but the result is slurped down with gusto nonetheless.

There is a right way to pack on the pounds, says Miyabiyama: "I'm very fussy about food. When I see the younger [wrestlers] eating foods that aren't good for them just to gain weight, I say something about it. Cakes, cookies, sweets, and chips aren't helping them to gain weight healthily." He says that the *rikishi* don't talk too much about nutrition, but that "wrestlers are susceptible to diabetes—we talk about that."

When we visit, the atmosphere is relaxed and collegial as the lower-ranked wrestlers cook. This is the kitchen for their training camp in Nagoya, where the club's top wrestlers will compete in a week's time. The *rikishi* carted the contents of the Tokyo kitchen to Nagoya and cooked the following day as though they hadn't moved hundreds of miles.

They chop vegetables on long stainless steel countertops, grate white radish into snowy white mounds, and open cans of mackerel, which two men dump on plates and sprinkle with ground chilies.

The chief chef, Akira Nagai, tastes a sumo-sized pot of *chanko nabe* simmering on the stove. He adds sake and tastes it again. "I need to teach someone to taste, so that when I die..." The chef, who is also a wrestler, says this to no one in particular, trailing off as he grabs a pair of chopsticks to test the *gobo* (burdock root), which he has braised with soy sauce, sesame oil, sesame seeds, and chili peppers.

The chef splits the dish between several plastic plates as others move the pots of soba noodles, cooked pasta, and steamed rice from the kitchen to the adjacent room, where eating has already begun. The kitchen is large, but it seems small because of the size of the men in it. "Oh, you're too fat," says one *rikishi* to another as he tries to sidle by with a pan full of grilled chicken breasts.

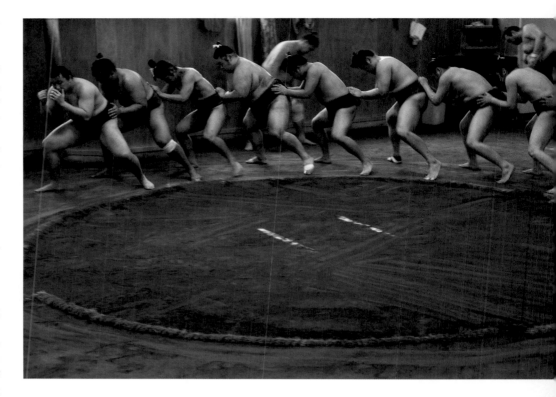

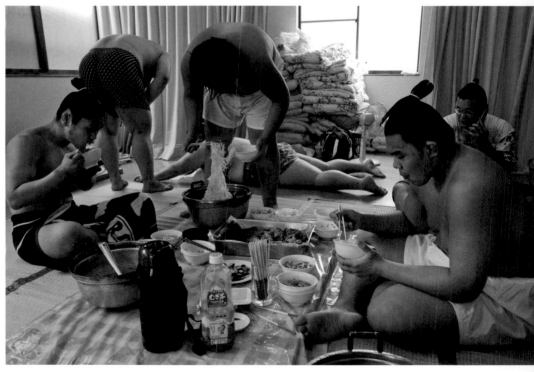

Younger, smaller, and less experienced members of the stable wear black loincloths. At the end of a grueling morning practice in their Tokyo ring, they finish with exercises emphasizing team unity (top right). The wrestlers take turns cooking (at left), and the younger ones do most of the work. Their dining area is also their sleeping area (bottom right). All the wrestlers eat together on tatami mats; the bedding is stacked up at the rear. Because younger wrestlers must bulk up to fighting weight, they're encouraged to eat and eat and eat. Sponsors pay for most of the food, but it isn't always Japanese fare: "If I serve fast food, it goes faster than the Japanese food," says the chef.

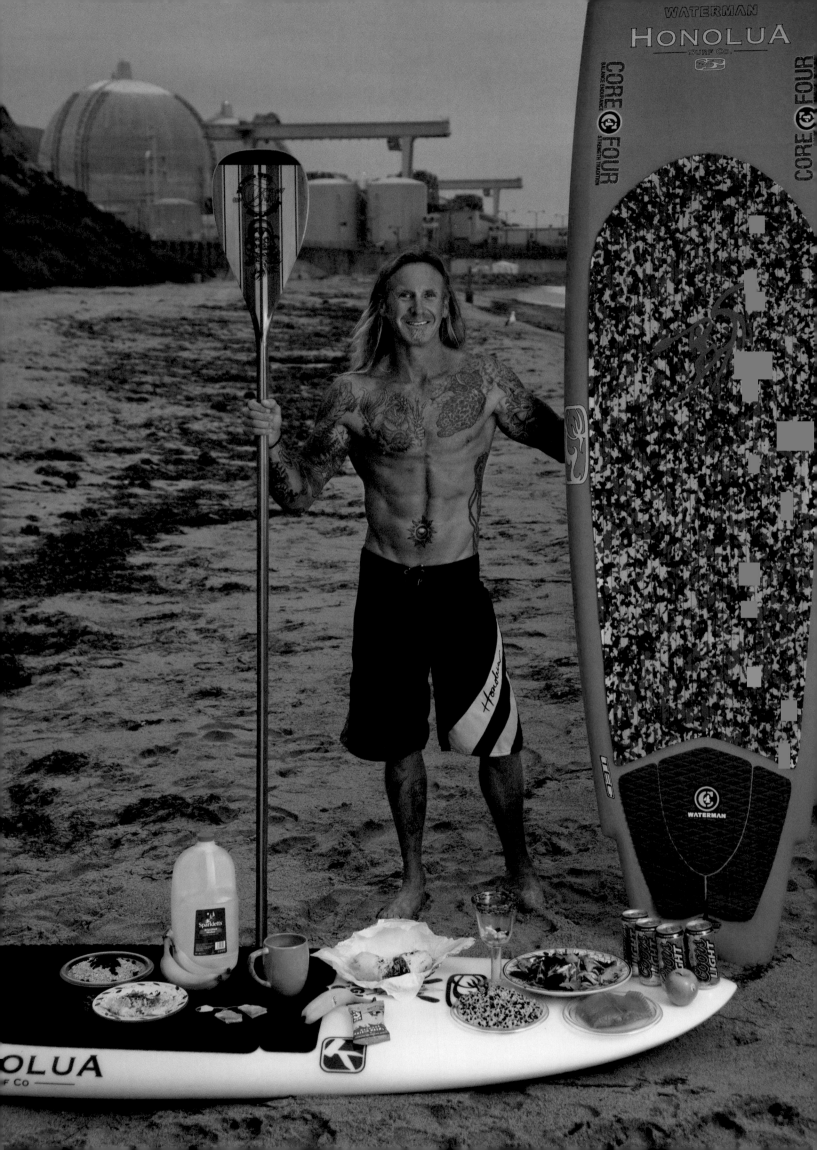

USA

Ernie Johnson
The Paddle Surfer

ONE DAY'S FOOD

IN SEPTEMBER

BREAKFAST *Kirkland Signature* liquid egg whites with hot sauce and black pepper, 8.4 oz; cooked with olive oil, 1 tsp • *Coach's Oats* oatmeal, 3.7 oz; with *Ocean Spray Craisins* (sweetened dried cranberries), 0.4 oz • Bananas (2), 12 oz • Green tea, 12 fl oz

LUNCH White-meat chicken burrito with pinto beans and salsa from Las Golondrinas restaurant, 1 lb • Banana, 6 oz

DINNER Salmon filet, 9.4 oz (raw weight) • *Trader Joe's* long-grain brown rice with black barley and daikon radish seeds, 9.5 oz • Salad of lettuce, bell pepper, tomato, carrot, and mushroom, 4.9 oz; with *Bernstein's* Italian dressing, 2 oz • *Coors Light* beer (4), 47 fl oz

SNACKS AND OTHER *Clif Bar*, oatmeal raisin walnut, 2.4 oz • Apple, 5.5 oz • *Sparkletts* bottled water, distilled, 1 gal • Supplements: mu timineral; arginine (amino acid); B complex; beta-carotene; calcium; fish oil; glucosamine chondroitin; milk thistle; tryptophan (amino acid)

CALORIES 3,500

Age: 45 • Height: 5'10" • Weight: 165 pounds

SAN ONOFRE, CALIFORNIA • Ernie (EJ) Johnson and his wife, Andie, live aboard their 38-foot sailboat in the harbor at Dana Point, south of Los Angeles. He's a finish carpenter by trade and a longtime surfer who found his niche in 2006: stand-up paddle surfing.

Several days a week EJ can be found standing around on the waves sweeping the ocean with a long-handled paddle. "Yeah, they call us janitors of the sea," says EJ, laughing. With his board and paddle, he can navigate and accelerate to go after the big swells, and also turn on a dime if he needs to. Stand-up paddle surfing, which dates back to Hawaii in the 1920s and 1930s, has become a popular competition sport in both quiet harbors and rough ocean waves.

EJ's long blond hair makes him easy to spot on the horizon. "I've been a long-haired guy all my life. Anyone can do the buzz-cut; it takes dedication to have long hair," he says. He's equally dedicated to eating habits honed since age 18, when he started weight training. "No junk food," he says emphatically. He drinks protein shakes made with skim milk and banana, eats only the whites of eggs, and chooses foods that are labeled organic:

Ernie Johnson, a finish carpenter and paddle surfer, near the San Onofre Nuclear Generating Station with his typical day's worth of food. At right: EJ and Andie dine on grilled salmon.

"Big spinach salads with bell peppers and tomatoes, wild fish, organic chicken breasts—that's pretty much all week." He drinks two to six beers or has wine most nights. "Don't tell my doctor," he jokes.

Although he and Andie usually buy fish locally, occasionally they take the boat out to spear wild fish. "We'll go 20 miles out and find kelp—dive in and shoot the big fish underneath. It's pretty exciting stuff," he says.

The beach he prefers for paddling is directly opposite the nuclear power plant in San Onofre; it's not crowded and is dog-friendly—much appreciated by his dog, Taco. None of the regulars are phased by the plant. "I'm not really bothered. I surf mostly right out in front of it. Fishermen tell me they catch odd fish around there... That's when I say, 'Hey, maybe I'll have some three-eyed fish for dinner...' We have warning sirens that they test biannually; when they go off it kind of makes you think, 'Whoa, hopefully that will never happen.'"

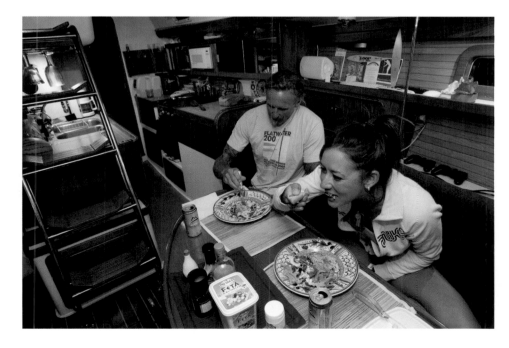

3600

USA

Bob Sorensen
The Greenskeeper

ONE DAY'S FOOD

IN SEPTEMBER

BREAKFAST *Eating Right Granola Cereal* with raisins, 2.9 oz; with *Lucerne* skim milk, 4.8 fl oz • Coffee, 8.5 fl oz

LUNCH Peanut butter and jelly sandwich: *Oroweat Original Oatnut* bread, 3.1 oz; *Safeway* peanut butter, chunky, 2.2 oz; *Safeway* jam, apricot, 1.2 oz • *Mission* tortilla chips, 4.1 oz; with *Safeway* salsa, fresh, 5.3 oz • *Nature Valley* granola bar, peanut butter, 1.5 oz • Apple, 5.9 oz

DINNER *Safeway* spirelli pasta, 3.4 oz (dry weight); with a sauce of *Hillshire Farm* sausage, tomato, zucchini, squash, and bell pepper, 1.3 lb; cooked with olive oil (not in picture), 1 tbsp • *Safeway* crescent rolls (3), 2.6 oz • *Tecate* beer, 12 fl oz • *Safeway Select* fat-free frozen yogurt, vanilla, 7.5 oz

THROUGHOUT THE DAY Tap water, 1.1 gal

CALORIES 3,600

Age: 25 • Height: 5'11" • Weight: 175 pounds

GRAND JUNCTION, COLORADO • Before sunrise, a small army of groundskeepers swarms over the lush, hilly course at the Golf Club at Redlands Mesa, in the high desert foothills of western Colorado. Assistant superintendent Bob Sorensen is here, directing the care of the very green grass and repair of yesterday's divots on the 18-hole custom course.

The Grand Junction native worked at a different course when he was growing up, then studied criminal justice in college. "I studied at Mesa State, right here. I was about to take a job in my field, and I just couldn't do it. I love being outdoors. I couldn't see myself sitting behind a desk." So he earned an online degree in turf grass management

and took his current job at Redlands Mesa.

The course is nestled in a winding canyon between towering, flat-topped red and gold mesas, surrounded by multimillion-dollar homes. Do golfers ever drive their carts off the narrow winding paths while swept up by the breathtaking view? "They're pretty focused on their game," he says, "but some of the steeper pathways do present a challenge."

One perk of the job is the chance to play the course himself, but there's no time during football season because he coaches the varsity team at the high school where his wife teaches. "It's every afternoon after work," he says—and getting home late on game nights.

He does make time for a backyard garden, which means homemade soup or pasta with whatever is ready for harvest—zucchini, tomatoes, and peppers—and cucumbers for fresh salad. "We'll throw a few sausages in there sometimes," he says, and he has a weakness for refrigerated crescent rolls. On game nights though, it's pizza out. There's a glass of beer or wine at night, and water throughout the day.

Breakfast most mornings is granola and a cup of black coffee, and he usually brings lunch to work—leftover soup or a peanut butter and jelly sandwich, chips and salsa, a granola bar, and an apple. "Pretty much the same thing every day," he says.

Bob Sorensen, a golf course assistant superintendent, on the fairway of the twelfth hole at the Golf Club at Redlands Mesa with his typical day's worth of food. Switching career paths from criminal justice to turf maintenance enabled Bob to escape a desk job and work outdoors in a picturesque Western landscape. Some of his work is physical, but technology makes his irrigation chores easier. From one of many rock outcrops overlooking the lush fairways and greens in the dry, high desert valley, he can control a matrix of sprinklers with a single radio controller. At left: In his backyard garden, Bob picks vegetables while his dog romps with a friend.

3500–3900

Robina Weiser-Linnartz, a master baker and confectioner, in her parent's bakery with her typical day's worth of food. She's wearing her Bread Queen sash and crown, which she dons whenever she appears at festivals, trade shows, and educational events, representing the baker's guild of Germany's greater Cologne region. At the age of three, she started her career here, in her father's cellar baking room, helping her parents with simple chores like sorting nuts. Her career plan is to return to this bakery, which has been in the family for four generations, in a few years. She will remodel the old premises slightly to allow customers the opportunity to watch the baking process, but plans to keep the old traditions of her forebears alive.

GERMANY

Robina Weiser-Linnartz
The Bread Queen

ONE DAY'S FOOD

IN MARCH

BREAKFAST Walnut roll, 3.8 oz; with ham, 0.6 oz; and *Thomy Gourmet-Remoulade* mayonnaise with herbs, 1 tbsp • Croissant, 2.5 oz • Banana, 4.8 oz • *Danone Actimel* probiotic drink, 3.4 fl oz

LUNCH Whole grain bread, 3.1 oz • Ham, 1.2 oz • Bologna, 0.8 oz • Lachsschinken (smoked pork loin), 0.6 oz • Gouda cheese, 1.6 oz • *Thomy Delikatess-Senf* mustard, 2 tsp • *Thomy Gourmet-Remoulade* mayonnaise with herbs, 1 tbsp

DINNER Radiatori pasta, 1.1 lb; with homemade Bolognese sauce, 1.4 lb

THROUGHOUT THE DAY "Muddy water" (apple and grape juices, diluted with water), 1.6 qt • *Hohes C* orange juice, diluted with water (2), 9 fl oz • *Schloss Veldenz* grape juice, diluted with water, 7.9 fl oz • *Belsina* apple juice, diluted with water, 7.2 fl oz • Fennel tea, organic (4), 13.5 fl oz • *Wrigley's* gum, 1 piece

CALORIES 3,700

Age: 28 • Height: 5'6" • Weight: 144 pounds

COLOGNE • Robina Weiser-Linnartz, a fourth-generation master baker and confectioner, is the first Bread Queen of the bakers association of the greater Cologne area, and takes the title very seriously, making appearances throughout the region on behalf of her peers in the regional baker's guild to showcase the centuries-old German profession of making bread by hand. This is continuing education for a public that has begun to replace handcrafted baked goods with less expensive baked goods from supermarkets and discount chains. "I use this honor to show people the intense feeling I have for this profession," Robina says, "to explain how master bakers work—the importance of the work, that we not lose it. In Germany, we have a lot of firms now who make bread not with their hands but with machines."

For centuries Germans have had easy access, via small family-owned neighborhood bakeries, to high-quality baked goods: dense sourdoughs, ryes and pumpernickels, black breads, *Brotchen* (hard breakfast rolls), and regional specialties like soft pretzel bread speckled with rock salt—*Laugenbrezeln* (lye-bathed pretzel bread)—not to mention cakes and sweets. But industrial bakeries are inexorably nibbling at the customer base. Many of Germany's family-run bakeries are closing, and its master bakers are leaving the profession.

Robina grew up living over the 100-year-old bakery that her parents, Detlev and Barbara, still run, one block west of the Rhine River in north Cologne. "It's a bakery shop and a little café," she says, "about 30 seats, very close together." The baking ovens are in the cellar and there's an 85-year-old oven. "You have to fire it with coal." She did her apprenticeship here, before going on to complete her master's in baking and confectionery. Her brother is in the business as well.

"When I was three and could first climb down the stairs to the cellar," she says, "my first work was to sort nuts. And I think my parents did this very well with me. They never said, 'You have to do this.' They always said, 'It's interesting. Do you want to help us? It tastes good, and you can make people happy by baking a bread or making a cake.'"

Robina's plan is to take over the business when her parents retire, modernize it a little, and keep tradition alive, but currently she plies her trade in a more modern sector of the economy. In the morning, when she arrives at Bastian's, an upscale investor-owned café and bakery in Cologne's trendy downtown pedestrian zone, her father has already been baking for three hours in his shop across town. "A normal bakery like my father's opens at 6 a.m.," she says, to serve the morning customers, but

The Cologne Cathedral, a World Heritage Site, is illuminated against the predawn city skyline (top left). At dawn, 10 blocks from the Cathedral, Robina begins her baking duties at Bastian's (at right), weighing then shaping the dough that one coworker has mixed and another coats with sunflower seeds. By midmorning, she goes into confectionery mode, topping tarts with frozen berries (bottom left).

Bastian's caters to a downtown shopping and business crowd and doesn't open until 8 a.m. "No one is around here early," Robina says.

The restaurant, styled as a Viennese café with bakery, uses organic and natural ingredients and a European fusion approach to its menu, and handcrafted baked goods are integral. She and her colleagues work behind a large window mixing and kneading dough, forming loaves, and dredging them in shallow trays of oats and various seeds. She lifts a heavy pallet of loaves with a colleague, and her considerable baker's biceps bulge. "It doesn't look so pretty when I have a dress on," she says, laughing, referring to her queenly duties.

By 7:30 a.m. she has moved to the confectionery and prepares the days pastries: sand cakes, decadent chocolate desserts, marble cakes, and fruit tarts. "We have a little fight between confectioners and bakers," she says, laughing. "It's like cats and dogs. The confectioners say, 'We are the greatest.' And the bakers say, 'Ah, they are just artists. They don't work really.'" How is what they make here different from what her father makes? "My dad makes the same things," she says, "but not the same volume. A bit more confectionery, especially on Sundays. He's got a lot more cakes with creams, butter creams, fruits."

Her life isn't all work. There's also her horse Zorro at the stable where she has ridden for two decades, choir practice some nights, and her husband Sven, whom she doesn't see as much as she'd like because their schedules misalign.

She says that when she joins her family's bakery again, "My father's intention is, we will work two years side by side, and then he will grow the tomatoes in back and I will do the baking." Robina points to her last year's Christmas present to her parents, a placard hung in the bakery that reads *Brot unentbehrlich fur alle!* Everyone needs bread!

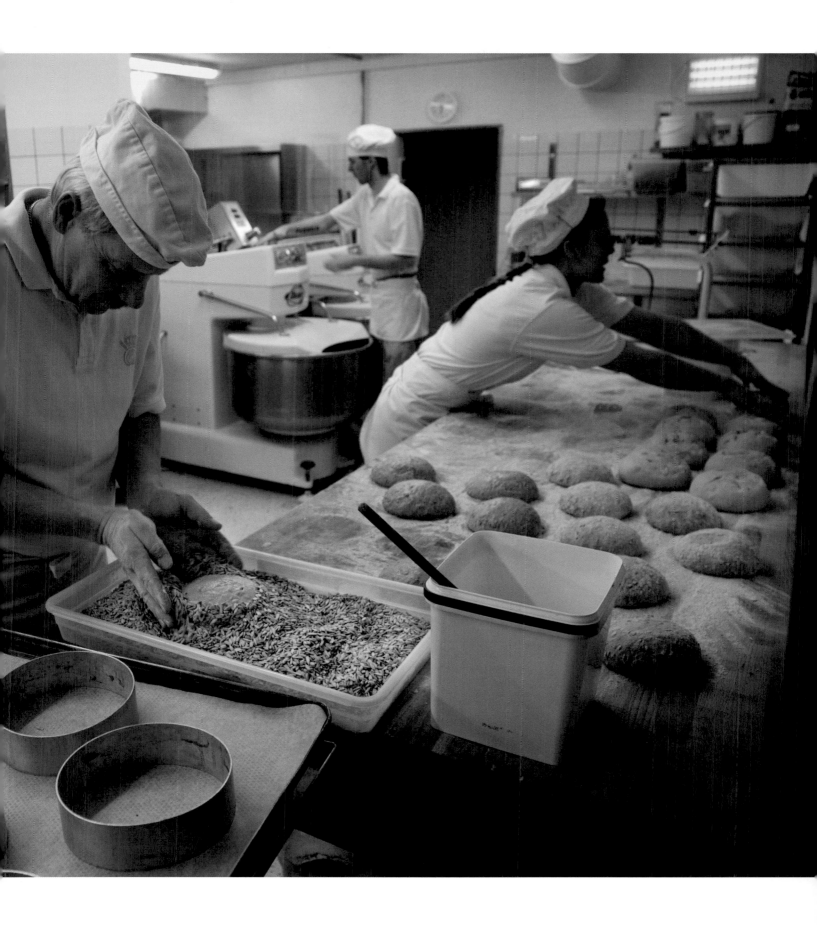

3700

USA

John Opris
The Wind Farm Engineer

ONE DAY'S FOOD

IN JULY

BREAKFAST *Raley's Fine Foods* oatmeal, 11.3 oz; with brown sugar, 1.5 oz; and *Raley's Fine Foods* raisins, 1.5 oz • Coffee, prepared at home, 16 fl oz; with cream (not in picture), 1 fl oz • *Burger King* coffee with cream (en route to work), 16 fl oz

LUNCH Turkey sandwich: multigrain bread, 2 oz; turkey, 4 oz; tomato, 2 oz; lettuce, 0.9 oz; Cheddar cheese, 0.5 oz; mayonnaise, 1 tbsp; mustard, 1 tsp • Apple, 7.1 oz • *Coca-Cola Plus*, diet, 12 fl oz

DINNER Ravioli filled with artichoke and cheese, 10 oz; and *Bay Area Herbs and Specialties* basil, 0.2 oz; with olive oil, 2 tbsp; and melted butter, 1 tbsp • French bread, 3.9 oz • *Nob Hill Trading Co.* Asiago cheese, 1.4 oz • *Fresh Express* baby lettuce spring mix, 5.9 oz; with *Hidden Valley* buttermilk ranch dressing, 2.6 oz • *Forest Ville* Zinfandel (2), 12 fl oz

SNACKS AND OTHER *Odwalla* cereal bar, chocolate chip peanut, 2.2 oz • *Kraft* mozzarella string cheese, 1 oz • Black tea (2), 16 fl oz • *Arrowhead* bottled water, 24 fl oz

CALORIES 3,700

Age: 50 • Height: 5'10" • Weight: 180 pounds

BIRDS LANDING, CALIFORNIA • Although John Opris grew up on typically American fare, his Romanian roots feed his earliest memories of holidays at home. His mother would make *mamaliga*, a traditional eastern European cornmeal porridge similar to polenta and prepared with varying degrees of firmness and ingredients. "The version my mother makes is very rich, hearty, soft, multilayered, and has sour cream and cream cheese," he says.

Travel broadened the wind engineer's eating habits—most dramatically when he went to Spain in the 1990s for work and tasted eggs cooked in olive oil for the first time: "I never recall my family using olive oil much or at all, probably because it was more expensive," he says. He brought the taste for it home to his wife and children.

John's wife, Cathy, did most of the cooking when their three children were young—

chicken dumplings, pot roast with potatoes, and "Waikiki" meatballs made with ginger and pineapple. But as the children got older, John began to cook more, making homemade ravioli or tacos with a surprising blast of soy sauce as he played with a concept he learned while watching food television: umami, the so-called fifth flavor (after sweet, sour, salty, and bitter), in this case imparted by glutamate, an amino acid found in tomatoes and salt-cured and fermented products like soy sauce and ham.

He's a self-admitted food show addict. "I like cooking shows," he says. "I started with Graham Kerr's *The Galloping Gourmet* in the 60s and 70s as a kid, and PBS had shows like *Cooking at the Academy* (from the California Culinary Academy).

"Later, my wife found some of those tapes at the library. I learned a lot from them." Does he watch modern cooking shows? "I enjoy the older programming; however, the Food Network is great. *Good Eats* is one of my faves. Food and quasi–food science—that's what I like. I have cooked a lot of the [dishes] and gotten some good ideas on technique."

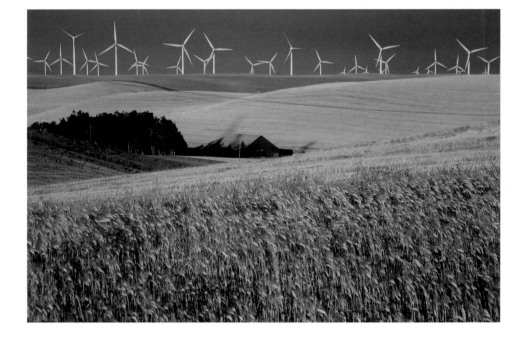

John Opris, a wind farm operations manager for enXco, with 265-foot wind turbines and his typical day's worth of food. Each wind turbine produces enough electricity per year to power 350 average-size California homes.

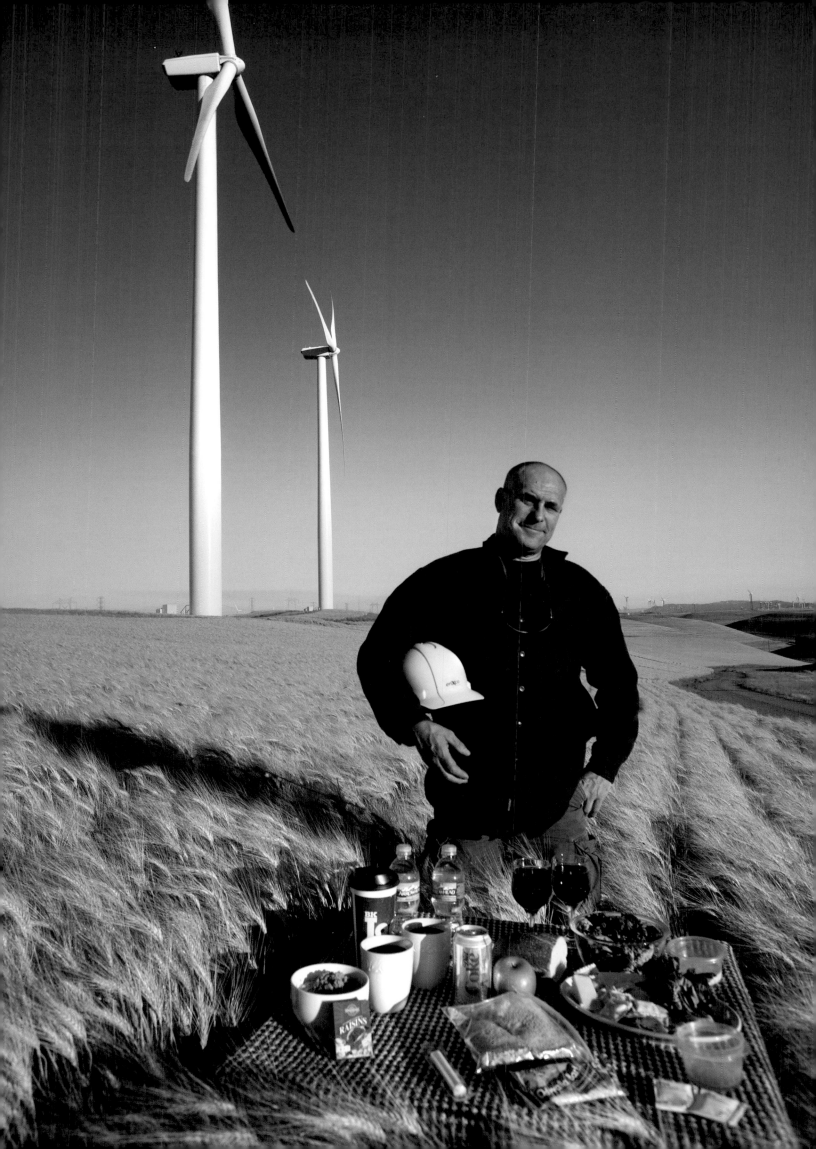

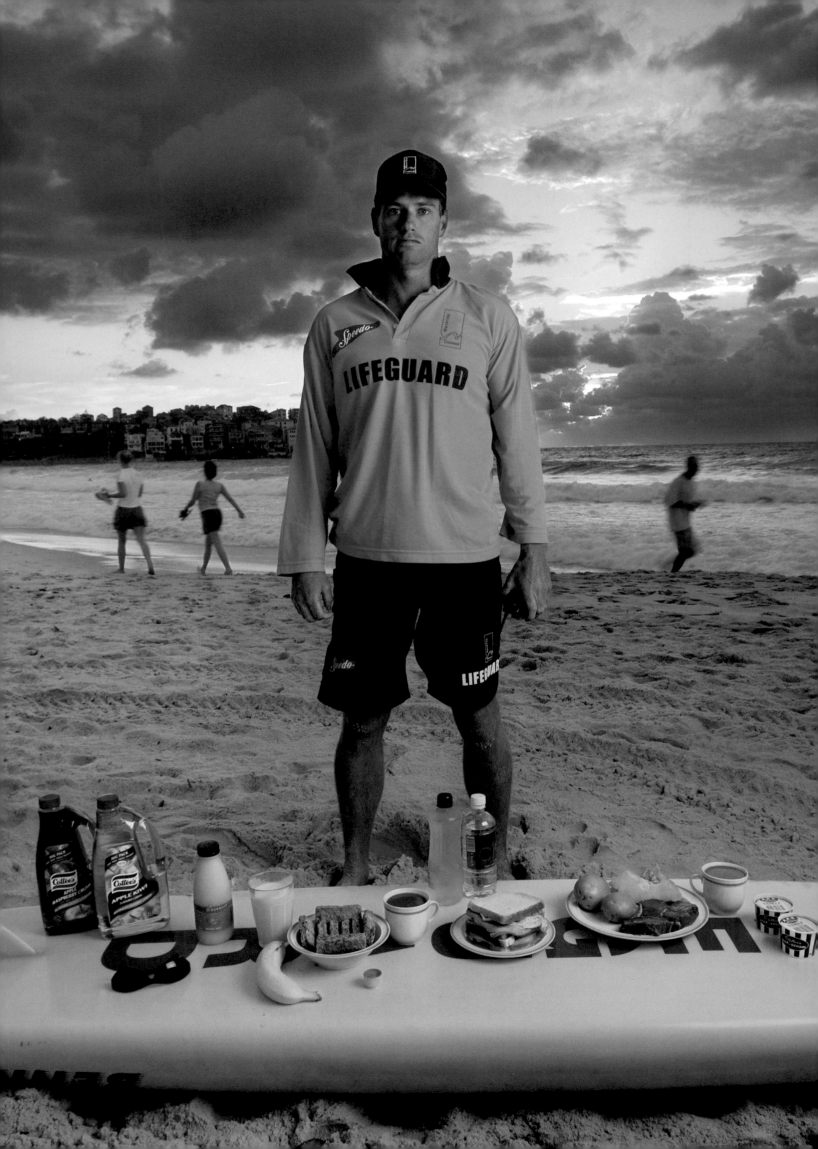

AUSTRALIA

Bruce Hopkins
The Lifeguard

ONE DAY'S FOOD

IN FEBRUARY

BREAKFAST *Weet-bix* cereal, original, 4.7 oz; with skim milk, 10 fl oz; and honey, 1 tbsp • Banana, 4.2 oz • Orange juice, 16.9 fl oz • Coffee, 9 fl oz; with skim milk, 1 fl oz

BAG LUNCH Ham sandwiches (2): white bread, 5.5 oz; ham, 2.5 oz; lettuce, 1.1 oz; mustard, 2 tbsp

DINNER Beef filet, 10.1 oz (raw weight) • Red potatoes, 6.3 oz; and pumpkin, 7.1 oz; cooked with vegetable oil, 1 tbsp • *Cadbury* ice cream, vanilla (2), 8 oz • Coffee, 9 fl oz; with skim milk, 1 fl oz

THROUGHOUT THE DAY *Cottee's* cordial drink, apple raspberry, 2.1 qt • *Cottee's* cordial drink, apple kiwi, 2.1 qt • Tap and bottled water, 1.1 qt

CALORIES 3,700

Age: 35 • Height: 6' • Weight: 180 pounds

BONDI BEACH, NEW SOUTH WALES • A day at the beach is no picnic for the lifeguards of Australia's celebrated Bondi Beach. On a busy day, 8 to 10 lifeguards and a cadre of volunteers can be responsible for as many as 40,000 people. "Sometimes it's a sea of heads," says Bruce "Hoppee" Hopkins, a longtime lifeguard who manages the guard staff, "so many that you can't see the sand."

Surf lifesaving is a time-honored profession in Australia, a country of swimmers with a predominantly coastal population. The company Speedo originated here, and lifeguards and casual beachgoers alike grow up swimming in the ocean.

Bruce, married with two children, trains hard two times a day, six days a week, to keep in shape. He's not much of a snacker and drinks alcohol only when out with friends. His diet is largely low-fat, except for ice cream a few times a week. In his twenties, Bruce used protein powder when he competed in the Iron Man circuit, but then he quit: "You don't want to be big and bulky if you're swim-

ming," he says. "It just slows you down."

Has anything changed in the time that he's been saving lives on the Australian coast? Beachgoers are getting noticeably bigger—and overweight swimmers are harder to rescue. The protocol is to paddle out to distressed swimmers, pull them onto the surfboard, then pin them to the board with your chest and ride to shore on the next wave. "It's harder to get them on the board," he says. "And they're the ones who have to be rescued more often."

Bruce Hopkins, a Bondi Beach lifeguard, with his typical day's worth of food. Australia has 10,685 beaches and the world's highest incidence of skin cancer.
Above: An annual 2-kilometer (1.25-mile) ocean race at Bondi Beach attracts hundreds of swimmers.

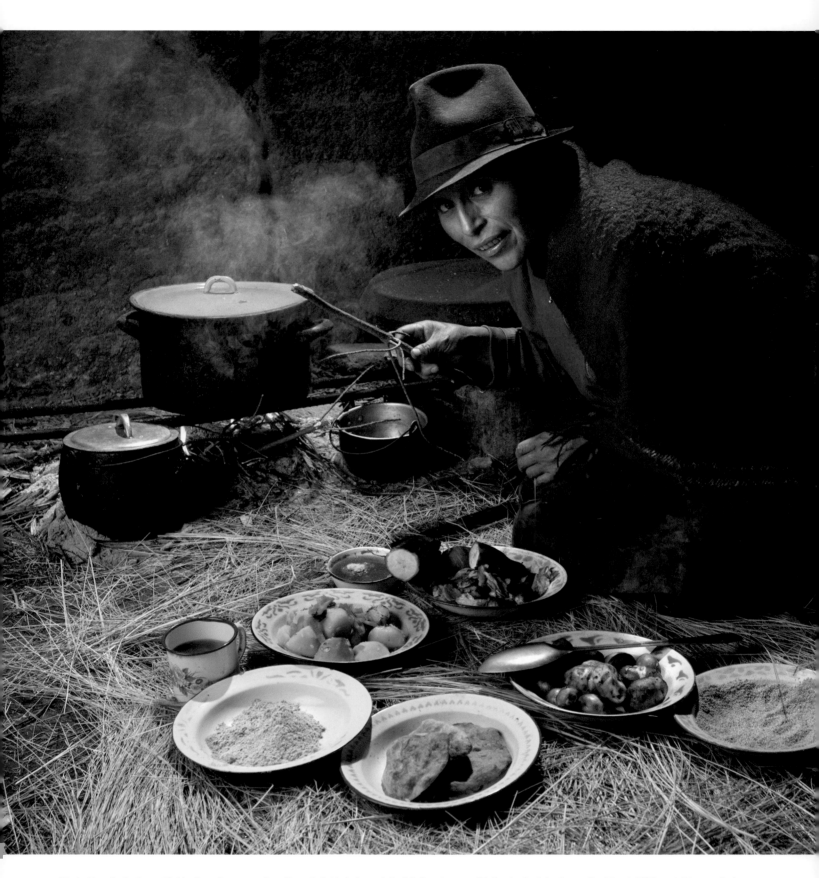

Maria Ermelinda Ayme Sichigalo, a farmer and mother of eight, in her adobe kitchen house with her typical day's worth of food. With no tables or chairs, Ermelinda cooks all the family's meals while kneeling over the hearth on the earthen floor, tending an open fire of sticks and straw. Guinea pigs that skitter about looking for scraps or spilled grain will eventually end up on the fire themselves when the family eats them for a holiday treat. Because there is no chimney, the beams and thatch roof are blackened by smoke. Unvented smoke from cooking fires accounts for a high level of respiratory disease and, in one study in rural Ecuador, was accountable for half of infant mortality.

ECUADOR

Maria Ermelinda Ayme Sichigalo
The Mountain Farmer

ONE DAY'S FOOD

IN SEPTEMBER

BREAKFAST Empanadas (fried turnovers) filled with cheese, 8.1 oz • Chapo (toasted barley and wheat flours, mixed with instant coffee, panela [hard brown sugar], and hot water), 7.5 oz • Panela mixed with hot water, 6.4 fl oz

LUNCH Barley flour, added to water to make barley flour soup, 10.6 oz • Boiled potatoes with carrots and green beans, 1.4 lb

DINNER Salad of lettuce, potato, and carrot, 15.2 oz • Green plantain, 3.5 oz • Yellow plantain, 7.8 oz

SNACKS AND OTHER Roasted potatoes, 1.4 lb • Machica (toasted barley and wheat flours), added to hot water throughout the day, 4.6 oz • Water from a nearby spring, for cooking, 2.1 qt

CALORIES 3,800

Age: 37 • Height: 5'3" • Weight: 119 pounds

TINGO, THE ANDES • The steep slopes that Maria Ermelinda Ayme Sichigalo, her husband, Orlando, and their eight children farm in the high central Andes are much less fertile than the fields farther down the mountainside toward the market town of Simiatug. But this is the area that their families have farmed for generations, and the land below is too expensive, says Orlando, who is a local tribal representative.

The family grows root vegetables and wheat and, together with their extended family, own a flock of sheep. Between harvests they sell a sheep or two to buy grain, vegetables, and *panela* (hard brown sugar) at the weekly market in the valley, but they seldom eat the sheep themselves. Their animal protein comes from eggs and the occasional chicken that no longer lays eggs, or in small bites on holidays when they eat the *cuy* (guinea pigs) that scamper around the warmth of the kitchen fire, nibbling grasses and spilled grain.

Ermelinda is a midwife who practices medicinal healing. She gathers mountain herbs and brews herbal teas for all manner of sicknesses, especially for the ailments of women, she says. But the range of her jobs exceeds the hours in the day. There are many mouths to feed, animals to provide care for, and fields to plant, hoe, and harvest. She does all of this with a baby in a sling on her back, moving up and down the steep

mountain paths seemingly without effort.

To accomplish these feats during the long, cold, and windy days at 11,000 feet, she eats a lot—and often. After a breakfast of cheese empanadas and *chapo*—a thin porridge of toasted barley and wheat flours mixed with instant coffee and *panela*—she snacks on tiny roasted potatoes and *machica*, toasted barley and wheat flours mixed with hot water, throughout the day. On the days she doesn't eat empanadas her favorite food, she eats plantains, but she always has *chapo*. Carrots from their fields and plantains from the lower regions also provide fuel for Ermelinda's long, physically demanding days.

The entire family loves *panela*. They eat it bit by bit or dissolve it in hot water to make a sweet energy drink. They buy large blocks of it on market day, and Ermelinda carries all of their purchases home, strapped on her back along with the baby. She rarely has the helping hands of her children on market day. "They ask for everything," she says; when possible, she leaves them at home.

For a rare treat, Ermelinda and Orlando might indulge in lunch at a Simiatug market stall: sheep's head stew, or small pieces of pork or lamb atop shredded lettuce and tomato, served on a bed of rice. Either of these would cost about $1 (USD)—usually too expensive when compared to a 100-pound bag of potatoes selling for $4 (USD).

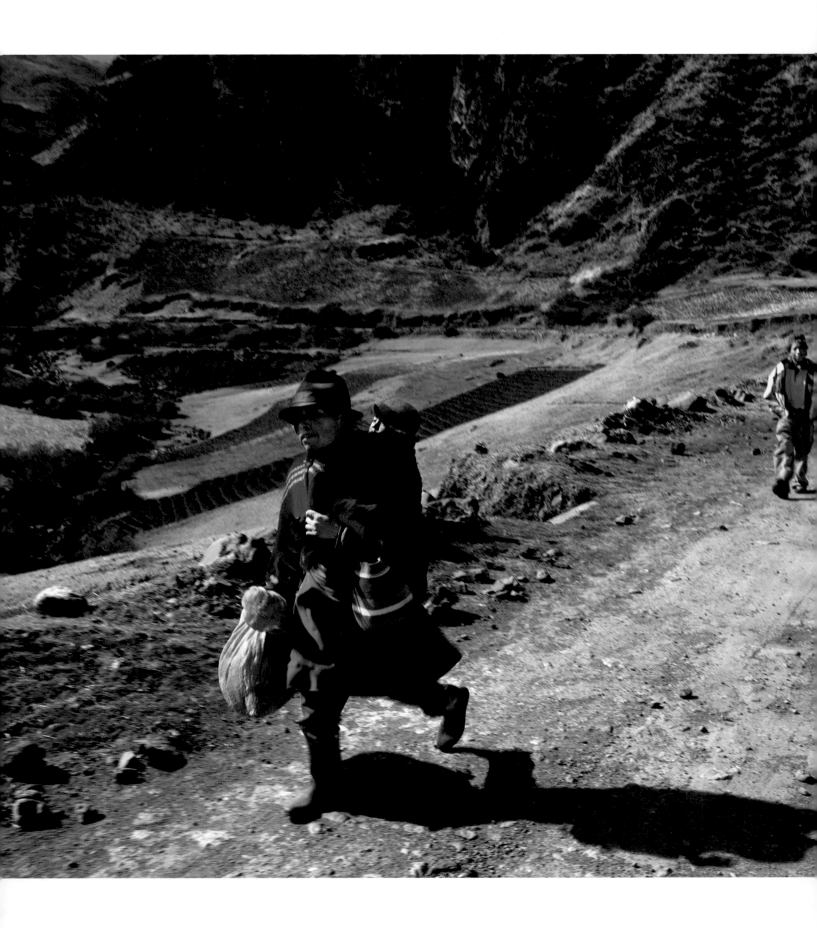

Ermelinda, with Orlando Jr. on her back, and her husband, Orlando, their son, Moises, and two sheep, trek an hour down to Simiatug for the weekly market (at left). Together, the two sheep fetch $35 (USD) at the market (top right). Bottom right: Sitting on the ground and on small stools in the cooking house, four of Ermelinda's children eat a breakfast of empanadas and soup.

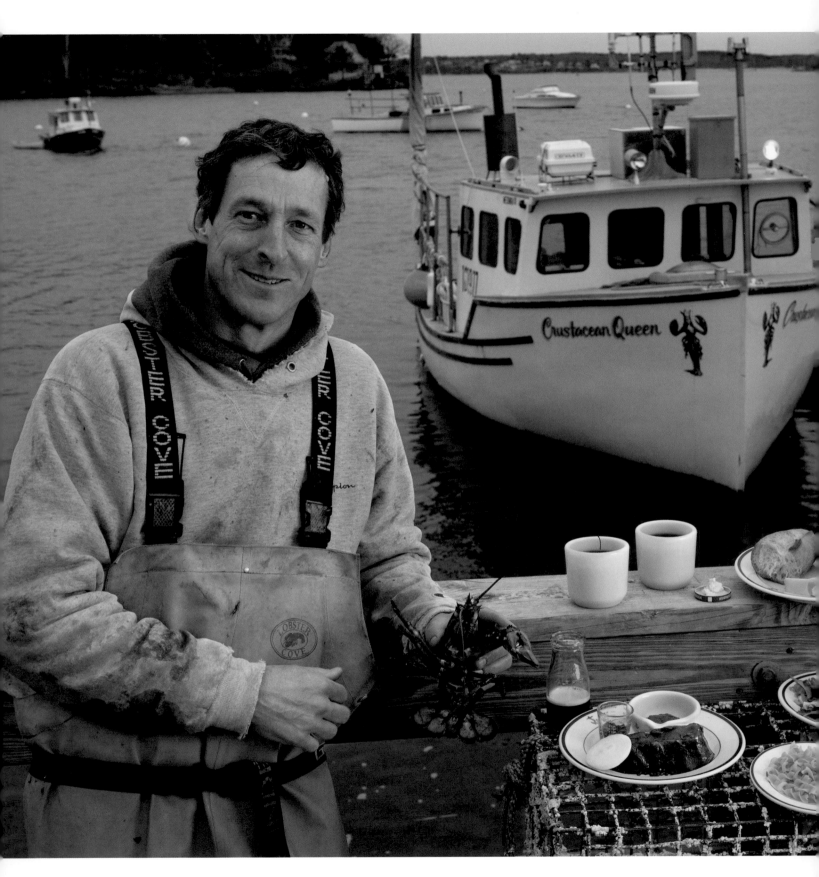

Sam Tucker, a lobsterman, in front of his boat at the Great Diamond Island dock with his typical day's worth of food. Sam works the lobster boat by himself, saving on labor, but in the summertime his son Scout comes along. "He's a blast," says Sam. "I take him and some of his friends out; they're all just leaning over the rail in their life preservers looking to see what's in the trap when it comes up. They're pretty good at saying, 'He's got a keeper.'" Sam's state license restricts his traps to the bay, where he averages only one lobster for every two traps. After paying for fuel and bait, there's not much profit. He supplements his income with fish auction commissions, and his family's diet with venison culled from the island's deer population.

USA

Sam Tucker
The Lobsterman

ONE DAY'S FOOD

IN MARCH

BREAKFAST *Kellogg's Mueslix* cereal, 5.1 oz; with *Oakhurst* whole milk, 4 fl oz • *Tropicana* orange juice (not in picture), 6.8 fl oz • *White Coffee* decaffeinated coffee, Seville orange flavored (2), 16 fl oz; with *Oakhurst* whole milk, 2 fl oz

BAG LUNCH Demi baguette (only half is pictured), 7.9 oz • *Bel Leerdammer* (Dutch semihard cheese), 3 oz • Tomato, 4 oz • *Heluva Good* horseradish, 1.5 tbsp

DINNER Venison, 6.7 oz (raw weight); stewed with *Murphy's* stout ale, *Heinz* chili sauce, brown sugar, onion, and black pepper, 9.2 oz • *Goodman's* egg noodles, 1.3 oz (dry weight) • Mesclun greens, 1.8 oz; with *Marie's* blue cheese dressing, 1 tbsp • *Girl Scout Thanks-a-Lot* cookies, 1.6 oz • *Oakhurst* whole milk, 7 fl oz

SNACKS AND OTHER *Diamond* walnuts, 1.2 oz • Carrots, 5.1 oz • *Oakhurst* whole milk (not in picture), 27.8 fl oz • *Budweiser* beer, 12 fl oz • *Polana Springs* bottled water (not in picture), 1.1 qt • *Centrum* multivitamin • Inhaler, for asthma

CALORIES 3,800

Age: 50 • Height: 6'1½" • Weight: 179 pounds

GREAT DIAMOND ISLAND, MAINE • "Scout, are you coming?" Sam Tucker calls upstairs as he flips pancakes he's made with Maine blueberries. His teenage stepsons Colin and Brendan eat the first batches, then eight-year-old Scout appears, toys in one hand, socks in the other, to claim one. At 6:15 a.m., it's still dark on this snowy March morning on Great Diamond Island in Maine's Casco Bay. The inevitable race for the ferryboat looms large as the kitchen clock ticks off the minutes.

"We have a seriously tight schedule in the morning," says Sam's wife, Karen, who works off-island at an advertising agency in Portland. That's an understatement this day—the one day a week Karen works from Boston. "We have to catch the 7 o'clock boat, and then I have to catch the 8 o'clock bus down to Boston," she says as she mops up syrup with a pancake. "It's really not bad," she says. She keeps a car in Portland and drives the boys to school before boarding the bus for her two-hour journey.

Normally pancakes are reserved for the weekend, but Sam is taking a later boat: "I'll go on the 8:55," he says, "and keel around Portland until the auction." That's the fish auction at the Portland Fish Exchange, where he'll bid on the day's catch on behalf of a Boston buyer.

Sam's schedule, by design, is less harried than Karen's. He's a jack-of-all-trades, cobbling together auction work, shrimp peeling, odd jobs, and lobstering. "I only fish 250 traps," he says of the lobstering. His permit is from the state of Maine for lobsters and crabs, not a federal license for deep-sea work. "You're allowed 800 traps," he says. "And pretty much everyone who has that many has a stern man too" (an extra person to help on the boat). "I'd have to do it more aggressively if my sole living were from the lobstering."

The fish auction is becoming less of an income producer for him as the years pass. A decade ago, in the flush days of virtually unlimited catches, hundreds of thousands of pounds of fish changed hands daily at the exchange. Today, there's rarely much to auction in the half-acre waterfront warehouse. Overfishing, declining fish populations, and government restrictions are all factors. "I don't even know how long it's going to last, that's the scary thing. Yesterday we had no auction. Monday we had no auction," Sam says. In the summer there's more activity, but on average, volume is down drastically year-round, nearly 90 percent.

Before and after the auction, Sam peels shrimp for extra cash. "I'm one of those people that can sit there for hours and peel," he says. "I peel for a bunch of different people—

Karen Tucker discusses morning logistics over pancakes before heading to the ferry with her sons (top left). Sam will eat fresh shrimp and eggs (bottom left) before he takes a later ferry to Portland. At right: As an auction buyer, Sam examines sow hake in the nearly empty warehouse before the fish auction. Catches are increasingly sparse, and today's will require only a half hour to auction.

whoever has shrimp; I just show up. Piecework is a great concept. When you want to leave, you just leave. You get about a dollar, a dollar and a quarter a pound, depending on where you go." Like his income, Sam pieces together his diet, and draws on what's left of the bounty of the sea. "I peel shrimp in one place where the guy who owns the restaurant owns fish companies, so they do their own fish," he says. "I usually end up spending more money than I earn peeling shrimp, just buying fish from the guy."

And then there's the bounty of the land. Sam culls the deer population for the local homeowners association and is allowed to

keep the meat in exchange for the work. "This is pretty tasty venison," he says. "We don't have hunting out here where people chase the deer through the woods and the deer get adrenaline in their system, which makes them gamier. I don't shoot at running deer. I usually do neck shots and they fall over—no fear."

He butchers the animals himself and most of the meat ends up frozen, then parceled out for slow-cooking stew. "It's a simple recipe from friends of ours," he says. Karen chops the venison into bite-size chunks and browns it. "She throws it in the crock-pot with a bottle of stout," he says, "then puts in chili sauce, brown sugar, a chopped onion, and black pepper. And that is all: no water, no nothing; the stout is the liquid. It's slightly sweetish. It's delicious. It really—it kicks ass is what it does."

Fewer than 100 people live on the mile-long long island year round, but in the summertime when the population explodes, Sam gets calls at all hours from hungry visitors looking to buy a lobster. "In business you've got to be businesslike, and the customer is the most valuable part," he says. "Some guy called up one night and my wife said, 'Tell him you won't deliver, it's 9 p.m.!' I ended up selling him lobsters, a bottle of wine, and a stick of butter," he says, laughing.

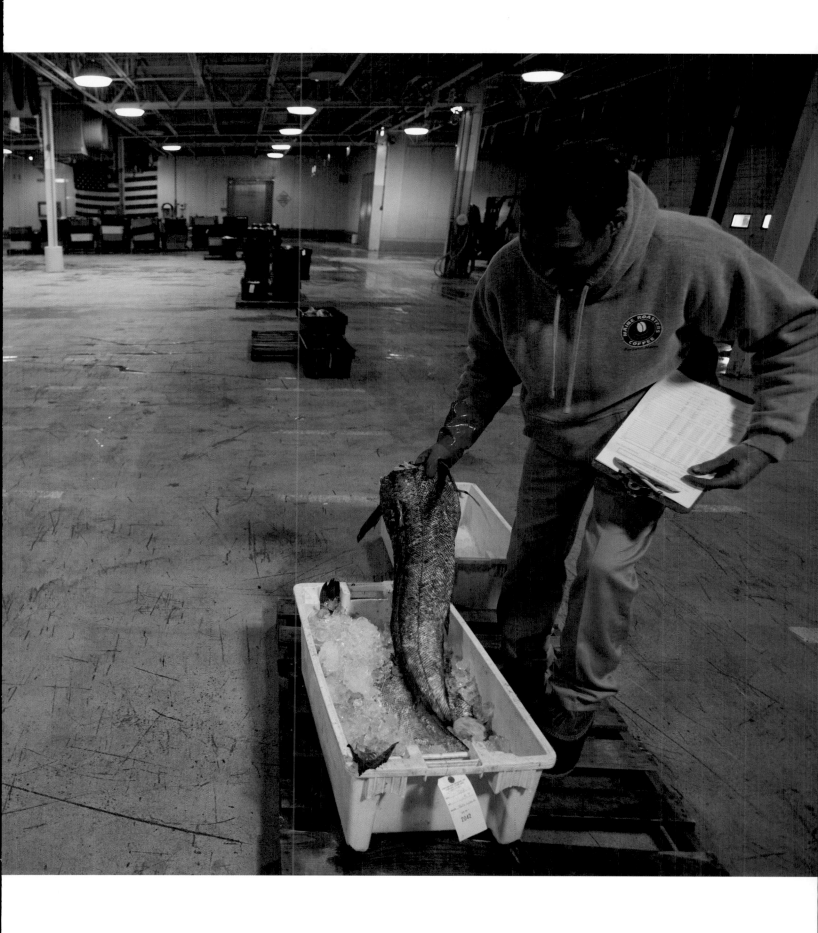

3900

Miguel Ángel Martín Cerrada
The Shepherd

ONE DAY'S FOOD

IN APRIL

BREAKFAST Lamb, 8.2 oz (raw weight); cooked with olive oil, 1 tbsp • Tocino de panceta (cured pork belly), 2.9 oz • Baguette, 5.3 oz • Coffee, 3.2 fl oz; with sugar, 2 tsp • *Mahou Clasica* beer, 11.2 fl oz

WHILE SHEPHERDING Omelet with canned tuna, 9.8 oz • Baguette, 5.3 oz • *Mahou Clasica* beer (3), 33.6 fl oz

DINNER Merluza (hake, a saltwater fish), 9.5 oz (raw weight); pan-fried with olive oil, 1 tbsp; after being cooked in a garlic and herb broth, 4.9 fl oz; with potato (not in picture), green onion (not in picture), and salt, 9.6 oz • *Mahou Clasica* beer, 11.2 fl oz

SNACKS AND OTHER Banana, 4.3 oz • Orange, 5.7 oz • *Malaga Virgen* muscatel (sweet wine made from muscat grapes, similar to port) (2), 5.1 fl oz

CALORIES 3,800

Age: 47 • Height: 5'7½" • Weight: 154 pounds

For centuries, vast flocks of sheep known as trashumantes *grazed along seasonal migration routes throughout the Spanish countryside, tended by their shepherds.* Estantes, *or stationary flocks, also have a long history here. The latter is Miguel Ángel Martín Cerrada's heritage—more than four generations of his family have raised sheep on the Meseta Central, Spain's central plateau.*

ZARZUELA DE JADRAQUE • Miguel, 47, and his brother, Paco, 37, raise their 400 sheep and 60 goats for the meat, not the wool. "We practically give the wool away," says Miguel. While it once commanded a good price, the market for smallholder's wool never recovered from the rise of synthetic fibers in the 1960s. The men sell their lambs when the animals reach 22 to 24 pounds and butcher some for their own freezer.

The brothers, who are both single, house their flock in a large barn near their family home in the village of Zarzuela de Jadraque, 75 miles northeast of Madrid. In the past they could graze the animals on public land and right-of-ways at no cost, but now they pay to do so. The brothers do the shepherding themselves, covering considerable distances on foot each day, as they did when they were young, and as their forefathers did.

After high school, Miguel joined the growing exodus of young Spaniards leaving village life for the city. He waited tables in Madrid for eight years, after what was then compulsory military service, but in 1988 he returned home to the family business when Paco left to do his own service and their father, Máximo Martín Pérez, retired.

Four massive mastiffs stand near the barn, guarding against Iberian wolf attacks, which have become common in recent years. After quickly checking the flock at first light, Miguel starts the kitchen fire for breakfast—the biggest meal of the day—then nips around the corner for a coffee, sometimes with a muscatel chaser, at the village bar. Zarzuela de Jadraque is quiet as a crypt on weekdays, but on weekends it's packed with urbanites visiting second homes and old family houses. Only three families live in the village full-time, but on the weekends its sole eating and drinking establishment is hopping.

"All of my school friends, everybody, they left as soon as they could for work," Miguel says. This is the story in much of Spain's countryside, which has seen a monumental drop in rural population through the last half century. In 1950, over 48 percent of the population lived in rural communities; by 2005, the number had dropped to 23 percent, and

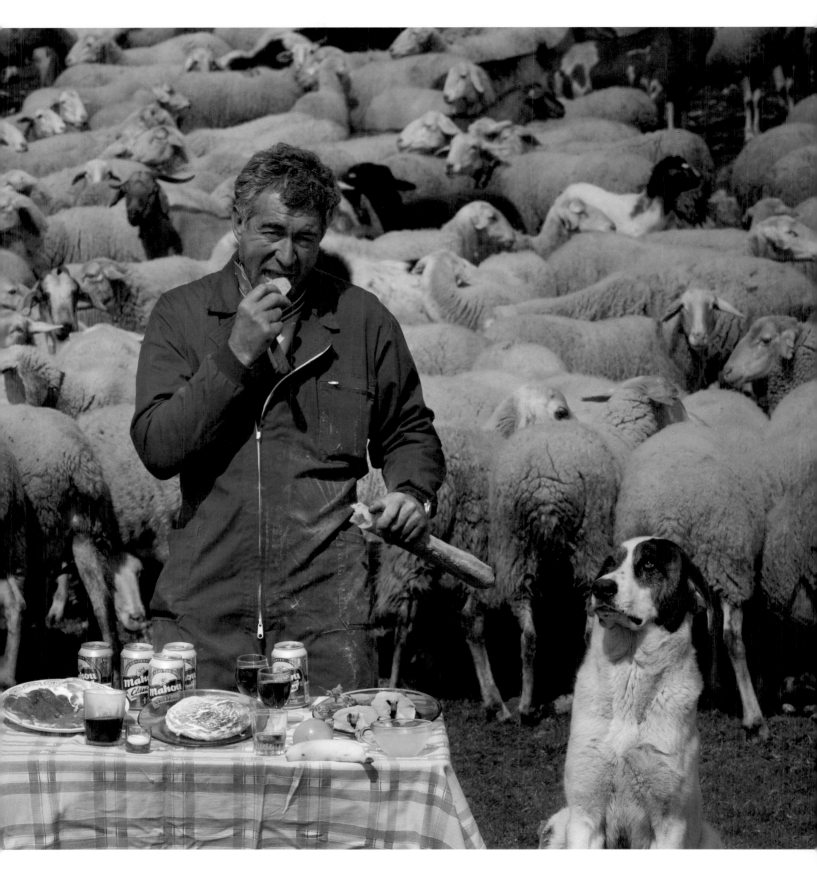

Miguel Ángel Martín Cerrada, a shepherd, with his flock and sheepherding mastiff and his typical day's worth of food. Miguel and his younger brother, Paco, tend 400 sheep and 60 goats on their family ranch in the tiny village of Zarzuela de Jadraque, 75 miles northeast of Madrid. Since their mother died in 2006, their father, 84-year-old Máximo Martín Pérez, divides his time between living with his sons in the country and living with his two daughters in Madrid. While outdoors from sunrise to sunset tending the flock, Miguel and Paco drink beer and wine, rather than water, believing that alcohol keeps them warm. Although animal husbandry has been the family occupation for many generations, both brothers are bachelors and the shepherding lineage will most likely end with them.

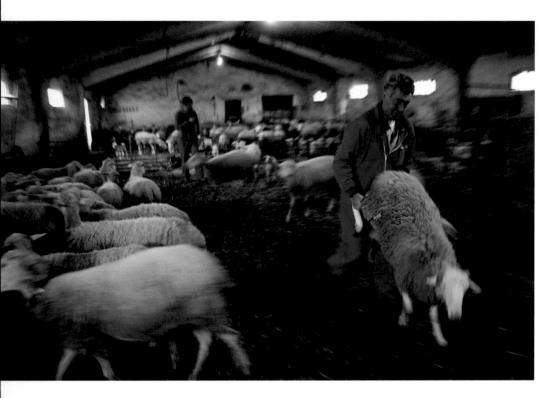

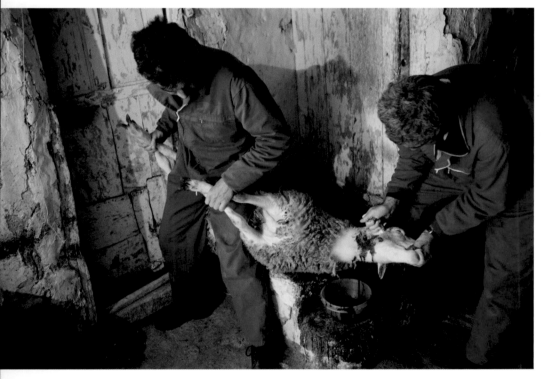

On a cold, foggy morning three days before Easter, Miguel escorts a sheep out of the barn (top left) to the vacant house in town where they do their slaughtering. While Paco holds the sheep's legs, Miguel slits its throat (bottom left). The sheep will be skinned, gutted, and hung in the cold house, and the meat will be eaten at Easter, when the extended family comes for dinner. At right: Miguel nurses a beer while tending the lamb chops grilling over glowing coals, and Paco quenches his thirst with a long pour of red wine from a *porron*, a traditional glass container designed to eliminate the need for individual glassware. The simple meal of bread, bacon, pork ribs, and lamb chops is, as usual, devoid of vegetables. Because the brothers eat mainly meat, they're largely self-sufficient when it comes to food. Because there isn't a bakery or market in their small village, they shop once a week in Guadalajara or another larger town about a half-hour drive away.

it's projected to decrease further, to under 14 percent, by the year 2050.

Back at home, Paco drinks red wine and Miguel pops the top of the day's first can of *Mahou* beer as he rakes red-hot coals from the fire and grills lamb—*chuletas* (chops) or *lomo* (loin). Breakfast is always meat-centric; in addition to what they grill, there's *tocino de panceta* (cured pork belly), with bread and sometimes chorizo or fried pork ribs, which they store in a giant jar of oil. Paco microwaves a few ribs and gnaws them as he downs more red wine. On weekends and holidays, Miguel's girlfriend, Bea López Zazo, visits from Madrid and helps cook, but she says that Miguel is a better cook than she is.

They pack a lunch for the day's shepherding—either a lamb sandwich, a cold omelet with canned tuna, or a Spanish-style omelet with potato. Miguel brings beer and a piece of fruit, and Paco carries wine for their long day out with the flock. When their father worked, Miguel says, he carried red wine in a *bota*—a leather flask. "Tradition," says Miguel, about both the *bota* and drinking on the long, lonely days spent walking the plain with the flock, "and tradition here is like law." The two brothers split the flock and go their separate ways for the day, ranging great distances and returning home after nightfall.

On the coldest, wettest, snowiest days, they feed grain to the animals in the barn and spend the day catching up on chores— and popping over to the bar for a glass of muscatel and a visit. During lambing season, 100 or more of the ewes will give birth, and the brothers are there to provide assistance.

Miguel's sisters sometimes stock the larder with food when they visit, but neither brother eats many vegetables. "They only eat them if I put them in a soup and they don't see them," Bea says, laughing. When she visits, she prepares foods they don't normally make themselves, like cream soups from whatever she can find in the house or has brought with her from Madrid. Tonight she's cooking fish steaks for dinner, poached in garlic and herb broth, then pan-fried, but dinner could just as easily be a repeat of breakfast.

Miguel and Paco have no children, so there's little chance of passing the family business on to the next generation, but Miguel isn't sentimental about it. "Now when old shepherds retire, they sell all of the sheep and it's over," he says.

3900

LATVIA

Ansis Sauka
The Voice Coach

ONE DAY'S FOOD

IN OCTOBER

BREAKFAST Soft-boiled egg, 2.4 oz • Rye bread, 4.9 oz; with ham, 1.9 oz; *Valio* Swiss cheese, 1.2 oz; and butter, 2 tbsp • Shortbread cookies, 1.3 oz • *Verona Romeo* wafer cake, chocolate, 1.2 oz • Coffee with whole milk, 9 fl oz; and sugar, 2 tsp

LUNCH AT SCHOOL CAFETERIA Chicken in tomato broth, 7 oz • Potato with parsley, 9.7 oz; with mayonnaise, 2 tbsp • Pickled beets, 3.8 oz • Cherry crumble tart, 5.9 oz • *Apsara* green tea, 12.2 fl oz; with sugar, 2 tsp

DINNER Rye bread, 4.7 oz; with ham, 1.9 oz; *Valio* Swiss cheese, 1.1 oz; and butter, 1.5 tbsp • Carrot salad with sesame seeds, 5 oz • *Messmer* green tea with aloe vera, 12.2 fl oz; with sugar, 2.5 tsp

SNACKS AND OTHER Shortbread cookies, 1.6 oz • *Verona Romeo* wafer cake, chocolate, 1.6 oz • Chamomile tea, 9.3 fl oz; with sugar, 2 tsp • Hot chocolate, 5.8 fl oz • *Mangali* bottled water, 1.6 qt

CALORIES 3,900

Age: 35 • Height: 6'1½" • Weight: 183 pounds

RIGA • A rich, deep bass voice calls out a greeting as we meet Ansis Sauka, a voice coach for one of Latvia's most celebrated choral groups, the youth choir Kamer. Ansis sang with choirs himself and was an operatic soloist at one time, "But how many bass singers do you know?" he asks. "Everything is written for tenors." His country is home to one of the world's great singing traditions, and its people have sung through the ages—even in its darkest hours.

During the week Ansis doesn't have time to cook and neither does his wife, who's a publisher. They and their 15-year-old son are apt to rely on cold cuts, rye bread, and supermarket salads, reserving home cooking for weekends and summer holidays.

Ansis suffers from an esophageal hernia, which causes a burning sensation in his stomach when he eats the wrong foods. This means many of the traditional foods of Latvia—fermented, pickled, and sour—are off limits. No tomatoes, borscht, or sauerkraut without suffering. He eats them from time to time anyway, despite the consequence.

Carbonation is also a problem. So, while he loves *kvass*, a naturally carbonated beverage made from fermented bread, he can't drink it. Nor can he drink modern soft drinks. This isn't a problem, since he doesn't like them, but he remembers when they first came to the country: "At the end of the Soviet period, when everyone here thought everything outside of the Soviet Union was good...everyone drank this stuff. I did too."

As a vocal coach he's very aware of how food and drink affect his voice—no ice cream ever. But, he says, "strong drink—cognac, brandy, whiskey—are good for my voice."

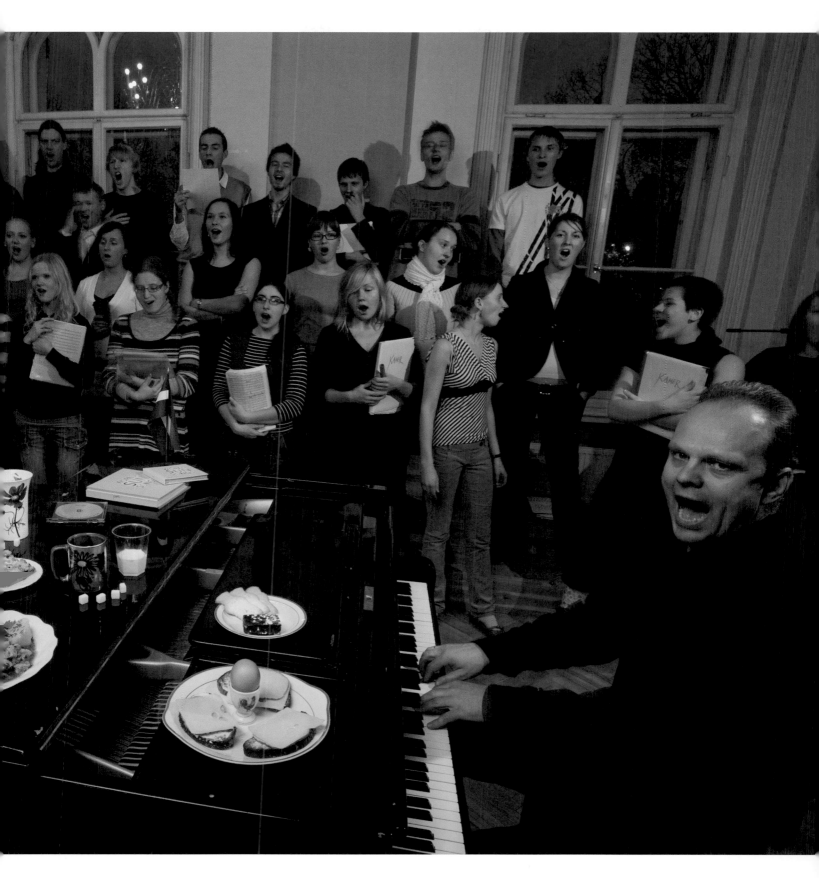

Ansis Sauka, a voice teacher, musician, and composer, with his typical day's worth of food, rehearsing the Riga youth choir Kamer. Latvia's capital city, Riga, a UNESCO World Heritage Site with the oldest continuously running market in Europe, is known throughout Europe for its choral traditions. It proudly hosts the nationwide Latvian Song and Dance Festival every five years. In 2008 more than 38,000 singers, dancers, and musicians participated in the weeklong event. At left: The Nativity of Christ Cathedral, with Riga's Old Town and the Daugava River in the distance.

Joel Salatin
The Sustainable Farmer

ONE DAY'S FOOD

IN OCTOBER

BREAKFAST Farm-fresh eggs (2), 3.4 oz; fried with butter, 1.5 oz; with black pepper, 1 tsp • Homemade pork sausage breakfast links from homegrown hogs, 7.7 oz • Apple, 5.1 oz • Banana, 5.1 oz • Whole milk (not in picture), 9.5 fl oz • Homemade apple cider, 9.5 fl oz

LUNCH *Pearl Valley Cheese Company* Colby cheese, 2.6 oz • Apple, 5.9 oz • Green bell pepper, 2.1 oz • Yellow bell pepper, 2.6 oz • Tomato, 4.2 oz

DINNER Chicken, 11.6 oz (raw weight); baked with *Gunter's* honey, 1 tbsp • Homemade applesauce, 9.9 oz • Potatoes, 5.5 oz; with butter, 1.5 oz • Homegrown beets, 4.7 oz; with butter, 1.5 oz • Homegrown green beans, 2 oz; with bacon, 0.6 oz • Homemade pumpkin pie, 3.7 oz; with *Breyers* ice cream, vanilla, 4 oz

OTHER Well water, 1 gal • Supplements: *Bronson* vitamin C crystals (not in picture), 0.5 tsp; multivitamin; zinc

CALORIES: 3,900

Age: 50 • Height: 5'11" • Weight: 198 pounds

SWOOPE, VIRGINIA • Five hundred and fifty acres of pastoral bliss for his animals is how Joel Salatin describes the Shenandoah Valley farmland that his family has worked since the 1960s. "These are happy chickens," Joel says, tucking one under his arm as he shows us where it lives: a henhouse on skids that moves to a fresh patch of pasture every few days. He shows off his pigs as well, happily snorting and rooting around in an electric-fenced woodland plot, snacking on acorns and feeding on local grain—animals soon to be ready for slaughter, but living a good life until then.

Bucking the trend to modernize, industrialize, and overutilize the land, the Salatins, through trial and error, have built sustainable farming practices that take advantage of the earth's natural rhythms and try to return to the land what they take from it. "Never produce more manure in one spot than can be metabolized in the spot where it's produced," Joel says. And they don't. This is just one of his "core values," as he calls them.

Polyface Farms is pasture-based and what he calls "beyond-organic": a holistic agricultural enterprise raising cattle, hogs, chickens, turkeys, rabbits—and grandchildren. By carefully managing and rotating pastures and animals (but not the grandchildren) in a pattern that naturally fertilizes and regenerates the earth, he raises healthy animals in humane environments without the need for chemical fertilizers.

Another key core value? "Every single person who eats our food is within a half day's drive," he says. And Polyface won't ship food anywhere—period. "Go find your own local farmer," he says. It was this last point that pricked the interest of writer Michael Pollan a few years ago, so much so that he signed on for a week as a Polyface apprentice, then brought the farmer—already famous (and infamous) in certain circles—to national attention in the book *The Omnivore's Dilemma.*

A writer himself, who once ruffled feathers as a young newspaper reporter, Joel has set much of his barnyard philosophy to paper, writing about farming practices, and also tilting at what he sees as chronically irrational government practices. "The animals are over here, but we have to slaughter them over there [off the farm]," is just one of his complaints. That and much more is outlined in his book *Everything I Want to Do Is Illegal.*

More core values? "Never sell or go public," he says. And he and his wife Teresa don't believe in marketing plans: "We have zero sales goals. As soon as you start making sales goals, those begin driving production, then they drive distribution. If you have an empire mentality,...you will look at your business differently, your employees differently, your family differently, your patrons differently,...your ecological resources differently, and your society differently. You look at everything differently."

These days the self-proclaimed "lunatic farmer" is still farming, is much in demand as a lecturer, and his work to formulate environmental and moral values and practices is ongoing. Although he has ceded the day-to-day operation of Polyface Farms to the next generation—son Daniel who has worked on the farm since preschool—he's still hands-on: "I tell him to put me to work," Joel says.

Joel Salatin, a farmer and author, on his family farm in Virginia's Shenandoah Valley with his typical day's worth of food. Much of his daily fare is from his own farm, including applesauce and apple cider canned by his wife, Teresa, who fills the basement larder with the bounty of their farm each year. At right: After moving the portable henhouses to a fresh pasture with his tractor at dawn, he heads back to the barns to help rotate cattle from one pasture to another.

A prayer and then supper (at left) at Joel and Teresa Salatin's eighteenth-century farmhouse. Joel, center, and Teresa, at his left, are joined by Joel's mother, Lucille, who lives on the farm, and farm apprentices Andy Wendt and Ben Beichler. Supper tonight is Teresa's honey-baked Polyface Farms chicken, which "can't be served without her homemade applesauce," says Joel. In addition, there are buttered potatoes, garden-fresh green beans with cured bacon, buttered beets, and sliced fresh garden vegetables. But Joel's favorite meal of the day? Breakfast! "Aw man, pancakes, eggs, and sausage or bacon!" Top right: At dawn, the chickens in an eggmobile (portable henhouse) are released to spend the day pecking in the pastures that cattle have just vacated, eating insects, grass, seeds, and undigested bits in the cattle manure (helping to scatter it in the process). Bottom right: Apprentice Andy Wendt gathers eggs inside another portable henhouse, which is moved to a fresh section of pasture every few days.

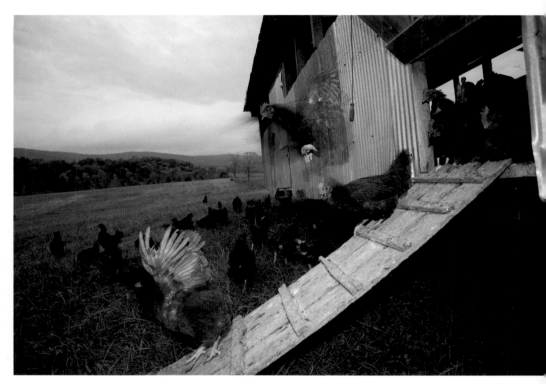

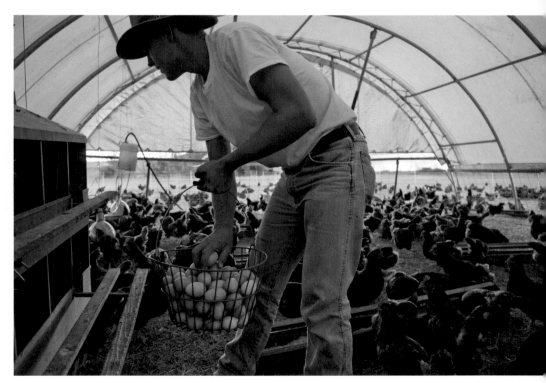

3900

Vyacheslav Grankovskiy
The Art Restorer

ONE DAY'S FOOD

IN OCTOBER

MORNING Coffee, 23.7 fl oz; with sugar, 1.9 oz • *Winston* cigarettes (totaled below)

BAG LUNCH Open-faced egg and ham sandwiches: white bread, 4.4 oz; fried eggs (2), 2.3 oz; ham, 0.5 oz; cucumber, 7.9 oz; tomato, 5.1 oz; radishes, 2 oz; onion, 1.8 oz; pickle, 0.7 oz; hot red chili pepper, 0.4 oz; dill weed, 1 tsp; mayonnaise, 2 oz

DINNER Solyanka (pickled vegetable soup with chicken and ham), 15.7 oz; with mayonnaise, 2 tbsp • Red and green bell peppers stuffed with pork, beef, onion, tomato, garlic, and dill weed, 1.6 lb; with mayonnaise, 3.8 oz

EVENING *Nevskoe Original* beer (2), 33.8 fl oz

THROUGHOUT THE DAY Drink made from fresh cranberries and sugar, 2.6 qt • *Winston* cigarettes, 2 packs

CALORIES 3,900

Age: 53 • Height: 6'2" • Weight: 184 pounds

SHLISSELBURG, NEAR ST. PETERSBURG • What does Vyacheslav Grankovskiy's day's worth of food consist of? "You'd better ask my wife, because I often fail to notice what it is," says the artist and art restoration expert. Slava can, however, identify breakfast: "coffee and cigarettes."

Slava has worked for over two decades restoring art and artifacts in one of Russia's most ornately beautiful cities—St. Petersburg, in the country's far northwest on the Gulf of Finland. His mobile phone rings incessantly as we talk. Conservationists at the Peterhof, an eighteenth-century Russian palace, want him to stop by, and the private owner of a suit of armor in need of repair wants to see Slava later today for a consultation.

The ideologically driven destruction of the Eastern Orthodox Church and its relics, along with neglect of the rich trappings of imperial Russia after the Bolshevik revolution of 1917 and during the Soviet era, means there's plenty of art restoration work in the present. "If it's a historical artifact or something done by a really good craftsman artist, then it's interesting," he says. "But I don't say no to dull and boring jobs, because I have to eat."

Trained in engineering and the arts in the Ukrainian city of Odessa, the Odessa native taught himself 24 different artisan crafts and learned restoration techniques for each of them. "I had knowledge of chemistry, smithing, and welding," he says, "but there aren't any educational facilities where you can actually get a degree in metalworks restoration, so I read a lot of books." His favorite medium? "I'm omnivorous."

When life-size statues in the Summer Garden of the Peterhof were deemed too damaged to preserve, he was commissioned to make copies. His most recent work was a monthlong restoration of the gem-encrusted silver hilt of a saber from the Caucasus. He was also commissioned to restore more than 100 miniatures from Russian nobleman Pavel Nashchokin's dollhouse for the Alexander Pushkin Museum in St. Petersburg. They had already been restored once—poorly. "The pieces are fully functional," he says of the miniatures, "…a grand piano that can be played with matchsticks…chandeliers and little oil lamps that light, and an arsenal."

About restoration in general, he says, "There are technical specifications and chemical details for every material. If it's an old rifle, an arquebus, for example, the stock may have inlays of ivory or horn, gold, silver, mother of pearl—I must be able to work in all of them."

"There is no improvisation," he says. "I do the research before the work is started."

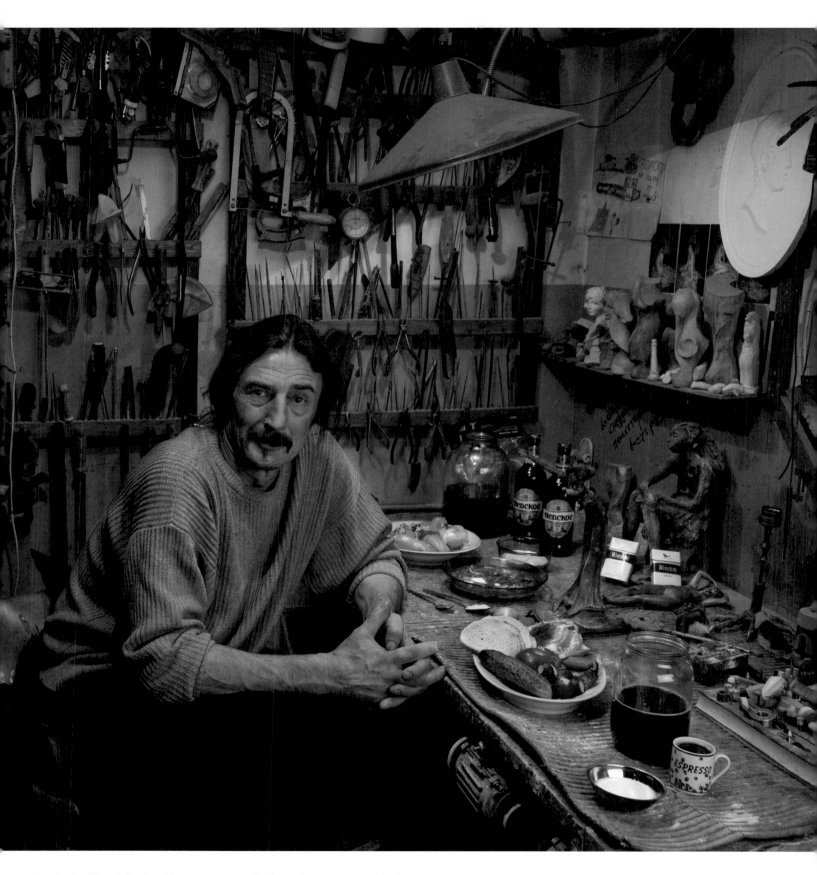

Vyacheslav "Slava" Grankovskiy, an art restorer, in his studio workshop behind his home with his typical day's worth of food. The son of a Soviet-era collective farm leader, he was raised near the Black Sea and originally worked as an artist and engineer. Over the years, he's learned a few dozen crafts, which eventually enabled him to restore a vast number of objects, build his own house, and be his own boss. His travel adventures have included crossing the Karakum Desert in Turkmenistan, where he spent time with a blind hermit and dined with a Mongol woman who hunted bears and treated him to groundhog soup. His favorite drink: Cognac. Does he ever drink soda? "No, I use cola in restoration to remove rust, not to drink," he says.

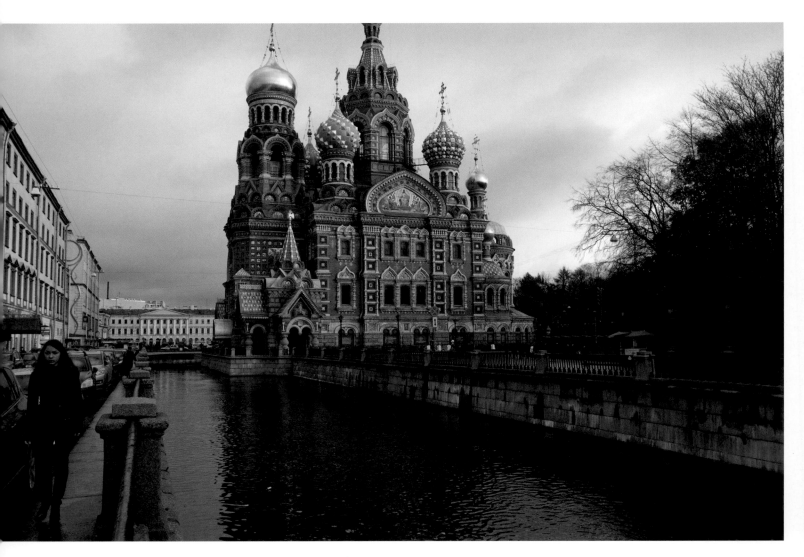

Suppression and neglect during the Soviet era have bequeathed Slava with a lifetime of restoration work. Much of the art and architecture in and around St. Petersburg has benefited from his talents. The Church of the Savior on Spilled Blood (top left) and the vast State Hermitage Museum (at left) have occupied Slava for years. Top right: In the house he built on Lake Ladoga, Slava's family shares a supper.

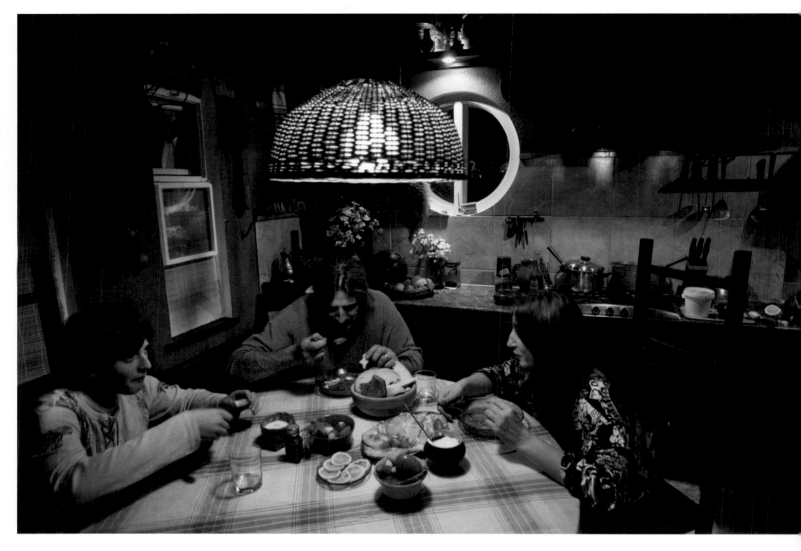

He consults with experts and art critics and spends hours in libraries. Slava does most of his museum restorations in the workshops of the museums that commission him and restores privately owned pieces in his home workshop, crowded with plaster cherubs and salvaged bits of Russian history.

The house he shares with Larissa, his wife, and youngest son, Anton, 13, is almost a museum itself, with artful lighting and collections of cultural artifacts and art from decades of dumpster diving and salvage, including four walls of eighteenth-century religious icons and a 2,500-year-old Scythian vessel that was being used as an ashtray when Slava found it. He built the ladder-back chairs and the table in the dining room, and he and Larissa did the interior design of the house. He asks us not to mention to his wife that we have noticed there are pieces of decorative plaster missing from the ceiling medallion in the icon room: "'Are you a restorer or are you not?!' my wife asks when she looks at this," he says, a bit ruefully.

Larissa, herself an artist who draws and paints, is also the keeper of the kitchen. She laughs when she hears that Slava has had a hard time detailing what he eats in a day, and corrects his list. "This is more typical," she says: 10 cups of coffee, not 15 or 20 as Slava had said. And five peppers stuffed with meat and minced onions at dinner, not two or three, with more than twice as much mayonnaise dressing as he originally accounted for. And it's mayonnaise, rather than the traditional eastern European *smetana* (soured heavy cream), which they sometimes eat. "She lies," Slava says, teasing. "She doesn't feed me at all."

Slava takes his lunch to work most days: open-faced sandwiches prepared by Larissa, with ham, fried egg, fresh onion, hot red chili peppers, and pickles. There is a thermos of coffee as well, which she says he usually forgets to take with him. "And sometimes my wife is lazy and there's no fried egg," says Slava.

Their evening meals are largely the cold-climate fare traditional in the region—heavy on meat, root vegetables, and pickled and preserved ingredients, with liberal amounts of dill, lemon, and cilantro. Most nights there's beer to drink—"two or six," he says, but most typically two—and sometimes large amounts of Cognac, but only for special occasions. Last night they drank in celebration of the car he bought for Larissa—Cognac with lemon-slice chasers. For Slava, most nights the dinner hour doesn't come until midnight or 1 a.m., which fits in with the work schedule he likes to keep, and which also means he often eats alone.

For tonight's dinner, in addition to stuffed peppers Larissa has prepared *solyanka*, a stewlike pickled-vegetable soup that can be made with meat, chicken, fish, or just the vegetables; this evening she prepares it with chicken and ham. Along with his teasing commentary, Slava pays his wife a compliment: "She's an excellent cook, and she's got good imagination." When Slava helps cook, he favors the spicier foods of the south, but "every dish begins with the great ritual of onion frying," he says.

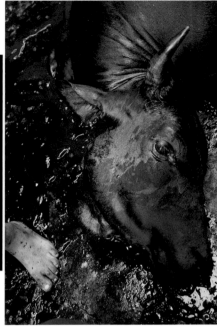

Food Taboos

By Ellen Ruppel Shell

It's been several decades since I ate horse for the first time. As a new college graduate, I loaded up an old van and drove 3,000 miles west to Seattle to begin my new life as—well, I didn't know what exactly. What I did know was that I was poor, and after paying for rent and gas, I had very little money left for food. Horse meat was the cheapest form of animal protein I could find, so I somehow bent my mind around eating it. For a former rider and lover of all things equine, this was no easy feat. I disguised the horse burgers as best I could, slathering them with ketchup, pocking them with pickles, and shrouding them completely in buns before bringing them, shamefaced, to the table. Still, the steely tang of horse remained as indelible

as the spots on Lady Macbeth's bloodstained hands, affirming that no matter how extenuating the circumstances, eating horse meat was for some reason not okay.

Last spring I ate horse for the second time. I was traveling in Puglia, on the east coast of Italy. A gritty but authentic trattoria presented horse meat in several forms: salami, sausage, and grilled in twisted strips. My tablemates could barely keep their hands off the communal platter, but I managed only a fretful nibble. The telltale metallic tang brought back guilty memories accompanied by a powerful gag reflex.

There is nothing more intimate than what we put into our mouths, yet for most of us precisely what we're eating often remains a mystery. In Western culture, how many of us genuinely know the provenance of our last meal, or even a single component of that meal? Yet as clueless as we may be, few people will ingest just anything. Most of us draw an emphatic line between what we will and will not eat.

Take dog, for instance. I once attended a funeral feast on the island

of Kosrae in Micronesia, a charming event where friends and family of the deceased gathered to share memories and an array of delicacies. Dog was on the menu, and later I understood why: In Kosrae, resources are few and pets a liability. Every species on the island has to carry its own weight, and with no sheep to herd or other obvious useful function to fulfill, dogs are regarded as a nuisance unless and until they serve as dinner.

Given that dog is nutritious and tasty, the question isn't why some of us would choose to eat it, but why so many of us choose not to. In *Good to Eat: Riddles of Food and Culture*, anthropologist Marvin Harris wrote, "Westerners refrain from eating dogs not because dogs are their most beloved pets, but essentially because dogs, being carnivorous, are an inefficient source of meat." Dog-eating cultures, by contrast, don't have as many alternatives in terms of animal flesh, and as Harris points out, "the services which dogs can render alive are not sufficient to outweigh the products they can provide when dead."

Unlike dogs, pigs seem created for consumption. Incredibly efficient storehouses of calories, pigs convert 35 percent of what they eat into meat, compared to only 6.5 percent for cattle. A sow can produce eight or more piglets in a mere four months, each of which can bulk up to

Ellen Ruppel Shell, a correspondent for the Atlantic, *is professor and codirector of the graduate program in science journalism at Boston University. She is the author of* Cheap: The High Cost of Discount Culture *and* The Hungry Gene.

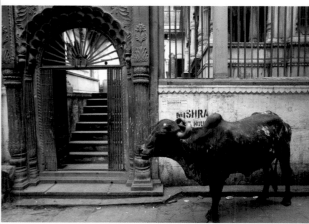

Left to right: Chicken feet and heads at Sonargaon market, Bangladesh. A bull, freshly slaughtered during Eid Adha holiday, in Dhaka, Bangladesh. A roasted dog at Cho Chau Long market in Hanoi, Vietnam. A pig's head and pigs' feet at the municipal market in Cuernavaca, Mexico. Freshly harvested sago grubs, extracted from a rotting sago palm log in Komor, Papua. A cow on the street near Manikarnika Ghat, Varanasi, India.

400 pounds in six months. Pigs are so efficient at making and storing meat that the Chinese call them "walking refrigerators." So why the many taboos on pork?

Typical explanations hover around fear of disease. Pigs eat feces and wallow in mud—not exactly appetizing behaviors. And undercooked pig flesh can confer trichinosis. But these reasons, while compelling, aren't wholly persuasive. After all, anyone who has set foot on a farm knows that chickens and goats will eat almost anything, including dung. And while trichinosis is no picnic, it's no worse than diseases brought on by eating the meat of other infected animals, including cattle.

Harris contended that pork phobia comes down to climate and geography. The Middle East is no place for a self-respecting pig. Pigs need shade, water for wallowing, and at least some grain and other valuable plant foods that might otherwise go to feed humans directly. And like dogs in Kosrae, pigs neither pull a plow, nor grow wool, nor produce milk or eggs for consumption. So, Harris sensibly asked, what good are they to a pastoral, nomadic people like the Bedouin? Pork may be a tasty temptation, but raising pigs in the desert is ecological folly, so banning them by religious ordinance makes sense.

Can we reduce food taboos to simple economic arguments? Well, yes and no. Consider India: 30 percent of all cows on earth make their home there, leading long but not always happy lives. They have their uses, of course: pulling plows, making milk, creating fertilizer, and more. Still, many are skinny, sickly beasts roaming village streets in a state of endless hunger—a walking traffic hazard at best. However, Hindus believe that cows are but one rung below humans on the ladder to nirvana, and any human foolish enough to kill one, let alone eat it, is fated to slip to the bottom rung of that ladder. So in India, devout Hindus would rather starve than eat Bossy. If at one time economics

alone explained the Hindi prohibition on eating beef, it clearly no longer applies, at least not directly.

But the taboo may have strengthened people's faith. "As the history of Hindu cow protection shows," Harris opined, "religions gain strength when they help people make decisions which are in accord with preexisting useful practices, but which are not so completely self-evident as to preclude doubts and temptations."

This helps explain why there aren't many religious prohibitions on eating insects, a practice favored by more cultures than a Westerner might suspect. Indeed, the reluctance of Americans and Europeans to eat insects is more the exception than the rule. Amazon tribespeople eat larvae, Chinese farmers eat silkworms, and Laotian, Thai, and Vietnamese peasants are known to vie for the largest, juiciest water bugs. I myself have savored the salty crunch of grasshopper in Oaxacan street markets. Insects are the most ubiquitous fauna on earth, easy to snare, and rich in protein. But they also pester, bite, and kill our livestock—and us. This may explain why most Americans and Europeans harbor a phobia of insects that for some reason makes eating them out of the question. As Harris wrote, "Since we don't eat them we are free to identify them with the quintessential evil—enemies who attack us from within—and to make them icons of dirt, fear, loathing and disease."

Certainly the old adage applies: "One man's meat is another man's poison." Still, it isn't entirely clear how we pick our poisons. How can we Westerners justify eating lambs and piglets while eschewing less adorable creatures, like water bugs and larvae? Clearly, economics don't account for this—after all, insects are free. Nor does religious belief explain it, as the Old Testament encouraged chowing down on beetles, grasshoppers, and locusts. No, there's something more mysterious at play, something no one can account for... Let's call it taste.

4000

USA

Curtis Newcomer
The U.S. Army Soldier

ONE DAY'S FOOD

IN SEPTEMBER

MESS HALL BREAKFAST Corned beef hash, 2.2 oz • Scrambled egg, 3 oz • Bacon, 0.7 oz • Apple, 6 oz • *Otis Spunkmeyer* cookie, chocolate chip, 2.3 oz

LUNCH MRE (Meal, Ready-to-Eat) ham and shrimp jambalaya, 8 oz (dry weight) • MRE vegetable and cheese omelet, 8 oz (dry weight) • MRE shredded potatoes with bacon, 5 oz (dry weight) • MRE cinnamon scone, 2 oz • MRE toaster pastry, strawberry, 1.6 oz • MRE crackers, 1.3 oz • MRE *Pangea World Bakers* pound cake, vanilla, 2.5 oz • MRE dairy shake fortified with calcium and vitamin D, strawberry, powdered, 3.5 oz (dry weight) • MRE orange carbohydrate electrolyte beverage, powdered, 1.5 tbsp (dry weight) • MRE *Crystal Light* red tea, 0.5 tsp (dry weight) • MRE jam, blackberry, 2 tbsp • *Frank's Red Hot* pepper sauce, 1.5 tbsp

MESS HALL DINNER Shrimp scampi, 2.7 oz; with Parmesan cheese, 0.5 tsp; and *Frank's Red Hot* pepper sauce, 1.5 tbsp • White bread, 2.5 oz • Salad of lettuce and tomato, 2.4 oz • Peas, canned, 1.8 oz • *Del Monte* fruit cocktail, lite, 4 oz • *Famous Amos* cookies, chocolate chip, 2 oz

THROUGHOUT THE DAY *Gatorade* sports drink (3), 1.1 qt • *Deja Blue* bottled water (5), 2 gal (also used to hydrate the drink powders and all MREs) • Cigarettes (in sleeve pocket), 1 pack

CALORIES 4,000

Age: 20 • Height: 6'5" • Weight: 195 pounds

FORT IRWIN, CALIFORNIA • When Curtis Newcomer's college football scholarship at Texas Tech ended due to an injury, he joined the army—something he'd wanted to do since he was a boy and an older cousin regaled the family with stories from his time in the Air Force. Curtis has already served one tour of duty in Iraq as an infantryman. Now he and his unit from Fort Hood, Texas, are at the National Training Center at Fort Irwin, staffing field exercises at the remote Mojave Desert camp for two weeks before redeployment to Iraq, where he'll serve as a radio operator this time around.

"I've never been on a radio before. I had a weapon in my hand—running through the streets, getting shot at," he says. "I'm okay on the radio because I'm a really confident person when I talk. I don't try to beat around the bush. I don't stutter. Radio's pretty easy for me."

He says that he liked being in Iraq more than being at Fort Irwin. "The only thing that could make being in Iraq better is if your family could be there, because there are no rules in Iraq—you could almost do whatever you wanted. Didn't have to report to anybody;

we did seven or eight missions with Special Forces, also with Blackwater and [the U.S. Army] Rangers...I want to come home and tell my kids cool stories some day. It's a great opportunity."

When asked about his diet, he says, "Hey, do I ever stop eating? We used to go to Hooters all the time, like three times a day.... My wife used to work [there], and I'd get free food...I used to go to Sonic...and, seriously, spend 15 or 20 bucks: I'll eat two extra-long cheese Coneys and one extra-big tater tots with chili cheese on it. And I get a milk shake and a regular cherry limeade. Never gained weight. Everyone in my family's skinny. Maybe a little stocky, but not fat.... Vanilla bean ice cream is the only ice cream I'll eat, and I put hot sauce on it. I put hot sauce on everything...I love spicy foods." When asked what he's looking forward to eating when he gets home, he doesn't hesitate: "jalapeño poppers."

Does he have any vices? "I go through a pack or a pack and a half [of cigarettes] a day. If someone comes up to me with chew and I've got a cigarette, then no. I have to be totally out of cigarettes to chew."

Curtis Newcomer, a U.S. Army soldier, at the National Training Center at Fort Irwin in California's Mojave Desert with his typical day's worth of food. During a two-week stint before his second deployment to Iraq, he spends 12-hour shifts manning the radio communication tent (behind him). He eats his morning and evening meals in a mess hall tent, but his lunch consists of a variety of instant meals in the form of MREs (Meals, Ready-to-Eat). His least favorite is the cheese and veggie omelet. "Everybody hates that one. It's horrible," he says. A mile behind him, toward the base of the mountains, is Medina Wasl, a fabricated Iraqi village—one of 13 built for training exercises, with hidden video cameras and microphones linked to the base control center for performance reviews.

In Medina Wasl (top left), built by set coordinators from Paramount Pictures, hundreds of actors (military and civilian) and scores of directors participate in elaborate training exercises for soldiers deploying to Iraq. At right: A medic responds to mayhem after a simulated explosion seemingly destroys an Army Humvee. Some actors are actually amputees, adding to the realism of the scene, which is embellished with fake blood and dismembered limbs.

At lunchtime, Curtis Newcomer (top right) eats chili mac, his favorite MRE. His weapon is fitted with a laser that interacts with receivers worn by all of the soldiers and actors in the training exercise, regardless of duty, rank, or location in the training theater. At left: After the second of three mock battles of the day, Iraqis and Americans playing soldiers, victims, and insurgents relax together in the shade until the next 20 minutes of choreographed crisis.

4000

Riccardo Casagrande
The Friar

ONE DAY'S FOOD

IN JULY

BREAKFAST Baguette, 2.1 oz; with honey, 1 tbsp • Cantaloupe, 2.5 oz • *Lavazza* coffee (Italian espresso-style), 1.5 fl oz; with sugar, 1 tsp

LUNCH Spaghetti, 8.8 oz; with tomato sauce, 4.3 oz • Beef filet, 5.4 oz (raw weight); cooked with *Carapelli Delizia* extra-virgin olive oil, 1 tbsp • Grilled eggplant with basil, garlic, and red chili pepper, 2 oz • Zucchini, 2.7 oz; grilled with olive oil, 1 tbsp • Salad of fresh tomato, cucumber, and fennel, 11.3 oz • White bread, 3 oz • Swiss cheese, 0.4 oz • Homemade white wine, 12 fl oz

DINNER *Barilla* pasta, 1 oz (dry weight); with mixed fresh vegetables, diced, 1.4 oz; eaten in a broth made from *Knorr* chicken bouillon cubes, dissolved in water, 9 fl oz • Chopped steak, 5.6 oz (raw weight) • Potato, cauliflower, mushroom, garlic, and basil, 7.7 oz • Olive oil for cooking the steak and vegetables, 2 tbsp • White bread, 3 oz • Caciotta cheese, 0.8 oz • Homemade red wine, 12 fl oz

OTHER *Granarolo* whole milk (2), 20 fl oz • *MS Filtro* cigarettes, 1 pack • Holy host wafer (not in picture)

CALORIES 4,000

Age: 63 • Height: 5'8½" • Weight: 140 pounds

SAN MARCELLO AL CORSO, ROME • At dinner, the Servite friars of the Church of San Marcello al Corso in Rome eat farfalle (butterfly pasta) with peppers cooked very slowly on the stovetop. "Very, very slowly," says Fr. Patrick Carroll, who's visiting from Dublin. "They almost melt on the tongue." "Almost a cream, they cook so slowly," says Fr. Riccardo Casagrande, who, when he's not saying mass in the sixteenth-century church, directs the kitchen staff and tends the

wine cellar under the large church complex.

Archaeologists have worked for years on the fourth-century ruins under the church compound, and centuries of art and architecture mingle with the scent of warm wax and incense in the gilded and frescoed Renaissance church. But fewer and fewer modern Romans attend mass here.

In the center of the complex, in a cloistered rooftop garden, caged birds sing, and Fr. Riccardo clips herbs for the cook.

Basil and rosemary grow in abundance, but he allows no one else to trim the basil's tender tops. In theory, if he isn't home, then no one gets basil.

The farfalle with peppers is *il primo piatto* (the first course), served with nutty pecorino cheese. There is also *il secondo piatto*—meat and vegetables, which today is steak and green beans. "I like the cow still pulsing on the plate," says Fr. Riccardo. The friars pass a fruit plate and cheese to finish the meal—pecorino and caciotta. Wine, of course, is served at both lunch and dinner—red and white, produced by the Servites in Tuscany. Fr. Riccardo decants the wine from large casks into bottles in the musty, cavernous underground wine cellar of the church.

The friars and priests who live at San Marcello dine together, joined by a rotating cast of visiting religious from around the world. Everyone who comes knows he'll get a very good meal and a warm historic bed.

Riccardo Casagrande, a Roman Catholic friar and gastronome, in the San Marcello al Corso church dining hall with his typical day's worth of food. For over 20 years he has overseen the kitchen, the rooftop garden, and the basement wine cellar (at left) for the friars and priests living in the church complex near Rome's Spanish Steps.

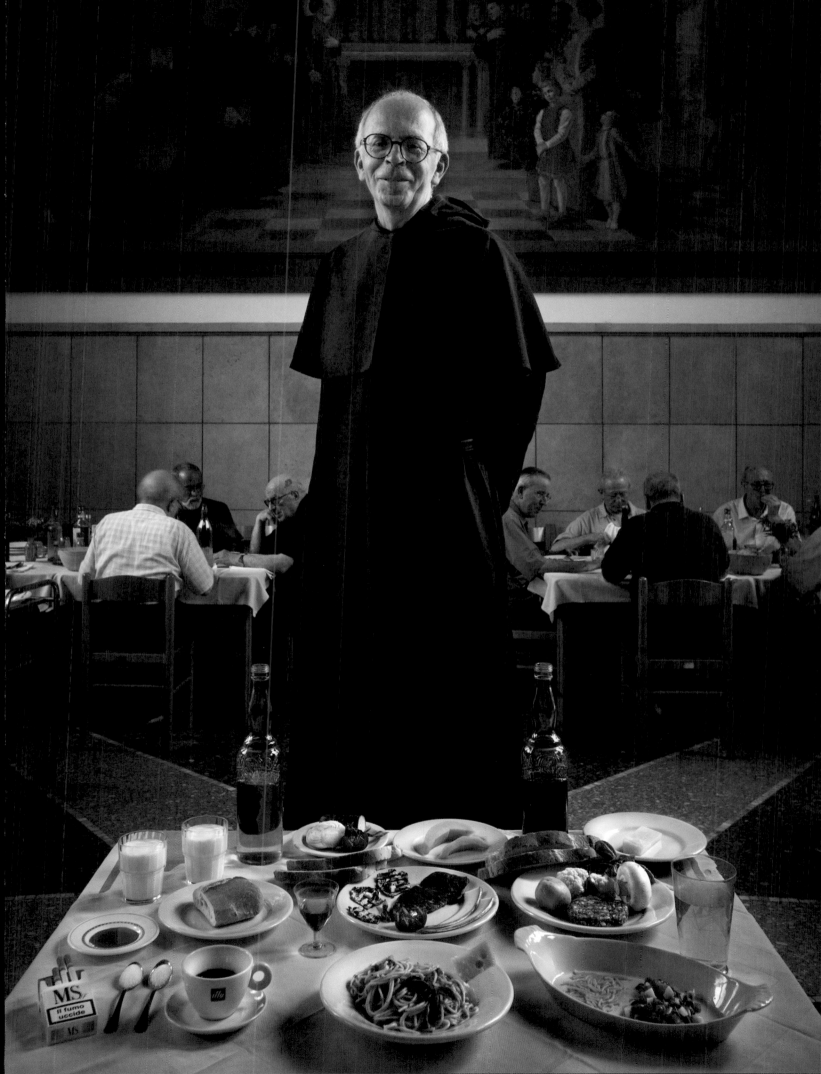

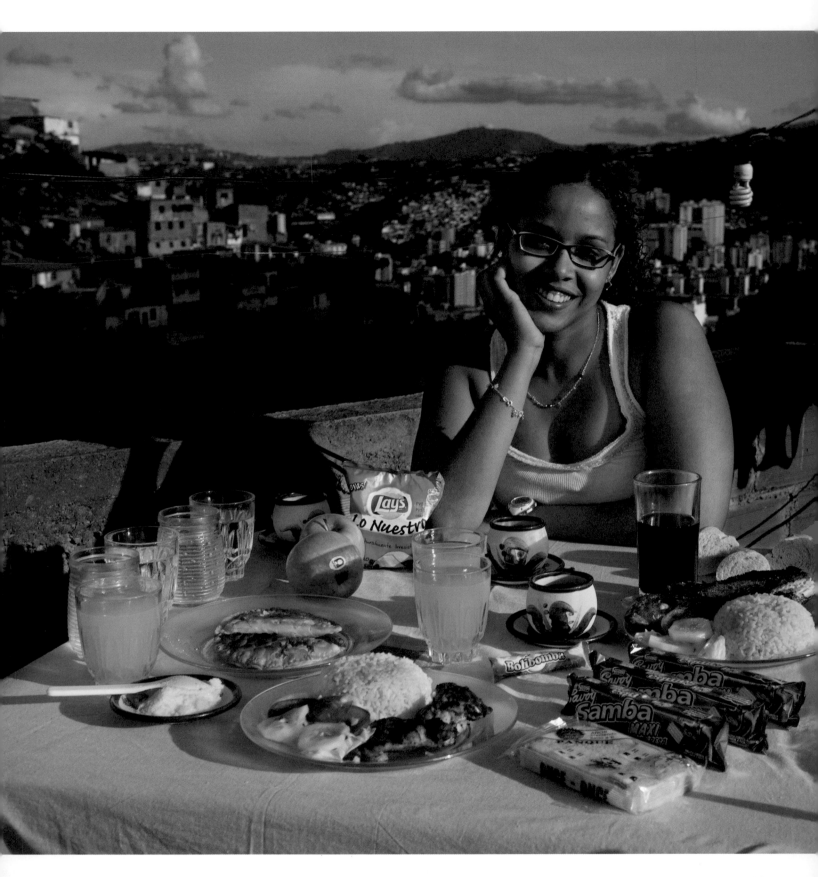

Katherine Navas, a high school student, on the roof of her family's home in a Caracas barrio with her typical day's worth of food. Unlike housing in most of the developed world, the higher the house, the cheaper the rent in the dangerous Caracas barrios. Those living at the top of the steep hillside have to travel the farthest to reach services, shops, and the main street, a trip normally made only in the daylight hours. At right: Mealtime at Katherine's house is a family affair. Her mother is the chief cook, but everyone helps. Tonight's dinner is fresh fried fish from an uncle's shop. During meals, the television is turned off and the day's events are recounted by even the youngest.

VENEZUELA

Katherine Navas
The Student in the Barrio

ONE DAY'S FOOD

N NOVEMBER

BREAKFAST Pastelitos (deep-fried, stuffed pastries) made with cornmeal dough and stuffed with chicken (2), 2.3 oz • Apple, 7.2 oz • *Frica* orange juice, 7.5 fl oz • Coffee, 3.3 fl oz; with sugar, 1 tsp

LUNCH Chicken, 3.4 oz • *Mary* white rice with *Amparito* coloring, 7.2 oz • Salad of lettuce, cucumber, and tomato, 1.4 oz; with oil and lemon juice dressing, 1 tsp • Coffee, 3.3 fl oz; with sugar, 1 tsp

DINNER Fried red snapper, 11 oz • *Mary* white rice with *Amparito* coloring, 7.2 oz • Salad of lettuce, cucumber, and tomato, 1.4 oz; with oil and lemon juice dressing, 1 tsp • White bread, 2.3 oz • *Coca-Cola*, 10 fl oz • Coffee, 3.3 fl oz; with sugar 1 tsp

SNACKS AND OTHER Apple, 7.2 oz • *Once-Once* vanilla cake, 1.8 oz • *Lays* potato chips, cheese flavored, 1.2 oz • *Samba Maxi* candy bars (3), 6.9 oz • *Bolibomba* mint gum, 5 pieces • *Frica* orange juice (2), 15 fl oz • Tap water, 28.2 fl oz

CALORIES 4,000

Age: 18 • Height: 5'7" • Weight: 167 pounds

LA SILSA, CARACAS • The impoverished barrios of Caracas are notoriously dangerous places for outsiders and residents alike. "I can walk here," says one Caraqueno who has lived his entire life in the barrio called 12 October, "but not over there," pointing only a few short steps away. Caracas earned the ignoble distinction of being murder capital of the world in 2008. As we search for a willing nutrition subject, we are handed off from one barrio street to the next as though we are at border crossings.

Stacks of squat houses on narrow streets snake up hillsides, interconnected by warrens of walkways and precarious stairs. Finally, we find a willing participant: 18-year-old Katherine Navas, working in her stepfather's copy and Internet shop at the base of the barrio La Silsa, a two-minute hike down from her home and only a block from a Caracas thoroughfare.

"It's dangerous, but we know how to live here," says the senior in high school, who splits her time between the copy shop, school, and her community basketball league. She has lived in La Silsa her entire life, with her mother, stepfather, and three younger siblings, and extended family members live in nearby flats. Behind barred doors and windows, everyone cooks together, and there are housefuls of people for meals. "We just talk and talk about everything we're doing," says Katherine, "but not about [the barrio]. That's outside."

When we met her, Katherine had just returned from a school year abroad living with her aunt in New York City—a great experience, she says, but she came home 20 pounds heavier. "McDonald's," she says, by way of explanation. She says her slender mother was blunt: "'What happened to you?! You're so fat!'" Does she eat at McDonald's in Caracas? Not often, she says, and she's trying to lose weight, but along with her favorite Venezuelan dishes of fish and rice, there are still candy bars, chips, and deep-fried food.

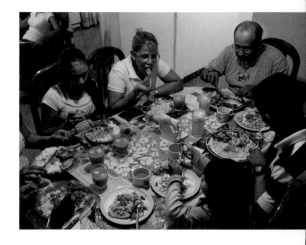

Behind the counter of her stepfather's Internet and copy shop, Katherine Navas tends to a customer. Bars on all the windows, doors, and balconies signal that security is a major concern in this neighborhood. Caracas was the murder capital of the world in 2008; 50 murders in one weekend is not unheard of. Local gangs are viciously territorial and ruthless in their victimization of the hardworking, law-abiding majority. Noemi Hurtado, an 83-year-old who has lived a stone's throw from Katherine's house for the past 51 years, has never once crossed into the barrio of La Silsa. "It's too dangerous," she says. "I would never go there." When Noemi moved to western Caracas, the La Silsa barrio didn't yet exist; the hills surrounding the valley were forested and, she remembers, there were waterfalls.

253

4000

EGYPT

George Bahna
The Businessman

ONE DAY'S FOOD

IN APRIL

BREAKFAST *Kellogg's Crunchy Nut* cereal, 3.4 oz; with whole milk, 18.2 fl oz • *Enjoy* apple juice, 1.1 qt

SECOND BREAKFAST Fruit salad of apple, banana, orange, and strawberries, 17.5 oz; with honey, 3 oz • Hard-boiled egg white, 2.2 oz

LUNCH Breaded veal cutlets, fried, 9.8 oz • White bread rolls (2), 2.8 oz • Lettuce, 0.8 oz

DINNER Chicken baked with tomato sauce, 11.4 oz • Peas and carrots in tomato sauce, 1.6 lb • White rice, 6.9 oz • Salad of lettuce, tomato, and green onion, 9.2 oz; with olive oil and balsamic vinegar dressing, 2 fl oz; and pepper, 0.5 tsp

THROUGHOUT THE DAY *Siwa* bottled water, 3.2 qt

CALORIES 4,000

Age: 29 • Height: 5'11" • Weight: 165 pounds

CAIRO • The Nile River bisects Cairo, and in the middle of the river the Zamalek neighborhood, filled with expensive apartments and upscale restaurants, shares its island oasis with the Gezira Sporting Club, a tony respite of green, with swimming pools, polo fields, and clubhouses.

Businessman George Bahna lives with his brother in a spacious high-rise flat in Zamalek, across the hall from his parents, and works in his father's engineering firm, 13 floors below on the mezzanine level.

The son of wealthy Egyptians, he grew up in England, reading comic books and obsessed with superheroes. When he was six, he saw a Jackie Chan film: "It was the closest I'd seen a real person come to the superheroes in my comic books," he says. "I wanted to do that!" Many martial arts classes later, he's a businessman in Cairo by day and a Fujian White Crane Kung Fu martial arts instructor by night, taking on all comers—after a second breakfast, that is.

His job takes him around the world, but at home he eats for both the businessman and the athlete—four times a day, and sometimes five. His meals are more typically British than Egyptian—boxed cereal, breaded veal cutlets, and peanut butter and jam sandwiches—but he has a taste for his cultural roots as well: "I like a lot of the meats here, like kebab, the chops, and the *shish taouk* [chicken marinated in yogurt or tomato]. It's real nice; it's one of my favorite things here. And the Egyptian vegetables—okra and *fasooliya* [a stewed bean dish with tomato and garlic]."

George rarely misses a workout, whether on the road or at home, and he teaches and trains at the Gezira Sporting Club, a five-minute drive from his apartment. When he was training for competition, he drank protein shakes with raw eggs, but that was years ago. "There was a period when I was eating a clove of garlic raw every morning," he says. "Apparently it's very good for your yang."

George Bahna, an engineering company executive and martial arts instructor, in his apartment overlooking the Nile River, with his typical day's worth of food. George eats four to five times a day but doesn't worry about gaining weight because he's active, working out in a special room in his flat (at left), and at the private Gezira Sporting Club near his apartment. The Nile River bisects the cacophonous metropolis of Cairo, home to 17 million people, many of them very poor. Although Egypt's stock market and gross domestic product have risen steadily for the past four years, the standard of living for the average Egyptian has not. The government continues to provide food subsidies for those in need, creating a sizable budget deficit.

4100

Gordon Stine
The Commodity Farmer

ONE DAY'S FOOD

IN SEPTEMBER

BREAKFAST *Post Honey Bunches of Oats with Almonds* cereal, 2.8 oz; with *Prairie Farms* 2% milk (not in picture), 4 fl oz • Coffee, 10 fl oz

LUNCH Homemade sausage links, from whole hog, 4 oz; on a white bread hot dog bun, 1.7 oz; with *Briargate* yellow mustard, 1 tsp • Green beans, 2.8 oz • *Clancy's* potato chips, original, 1.2 oz • *Betty Crocker* cake, milk chocolate, 2 oz; with *Betty Crocker* frosting, milk chocolate, 1.2 oz

DINNER Vegetable and beef stew, 1.5 lb • Homemade white bread, 4.6 oz; with *Blue Bonnet* spread, 48% vegetable oil, 1.5 tbsp • *Betty Crocker* cake, milk chocolate, 2 oz; with *Betty Crocker* frosting, milk chocolate, 1.2 oz; and *Prairie Farms* ice cream, vanilla, 8 oz

THROUGHOUT THE DAY Iced tea (5), 1.6 qt; with sugar, 3 oz • *Prairie Farms* 2% milk, 10 fl oz • *Coca-Cola*, 12 fl oz

CALORIES 4,100

Age: 56 • Height: 5'9" • Weight: 245 pounds

ST. ELMO, ILLINOIS • Gordon and Denise Stine's commodity crops are feeding the nation, but their vegetable garden feeds only them. What's for dinner tonight? Denise, just home from her job at the county clerk's office, says, "vegetable soup," made with fresh corn, green beans, cabbage, potatoes, peas, and tomatoes. "The potatoes and peas aren't ours," she says, "but we grew the rest of them." "Vegetable soup? There's a huge chunk of meat in it! Everything we eat has beef," Gordy says. "When you raise it you eat it."

They raise several steers a year, selling most of them and butchering one, which they parcel out to their children for Christmas presents. They don't raise dessert, but Gordy eats that too. "If there's cookies around or cake or pie, I'll eat it," he says. "He made a cake last night so he could have dessert," says Denise. Did he make it from scratch? "Oh no, from a box. I wouldn't even know where to start from scratch!" he says, laughing. Denise pulls out the Betty Crocker chocolate cake. "Whoa," she says, "you have hit this. There's

only half a cake left in this pan!" "I took it down to Mom's," he explains. "I did not eat half this cake myself." "Oh," she says, laughing.

Five generations of Stines (and Steins) have farmed on America's Midwest plains 80 miles east of St. Louis, Missouri, since the family emigrated from Germany in 1838. "They settled right here in this township," says Gordy, "a mother and two sons. The father died on the way here, somewhere in Ohio. One of the sons got married and they had 17 kids, so we started with a bang around here," he says.

Gordy and his brother, Stanton, grew up farming corn, wheat, and soybeans with their father, Stanley, and the brothers still farm the land today. "My dad helps when he can," says Gordy. "He's 83 and probably helps more than he should."

In the 1930s, 25 percent of the U.S. population lived on farms; today that number is only 2 percent, with just 1 percent claiming farming as their primary occupation. This consolidation of farms and farmland means fewer, bigger farms, especially those that produce commodity foods like corn, soybeans, and wheat, which are traded and sold like other commodities, such as metals and oil.

Gordon Stine, a farmer, in his family's soybean field with his typical day's worth of food. At left: Gordy ladles out hearty homemade vegetable and beef stew for his wife, Denise, after a day of corn harvesting.

Gordy harvests corn with his John Deere eight-row combine (top right) on leased land. A grain cart (top left) driven by his brother, Stanton, offloads corn into one of their 10-wheel trucks, which will transport it back to their silos for drying and storage. Bottom right: Gordy checks on a nephew's steers, which are being fattened for slaughter on an adjacent farm. The proportion of income spent on food in the United States has declined steadily since the 1950s and is now among the lowest in the world.

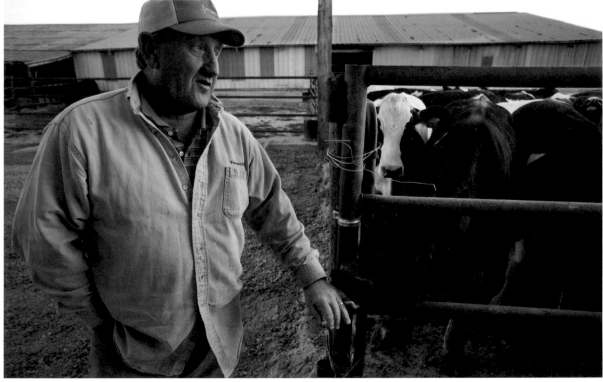

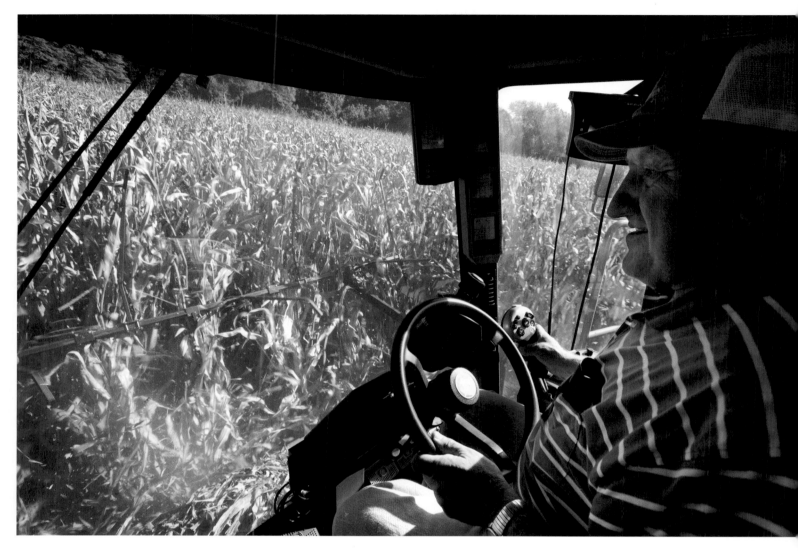

Gordy and other farm operators across the vast central plains plug into the industrial food complex, growing raw materials used in food factories, cattle feedlots, and refineries that make ethanol and high-fructose corn syrup. Consolidation has had a huge effect on all aspects of modern farming. "We used to have five or eight options to buy seed and fertilizers," he says. "Now we've got one or two. You've got one or two places to buy, and one or two places to sell, so we're controlled."

In an area that leans to the right, Gordy grew up in a houseful of Democrats. "You don't like to put yourself in those categories, but there they are," he says. He's been politically active throughout his farming career and is a past president of the Illinois Farmer's Union. "We fight for family farmers...and our philosophy is 'Big is not good; Big Ag will not take care of you,'" he says. "For years it was the Big Ag players, ADM and Cargill, all the big shots, 'We'll take care of you guys. Don't worry about it.' Well BS! They worry about themselves and their stockholders."

Gordy and his brother farm 2,500 acres, some owned, some leased. "That's not big anymore," says Gordy. "There's guys around here farming 5,000 to 10,000." They operate their businesses independently, each with their own income and farm expenses. Gordy's farm is medium-sized, so-called because of his income, not the acreage—in the range of $400,000 gross annually. This includes his federal subsidy, funds paid to commodity farmers to help their often-thin bottom line. But his expenses chew up most of that $400,000—anywhere from $330,000 to $340,000 a year, or more.

About the subsidies, he says, "I don't like 'em, but I need 'em." That money is sometimes the only profit he'll make in a tough year. But now he gets what are called direct payments—tied to historical production, not to what he's actually growing now. "Ten years ago or so, [the subsidy] was tied to your production," he says. "Now it really doesn't pertain to what the price is, and supply, or what's going on—now it almost looks like a welfare check, for lack of a better term. It's not tied to anything."

Gordy and Denise raised four children across the rural road from the house where he grew up. All of their children worked as field hands at one time or another. But when his oldest son, Chris, wanted to switch from majoring in engineering to farming, Gordy pulled out the balance sheets. "He was just hell-bent that he was gonna do it," says Gordy. "I sat down with him and I said, 'Here, Chris, this is what happened in the last 10 to 15 years.' And I explain it to politicians this same way: I go into a year, I don't know whether I'm going to make 50 cents an hour, or whether I'm going to make 30 bucks an hour. I said, 'Is this what you want?'" Chris got the engineering degree.

Will there be future generations of Stines farming this land? Gordy's nephews would like to, but the costs and risks for independent farmers have never been higher. "It took me 20 or 30 years to build this machinery up. Will they be able to write me a check for what I'm going to have to get for it? They'd be in the hole for 10 years before they saw a profit. Well, how many young people will want to do that?"

4200

SPAIN

Oscar Higares
The Bullfighter

ONE DAY'S FOOD

IN APRIL

BREAKFAST Baguette, 1.8 oz; half with tomato, 4 oz; olive oil, 1 tsp; and salt, 0.5 tsp; the other half with strawberry jam, 1 tbsp; and *Arias* butter, 2 tsp • Black tea, 6.1 fl oz; with *La Estrella* sugar, 2 tbsp

LUNCH Steak, 8.8 oz (raw weight) • *Gallo* spaghetti, 4.9 oz (dry weight); with *Ramon Pena* canned tuna belly fillets, 2.8 oz; *Orlando* ketchup, 3 oz; and olive oil, 2 tbsp • Spanish green beans, 14.6 oz; with olive oil, 1 tbsp • *Danone* chocolate pudding, 4.6 oz • *Trina* orange soda, 11.2 fl oz

DINNER Dorada (gilthead seabream, a saltwater fish), 11.3 oz (whole, raw weight, without head); and potatoes (not in picture), 9.4 oz; cooked with olive oil, 1 tbsp • *El Dulze* lettuce hearts, 5.3 oz; and tomato, 4.9 oz; with olive oil, 1 tbsp; and vinegar (not in picture), 1 tbsp • *Danone* chocolate pudding, 4.6 oz • *LU Pim's* cookies, raspberry, 0.9 oz • *Trina* orange soda, 11.2 fl oz

SNACKS Picos (small crackers similar to bread sticks), 0.8 oz • Pomegranate, 11.4 oz • Mango, 14.1 oz • *Font Vella* bottled water, 1.1 qt

CALORIES 4,200

Age: 34 • Height: 6'2" • Weight: 174 pounds

The centuries-old cultural exposition that began as bull sacrifice and morphed into ritual sport is both beloved by many and decried as animal cruelty by others. Bullfighting, widely practiced in parts of Latin America and Europe, is a spectacle that has always drawn crowds, especially in Spain.

MIRAFLORES DE LA SIERRA • Bullfighter Oscar Higares of Madrid says he was 15 years old when he saw his first fight and that it changed him forever. "Bullfighting is an art," the *madrileno* says, "but more than that it's also a way of life; it's just a way of feeling things. You're from another time. You're somebody that has nothing to do with other people. You're born a bullfighter.

"My father was a bullfighter," he says, "and my grandfather bred fighting bulls. The first time I went to a bullfight it was like magic, like nothing I had seen before—I knew I was a bullfighter. When you are bullfighting, you feel alone, you feel strong. But it's not only in the ring. You live like a bullfighter; you feel like a bullfighter."

Does your family worry about your safety?

"Yes, I have been wounded many times.

We're really risking our lives, and that's what makes it beautiful... Not just anybody can do it. My wife has a lot of nervousness when she watches me; she's very scared. She's always known me as a bullfighter. When we met I was already a bullfighter. She's always respected everything: my loneliness, my fear, my strength. She says it's different to see the bullfights when you know what it's about.

"After years of watching bullfights, you feel it if the bull is complicated—a mean bull. Whenever I'm watching the bullfight of someone else, I suffer; I'm scared for him. My wife can feel this too. And she suffers also because the people watching the fights are mean and cruel. They say nasty things; they don't know it's my wife. My oldest daughter, sometimes she is scared and yells, 'Enough, Dad!'"

How do you prepare physically for the ring?

"I am training hard. I get up in the morning and have breakfast...run for [one hour], and then I do exercises like stretching, abs. Then I go and train, but not with a real bull; it's mostly to get familiar with my body—the movement, the feeling.

"I have to do it for the *capote* [the bull-

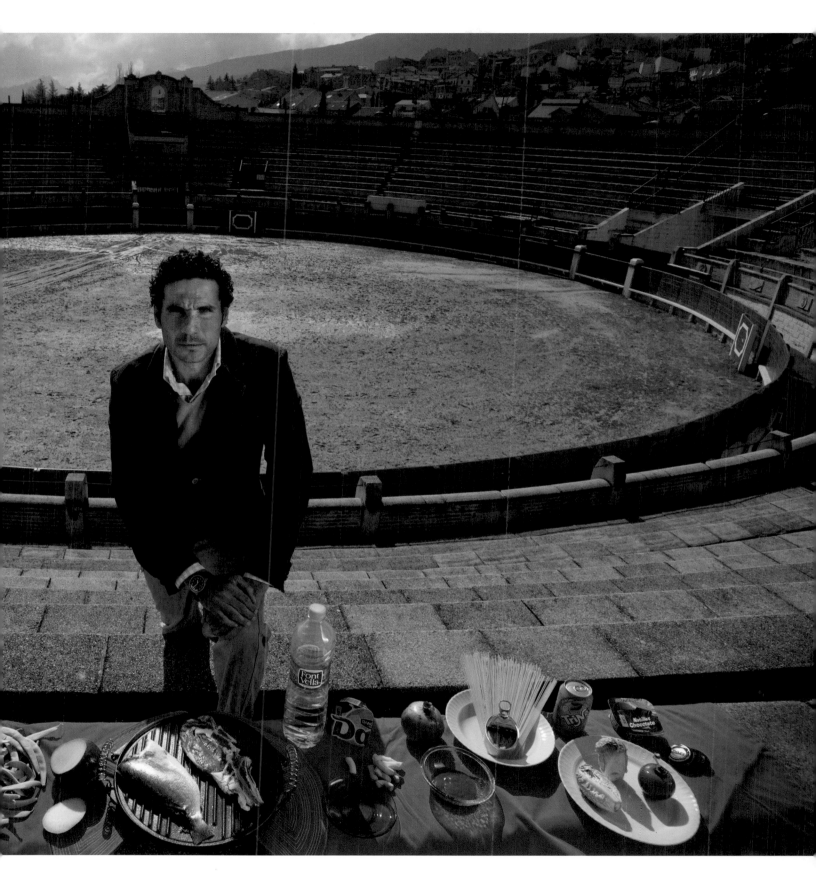

Oscar Higares, a professional bullfighter, in the Miraflores bullring with his typical day's worth of food on a training day. On the day of a bullfight, Oscar tries to sleep late and usually skips breakfast. Because he is a "bit scared" he isn't hungry and eats very little. "The good months of bullfighting are August and September, and it's really hot. The jackets we have to wear are so tight, and they're really heavy. And the pressure of the people watching you—you have to be so concentrated. You lose weight. You lose two kilos [4.4 pounds] every time you go out." He says that in the evening after a fight, "dinner is big... I eat lots of meat."

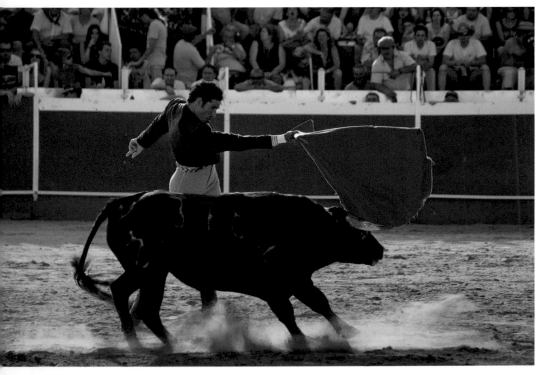

On a stifling midsummer day in Campos del Rio, near Murcia in southern Spain, the annual village festival of San Juan ends with the sacrifice of five bulls by three professional *matadors* (bullfighters). Outside the ring before the event begins, Oscar Higares mentally prepares for the fight (bottom left), practicing moves by substituting his sombrero for his cape. Top left: His first bull roars by him not long after charging out of the gate. At right: On his second bull of the day, Oscar guides the animal—charging past his body at full speed—just after the *banderillas* (brightly decorated short, barbed spears) have been set by his teammates. After a dozen more passes, he kills the bull on his first attempt, eliciting a standing ovation from the crowd, which awards him the bull's ears and tail. Oscar and the bull spend just under 15 minutes together in the ring—an anxious period in which Oscar must control not only the objective dangers, but also his fear.

"The first time I went to a bullfight it was like magic, like nothing I had seen before—I knew I was a bullfighter."

fighter's cape used for the first stage of the fight] and the *muleta* [the smaller red cape used in the last stage of the fight] to be an extension of my arm, part of my body, like a racket for a tennis player. It's like a soccer player trains, doing things he's never going to do in a game, but he does it just to know he controls the ball."

What is your typical diet on a day when you're not in the ring?

"In the morning I always have tea and then I have bread—one toasted with tomatoes, olive oil, and salt; and one sweet one... then after that, something really sweet, like chocolate. Midday I have lots of vegetables and then a big piece of meat, but always with potatoes or salad on the side. I have to have something sweet for dessert, always. If not, I feel like I didn't eat...

"I don't take vitamins or supplements, and I never drink alcohol. I don't like the taste... I try to do the things that make me feel as good as possible. When I go out at night with my friends, the only thing I drink is water. When I see a friend drunk, I always say, 'Well, that's what I don't want to be.'"

What is your routine on the day of a bullfight?

"The day of [an important] bullfight, I just stay in the hotel and try to think about other things, not to be scared. Mostly I don't do anything, just watch TV in the hotel, call my friends—try not to think of the fight. Since I wake up late, I usually don't have breakfast before the fight. You're a bit scared, you're nervous, you're not really hungry. So I eat a little bit of *tortilla* [an omelet dish with potatoes] or a little bit of pasta, and that's it. But then dinner is big afterwards. And I eat lots of meat, depending [on] where I am. If I'm in the north, I'll have fish, or if I'm in some place that's known to have good meat, I'll have meat.

"And then when I have smaller bullfights, it's not a big responsibility... I have my golf clubs in the car and I go golfing, just to relax."

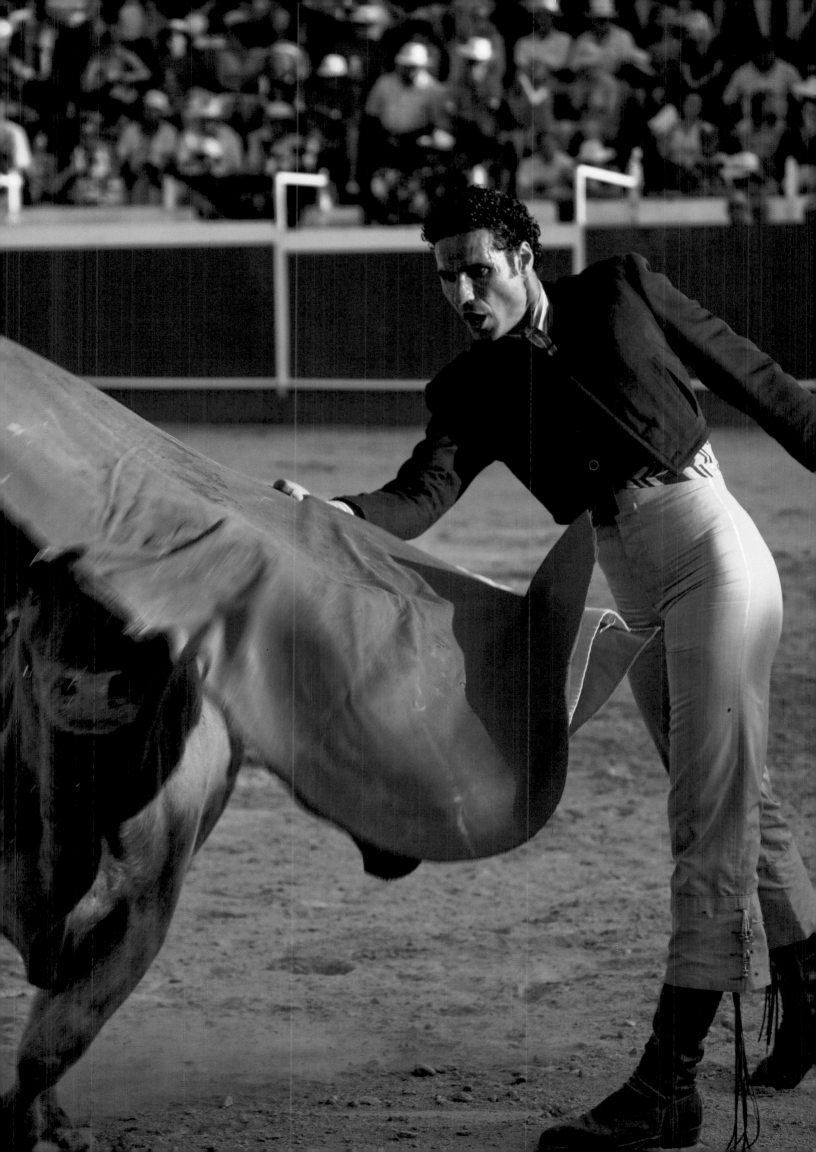

4300

CHINA
Huang Neng
The Welder

ONE DAY'S FOOD

IN JUNE

BREAKFAST AT FOOD STALL Pork baozi (steamed dumpling filled with minced meat), 3 oz • Mantou (steamed white bread), 3.5 oz • *Mengniu* whole milk, 8.6 fl oz

LUNCH IN WORK SITE CAFETERIA Zha zhupai (marinated pork cutlet, battered and deep-fried), 14.6 oz • White rice, 10.7 oz • Sautéed garlic sprouts, 5.2 oz • Cucumber, sautéed with egg and red chili pepper, 5.3 oz

DINNER IN WORK SITE CAFETERIA Dougan (dried tofu), stir-fried with mustard greens and ginger, 4.7 oz • Pig's liver, stir-fried with green bell pepper, 6.5 oz • Stir-fried okra, 7.2 oz • White rice, 14.1 oz • Beer, 16.9 fl oz

THROUGHOUT THE DAY Green tea (2), 1.2 qt • Boiled water, 3.2 qt

CALORIES 4,300

Age: 36 • Height: 5'6" • Weight: 136 pounds

Just 20 years ago villagers worked rice paddies and farmland on the eastern border of Shanghai's Huangpu River. Today, China's most sparkling modern shrine to finance and economic growth—Pudong—rises from the land across the river from old Shanghai, and thousands of migrant construction workers tend to the business of building it.

PUDONG NEW AREA, SHANGHAI • Two cooks dish out rice, stir-fried vegetables, and a braised pork dish to hungry construction workers waiting with bowl and chopsticks in hand. Welder Huang Neng and coworkers have chipped in for bottles of cold, local Shanghai brew to drink with dinner. They're off the clock, but not off the job site—all live in bunkhouses at the foot of the skyscraper they're building in Pudong's Lujiazui financial district.

"Safety first," screams the sign over their head; alcohol is allowed only in the cafeteria at dinner, and the rule is strictly enforced.

Neng was a farmer in Central China's Henan Province, a 10-hour bus ride away, before he became a welder. His wife and two sons still live there, but most of the high-rise jobs he gets are in Guangzhou, Beijing, and Shanghai, so he only sees his family once a year, usually for Chinese New Year. "We work every day," the 36-year-old welder says, "seven days a week until the job is done."

Neng eats lunch and dinner at the job site cafeteria because the subsidized meals cost only 3.5 yuan ($0.43 USD). "The food here is a pretty good deal; you get a lot for what you pay," he says.

The cook, Huang Yujuan, a former farmer from Sichuan Province in western China, says she doesn't have the time or money to cater to requests from workers who hail from all parts of the country and have different tastes: "Every single day here it's rice. Sometimes they want to eat noodles or dumplings; that's normal, but how do I have time to wrap dumplings?" Why doesn't she stock ready-made supermarket dumplings? "They have a strange taste. I'm not going to serve that."

Most mornings the welder eats a steamed pork bun and steamed bread at an off-site food stall. He earns a bit more than less experienced welders—about 2,800 yuan ($349 USD) a month—so he can afford to spend a little extra on food, he says, even though he's saving to buy a better house. He buys milk at the Super Brand Mall near his job site, stores it in his bunkhouse, and drinks a packet a day.

He craves his homegrown vegetables but brings a taste of home wherever he goes: green tea leaves from his home province. "Our tea is very good for heat exhaustion," he says, "a [frequent] problem when we're working in full gear."

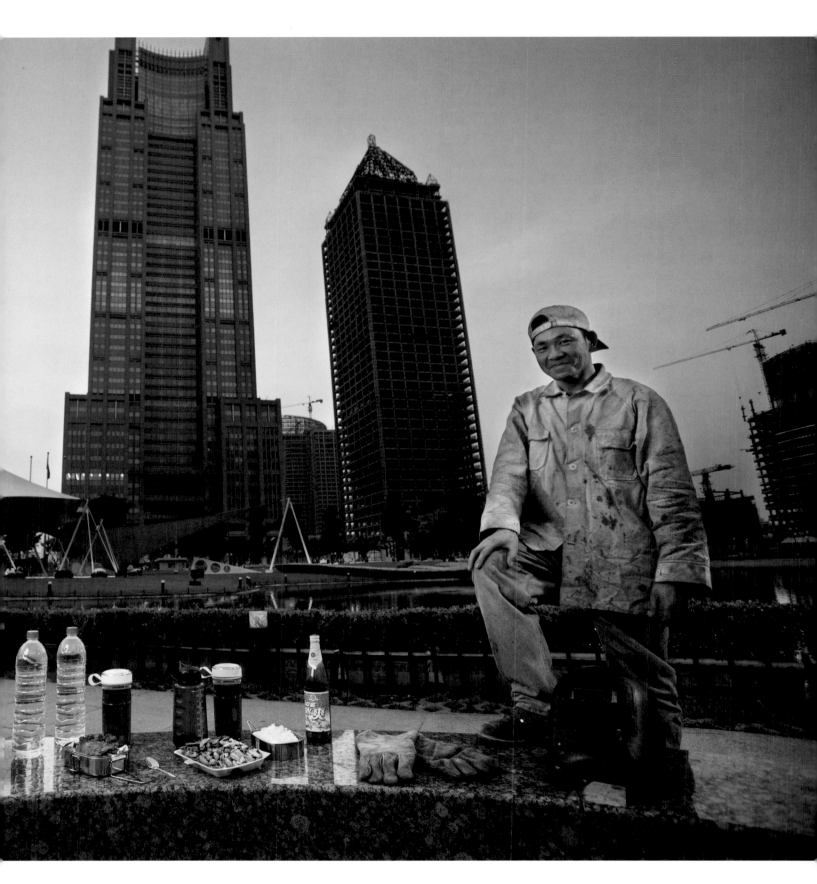

Construction welder Huang Neng, with his typical day's worth of food in Pudong's Lujiazui Central Green Park. The migrant welder has worked on a dozen trophy skyscrapers on the Huangpu River in Pudong New Area, across the river from old Shanghai. His current project is the Zhongrong Jasper Tower, at far right, which will top out at 48 floors—a short-statured building compared to its neighbors.

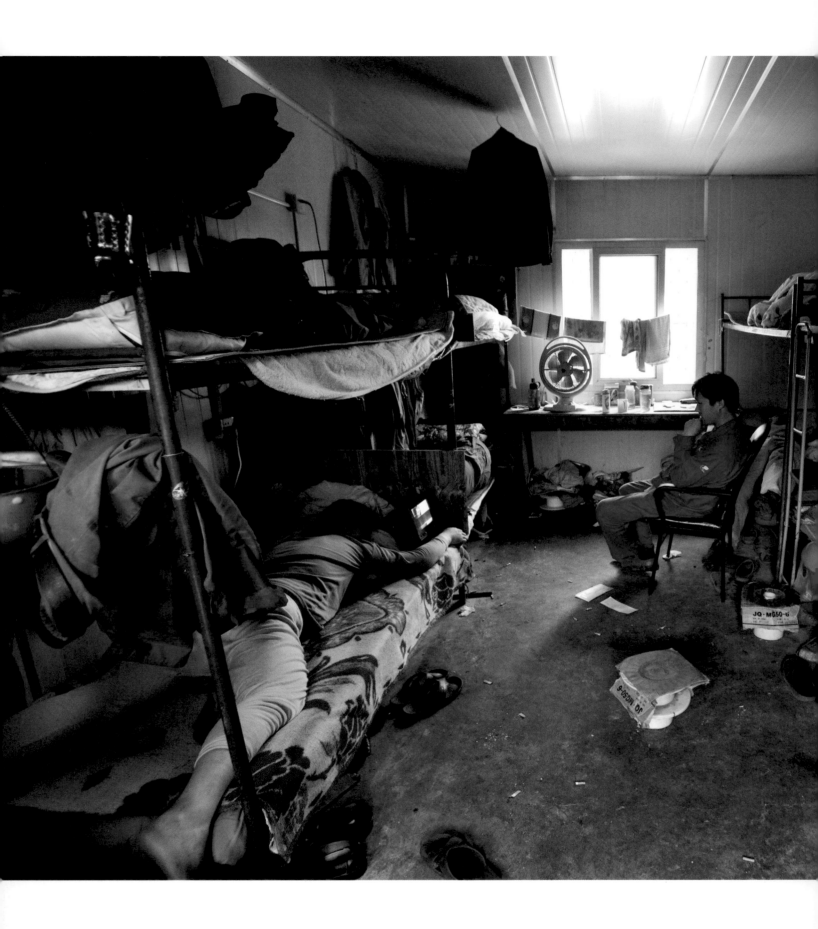

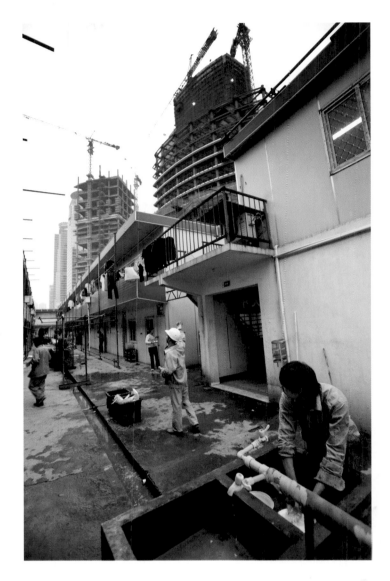

In China, migrant laborers often live directly on the job-site grounds of big construction projects and work 12-hour shifts, seven days a week. Alcohol is only tolerated in the company cafeteria (bottom right), after dinner. The skyscraper in progress (at right) looms above the rows of dormitories where Huang Neng shares a room with nine other workers (at left). On this stormy summer afternoon, they take advantage of a rare workday shortened by weather to nap in their bunks.

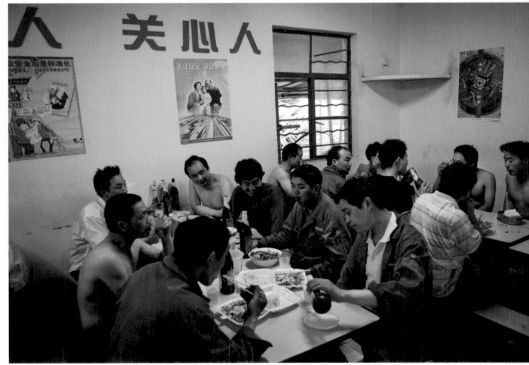

Uahoo Uahoo, an Etosha National Park warden, standing in the back of his truck watching a herd of springbok, with his typical day's worth of food. Uahoo's love of the outdoors began in his youth, growing up near Waterberg National Park, 225 miles south of Etosha. Seeing conservationists and tourists passing by the cattle breeding station where his father was employed piqued his interest. He began working with an entomologist while on school holidays, and he ran an environmental club in school. After completing a degree in natural resource management, he landed a job as one of only seven wardens in Etosha National Park, which is the size of New Jersey. Uahoo is now completing a master's degree online.

NAMIBIA

Uahoo Uahoo
The Game Warden

ONE DAY'S FOOD

IN MARCH

BREAKFAST *Schweppes* tonic water, lemon, 6.8 fl oz • *Five Roses* tea, zesty lemon, 10 fl oz; with sugar, 1.5 tbsp; and *Nestle Cremora* nondairy powdered creamer, 2 tsp

LUNCH *Hartlief* lamb ribs, 10.9 oz (raw weight); stewed with tomato (not in picture), onion, and green bell pepper (not in picture), 3.4 oz • White bread, 2.5 oz • *Sprite*, 11.2 fl oz

FIELD SNACKS *Prima* canned wieners, 9.9 oz • Oranges (2), 9 oz • Spice cookies (2), 1.7 oz

DINNER *Hartlief* stewing beef, 1.1 lb (raw weight); stewed with tomato (not in picture), onion, and green bell pepper (not in picture), 3.5 oz • White rice, 5.7 oz • *Koo* canned guava halves in syrup, drained, 8.5 oz • *Sprite*, 11.2 fl oz

SNACKS AND OTHER *Baker's Red Label* sweet biscuits (cookies), lemon cream (4), 2.9 oz • *Parmalat Pure Joy* pineapple juice, 10.8 fl oz • Boiled water, 1.1 gal

CALORIES 4,300

Age: 31 • Height: 5'10½" • Weight: 178 pounds

ETOSHA NATIONAL PARK • While we scout for his food portrait location in Namibia's most famous national park, warden Uahoo Uahoo suddenly veers off the gravel road and through the tall grass in his four-wheel-drive truck, coming within earshot of a leopard ripping apart a springbok in a mopane tree. What tipped him off? The head of a hyena barely visible above the grass as it waited for a leftover morsel. Binoculars raised, Uahoo watches intently as a fellow meat lover devours an afternoon snack.

Etosha National Park is the crown jewel of the world's wildlife sanctuaries: a vast shallow salt pan in the north of Namibia, hundreds of miles across, surrounded by savanna and spring-fed waterholes. Scores of species as diverse as flamingos, elephants, rhinos, zebras, wildebeests, giraffes, kudu, and springbok range there.

Uahoo, one of seven park wardens, splits his time between fieldwork—managing animal populations and misbehaving humans— and shuffling papers in his office at Etosha's Halali Camp, where he lives in government housing with his girlfriend and two young daughters. His favorite part of the job though, is out in the wild, scouting with the rangers who work for him. His favorite spot? Standing in the back of a moving four-wheel drive truck. "That's me. I love that," he says.

His university degree in natural resources management took him far afield of his home village of Ombuyovakuru, 200 miles southeast of Etosha, but his Herero pastoralist culture and his family ties keep him connected to his land and his village, "like all African men," he says. "We have our village. That's my place to stay, [no matter] where I go." He and his family keep a herd of 400 cattle, goats, and sheep in Ombuyovakuru, and he makes the trip home about once a month.

Meat muscles into nearly every facet of life in Namibia—the quest for it, and the enjoyment of it. "Dinner has to include a piece of meat, otherwise it isn't dinner," he says. On occasion he'll bring a carcass from his village back to Etosha and eat it piecemeal until it's gone.

Growing up, cornmeal porridge was the daily staple, eaten at every meal. Does he still eat it? "Definitely there are those indigenous foods that I cannot run away from," he says. "There's porridge and sour milk and meat, a bit of soup." But it was affordability and accessibility that guided food choices in the village. "Now I can mix it up with chicken and fish, and rice and potatoes."

In the tall grass on the edge of the salt pan, a normally dry lakebed bigger than Rhode Island, a male lion looks for something to kill and eat. Etosha National Park hosts large herds of springbok and kudu, both of which are favored by lions, and by the patrons of several popular restaurants in Namibia's capital, Windhoek. The park's 500 miles of perimeter fences protect the animals of Etosha but also interfere with migration, mostly for wildebeests and zebras. Uahoo's favorite part of his job is fieldwork, which is mostly hands-off observation of plentiful game, but also includes managing big game species that are few in number, like rhinos and elephants, and sometimes intervening to help a sick or injured animal.

4600

GERMANY

Markus Dirr
The Master Butcher

ONE DAY'S FOOD

IN MARCH

EARLY MORNING Pork rib, salted, 7.8 oz • Potato, 3.8 oz; with olive oil, 1.7 fl oz

MIDMORNING French bread, 0.8 oz; with Brie cheese, 4 oz; and olive oil, 1 tbsp • Espresso, 2.3 fl oz; with raw sugar, 1 tsp

LUNCH Lyonnaise sausage, 2.2 oz • Hard white bread roll, 2.2 oz • Radicchio, 0.4 oz • Tomato, 0.9 oz • Apple, 5.4 oz • *Lieler* bottled water, 1.4 qt

DINNER Porterhouse steak, 1.4 lb (raw weight); cooked with butter, 1.8 oz • Fennel, 7 oz: cooked with olive oil, 2 tbsp • Sea salt and black pepper for the steak and fennel, 1 tbsp • Brown bread, 2.6 oz • Apple, 5.3 oz • Homemade fresh ginger water (2), 14 fl oz • Red wine, 5.1 fl oz

SNACKS AND OTHER Salad of chicken, mushroom, leek, and celery with olive oil and lemon juice dressing, 3.5 oz (raw weight) • *Riegeler* beer, 16.9 fl oz

CALORIES 4,500

Age: 43 • Height: 5'9" • Weight: 160 pounds

ENDINGEN AM KAISERSTUHL • If butchers were rock stars, Markus Dirr would be facing a sea of lighters and a mob of groupies. Instead, his fans wait patiently, shopping bag or basket in hand, for his sausages, hand-tied hams, and fresh cuts of beef and pork at an open-air farmer's market in the city of Freiburg im Breisgau in the Black Forest region of southwestern Germany.

"The meat is hung well, which you seldom find, and I like his liverwurst," says one woman. "I like his Italian-influenced hams," says her

friend. Markus takes his time with each customer, leaning in conspiratorially at times to offer sausage samples or advice about the cooking of a lamb loin.

Woodworker Martin Ginter savors a quick bite of his purchase, a thinly sliced prosciutto that has been air-dried and aged for several months in Markus's shop in the town of Endingen am Kaiserstuhl: Metzgerei & Wursterei Peter Dirr (Butchery & Sausagery), named for Markus's father, who is still chief butcher. "Simply the best," Martin says. "I

used to drive the 30 kilometers [18.6 miles] to their shop to buy my meat." Now the meat comes to him.

Markus's line of customers snakes around the front of his bright white mobile market in Freiburg, amidst vendors of local vegetables, regional wines, and *biofleisch* (organic) meat, all serving far fewer customers.

The 43-year-old butcher says he has no need for the organic label that has become so important in a world of mass-produced food, as he knows the farmers who raise his animals, handpicks them personally, and oversees the slaughter and processing from start to finish. "My philosophy is simple," he says, "and this is also the idea behind [the] slow food [movement]: to process regional products ourselves and to make a good product with only natural spices and salt."

His customers are making a conscious choice when they buy from him, as his prices are 10 to 15 percent higher than those of other butchers, but most of their countrymen are shopping instead for mass-produced meats at discounters and supermarkets. By 2015 these modern markets are projected to command 86 percent of the marketplace,

Markus Dirr, a master butcher, in the back room of his shop with his typical day's worth of food. At left: With his father, Peter Dirr, at the controls of the mixer, Markus moves gobs of *Weisswurst* (white sausage) paste into the adjacent extruder.

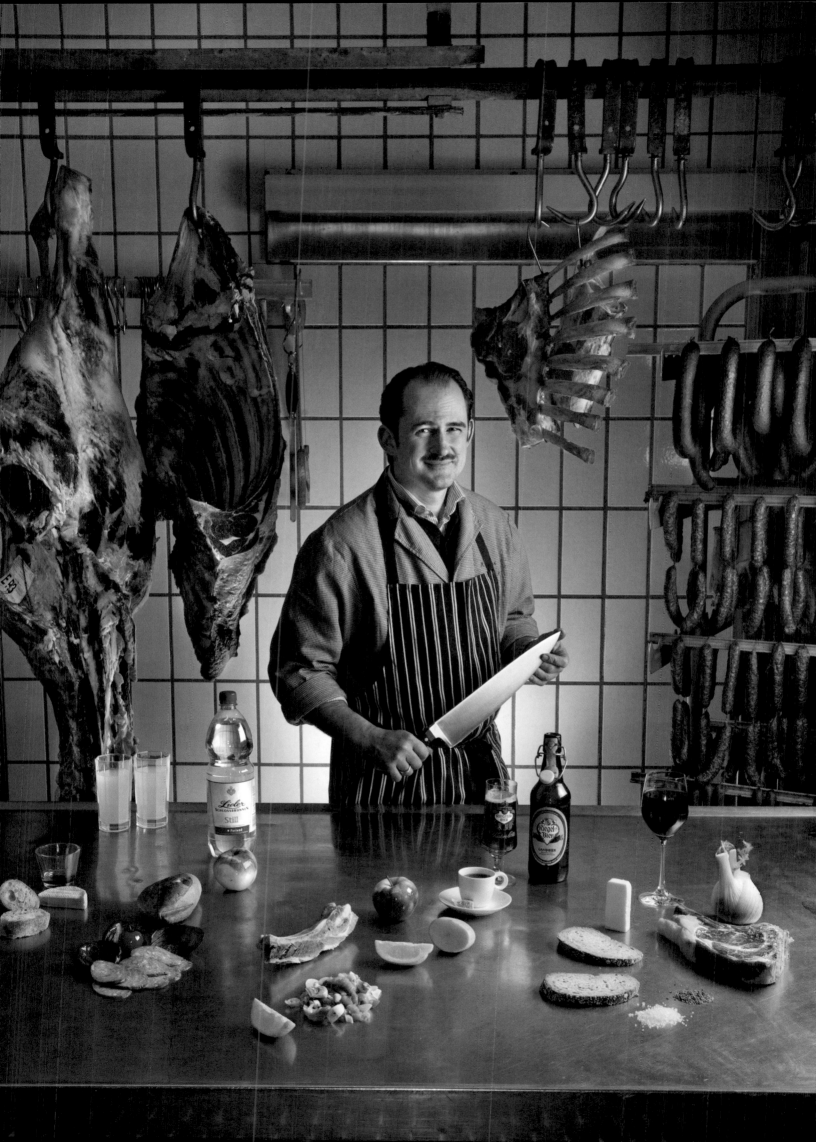

The Dirrs know the farmers who supply their animals, and in fact hand choose the animals and watch them grow. Top left: Markus visits his neighbor, Hannes Ekström, a dairy farmer, to discuss which veal calf will next go into his sausages, like the freshly made and parboiled *Weisswurst* (white sausages; bottom left). At right: After hours of work and a breakfast of pretzel bread, sausage, and coffee, Markus and his wife, Sonja, discuss the day's plans for their catering business. Germans are among the biggest meat eaters in Europe, but eat slightly less meat than in decades past.

and traditional butchers are leaving the field in droves.

Markus says German butchers must diversify or die. Bringing his shop on wheels to well-heeled consumers in the city of Freiburg is just one of his efforts to reinvent the family business, which has spanned four generations. There's also catering, which he does with his wife, Sonja, lectures and seminars, and his pride and joy—a new line of air-dried hams and salamis that he sells alongside traditional handcrafted offerings.

Markus was well-positioned to rework the business model of his father's traditional butchery. He had roamed the world for over a decade working as a chef and a butcher, and when he came back to work with his father in the mid 1990s, he brought inspiration. "I did this air-dried stuff—big hams like in Italy—16 months air-dried in the fridge, and I have about 15 different herbs I work with. I make prosciutto with fennel, I make one with rosemary, I make one with coriander. I have this salted salami of wild pig with raisins,

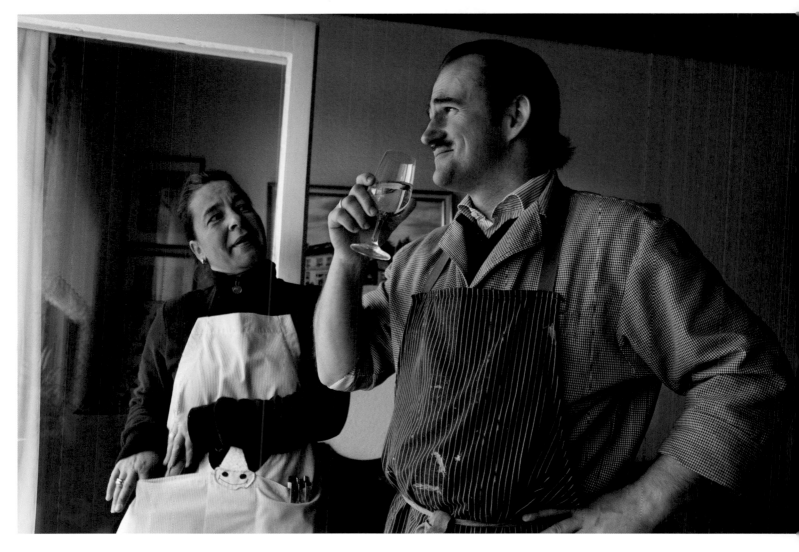

almonds, and walnut. Very nice." These are very different from traditional German products. Do people here ask for them? "Some do," he says, "but in the whole of Germany I have about 600 clients who order every two or three months my homemade salamis and special hams."

When he reinvented the business, he also cleaned house. "In the eighties it was very popular for a butcher to buy sausages from industry that weren't efficient to make by yourself and sell, but then you're not a butcher, you're a seller," he says. "I threw out all these products and we kept only our own handwork. It was a good decision because the people really appreciate what we're doing."

There's a strict daily schedule to be followed at Metzgerei & Wursterei Peter Dirr to ensure that everything is ready for the main selling days, Friday and Saturday. Seven or eight pigs, one cow, a steer, and, depending on the week, veal calves and lambs are brought to Endingen on Sunday night and slaughtered Monday morning, and then the

different *Kochwursts*—cooked sausages like blood sausage and liver sausage—are made soon after. "We have to make the blood sausage on the day we do the slaughtering," says Peter, "before the death grip comes. Otherwise the flavor isn't right."

The rest of the week is devoted to processing the carcasses into fresh meat, hams, and other sausages: *Bruhwurst* (sausages that are scalded), like *Weisswurst* (Bavarian-style white sausage made of finely ground pork shoulder and veal); and *Rohwurst*, raw sausages that are cured, smoked, or air-dried. "The *Rohwurst* are very difficult because you produce them and then you have to wait and let them ripen like an apple," says Markus. "It is always a risk because to get a perfect naturally ripened salami depends on so many things, like temperature, humidity, air movement."

Some of the preserved meats are perfected recipes and others are merely trials. "These here," he says, pointing at pieces of pig shoulder, "take about five months to dry and to ripen; to get spicy, to get flavor. And all these

mushrooms and molds you see on them—when I was first [experimenting], I saw this and I was like, 'Oh my god!' I took them to a chemical lab and said, 'What am I going to do? This is all of my money invested in this.' And they said, 'There's no problem.'" The mold is a natural part of the curing and fine to eat.

In his giant walk-in coolers there are racks and racks of sausages, hams, and salamis, and also a juniper-seasoned salted ham that he can't legally label "Black Forest," although the recipe is similar. "Black Forest" is a protected geographical indication, an EU designation reserved for certain specialty foods unique to a particular geographic area. The Dirrs' shop is located five miles outside the Black Forest. They call their version Kaiserstuhl (meaning "the emperor's chair"), after their own region.

"It's important to do the traditional things like blood sausage, liver sausage, the white sausages, and the traditional ham that we do," he says. "But I think if I hadn't started these new products, we wouldn't exist here."

4700

CANADA
Willie Ishulutak
The Inuit Carver

ONE DAY'S FOOD

IN OCTOBER

BREAKFAST AND THROUGHOUT THE DAY Two pots of *Folgers* coffee, 3 qt; with sugar, 6.4 oz; and nondairy powdered creamer, 1.3 oz

LUNCH Arctic razor clams, 1.7 lb (includes shell weight) • Bannock (fry bread), 6.8 oz

DINNER Pork chop, 15 oz (raw weight); pan-fried in vegetable oil, 1 tbsp • *Green Giant* mixed vegetables, 4.9 oz; with margarine, 1.3 oz; and black pepper, 1 tsp

SNACKS AND OTHER *Ritz* crackers, Cheddar flavored, 3.5 oz • *Welch's 100% Juice Blend*, grape strawberry, 16.9 fl oz • *Molson Canadian* beer (8), 96 fl oz • *Kellogg's Raisin Bran Crunch* cereal, eaten dry, 1.7 oz • *Players* cigarettes (5)

CALORIES 4,700

Age: 29 • Height: 5'9" • Weight: 143 pounds

Nunavut, Canada's youngest, largest, and least populated territory, was carved from the country's Northwest Territories in 1999 to create a home territory in Canada's eastern and central Arctic for the Inuit who have lived in the region for the last four centuries. Long before this land became Canada, the Inuit hunted and fished the great wilderness of the Arctic north for polar bear, caribou, narwhal, and seal. These days, a modern grocery store is more apt to be the Inuit's hunting ground, but local game, called "country food," is still preferred.

APEX, NUNAVUT • An icy drizzle falls, but Willie Ishulutak ignores it. Seated on a milk crate with a view of the rocky Baffin Bay coastline, the solitary Inuit carver brings his electric grinder to the stone in his lap, and the shape of a dancing polar bear emerges. He sets it down and begins carving another arctic creature—a narwhal. He stops to adjust his mask, sending clouds of fine, white stone dust into the cold arctic air. He begins to carve again, and the marbled soapstone whale grows a tail: "I see what a piece of stone will be before I carve it," he says. "I see something in nature and I can feel what the stone should be."

Occasionally he stops work for a cigarette and coffee; by the end of the day, Willie will consume two pots' worth. "I really love coffee," he says, chuckling at the understatement. Willie buys the stone from his friend Russell and picks up extra cash by helping him mine it, traveling by boat for two weeks at a time and jackhammering for 13 or 14 hours a day. "Oh yeah, it's hard work," he says. "We don't get paid by day or week… What we earn depends on how many pounds we get."

The 25-year-old works outside the house he shares with his mother in Apex, a small town near Nunavut's capital of Iqaluit, located on Frobisher Bay on the southern coast of Baffin Island. There's only one bedroom, so he sleeps on the couch, his belongings piled in a corner of the living room.

The Inuit have always carved, making tools, fetishes, and amulets to bring luck in

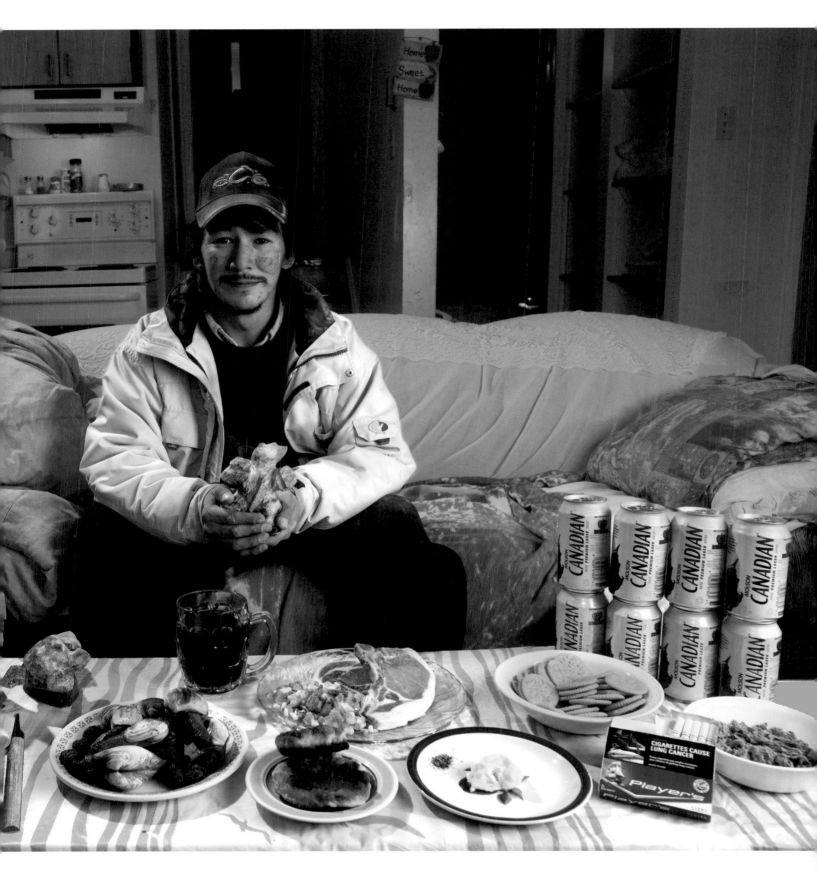

Willie Ishulutak, an Inuit carver, in the home he shares with his mother, with his typical day's worth of food. Carving is one of the few traditions of the Inuit that has made the leap into the wage-earning modern world. He holds a work in progress: a soapstone dancing polar bear. Other unfinished carvings sit on the table as well. Willie says he can complete two or three pieces in a day, then sell them in the evening at bars and restaurants in Iqaluit for $100 ($93 USD) each, and sometimes more. At left: A finished carving of a narwhal.

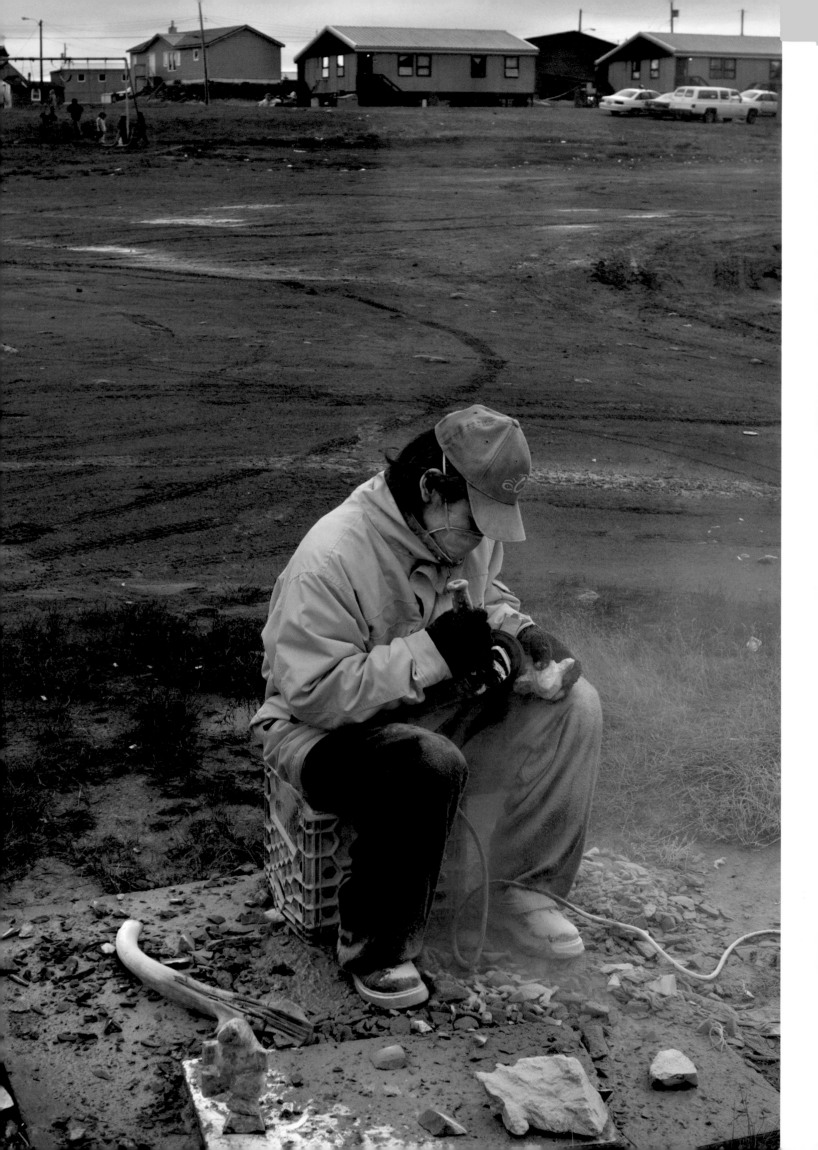

hunting, but now they mostly sell decorative pieces directly to the public at the few hotels and restaurants in Iqaluit, and occasionally to collectors and galleries. In recent years the Inuit community has worked to create a marketplace for indigenous art both as an avenue for artistic expression and for employment.

Good quality carvings, and even bad ones, can bring $100 ($93 USD) or more, depending on size and complexity. "I get a lot more than that sometimes," says Willie. He takes quiet pride that some of his pieces are in a gallery in Ottawa, a place he's never been.

Today Willie took a break from work to go clamming with a few friends in the bay near his house. He brought home a bucket of Arctic clams. How many did he get? "Oh, I really don't know. Let me think. Not a lot. Less than 20." How does he cook them? "I ate some raw and steamed the others at home. It's best to just boil them. It's a more natural taste."

He cooks most of his own meals but also eats his mother's bannock—a fried bread that the northernmost Inuit began to eat after non-aboriginals arrived. He says his aunt's bannock is actually better. "It's sweeter—that's all I can say... It's got a salty kind of sweetness, if you know what that means."

Willie buys most of his food at the grocery store: pork chops, frozen vegetables, crackers, juice, and boxed cereal. Because supplies only come in by ship during the summer season when the sea ice breaks up, and must be flown in the rest of the year, the cost of living in Nunavut is among the highest in the country, despite government subsidies.

Willie buys beer as well—seven cans a day on average. Does he think that's a lot of beer? He avoids the question: "If I have the money I buy it," he says. There's no retail beer available in Iqaluit; a local ordinance meant to prevent binge drinking forbids it. There is, however, alcohol for purchase at restaurants and bars, and on the black market, and each beer costs more than $7 ($6.50 USD). Does he eat traditional food other than clams? "I barely eat country food because it's not available much," he says. "If I eat it, I eat caribou, seal, arctic char, ptarmigan." How many times in a month? "I don't know the answer to that. It depends. Whenever my grandmother cooks any kind of seal meat or char, when I hear she's cooking something like that, I go there to eat." Most nights, though, he eats alone, then walks the three miles from Apex to Iqaluit to sell his carvings of the day.

Covered with dust from his electric grinder, Willie (at left) roughs out the fins of a soapstone narwhal sculpture outside his mother's house in Apex. Top right: A stone *inukshuk* sits on the crest of a hill above Iqaluit. These traditional Inuit stone markers are built to serve as landmarks in permafrost areas where there are no trees or other distinctive features. In the distance, a taxi climbs the grade on the Road to Nowhere, so named because Iqaluit isn't connected by road to the mainland—or to other parts of Baffin Island. Bottom right: A barge loaded with food and supplies from the last cargo ship of the season is offloaded onto the rocky beach at low tide. Pack ice typically closes regional shipping lanes from October until early July.

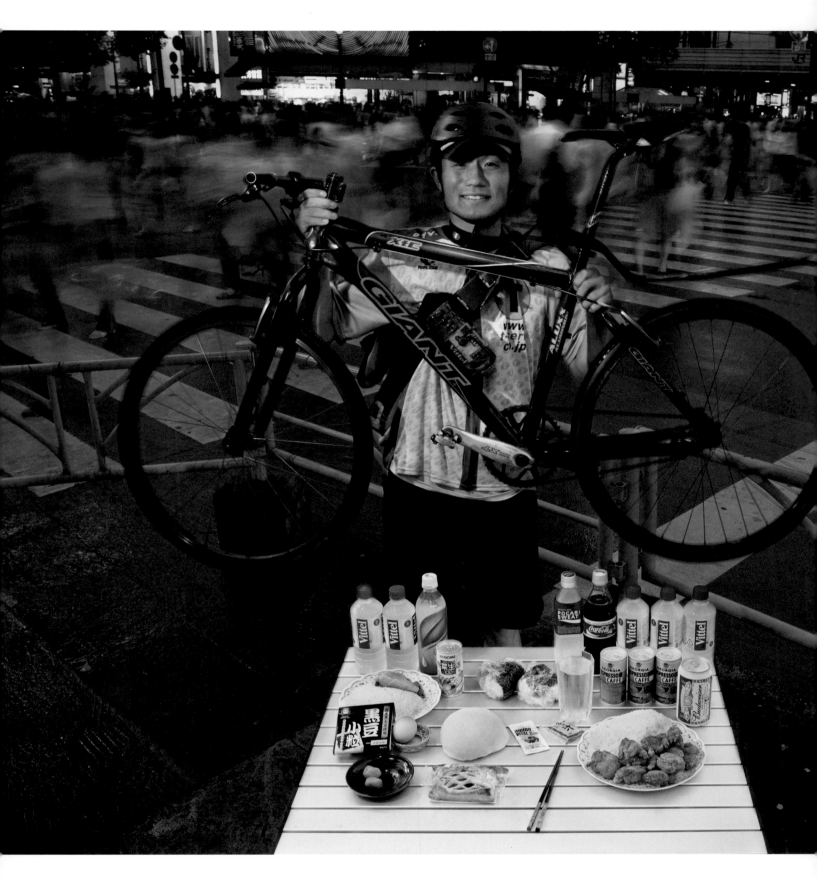

Yajima Jun, a bike messenger for the company T-serv, at a busy intersection in the Shibuya district during evening *rasshuawa* (rush hour), with his typical day's worth of food. Jun holds his Taiwanese-made bicycle while pedestrians blur their way across the street en mass; no one disobeys traffic signals or jaywalks in law-abiding Japan. The photo, however, was taken guerrilla-style—set up in under a minute with the food neatly displayed on a portable table and lit with a handheld flash—to avoid the attention of the traffic police in the kiosk across the street, who would have demanded to see our nonexistent permit if they had spotted us.

4800

JAPAN

Yajima Jun
The Bike Messenger

IN JUNE

BREAKFAST Salmon fillet, 3.5 oz • White rice, 12.7 oz • Egg, 2.2 oz; scrambled and eaten with natto (fermented soybeans), 1.6 oz; and soy sauce, 2 tsp • Umeboshi (pickled ume plums), tuna flavored (2), 0.7 oz • *Kagome* vegetable juice, 6.8 fl oz

LUNCH ON THE BIKE Homemade onigiri (rice balls wrapped in seaweed), 1.1 lb; stuffed with ume plums and yukari (pickled red shiso leaves, dried and powdered), 1 tbsp • Steamed white bread, 6.7 oz • *Yamazaki* apple pie, 4.4 oz • *Coca-Cola*, 16.9 fl oz

DINNER Fried chicken, 10.1 oz • White rice, 1.5 lb • Miso soup (not in picture), 8 fl oz • *Budweiser* beer, 11.8 fl oz

THROUGHOUT THE DAY *Amino Vital* supplements, 0.1 oz • *Pocari Sweat* sports drink, 16.9 fl oz • *Kirin* green tea, 16.9 fl oz • *Georgia Espresso Caffe* coffee, with whole milk and sugar (3), 19.3 fl oz • Boiled water, 10 fl oz • *Vittel* bottled water (5), 2.6 qt

CALORIES 4,800

Age: 26 • Height: 6' • Weight: 180 pounds

TOKYO • Armed with an undergraduate degree from an agricultural university and in search of a job, Nagano native Yajima Jun found himself watching bike messengers working in downtown Tokyo. "I thought they looked happy," says Jun, who has been riding now for several years for T-serv, Tokyo's biggest messenger service—an interesting career choice for a guy who rarely rode a bike before he got the job, but Jun is a top rider. He averages more than 50 miles a day as a messenger.

At 6 a.m., Jun eats a high-protein breakfast in his dorm-style flat in Koganei City, west of downtown Tokyo: black *natto* on scrambled eggs with ume plums, and a piece of salmon with rice. *Natto* (fermented soybeans) has a strong flavor—and a devoted following. The T-serv riders discuss which foods and supplements will give them an edge on the street, to stay healthy and fuel long hours of riding. High-protein *natto*, they say, is one of them.

He sets his rice cooker for his evening meal, downs a can of vegetable juice, and at 6:45 a.m. is on a crowded train, headed to work at T-serv's headquarters in Minato, where he keeps his bike. He dozes standing up, holding on to a strap for the hour-and-a-half commute, then it's a morning meeting, a quick stretch, delivery details, and a nine-hour day on his bike—five to six days a week.

In a country where politeness on the street is virtually a cultural imperative, a bike messenger's duty to make on-time deliveries can create a bit of culture clash. Fortunately, Jun's employer pays by the hour, not by the job, so although its messengers race to make deliveries on time, they aren't also racing for wages.

Jun's workday meals are eaten on the run and packaged for speed. For lunch he pulls out *onigiri* (rice balls), stuffed with dried *shiso* leaves and pickled ume plums, and wrapped in seaweed. He washes them down with Coke.

There's plenty of hydration available—at a price. In Tokyo, virtually every corner has vending machines with cold and hot drinks. Jun buys minimart snacks and copious amounts of water, green tea, and coffee throughout the day. A bottled sports drink—Pocari Sweat—in the late afternoon replenishes his electrolytes.

He strap-hangs back to Koganei City on the evening train, buys fried chicken from a local minimart, and arrives home at 9 p.m. The rice is cooked and his can of Bud is cold. He adds hot water to instant miso soup powder, opens the beer—and dinner, which he eats while watching television, is ready. By midnight he'll be asleep, and six hours later, he'll be up and fueling himself for another day.

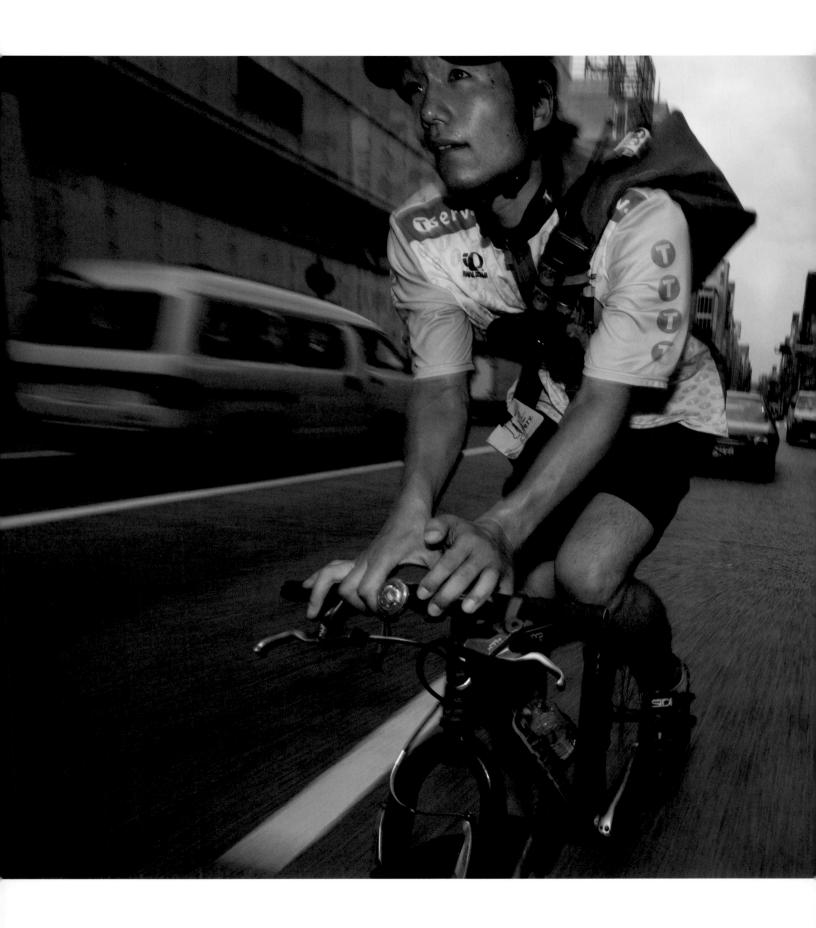

Often making better time than cars and nearly as fast as a motorcycle, Yajima Jun powers through downtown Tokyo traffic (at left) to deliver a package suspended in his shoulder bag, while also keeping an ear out for his dispatcher to assign him his next pickup location. On a typically busy Friday afternoon, dispatchers in the "boiler room" (top right), each with a lot of bike delivery experience, talk to customers and then guide bikers to pickup and delivery locations. Physically exhausted at the end of a long day, Jun is able to nap on his long commute home on the subway (bottom right), while other passengers immerse themselves in their own private mental spaces.

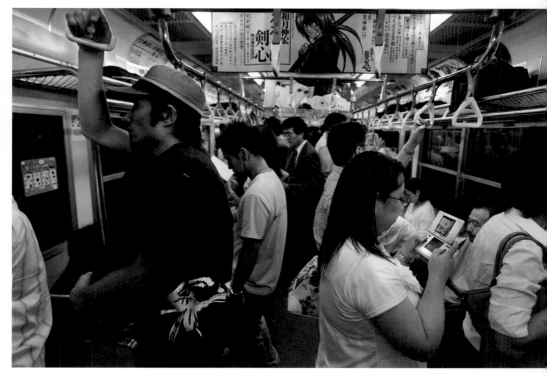

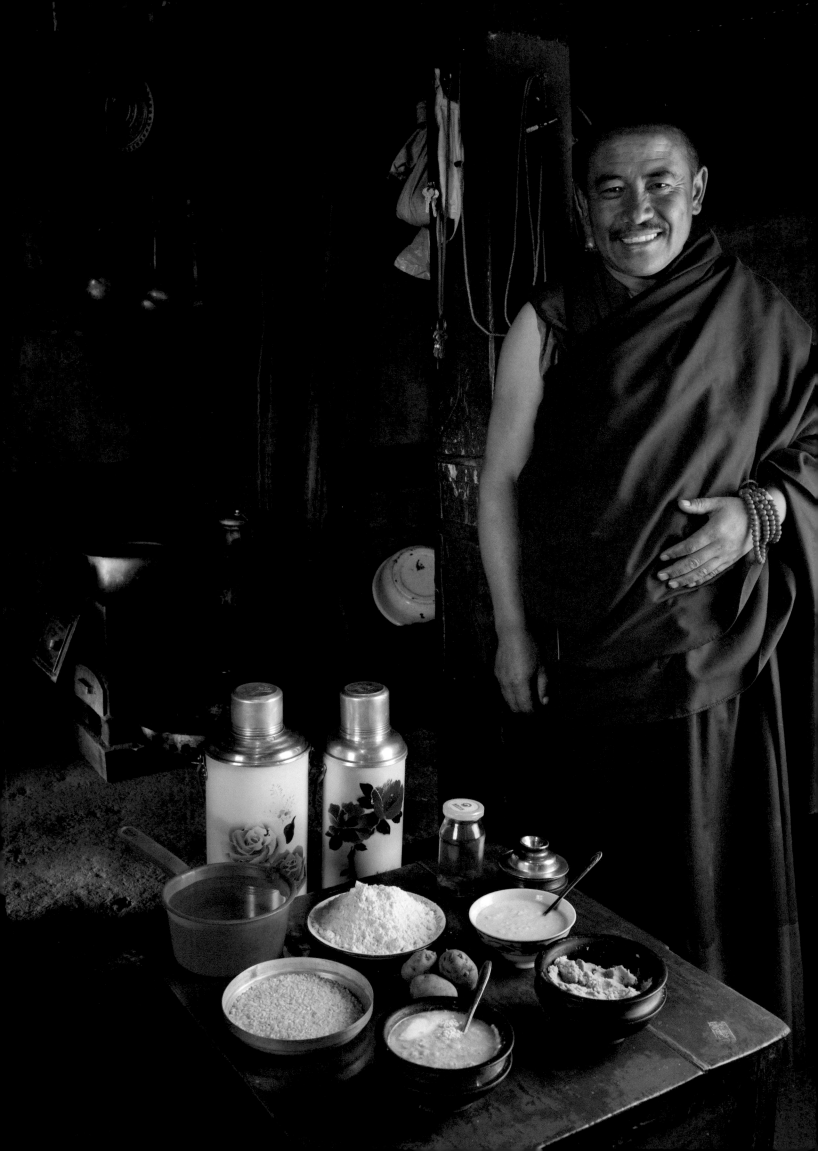

TIBET AUTONOMOUS REGION, CHINA

The Head Monk

ONE DAY'S FOOD

IN JUNE

BREAKFAST Boiled well water, 16 fl oz • Tsamtuk (butter tea and toasted barley flour soup): butter tea (brick tea, butter made from fermented milk, and salt), 7.5 fl oz; toasted barley flour, 3.4 oz; butter (made from fermented milk), 3.4 oz; dried cheese curds, 0.4 oz

LUNCH Pag (barley flour cake): toasted barley flour, 6.9 oz; butter tea, 1.4 fl oz; butter, 1.8 oz; dried cheese curds, 0.9 oz; sugar, 2 tsp • Yogurt, 8.5 oz; with sugar, 2 tsp

DINNER Noodle soup with potato: wheat flour noodles (made from flour and water; flour is pictured), 8.9 oz; potatoes, 6.1 oz; and butter, 2 tsp; in a salty broth, 1.1 qt • White rice, 6.1 oz

THROUGHOUT THE DAY Butter tea, 27.1 fl oz • Green tea (made from tea leaves from his home province), 17.8 fl oz

CALORIES 4,900

Age: 45 • Height: 5'5" • Weight: 158 pounds

The monks were open about their diet but asked that we be circumspect in describing the historical context of their lives. They also asked that we not disclose names or the location of their monastery, which dated from the seventh century and was destroyed in the early 1960s. They received permission to rebuild a small part of the monastery in the early 2000s. Our words are carefully parsed.

THE TIBETAN PLATEAU • Twenty monks in saffron red robes and tool belts split their time between devotional pursuits and carpentry as they work to finish the entrance of the main sutra hall, where holy Buddhist scripts are studied, read, and chanted. Shopkeepers in the nearby village and herders take turns supplying the monks with yogurt, dried meat, flour, butter, and root vegetables, and also help with carpentry. The villagers twirl prayer wheels as they walk the miles between home and monastery to bring their offerings and their assistance.

During three months of the year there are no meals after 2 p.m. for the Buddhist monks, to further them on their path toward enlightenment, but otherwise they eat as the neighboring villagers do. Each morning the

junior monks use a special churn to blend butter tea—Tibet's most ubiquitous drink. It's an infusion of brick tea mixed with salt and fermented butter. In addition to drinking the oily brew, they also add it to *tsampa* (barley flour) to make porridge and soup.

After meditation, the monks eat their morning bowl of *tsamtuk*—a soup of *tsampa*, butter, and butter tea, sometimes with dried cheese curds. The head monk uses his thumb to blend a *tsampa* and butter dough for lunch,

adding a little butter tea to hold it together. They use the same recipe to shape figures and cones—called *tormas*—for ritual offerings. Not all Buddhist monks are vegetarian, especially on the high plateau, where little grows. There is a dried leg of yak in the communal kitchen—an offering from a herdsman. Tonight though, the head monk cooks rice for himself and prepares a soup of potatoes with wheat flour noodles that he makes from scratch and pinches into the watery broth.

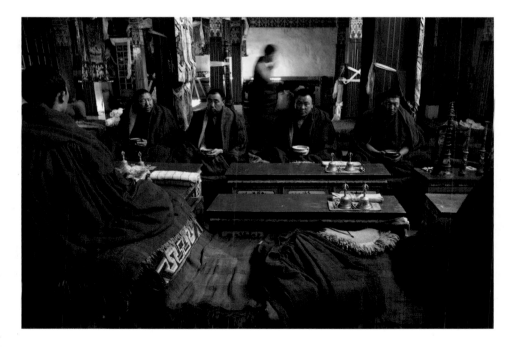

The head monk at his partially rebuilt monastery with his typical day's worth of food. At right: Tibetan Buddhist monks recite from holy scripts and chant during devotional practice.

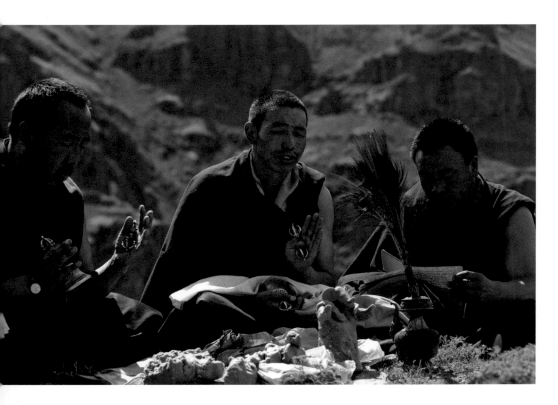

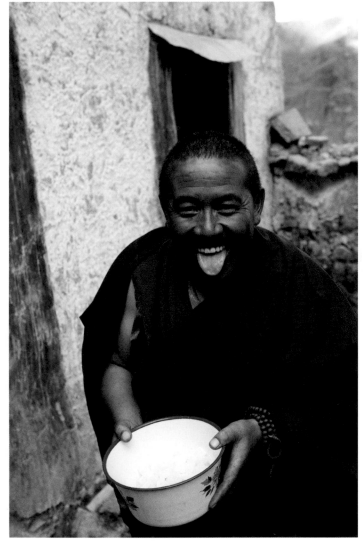

In a brisk morning breeze, two women (at right) from a nearby village tie prayer flags along a pilgrim path overlooking the monastery. Most of the buildings remain in ruins after being destroyed in the 1960s. On the crest of the same hill, three monks (top left) chant and read holy Buddhist scripts; the sculpted figurines, called tormas, are offerings made of *tsampa* (barley flour) and butter. The head monk's extended tongue (at left) is a common greeting that indicates respect.

4900

IRAN

Akbar Zareh
The Bread Baker

ONE DAY'S FOOD

IN DECEMBER

BREAKFAST Hard-boiled eggs (2), 4.2 oz • Sabzi khordan (fresh herb mix) with radishes, 3.2 oz • Nan-e taftoon (light, crusty flat bread), 10 oz • Black tea, 8.5 fl oz; with sugar, 2 tsp

SNACKS THROUGH THE DAY, GRABBED AS HE WORKS Khoshk yazdi (flat cracker bread, the type he bakes to sell, eaten fresh), 1.5 lb • Tomatoes, 5.3 oz • Grapes, 13.8 oz • Pomegranate, from the tree outside his bakery, 15.3 oz

DINNER Kabab koobideh (lamb kebab), 5.2 oz • White rice, 14 oz • Yogurt, 10.6 oz • Nan-e taftoon, 10 oz

LATE EVENING Whole milk, hot, 6.8 fl oz

THROUGHOUT THE DAY Boiled water, 3.2 qt

CALORIES 4,900

Age: 48 • Height: 5'3" • Weight: 143 pounds

YAZD • Every day of the week, Akbar Zareh's day begins and ends with bread. In the early morning the self-employed baker mixes large sacks of wheat flour with water in an industrial-size mixer, adding dried safflowers for color and a bit of yesterday's dough for leavening. He covers the dough with a heavy cloth and stops briefly for the first of the day's three prayers ordained by his Shiite Muslim religion. Afterward, he heats two hand-built gas-fired ovens (tandoors) for what will be a day of work with no breaks, except for prayers.

Most traditional Persian flat breads are soft and chewy and best eaten fresh, so they're purchased daily for family meals: *sangak*,

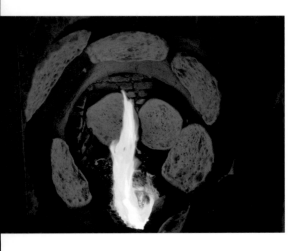

lavash, and *barbari*, among others. Akbar makes a different bread—*khoshk yazdi*, named after this ancient city in central Iran. He has been baking this bread since the age of 10, when he joined his father in the family bakery. It's baked longer than the daily flat breads, then dried to a crisp and broken up and sold by weight. The crackerlike bread is traditionally eaten with *doogh*, a thin, yogurt drink with salt, and sometimes mint. Akbar is one of only 10 bakers in the city who makes this type of bread, and it's the only type of bread he's ever baked. Does he ever deviate from the original recipe? "No one would," he says.

The government of Iran subsidizes the price of enriched bread flour for bakers, but in return prices for daily bread are fixed to ensure that, at the very least, every Iranian will have bread to eat. Akbar can charge a bit more for *khoshk yazdi* because it isn't the official daily bread, but his price is still low. Despite that, he says he earns enough to provide for his family.

The baker never attended school and regrets not having learned to read or write. He remembers that years ago, when he asked his father why he had been taught this very hot, difficult job, his father just laughed. The answer is straightforward: 40 years ago almost everyone worked in his or her family's

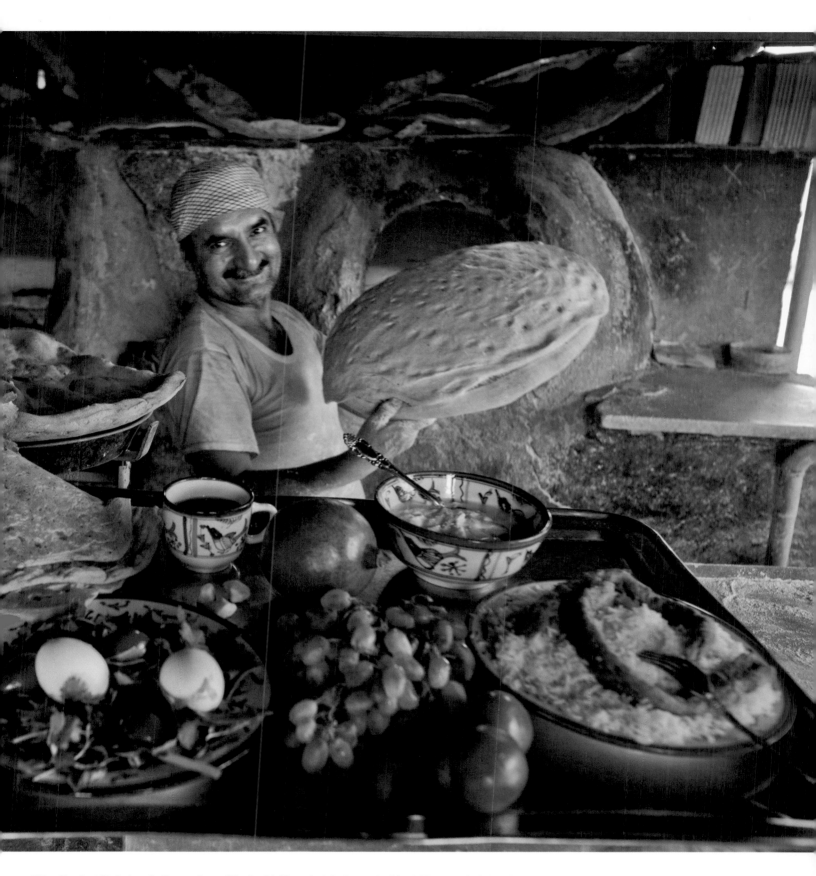

Akbar Zareh at his bakery in the province of Yazd, with his typical day's worth of food. The son of a baker, he began working full-time at age 10 and regrets that he didn't attend school and learn how to read and write. By working 10 hours a day, every day of the week, he has provided his four children with educations so they don't have to toil as hard as he does. The product of his daily labor is something to savor—his fresh, hot loaves are as mouthwatering and tasty as any in the world. After baking in the tandoor clay ovens (at left), most of the rounds of fresh bread are dried and broken into bits.

The central Iranian desert city of Yazd is one of the oldest continuously inhabited places on earth. At right: A series of domes, called *gonbads*, covering the Amir Chakhmaq Mosque complex and the adjoining souk (top right) are punctuated by *badgirs*, square mud-brick ventilation towers. Top left: Akbar uses the heat above the circular ovens to dry his fragrant flat loaves, turning them into cracker bread.

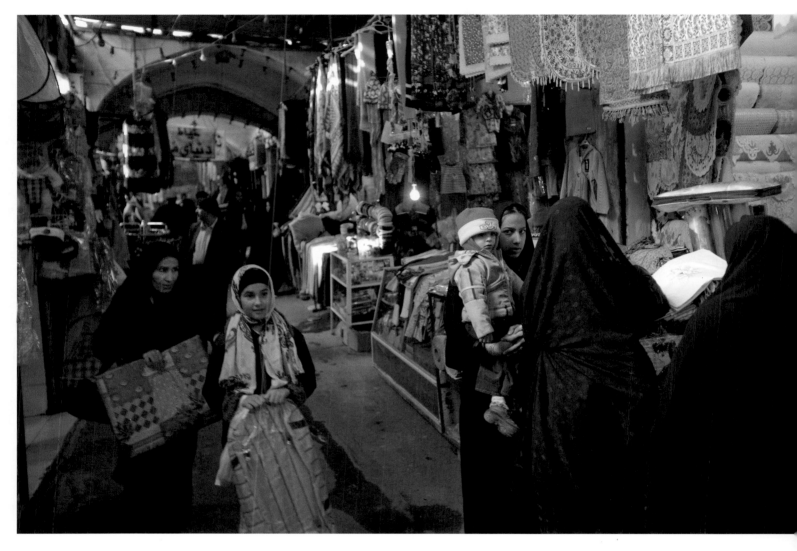

business, and Akbar's was a family of bakers. However, this ended with his children. Akbar didn't teach them to bake: "The income is too low," he says. All four of his children have gone to school, and despite chronically high unemployment rates throughout the country, his sons are employed and his daughter is married.

Akbar's family's bakery was in the heart of the sun-washed adobe city, near the warrens of market stalls covered for protection against the desert heat and cooled by *badgirs*—ancient towers designed to direct even the slightest breeze into the buildings below. After his father retired, Akbar opened his own small, one-man bakery on the outskirts of town, along a quiet street that turns to mud when it rains. There's no foot traffic here— only middlemen who buy the *khoshk yazdi* in bulk and sell it to local supermarkets and for export. The bread is highly favored in Germany, says one buyer who arrives at midday.

When we first meet Akbar, he's pulling baked flat breads from his oven with a long-

handled poker and tossing them on the shelf above to cool and dry. Some aren't quite cooked, so he flips them over and back inside, against the oven's hot, porous walls.

Periodically, he pulls a great armful of risen dough from the mixer and dumps it onto a marble slab. He flours his hands and shapes rounded mounds of dough until they cover the worktable. All the while, he continues to monitor the ovens, stopping occasionally to move bread or to prepare more of the proofed dough for cooking.

After the dough has rested, Akbar flattens the balls and uses his fingers to make indentations; this helps the bread hug the oven wall and cook evenly. Then he stretches the flattened and pummeled dough over a thick, circular, canvas-covered cushion and uses the cushion to slap the dough onto whatever open space he can find on the interior oven wall.

Between tending the fire, shaping the rounds of dough, and baking them, there is no time in Akbar's workday for a sit-down meal. In the morning as he works, he eats

fresh herbs, flat bread purchased from a different bakery, and eggs cooked by his wife. Throughout the day he munches more herbs, tomatoes, grapes, and a round of his own bread, eaten fresh before it dries. Depending on the weather, he drinks from two to five quarts of water a day. Yazd is scorching hot most of the year, and the bakery is even more so. Behind the shop, there are pomegranate trees, and when they're in season Akbar drinks fresh pomegranate juice as well. He rolls a whole fruit between his palms to break open the plump red pods inside the thick leathery hide, then pokes a hole in the skin and drinks the sweet juice.

Dinner comes at home at the end of his 10-hour day, after he stacks the last rounds, cools the ovens, scrapes down worktables, and sets up for morning. Tonight it's lamb kebabs and rice. He works seven days a week year-round except for a two-week period when he and his wife make their yearly religious pilgrimage to Mashhad, Iran, site of the shrine Imam Reza. It's the only time he eats in a restaurant.

Shielded from the sun and strangers' eyes, and wrapped up against the chilly December air, a woman cloaked in a black chador wends her way through the ancient streets in the old market district of Yazd. Narrow, mud-brick streets and alleys are sheltered by high walls, arches, and domes that shield residents from ferocious summer heat and biting winter wind. An intricate network of underground tunnels, called *qanats*, channel water to the city from aquifers in the highlands, sometimes more than 20 miles away, flowing by gravity into and under the city, and irrigating crops along the way. Rivaling the engineering of Roman aqueducts, the *qanats* accomplished the same goal but did it invisibly, underground. All of this marvelous ancient engineering makes the extreme climate habitable and the land productive.

The End of Cooking

By Michael Pollan

The Food Network can be seen in nearly 100 million American homes and on most nights commands more viewers than any of the cable news channels. Months after the finale, millions of Americans can tell you which contestant emerged victorious in season five of *Top Chef*. But here's what I don't get: How is it that we are so eager to watch other people cooking on screen but so much less eager to do so ourselves? Paradoxically, the rise of celebrity chefs as figures of cultural consequence has coincided with the rise of fast food and the decline and fall of everyday home cooking.

Today the average American spends a mere 27 minutes a day on food preparation, less than half the time we spent cooking in the 1960s. It's also less than half the time it takes to watch a single episode of *Top Chef* or *Chopped*. What this suggests is that a great many Americans are spending considerably more time watching images of cooking on television than they spend actually cooking. In recent years, the target audience for food programming has shifted from people who love to cook to people who love to eat, a considerably larger universe and one that—important for the networks—happens to contain a great many more men. So in prime time, the Food Network's mise-en-scène shifts to masculine arenas like the Kitchen Stadium on *Iron Chef*, where famous restaurant chefs wage gladiatorial combat to see who can concoct the most spectacular meal from a secret ingredient ceremoniously unveiled just as the clock starts. We learn things watching these cooking competitions, but they don't teach us how to cook.

The fact that television has succeeded in turning cooking into a

Michael Pollan is the Knight Professor of Journalism at the University of California, Berkeley. His most recent books are In Defense of Food: An Eater's Manifesto *and* Food Rules: An Eater's Manual. *This essay was excerpted from "Out of the Kitchen, Onto the Couch," published in the* New York Times Magazine.

spectator sport raises the question of why anyone would want to watch other people cook in the first place. Keep in mind that this isn't exactly a new behavior for us. The arc of transformation wherein a dish magically becomes something greater than the sum of its parts is an engaging narrative that kitchen spectators have observed for generations. Cooking shows also benefit from the fact that food is inherently attractive to humans. I suspect we're drawn to the textures and rhythms of kitchen work, too, which seem so much more direct and satisfying than the abstract and almost disembodied tasks most of us perform in our jobs nowadays.

So if cooking offers all of these satisfactions, why don't we do more of it? Well, for most of us it doesn't pay the rent, and often we feel that our work doesn't leave us the time. For many years now, Americans have been putting in longer hours at work and enjoying less time at home. Not surprisingly, in those countries where people still take cooking seriously, they also have more time to devote to it.

It's generally assumed that the entrance of women into the workforce is responsible for the collapse of home cooking, but that turns out to be only part of the story. The amount of time spent on food preparation in America has fallen at the same precipitous rate among

Left to right: A McDonald's restaurant sign in Shibuya district, Tokyo. A table at a food court inside the Mall of America in Bloomington, Minnesota. The snack aisle of Food City grocery store in Whitesburg, Kentucky. Curtis Newcomer eats an MRE (Meals, Ready to Eat) ration during training at Fort Irwin in the Mojave Desert, California. A Jumbo Corn Dog stand at the Napa Town and Country Fair in Napa, California.

women who don't work outside the home as it has among women who do, declining by about 40 percent since 1965. Many Americans now allow corporations to cook for them when they can—something these corporations started trying to persuade us to let them do long before large numbers of women entered the workforce.

After World War II, the food industry labored mightily to sell Americans on all the processed-food wonders it had invented to feed the troops. The same process of peacetime conversion that industrialized our farming, giving us synthetic fertilizers made from munitions and new pesticides developed from nerve gas, also industrialized our eating. The shift toward industrial cookery began as a supply-driven phenomenon.

So what are we doing with the time we save by outsourcing our food preparation? Working, commuting, surfing the Internet, and, perhaps most curiously of all, watching other people cook on television. Maybe we like to watch cooking on TV because there are things about it that we miss, and because cooking strikes a deep emotional chord in us, one that might even go to the heart of our identity as human beings. Cooking gave us not just the meal but also the occasion: the practice of sitting down to shared meals and making eye contact, which helped civilize us. If cooking is indeed central to human identity and culture, it stands to reason that the decline of cooking would have a profound effect on modern life. At the very least, you might expect that its rapid disappearance from everyday life would leave us feeling nostalgic for the sights, smells, and sociality of the cook fire. The Food Network may be pushing precisely that emotional button with food shows that are like campfires in the deep cable forest, drawing us like hungry wanderers to their flames.

Relegating cooking to something that happens just occasionally or mostly on television has weighty consequences. The fact is, not cooking may be deleterious to our health, and there is reason to believe that it has already taken a toll on our physical and psychological well-being. Consider recent research on the links between cooking and dietary health. A 2003 study by a group of Harvard economists found that the rise of food preparation outside the home could explain most of the increase in obesity in America. Mass production has driven down the cost of many foods, not only in terms of price, but also in the amount of time required to obtain them, transforming hard-to-make foods such as cream-filled cupcakes, fried chicken wings, and cheesy puffs into everyday fare you can pick up at the gas station on a whim. This same group of researchers also surveyed cooking patterns across several cultures and found that the more time a nation devotes to food preparation at home, the lower its rate of obesity. Other research supports the idea that cooking is a better predictor of a healthful diet than social class. A 1992 study in the *Journal of the American Dietetic Association* found that poor women who routinely cooked were more likely to eat a healthful diet than well-to-do women who did not.

So cooking matters—a lot. When you think about it, that should come as no surprise. When we let corporations do the cooking, they typically go heavy on sugar, fat, and salt—three tastes we're hardwired to like, which happen to be dirt cheap and also do a good job of masking the shortcomings of processed food. The question is, can we put the genie back into the bottle? Once a culture of everyday cooking has been destroyed, can it be rebuilt? Let us hope so. Because it's hard to imagine reforming the American way of eating or the American food system unless millions of Americans—women and men—are willing to make cooking a part of daily life. The path to a diet of fresher, less-processed food, not to mention to a revitalized local food economy, passes straight through the home kitchen.

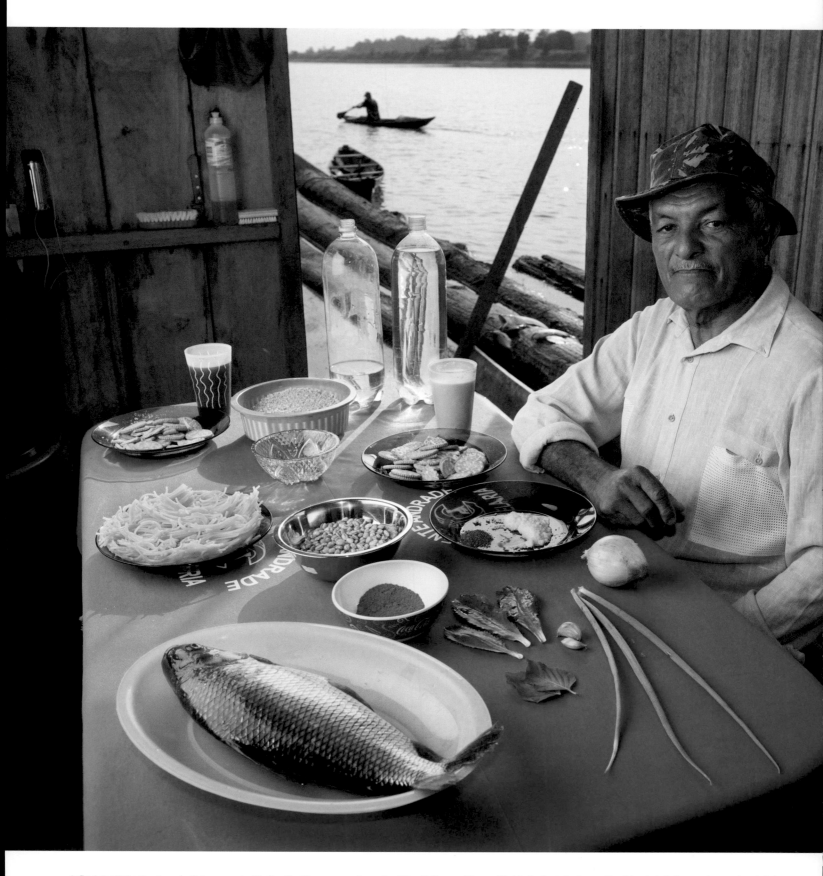

João Agustinho Cardoso, a fisherman, in his floating house on a branch of the Solimoes River with his typical day's worth of food. João's new house (at right) has no electricity and the toilet is simply the end of the big balsa wood logs the house is floating on. There is, however, running water, and plenty of it, in the half-mile-wide branch of the river they live on. Unfortunately the water is not potable, but it is teeming with fish, including piranha, which can make swimming during the early morning or evening worrisome. The *curimata* in the photo is just one of dozens of species that makes its way onto João's table. Absent from his daily diet are any alcoholic or caffeinated beverages, eschewed by his Seventh-day Adventist religion.

BRAZIL

João Agustinho Cardoso
The Fisherman

ONE DAY'S FOOD

IN NOVEMBER

BREAKFAST *Hileia* crackers, 3.2 oz • *Nestle Ninho* whole milk, from powder, 10.6 fl oz

MIDDAY SNACK *Hileia* crackers, 3.2 oz • *Windy* fruit drink, made from a powdered mix, 10.3 fl oz

LUNCH AND DINNER Curimata (a freshwater fish), 2.3 lb (whole, raw weight); boiled with onion and green onion, 5.8 oz; with garlic, chicory leaves, alfavaca (basil-like herb), black pepper, salt, and urucum powder (for red coloring), 0.9 oz • *Adria* spaghetti, 1.4 lb; and pinto beans, 5.9 oz (dry weight); cooked with *Sadia* soybean oil, 1.5 fl oz; eaten with the fish; and the salty broth from cooking the fish, 14.5 fl oz • Manioc flour, liberally sprinkled on every dish, 11 oz; salt for lunch and dinner, 1 tbsp

THROUGHOUT THE DAY Water, collected from a government-built well a 30-minute boat ride away, 2.1 qt

CALORIES 5,200

Age: 69 • Height: 5'2½" • Weight: 140 pounds

SOLIMOES RIVER, AMAZONAS • The Amazon River system forms the highway and feeder roads of Brazil's Amazonas state. Everyone jumps aboard a passing riverboat for anything from a short jaunt to a one-week journey from one remote location to another, including to the state capital of Manaus or the smaller nearby city Manacapuru for shopping and family visits.

Fisherman João Agustinho Cardoso's wife, Maria, flagged down a passenger boat two days ago to make the six-hour journey east from their home in Parana do Paratari to visit her brother in Manacapuru and to pick up her government pension. João will join her tomorrow to get his own monthly pension check, given to rural Brazilians when they reach their early sixties. They'll shop for a month's worth of provisions, then bring their purchases home together: fruit-flavored drink mix, powdered milk, plantains, eggs, beef, rice, crackers, dried pinto beans, and pasta.

João considers their pensions—about 465 reais ($247 USD) each—a windfall. "When I didn't have that money," he says, "I worked with a machete and cleared land for people. I helped them do anything they needed." When he could find a job, he earned about 18 reais ($10 USD) for a full day's work; the rest of the time he fished and traded fish for the staple *farinha de mandioca* (manioc flour), processed

by other families along the river. Manioc flour, made from cassava root, is eaten throughout the country. It has the texture of coarse meal and is sprinkled liberally onto most dishes and used to soak up the juices of many a meal.

Their basic diet today remains much the same—fish, manioc flour, homegrown greens, and plantains—but now there is greater variety. João's favorite food is beef, which he rarely ate before they got the pension. They've always eaten rice and beans: "beans every day," he says, "with manioc flour." But now they also have pasta, which he likes more than rice.

The Cardosos live in a tiny, three-room *flutuante*, a floating house, on a small artery

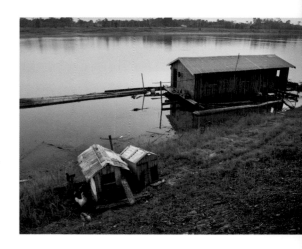

of the Solimoes River, as the upper Amazon River is known here. Their *flutuante* is moored to the hill behind the house. In the rainy season it rises with the river to the top of the hillside—about 40 feet—and during the other six months of the year it falls. As it rises, they pay passing riverboats to help push the house in toward shore.

Their chickens live ashore for part of the year. When the river rises, the henhouses are moved to the *flutuante's* floating balsa wood logs and the grain-fed chickens ride out the rainy season, with one losing its life to the dinner table each week. Who kills the chickens? Maria. "I have enough jobs," says João, smiling. Rain forest snakes and alligators claim chickens and eggs from time to time, so João and Maria keep nesting hens and chicks in a box in the house to protect them.

In addition to allowing for a more plentiful food supply, the pensions have changed their life in another way: Two years ago they built their new floating home at a cost of $600 (USD), and gave their old house, on the oppo-

site bank, to son Antonio Marco, who farms corn and processes manioc. Their new *flutuante* is tightly built, has screens, and can be closed up at dusk to guard against malarial mosquitoes. And it doesn't leak like a sieve when it rains like their old *flutuante*, with its patchwork of poor repairs to its leaky roof. "Before we had this house, we used to eat before the night came," says João, something they did to guard against the mosquitos.

The Cardosos have no electricity but do have a propane stove—a gift from one of their nine children—which they use now instead of a wood fire. There are plenty of hooks for visitors' hammocks, the customary sleeping accommodation throughout the Amazon. But there's no bathroom; people head to the edge of the float and the river current does the rest, or they find a dry hill a distance away.

There isn't a market nearby and they don't have a refrigerator, but they do have large polystyrene bins filled with ice (hauled from Manacapuru), where they refrigerate their fish and perishable purchases. They carry their drinking

water from a community well a half-hour boat ride away. Maria gardens in boxes balanced on the floats, raising green onions, chili peppers, chicory, and *alfavaca*, a basil-like herb.

Despite the newfound financial freedom provided by the pension, there will always be free fish for dinner, gathered from the mile-long curtain of fishing net father and son have staked in a shallow backwater lake. They paddle along and untangle an astounding variety of fish caught in the fine monofilament web. They drop the fish into the bottom of their wooden canoes and whack them with the blunt edge of a machete to keep them from flopping out: peacock bass (*tucunare*), *pirarucu*, *curimata*, and *aruana*, the latter called a water monkey because of its aerial acrobatics, and many others. There are also eels, but as Seventh-day Adventists the Cardosos don't eat fish without scales and fins, which are considered unclean by the church. Since joining the Adventists 16 years ago, they also abstain from alcohol and caffeinated beverages.

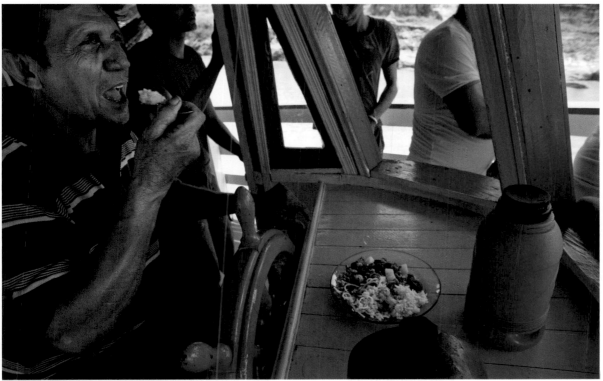

Riverboats ply the network of rivers that drain the vast Amazon basin (top left). In the dry season the banks of the Solimoes are exposed, but during the rainy season the water rises 40 feet to the top of the banks, filling inland lakes and depositing a blanket of silt. Top right: On longer trips, passengers while away the hours or days in hammocks. A riverboat captain (at left) lunches on rice, beans, spaghetti, potatoes, and pork as he steers upstream from Manacapuru.

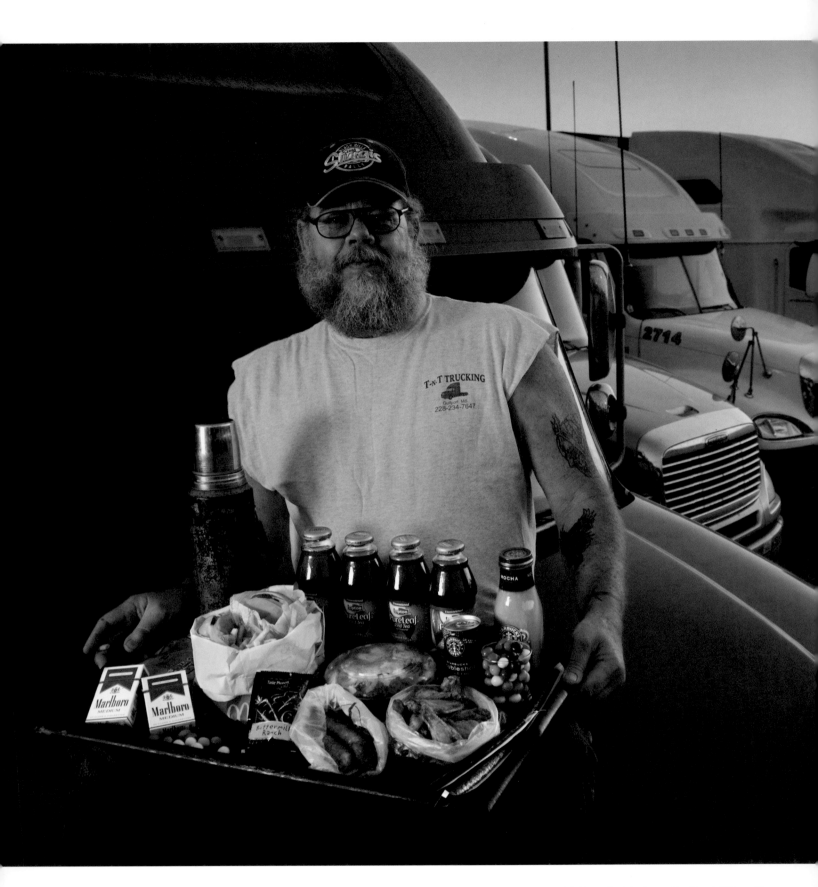

Conrad Tolby, a long-distance truck driver and ex-biker, on the cab hood of his semi at the Flying J truck stop, with his typical day's worth of food. "Those big trucks on the road with all the lights on them? Those are chicken haulers," says Conrad. "I used to be on the road 24-7, 300 days a year, hauling fresh-killed chickens packed in ice. I'd leave Mississippi and haul ass to California. You've only got so much time to deliver or you get fined big time." After two heart attacks, both of them in the cab of his truck, and a divorce back in Mississippi, Conrad now travels with his best friend and constant companion, a five-year-old shar pei, named Imperial Fancy Pants (at right), who gets his own McDonald's burger and splits the fries with Conrad.

USA

Conrad Tolby
The Long-Haul Trucker

ONE DAY'S FOOD

IN SEPTEMBER

BREAKFAST *Bon Sole* glazed honey bun, 5.3 oz • Coffee, 1 qt

LUNCH AT MCDONALD'S *McDonald's* double cheeseburger (2), 11.6 cz • *McDonald's* french fries, supersized, 3.5 oz (not including the half he shares with his dog Fancy Pants)

DINNER FROM FLYING J TRUCK STOP CONVENIENCE STORE Salad of lettuce, ham, egg, cheese, and black olives, 15.2 oz; with buttermilk ranch dressing, 1.5 oz • Fried chicken wings, 1 lb • Deep-fried egg rolls, pork (2), 5.7 oz

SNACKS AND OTHER *M&M's*, peanut, 7.3 oz • *Jack Link's* beef sticks (2), 2.7 oz • *Starbucks Doubleshot Espresso & Cream* coffee drink, 6.5 fl oz • *Starbucks Frappuccino* coffee drink, mocha, 13.7 fl oz • *Lipton PureLeaf* iced tea, unsweetened (4), 64 fl oz • *Marlboro Medium* cigarettes, 2 packs

CALORIES 5,400

Age: 54 • Height: 6'2" • Weight: 260 pounds

EFFINGHAM, ILLINOIS • Independent trucker Conrad Tolby and his cab companion, Fancy, have stopped for the night when we meet them at a truck stop in Effingham, Illinois. Their plan, as it is most nights, is to eat in the cab—their home on the road. Fancy—or Imperial Fancy Pants, as he's introduced to us—is a five-year-old shar pei, and Conrad's best friend. "He rides with me everywhere I go," says the onetime Bandido biker. Conrad had the passenger seat removed because the dog refused to sit in it. "Won't even look out of the window," he says.

Conrad's meals on the road haven't changed much over the years—truck stop and fast-food fare, heavy on the grease—despite warnings from his doctor. He has more reason than most to watch his diet, as he's already suffered two heart attacks—both in the cab of his truck.

He wasn't driving either time, but each time he wasn't expected to live. And his family health history should be sufficient warning for anyone. "Everyone on my daddy's side died of a brain aneurysm or exploding arteries, all before the age of 45," explains Conrad. "Within six months of my forty-fifth birthday, I had my first heart attack."

Although he has made some changes—cutting back from 300 days on the road each year to 200, his daily fare while working is still limited to what he can find near the highway: "I find that the hot wings, especially the ones from Flying J, are not too bad, grease-wise. I don't eat Kentucky Fried or Popeyes 'cause that plays heavy on an old man's tummy."

Road snacks like beef sticks are shared by man and beast, and lunch is oftentimes McDonald's. "We split the fries, and he gets his own hamburger," says Conrad.

When he's home in Mississippi, the trucker prepares foods he never gets in truck stops. "The secret to good french toast," he says, "is fresh grated nutmeg and flavored nondairy creamer." Amaretto, French vanilla, and hazelnut are his favorites. "And barbecue. I love a good barbecue," he says.

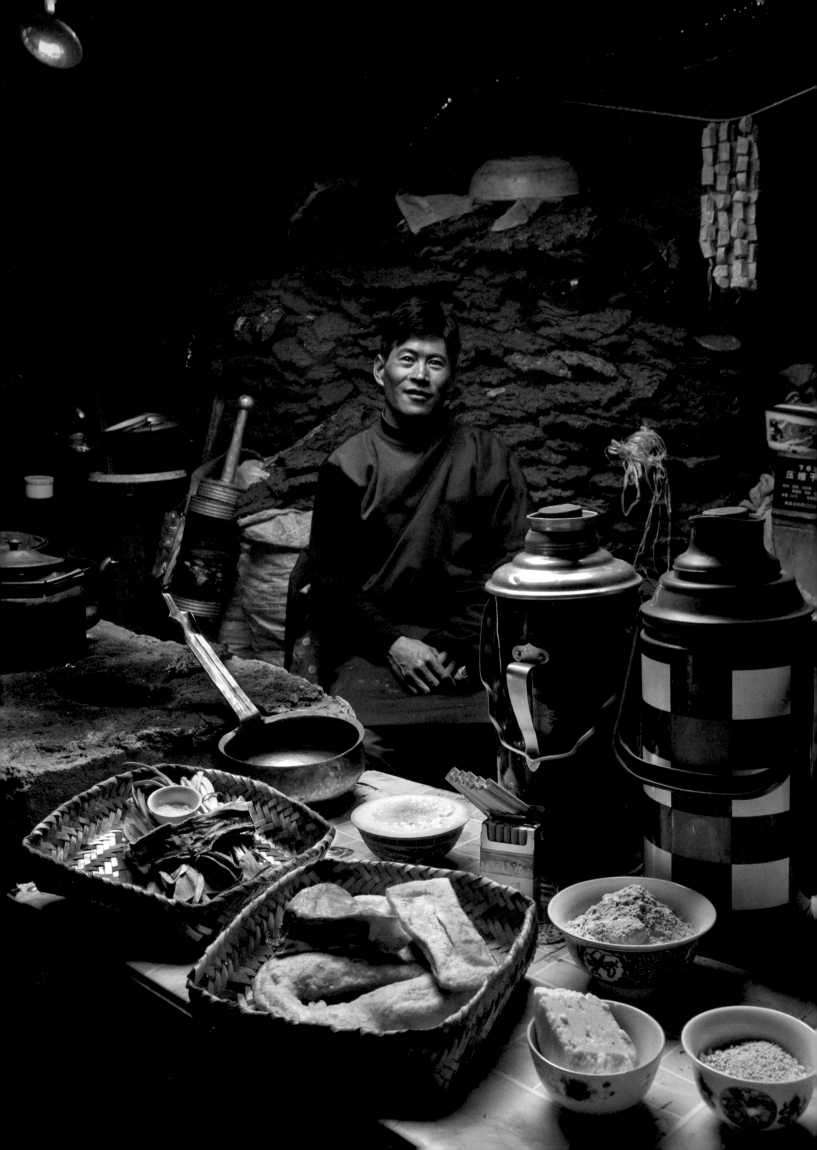

TIBET AUTONOMOUS REGION, CHINA

Karsal
The Yak Herder

ONE DAY'S FOOD

IN JUNE

BREAKFAST Barley flour cake: toasted barley flour, 4.7 oz; butter tea (brick tea, butter made from fermented milk, and salt), 1 fl oz; butter made from fermented milk, 3 oz; dried cheese curds, 1.6 oz; sugar, 2 tsp (not in picture) • Yogurt, 10.2 oz; with sugar, 2 tsp

LUNCH Dried mutton, 4.6 oz • Balep korkun (fried wheat flour bread), 9.4 oz

DINNER Soup of dried mutton, 4.2 oz; wheat flour noodles (flour is pictured), 8.6 oz; bok choy, 4.4 oz; and green onion, 1.7 oz; in a salty broth, 24.3 fl oz

THROUGHOUT THE DAY Butter tea, 2.6 qt • Cigarettes 1.5 packs

CALORIES 5,600

Age: 30 • Height: 5'6" • Weight: 135 pounds

Tibetans laugh when they hear English speakers refer to all of the stout-bodied, long-haired animals they see grazing on Tibet's high plateau as yaks. For them, there is no such animal as a female yak; the male of the species is the yak and the female is called a dri. Crossbreeding with other bovines creates a dizzying array of other gender-specific names, including the dzomo—a female yak-cow hybrid. Whatever they're called, the animals are the lifeblood of Tibet's nomadic herders as they eke out their existence on the arid, cold, non-arable grasslands of the Tibetan plateau.

THE TIBETAN PLATEAU • Fifty shaggy-haired beasts and their babies lumber down the mountainside in the late afternoon, persuaded by six-year-old Nyima Dun Drup and his handful of rocks. The boy's mother, Phurba, calls the dris and dzomos by name as she stakes them out for milking. She gives each a handful of salt from a hand-stitched leather pouch and lets the calves suckle for a moment to start the flow of milk before drawing the family share.

Phurba and her husband, Karsal, are semi-nomadic pastoralists on the Tibetan plateau

100 miles east of Lhasa, the capital. They live for half the year—spring and summer—in a yak-wool tent woven by Phurba, grazing their animals on the surrounding grasslands.

In the fall, Karsal drives the animals back to their winter corral a few miles away and the family moves into their winter home, earthen walled and with a hard roof, for the coldest part of the year. All prefer life in the tent.

As Phurba milks, her son heads off animals that stray toward the nearby road. The family rarely eats the yaks, dris, and dzomos, which provide them with milk, wool, and cook-

ing fuel in the form of dried dung. Instead, they eat dried mutton from the flock of sheep they own together with their extended family and sell two or three yaks or dzomos a year to buy barley flour, wheat flour, tea, mustard oil, green onions, and sugar. As Buddhists, they don't kill and butcher their own animals—others do this work.

Even in a cold spring rain, the gauzy black tent is warm and dry. Smoke from an earthen stove in the center of the room curls upward through a flap in the roof. At this 15,000-foot elevation, trees and firewood are nonexistent,

Karsal, a nomadic yak herder, inside the family's yak-wool tent with his typical day's worth of food. A pile of yak dung, used for fuel, looms in the background. At right: Karsal's son wrangles the calves so that Phurba can milk their mothers.

Karsal's wife, Phurba, milks one of the dris in the early morning (top right). The male yaks remain free at night, grazing at higher elevations, and the dris and their calves are tethered close to the tent to make milking in the morning convenient. Top left: Six-year-old Nyima Dun Drup takes a turn at the butter churn as Phurba puts a pot of milk on the fire and Karsal talks to a neighbor. At right: Karsal pours steaming butter tea into Phurba's breakfast bowl of porridge.

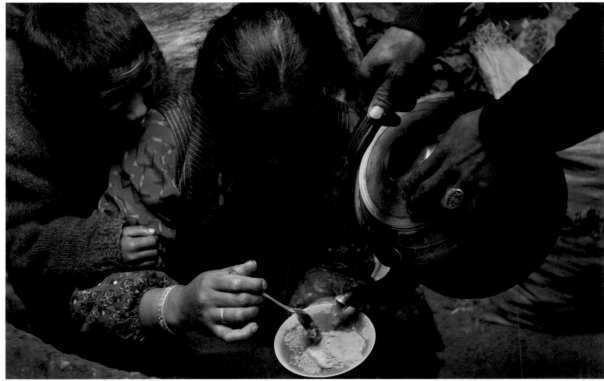

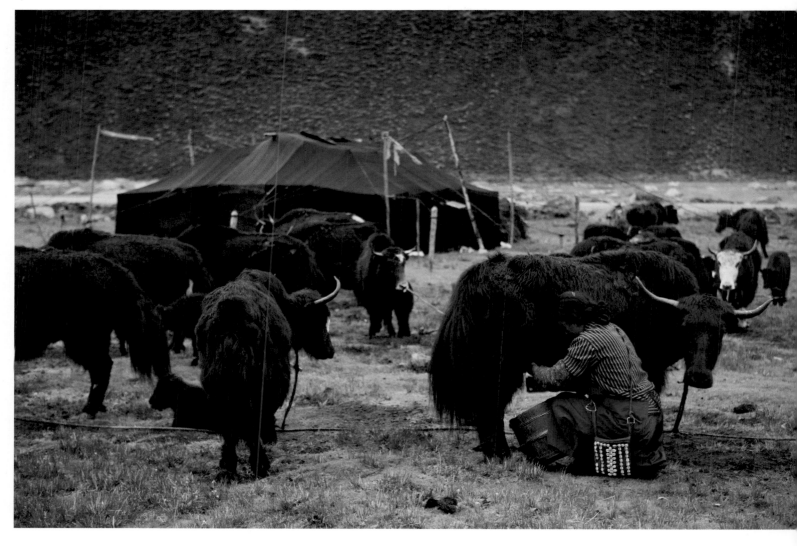

so they burn dried yak dung for cooking and heating—about 35 pounds of it each day. Flat dried rounds of yak dung are stacked near the stove, towering almost to the ceiling, and a credenza-sized wall of patties does double duty as a shelf.

Phurba gathers steaming piles of fresh yak dung in the morning after milking and shapes it into patties with her bare hands. Bright-colored homemaker's cuffs protect her clothes as she works, and afterward she cleans up in the icy stream.

The women in Tibet's nomadic families handle most of the day-to-day household chores. Does Karsal ever make the patties? Phurba laughs at the thought—it just isn't done. When we ask her to be a subject in our book, she resists, saying she is too shy—and too busy. She offers Karsal, who agrees.

A red and gold wooden chest painted with pink flowers sits on the floor next to the earthen stove, between comfortable cushioned platforms that are beds by night and seating by day. Thick yak-wool blankets, made by

Phurba as her winter occupation, are draped around the room, and men from neighboring tents lounge against them as they play cards and drink endless cups of salty butter tea. Most Tibetans drink an astonishing amount of the brew, which is a blend of brick tea boiled for hours, liberally dosed with hand-churned butter and salt.

Meat and purchased barley flour figure prominently in the family's diet, but dairy is the cornerstone, and much of Phurba's day is consumed by producing butter, yogurt, and cheese. Each day she heats the fresh raw milk she draws, then adds some of yesterday's yogurt and sets it aside to sour. Some of the thickened soured milk is eaten plain, but Phurba churns most of it. She works for an hour each morning to turn out a two-pound ball of tangy butter.

After churning, she boils the buttermilk—the liquid that remains after the butter is made—and makes cheese from the soft curds that form. She also makes a dry cheese that she cuts into 1-inch squares, threads

on string, boils in milk, and then smokes by the fire until rock hard. They eat this cheese themselves as a snack and sell it, 12 blocks to a string, to passersby.

The butter tea is also mixed with *tsampa* (barley flour), and still more butter, to make a porridge. Many eat a soupier version, called *tsamtuk*, made by adding extra butter tea. Karsal and Phurba's morning meal is more like a paste, and they add cheese—and sugar if they have it.

For lunch they slice pieces of mutton from a smoked dry leg hanging in the corner and eat it cold with porridge or *balep korkun*, a flat wheat flour bread fried in mustard oil that Phurba makes every day. Dinner is sometimes porridge again, or broth with dried mutton, green onion, salt, and wheat flour noodles.

Karsal and Phurba bring care packages of *balep korkun* to their daughter Choe Ney Drukar, 11, who boards at a district school and eats instant noodles most of the week. On each visit to town, their son angles for a bottle of Coca-Cola, and pouts if he doesn't get it.

Outside the handmade yak-wool tents where they make their home in spring and summer, a group of Tibetan nomads show off their satellite dish. It was provided by China's central government—along with a solar battery charger, a truck battery, and a TV—so the nomads can watch Chinese broadcasts and learn the Chinese language; an attempt, some say, to assimilate indigenous Tibetans. The government has attempted to remove Tibetan herdsmen from their traditional grazing lands and relocate them into permanent settlements, citing the need to protect watersheds for the benefit of millions of Chinese living downstream. However, studies suggest that the nomads' time-honored practices for managing the vast grasslands they use for grazing, which are unsuitable for growing crops, have been environmentally sound for more than 8,000 years. As winter approaches, this group will move their animals, motorcycles, tents, and television down to their earthen-walled houses at a lower elevation.

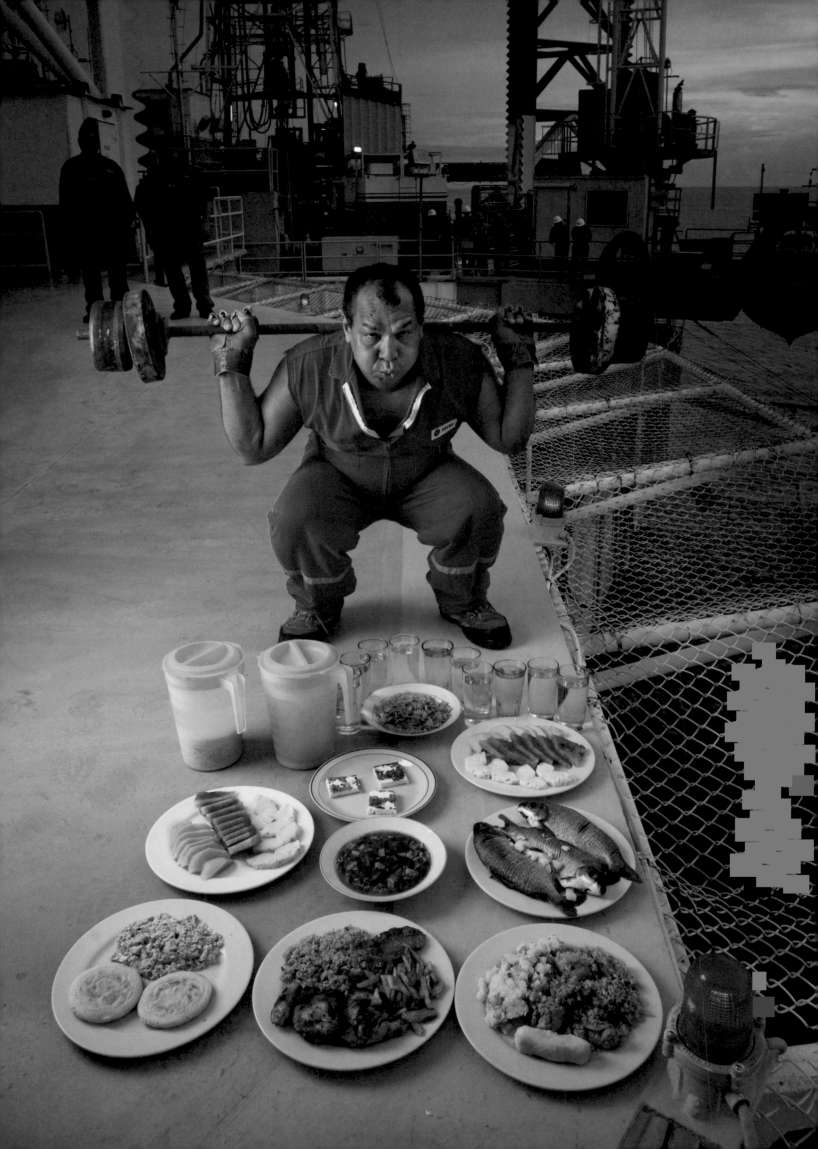

VENEZUELA

Oswaldo Gutierrez
The Oil Platform Chief

ONE DAY'S FOOD

IN NOVEMBER

BREAKFAST Scrambled eggs with tomato and onion, 8.4 oz • Arepa (cornmeal flat bread), 4.7 oz

LUNCH Beef, 2.6 oz • Chicken, 11.6 oz • Yuca (cassava, a root vegetable) fries, 3 oz • Rice (cooked in chicken drippings with oil, onion, and carrot), 5 oz • Grilled palmita cheese, 4.4 oz • Minestrone soup, 10.7 oz

DINNER Corocoro (burro grunt, a freshwater fish), 4.6 lb (whole, raw weight); with garlic, 0.2 oz • Potato salad with carrot, onion, and red bell pepper, 10.7 oz • Chicken, 7.5 oz • Rice (cooked in chicken drippings with oil, onion, and carrot), 7.7 oz • Bollito (boiled cornmeal bread roll), 3.2 oz

LATE-NIGHT SNACKS *Kellogg's* corn flakes, 2 oz; with water, 8 fl oz • Cantaloupe, 5 oz • Watermelon, 9.6 oz • Pineapple, 4.9 oz

THROUGHOUT THE DAY Cantaloupe, 5 oz • Watermelon, 9.6 oz • Pineapple, 4.9 oz • *Quaker Oats*, 6.2 oz; flaxseeds, 1.4 oz; and sugar, 1 tbsp; soaked in water and drunk throughout the day (liquids only), 1.1 qt • Fresh orange juice, 1.1 qt • Bottled water, 2.7 qt

CALORIES 6,000

Age: 52 • Height: 5'7" • Weight: 220 pounds

LAKE MARACAIBO • Oswaldo Gutierrez charges into the cafeteria of the offshore oil-drilling platform he manages on Venezuela's Lake Maracaibo and fills lunch plates with enough fried chicken, beef, seasoned rice, and yuca fries to feed a family of four in some countries. Chef Dario Vera, an eight-year veteran of the platform's kitchen, says that this is a normal meal for his chief. Oswaldo is clearly an eating machine, but he keeps his weight in check with a grueling exercise program, both on and off the platform.

The cooks on the rig work in 12-hour shifts, just like the 40-man drilling crew, and the kitchen is open around the clock. Food arrives by boat two times a week from the city of Maracaibo, 20 miles away: fresh fish, fruit, and vegetables, along with whole chickens, beef, and staples like rice and beans, but no alcohol. The cooks make their own *bollitos* and *arepas*—boiled cornmeal rolls and cornmeal flat bread. Crew members can eat as much as they want: "If we didn't let them, they'd drop us into the water," jokes Dario.

Oil-drilling platform GP-19, owned and operated by Venezuela's national oil company, is a jack-up rig: part drilling machine, part hotel, and part barge. Once its support legs are driven into the lakebed and the barge is jacked up high enough to be safe from storm waves, it's ready to tap the country's vast oil resources.

Rig chief Oswaldo, on call 24 hours a day, works one week on the rig, then has the next week off at home with his wife and three children in Maracaibo. At home, he lifts weights and practices karate and judo (and karaoke at night). On the rig, he does countless bench presses and jumps rope in endless circles around the helipad.

He keeps fruit in his cabin, prizes fresh fish above all else, and mixes several drinks "for health," he says. One favored brew is a chilled mixture of oatmeal, flaxseeds, and water. He drinks the liquid and leaves the solids. "I think it lowers cholesterol," he says. "My father drinks it too, and he's 97. I don't know if it's the reason, but we've been doing it for a long time, and we're both still alive."

Oswaldo Gutierrez, a drill rig chief, at the edge of oil platform GP-19 in Lake Maracaibo with his typical day's worth of food, as two chefs look on. At right: Oswaldo (center) at the hydraulic controls that adjust the oil platform's legs.

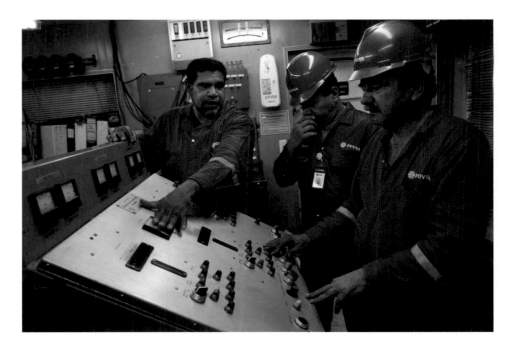

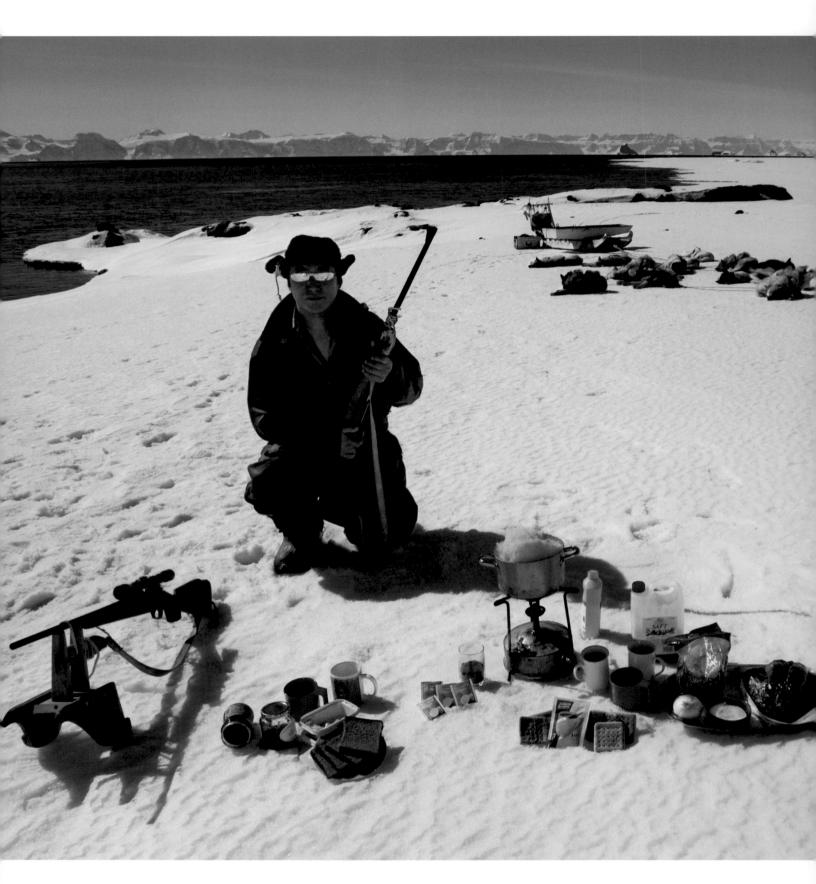

Emil Madsen, a seal hunter, on the sea ice in front of his sleeping sled dogs with his typical day's worth of food. Armed with two rifles, a shotgun, and generations of survival knowledge passed on by his father (also a seal hunter), Emil is ready and able to feed himself and his family. Sunny days in May bring 24-hour daylight at this latitude near the Arctic Circle—midday temperatures above freezing cause the ice to retreat or break off into Scoresby Sound, seen behind him. Although wild game is his favorite, Emil packs bread, jam, margarine, coffee, tea, sugar, and onions on his hunting trips. He uses a kerosene stove, rather than burning seal fat, as was traditional, to cook his food and to melt snow for water.

GREENLAND

Emil Madsen
The Arctic Hunter

ONE DAY'S FOOD

IN MAY

BREAKFAST Rye bread, 2.4 oz; with marmalade, strawberry, 1.8 oz; margarine, 2.6 oz; and *Foodline* chocolate cream spread, 2.8 oz • *Nescafe* instant coffee (2), 19 3 fl oz

LUNCH *Knorr* minestrone soup mix, powdered, 2.3 oz; mixed with melted snow, 18.7 fl oz • Skibskiks (hard, dense crackers) (5), 4.2 oz

DINNER Seal meat, 4.4 lb (raw weight); boiled with onion, 3.9 oz; and salt, 1.4 oz • *High Class* white rice, 4.4 oz (dry weight)

THROUGHOUT THE DAY *Nuuk Imeq* fruit drink, made from a concentrate mixed with melted snow, 3.7 qt • *Pickwick* tea, lemon flavored, made with melted snow (4), 1.2 qt • *Nescafe* instant coffee, 9.6 fl oz • Sugar (for teas and coffees), 4.2 oz • *Prince* cigarettes (not in picture), 1 pack

CALORIES 6,700

Age: 40 • Height: 5'8½" • Weight: 170 pounds

CAP HOPE • Fewer than 700 people live on the central east coast of Greenland—most in the town of Ittoqqortoormiit, overlooking Scoresby Sound and the Greenland Sea. There are no roads to Ittoq, as the locals call it; provisions come in by ship during the summer and by air and snowmobile, over frozen Scoresby Sound, during the rest of the year.

Like his forefathers, Emil Madsen, of the tiny village of Cap Hope, outside Ittoq, hunts seal, musk ox, sea birds, walrus, arctic hare, and polar bear to put food on his family's table. But these days, more often than not he and his wife, Erika, and other Inuit (Kalaallit, as they call themselves) are hunting for packaged foods in the government-run supermarket in Ittoq. They also live in modern houses, with modern conveniences, due in part to the country's status as a Danish protectorate.

The indigenous Greenlandic diet has historically, and by necessity, been high in protein and fat and centered on meat. Hunting and fishing were the only ways to obtain food in the arctic. Although the land and sea still provide favored foods, snowmobiles have generally replaced dogsleds. Polar bear and musk ox meat are in competition with cold cuts, mayonnaise, and store-bought sliced bread.

Emil is one of the few remaining full-time hunters on Greenland's eastern seaboard and still hunts from a dogsled. Both he and Erika prefer traditional Kalaallit fare, especially narwhal oil, which they use as a dip for dried cod. However, their three children are apt to choose a sandwich or a bowl of sugar-frosted cereal instead. "The children will get a taste for [the oil] when they're older," says Emil.

He shoots two or three of the tusked narwhals a year for their meat and the highly pungent oil, which is prized by the Kalaallit and shared liberally in the community. Erika keeps their store of oil sealed in an old powdered milk container.

All will eat the brace of dead seabirds lying in the entryway and the seal that Erika cleaned in the mudroom of their house this morning. They give the entrails and carcasses to the sled dogs; when the snow melts during the brief summer, the area around the house is a boneyard.

Emil hunts often, parka-clad and covered in pelts, taking his team of dogs and his sled out for a week at a time across the frozen wilderness. Throughout the day he chews on a pocketful of *skibskiks* (seaman's biscuits). He camps or stops for the night at small, rough government-built way stations and boils meat in a pot of melted snow on a kerosene cookstove. Sometimes the meal will include noodles and dry soup or curry mix. If he's cooking seal meat, though, he prefers it plain—with a little pepper, and a lot of salt.

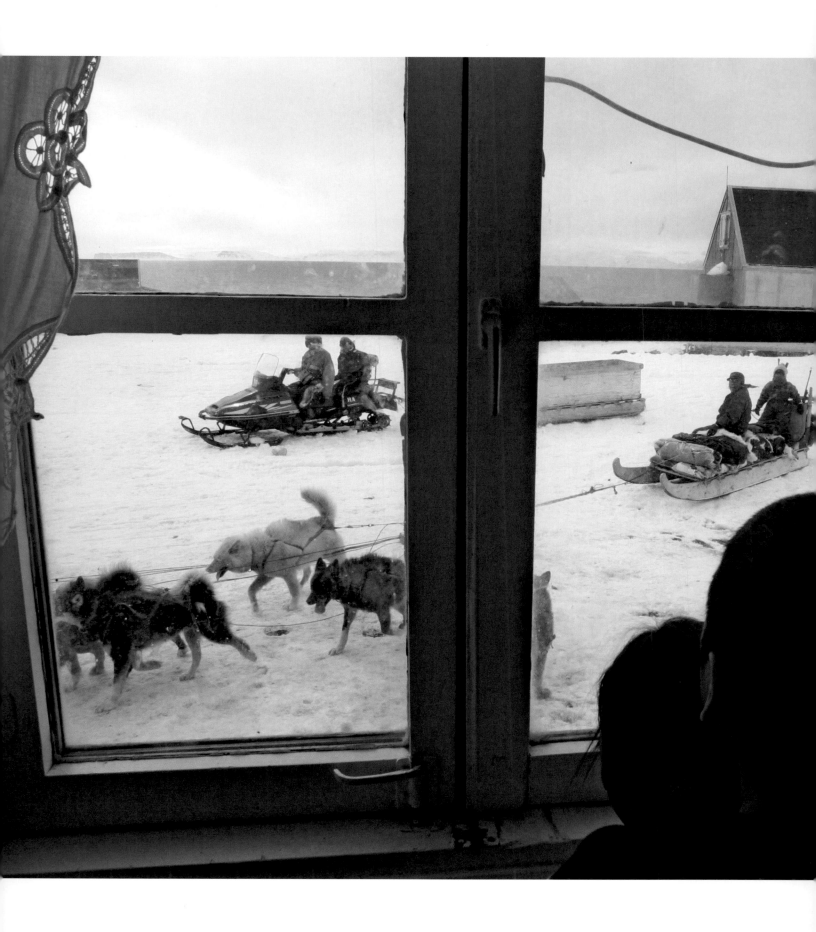

Barking sled dogs beckon Abraham Madsen, 12, and his brother and sister to the window (at left) to catch a glimpse of passersby: returning hunters, their sled loaded with seals, and a snowmobile pulling a cargo sled from the dirt airstrip at Constable Point. Preferring canine power to horsepower, the Madsens have two dogsleds and two dog teams and no snowmobile. Abraham was severely mauled by dogs at an early age and doesn't intend to follow his dad's career path. Instead, his younger brother Martin, age nine, is learning to mush and hunt. After returning from a hunt and a trip to the supermarket in Ittoq, two hours away by dogsled, Emil's family digs in to a big breakfast (top right). One of Erika's chores is to butcher a seal in the mudroom of their home (bottom right). The sled dogs will get the bones and entrails.

Delayed for a day by offshore winds and cracks that threatened to push new islands of ice out to sea, Emil readies his small plywood skiff on this calm, sunny day. He drags it to the edge of the ice in anticipation of rowing out to snag a seal. After he shoots, he rows out to the reddish ring in the clear water that marks the kill, but he doesn't get there in time; the dead seal, with minimal body fat at the end of a long winter, isn't buoyant and sinks just out of reach. Emil says the towering icebergs of his youth don't tower as high as they used to, and he worries that when his children grow up there will be nothing left to navigate by. He also worries that his children, who spend a lot of time in front of the television set—nights, weekends, and during school breaks—won't want to navigate at all.

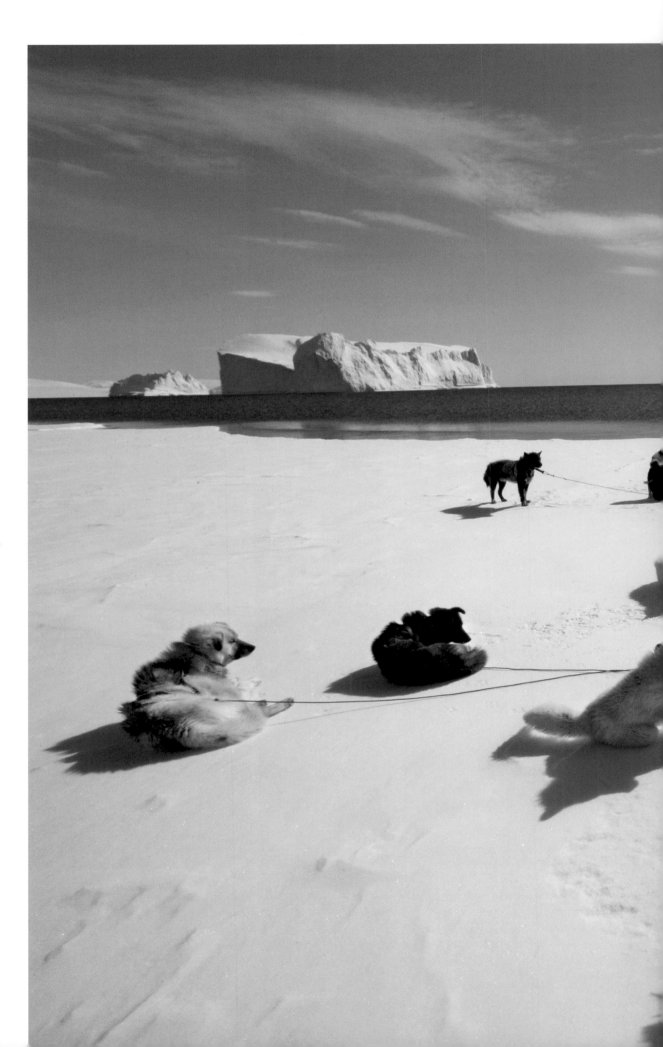

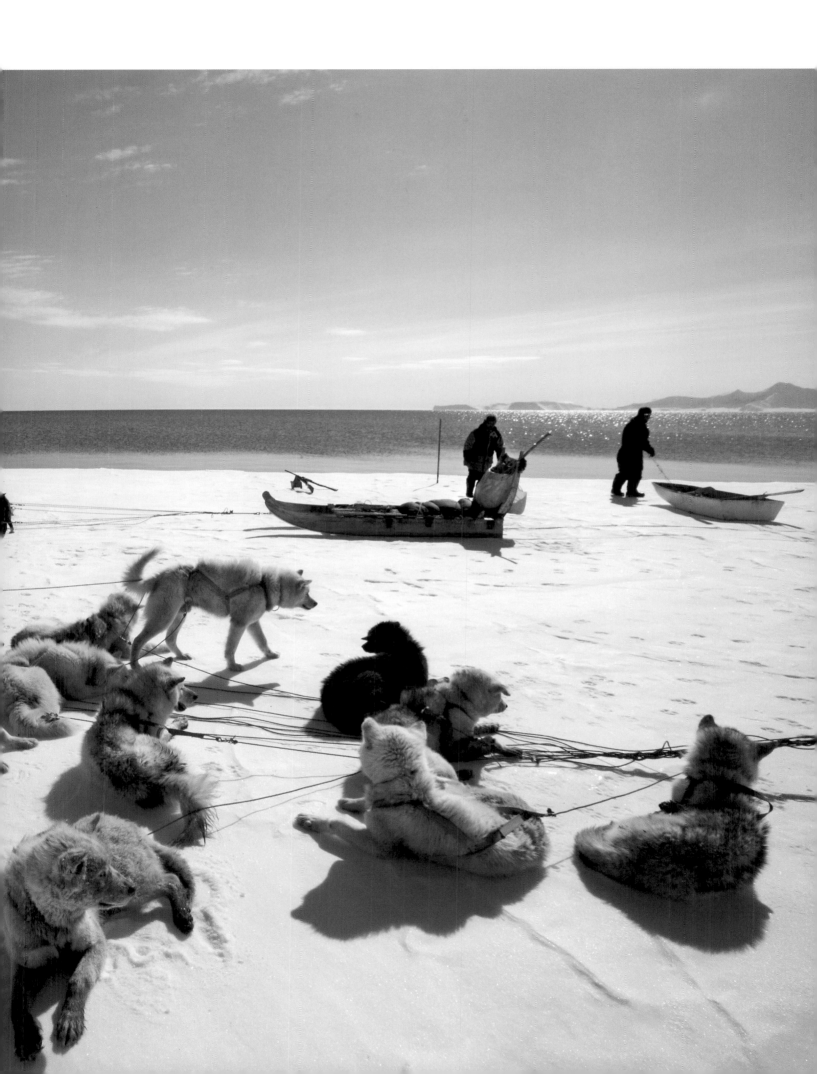

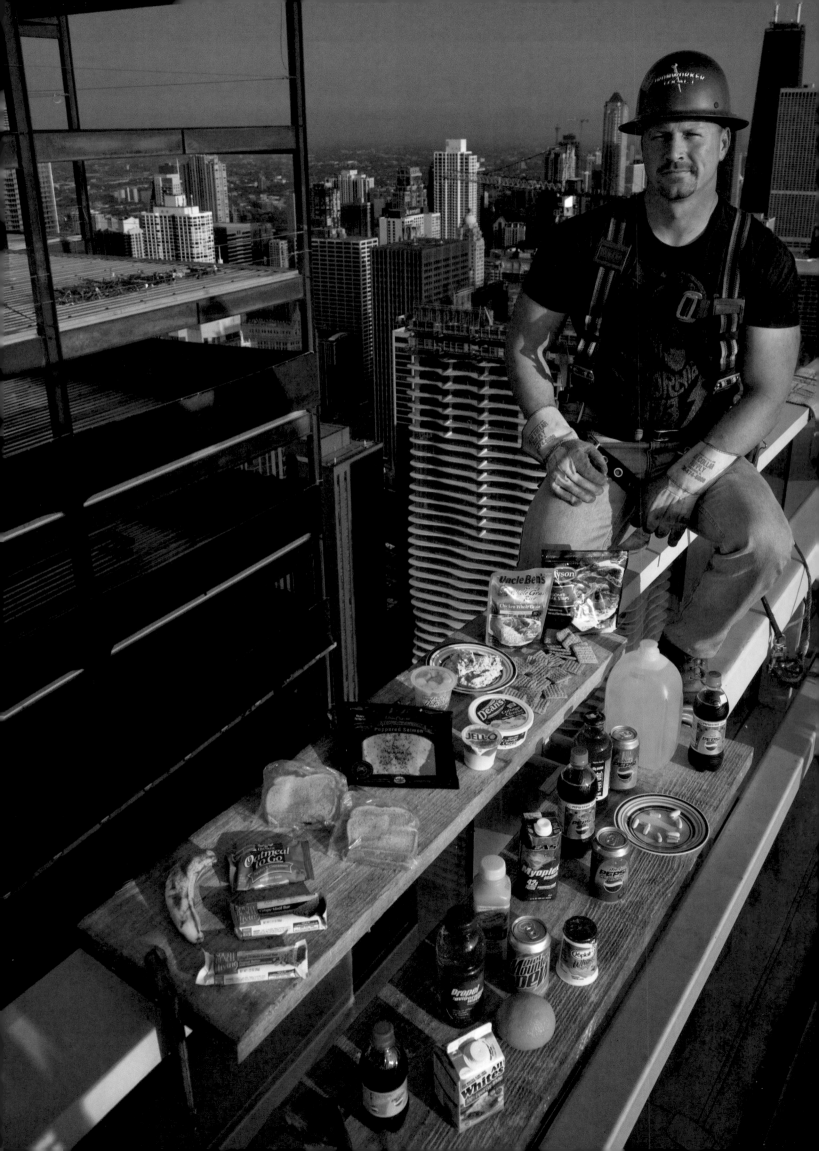

USA

Jeff Devine
The High-Rise Ironworker

ONE DAY'S FOOD

IN SEPTEMBER

BREAKFAST *All Whites* liquid egg whites, consumed raw, 1 lb • *South Beach Living Crispy Meal Bar*, chocolate peanut butter, 2.1 oz • *South Beach High Protein Cereal Bar*, peanut butter, 1.2 oz • *Quaker Oatmeal to Go* breakfast bar, apple and cinnamon, 2.1 oz • Banana, 7.7 oz • *Pepsi*, diet, 20 fl oz

LUNCH Peanut butter and jelly sandwiches (2): *Sara Lee* honey wheat bread, 4 oz; *Skippy* reduced-fat peanut butter, creamy, 4.2 oz; *Welch's* jelly, grape, 2 oz • *Jell-O* sugar-free pudding snack, dulce de leche, 3.7 oz • *Propel Invigorating Water*, berry flavored, 20 fl oz • *Pepsi*, wild cherry, diet, 12 fl oz

SNACKS DURING THE WORK DAY *Vita Classic* peppercorn salmon, smoked, 4 oz • *Dean's* low-fat cottage cheese, small curd, 8 oz • *Del Monte Fruit Naturals* fruit cup, 8 oz • *Yoplait Whips!* yogurt, orange cream flavored, 4 oz • *Naked Orange Mango Motion* juice smoothie, 15.2 fl oz • Orange, 8.6 oz • *Mountain Dew*, diet, 12 fl oz • *Pepsi*, diet, 20 fl oz

AFTER WORK *Triscuit* crackers, rosemary and olive oil flavored, 12.8 oz; with *Tostitos* creamy spinach dip, 15 oz • *Myoplex* protein drink, strawberry cream, 16.9 fl oz

DINNER *Tyson* seasoned steak strips, 6 oz • *Uncle Ben's Ready Rice* whole grain rice, chicken flavored, 10.6 oz • *Pepsi*, diet, 12 fl oz

EVENING *Nature's Best Isopure* dietary supplement protein drink, alpine punch, 20 fl oz • *Pepsi*, diet, 20 fl oz

OTHER Tap water, 1 gal • Supplements: amino acid; glucosamine chondroitin; fish oil (not in picture); milk thistle; multivitamin

CALORIES 6,600

Age: 39 • Height: 6'1" • Weight: 235 pounds

CHICAGO, ILLINOIS • Fifty stories above the lakeshore skyline of Chicago, gangs of ironworkers have a bird's-eye view of their colleague, Jeff Devine, as he prepares to step into a portrait surrounded by his day's worth of food. "Hollywood's calling," yells one. "Pose in your Speedo," yells another. Jeff reddens but ignores them, clips on his safety harness, swings his leg over the rooftop railing, and gets ready for his close-up.

On this high-rise job on 300 East Randolph, Jeff Devine, of the Iron Workers Local Union No. 1, is on the bolt-up gang alongside other teams of ironworkers raising beams, welding, plumbing up, and decking.

The burly 39-year-old ironworker brings a cooler packed with food to work, but most of his coworkers buy their meals on-site. "It's more convenient to order off the pizza truck than it is to make their own ham sandwich," he says. Jeff's food is packaged and ready to eat, high in protein, and low in refined

carbohydrates—not the typical ironworker's fare. It's calibrated to his tastes, his bachelor status, and his weight-lifting regimen. "It does me no good to go to a gym five days a week and eat crap food," he says. In addition to easily prepared foods, he includes a significant amount of bodybuilding supplements in his diet.

He dismisses the possibility that the highly processed nature of most of his food might not be the best means of achieving his nutrition and health goals. "I'm a bachelor and I can't cook," he says, and he's unapologetic. "I haven't used an oven in 15 years." He does grill though. "Tilapia, burgers, chicken breasts—that's about it."

His mother was Lithuanian, and he grew up eating eastern European fare: sauerkraut, sausages, and savory meatballs. His favorite food? "Prime rib. [But] after I found out how much cholesterol it has, it was back to the 9-ounce lean filet."

Overlooking his fiftieth floor worksite, ironworker Jeff Devine sits on the roof of a high-rise with his typical day's worth of food. He carries a cooler of ready-to-eat food from home rather than eat at fast-food restaurants and vending trucks. At right: Jeff tightens the bolts on an I beam.

8400

NAMIBIA

Tersius Bezuidenhout
The Trans-Kalahari Trucker

ONE DAY'S FOOD

IN MARCH

PREPARED IN THE MORNING TO EAT THROUGHOUT THE DAY *Fatti's & Moni's* macaroni pasta, 1.1 lb (dry weight); mixed with *Knorrox* soy mince, mutton flavored, 7.1 oz (dry weight); *Knorr* curry vegetable soup mix, 2 tbsp; *All Gold* tomato ketchup (not in picture), 3.6 fl oz; cooked with sunflower oil (not in picture), 3.2 fl oz

EATEN THROUGHOUT THE DAY AND NIGHT *Spar* canned corned meat product, 10.2 oz • *Prima Meatballs in Rich Gravy* canned meat product, 14.1 oz • *Koo Meal in One* canned spaghetti and Vienna sausages in tomato sauce, 14.5 oz • *Bull Meatballs in Rich Gravy* canned meat product, 14.1 oz • *Simba Nik Naks* popcorn, original cheese flavored party bag, 8.8 oz • *Tasty Treats* sweet biscuits (cookies) with cream and chocolate, 3.5 oz • *Red Bull* energy drink (3), 25.4 fl oz • *Twist* mandarin soda, 2.1 qt • *Nestle* bottled water, 27.1 fl oz

CALORIES 8,400

Age: 25 • Height: 5'2" • Weight: 191 pounds

MAMUNO BORDER POST, BOTSWANA • Red Bull and music cranked up to earsplitting levels help Tersius Bezuidenhout stay awake through the days and nights of his monthly journey driving building supplies from South Africa to Angola and back again. "All kinds of music," he says, grinning. "I like everything—local music, rock; I have to dance!"

Normally he'd be dancing, and singing, and driving—and halfway to Angola by now—but he's stuck at the border between Botswana and Namibia, on the Trans-Kalahari Highway, waiting for paperwork that's held up in South Africa. This wait is the only reason he has time to talk to us about his diet.

When he's home, the father of three eats traditional Namibian fare—cornmeal porridge and boiled beef—but on the road there are few hot meals. He buys his food in volume at a big-box grocery store in Johannesburg, South Africa, before he picks up his cargo, then pops the tops off cans of spaghetti, corned beef, and meatballs in gravy and chugs them, unheated, while he drives.

He does eat a hot meal in the morning, cooked on his small gas stove at the side of the road. And he makes plenty so he can eat the leftovers later, but like most of his fare, they're eaten cold. His usual hot meal is pasta with reconstituted soy-mutton nuggets dosed with ketchup.

Throughout Africa, the rules of the road for truckers are oftentimes viewed as suggestions at best, and many truckers drive to the point of exhaustion: "Our job is, you have to drive through the night and through the day," says Teri. "Just drive, and when you get tired, you take two or three hours to rest and then you start again."

In this region, truckers face road hazards from both wild and domestic animals—kudu, springbok, meerkats, donkeys, goats, and cows—and there's always the chance of a hijacking. But so far, since Teri started driving big trucks a year ago, he's been lucky on all counts. The one accident he's had was his fault; he flipped his truck over, with his girlfriend and children in it, not long after he started driving. "No one was hurt much," he says, "a few scratches." He chalks it up as an experience—one he hopes not to repeat.

His previous job, butchering meat in a slaughterhouse in his hometown of Witvlei, in central Namibia, was safer, but the pay was much lower. "For the first time, I'm saving money for my children," he says. "When I die one day and there is this little money in the bank, I want them to say, 'My father lived for us, so let's also work hard.'" There is a tradeoff, though, to making more money: now he only sees his family two or three days a month.

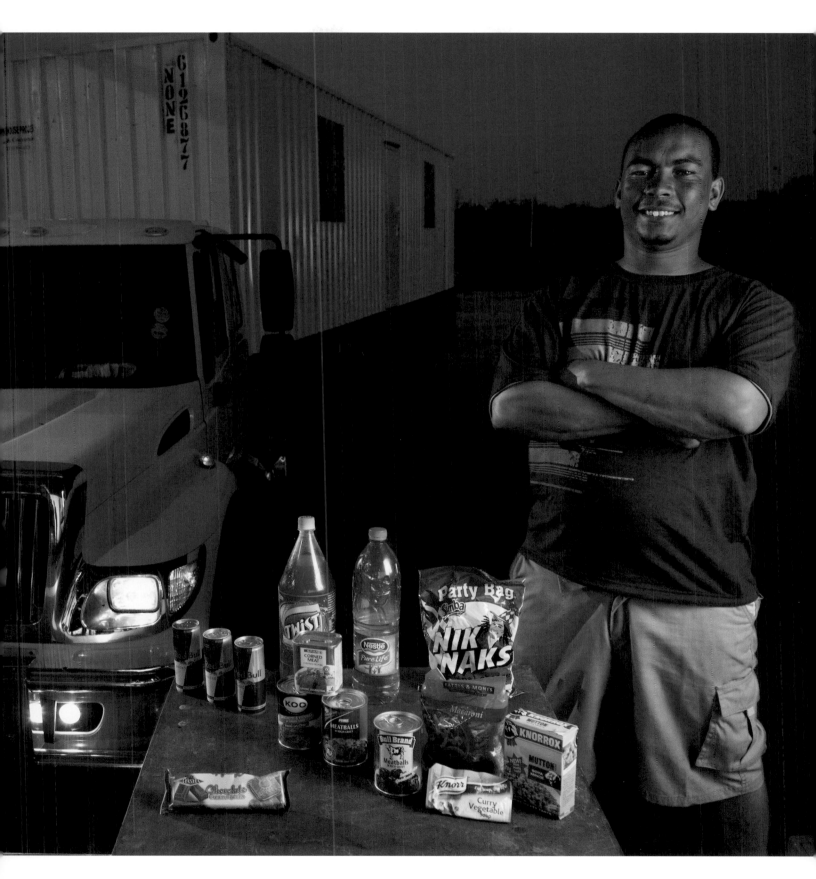

Tersius "Teri" Bezuidenhout, a long-haul trucker delayed by paperwork at the Botswana-Namibia border, with his typical day's worth of road food. Compared to highways in North America and Europe, African highways have more dangers and fewer services. Beyond wildly varying road conditions, hazards include cattle and wild animals wandering into the road at will. To make better time, he eats from cans, boxes, and jars while he drives—food very different from the simple porridge and boiled meat he eats at home with his girlfriend and children. His girlfriend, who still works at the slaughterhouse where Teri used to work, is jealous. She tells him, "You don't spend this much money in your own home, but for your truck you buy so much good food!"

Jill McTighe, a mother and school aide, in her northwest London kitchen with the food she eats on a day she's bingeing. Honest about her food addiction replacing a drug habit, Jill joked about being a chocoholic as she enthusiastically downed a piece of chocolate cake at the end of the photo session. Her weight has yo-yoed over the years, and at the time of the picture she was near her heaviest; walking her children to school every day was the sole reason she didn't weigh more. She says this photo experience was a catalyst for beginning a healthier diet for herself and her family. "Do I cook? Yes, but not cakes. I roast. Nothing ever, ever is fat-fried!"

Jill McTighe
The Snacker Mom

ONE DAY'S FOOD

IN SEPTEMBER

BREAKFAST Egg sandwiches (2): *Kingsmill* white bread, toasted, 5.6 oz; eggs (3), 5.7 oz; fried with margarine, 4 oz • *McVitie's Digestive* sweet biscuits (cookies), chocolate (8), 4.8 oz • Black tea with *Asda* whole milk (2), 20 fl oz

MIDMORNING SNACK Ham and cheese sandwich: *Kingsmill* white bread, 2.8 oz; ham, 6.9 oz; *Sainsbury's* Cheddar cheese, 6 oz; salad dressing, 3.9 oz

LUNCH Bacon sandwiches (2): *Kingsmill* white bread, 5.6 oz; *Londis* bacon, unsmoked, 6.5 oz (raw weight); *Heinz* salad cream, 3.7 oz • *Walkers* salt and vinegar chips, 1.8 oz • *Walkers* cheese and onion chips, 0.9 oz • Black tea with *Asda* whole milk (2), 20.2 fl oz

TEA Chicken, 10.8 oz; with gravy, 2 tbsp • *Green Giant* canned corn, 10 oz • Potatoes, 7.1 oz

DINNER *Iceland* thin pork sausages (8), 7.1 oz • *Iceland* french fries, 12.3 oz • *HP* baked beans in rich tomato sauce, 1.9 lb • Black tea with *Asda* whole milk, 10.1 fl oz

EVENING TV SNACKS *Twix* candy bars (2), 4.1 oz • *Mars* candy bars (3), 6.6 oz

SNACKS AND OTHER Chocolate cake, 10.4 oz • *Iceland* ice cream, mint chocolate chip, 9.6 oz; with chocolate sauce, 2 oz • *Star* lemon soda, 14 fl oz • Cigarettes (6)

CALORIES: 12,300

Age: 31 • Height: 5'5" • Weight: 230 pounds

WILLESDEN, NORTHWEST LONDON • When we meet Jill McTighe, the mother of three is seasoning chicken for Sunday dinner—"all-purpose seasoning: cumin, paprika, and oil," she says as she brushes it on a pan full of chicken legs and thighs. "Ooh, chocolate biscuits. Can I have one?" asks her daughter Bella, who has spied Jill's not-so-secret stash of sweets. "Just one," her mother says. Jill's boyfriend, Earl Gillespie, is mopping the floor of their sunny green and white kitchen. "He is lovely," Jill says. "Like an old married couple, we are."

Jill is the life of the party, even at home with only her children as an audience—funny, boisterous, fun-loving. Earl is her rock—a sweet family man of Jamaican descent who grew up in London and works for a courier service. The northwest Londoners live in Willesden in public housing and are the parents of two young girls. Jill has a teenage son with a former partner.

Her interview for this book is part what-I-eat-in-one-day-is-an-incredible-amount-of-food and part insight into her struggles with amphetamines. Jill is open about both. "I used

speed to help me get down to the weight I wanted," she says. She would balloon in weight, then use the drugs to drop several dress sizes. "I obviously wasn't dieting properly. I wouldn't know how." Amphetamines are addictive, mood-altering stimulants that induce euphoria and are often used for weight loss. At one point, "I was very gaunt looking, lost all my weight," she says. "I had no color in my face. I was very, very sick." Jill would quit the drugs and recover, the danger would pass, and then she would start speeding again to lose weight. "My mom gave me a year. She said to me, 'That's it. You're going to be dead in a year.'" Finally, Jill was able to end the vicious cycle.

Now that she's no longer using speed, Jill weighs more than she ever has and, self-admittedly, has little self-control where food is concerned. "I eat because food is there. I can't eat it if it's not; if it's there I gorge out," she says. "I keep yogurt and crisps and little Snickers and snacks for the kids, and then they're in bed and I'm watching CSI..." She pantomimes eating everything in sight. "Then I'll look around and be like, okay then,

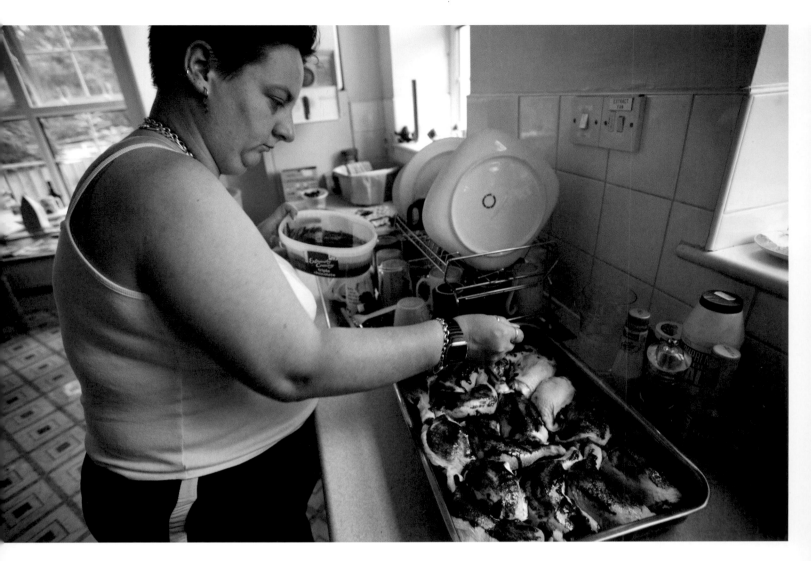

Jill spreads her homemade sauce on a tray of chicken (top left) before roasting it for a Sunday afternoon meal. There are also mixed vegetables today. "I leave the vegetables for the weekend," she says. That's when Earl can enjoy them as well." At the table, she ladles gravy onto her food (bottom left). Earl, the father of her two daughters, Toni and Bella (top right), adds his favorite greens and tomato salad to his plate before sitting down. After surviving a diabetic coma a few years ago, he's eating healthier meals.

I had a good munch." She thinks she'd be twice the size she is now if she had a car or didn't walk her daughters to and from school, a half-hour from home.

"If my dad comes down he will drop me a big bag of Mars, Twix, and chocolate biscuits," she says. Will she eat all of it in one night? "Well, try to at least. Then I'll sit there and rub my belly and think, 'Aghhh. I shouldn't have eaten that.'"

It's been hard to reconcile the image she sees in the mirror now with the one she was happiest with: a sassy size 8 coquette. She pulls out a pair of the jeans she wears now, size 16, and a pair of her old size 8s. "I used to be this size—" She slaps at the skinny size 8s for emphasis. "I would walk down the road and have men beeping at me—beep beep beep," she says. "I loved it. And now, nothing." She pauses for a moment. "And I notice the social difference. I hear, 'My god, haven't you gotten big! Are you pregnant again?' But now I've got to the stage where I laugh it off. I'm like, 'I'm big heffy the heifer.'"

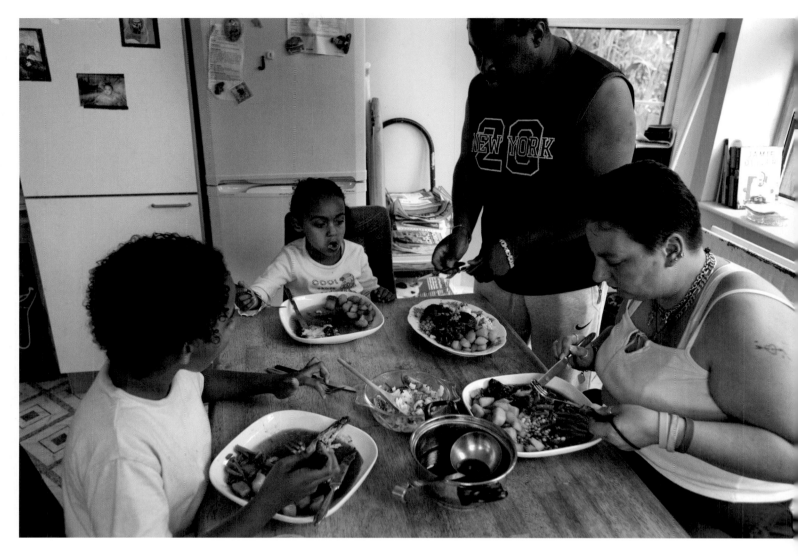

Earl was in the dark about her drug use, but he noticed her weight loss. Jill chalked it up to being busy with the kids. "And he honestly thought I was telling the truth," she says. "Then it all came out. I owe all this money! He was shell-shocked. And he says, 'Why do you have this perception that only skinny women are beautiful?' 'Because I want to be like that. I want to be thin!' I told him."

POSTSCRIPT • *Our food portraits are each a snapshot in time, and therefore, as a rule, we didn't revisit subjects for updates. But we decided to do so in Jill's case, to see how she had fared in the intervening time, because of her struggle with overeating and amphetamine abuse, and the extreme number of calories she was calculated to have eaten for this day's worth of food three years ago.*

At the time of our first interview Jill wasn't sure if she had quit drugs for good, but she says now she has—cold turkey. "I've been off them for, oh my gosh, since you guys were here taking the pictures. I'm totally, totally clean," she says. "I decided to come clean because I didn't want to risk losing my children... I did a bit of therapy for the drug use. They showed me if you can find out why you're taking it, then you can find a reason to stop. So I battled my problems, one by one: my weight, financial difficulties, past history, past relationships—I dealt with them one by one."

And the desire to fit into size 8 jeans again? "You know what? I came to realize I am who I am. If I was meant to be a size 8, I would have been a size 8. If I'm meant to be big, then I'm meant to be big; I've got the bubbly personality to go with it," she says, laughing. "So, ya know, there's more of me to love!"

She's shocked when she learns the number of calories she was eating at the time of the photo but says that bingeing was short-lived and occurred during a time in her life when she had few boundaries. She doesn't know how many calories she's eating now. "I'm just watching more closely what I'm eating—a lot more salads, a lot more healthier basically."

She was at her highest weight at the time we met her, weighs 196 pounds now, and hopes to drop 30 or 40 more pounds. "Roughly 11 or 12 stone (154 or 168 pounds) and I'll be fine," she says.

Jill has worked as an aide at her daughters' school for the last year and still walks every day. Her goal is to be fit, and she's tried many different diets: "I've tried and given up many a time," she says. "Right now I'm trying the Special K [cereal] diet. It's advertised on the telly over here in England: Get back into your jeans within two weeks and feel good, so I thought, 'Ah! I can do that, I'll give it a go.'"

"There are 10 different varieties, so I don't stick to just one." Is the chocolate one on the diet? "Yessss!" she says, laughing. "I can't give up my chocolate—that's my new drug. A girl can never give up her chocolate!" And her daily candy bar ration? "Oh my gosh, it's dropped down a lot! Oh my! It's not even a quarter of what it was. If you were to see me, you'd go, 'Oh my gosh.' Since that picture I look like Kate Moss, love," she says.

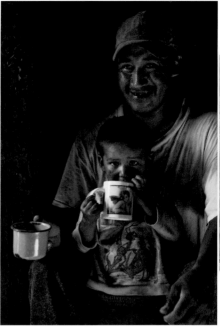

The Pleasures of Eating

By Wendell Berry

Many times, after I have finished a lecture on the decline of American farming and rural life, someone in the audience has asked, "What can city people do?"

"Eat responsibly," I have usually answered. Of course, I have tried to explain what I meant by that, but afterward I invariably felt that there was more to be said than I had been able to say. Now I would like to attempt a better explanation.

I begin with the proposition that eating is an agricultural act. Eating ends the annual drama of the food economy that begins with planting and birth. Most eaters, however, are no longer aware that this is true. They think of food as an agricultural product, perhaps, but they do not think of themselves as participants in agriculture. They think of themselves as consumers. If they think beyond that, they recognize that they are passive consumers. They buy what they want—or what they have been persuaded to want—within the limits of what they can get. They pay, mostly without protest, what they are charged. And they mostly ignore certain critical questions about the quality and cost of what they are sold: How fresh is it? How pure or clean is it, how free of dangerous chemicals? How far was it transported, and what did transportation add to the cost? How much did manufacturing or packaging or advertising add to the cost? When the food product has been manufactured or processed or precooked, how has that affected its quality or price or nutritional value?

Most urban shoppers would tell you that food is produced on farms. But most of them do not know what farms, or what kinds of farms, or where the farms are, or what knowledge or skills are involved in farming. They apparently have little doubt that farms will continue to produce, but they do not know how or over what obstacles. For them, food is pretty much an abstract idea until it appears on the grocery shelf or on the table.

When food, in the minds of eaters, is no longer associated with farming and with the land, then eaters are suffering a kind of cultural amnesia that is misleading and dangerous. The passive American consumer, sitting down to a meal of pre-prepared or fast food, confronts a platter covered with inert, anonymous substances that have been processed, dyed, sauced, ground, strained, blended, prettified, and sanitized beyond resemblance to any part of any being that ever lived. Both eater and eaten are thus in exile from biological reality. The result is a kind of solitude, unprecedented in human experience, in which the eater may think of eating as, first, a purely commercial transaction between him and a supplier, and then as a purely appetitive transaction between him and his food.

This is of obvious benefit to the food industry, which has good reasons to obscure the connection between food and farming. It would not do for the consumer to know that the hamburger she is eating came from a steer who spent much of his life standing in his own excrement in a feedlot, polluting local streams, or that the calf that yielded the veal cutlet on her plate spent its life in a box in which it did not have room to turn around. And though her sympathy for the slaw might be less tender, she should not be encouraged to meditate on the hygienic and biological

Wendell Berry, a Kentucky farmer, is the author of 50 books of essays, fiction, and poetry. This essay is excerpted from "The Pleasures of Eating," which originally appeared in What Are People For? *Reprinted by permission of Counterpoint Press.*

Left to right: Maria Kwiatkowska, 93, slices cheesecake in Adamka, Poland. José Ángel Galaviz and son in La Dura, Mexico. Vegetables at the Sonargaon market in Bangladesh. Snapper and parrotfish at the Naha City Public Market in Okinawa, Japan. Kousuke Tominaga, age 10, eats mussels prepared by Cindy Pawlcyn in Napa Valley, California. Carson "Collard Green" Hughes devours a hamburger in Newport News, Virginia.

implications of mile-square fields of cabbage, for vegetables grown in huge monocultures are dependent on toxic chemicals—just as animals in close confinement are dependent on antibiotics and other drugs.

The consumer must be kept from discovering that in the food industry the overriding concerns are not quality and health, but volume and price. For decades now the entire industrial food economy, from large farms and feedlots to chains of supermarkets and fast-food restaurants, has been obsessed with volume. But as scale increases, diversity declines; as diversity declines, so does health; as health declines, dependence on drugs and chemicals necessarily increases. As capital replaces labor, it does so by substituting machines, drugs, and chemicals for human workers and for the natural health and fertility of the soil. The food is produced by any means that will increase profits. The business of the cosmeticians of advertising is to persuade the consumer that food so produced is good, tasty, and healthful.

Eaters must understand that eating takes place inescapably in the world, that it is inescapably an agricultural act, and that how we eat determines, to a considerable extent, how the world is used. This is a simple way of describing a relationship that is inexpressibly complex. To eat responsibly is to understand and enact, so far as one can, this complex relationship. What can one do?

- Participate in food production to the extent that you can. If you have a yard or even just a porch box or a pot in a sunny window, grow something to eat in it. Make a little compost of your kitchen scraps and use it for fertilizer. Only by growing some food for yourself can you become acquainted with the beautiful energy cycle that revolves from soil to seed to flower to fruit to food to offal to decay, and around again.
- Prepare your own food. This means reviving the arts of kitchen and household. This should enable you to eat more cheaply and give you a measure of quality control.

- Learn the origins of the food you buy, and buy the food that is produced closest to your home. The idea that every locality should be, as much as possible, the source of its own food makes several kinds of sense. The locally produced food supply is the most secure, the freshest, and the easiest for local consumers to know about and to influence.
- Whenever possible, deal directly with a local farmer. This eliminates the whole pack of merchants, transporters, processors, packagers, and advertisers who thrive at the expense of both producers and consumers.
- Learn as much as you can about the economy and technology of industrial food production. What is added to food that is not food, and what do you pay for these additions?

The pleasure of eating should be an extensive pleasure, not that of the mere gourmet. People who know the garden in which their vegetables have grown and know that the garden is healthy will remember the beauty of the growing plants, perhaps in the dewy first light of morning when gardens are at their best. Such a memory involves itself with the food and is one of the pleasures of eating. Likewise, the thought of the good pasture and of the calf contentedly grazing flavors the steak. Some think it bloodthirsty or worse to eat a fellow creature you have known all its life. On the contrary, I think it means that you eat with understanding and with gratitude. A significant part of the pleasure of eating is in one's accurate consciousness of the lives and the world from which food comes.

Eating with the fullest pleasure is perhaps the profoundest enactment of our connection with the world. In this pleasure we experience and celebrate our dependence and our gratitude, for we are living from mystery, from creatures we did not make and powers we cannot comprehend.

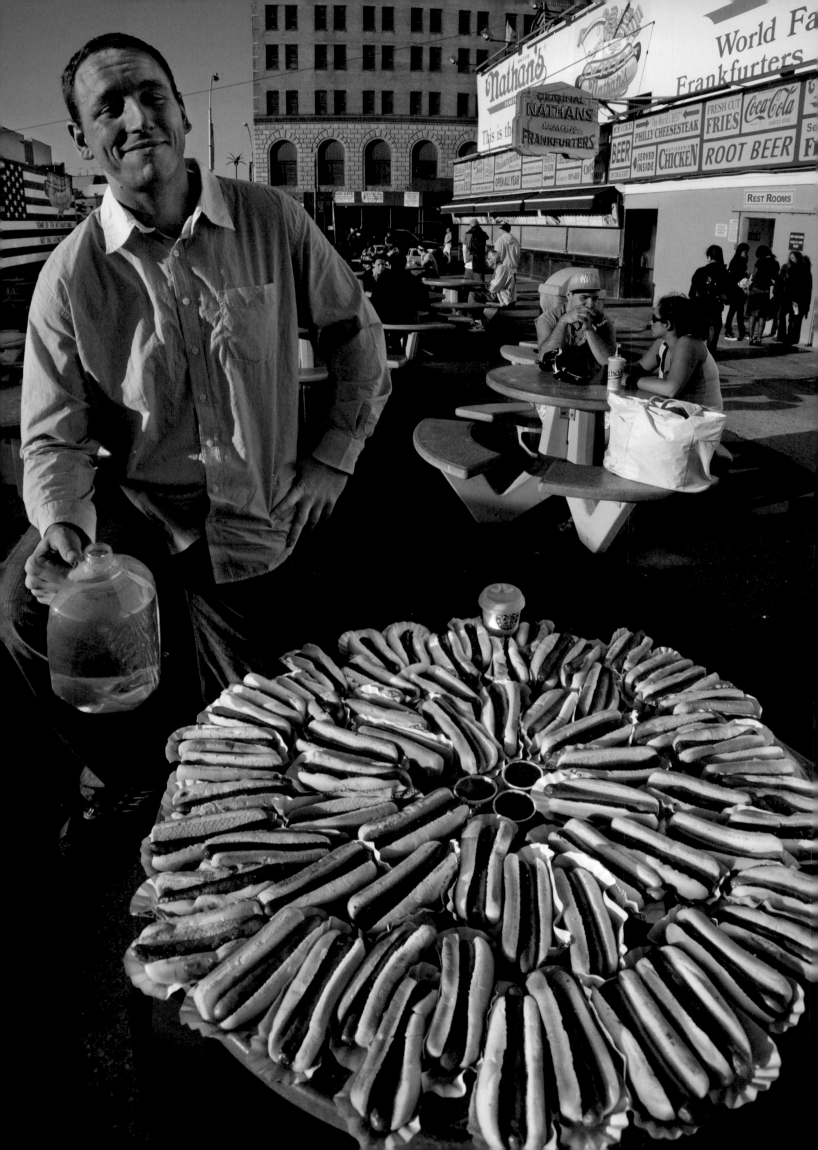

Afterword

Check, Please

By Peter Menzel

For more than a dozen years, I've shared an obsession about food with my wife and partner, Faith D'Aluisio. Together we've traveled the globe, with me shooting pictures and Faith wearing many hats: writer, reporter, food stylist, and photo assistant. We've visited more than 60 countries, eating and drinking, photographing and interviewing, learning and discovering. In the late 1990s, before *Fear Factor* was a TV show, we ate scores of insect species in 13 countries as we researched our book *Man Eating Bugs: The Art and Science of Eating Insects*. Faith gagged around the globe, but I relished the unusual fare as we ate bugs in forests, fancy restaurants, and far-flung locales, always with families whose cultures embraced rather than eschewed the practice—and with good reason. It turns out that insects are highly nutritious, and can also be quite delicious.

Although that journey was focused on foodstuffs unfamiliar to most Westerners, we saw the signs of globalization of the food supply even in the most remote regions. This spurred us to document what I've come to think of as McWorld, so we embarked on another culinary cultural odyssey at the turn of the millennium. In *Hungry Planet: What the World Eats*, we showcased 30 typical families in two dozen countries with a week's worth of food. We learned a lot while producing that book, with its ambitious portraits, grocery lists parsed to the penny, and life stories laced with the family's favorite recipes. The book won two James Beard awards, and the photos are still zinging around the blogosphere, feeding a frenzy of food interest. The book continues to inform, engage, and sometimes enrage as people puzzle over why the United States is home to so many of the fattest, unhealthiest people on the planet, in spite of spending so much on health care.

The fact that fueled our *Hungry Planet* adventure—that for the first time in the history of our species just as many people were overfed as underfed—still intrigues me every time we visit our neighborhood grocery store, or the gleaming Goliaths of agribusiness now gobbling up the retail food trade across the nation, and the globe.

The idea for *What I Eat* was born almost five years ago, on Bondi Beach in Australia as we tested my idea of photographing people at work or at home with an ordinary day's worth of food. The first person we covered was a very fit lifeguard, Bruce Hopkins. Perhaps not so coincidentally, he's on the cover (and on pages 218–219). Focusing on a day's worth of food for one individual was more practical than photographing an entire family's week's worth of food, and it turned out to be even more revealing. Swept up in the concept, we traveled the globe with the goal of documenting 101 people and calling the book *Nutrition 101*.

As we met, interviewed, and photographed more and more people,

Joey Chestnut (at left), the world's most successful competitive eater, with 66 Nathan's Famous hot dogs and a gallon of water at Coney Island, New York City. This represents what Joey ate (and drank) in 12 minutes on July 4, 2007, to claim the title of world champion hot dog eater. The 66 hot dogs weighed 14.5 pounds and totaled 19,602 calories. Above: Pulitzer Prize–winning restaurant reviewer Jonathan Gold and some semblance of his day's worth of food at Jitlada Thai Restaurant in Hollywood, California. Because restaurant reviewers try to keep their identity secret in order to write unbiased reviews, Jonathan agreed to the photograph under the condition that it help preserve his anonymity, thus the lighting in this portrait.

Afterword

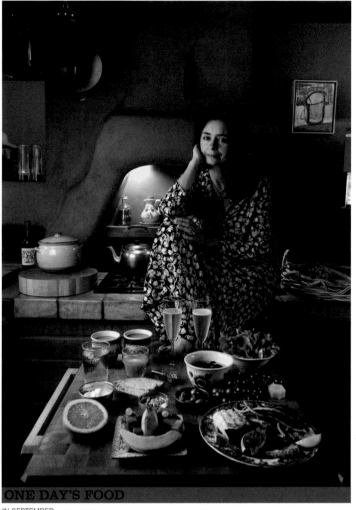

ONE DAY'S FOOD

IN SEPTEMBER

FAITH D'ALUISIO

BREAKFAST Fruit bowl of grapefruit, cantaloupe, watermelon, banana, and grapes, 13.7 oz; with *Mountain High* yogurt, plain, 3.5 oz; and walnuts, 0.4 oz • Grapefruit juice, 4.1 fl oz • *Café Sarks* coffee, 12 fl oz; with *Clover Organic Farms* whole milk, 6 fl oz

LUNCH Homemade summer squash soup, 10.2 oz • *The Model Bakery* artisan bread, 1.7 oz • Mixed greens, 2.5 oz; with lemon juice and olive oil dressing, 1 tbsp • Green olives, 1.7 oz • Black olives, 0.4 oz

DINNER Grilled Alaskan halibut, 3.2 oz • Steamed green beans, 2.9 oz; with butter, 0.5 tsp • *Dubliner* cheese, 0.4 oz • Cherry tomatoes, 8.9 oz • Grilled summer squash with olive oil and balsamic vinegar, 6.1 oz • *Zonin* prosecco, 8.6 fl oz • Sparkling soda water, 10 fl oz

SNACKS *Tootsie Roll Pop* (1), 0.6 oz

CALORIES 1,500

Age: 52 • Height: 5'8" • Weight: 135 pounds

we realized that too many of us fail to successfully negotiate the complex calculus of calories and motion. Knowing that we can learn equally from the success and failure of others, we sought out people who seemed to be in complete control of their diet, body, and physical image: an acrobat in China, a model in New York City, an ironworker and body-builder in Chicago, a bullfighter in Spain, and a sumo wrestler in Japan. We also looked for subjects at the other end of the spectrum, valiantly battling the bulge but not making much progress: a teenager at a summer weight-loss camp in the Catskills, a weight-loss surgery candidate in Tennessee, a Native American carpenter and tattoo artist in Arizona, and a bingeing housewife in London. We also focused on subjects who allowed us to explore our interest in agriculture, such as a commodity farmer in the Midwest, a citrus grower in China, a subsistence farmer in Ecuador, a tea grower in Kenya, and a rancher in Mexico. We documented the disappearing lifestyles of shepherds, nomads, and pastoralists in Spain, Tibet, Kenya, and Namibia. Food professionals including bakers, butchers, chefs, and restaurateurs from locales as diverse as Illinois, Iran, Germany, and Taiwan shared the secrets of their trade. We spent time on boats with fishermen off Iceland and Maine, in Brazil's Amazon Basin, and in the Arctic. And high above it all, weighing nothing and eating equally weightless food as he orbited the earth for two weeks, a NASA astronaut shared a feast of canned delicacies with the international crew on the Space Station (page 136).

Three years later, our self-assigned and self-financed project had reached the magic 101, and we began to assess the caloric values of the thousands of food items we recorded and photographed. We found that the simple idea of showing real people's real meals for a single day provided a huge stimulus to better understand our own diets. For all of us, our proximity to our own food habits can prevent us from evaluating them objectively. Maybe that's why most people can't accurately report what and how much they eat. They don't really know; they've never weighed and measured it like we did.

As we tried to organize the 101 subjects we had photographed into a book, we discovered that we had fallen prey to another form of overconsumption. We simply couldn't fit all 101 people into a book of reasonable size, so we culled our dinner party by 21 people (all of whom we regretted ushering out the door) and retitled the book *What I Eat: Around the World in 80 Diets.*

Our goal is to raise awareness so that people who are fortunate enough to be able to make choices will hopefully make better, healthier choices for themselves, and ultimately for the planet. But there's a problem. If you're reading this book, chances are you're already fairly aware of this issue. Chances are you're fairly healthy. So what do you care if others are choosing to overeat, making poor food choices, or succumbing to diet-related chronic diseases? For starters, you might care because of the costs to our society and our health care system, and ultimately your own soaring premiums. And you might care because even amidst this epidemic of obesity and dietary excess, people still go hungry—and not just in distant corners of the earth, but also against the backdrop of great affluence and overconsumption. Or you might care because if this continues unabated, the resources of our planet will be stretched to the seams and all of us—or our children—will ultimately pay the price.

But the truth of the matter is, there's no quick fix. We don't get fat overnight, and we can't get healthy in a day. The problem isn't easy to fix because it's become so deeply ingrained in our culture—the culture of consumerism. We tend to find meaning, happiness, contentment, and affirmation in consuming, rather than creating. As a society, we've lost

respect for farmers and agriculture in general. Less than 2 percent of the population is involved in food production, yet food is ubiquitous—as are what Michael Pollan rightly calls "foodlike substances." Most American consumers have become oblivious to the chemistry-project list of ingredients that have replaced natural ingredients in our meals. We are so far removed from the sources of our food that some of us can't recognize the raw products and have no concept of how, when, or where they were raised. Misguided policies rooted in profit motives rather than science and our humanity can be difficult to change, but it isn't impossible. An example of this level of change has been demonstrated by the Grameen Bank and BRAC. Their success in lending to poor people, mainly women, disproved the conventional banking belief that the poor are not creditworthy, exposing the big banks as not people-worthy. During our journey to research this book, we witnessed microloan food business successes in a village in Bangladesh (page 80) and a slum in Kenya (page 116). Restoring our connection to our food and a sense of personal responsibility is essential if we are to avoid a disaster of unsustainability.

Stepping down from the soapbox and turning from the political to the personal, Faith and I both love to eat, travel, and meet interesting people. Working on *What I Eat* provided us with those opportunities over and over again. Not surprisingly, we were astounded during our days in the kitchens of Dan Barber's and Ferran Adrià's restaurants (you can see more of both on the book's website). Yet, on the other end of the spectrum, some of our best and most memorable meals were at hole-in-the-wall eateries or even on the street, in Bangladesh, Yemen, Tibet, Vietnam, and Taiwan. Eating with people in their homes in Iran, Kenya, Spain, India, and Brazil proved to be a companionable and delicious adventure.

Faith and I learn a lot about ourselves by learning about others, and the experiences and encounters reflected in this book have shaped our worldview. We hope the stories in this book touch your life as they have ours. In these pages, you can discover how people all over the planet have come up with solutions that work for them—and sometimes have resorted to strategies that don't work so well. We all need to learn what works for ourselves.

In the process of creating this book, we also learned a great deal from scores of books and thousands of articles. In addition, we spent a few weeks recording our own daily caloric intakes, and those of several nieces who spent the summer working with us. We used the same small electronic scale that we carried around the world to measure what we all ate. Once we got a feel for our daily patterns at home, we chose a day to photograph our food and compile our own food lists (at left and at right). On the road, we eat whatever and whenever others around us do.

Our experience of working on this book also reinforced the importance of motion throughout the day. It need not be vigorous, but some amount of exercise is essential. Toward the end of this last year of research and writing, we noticed that we were both gaining weight. As the deadline loomed closer and closer, our workdays, spent mostly seated in front of the computer, stretched from 12 hours up to 16 and then 18. We began to sacrifice daily exercise, hiking, and biking to the book, and in the last four months gained about eight pounds each—not because of eating more, but due to moving less. We consciously cut back on our calories, but apparently not enough to compensate for our temporary sedentary lifestyle. Thankfully, the book is now a reality and I can finally go outside and enjoy the one-mile walk to get the mail and newspaper, and then get busy in our garden. It's April in the Napa Valley, and in another month our vegetable seedlings will be pushing their way toward the sun.

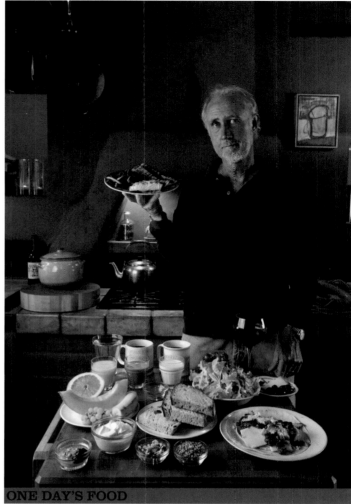

ONE DAY'S FOOD

IN SEPTEMBER

PETER MENZEL

BREAKFAST Fruit bowl of banana, grapefruit, cantaloupe, and grapes, 11.8 oz; with *Mountain High* yogurt, plain, 6.2 oz; *Grape-Nuts* cereal, 1 oz; and walnuts, 0.9 oz • *The Model Bakery* artisan bread, 3.8 oz; with *Maranatha* organic peanut butter, crunchy, 1 2 oz; and *Sorrell Ridge* spreadable fruit, boysenberry, 2 tsp • *Odwalla* orange juice, 4.1 fl oz • *Odwalla* carrot juice, 4.1 fl oz • *Café Sarks* coffee, 13.8 fl oz; with *Clover Organic Farms* whole milk, 4.1 fl oz; and *Ghirardelli* chocolate powder, 1 tsp

LUNCH Chicken burritos (2): *La Tortilla Factory* white corn tortillas (2), 2.9 oz; grilled organic chicken, 1.1 oz; *La Costena* black beans, 1.1 oz; jack cheese, 1.5 oz; *Trader Joe's Salsa Especial*, medium, 1.5 oz; white rice, 0.9 oz; avocado, 1.4 oz; cilantro, 0.1 oz; and *Cholula* hot sauce, 0.5 tsp • Mixed greens, 1.1 oz; with olive oil, 1 tbsp • Well water, 8 fl oz

DINNER Grilled Alaskan halibut, 4.9 oz • Steamed green beans, 2.9 oz; with butter, 0.5 tsp • *The Model Bakery* artisan bread, 1.9 oz • *Dubliner* cheese, 1.1 oz • Cherry tomatoes, 8.8 oz • Grilled summer squash with olive oil and balsamic vinegar, 6 oz • Black olives, 1 oz • Red wine, 5 fl oz

CALORIES 2,800

Age: 61 • Height: 6'1" • Weight: 168 pounds

Statistics

	Total Population	Urban Population	Fertility Rate	Life Expectancy (F/M)	Gross National Income	Health Expenditure	Total Health Expenditure	Overweight (F/M)	Obesity (F/M)	Undernourished	Diabetes	Meat Consumption	Alcohol Consumption	Tobacco Use (F/M)
	millions	% of pop.	births per woman	years	per capita PPP$	per capita PPP$	% of GDP	% of pop. >15 yrs. of age	% of pop. >15 yrs. of age	% of pop.	% of pop.	annual, per capita, pounds	annual, per capita, quarts	% of pop. >15 yrs. of age
Australia	21.3	89.1	1.8	84.1/79.3	34,040	3,122	8.7	62.7/72.1	24.9/23.8	<5	6.2	—	9.5	21.8/27.7
Bangladesh	162.2	28.1	2.3	63.0/57.6	1,440	69	3.1	5.4/6.7	0.2/0.1	27	3.9	6.8	0.0	3.8/47.0
Botswana	2.0	61.2	2.8	62.0/61.7	13,100	635	7.2	49.4/37.8	14.6/5.4	26	3.6	60.2	4.5	—
Brazil	193.7	86.5	1.8	75.7/68.4	10,070	765	7.5	53.5/47.4	18.3/8.7	6	5.2	181.7	6.1	—
Canada	33.6	80.6	1.6	83.9/78.7	36,220	3,672	10.0	57.1/65.1	23.2/23.7	<5	9.0	238.3	8.2	18.9/24.3
Chad	11.2	27.6	6.1	48.8/46.7	1,160	40	3.6	19.2/12.0	1.7/0.4	39	2.7	31.5	0.3	2.6/16.0
China	1,345.8	44.9	1.8	75.5/71.6	6,020	342	4.5	24.7/33.1	1.9/1.6	9	2.7	115.5	5.5	3.7/59.5
Ecuador	13.6	66.9	2.5	78.4/72.4	7,760	297	5.4	52.6/41.7	16.7/6.7	15	4.8	99.2	2.5	5.8/23.9
Egypt	83.0	42.8	2.8	74.8/69.6	5,460	316	6.3	74.2/64.5	45.5/22.0	<5	9.8	49.6	0.2	1.3/28.7
Germany	82.2	73.8	1.3	82.4/76.3	35,940	3,328	10.4	55.1/65.1	20.4/20.9	<5	10.2	181.0	12.7	25.8/37.4
Great Britain	61.6	90.1	1.9	81.6/76.5	36,130	2,784	8.4	61.9/65.7	24.2/21.6	<5	3.9	175.5	12.5	34.7/36.7
Greenland	0.1	84.0	2.2	72.9/67.4	45,346	3,756	9.2	—	—	3	2.1	250.9	—	67.8/64.3
Iceland	0.3	92.3	2.1	82.9/78.5	25,220	3,319	9.3	61.7/59.0	23.2/16.7	<5	2.0	187.0	7.4	26.6/26.1
India	1,198.0	30.1	2.7	67.2/65.1	2,960	109	4.9	15.2/16.8	1.4/1.1	21	5.9	11.5	0.3	3.8/33.1
Iran	74.2	69.5	1.8	72.7/69.7	10,840	731	7.8	57.8/48.5	27.0/10.0	<5	3.6	50.9	0.0	5.5/29.6
Israel	7.2	91.7	2.8	83.0/78.6	27,450	2,263	7.8	57.5/57.2	24.3/16.2	<5	7.1	214.1	2.6	17.9/31.1
Italy	59.9	68.4	1.4	83.3/77.3	30,250	2,623	9.0	38.3/52.7	12.6/12.9	<5	6.6	199.3	8.4	19.2/32.8
Japan	127.2	66.8	1.3	85.6/78.8	35,220	2,514	7.9	18.1/27.0	1.5/1.8	<5	6.9	96.8	8.0	14.3/44.3
Kenya	39.8	22.2	4.9	58.2/57.5	1,580	105	4.6	21.7/6.9	1.9/0.1	32	2.5	31.5	1.6	2.2/27.1
Latvia	2.2	68.2	1.4	77.6/67.0	16,740	974	6.0	44.7/49.9	15.0/09.7	<5	9.9	100.8	10.1	24.1/54.4
Mexico	109.6	77.8	2.2	79.0/73.3	14,270	756	6.2	67.9/68.4	34.3/24.0	<5	7.4	129.2	4.9	12.4/36.9
Namibia	2.2	38.0	3.3	50.9/51.6	6,270	338	4.9	32.6/12.3	5.3/0.3	19	3.1	75.0	6.3	10.9/38.6
Russia	140.9	72.8	1.4	73.1/59.3	15,630	638	5.3	51.7/46.5	23.6/9.6	<5	9.2	112.4	10.9	26.5/70.1
Spain	44.9	77.4	1.5	83.6/76.7	31,130	2,388	8.1	47.7/55.8	15.8/15.6	<5	9.9	261.5	12.4	30.9/36.4
USA	314.7	82.3	2.1	80.7/75.7	46,970	6,714	15.3	72.6/75.6	41.8/36.5	<5	8.0	275.1	9.0	21.5/26.3
Venezuela	28.6	94.0	2.5	76.8/70.5	12,830	396	5.1	61.4/69.1	26.2/23.2	12	5.2	124.8	7.0	27.0/32.5
Vietnam	88.1	28.8	2.0	74.5/69.2	2,700	264	6.6	8.7/4.1	0.3/0.0	14	1.0	63.1	1.0	2.5/45.7
Yemen	23.6	31.8	5.1	65.1/61.0	2,210	82	4.6	29.4/24.6	5.1/2.0	32	7.7	32.4	0.0	—

SOURCES FOR TABLE • **Total Population** United Nations Population Division (2009). **Urban Population** United Nations Population Division (2010). **Fertility Rate** United Nations Population Division (2009). **Life Expectancy** CIA World Factbook (2009). **Gross National Income*** United Nations Population Division. World Bank, World Development Indicators online (2008). **Health Expenditure*** World Health Organization (2006). **Total Health Expenditure*** World Health Organization (2006). **Overweight** World Health Organization (2005). **Obesity** World Health Organization (2005). **Undernourished*** World Resources Institute (2003-2005). **Diabetes*** World Health Organization (2003). **Meat Consumption** World Resources Institute (2002). **Alcohol Consumption** World Health Organization (2003). **Tobacco Use*** World Health Organization (2005). *Greenland figures from Greenland's Department of Health.*

SOURCES FOR OPPOSITE PAGE • **Australia** Australian Government, Department of Health and Ageing (2008); CIA World Factbook (2009) • Australian Bureau of Statistics (2009) • Kangaroo Industries Association of Australia (2008) • Government of Western Australia, Department of Agriculture (2009) • Australian Government, Australian indigenous cultural heritage website (2008). **Bangladesh** International Labor Organization and UNICEF (2008) • Food and Agriculture Organization of the United Nations database (2006). **Botswana** The World Bank Group, Botswana at a glance (Dec. 2009) • World Bank World Development Indicators database (2009) • International Telecommunications Union (2007). **Brazil** www.adherents.com • www.rainforests.mongabay.com • Greenpeace Brasil (2009). **Canada** Canadian Fitness and Lifestyle Research Institute (2008) • www.unitednorthamerica.org • Human Resources and Skills Development Canada (2006) • *Canadian Medical Association Journal* 182(3):249-256. **Chad** CIA World Factbook (2005) • World Bank World Development Indicators database (2007) • World Bank World Development Indicators database (2009) • **China** China Btrax White Papers, "China Web Trends" (2008) • Internet Network Information Center (2009) • United Nations data, contraceptive prevalence rate (2007) • Food and Agriculture Organization of the United Nations, Food Outlook online (Dec. 2009). **Ecuador** United Nations Development Programme (2001) • Simkin, T., and L. Siebert, *Volcanoes of the World*, Geoscience Press (1994). **Egypt** *Financial Times* (Dec. 11, 2006) • *National Geographic Atlas of the World* (2004) • National Geographic News online (Jan. 8, 2008). **Germany** www.beers.co.uk • Federal Agency for Agriculture and Food, Federal Association of the Meat Products Industries, Fraunhofer Institute, CMA (2006) • *The Guardian* (Jan. 23, 2009). **Great Britain** Global Market Information Database, published by Euromonitor (continued on page 332)

WHAT I EAT

AUSTRALIA

World rank in skin cancer: 1

Population (in millions): people, 21; beef cattle, 25; kangaroos, 25; sheep, 79

Number of years by which Aboriginal settlers from Southeast Asia preceded Europeans: 50,000

BANGLADESH

Migration to Dhaka each year: 300,000-400,000

Children (age 5-14) who work: 13% (about 8.3 million)

Orphans (age 0-17): 5,000,000

Food expenditures as a percentage of income: 66%

Calories from rice as a percentage of calories consumed: 71%

BOTSWANA

HIV rate (age 15-49): 24%

Largest export industry in 2008: diamonds, $3,358,000,000 (USD)

Mobile cellular subscriptions per 100 people: 76

BRAZIL

World rank in Christian religion in 1997: 2

Forest loss, 1990-2005: 8.1%

Deforested land in the Brazilian Amazon used for cattle ranching: 79.5%

CANADA

Adults who are physically inactive: 51%

Tax receipts as a percentage of GDP in 2005: 33.4% (U.S. = 27.3%)

Aboriginal population: 3.8%

Saskatchewan native population with diabetes in 1937: 0%; in 1990: 10%; in 2006: 20%

CHAD

Arable land: 3%

Population with access to electricity: <2%

Portion of roads that are paved: <1%

Number of TVs per 100 households: 2

Adult illiteracy rate: 73% (male), 76% (female)

CHINA

Number of Internet users in 2009: 338 million

Increase in number of Internet users, 2000-2008: 1,024.4%

World rank in use of contraceptives: 2

Portion of world's 1 billion pigs: 70%

ECUADOR

Indigenous population: 40%

Number of active volcanoes: 16

EGYPT

Workers employed in the tourism industry: 12.6%

Population living along the Nile River: 95%

Portion of land that is desert: 95%

GERMANY

Annual per capita beer consumption in 1997: 33.5 gallons; in 2009: 28.9 gallons

Annual per capita pork consumption: 85.8 pounds

Calorie intake from meat and meat products: 39%

GREAT BRITAIN

World rank in tea consumption: 1

Number of fish and chips vendors: 10,500

Number of McDonald's restaurants in 2006: 1,250

GREENLAND

World rank in least densely populated countries: 1

Arable land: 0%

Portion of global ice mass located in Greenland: 10%

Average thickness of ice cap (which covers 80% of the land): 1.4 miles

Native Inuit population: 96%

ICELAND

Workforce employed by the fishing industry: 7%

Export income from the fishing industry: 40%

Land covered by glaciers: 11%

INDIA

World rank in wheat production: 2

Number of call center workers in 2003: 160,000; in 2008: 1.3 million

Portion of world's cattle: 28.3%

IRAN

Military spending as a percentage of GDP in 2006: 3.5%

Population that favors normal relations with the U.S.: 77%

World rank in pomegranate production: 1

ISRAEL

Military spending as a percentage of GDP: 7.3%

Weapons per million people: 2,546,600

World rank in spending on research and development as a percentage of GDP: 1

U.S. military aid per day in 2008: $7 million (USD)

ITALY

Population that attends mass weekly: 25%

Number of pizzerias: 25,000

Number of McDonald's restaurants in 2004: 290

JAPAN

World rank in life expectancy at birth: 1

Average number of cigarettes smoked per adult annually: 3,023

Annual per person consumption of seafood: 136 pounds

KENYA

Coffee crop lost due to disease caused by unpredictable weather in 2007-2008: 23%

World rank in tea export: 1

LATVIA

Mobile cellular subscriptions per 100 people: 99

Ethnic Russian population: 29.6%

MEXICO

Drop in price of corn in Mexico, 1994-2001: 70%

Number of agricultural jobs lost due to NAFTA: 1.3 million

Annual per capita tortilla consumption: 175.4 pounds

World rank in per capita Coca-Cola consumption: 1

NAMIBIA

Population living on less than $2 (USD) per day: 62%

Contribution of diamond mining to GDP: 8%

RUSSIA

Gallons of alcohol consumed per person per year: 7.1

Deaths among Russian working-age men attributable to alcohol-related causes: 43%

SPAIN

Portion of world's olive oil produced in Spain: 36%

Decrease in per capita wine consumption, 1987-2004: 39%

Increase in per capita consumption of nonalcoholic beverages, 1987-2004: 73%

TAIWAN

Number of registered food stalls: 234,097

Annual per capita seafood consumption: 81.6 pounds

Average number of registered motorcycles per household: 1.9

TIBET

Population in Tibet Autonomous Region in millions: people, 2.9; yaks, 4

Increase in Chinese non-Tibetan population, 1990-2000: 92.2%

Tibetans who are nomadic herders: 25%

Energy released (in kcal) by burning 1 pound of coal: 1,225; dried yak dung: 1,500; wood: 1,588

USA

Food in the supply chain that is wasted: 40%

Farmers' share of the retail food dollar in 1973: 40%; in 2000: 20%

Increase in gastric bypass surgeries, 1993-2003: 600%

Number of hours of daily media use by children (age 8-18): 7.6

Annual health costs due to diet-related diseases: $120 billion

VENEZUELA

World rank in oil reserves: 6

Population living below the poverty line: 37.9%

Number of murders per year in Caracas: 5,200

VIETNAM

Calories from rice as a percentage of calories consumed: 65%

Annual per capita rice consumption: 48.9 pounds

YEMEN

Population living on less than $2 (USD) per day: 46.6%

Portion of income the average qat consumer spends on qat: 10%

GDP accounted for by qat production: 6%

Working Yemenis engaged in qat production: 14%

Sources

SOURCES FOR STATISTICS (continued from page 330) • **Great Britain** The Independent online (Jan. 10, 2010) • BBC News online (Feb. 28, 2006). **Greenland** www.fact-index.com • CIA World Factbook (2005) • U.S. Geological Service (2009) • *New Book of Popular Science*, vol. 2, Grolier (1996) • Statistics Greenland, *Greenland in Figures* (2009). **Iceland** CIA World Factbook (2007) • *National Geographic Magazine* (Mar. 2008). **India** USDA Economic and Statistics System (2000-2001) • www.spectrumcommodities.com • www.stanford.wellsphere.com • www.cattlenetwork.com (2008). **Iran** www.globalsecurity.org • *Washington Post* (June 15, 2009) • www.uasd.edu/pomegranatesymposium (2009). **Israel** CIA World Factbook (2006) • Washington Report on Middle East Affairs (Nov. 2008) • Congressional Research Service Report on U.S. Foreign Aid to Israel (Dec. 4, 2009). **Italy** *New York Times* (Apr. 19, 2005) • BBC News online (Feb. 4, 2010) • www.nationmaster.com. **Japan** World Health Organization (2004) • CIA World Factbook (2009) • Greenpeace fact sheet, "The Whale Meat Market in Japan" (2009). **Kenya** Reuters online (Feb. 11, 2010) • *Daily Mirror* (Feb. 25, 2010). **Latvia** International Telecommunications Union (2007) • CIA World Factbook (2008). **Mexico** Women's Edge Coalition (2004) • Oxfam Briefing Paper, "The Rural Poverty Trap" (June 2004) • www.cnnexpansion.com (Feb. 13, 2010) • Coca-Cola Company annual report (2009). **Namibia** Population Reference Bureau, "World Population Data Sheet" (2009) • U.S. Department of State, Bureau of African Affairs (2010). **Russia** Pravda online (Sept. 11, 2006) • *Lancet* 369(9578):2001-2009. **Spain** United Nations Conference on Trade and Development (2005) • Spanish Wine Federation (2005). **Taiwan** Directorate-General of Budget, Accounting, and Statistics, Executive Yuan • Agriculture and Food Agency, Council of Agriculture, Executive Yuan (2007) • Ministry of Transportation and Communications. **Tibet** China's Tibet Facts and Figures (2002) • http://tibet.news.cn • National Bureau of Statistics of China (2006) • www.factsanddetails.com (2008) • *Developments in Quarternary Sciences* 9:205-224 • "Small-Scale Forest Enterprises" (*Unasylva* 157/158). **USA** Laboratory of Biological Modeling, National Institute of Diabetes and Digestive and Kidney Diseases (Nov. 2009) • USDA Economic Research Service, Price Spreads from Farm to Consumer online Briefing Room (Feb. 2007) • www.bariatric-surgery.info • Kaiser Family Foundation (2010) • Corporate Accountability International. "Fast Food Giants Urged to Value [the] Meal" (Mar. 11, 2009). **Venezuela** CIA World Factbook (2009) • CIA World Factbook (2005) • www.cnn.com (Dec. 31, 2008). **Vietnam** International Rice Research Institute. "Rice Calorie Supply as a Percentage of Total Calorie Supply" (2005) • International Rice Research Institute. "Rice Consumption per Capita" (2008). **Yemen** Human Development Report (2009) • World Bank Sustainable Development Department, Middle East and North Africa Region (2007).

SOURCES FOR FOOD LISTS • **USA** USDA. National Nutrient Database for Standard Reference. www.ars.usda.gov/ba/bhnrc/ndl (2009). **Canada** Health Canada. Canadian Nutrient File. www.healthcanada.gc.ca/cnf (2007b version) • McGill University's Centre for Indigenous Peoples' Nutrition and Environment. Traditional Food Composition Nutribase. www.mcgill.ca/cine/resources/nutrient (2010). **Germany** Max Rubner-Institut. Bundeslebensmittelschlussel (German Nutrient Database). www.blsdb.de (2005-2010). **Taiwan** Department of Health. www.doh.gov.tw (2009). **China** Centre for Food Safety, Government of the Hong Kong Special Administrative Region. Nutrient Information Inquiry System. www.cfs.gov.hk (2010). **France** French Food Safety Agency, French Data Centre on Food Quality. French Food Composition Table. www.afssa.fr/TableCIQUAL (2008). **Denmark** National Food Institute, Technical University of Denmark. Danish Food Composition Databank. www.foodcomp.dk (2009). **Israel** Ben Gurian University of the Negev, the Faculty of Health Science. Israeli Food Nutrient Database. http://web.bgu.ac.il/Eng/fohs/ResearchCenters/Nutcent/israeliFood.htm (2007). **Italy** Food Composition Database for Epidemiological Studies in Italy (Banca Dati di Composizione degli Alimenti per Studi Epidemiologici in Italia). www.ieo.it/bda2008 (2008). **Japan** Ministry of Education, Culture, Sports, Science, and Technology (MEXT). Food Composition Values, Resources Survey Report Subcommittee. www.mext.go.jp/b_menu/shingi/gijyutu/gijyutu3/toushin/05031802/002.htm. **Other** Food and Agriculture Organization of the United Nations historical tables (online) • Spreer, E. *Milk and Dairy Product Technology*. Marcel Dekker (1998) • Tamang, J. P. *Himalayan Fermented Foods: Microbiology, Nutrition, and Ethnic Values*. CRC Press (2010) • McGee, H. *On Food and Cooking*. Scribner (2003) • Batmanglij, N. *The New Food of Life: A Book of Ancient Persian and Modern Iranian Cooking and Ceremonies*. Mage Publishers (2003) • Davidson, A. *The Oxford Companion to Food*. Oxford University Press (2003) • Kent, N., and A. Evers. *Technology of Cereals*. Elsevier Science (1994).

SOURCES FOR TEXTS AND CAPTIONS • **Australia** Beach count: Australian Government, Culture Portal (2008) • Incidence of skin cancer: Australian Government, Department of Health and Ageing (2008). **Bangladesh** Population: www.dhakacity.com.bd • Population in substandard housing: *Daily Star* (Sept. 2009) • Flooding: National Geographic News online (Aug. 27, 2009) • Clothing exports: International Textiles and Clothing Bureau (2007) • Buriganga River pollution: www.asiawaterwire.net (Sept. 11, 2006) • BRAC: www.brac.net • Grameen Bank: www.grameen-info.org • Environmental impact of nylon bags: New Age National online (Jan. 27, 2007). **Botswana** HIV infection rates: University of California San Francisco, HIV InSite (2009) • World Health Organization. "Epidemiological Fact Sheet on HIV and AIDS" (2008) • UNAIDS fact sheet. "AIDS in Sub-Saharan Africa" (2009). **Brazil** Solimoes River: Encyclopaedia Britannica online • Amazon river system: earthobservatory.nasa.gov • Brazilian fruits: www.hort.purdue.edu • Rural pension fund: Maybury-Lewis, B. *The Politics of the Possible: The Brazilian Rural Worker's Trade Union Movement, 1964-1985*. Temple University Press (1994) • Manioc flour: Jones, W. O. *Manioc in Africa*. Stanford University Press (1959) • Alfavaca: Quattrocchi, U. *CRC World Dictionary of Plant Names*. CRC Press (2000). **Canada** World's highest wine cellar: www.cntower.ca • Alcoholism in Nunavut: Canadian Centre on Substance Abuse • Nunavut Planning Commission: www.nunavut.ca. **Chad** Breidjing camp: Braker, K. "Sudanese Refugees in Chad: One Year On." www.doctorswithoutborders.com (Nov. 10, 2004) • Size of camps: UN Refugee Agency (2004). **China** Internet users: Buckley, C. "China Internet Population Hits 384 Million." Reuters online (Jan. 15, 2010) • Collectivism: Zhou, M. "Continuation, Transition, and Challenge: Collectivism in China after 1949." *Switch* (Jan. 2002) • KFC: www.yum.com • Nutrition: Lang, S. "Chinese Child Nutrition Study Shows Reform Benefits Lagging in Rural Areas." *Cornell Chronicle* 27(43). **Ecuador** General information: Weismantel, M. J. *Food, Gender, and Poverty in the Ecuadorian Andes*. Waveland Press (1998) • Effects of smoke: *American Journal of Tropical Medicine and Hygiene* 76(3):585-591. **Egypt** Standard of living: CIA World Factbook (2010) • Camel facts: "Camels and Dromedaries." www.livius.org. **Germany** German Beer Purity Law: Trade and Environment Database (1997) • Reinheitsgebot: www.german-way.com • German master baker program: www.baecker-berlin.de • Bakers in decline: German Federation of Bakers (2007) • Breads: www.germanfoodguide.com • Sausages: www.germanfoods.org • Association of the Black Forest Ham

Manufacturers: www.schwarzwaelder-schinken-verband.com • Meat consumption: The Local online (Jan. 22, 2009). **Great Britain** Amphetamines: Encyclopaedia Britannica online • www.health.discovery.com. **Greenland** Ittoqqortoormiit town: www.eastgreenland.com • Kalaallit: www.thewe.cc/weplanet/poles/mastkala.html. **Iceland** Natural resources: CIA World Factbook (2010). **India** Kumbh Mela: Encyclopaedia Britannica online • Shivambu: Sharma, S. K. *Miracles of Urine Therapy*. Diamond Pocket Books (2005) • Rickshaw wages: www.dare.co.in/opportunities/idea/micro-financing-cycle-rickshaws.htm • AOL in Bangalore: www.cnet.com (July 16, 2003). **Iran** Health effects of hookah: Asotra, K. "What You Don't Know Can Kill You." *Tobacco-Related Disease Research Program Newsletter* 7(1) • Subsidized commodities: Food and Agriculture Organization of the United Nations, Resources for Advancing Nutritional Well-Being. "Nutrition in Agriculture" (2001) • Badgirs: www.depts.washington.edu/silkroad/cities/iran/yazd/yazd.html • Gonbads: Amirahmadi, H. *Small Islands, Big Politics: The Tonbs and Abu Musa in the Persian Gulf*. St. Martin's Press (1996) • Qanats: www.waterhistory.org. **Israel** History: CIA World Factbook (2010) • Kashruth: Dresner, S. H. *Keeping Kosher: A Diet for the Soul*. Burning Bush Press (2000) • Nathan, J. *The Foods of Israel Today*. Knopf (2001) • Shihab, A. *A Taste of Palestine*. Corona Publishing (1993) • Halal-food certification: Islamic Food and Nutrition Council of America. **Italy** Servite order: www.servidimaria.org. **Japan** Musashigawa Beya: www.musashigawa.jp • Sumo terms: www.sumotalk.com • T-serv: twev.t-serv.co.jp. **Kenya** Masai Mara National Reserve: www.maratriangle.org • Major ethnic groups: U.S. Department of State, Bureau of African Affairs (Jan. 2010) • Population of Kibera slum: Kibera Slum Foundation • Umande Trust: www.umande.org • Toilet malls: "Entrepreneurs Tackle Sanitation in Africa." www.us.oneworld.net (Mar. 2, 2009) • Kenya Tea Development Agency: www.ktdateas.com. **Latvia** Among poorest countries in EU: "Europe's Poorest Countries Set to Forfeit Aid Money." Deutsche Welle online (Sept. 9, 2009) • Declining population: Iwaskiw, W. R. (ed.). *Latvia: A Country Study*. Library of Congress (1995) • Song and Dance festival: www.dziesmusvetki2008.lv. **Mexico** Diabetes and the Pima: National Institute of Diabetes and Digestive and Kidney Diseases. "Obesity and Diabetes" (2002) • Schulz, L. O., P. H. Bennett, E. Ravussin, et al. "Effects of Traditional and Western Environments on Prevalence of Type 2 Diabetes in Pima Indians in Mexico and the U.S." *Diabetes Care* 29(8) • Disconsa: www.diconsa.gob.mx. **Namibia** General information: Malan, J. S. *Peoples of Namibia*. Rhino Publishers (1995) • Fage, J. D., and R. Oliver. *The Cambridge History of Africa*. Cambridge University Press (1975) • Bollig, M. *Risk Management in a Hazardous Environment*. Springer (2006) • "The Technology of Traditional Milk Products in Developing Countries." FAO Animal Production and Health Paper (1990) • Diamond polishing: Whitlock, H. P. "How Diamonds Are Polished." *Natural History* (May-June 1921) • Diamond cutting: American Institute of Diamond Cutting • Diamonds and the economy: CIA World Factbook (2010) • Etosha National Park: www.namibian.org/travel/namibia/etosha.htm. **Russia** Destruction of relics: Solomon, A. "The Spoils of War." *New York Times* (Oct. 22, 1995) • The Peterhof Palace: www.thepeterhofpalace.com • Churches and museums: www.saint-petersburg.com. **Spain** Pastoral dominance: Easton, B. "The European Economy: A History." Te Ara, the Encyclopedia of New Zealand online (Mar. 2009) • Rural population: United Nations World Urbanization Prospects (Feb. 2010) • Bullfighting: Shubert, A. *Death and Money in the Afternoon: A History of the Spanish*. Oxford University Press (1999). **Taiwan** Luwei: Taipei Times online (June 4, 2004) • Taipei 101: "Taiwan Tops Out Tallest Building." BBC News online (Oct. 17, 2003) • Seafood consumption: Agriculture and Food Agency, Council of Agriculture, Executive Yuan (2007). **Tibet** Food: Dorje, R. *Food in Tibetan Life*. Prospect Books (1985) • Yak species: Leslie, D. M., and G. B. Schaller. "*Bos grunniens and Bos mutus*." *Mammalian Species* 836:1-17 • Briefings on Tibet: Environment and Development Desk, Central Tibetan Administration (www.tibet.net). **Venezuela** Murder capital: Brice, A. "No Surprise Caracas Named 'Murder Capital of the World.' " www.cnn.com (Dec. 31, 2008) • National oil company: www.pdvsa.com. **Vietnam** The American War: Le, C. N. "The American/Viet Nam War." www.asian-nation.org • Pollution: Fuller, T. "Air Pollution Fast Becoming an Issue in Booming Vietnam." *New York Times* (July 6, 2007) • Growing population: Cambridge Encyclopedia online (vol. 77) • Urbanization: Vietnam Financial Review, Ministry of Finance (May 2008) • Floods ruining rice crops: "Rains, Mekong Floods Threaten Vietnam Rice Harvest." Reuters online (July 23, 2009). **Yemen** Food and culture: Yemen Times online • CIA World Factbook (2010) • Qat: World Bank Sustainable Development Department, Middle East and North Africa Region (2007). **USA** • **Arizona** Water rights: Lewis, R. B., and J. T. Hestand. "Federal Reserved Water Rights: Gila River Indian Community Settlement." *Journal of Contemporary Water Research and Education* (May 2006) • Gila River Indian Community: www.gilariver.org • Pima and obesity: National Institute of Diabetes and Digestive and Kidney Diseases. "Obesity and Diabetes" (2002) • Pima and Disease: Russon, C., J. Horn, and S. Oliver. "A Case Study of Gila River Indian Community (Arizona) and Its Role as a Partner in the NSF-Supported UCAN Rural Systemic Initiative (RSI)" (2002). **California** Stand-up paddle surfing: Dixon, C. "Whatever Size the Wave, Some Surfers Reach for the Paddle." *New York Times* (Apr. 13, 2007) • Mamaliga: Webb, L. S. *Holidays of the World Cookbook for Students*. Oryx Press (1995) • Umami: www.umamiinfo.com. **Illinois** Devon Avenue: Koval, J. P. *The New Chicago: A Social and Cultural Analysis*. Temple University Press (2006) • Type 2 diabetes: www.mayoclinic.com • Little Village: www.chicago.com/neighborhoods • Polycystic ovary syndrome: www.mayoclinic.com • National Institute of Food and Agriculture: www.csrees.usda.gov/index.html • Farm demographics: United States Environmental Protection Agency, Ag 101 (2009). **Kentucky** Continuous mining: United States Department of Labor, Bureau of Labor Statistics (2008). **Maine** Portland Fish Exchange: www.pfex.org. **Minnesota** Mall of America: www.mallofamerica.com. **New York** Camp Shane: www.campshane.com • Food pantries for the homeless: www.coalitionforthehomeless.org. **Pennsylvania** Calorie restriction studies: Payne, A. M., S. L. Dodd, and C. Leeuwenburgh. "Life-Long Calorie Restriction in Fischer 344 Rats Attenuates Age-Related Loss in Skeletal Muscle-Specific Force and Reduces Extracellular Space." *Journal of Applied Physiology* 95(6) • Filamentous fungi: Program for the Biology of Filamentous Fungi, Texas A&M University (pboff.tamu.edu). **Tennessee** Obesity and gastric bypass: www.mayoclinic.com • Bariatric surgery: Weight-Control Information Network, National Institute of Diabetes and Digestive and Kidney Diseases (2009). **Texas** NASA mission, food history, and general information: www.nasa.gov • Weightlessness in space: www.jamesoberg.com • Fort Hood: www.globalsecurity.org • Medina Wasl: "Fighting Insurgents in Baghdad, USA." Times Online (Oct. 5, 2008). **Virginia** Salatin, J. *Everything I Want to Do Is Illegal: War Stories from the Local Food Front*. Polyface (2007) • Sustainable agriculture: University of California Agriculture and Natural Resources, Sustainable Agriculture and Education Program (2010) • Local food: www.slowfoodusa.org.

Index, additional sources, and recommended reading: www.aroundtheworldin80diets.com

Ricki the chimp with his typical day's worth of food. His owners, Pam Rosaire-Zoppe and Roger Zoppe say that he likes fresh fruits and vegetables, and an occasional yogurt drink, far more than packaged monkey chow. Photographed at the Bailiwick Ranch and Discovery Zoo, in Catskill, New York.

All photographs copyright © Peter Menzel, except for photo of cattle carcasses in Kenya
© Michael Santeto Tiampati, page 22; and photos of space shuttle liftoff and
astronauts in space © NASA, pages 134–137.

Distributed in the United States by Ten Speed Press, an imprint of the Crown Publishing Group,
a division of Random House, Inc., New York.

www.crownpublishing.com

www.tenspeed.com

Ten Speed Press and the Ten Speed Press colophon are registered trademarks
of Random House, Inc.

Cataloging-in-Publication data is on file with the publisher.

ISBN 978-0-9840744-0-2

Printed in Singapore

10 9 8 7 6 5 4 3 2 1

First Edition

Acknowledgments

A Buddhist pilgrim prostrates herself and prays in front of the Jokhang Monastery in Lhasa, Tibet.

We dedicate this book to our beloved parents and children: Ellie and Howard, Susan, Nick and Mary, Josh and Kei, Jack and Juliet, Adam, Evan, and Emma.

Our heartfelt thanks to the people and families who opened their homes, hearts, and refrigerators to make this book possible. Thanks as well to our translators who worked tirelessly both during and after the fieldwork. In addition, we couldn't have researched, reported, photographed, and assembled this book, whose subjects live in 30 countries and more than a dozen U.S. states, without the help of hundreds of people. We are grateful to them all, especially the following:

Design • David Griffin
Chief editorial assistant • Kendyll Naomi Pappas
Copyeditor and chief proofreader • Jasmine Star

External editorial associates • Peter C. Hubschmid, Joshua D'Aluisio-Guerrieri
Editorial assistant • Emma S. D'Aluisio
Nutritionists • Colette LaSalle, RD; Mary Nicole Regina Henderson, MS, RD
Office staff • Sheila D. S. Foraker, Colleen Leyden D'Aluisio
Editorial assistance, former staff, and other helpful sorts • Peter Rossomando, Adam Guerrieri, Evan Wright Menzel, Bo Blanton, Laura Arnold, Aaron Kehoe, Luiza Trabka, Daniel Tkach, Leonore Wilson, Kathryn Quanstrom, Dr. Lorenzo Mills, Laura and Susan D'Aluisio
Esteemed editorial consultants • Charles C. Mann, James Conaway

Ten Speed Press • Julie Bennett, Melissa Moore, Aaron Wehner, Mary Ann Anderson, Nancy Austin, Nicole Geiger, Lisa Regul
Postproduction • Bryan S. Bailey Photographic Services; Peter Truskier, Premedia Systems; Eric Lompa and Todd Takaki, ScanArt
GEO • Peter Mattias-Gaede, Ruth Eichhorn, Venita Kaleps

Essayists • Wendell Berry, Mary Collins, Michael Pollan, Ellen Ruppel Shell, Bijal P. Trivedi, Richard Wrangham, Lisa R. Young

Foreword contributors • Ferran Adrià, Dan Barber, Mark Bittman, Frank Bruni, Tim Cahill, T. Colin Campbell, Francis Coppola, Jonathan Gold, Jane Goodall, Hendrik Hertzberg, Kevin Kelly, Graham and Treena Kerr, Corby Kummer, Jack LaLanne, Harold McGee, Sally Fallon Morell, Marion Nestle, Dean Ornish, Ruth Reichl, David Servan-Schreiber, Amy Tan, Alice Waters, Andrew Weil, Walter Willett, Richard Wrangham, Richard Saul Wurman
Foreword facilitators • Dana Wolfe, Michael Hawley, Melanie Lawson, Pam Hunter, Rick Smolan, Anna Sever, Maria and Rob Sinsky

Australia
Australian Professional Ocean
Lifeguard Association

Vic Cherikoff
Norma Malloy, Emerald City
Images (www.emeraldcity
images.com.au)

Bangladesh
Translator • Mahmudul
Hasan
(rajibexe@yahoo.com)

Jahangir Alam
Pushpita Alam, BRAC
Syed Ishtiaq Alam
Ambrosia Guest House
Hosne Ara
Renu Begum
Ismail Hossain
Iqbal Anwarul Islam

M. D. Azadul Ismal (Pavel)
Alice Jian
Farzana Kashfi
Jalil Matbor
Shahriar Tofael
Abdullah Al Mohammad Yasin
Asif Zahir, Ananta Apparel

Botswana
Translator • Outhuritse
Rinouaro Kulanga

Translation assistance •
Thimo Tjiramanga

Pastor Johannes Kahuadi, the
Window of Hope Center in
Ghanzi

Beauty Kennetseng
Teresa Mcad
Kitso Moahi
Mesti Ratalia

Brazil
Translator • Jose Antonio
Cunha Assunção Assunção,
Amazon jungle guide (www.
wildtrack.com.br)

Mac Agustinho Cardoso
Francisco Lopes Correia
Franciso Rios
Manuel Rios
Edson dos Santos Rios
Maria Elina dos Santos Rios

Canada
Muna Ali
Khadra Ali
Uban Ali
Famdumo Ibrahim
Antonio E. De Luca, *the
Walrus magazine*

Kirk and Anna Finken
Danielle Roy
Peter George, CN Tower
Rob Groh
Irene Knight
Natalie Matutschovsky
Leanne Wright
Moses Znaimer, ideaCity

Chad
Translators • Abakar Saleh
and Khamis Hassan Jouma

Office of the United Nations
High Commissioner for
Refugees:
Jean Charles Dei
George Harb
Guy Levine
Stefano Porretti
Colin Pryce

China
Translator • Joshua D'Aluisio-
Guerrieri (www.entim.net)

Li Genlian and Jiang Zheng-
ping, Shanghai Circus World

Yang Haijuan
Xiang Jiahua
Yang Lijuan
Li Shaofang
Wu Siping
Yang Zhongxiao

Ecuador
Translator • Oswaldo Muñoz,
Nuevo Mundo Expeditions
(www.nuevomundo
expeditions.com)

Orlando Ayme
David Muñoz
Pablo Corral Vega

WHAT I EAT

Egypt
Translator • Mohamed Khalel
Translation assistance •
Claudia Wiens

Paul Bahna

France
Annie Boulat, Cosmos Agency
(www.cosmosphoto.com)

Isabelle and Pierre Gillet
Nicolas Vinatier

Germany
Translator • Venita Kaleps
Margot Klingsporn,
Focus Agency
(www.agentur-focus.de)

Christiane Breustedt
Franzska Breyer
Peter Dirr
Sonja Dirr
Maximilian Erlmeier
Martin Ginter
Peter Ginter

Great Britain
Michael Marten, Simon
Stone, and Rose Taylor of
Science Photo Library
(www.sciencephoto.com)

Charlie Boniface
Earl, Toni, and Bella Gillespie

Greenland
Karina Bernlow and Martin
Monk, Nanu Travel
(www.nanutravel.dk

Iceland
Translator • Lynda Gunn-
laugsdóttir, and Björn
Thoroddsen

India
Translators • Neha and Vinay
Diddee

Meera and Mamta Kailash
Rajesh Kamat
Sameena Khanam, Aegis
Abhik, Tashi, and Tara Mitra
Sangeeta Patkar
Kuldeep B. Rane
Pulin Sasmal
Santosh Kumar Singh

Iran
Translator • Hassan Azadi
(hassanazadi@yahoo.com)

Mostafa, Mehri, and Ali
Fotowat

Hajreza Sedighi Fard
Nariman Mansouri
Maryam Mohammadi
Mohammed Riahi
Stephan Schwarz
Mahmoud Zareshahi

Israel
Lisa Perlman
Rachel Sabath Beib-Halachmi
Issa Freij
Aaron and Natalie Willis

Italy
Translator • Jennifer Zaida
(lemans.venere@gmail.com)

Fr. Patrick Carroll of Dublin,
Ireland
Grazia and Michele Neri
Giovanni Picchi, Luz Photo
Agency (www.luzphoto.com)

Japan
Translators • Lina Sanae
Wang, Un photo Press Inter-
national (www.uniphoto.co.jp),
and Ayu Suzuki

Mizoguchi Ayako
Peter Blakely
Hideki Fujiwara
Kouichi Hashimoto
Kumiko Ikada
Etsuji Isozaki
Kenji Matsumoto
Ayako Mizoguchi
Takuya Mizuhara
Masako Mizuhashi
Kaori Mori
Masaru Ode
Toyoo Ohta, Uniphoto
Kayoko Sairo
Keiko Sasaki
Yusuke Yamaoka and T-serv

Kenya
Translator • Michael Santeto
Tiampati (tiampati@hotmail
.com)

Priscilla Chebwogen
Hakilssa Kamuye
Emily Koros
John Kipkoros Langat
Nancy Langat
Kennedy Mbori
Emily Naini
George Owiti
David Kipkoech Ruto
Chief Sammy (Kipanoi Ole
Tarakuai)

Alice Musunkui Tarakuai
Sanaet Tarakuai
Moonte Tarakuai
Margaret Sompet Tarakuai
Reut Tarakuai
Kinyikita Tarakuai
Joel Tumate

Latvia
Translator • Irēna Muļica
(irena.mulica@gmail.com)

Venita Kaleps
Ingrida Gulbe-Otaņķe
Ilona, Linda, Ieva, and
Madara Radziņš

Mexico
Translator • Ana Cristina
Gallegos Aguilar

Bertha Pachero Moreno
Rosario Caraveo
Esthela Jimenez Contreras
Ángel Gustavo Galaviz
Jimenez

Favian Edriel Galaviz Jimenez
Osvaldo Galaviz Jimenez
Jay Koedaa
Manuel Peyez
Mauro E. Valencia, PhD,
Centro de Investigación en
Alimentación y Desarrollo, AC

Namibia
Translator •Thimo Tjiramanga
(Ttjiramanga@yahoo.com.na)

Logistical assistance and
insight • Tawanda Kanhema
(Kanhema@gmail.com)

P. G. Bille, professor of food
and science at the University
of Namibia

Mukoohirumbu
Muningandu
Lesley Tjikuzu
Sandra Tjiramanga
Aumacky Uahoo
Uariinani
Uekuta
Uhlander Guest House

**Palestinian Territories and
East Jerusalem**
Munira, Mohammad, Jinan,
Mariam, Maram, and Habib
Razem

Russia
Translator • Mikhail "Mick"
Yagupov (retroeffective@
gmail.com)

Hans-Juergen Burkard
Larissa and Anton
Grankovskiy

Spain
Translators • Beatriz
Zunzunegui, Anna Sever
Roubène, Nicolas
Linares Sever

Anna Sever Agency,
(www.asa-agency.com)

Bea Belen
Juan Linares
Laura Ramírez
Maria Jesus Santos

Taiwan
Translators • Joshua D'Aluisio-
Guerrieri (www.entim.net) and
Kei (Hui-ling Sun)

Tibet
Translator • Buchung
Dowa (Dadrung)
Choe Ney Drukar
Tsul Tim Khamu
Muru Nyachung Monastery
Nyema Dun Drup
Brent Olson, Geographic
Expeditions
(www.geoex.com)

Phurba
Wangchung
Thanks to our monastery
friends. Be safe.

United States

Arizona
Clifton Bogardus
Gary Karademos
Ellie Menzel
Eric Ravussin
Judy Rusignuolo
Jourene, Yvana, and Jovan
Soto

Mary Tatum

California
Larry, Maria, and Ben Adams
Richard Beam
Joey Chestnut
Chris Colin
Jonathan Gold
Laurie Ochoa
Adrian Grannum
Philip Greenspun
Valerie Hunter
Andie Johnson
Evan and Jack Menzel
Dr. Lorenzo Mills
Marissa Mills Carlisle
Amy Stander
Adriana Arriaga and Maya

Fort Irwin:
Manah Ali A alaq
Captain Lindsey Dane
Ken Drylie
Tim Hailey
John M. Wagstaffe

Colorado
Andrew Nikkari
Karen Sherman Perez

Illinois
Oscar and Alejandra Alvarez
Laura Lee Barrette
Gloria Ciaccio
Jesse DeSoto
Mike Foran
Jesus Lopez
Vicente Martinez

David Mosena,
Anne Rashford, Jennie
Kimmel, Patricia Ward,
of Museum of Science and
Industry

Denise Stine
Kate Walsh
Jessica Wharton

Kentucky
Wes Addington
Ted Combs
Andy Fields
Jimbo Fleming
Dan Johnson
Christy Kincer
Curtis Scott

Maine
Tina Bridgham
Karen Tucker and the boys

Minnesota
Dan Buettner
Erica Dao, Mall of America
Dave Lee, Rochester Meat
Company

Debbie and Kiara Lester
Rudy Maxa and Ana Scofield
John and Laurie McQuiston
Hokan Miller

New York
David Barber
Father Mike Carnevale, St.
Francis of Assisi Church

Robert Clark, Ten Ton Studio
Robert and Stephanie Crease
David Etterberg, Camp Shane
Mal Nesheim
Irene Hamburger, Blue Hill at
Stone Barn

Dawn D'Aluisio, Ruby and
Luiza Trabka

Rev. Elizabeth G. Maxwell,
Neville Hughes, and Chris
O'Neill, Holy Apostles Soup
Kitchen

Brian Halweil
Pam Rosiare-Zoppe, Roger
Zoppe, and Ricki the chimp

Bailiwick Ranch and
Discovery Zoo

Pennsylvania
April Smith

Tennessee
Connie and Greg
Bumgardener

Paul Lowe
Teresa McCusker and Nicole
M. Yarbrough, Mercy Health
and Fitness Center

Tesa Finn MS, RD and
Tennessee Weight Loss and
Surgery Center, University of
Tennessee Medical Center

Texas
Kylie Clem and Tom Joiner,
NASA

Virginia
Ben Beichler
William Carson "Collard
Green" and Tereasa Hughes

Lucille and Teresa Salatin
Irene and Dean Sarnelle
Andre Wendt

Venezuela
Translator • Nahomi Martinez
(nahomi_m@hotmail.com)

Ciro Marcano
Daniel Niles
Redy Jose Portillo, PDVSA
Oscar Rodriguez and Dario
Vera, PDVSA oil rig chefs

Vietnam
Translator • Do Minh Thuy
(dominhthuy@yahoo.com)

Nguyễn Văn Doanh
Vie Thi Phat

Yemen
Translator • Sami Saleh
Al Saiyani
(www.travelyemen.net)

Carolyn McIntyre
(www.girlscloinarabia.
typepad.com)

Tina Ahrens
Arabia Felix Hotel
Fadhil Haidar and sons
Karim Ben Khelifa
Bashir and Anaia Sabana
Faris Sanabani, *Yemen
Observer*

Dance instructor Jesse Desoto with his typical day's worth of food at the Fred Astaire Dance Studio in Chicago, Illinois. Expanded coverage of the people photographed for *What I Eat* can be found online at www.aroundtheworldin80diets.com, along with complete coverage of others from around the world who don't appear in these pages.

www.aroundtheworldin80diets.com